Some call it a scene, some call it a subculture, some call it a movement, but all of us call it steampunk. What began as a joke of a literary genre in the 1980s became, in the first decade of the twenty-first century, an idea that fundamentally challenges humanity's interactions with its technology.

This anthology collects nearly everything from the first seven issues of SteamPunk Magazine, published between 2007 and 2010. The magazine, like the best of what steampunk has to offer, has always been DIY. The first four issues were published by the anarchist collective Strangers In A Tangled Wilderness in the USA, who were joined by the UK collective Vagrants Among Ruins for issues five through seven. All of us editors have been volunteers for the whole of this project, and without profit as a motivation, no commercial interests have guided our hands.

We've always considered steampunk to be something more than a veneer of brass applied to the mundane status quo of mainstream society. And while I suspect no two of our contributors—or editors—would agree on *exactly* what we'd like to see our movement become, we're proud to be doing our part to keep steampunk punk.

—*Margaret Killjoy*

The cover was illustrated by John Coulthart

Introduction
by Jake Von Slatt

The first talk of *SteamPunk Magazine* blossomed in my inbox in late 2006, shortly after I created my website: *The Steampunk Workshop*. Margaret Killjoy wrote me concerning an idea for an article in the first issue based on a project I had posted about on the site. I was excited that Margaret was highlighting all of the aspects of steampunk that I found most interesting. But even more so, I was excited to meet people that shared a vision of what steampunk could become.

Art by Steven Archer

"I've always been a steampunk, I just didn't know there was a name for it."

I can't tell you how many time I've heard that--hundreds at least. It's a statement that resonates strongly with me, because I have always been this way; I just didn't know what to call it.

Half of what makes steampunk meaningful to me is that half, the half that describes who I am and how I grew up. It describes the past me. The other half, though, is about the future and my journey, about the importance of putting a name to your passion and what happens when you do.

Since a very young age I have been a do-it-yourselfer, a maker, a tinkerer. My first word was not "Mama," or "Papa," but "light," presaging my lifelong fascination with lamps and lighting devices from throughout history. When I was 10 years old I used to trash-pick in my old neighborhood. I'm still an inveterate dumpster diver and trash picker, but back in those day it was something I was mercilessly teased about. But I did it anyway.

One Wednesday evening in the summer (Thursday was trash day) I came across a can filled with what appeared to be the contents of someone's desk. There were bundles of old letters with two-cent stamps featuring engravings of George Washington, there were pencils, one of those round erasers with a brush, an ink blotter, several bottles of ink--some dry, some still liquid--, and about a dozen fountain pens.

I grabbed the whole cache and took it back to my room to see what was worth keeping and what to throw back in the trash. The two-cent stamps didn't have any value in 1971, but they did date the cache of items mostly to the mid nineteen-twenties.

I took those pens to school and started using them in class. I learned the ritual of cleaning them and filling them with ink. I discovered that, when using blue ink, the opacity of the line varied and you could see the stops and starts in your writing. I learned how to use the blotter to soak up ink blots. I also learned to love the feel of the nib on paper; it made writing somehow more worthwhile. And believe me, at that age I did not enjoying writing.

When I was 14 and my bicycle broke I didn't ask my parents for a new bike, I went to the hardware store and bought a brazing torch.

When I was a little older, I got interested in music. I had a cheesy little record player but I wanted something better so I went to the library and got several books on "Hifi" and "Stereo" systems. Our local library had made an investment in such books in the 1950s but had not seen fit to update their collection since. That was okay with me because the cutting edge, state of the art equipment in those books was exactly

the same stuff that was showing up in the garage sales and in the trash of my neighbors.

So I became an expert in 25-year-old music reproduction technology. I built my own speakers in wood shop at my school, refurbished a pair of EICO HF-20 tube amplifiers, and teamed them with a Garrard Model 88 turntable. It sounded good. In fact, those tube amps are sought after today and command a high price, but back then they were about $10 each at garage sales.

Using and listening to these components was a 1950s experience: the smell of the hot tubes, the weight of the tone arm, the massive size of the base reflex speakers were all things from the past even though it was Blondie's *Eat to the Beat* spinning on the platter.

That's what we do as steampunks: we mine the midden yards of history for artifacts and ideas that are relevant to our lives today but also provide some connection to our past. And we do this with ideas just as easily as we do it with objects.

I've continued throughout my life to repair and create all manner of things. Just prior to the turn of this century I began to share some of my projects online and in 2004 I embarked on what was my most ambitious project yet, the conversion of an old school bus into a family camper. I had decided that I wanted to create the feel of a New England seashore cottage, something from the 19th century the had survived relatively unchanged into the present. I chose colors and accessories to give my camper a "Victorian" feel.

It was shortly after finishing the camper that I encountered the word "steampunk" used not in reference to a literary form but instead to describe an aesthetic, a style. My passion had a name, and learning that name crystallized and catalyzed my creativity. I started to purposely design and create in a steampunk style.

In the late autumn of 2006 I started a website where I posted pictures and descriptions of some of the projects I had been working on and I was immensely gratified with the response that I received from fellow makers and craftspeople all over the world. I called that website *The Steampunk Workshop*.

What I discovered that fall was that there were a lot of people doing the same thing as I was, but in different media and disciplines. Some people were making clothing, some were creating computer modifications a lot like mine, some were writing stories, some were making music, and some were *living* it. And that brings me to the second half of why steampunk is meaningful to me and how it changed who I am and what I hold dear.

If you're reading this anthology, you are likely aware that the term "steampunk" originally referred to a literary genre, a sub-classification of science fiction that came to popularity in the late 1970s and early 1980s. This literary tradition seems to have planted the seeds for what has become a... well nobody is really sure what to call steampunk, but I'm comfortable with "subculture."

When you start talking about subcultures, their importance, and their ability to "change the world," eyes often start to roll. The dubious response is even more pronounced when one is discussing a subculture whose primary aspect is visual, as is steampunk's. The feeling is that these subcultures are mostly about superficial things like fashion and are therefore not important.

But nobody can deny that involvement in a subculture introduces you to new people, to people that share deep passions and carry those passions into their daily lives. Steampunk introduced me to people who had a different view of many aspects of our world and our society. In many cases these views were at odds with what I grew up believing, or to what I grew up never questioning because they seemed peripheral to my life. The steampunks that I met that influenced me so had taken ideas from the trash bins of history--thoughts on race, class, gender and social mores--and re-contextualized them in a compelling way.

Involvement in subculture introduces people to political thought. I'm not talking about government and elections here, I'm talking about personal politics. The politics of power, race, gender, class, and personal expression. The politics of who you are in the world and how the world responds to you, and how the world pressures you to conform yourself to it. The politics of power for power's sake that largely drives our society and the fact that money looks out for itself. That's the important thing that involvement in the steampunk community did to me and that involvement in subcultures does to people in general: it opens your eyes to new ways of viewing your world.

I am preparing to celebrate my 50th birthday. Fittingly, I'll be doing so in the desert with friends for a week at Burning Man, the yearly celebration of art and freedom that I believe provided the genesis for steampunk as something you make, and make a part of your life, rather than simply something you read or write. I know I will meet many like-minded people on the playa and I feel certain that I'll learn a lot about myself and what I want and need from life.

I'm coming to a new understanding of how the world works, an understanding that I suspect many of you share, only now largely because I didn't really belong to a subculture when I was growing up. Furthermore, going though this process so late in life has given me the perspective and privilege of being able to observe it happening, step by step. It also gives me hope that we as a society are not so firmly locked into our current worldview that we can't change. And finally naming my passion gave me a new family, a tribe, of like minded people that I cherish.

Jake von Slatt
August 8, 2011

Contents:

Issue #1 6	
Issue #2 60	
Issue #3 118	
Issue #4 168	
Issue #5 228	
Issue #6 280	
Issue #7 360	

Interviews:

Michael Moorcock 22
Abney Park 30
Thomas Truax 44
Darcy James Argue's Secret Society 52
I-Wei Huang 80
Alan Moore 138
Dr. Steel 152
Donna Lynch & Steve Archer 192
Ann & Jeff VanderMeer 204
The Chronabelle 242
Voltaire 262
Ghostfire 328
Sunday Driver 404
The Men That Will Not Be Blamed For Nothing 420

Fiction & Poetry:

Mother of the Dispossessed 16
The Catastrophone Orchestra

Yena of Angeline and the Tale of the Terrible Townies, Part One 25
Margaret Killjoy

The Baron 49
J.T. Hand

Uhrwerk: The Incredible Steam Band 74
John Reppion

Mining Medusa 83
Donna Lynch

Unbound Muscle 95
The Catastrophone Orchestra

Yena of Angeline and the Tale of the Terrible Townies, Part Two 109
Margaret Killjoy

The Ornithopter 135
Will Strop

Reflected Light 146
Rachel E. Pollock

A Spark From The Rails 154
Olga Izakson

Yena of Angeline in Sandstorms by Gaslight 159
Margaret Killjoy

A Fabulous Junkyard 183
David X. Wiggin

Doppler and the Madness Engine: Part One 197
John Reppion

The Duel 213
Nicholas Cowley

Antonio's Answer 220
The Catastrophone Orchestra

Steampunk Ad-libs 246
Margaret Killjoy & Usul of the Blackfoot

Dopper and the Madness Engine: Part Two 258
John Reppion

Funny Thing About Horizons 273
J.T. Hand

Of Mice and Journeymen 294
Dylan Fox

The Catch-Valve Journal 302
Austin Dyches

La Lotería de San Leonardo 314
Joshua Gage

Freedom 315
A.M. Paulson

Yena of Angeline in "Lizard Town Woes" 324
Margaret Killjoy

Doppler and the Madness Engine: Part Three 342
John Reppion

The Useless Pistol 255
Leah Dearborn

The Mary Golden 378
C. Lance Hall

Museum 384
Brenda Hammack

Alice's Tumble 396
Katie Casey

The White Rabbit's Other Story 398
Dylan Fox

Liberty 413
C. Allegra Hawksmoor

Non-fiction:

What Then, Is Steampunk?
Colonizing the Past So We Can Dream The Future 10
The Catastrophone Orchestra

The Pyrophone ... 13

Glass Armonica .. 14

Electrolytic Etching 34

The Courage to Kill A King:
Anarchists in a Time of Regicide 40

Earth, Sea, and Sky: Part One 56

To Electrocute an Elephant:
How Edison Killed a Century on Coney Island 66
The Catastrophone Orchestra

Steam Gear: A Fashionable Approach to the Lifestyle 68
Libby Bulloff

Sew Yourself a Lady Artisan's Apron 88
Rachel E. Pollock

The Penny Fakething: The Steampunk's Bicycle of Choice .. 91
Johnny Payphone

The Steampunk's Guide to Body Hair 102

O Coal, You Devil .. 104

Earth, Sea, and Sky: Part Two 114

What, Then, is Steampunk? Steampunk is Awesome! 124

It Can't All Be Brass, Dear:
Paper Maché in the Modern Home 126
B. Zedan

The End Just Well Might Be Nigh, All Told 128

My Machine, My Comrade 140
Professor Calamity

Five-Button Spats .. 142
Rachel E. Pollock

Sew an Aviator's Cap 150
Juli(A)

The Airship of Tomorrow 156
Lord Richard von Tropp

Earth, Sea, and Sky: Part Three 164

For Freedom:
Being the Remarkable Life of One Isabelle Eberhardt ... 175
Esther

Build Yourself A Jacob's Ladder 179
Professor Offlogic

Sometimes Life Calls For An Unexpected Hat 188
Molly Friedrich

Victorians & Altered States 200
Professor Calamity

Paint It Brass: The Intersection of Goth and Steam 210
Libby Bulloff

Brass Monkeying ... 216
Professor Offlogic

The Future ... 227
CrimethInc.

Knights of the Road:
The Dawn and the Rise of the Tramp Printer 236
Charles Eberhardt

On Progress, On Airships 250
Carolyn Dougherty

The User's Guide to Steampunk 254
Bruce Sterling

On the "Validity" of Steampunk 256
Heather Pund

Selected Timeline of Steampunk Events 256
Margaret Killjoy

An Introduction to Casting 266
David Dowling

Emergency Welding Machine 276
Zac Zunin

The Luddites ... 290
Carolyn Dougherty

Steampunk Sculpture 306
Keith Newstead, Robin Martin, Andy Clark

On Alchemy .. 316
Benjamin Bagenski, C. Allegra Hawksmoor

A Corset Manifesto 332
Katherine Casey

Chasing the Will O' Wisp:
The Zenith and Decline of the Tramp Printer 334
Charles Eberhardt

Baritsu, Bartitsu, and the Ju-Jutsuffregettes 338
John Reppion

Waterloo: For a New Age to Rise an Old One Dies 346
Richard Marsden

Blowin' in the Wind:
A Study on the Construction of Windmills 350
Professor Offlogic

You Can't Stay Neutral on a Moving Train
(Even If It's Steam-Powered) 364
Margaret Killjoy

Towards A Brave New Land (And The Making Thereof) .. 368
Professor Offlogic

On Race and Steampunk: A Quick Primer 374
Jaymee Goh

The Future of Steampunk Fashion 386
Libby Bulloff

The Man Who Ate Germany 390
Dylan Fox

Shimmies and Sprockets:
Analyzing the Use of Bellydance in Steampunk 400
Ayleen the Peacemaker

All Fashions of Loveliness:
Women In Victorian Penny Dreadfuls 408
Allie Kerr

Hartmann the Anarchist 427

SteamPunk Magazine
Putting the Punk back into SteamPunk
[Lifestyle, Mad Science, Theory & Fiction]

#1

Contrary to the honeyed words of gentlemen, this Age of Empire is a pestilence upon every continent and soul, through colonization manifest or implied.

Rich men from stone buildings wade blindly through the penniless on their way to the opera, at leisure after a day spent plotting wars across the seas; and though these gentlemen are excellent at imposing a world order, they are equally adept at colonizing the women who maintain their homes.

All the while their attention is turned outwards, and all the while we plot from within. Discontent with the complex machinations of the imperialist state, we build a system of co-operation and autonomy. Fed up with the hunger about us, we glean and tax the rich. Tired of playing master or servant, we work only as friends and lovers.

And when approached by the newspapers, how they look at us queerly when we tell them with open hearts, "Death to the Empire! No longer will we cower; we are all nobility! Your colonization of our bodies and hearts is an act of war!"

—Erica A. Smith, *On The Political Situation Experienced In Our Era*

The cover was illustrated by Nick Kole

Putting the Punk back into SteamPunk
Issue One :

It is with many pleasantries and with much joy that I welcome you, dear reader, to the first issue of *SteamPunk Magazine*. You hold in your hands (or stare at on a screen, if you're cheating) the product of a near-ridiculous amount of volunteer work by a variety of people. Our budget was literally nothing.

One of the goals of this magazine is to bring the SteamPunk culture offline, a step we consider crucial to its vitalization. We want SteamPunk to be more than a blog, more than a website. Hell, we want SteamPunk to be more than a magazine; we imagine it as a way of life. And while we respect that the internet—as a tool—can be useful, we also see that it—like many tools—has become a monster of its own.

The magazine is a dying medium, and only the massive consumer magazines, driven by glossy advertisements, are surviving without heavy attrition. And—not to hold magazines on too high of a pedestal, mind you—along with the death of physical media comes a lack of physical culture. No longer are we introduced to new concepts face-to-face, no longer do we debate in person.

But it is the physical nature of SteamPunk that attracted us to it in the first place, however we first heard of it. We love machines that we can see, feel, and fear. We are amazed by artifacts but are unimpressed by "high technology." For the most part, we look at the modern world about us, bored to tears, and say, "no, thank you. I'd rather have trees, birds, and monstrous mechanical contraptions than an endless sprawl that is devoid of diversity."

Included in this magazine are a few pieces of radical political thought. Most prominent among these is "The Courage to Kill a King", an essay which explores the period in time when anarchists were quite prone to political assassination. We feel it is important to disclaim, then, that this piece does not necessarily represent the views of any other contributors or the editorial staff of the magazine.

It is the "punk" side of SteamPunk that is controversial, of course, and it is to the punk side of SteamPunk that the editorial staff owes its loyalty. But we hope to provide a range of material that will appeal to a reasonably wide audience. A bit of a contradiction, perhaps, but we believe it's one that we've balanced herein. We are always open to correspondence, and plan to include a letters section in the second issue. Further, we are a contributor-run magazine: we get all of our material from submissions.

I hope you enjoy the magazine. If you don't, contribute something you would rather have seen!

— *Margaret P. Ratt*

WHAT THEN, IS STEAMPUNK?
Colonizing the Past so we can Dream the Future
by the Catastrophone Orchestra and Arts Collective (NYC)

STEAMPUNK IS A RE-ENVISIONING OF THE past with the hypertechnological perceptions of the present. Unfortunately, most so-called "steampunk" is simply dressed-up, recreationary nostalgia: the stifling tea-rooms of Victorian imperialists and faded maps of colonial hubris. This kind of sepia-toned yesteryear is more appropriate for Disney and suburban grandparents than it is for a vibrant and viable philosophy or culture.

First and foremost, steampunk is a non-luddite critique of technology. It rejects the ultra-hip dystopia of the cyberpunks—black rain and nihilistic posturing—while simultaneously forfeiting the "noble savage" fantasy of the pre-technological era. It revels in the concrete reality of technology instead of the over-analytical abstractness of cybernetics. Steam technology is the difference between the nerd and the mad scientist; steampunk machines are real, breathing, coughing, struggling, and rumbling parts of the world. They are not the airy intellectual fairies of algorithmic mathematics but the hulking manifestations of muscle and mind, the progeny of sweat, blood, tears, and delusions. The technology of steampunk is natural; it moves, lives, ages, and even dies.

Steampunk, that mad scientist, refuses to be fenced in by the ever-growing cages of specialization. Leonardo DaVinci is the steampunker touchstone; a blurring of lines between engineering and art, rendering fashion and function mutually dependent. Authentic steampunk seeks to take the levers of technology from those technocrats who drain it of both its artistic and real qualities, who turn the living monsters of technology into the simpering servants of meaningless commodity.

WE STAND WITH THE TRAITORS OF THE PAST AS WE HATCH IMPOSSIBLE TREASONS AGAINST OUR PRESENT.

Authentic Steampunk is not an artistic movement but an aesthetic technological movement. The machine must be liberated from efficiency and designed by desire and dreams. The sleekness of optimal engineering is to be replaced with the necessary ornamentation of true function. Imperfection, chaos, chance, and obsolescence are not to be seen as faults, but as ways of allowing spontaneous liberation from the predictability of perfection.

Steampunk overthrows the factory of consciousness by means of beautiful entropy, creating a seamless paradox between the practical and the fanciful. This living dream of technology is neither slave nor master, but partner in the exploration of otherwise unknowable territories of both art and science.

Steampunk rejects the myopic, nostalgia-drenched politics so common among "alternative" cultures. Ours is not the culture of Neo-Victorianism and stupefying etiquette, not remotely an escape to gentlemans' clubs and classist rhetoric. It is the green fairy of delusion and passion unleashed from her bottle, stretched across the glimmering gears of rage.

We seek inspiration in the smog-choked alleys of Victoria's duskless Empire. We find solidarity and inspiration in the mad bombers with ink-stained cuffs, in whip-wielding women that yield to none, in coughing chimney sweeps who have escaped the rooftops and joined the circus, and in mutineers who have gone native and have handed the tools of the masters to those most ready to use them.

We are inflamed by the dockworkers of the Doglands as they set Prince Albert's Hall ablaze and impassioned by the dark rituals of the Ordo Templi Orientis. We stand with the traitors of the past as we hatch impossible treasons against our present.

Too much of what passes as steampunk denies the punk, in all of its guises. Punk—the fuse used for lighting cannons. Punk—the downtrodden and dirty. Punk—the aggressive, do-it-yourself ethic. We stand on the shaky shoulders of opium-addicts, aesthete dandies, inventors of perpetual motion machines, mutineers, hucksters, gamblers, explorers, madmen, and bluestockings. We laugh at experts and consult moth-eaten tomes of forgotten possibilities. We sneer at utopias while awaiting the new ruins to reveal themselves. We are a community of mechanical magicians enchanted by the real world and beholden to the mystery of possibility. We do not have the luxury of niceties or the possession of politeness; we are rebuilding yesterday to ensure our tomorrow. Our corsets are stitched with safety pins and our top hats hide vicious mohawks. We are fashion's jackals running wild in the tailor shop.

It lives! Steampunk lives in the reincarnated collective past of shadows and ignored alleys. It is a historical wunderkabinet, which promises, like Dr. Caligari's, to wake the somnambulist of the present to the dream-reality of the future. We are archeologists of the present, reanimating a hallucinatory history.

THE PYROPHONE
Thermo-Acoustic Flaming Organ Of Doom!
illustration by Aka

In 1869, a scientist and musician by the name of George Frederic Kastner stuck flames into glass tubes to see what would happen. Lo and behold, sound emerged from the other end. In the version that he perfected, the tone emerged when two flaming gas jets separated, and disappeared when they were brought back together. We have no idea how that worked[1], but he hooked the gas jets up to a keyboard and called it a "pyrophone," or "flame organ."

But there is a simpler method of thermoacoustic music to be had, and we even dare call it a pyrophone. A single flame, when placed within a tube, causes a temperature difference. The temperature difference causes the air to oscillate, which we perceive as sound.

And what a sound! The attack is slow and the note builds over a second or two, with pronounced harmonics on the octave of the root. We can have a beautiful pad synth sound without such antiquated ideas as "electricity", and a pyrophone's size is limited only by imagination and source of heat.

The simplest way to hear a pyrophone is to acquire yourself a metal pipe of a 3-5cm diameter and a propane torch (check the plumbing section of a store). Light the torch and stick the nozzle a ways into the tube. Very quickly a sound will emerge. Very quickly, as well, security will emerge—if you're still in the store.

But for a polytonal pyrophone there are two problems to be surmounted: the method of applying fire to the pipes, and the tuning of the pipes.

The simplest method of fire application is the use of hand-held propane torches. Limited by your two hands, you will have to make friends with someone to form three or four note chords, but all kinds of mechanical (or, yes, electrical) systems can be devised to control the jets of flame. A mechanical system could route input from a keyboard to valves and sparkers set under the pipes.

One musician noted that candles were not hot enough, and that the flame from bunsen burners was pulled away from their source of gas by the convection taking place in the tube. The recommended solution was a Fisher burner, a common lab instrument that has a grill across the top that acts as a mantle.

Tuning the pipes will also be difficult. For someone more interested in experimentation than western music, there is an easy solution to tuning: don't. Just get pipes of different lengths. Longer pipe = lower pitch, shorter pipe = higher pitch.

But if you want to harmonize with the rest of the world, you will have to tune your pipes. A pipe resonates at a certain frequency, depending on whether it is open at both ends or only one. We assume that we can consider our flame organ to be composed of open-ended pipes.

The resonant frequency of a pipe is a function of the length and diameter of the pipe and of the speed of sound. Unfortunately for us pyros, the speed of sound changes as the temperature does.

We ran a few experiments to determine the pitch of different pipes at different lengths. It appears that the speed of sound is differing in our pipes, but not too greatly (approx. 407-413 m/s). This chart provides *rough* guidelines—fire is a chaotic force, and we have not done as much experimentation as we would like. **Do not expect this to work!** Overestimate the length *a lot* and then tune it by shortening the pipe.

L = length in meters
L' = effective length in meters
d = diameter in meters
t = degrees in celsius
f = frequency in hertz
v = velocity in meters per second

Speed of Sound (v)
$v = 331.6 + .6t$

Effective Length (L')
$L' = L + .3d$

Length (L)
$L = \left(\dfrac{v/f}{2}\right) - .3d$

Note	f[2]	L'[3]
C	130.8	1.567
C#	138.6	1.479
D	146.8	1.396
D#	155.6	1.317
E	164.8	1.243
F	174.6	1.174
F#	185.0	1.108
G	196.0	1.045
G#	207.7	0.987
A	220.0	0.932
A#	233.1	0.879
B	246.9	0.830
C	261.8	0.783

1 - If you can figure it out, let us know!

2 - To determine the frequency of a note in the next lower octave, divide the note in half. To raise it by an octave, multiply it by two.

3 - Effective Length was calculated by using v=410, the average of our experiments.

GLASS ARMONICA
Benjamin Franklin's Mechano-Acoustic

"If Chimes could whisper, if Melodies could pass away, and their souls wander the Earth... if Ghosts danced at Ghost Ridottoes, 'twould require such Musick, Sentiment ever held back, ever at the edge of breaking forth, in Fragments, as Glass breaks."

–Thomas Pynchon

Choir of Serahpic Deviltry
illustration by Aku

ALTHOUGH NOT THE FIRST CRYSTALLOPHONE, BENJAMIN Franklin has been credited for the invention of this beautiful instrument in 1761. It was possibly the first instrument invented by an American, and it predates the similarly named, but musically disparate, free-reed Harmonica by about sixty years. Franklin's instrument was an improvement upon the Seraphim, a system of wineglasses that are tuned by being filled with water.

You may know already that if one runs a wetted finger along the edge of a wineglass, you can produce a single, clear note.

The most startling thing about the glass harmonica is—ironic to its name—the lack of harmonics produced. Although some players have learned to bring out harmonic notes, glass in general gives a remarkably pure tone.

Franklin arranged 37 bowls horizontally on a spindle, separated by cork. A simple foot pedal powered the flywheel that spun them all, and multiple bowls could be sounded at once, allowing a musician to create chords with the voice of the angels.

AND YET, ALTHOUGH THE INSTRUMENT gained widespread acceptance as a parlor instrument—and was written into orchestral pieces by Mozart, among others—it went out of vogue by 1810. You see, the Armonica was more than a musical instrument. Dr. Franz Mesmer, from whom we have the word mesmerize, used the singing bowls in his medical treatments.

Everything went downhill for the Armonica when people got the bright idea that it was supernatural, and therefore evil. Insanity, convulsions, marital disputes, death and even the waking of the dead were blamed on its seraphic voice. Its popularity never returned.

BUILDING ONE WILL PROBABLY BE DIFFICULT. THE construction of the apparatus to spin the bowls would not be overly complex, but glass-blowing the bowls to specific notes would be.

Yet hope is not lost; many of the original glass harmonicas were tuned by grinding bowls down. The shallower the bowl, the higher the pitch. It seems not inconceivable to take a variety of second-hand glass bowls and tune them in this manner. Unfortunately, the physics of how to best pre-determine pitch of a bowl are quite beyond the scope of this article or author, so we suggest simply playing a bowl into a tuner and working from there.

The original Armonicas were made from a lead-based glass, but modern Armonicas are usually built with quartz glass. Some collectors insist that this changes the tone, but we of DIY spirit will work with what is available.

Benjamin Franklin refused to patent the instrument, and he made a powerful statement against the tyrannies of iron-fisted intellectual property we face today: "As we enjoy great Advantages from the Inventions of others we should be glad of an Opportunity to serve others by any Invention of ours, and this we should do freely and generously."

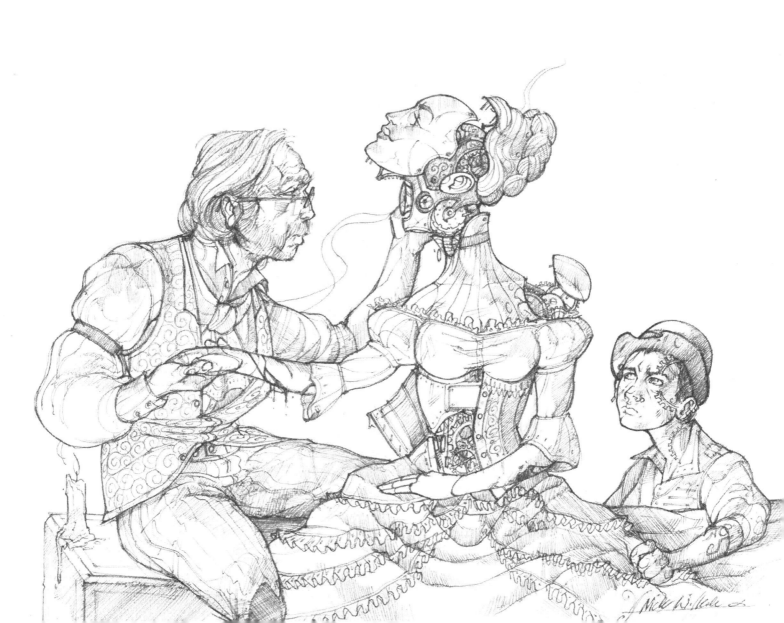

Mother Of The Dispossessed
A Winter's Seasonal Tale Designed to Educate and Illustrate
Illustrated by Nick Kole

December 26th, 188?, New York City in Winter

Boxing day was a day of family, and of celebration and gift-giving—for the rich, that is. For the denizens of New York City's many slums, this was just another frozen day. The only gifts they would receive would be *those that they took for themselves.*

Professor Calamity was in his fiftieth hour without sleep, but his half-mad companion Mathilda knew what made him shake; it wasn't sleepless nights. She had seen him work for more than four days at Bellevue without sleep, burning with the steady glow of laudanum during those tumultuous days of the draft riots. Now he could barely steady his hand to remove the charred flesh of the terrified Polish girls who lay on the dirty floor of their flophouse clinic.

Neal—their bulky ex-steelworker assistant—passed out numbers to the semi-conscious girls waiting as if they were queuing for a bakery. He tried to give the lowest numbers to the most severe cases, but to his untrained laborer's eye, each looked equally as bad as the next.

As the sweating hulk passed out tickets, Pip, a second assistant, checked the unconscious seamstresses for change to purchase the Professor his opium. Though he appreciated the ideals of a free clinic, Pip knew that Calamity would need some chemical steam to get him through the long night's work.

The filthy tenement clinic was often filled with screams, stench and roiling chaos. Fires were always the worst, and they were becoming more and more common on the Lower East Side; greater demand for textiles during the war years had created a glut of sweatshops in and around lower New York. Now, with the horrors of war drifting into the quiet despair of the depression, the sweatshops were a powder keg that was touched off with an infernal regularity; owners, desperate to squeeze as much profit as possible into twenty-four hours, were forcing more and more machines into their crowded and poorly ventilated sweatshops. Ever suspicious of the dishonesty and slothful machinations of their immigrant employees, the owners had taken to locking doors during shop hours to ensure that the girls stayed at their machines and did not steal a single rag. There were no smoking breaks, and so the girls—most in their early teens—were trapped within the walls of their workplace prison, smoking in their seats. Surrounded by swirling clouds of flammable textile dust, sweatshops became suffocating infernos all too often.

And after the volunteer firemen looted what they could while the building still blazed, the newspapers would screech that the seamstresses were to blame for their own deaths, that it was unfair that the city had to spend a buck forty-five to bury each dead child in Potter's Field. In their cigar rooms around Washington Square, the owners would wait anxiously for their insurance checks.

Those lucky enough to survive could not afford private doctors and were forced to seek the free services of Professor Calamity—a nefarious alienist and drug addict—and his band of revolutionaries.

Three street arabs* had slipped through the chaos of the overcrowded clinic unnoticed—it was a skill they had perfected in the suffocating alleys of Hell's Kitchen. They pulled back the ripped Chinese curtain that separated the 'clinic' from Professor Calamity's cot.

Mathilda hissed at the intruding children, a slow yet sharp sound that froze their blood. She still wore the elegant mourning clothes that hinted at a past far removed from the teeming tenements of the Bowery, but her disheveled hair and frenzied eyes belied the effects of her burning insanity. She swiped at the children with long chipped nails.

"Mathilda my angel," Calamity mumbled, ignoring the intrusion and rubbing his inflamed eyes, "I need my medicine."

Mathilda's mood instantly transformed from fiercely defensive to exquisitely tender as she turned to him and rolled up his blood-soaked sleeve. She found her mark with the needle and sunk the rewards of Pip's hard work into her lover's thinning vein.

"You are Runts," the doctor said dreamily, glancing toward the children and stroking Mathilda's bare thigh, "and mighty far from Hell's Kitchen, I might add."

One of the two boys pushed the girl, the tallest and the oldest of the three, to the front. She came only to the lanky man's waist, but she stared into the doctor's red eyes and steadied her nerve.

"It's mama. She's hurt bad," she said, her voice so soft that it was nearly capsized by the screams coming from behind the curtain, "She needs a doctor. We have money."

"Can't you see he is sick?!" Mathilda was shouting, and the doctor winced. "You think you little cretins can just barge in here?!"

"Mathilda," Professor Calamity intervened, "it's quite alright. Let the Runts speak."

The girl gathered her courage once more and nudged one of the boys. "We have money," she repeated.

The boy wore an over-sized derby that fell forward over his face as he unearthed a few dingy coins from deep inside one of his many padfoot pockets. He presented them to Mathilda as though they were gold.

"Girls are dying in there, and you are wasting our time with these…." Mathilda pushed Calamity's wandering hand back down her leg, away from her waist, and straightened her black funeral dress.

"Children, I'm quite sorry to inform you that my *angel nocturne* is quite correct. There was a dreadful inferno at the Wedemeyer Corsettery and we are quite unable to provide you aid. But if you could entreat your good and loving mother to come from the west side to see me, say in a few days time, I can't see any possible reason not to survey her. I shall have her right as rain, I promise you, my considerate gents and lady. Take your coins and make haste to the Chemist. Get some Dr. Parker's Drops; they will no doubt ease the suffering of your dear mother until such a time as she may make my acquaintance. I look forward…." Calamity's monologue was cut short as he nodded out, covering his eyes with his arm.

Mathilda stepped past the children and into the main room. "There will be a break," she announced to the writhing seamstresses. "The doctor is consulting his books, and will see no one for at least another hour."

She walked over to Neal and began to consult with him about the waiting patients, while the three children disappeared as quietly as they had entered. They stepped over girls dying from burns so grotesque that Goya would have shuddered, but their minds were filled only with worry for their mother. They had seen worse despite their tender age.

The children ran to the corner of the block, where Tinder was waiting for them. Tinder was the oldest of the Runts; no one knew how old he was, least of all himself, but a few whiskers were beginning to shadow his upper lip. These downy hairs were his greatest pride.

Tinder listened to the girl describe their encounter with the professor, running his soot-stained hand through his mohawk while she explained breathlessly.

"We will bring mama to the doctor," he said and then pointed at a scrawny boy, barely out of diapers, who accompanied him. The child pulled a crumpled cigarette out of his rag hat and passed it to Tinder.

"He won't see her," the girl cried, stamping her foot on the cobblestone street.

"We will make him. We just got to get mama to him." With this Tinder ended the discussion and turned, leading the smaller children down the shadow-soaked alley and back to their nest.

THE RUNTS WERE NOT A GANG, PER SE. THE Dead Rabbits, the Plug Uglies, the Mods, and the Bowery Boys were gangs. The Runts were not as organized as the Newsies, nor under the sway of an adult like the Five-Point chimney sweep gangs. Nor were they an ethnic fellowship like so much of New York. They were of no interest to political groups like Tammany Hall, the nativist Know-Nothings, or even the anarchistic steampunks. They were more akin to a family, albeit one quite large and poor—poor even by the standards of Hell's Kitchen. The Runts had been around for twenty years at least, and many famous street characters had been Runts in their earlier years, including the pugilist Copper O'Conner and the war hero Antonio Garlic.

The Runts inhabited—"lived" would be too gratuitous of an exaggeration—a series of conjoined basements that had once stored hay for the 35th Street stables. A fire had claimed the stables and all sixty-five working drays.

The Gotham Hack Association had raised enough money to have the stables rebuilt, but predictable corruption had siphoned the funds into the marble rooms of Tammany Hall. What was left was a burnt-out shell and a basement full of orphans who cried, grew, and stole under the benevolent violet eyes of Mama Giuseppe.

* [note that "street arab" is not a racial term, but was used rather in american slang to mirror the more enduring british slang "street urchin". –ed.]

When Tinder returned to the children waiting in the cool basement, they had barely touched the potatoes they had lifted from Fulton Street market three hours earlier. They were all too anxious to eat; even Piggy Hovek hadn't swallowed a spud.

"She is too heavy to move. We cannot get her to the doctor," Tinder told the children, matter-of-factly.

Some of the smaller among them began to weep.

"Is she going to die?" Piggy asked, choking on the words.

"No. There is someone who can help, but I need to talk to Spinner and Sal first." Tinder pointed to the older boys who stood in the back of chaotic common room.

Tinder and the two older boys entered the room where Mama lay, the room where Tinder planned to reveal the secret he had kept for years, the secret that he had half-forgotten in his love for Mama. It was a secret he had not asked to know, but Wild Kip had to tell *someone* before the ex-Runt had headed out west. Tinder lifted Mama's petticoat as she lay sleeping on her mattress and revealed the truth to Spinner and Sal. He needed their help to locate this "Harlowe."

CHESTER HARLOWE RECUPERATED ALONE IN his formal study. He found more enjoyment in the holidays now that he had grandchildren, but he was still relieved when the festivities were over and he could return to the gentle habits of retirement. His post-celebratory thoughts drifted to his youngest son's new fiancée as he sipped his club soda by the dying fire, to how shapely she had looked in her yellow velveteen dress earlier in the evening.

The sound of breaking glass woke him out of his reverie and he felt the cold Hudson wind invade his gloomy study.

"What in blazes are you doing?" Harlowe demanded of the three boys who were rushing in through the shattered garden door.

"Aye, are you Harlowe?" Sal asked as he freed his shirttail from one of the jagged pieces of glass.

Harlowe could tell by the Sal's many piercings that the kid was not from Gramercy. "This is my home and you are…."

Tinder wasted no time in sapping the elderly man, who fell to his knees still holding his glass. Even in excruciating pain, he was careful not to spill his drink on the antique Ankara rug.

Spinner hit Harlowe with the chair leg that he always carried and the old man went down. The last thing Harlowe heard as he drifted to the soft carpet of his study was one of the ruffians saying to another of them that their only hope had just been killed.

THE SHARP, THROBBING PAIN FORCED CHESTER Harlowe back into consciousness. He was only a mile or so from his study, but it was a world away.

His eyes could barely see in the sooty gloom of the Runts' cavernous cellar-home. He could hear their voices whisper in the darkness. They sounded to him like his own grandchildren talking late after midnight mass, speculating in hushed voices about the presents that would await them under the tree. He couldn't see them, but still he could not shake the feeling that his sweet, tender grandchildren were somehow down in this dungeon with him.

Tinder was the first to realize that the old businessman was awake. He poured some cool water into a dented can and handed it to Harlowe.

"I'm sorry we had to sap you mister. You see, our ma's real sick, and you can help." Tinder spoke in a voice more a boy's than a man's. "Don't you worry, we won't hit you again."

Harlowe could only just make out Tinder's face by the greenish glow of a soap candle; the child's pierced visage glowed a soft white in the faint illumination. He had seen these children before, perhaps not the Runts specifically, but their kind. He had seen their skinny tattooed arms reaching into his fireplace as they cleaned his three chimneys. He had seen their dyed hair glowing in the summer's daylight as they chased rats, with sticks, by the reservoir. He had been around these children almost every day of his life in the city, but had taken no notice. Like most of his fellow well-heeled colleagues, he had witnessed these street arabs but had never really noticed them. But looking upon them in the dank dungeon that was their home, he saw not only pests but also his own grandchildren.

He was not afraid of these children. He knew they would not hurt him again.

"Will you look at our mama, mister? Will ya?" Spinner pleaded.

Chester nodded that he would, but he was nauseated by the smell of Spinner's newly dyed blue hair when the boy moved closer to him. As he bent over, trying to keep himself from gagging, he wondered why these children mortified their flesh with needles, colored lye, and tattoos. Tinder helped him to his feet.

"Watch the timbers, they're low in here," Tinder warned, taking the businessman's hand.

"Tell me, why do you do it?" Chester asked as the pair descended further into the cellar. "The silver ring in your eyebrow … and those tattoos on your arms."

"They can't nick it from you," Tinder answered absent-mindedly, "they'll take everything else, that's for sure."

Chester walked past dozens of children lying on filched pallets, huddled under patchwork blankets. They feigned sleep, every one, but peeked through half-open eyes at the well-dressed stranger in their midst.

Chester was certain that he could convince his brother-in-law, a physician, to help care for the mother of these unfortunates—if she wasn't beyond hope already. He found that he wanted to help these children, children he had passed a thousand times without giving them a single thought or penny. Perhaps it was the holidays; perhaps it was the throbbing pain in his skull. All he knew was that he would help them tonight. Let tomorrow forget that they had ever entered his life.

By the time the businessman and the pauper entered Mama's room, Spinner and Sal were already beside her. Sal held Mama's lifeless hand in his own while Spinner tried in vain to wipe clean the dark fluid that dripped from her neck. Chester was struck immediately by the vivid whiteness of the woman collapsed on the rat-eaten mattress; she looked as cold as a ghost, as pale as a woman who had never seen the sky. Her dress was ancient and ridiculously fringed with

gaudy lace. She looked more like a Luna Park fortune-teller than a mother to twenty children living in a burnt-out stable cellar.

Chester knelt in front of the woman and drank in the loveliness of her countenance; the ghastly light of the sputtering candles added to the oddly Catholic aura about her, making her seem like a sort of Bowery Madonna, peaceful and divine.

Chester went to take Mama's hand from Sal, who released it only after a nod from Tinder. Her hand was as cold as it looked, but it was also exceedingly hard. He dropped it at first, frightened by its unearthly texture. He shyly picked it back up and thin ivory curls of paint flaked off of her fingers; he tapped the back of her hand with his university ring, eliciting a dull clank.

"She is metal," Chester murmured to himself, though all the room heard.

"Show him, Spinner," Tinder said.

Spinner slowly unbuttoned the mother's whalebone corset to reveal a frame of dull iron. Chester held a candle up to the lifelike doll, and in the dancing light he saw the most amazing constellation of gears and springs he had ever witnessed. They looked almost natural, like metallic moss, intricate and interconnected. He was overwhelmed by the hundreds of tiny clockworks, counterweights, and pendulums—and he had seen a great many machines in his time. He had been the chairman of Schneider & Harlowe Metalworks, the largest machine shop on the Eastern Seaboard. He had made hundreds of thousands of dollars by supplying precision metal works for all sorts of projects, including the new subway and the amusements at the Steeplechase Fairgrounds.

Spinner pointed to a small tin plate attached to the front of the automaton's chest:

P. A. Schneider & C. D. Harlowe
1856

"That's you. Chester Harlowe, right?" Spinner said proudly.

"Yes. No. I mean that is from my company, but surely you do not think.... Listen boys. I am, I mean I was, a businessman, but I am quite retired. I owned the company that may have made some of these parts, but by the looks of it, there are all sorts of parts in here. This plate, this might have been from one of our steam wringer-washers, but the rest of this machine.... I can assure you I had nothing to do with this ... woman."

"But its got your name right here, right as rain it does," Sal interjected, holding up another candle to cast more light.

"Yes. It's a mistake. My machine shop may have made that piece, but it had nothing to do with her assembly. Whoever made this was a genius. An absolute genius. This belongs ... I don't know where, but certainly not here."

"What is that supposed to mean?" Spinner said, a sinister undertone creeping into his voice.

Tinder came between the two. "She's our mother, mister. She's the only mother any of us know. If you think you can take her.... She will stay here, that's for sure. Can you fix 'er?"

"No, I can not," Harlowe replied, raptly staring at the intricate brass lace of the mother's metallic organs.

Tinder whispered to Spinner, "Then we must find this Schneider."

Harlowe overhead them and answered: "Listen boys. You don't want to do that. He can no more help you than I can. You need ... I don't know who you need. But Schneider cannot help you. It's very complicated ... everything is counterweighted. Look, this spring has come off its hook."

Chester replaced the spring and immediately the lifeless hand in his lap opened and closed. Mama's left eyelid started to flutter and he could not help but let out a startled cry.

"It's really quite amazing, and it's all in pretty good order. This gear needs oil, that's plain to see. And here's probably the reason why: that tube, near her neck, it's leaking. No oil is getting through," he said, pointing to the vein-like intake tubes. "I'm not sure what this does, but it is connected to a whole string of other gears. Get me a little oil, and some wax to seal this hole."

Chester lost track of time as he tinkered with the automaton; he was shocked to find so little wrong with it. Within the first hour he had been able to get her to sit up and move her arms, back and forth, in a cradling motion. He found that by applying different amounts of pressure the limbs would react differently: sometimes they would cradle a baby ghost and other times they would gently reach out and pat an invisible child. He even got her to play patty-cake once, but could not replicate the feat. And every time he fixed one thing he had to realign the counterweights and pendulum.

Sal and Spinner were exhausted, both their kidnapping adventure uptown and their worry wearing them down. They slunk away to join the other children in the main room to sleep. Only Tinder remained behind to hold a candle for Harlowe.

Not even Wild Kip, the oldest Runt before Tinder had known the whole truth behind Mama. In fact, an Italian clockmaker had built the automaton many years ago. The poor clockmaker had no children of his own, and—lacking in proper work—had owned a pushcart that sold molasses candies. Eventually he had befriended a number of the street children that would buy his penny wares. The clockmaker had built a machine from scrap so that the orphans could know the love they had never been spared.

Harlowe was able to guess parts of this truth as he uncovered pieces of countless different machines investigating the orphans' mother. He found telegraph striking-posts used as balance levers and mason jar locks twisted into springs. He found bits of debris from all over the city cunningly arranged, and the businessman in Harlowe marveled at their economic ingenuity even as the hobbyist engineer despaired at the chaotic array that impeded his repairs.

Chester was a man who had never used his hands or mind to make anything but money, but that night found him actually working, repairing a physical object. The sweat trickled down his neck in the muggy basement, he could see the oil tanning his fingertips, and he could feel the satisfying snap of a perfectly placed piece.

"Surely, the children must know that this is a machine," Chester said to Tinder, wiping down one of the six Italian-language phono-disks that gave voice and song to the automaton.

"Some suspect it when they get older, but by that time they love her dearly. She's always there with a song or a hug. Mama is our first memory, for many of us."

Chester shuddered at the thought of children knowing of love from only a machine. He thought of his own childhood, of his affectionate mother and house-keeper. His own first memory was riding a wooden horse, his father beaming down at him from under his broad mustache.

Tinder, reading the pity etched in Harlowe's face, stood up proudly. "Listen, Mister. We got it pretty good, better than most. We got each other, and older Runts that are gone still know where they came from and they look out for us. Besides, we got it."

Something had changed in Tinder; it was the first time he had referred to Mama as an it. And with that, he knew he was no longer a Runt. Seeing the rich man working on the machine—the machine that had been his sole source of love for his entire life—he realized it was a soulless thing, a cruel parody of life. He didn't like thinking that way, but he knew now that he would never be able to return to his childhood beliefs.

"Just finish up and I'll take you home. The streets here are not safe for a gentleman," Tinder said coldly.

"I would like to see what else she can do, maybe hear one of these disks. Are they lullabies? Or something more?" Harlowe asked, carefully replacing the soft wax disks on a spindle in her throat.

"No." Tinder said, pulling a cigarette from his pants' cuff. It was the first time he ever smoked in front of Mama, and he felt cold. Something was gone.

A crescendo of childish screams echoed throughout the cellars, intermingling with the gruff shouts of adult men. Tinder stubbed out his cigarette as he rushed out of the room, leaving Harlowe to hide behind Mama's wide dresses.

After much commotion from the common room, two cops yanked down the tattered dividing curtain, their bull-faces burning red with exertion and predatory excitement. Harlowe peeked out from behind the automaton, shy with fear.

"Mr. Harlowe? We're with the Met," one of the coppers said, wiping the blood from his hand before extending it to the cowering gentleman.

"You don't understand…" Harlowe muttered.

"He's got blood on his face," the older bull said to his junior partner, " He's dazed. Get him home; there are enough boys to chase the rest of the vermin down."

The officer yanked Harlowe to his feet and half-dragged him through the ex-stables that glowed with small fires and were dense with smoke. Here and there a small figure lay still, some still clutching for an absent friend. Though most of the Runts appeared to have escaped, Harlowe wondered if he would be able to forget the night so easily after all.

Out on the street, new snow fell, lost among the smoke. The bells of the season drifted softly to his ear, faint against the agony and rage that foamed and screamed throughout Hell's Kitchen.

Neal was not-so-gently tapping his ax handle against the sleeping legs of Pip. Roused, Pip rubbed his eyes to see that Neal was wearing his war-leathers.

"What's the big idea of…" Pip said, rolling over.

"There's a riot," Neal shouted with childlike enthusiasm, waking the others, "those damned cops are raiding the Runts' nest. They been rounding up street kids all night beating them senseless. We should get down there. The Dead Rabbits are already on their way. It's going to be a good dance."

"The Runts?" Calamity asked as he rose from bed. His voice sounded like it came from the bottom of a well.

"Yeah. I guess they grabbed some mucky-muck at the square. In his own god-damn house. Those kids got more guts than sense. Pip you coming?"

Pip reluctantly stood and grabbed a nearby length of chain.

Professor gently nudged the sleeping Mathilda.

"It seems the cops are smashing heads over at the Runts. Neal and Pip are off to join the riot."

"So go if you want," she said without opening her eyes.

"No it's not that…. It's just … they are only tots. I don't know."

"Everyone was child once, nothing special about that," Mathilda said dreamily. "Come back to sleep." ✺

This seasonal shows us the perennial truth: that truth, itself, is overrated. From the story of Harlowe and the Runts, we learn that disillusionment is a powerful factor in maturity, and that goodwill may manifest itself in the unlikeliest of places.

Interview With Michael Moorcock

Michael Moorcock is, in many ways, a legend. The author of more than 70 novels and journalistic works, Moorcock did much to humanize the mythical hero figure. He also pioneered the steampunk genre, before it earned its name, with his 1971 novel "The Warlord of the Air" that strays into the political sphere (collected with its two sequels as "A Nomad of the Time Streams"). He was a heavy influence on Hawkwind, a 70's rock band that he occasionally toured with; Hawkwind in turn was a major influence on punk. Moorcock was cordial enough to answer some of our questions.

illustration by Tim Wilson

MOORCOCK

Michael Moorcock

Many people have attributed the birth of steampunk to you; this seems fitting to me since you were an early influence on punk as well. Do you have any thoughts on the current state of a genre you helped to inspire, or thoughts as to what it could be?

As an 'intervention' into a particular kind of Edwardian fiction, I think the [Nomad In The Time Streams protagonist Oswald] Bastable stories did their best. I never expected it to become a subgenre.

I understand that you ran a magazine, New Worlds, with some people in the late 60s that, in one version of the story I heard, was condemned as leftist propaganda, for obscenity in the other version, but risked losing its funding from the Arts Council in both versions. Can you clarify this for me?

We weren't condemned directly. The right wing press would from time to time attack us as an example of what the left wing government was allowing. The Daily Express asked me "Mr. Moorcock: Would you like your children to be reading this sort of thing?" "They're five and six," I said, laughing. "I'll be grateful when they can read anything." The big distributors were more worried about 'pornography', though there was nothing visual in our magazine that couldn't be found pretty much anywhere. We weren't interested in 'breaking taboos'. We were interested in writers and visual artists wanting to express themselves as thoroughly as possible.

I've read once that Hawkwind was the kind of band which would go to the bar with the audience afterwards, and in most of what I read you seem to refer to your book's audience as composed of "readers" rather than "fans". Do you think that it's important to tear down the metaphorical stage? If so, how can this be done?

There are various ways—drinking with audiences is a good one, certainly. There is no gap between you and the audience as long as you don't let one grow up. It's all to do with your mind set. If you want to be a 'rock star' then by god you'll probably be one… That's what bodyguards exist for.

In a one interview you said "As punk sank, like hippies, into mere fashion, I lost interest." I fell into the basement show anarcho-punk scene in something like 2002, and I have to say that, although it may have missed a beat, punk at the moment can be a lot more than fashion. What were the aspects of punk that attracted you to it in the first place?

Punk had the same idealism as whatever bohemian movements came before it. I welcomed punk because I welcomed the idealism. Punks liked Hawkwind because they thought we were sticking to the ideals rather than holding out for record deals and big money and so on. We really did see ourselves as a 'peoples' band and so we had no difficulties with a shift in audiences any more than I did. I was cheerfully writing "The Great Rock N Roll Swindle" in 1980.

Not many of our readers are aware that you designed the chaos symbol that is so prevalent in punk and traveler culture today. A lot of people associate its history with TSR and D&D, but it started with you. Are you aware of the perhaps thousands of people with it tattooed who are doing things like riding freight trains and fighting against environmental degradation? How do you feel about the new life that this symbol has found?

Given that I drew the sign on our kitchen table when I was trying to think of a good sign to indicate 'Entropy', I had no idea it was going to taken up by so many. Though I suppose it's not surprising, since the [Role-Playing] games are based firmly on the main heroic fantasies series. So much is lifted, especially from me and Tolkien. I rather like the asymmetrical version first drawn by Walter Simonson and now being increasingly adopted! Nice to see it warping and changing to suit the times…

I was wondering if you had any opinions about the current intellectual property debate? Concepts like Creative Commons are gaining ground among many contemporary writers and artists while increasingly restrictive Intellectual Property laws are being passed in many countries.

I've watched most of my ideas go into the public domain and hung on to one or two of the salient ones. It's flattering and it's disappointing. You create particular images for particular needs, both philosophical and creative and when those images are co-opted for dumb reasons it does tend to take your breath away. But there you go.

> We were sticking to our ideals rather than holding out for big money.

"Yena flipped down her mask and began to play. The house-reed hummed, the cylindraphone sung and Fera beat the robot-bits in front of him with abandon. Fera and Set sang and the audience danced chaotically, and Yena's stress began to dissolve as she fell into the drunken stupor of performance. Her fingers splayed out into chords and melodies effortlessly and she even began to grin.

Yena of The Angeline and the Tale of the Terrible Townies

Serial Fiction by Margaret P. Killjoy

Part One: Of steam Music, Squatters, governmental Machinations, and sail Busses

A scorching blast of heat came from the iron-bellied boiler as Yena opened the hatch to triple-check the engine. She could feel the flames through the glass of her facemask and she slammed the door shut almost immediately.

"Don't worry," her sister clucked over her shoulder. "We've done this a dozen times at least."

"Yeah," Yena muttered, "but never with an audience."

Yena was the house-reed player and primary mechanic for Bellows Again, a three-piece punk band local to The Vare that had yet to play a show. She walked back to sit before the keyboard of her instrument, the tools hanging from her coveralls jangling reassuringly as she went. Given enough time, she knew she could fix anything. The trouble was, she wouldn't have the time while she was playing.

She raised her facemask up and leaned towards the brass mouthpiece suspended from a tube in front of her. "Testing," she spoke, and the words echoed throughout the empty club, amplified by soundhorn. She stepped hard on a pedal and the machinery to her left came to life.

A massive bellows began to breathe enormous, as tall as a person when fully extended. Double-action, it pumped air on both extension and compression, the constant cycle of inhale-exhale that had endeared Yena to the instrument in the first place.

The staff of The Cally Bird filtered into the room at the first rumble of mechanical breath. Yena saw Annwyn—a thin, severe sculptor who often lived upstairs—and caught her eye. They smiled, briefly, and Yena turned back to her keyboard, pressing a key and routing the bellows' breath over a large brass reed. The club shook with the note's slow power, and Yena smiled again. She was surrounded by her friends, she was safe. When she let go of the key, the air was diverted back into bypass mode, and only the slow breathing remained.

Fera, their diminutive and adorable drummer boy, tested his vocal soundhorn and engaged the wheel of the drum machine. The geared wheel would spin without effect until he triggered the drum-rod via

foot pedal. At that point, the next tooth of the gear would send a piston against a drum the size of a wasteland shack. Fera had drumsticks and a drum kit of abandoned contraptions splayed out in front of him for every drum noise higher than "boom."

Yena's twin sister Set played the cylindraphone, a high, wailing counterpart to the house-reed's bass hum. "A bit like the difference between us," Set had mentioned to her when they had formed the band, "only in real life, I'm a lot louder than you."

The cylindraphone was a lever-operated bank of spinning lead cylinders, each inscribed with a sine wave. The pitch rose as the rotation gained speed. Dozens of needles led the sound to a series of soundhorns placed throughout the high-ceilinged club, but they merely created a ghostly presence when played alongside the house-reed.

After their brief equipment test, the band quieted. People from all over The Vare were coming into the concert hall now, mostly squatters and youth that Yena recognized. An awkward, gangly kid with a two-decimeter mohawk ducked through the doorway and Yena reached up to touch her own mohawk self-consciously, but she remembered it was covered when she felt the leather skull-cap which protected her from the heat and steam.

The space filled all too quickly and soon the setting sun cast sharp shadows onto the wall. Set nodded to Yena, and Yena struck another long, low note. Conversation stopped and she released the key.

"Welcome to The Cally Bird," the trio said in unison, and the audience cheered. "We are Bellows Again!"

Yena flipped down her mask and began to play. The house-reed hummed, the cylindraphone sung and Fera beat the robot-bits in front of him with abandon. Fera and Set sang and the audience danced chaotically, and Yena's stress began to dissolve as she fell into the drunken stupor of performance. Her fingers splayed out into chords and melodies effortlessly and she even began to grin.

A blast of steam against Yena's mask woke her to the realities of mechanical musicianship and at the next break between songs she discovered the offending loose bolt.

She rose, wrench in hand, but a pounding shook the walls. She looked to Fera, but the drum-wheel was not engaged. She cursed under her breath and moved to shut down the steam engine.

A bald woman came barreling through the audience, her scarf trailing behind her. She conferred with Set briefly and Set spoke into the soundhorn while Yena diverted the steam out the flue to the roof and the skyline above.

"Punks and pilgrims, I've got some bad news. But first of all, don't worry." Set ran her hand through her close-cropped blonde hair as she spoke, a nervous habit that meant she was worried. "So just stay calm. The Townies seem to be at the front door, and of course they are hopping mad. Looks like there are too many out there to fight, tonight, so I suggest we disperse through the tunnels, orderly, and meet back the night after tomorrow, before sunset, so we can talk about what we ought to do, see if we need to strike."

To their credit, the audience moved calmly to the trap door hidden beneath the steps at the back of the hall. Yena wanted to fight—she was sick of running, and was pumped full of stage-fright adrenaline—but she trusted her sister's judgment on the matter.

She closed the oxygen intake of the boiler, suffocating the flames, and collected a few of her tools before walking over to join the conference between her band-mates and Suyenne, the bald woman.

"Hey," Set welcomed her sister, putting an arm over Yena's shoulder. "Suyenne says we should go. She'll stay here."

Yena nodded. "What do you think they want?"

"Same thing they always want," Fera answered, sweat dripping down his shirtless barrel chest. "They want us to start paying taxes or something, or rent on a building none of them built. To join in their ridiculous charade. But Suyenne, I'll stay too. I figure there ought to be two of us here, on the off-chance they get in."

Annwyn, the sculptor in residence, sauntered over, leading an awkward young man with the healthy tan and clueless face of a runaway from the Waste. Besides the six of them, the room was empty.

A finger-thick red line was tattooed down Annwyn's swarthy face and neck, starting below her left eye and disappearing into the unbuttoned neck of her filthy work shirt. Her face was a smear of grease, which meant she had just come from working upstairs; Annwyn would rarely let herself be caught underdressed.

"Can you all take our lost little lizard here with you when you go?" Annwyn indicated the young man, who did indeed look overwhelmed. "I've got to see to some things."

"Sure!" Set agreed immediately and Yena looked the boy over. He was handsome, to be sure, and probably only a few years younger than them, maybe eighteen or so. Cute and clueless, just the way her sister liked them.

Annwyn squeezed the boy's shoulder affectionately before disappearing down the steps herself. After luck-wishing the two who were to remain, the sisters and the stranger descended.

A FIFTEEN-MINUTE WALK FOUND THEM SPRAWLED on the floor of a large one-room shack. It was adorned by a large canopy bed and three-meter-tall bookshelves filled to overflowing. The floor was packed earth, the windows were barred, and the only entrance to the street was a steel door that was currently blocked by a stone as tall as Yena. The sisters had lowered it into place by way of a block and tackle of chains that led from the rock to the roof to a winch set into one wall, while the newcomer looked on quietly.

"So what's your name, lost little lizard?" Yena asked him.

"Icar," her sister interjected, "His name is Icar. We met him last night."

Yena laughed as she remembered. "You came in with Fera while we were playing Garakka?"

"The card game?" Icar asked.

"Yeah, yeah… the card game." Yena replied. The fast-paced game, Yena's favorite, was the way they whiled away time at The Cally Bird before the shows started. "So… first time in civilization?"

"Yena," Set admonished, "could you be ruder? We were strangers here ourselves, not so long ago."

"No," Icar said, "It's alright. And while we Of the Waste might be more civilized than you credit us for, I left my tribe for a reason. This is my second day in The Vare."

"Well, you fell in with the right crowd, I assure you." Yena took a thick book off the shelf to use as a pillow. "My sister is right, by the way. We haven't been here so long ourselves. Less than a year. Tonight was our first show."

Set stood up suddenly. "Hell!" She went to the window.

"What is it?" Icar stood as well.

"I saw someone looking in."

"Think they saw us?"

The door was shook with violent force.

"Yeah, I think they saw us." Yena still lay on the floor, her voice clear of emotion.

A rhythmic pounding, like that at The Cally Bird, began against the door.

"What're we going to do?" Icar asked nervously, palming a knife from a pouch on his belt.

"Do? Nothing." Yena reached into the chest pocket of her cover-alls and pulled out a thin cloth-wrapped package. "They can't get in, we can't fight them, and there's nothing we can do until Annwyn gets back and tells us what the hell is going on. We're going to sit down, maybe play some Garakka, and try to get some sleep."

Reluctantly, her sister and the new-comer left the window and joined in the game. Icar had to learn the rules, so Set instructed, and slowly the game picked up its pace until they were tossing the thin metal cards back and forth with abandon; the Townies outside were successfully ignored.

After a few hours the pounding relented. Yena put her cards away and pulled off her leather boots. She sat down on the edge of the wool mattress, unclipped her utility belt, emptied her various pockets into her shoes, removed her cap and lay down to sleep. On the other side of the bed, Set was doing the same. Icar curled up on the floor under his greatcoat, and the squatters slept.

"Come on now, wake up!"

"No way in hell." Yena refused to open her eyes or even identify the speaker by voice.

"Blast it! You're coming with us today. I need your help. You're the best mechanic I can find by morning light."

Yena sighed and opened her eyes to a tall, thin silhouette: half-shaven head of otherwise long hair, pungent odor of pheromones and engine grease, harsh poetic voice. It must be Annwyn.

"Come on, I packed us picnic. We're going to see the woods."

"What? How?!" Yena was awake. She saw Icar and Set standing at the window, peering through the bars.

"We're going to see the old woman of the mountain. I commandeered us a sailbus. But we have to go now if we're going to get everything we need and leave with twilight before us."

Yena had her shoes and belt on in moments, but fussed with her cap. She wished she had a chance to put her hair up; she liked to be pretty around Annwyn.

Annwyn read her mind. "You'll have time to get cleaned up on the way, I'm sure. I know how to sail." Annwyn had changed from the night before, wearing a leather greatcoat cut to maximize airflow and minimize her exposure to dust and sun. Only a thin, tan V of her chest was exposed by the open collar.

"Is the street clear?" Yena asked her sister.

"Street's clear."

Yena ratcheted the stone back to its place above the door and the four of them stepped outside onto a broad, empty city street, deep in the industrial district. The sun was newly emerged and Yena estimated that they had slept three hours.

"See that," she overheard her sister tell Icar, "those marks in the dust are where the steam-ram was set up. And if you look closely, you can see the trail that the tread left on its way coming and going."

"Same idea as the drum-machine?" Icar asked.

"Same idea. What's worse, we invented it. The Townies adapted it for battle, though."

Yena wished the squatters had thought of it first, though the invention predated both her immigration to The Vare and her hatred for Townies.

"Who are the Townies exactly, anyway?" Icar asked.

"Oh," Set replied, "everyone else."

The bus rocked back and forth on its wheels once they had pedaled it out of the city and onto the open plains, and Yena was grinning behind her captain's goggles. A trip by sailbus always put Yena in a better mood, and though she resented her sleep deprivation, she preferred the morning light and the lonely road.

"I can sail us, you know," Annwyn said from her seat behind the captain's chair.

"I know. But, with my sister fawning over that boy...."

Yena couldn't see Annwyn grimace at her words, so she continued. "He seems okay, I guess. But awfully inexperienced."

The two were out on the driver's platform. There was a wheel for steering the mainsail with two smaller steering wheels set within it: one to control the foresail and the other to steer the wheels on the axle beneath them. One lever was used to raise and lower each sail, a third to apply the brakes. Behind them was the cabin, an enclosure eight meters long by four wide by two high. Inside that were Set and Icar.

"Where'd you get this thing?" Yena asked, changing the subject.

"Someone lent it to us last night."

The two sat in front, mostly silent, just watching as the dusty wasteland went by for the rest of the two-hour ride.

Yena brought the bus to rest near an oasis at the base of the west hills. The city lay behind them; the downtown skyline still visible, and a purple-green grass lay in front of them.

The group disembarked and Annwyn produced a basket woven from copper wire filled with food and a blanket.

"Weren't joking about that picnic," Set observed.

"Why is this oasis here?" Icar asked.

Annwyn sighed. "What kind of question is that?"

"No," Icar continued, "I mean, why isn't anyone living here, defending this water, these plants?"

"The water is poisonous, Icar. All ground water east of the mountains is poisonous," Yena answered him, annoyed as one might be with a curious child "if you sow here, you reap only death."

Icar was silent. Yena realized she was being too hard on him.

"Well, we've got lunch!" Set tried to recapture the spirit of a joyful picnic. "We've got … buffalo meat in mushroom sauce, shelf mushrooms in a blood sauce, and oh! Two oranges!"

Yena missed Angelina, her home city, exactly twice a day: luncheon and supper. Say what you will about the authoritative government, obsession with obscure gender roles, and mandatory work scheduling, at least the land was fertile enough for plants. One day, she thought, she would go back and see the oppression ended.

They ate in a calm silence, and soon Yena and Annwyn were on their way, leaving the others to watch the bus.

The air grew colder as they ascended and Yena pulled up her hood. The path was rocky but relatively stable, and the pair had no trouble finding their way. Yena had only been up to see the old woman of the mountain once before, when Annwyn had brought her to be introduced.

It was several hours before they reached the small patch of woods. It was protected on all sides by steep cliffs, exposed only as one edge touched against a poisonous creek. They hopped the creek at a narrow bend and were soon lost in trees.

Trees were the stuff of legends. The Vare was situated on the High Waste, east of the mountains. Far, far to the west, at the end of the railroad, lay Angelina on a misty coast. But even there, the only forests were those of bamboo and other grasses. In the Northwest lay the true forests, where none ventured for fear of the beasts fell anddirethat traipsed within.

Yet these woods, tucked away among the mountains of the High Waste, were unknown but to a select handful of mechanics who had studied with the Woman of the Mountains.

Yena was nervous as she walked through the thick underbrush at the edge and into the forest proper. Flocks of birds adorned the branches like leaves of black and white. Nothing hunted the woods, she knew, but the large raptors seemed to turn a hungry gaze upon her as she walked up the wooded hill.

The two had traveled in silence, but there among the trees Yena felt the need for conversation. "You never explained what we're up here for."

"I went to talk to Gregor." Gregor was a spy, a Townie who fed the squatters information. "He says they're after me. That's why they came to The Cally Bird last night."

Annwyn stopped for a moment to get her bearings, and Yena laid a hand on her back in an attempt to be comforting. The Townies occasionally harassed the squatters to join the rest of The Vare's government—or to get them to speed up the natural gas harvesting—but they had never come for one of them individually that Yena was aware of. Certainly they had never come for the object of Yena's unrequited love.

"So what are we going to do?"

Annwyn began to walk again and left the question unanswered for the leaves and birds.

"Where's Annwyn?" Icar came up the last hundred meters to meet Yena and help carry the awkward leather sack she bore across her shoulders.

"She's going to be gone for awhile, it seems."

"Oh." Icar looked defeated.

Yena happily shared the weight of sack and the two walked carefully back over the stony ground to the oasis and the bus.

"We've got to go, now. We've got a hell of a lot of work to do before dawn."

They boarded the bus and raised sail back east to The Vare. Both Set and Icar climbed out onto the driver's platform and Yena knew that she ought to explain everything.

"We can't tell anyone we were here today." Yena felt the tug of the winds and reacted unconsciously, pulling at wheels and levers without a thought. "I don't think that the Townies even know the old woman is up there, but it had better stay that way. It looks like they're after Annwyn, but they won't say why. We expect them to raid her house, her other house, at dawn."

Annwyn kept two workshops. One above the club for when she felt social, one tucked away in an opulent residential district for when she wanted more privacy. She mostly built small statues and automatons, and Yena had no idea why the Townies were after her.

"Anyhow, we won't be able to negotiate until we put up a fight." She turned her attention to Icar, because she knew he was new. And for some reason all of her antagonism towards him had left when Annwyn did. "See, when the Townies want something out of us, they just raid our building. Unless we resist, we don't even get a chance to talk. Every time they imagine some new gripe, we have to defend ourselves."

"What's the deal with that… who are you all?" Icar had to yell to be heard, sailing as they were into a headwind.

"When those Of the Mountain came down, they found The Vare built and waiting, empty. They settled in and founded a government, a centralized oligarchy. Those who joined, of course, considered it benevolent. But we, the we of a thousand years ago, didn't.

"They expected us to work for the good of everyone, and they created a lower class where none had existed. We never agreed, we never consented to be governed. No one really did anything about until, I don't know, 1060…." She stopped to think and looked at Icar for a moment. "The tribes you're from, they use the same system of years?"

"Yup. It's year 1082 Modern Era, is it not? Over a thousand years since you coast people came up from underground?"

Yena nodded and continued. "In the 60s sometime they revolted, shook The Vare near apart. Did it some good, from what I've heard. But then again, I hang out with the squatters. Anyhow, government has been a remarkably casual thing in The Vare ever since. We siphon gas from the earth for their lamps and stoves, and they leave us alone, more or less. But everyone else is centralizing again, and they expect us to.

Icar nodded. "So tomorrow they raid Annwyn's squat, and we put up a fight?"

Set touched his sinewy forearm with a soft finger. "It's not like you might think. It's all a game, really. No one dies. They'll surround the place and we either occupy it or booby-trap it."

"Which are we doing?" Icar asked.

Yena smiled for the first time in hours. "What do you think?"

The night found the members of Bellows Again reunited, but they applied their skills to more practical tasks. They had returned to The Cally Bird, a building of four stories with an I-beam skeleton protruding with an extra four. Fera had been perched on a platform near the top, spyglass pasted to his eye, and they waved him down.

The Townies had never gotten in, he told them with a grin. The door was too strong.

He joined them on the twenty-minute walk to Annwyn's second workshop. It was outside the near-empty industrial district, on enemy territory, sandwiched between houses four times its single-story height. What was more, there was no tunnel access. There was a front door, a back door, and two barred windows facing the street; if they had chosen to occupy it, there would have been no escape.

But if they left it unoccupied, there was nothing to stop the Townies from going in and destroying half of Annwyn's work. What was more, the squatters would have no bargaining power when it came time to negotiate. The Townies knew better than to kill—or seriously injure—any of the squatters, because the gas production would stop. So they were setting the house up to look occupied.

Once inside, Yena went to the stone clockwork set into the sidewalk and cranked a steel reinforcing plate over the front door. Fera hit a switch and sparks lit the gas lanterns mounted in brackets on the wall. The one-room shack was built similarly to the room they had slept in the night before, but the shelves were covered in miniature metal people, each hand-made by Annwyn.

Yena didn't understand why the Townies wanted the complicated dolls. They were interesting, to be sure, but they were about as dangerous as a pet rock.

Icar untied the leather sack from the mountains and gently emptied its contents out onto the stone floor. It was mostly clock parts, but there was also a thick book of paper-thin metal plates. Each was engraved with machinations and diagrams.

It took most of the night to finish their work, with Yena directing, and they escaped exhausted out the back door shortly before twilight.

"So what's going to happen again, exactly?" Icar and Yena lay on the roof of a nearby building, passing the brass spyglass back and forth.

"They're going to knock on the door. The vibrations will set one clock into motion, the lights will turn on, and copper silhouette plates will block the windows at nearly random intervals, but the door won't open.

"So they'll set up the steam-ram, and bash into the door. The more powerful vibrations will trigger the trap door set in the back of the roof and pebbles and flash-bombs will catapult forward. No one should get hurt too bad, but they'll think we're inside. Eventually they'll let up for a moment. Set and Fera will attempt to negotiate with them. If they get attacked, we rescue them."

"And how many of them will there be?"

"Oh, about forty."

"Alright."

Yena was glad that he showed no fear. Yena was scared, to be certain, but there was nothing that could stop her from coming to the aid of her sister, if need be. When she was trying to comfort Icar, she was trying to comfort herself.

"Remember, this is all a complex game we play. They don't hurt us, we don't hurt them."

"Done this before?"

"Once."

"It work?"

"Yup."

"Alright."

They came with the first hint of color in the sky. It was just like before—three-dozen hotheads, aged twenty to fifty, all men. Why was it always men? The squatters had woman among them, some of them just as stupid and looking for a fight at every opportunity. Like Annwyn. Or herself.

They pedaled the steamram down the street, a minor siege machine mounted with a full steam engine and boiler. It took ten people to pedal along. The mob reached the house and a dozen of them moved through the alley to block the back door.

One older man knocked on the door. The lights inside flickered into life, and soon the windows looked alive.

The men ran hooked a length of chain from the steam-engine to the grill of one of the tiny windows.

"What are they doing?" Icar asked. "Nobody could crawl through there."

Yena ignored him and looked on in horror. The Townies started the machine and ripped the grill cleanly off. The older man raised a pole and smashed out the glass. A younger one threw something inside the building.

A moment later an explosion rocked the street and the roof of Annwyn's shack collapsed.

"It's just a game?" Icar gasped in shock.

Yena stood up. "Not anymore." ✦

To discover the outcome of this fateful morning—and to learn more of this nearly-fantastical world of mechanics and music, tribes and cities—be sure to obtain the second issue of SteamPunk Magazine.

Abney Park is a Seattle-based ensemble performing danceable ditties laced with old-world ideals and postmodern tech. Diverse instrumentation married to evocative lyrics conduct a shocking love affair with their infectious stage presence. I have taken the liberty of interviewing the gentlemen of Abney Park, who at the time, unfortunately, were the worse for drink. Please disregard the debauchery if you will—the aforementioned contains what little I was able to decipher from their sinful drunken slur.

interview by libby bulloff

Abney Park

For those readers who may not yet be familiar, characterize the Abney Park sound with a few choice adjectives. Pontificate about your instruments and their custom modifications, if you please.

Robert: Truth is, if you haven't heard it, it's not much like anything you've heard. We've got elements that you're familiar with: dance beats, Middle Eastern rhythms, solo violins and symphonic orchestration, male and female voice in harmony, blah, blah, blah, blah, but for some reason when we put them together, they sound different then when other people put them together.

Nathaniel: At the moment, I play violin and guitar—make and model vary from show to show. I'm always trying out different instruments, much to Robert's irritation. I usually play them both at the same time with the help of my steam-powered pneumatic arms (with the optional fine manipulation attachments) but they've been giving me all kinds of grief of late. Unfortunately, our next show is coming up too soon for me to really get the arms up and running, so I'll have to swap from instrument to instrument between songs. What a pain.

Why do your fans and critics attribute the genre of steampunk to your music, a genre which is as of yet mostly undefined aurally?

Nathaniel: To be honest, I couldn't tell you what steampunk really means. I mean, we just play the stuff we like and let people tell us what it is. I'm glad you like it, by the way!

Robert: From my understanding, "steampunk" is some new-fangled slang word referring to an anachronistic mix of things, old and new, in a way that wouldn't normally be mixed. If you look at us, listen to us, and read our lyrics, you'll notice things are riveted together in a way that doesn't exactly fit a standard timeline.

Inquiring minds want to know: if you were going to hell, in which circle would you find yourself and why?

Robert: I'm still hoping our heroic deeds will cancel out our sins.

Nathaniel: I've got the all-circle pass with unlimited access. I mean, I'm going to be there for an awfully long time; I might as well make sure I get the best deal possible. Besides, most of my friends are going to be down there too, so it'd be nice to be able to visit them on occasion.

Jean-Paul: Probably the 8th. We've been known to seduce a few audiences here and there.

As time progresses, the modern steampunk isn't just expected to be knowledgeable about the latest anachrotech, he or she is encouraged to look the part as well. Have you any advice for the aspiring lady or gent when it comes to fashionable garb?

ROBERT: I just stitch old junk together, and I'm sure I look like crap. But the ladies on this crew would beat my ass if I suggested that they make clothes for me, and I'll be damned if I'm gonna buy any of the clothes you people have in shops these days…back in my day you could buy a horse or two for what you charge for those ridiculous blue canvas pants everyone is wearing. I've got some shirts I took from a tramp steamer heading to the new Indias in 1887—that was only a couple months ago, so they are still in good shape. And my boots, well, I've been wearing them for years but they make 'em sturdy in 2137, so I expect them to last a while still.

NATHANIEL: It's true. He really does stitch old junk together. Personally, I like the feel of a well-tailored suit. I think mine might be a few years out of date, but it's still sound and allows me sufficient range of motion to play violin and guitar. In general, my rule of thumb is to show [Abney Park singer] Magdalene what I plan to wear. If she gives me the thumbs up, I'm golden. If she says I look like an idiot, then I know to rethink my plan.

Hats. Yea or nay? If so, what sort?

ROBERT: People make fun of my pith helmet, but I'll be damned if it hasn't saved my noggin a few times. Things fall…on my head…it happens.

NATHANIEL: A well-fitted hat is always appropriate. Top hats, aviator caps, pith helmets, anything! Unless you've got mad-scientist hair, in which case you should totally flaunt it!

Is there any sort of object or necessity Abney Park refuses to leave home without?

ROBERT: Eye protection would appear to be a big concern with this crew. It seems silly now, but ever since that old bass player got his eyes poked out by some dancing girl's "falls", we've all wanted to make sure we had some sort of safety lens handy.

NATHANIEL: My violin. Guitars are a dime a dozen, but do you have any idea how much of a pain it is to find a good violin? A good pair of flight goggles and a parachute has always proven useful, as well. As romantic as the thought of going down with the ship can be, I prefer to live to fly another day.

JEAN-PAUL: Rope ladders, grappling hooks and various other quick-exit paraphernalia.

Do tell us a tale of the finest show you believe you've played.

ON GOGGLES AND BURNING COMPUTERS
and hats and rehearsals

Robert: Oh god, they are all such a nightmare. It's a constant stream of one technical glitch after another, and we feel blessed when we aren't run out of town. Look, the only reason we keep doing those damn things is because people pay us…and leave their cars unattended while watching the shows. It's easy pickings, and that's all I'm saying.

Nathaniel: For me, that show would be our set at Dragoncon 2006. By the time we took the stage at midnight on Sunday, everyone in the room (fans and band alike) had been going close to full steam for the past 48 hours. There were easily over a thousand people in the audience and the energy I got off of them was wonderful. After the set, we spent at least 4-5 hours just hanging out, talking with the fans, signing autographs, and generally having a great after-show party. We made a lot of new friends that night.

Jean-Paul: Probably our 1st show at Bar Sinister in Hollywood, Ca. For all intents and purposes we were the only band that night and we totally sold out! Standing room only. The crowd was singing along to every song and energy was incredible! Plus the venue is beautiful! It's what so many other places try to do, but fall short. We sold out of everything that night and had people fighting over the scraps. Very satisfying indeed!

> Eye protection would appear to be a big concern with this crew.

Do tell us a tale of the most horrid show you believe you've played.

Robert: Where do I start? Tell you what, I'll let everybody else tell you about the time all the gear overheated on stage in Seattle.

Nathaniel: We played a summer show in Seattle on the hottest day of the year. It was 105 degrees outside and we were in a venue that didn't have air-conditioning. It must have been close to 110 degrees on stage under all those lights and we were up there for nearly an hour. I don't know about the others, but I went through a couple of quarts of water just to keep myself hydrated. After each song, I'd open a new bottle of water, drain it, and toss it aside just in time to start the next song.

I think it was during the third song of our set that our equipment started to fail. We use the cutting edge of modern computing technology in our stage set and, sadly, that edge gets rather blunted in 110 degree heat. Halfway through the song "The Change Cage" (right before the solo!) the laptop's sound card decided to commit suicide in a loud and raucous orgy of sound. It scared the hell out of me. I thought it was the coming of the Apocalypse! The fans loved it, though. They thought it was all part of the show!

With the help of a few stage fans and a brief reboot, we were back on track. Sadly, the heat only got worse and we ended up repeating this procedure a few more times before the computer well and truly died.

The people in the audience were amazing, though. In spite of the heat, they were dancing and really getting into the music.

They even cheered when the songs would cut off in that orgy of apocalyptic noise. It gave me a tremendous boost to see them out there on the dance floor. I couldn't have done it without them.

Practice makes perfect, as it were. Kindly advise those aspiring musicians among us regarding the style of your rehearsal sessions, and any pointers you might have on the subject of music recital.

NATHANIEL: If you plan to use something on stage, you'd damn well better be using in rehearsal. You need to know your equipment so well that it's entirely second nature. You can't be letting yourself get bogged down in minutiae when you're standing in front of an audience expecting to see a show. Get used to setting up and breaking down your stage gear quickly and efficiently.

As far as actually rehearsing goes, treat every take as if you're on stage. Be dynamic. Emote. Be a ham. Putting on a show is more than just playing the songs; you have to move and be an engaging performer also. And that takes practice. If you get used to playing a half-assed set in rehearsal, then that's what you're going to deliver when you're on stage.

It's also useful to have a heavy blunt object handy for use during the occasional difference of opinion.

JEAN-PAUL: You have to be able to tell the person next to you that what he/she is doing sucks.

ROBERT: Yeah, sorry about that Paul.

JEAN-PAUL: ...And you have to be able to hear it said of yourself as well. If the band can't do that, then too much mediocre crap will get through and you'll have a mediocre band. At best. But you have to be able to feel relaxed and unpressured so that you can play your best. It's a balancing act. And don't forget, it's just as important, maybe more important, to praise your bandmates when they do something brilliant. Fortunately for me, I get to do the latter far more than the former.

What place do you visualize Abney Park nesting in the current music world?

NATHANIEL: We're just a group of subversives bringing enlightenment to the huddled masses. Our plans of world domination proceed apace. Just you wait!

JEAN-PAUL: As the rulers of our world. Now, if we could just get everyone to tunnel under the fence into our world....

ROBERT: Current Music World? Eh, they kicked us out long ago, and we let 'em, the bastards!! SCREW 'EM ALL, I SAY! We don't need them...*sigh*

For more sober *information about Abney Park, view their website at http://www.abneypark.com*

MATERIAL COMPONENTS:

OIL MASKING:
- lithographic paint (any color)
- linseed oil
- japan drier (optional)
- something pointy (nail, dentist's tool, etc.)

IRON-ON MASKING:
- laser printer
- glossy inkjet photo paper
- clothes iron
- rubbing alcohol
- roller (optional)
- tray (optional)

ETCHING:
- 2 brass plates
- kitchen scrubby
- steel wool (optional)
- copper sulphate (rootkill)
- non-conductive tub, with lid (tupperware)
- stiff conductive wire (thick copper wire, brazing rod, etc.)
- DC power supply (car battery, DC power adaptor [3-4.5v], etc.)
- 2 alligator clips
- metal polish (optional)
- black spraypaint
- clear spraypaint (optional)

Bwa-ha ha ha!

Electrolytic Etching
adapted from the esteemed Mr. von Slatt

Warnings: Copper sulfate is a poison. If you eat it or stick it up your nose or something, your life will take a sharp turn for the worse. Electricity is dangerous. Although most of the methods mentioned below use less electricity than is truly damaging to the human nervous system, we suggest *not* shocking yourself. And thirdly, if you let things heat up too much, they can sometimes catch fire. We really don't see that happening, but well... reader beware. These methods we describe are not 100% safe. Curiously, neither is life.

For a long time now (significantly longer than any of us have been alive), people have been etching metal plates. Once etched, a plate can be used to print onto paper in a process called "intaglio", or it can be inked and treated as a beautiful piece of art in its own right. Partly owing to our great love of metal objects—and partly because we have yet to experiment with the intaglio process—we present here only the latter.

But most everyone does this etching through a toxic, foul, acidic chemical process, appropriately referred to as "chemical etching." Plates of copper or zinc are immersed in highly toxic solutions, at great hazard to both the earth and the artist. Not very punk.

Fortunately for the world, some artists have turned to another method of etchery, which we shall call "electrolytic etching." The chemical solution involved in electrolytic etching is remarkably less hazardous—though none would be wise to refer to it as "safe"—and it can be used near indefinitely. As a bonus, the same process can be used to *plate* copper onto one object while it *etches* it from another.

We will be using brass plates for our example, because brass is sexy and because it can be purchased relatively cheaply at the hardware store. The same process can apply for copper without changing anything. Zinc or even steel can be electrolytically etched as well, but different chemicals must be used.

There are essentially two important steps in electro-lytic etching. First, masking. Second, etching.

Masking is the process of marking off what is to be etched (or plated) and what is to be left alone. Since we will be working with an electric process, masking is accomplished by applying a non-conductive (insulating) material to the surface of the plate, in inverse to the image you want etched (or plated): you are masking off everything that you *don't* want etched (or plated).

The simplest—and for some most entertaining—method is to paint with a non-conductive substance directly onto the plate. We experimented with two different methods: acrylic and oil based paints. Acrylic paint has the advantage of drying more quickly, but the disadvantage of flaking off unappealingly. Oil paint (we used black lithographic ink, thinned with linseed oil and treated with japan dryer to speed up the process) gave us much better results, but we had to wait several days for the paint to dry, and oil paint is significantly more toxic (and smelly) than those plasticy acrylics. When either paint dried, we took a nail and scratched fun little drawings into them.

The other method is useful for those who want to reproduce an existing image exactly. At some point in recent history, people realized that if you ran *inkjet* glossy photo paper through *laser* printers, you could iron the resultant image onto metal plates. Photocopiers are laser printers, so you could theoretically take your image to a photocopy joint and use the manual feed option to put in your own paper. Or, if your image exists in the digital realm, print it out on a laser printer. Either way, you want your print to end up mirror-imaged and inversed (black for white, white for black).

Clean the hell out of your piece of brass, with a solvent like alcohol.

Once your image is printed, place it face down on your brass plate. Turn your iron on to its highest setting and iron

the paper: you are trying to melt the toner off of the paper and onto the plate. You might want to try using a roller to keep it pressed down as well. After several minutes, the plate and paper can be soaked in hot water and the paper backing slowly peeled off, using a stiff brush to get every last bit of white off. Honestly, we had very little luck with this method, but Jake von Slatt, our consultant, has repeatedly presented the world with gorgeous imagery by using it. We suspect that we should have tried a different brand of paper. See the bibliography (page 41) for more information on this process.

So now you have your masked plate, and the fun (read—mildly dangerous) part begins. You get to etch your brass plate.

First, an overview: if you run direct current electricity through a solution of copper sulfate diluted in water, between two parallel plates that have copper in their composition (which includes brass), the copper will be stripped from the plate on the positive terminal. Copper will be plated onto the negative terminal.

So you need a source of direct current electricity. Batteries provide direct current, but your wall outlet provides alternating current. One solution would be to use a car battery, although any sort of battery will end up drained and need to be recharged. A car battery *charger* is also a conceivable source. It turns out, by the way, that if you use a car battery, you need to make certain you don't short the leads, as this could melt your wire and set things (like your house) aflame. Also, car batteries are full of acid. Lacking in such monstrous appliances, we opted to obtain a wall-wart DC adaptor from Goodwill. Car batteries provide 12 volts each, and a car battery charger will provide the same, but we were warned that with a wall-wart DC adaptor we ought to stick to something within the 3-4.5 volt range. We found a Nokia phone charger at 3.7 volts.

The more electric power you can send through the solution, the faster the etch, but electricity turns out to be quite a complicated thing, with at least four distinct measurements—volts, amps, watts and ohms. Not fully understanding the complicated interplay between these variables, we heeded the 3-4.5 volts advice.

We then cut the tip off the cable, separated the two wires, and stripped the last inch or so from each. But they looked the same; we didn't know which wire was positive and which was negative. We then, with caution so extreme it resembled cowardice, touched the leads of our multimeter to the bare wires. When the meter read a charge, we assigned the black lead's wire to be negative and the red lead's wire to be positive.

We attached little screw-on alligator clips .

The electrolyte itself we made out of a tupperware tub from a thrift store, though any non-conductive container of adequate size would do (the lid is nice to have, however). We took thick copper wire (from the hardware store, or the scrap at a construction site) and formed holders to keep our plates submerged and parallel. It is important that these holders be conductive, and we have read information that states that using the same metal throughout the project is a positive—although not explicitly necessary—thing. We then filled the tub with water and added just a dash of Rootkill, our nealy-pure copper sulfate. Apparently, copper sulfate is also available in a pure form at chemical supply places, and is used in the making of some ceramic glazes, but Rootkill works fine. We just hate advocating something by brand.

We knew that the more dense the solution, the faster the etch, but also the more likely to overpower our meager DC adaptor.

We stirred it up until the water was blue, placed our masked brass plate and an identical but un-masked brass plate into the holders, and clipped on the alligator clips: red, positive, for the side to be etched, and black, negative, for the side to be plated.

We plugged in the wall-wart and waited. After about five minutes, we tested the wall-wart to make sure it wasn't warm. It wasn't, so we stirred in a bit more copper sulfate (after turning off the electricity!). We repeated this every five or ten minutes until the wall-wart was a little warm, and then stopped adding more. Then we waited again. For a really long time.

Our consultant has told us that this part is much more spectacular, and significantly faster, when more power is applied: bubbles, hot water, all kinds of madness.

With our first experiment, we let it etch too long—nearly twenty-four hours—and so the second time we etched it for only 3.5 hours. The second time it worked quite well. But you're going to have to do some experiments to find out how long... variables include the distance between the plates, the density of the solution, the voltage of electricity and the amount of exposed plate to be etched.

Once we had our plate etched, we turned off the electricity, pulled out the etched plate, and washed it off thoroughly. The acrylic was easy to wipe off, but oil-based paint took some dishsoap (ask any painter: dish soap breaks down oil) and scrubbing.

When the plate was clean, we inked it. We used the same black lithographic ink, but less diluted than before. We squeegeed the ink across with a piece of cardboard, pressing down to make certain it was pressed into the etched lines. We then took a spare piece of cloth (surely you sew your own clothes, don't you?) and wiped in circular motions to clear off a majority of the excess ink. Finally, we took a scrap of paper and rubbed the last bits off.

The method that Jake uses sounds promising however, and relies on spraypaint, which is quite useful in its own right:

> "...regular flat-black Krylon, and then coat with clear lacquer. I've been spraying the piece, then using a rubber squeegee to gently wipe off the excess paint. Once the paint is pretty dry (20 minutes) I take a paper towel and some alchohol and gently wipe off the haze of paint left on the piece. It's a little fussy... Oh, and I polish it first, it makes the paint easier to wipe off and it's easier to get a shiny finish."

And there you have it: a strange little piece of brass.

INSTRUCTIONS:

OIL-PAINT MASKING:

1—Mix lithographic ink and linseed oil in a cup (which you shall never drink from again). Add a little bit of Japan Drier.

2—Paint the surface of your clean brass plate with this ink, attempting to create as even of a surface as possible.

3—Wait a long time for it to dry. Inside, in winter, expect this to be several days.

4—Scratch your design into the dry ink with a nail, dentist's tool, staple from carpet, pointy stick, or whatever.

IRON-ON MASKING:

1—Scan your image into the computer. Create a mirror image ("flip horizontal") and inverse the image.

2—Print your image, with a laser printer, onto glossy photo inkjet paper.

3—Clean the brass by scrubbing it vigorously with rubbing alcohol. (DO NOT DRINK THE RUBBING ALCOHOL.)

4—Iron the image onto the clean brass plate, with the iron set at its highest setting. Two minutes may suffice to melt the toner onto the brass.

5—Soak the brass plate in a tray of hot water to make it possible to peel the paper away from the brass plate, leaving the toner behind. This may take about 10 minutes of soaking, depending.

6—Remove the last bits of paper with a stiff brush.

PREPARING A WALL-WART DC ADAPTOR TO USE:

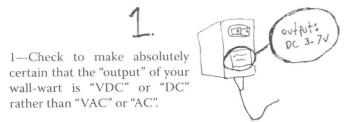

1—Check to make absolutely certain that the "output" of your wall-wart is "VDC" or "DC" rather than "VAC" or "AC".

2—Cut the tip off of the wires, pull the two wires apart, and strip each about an inch or so.

3—Making certain that the bare wires are not touching *anything*, plug the adaptor in and touch the leads of your multimeter to the wires (while set to DC-15 or a similar setting: read the multimeter's manual). If the meter reads a current, then your red lead is touching the positive wire. If it is not, touch the leads to the opposite wires and see if it reads a current.

4—Unplug your adaptor. Attach your red alligator clip to your positive wire, and your black alligator clip to your negative wire.

PREPARING THE ELECTROLYTE:

1—Bend your thick copper wire to a shape that will hold your brass plates against the walls of your tupperware tub.

2—Fill the tub with water, making certain to leave an inch or two from the top, to lessen the dangers of spills and the effects of displacement.

3—Place your plate-holders onto the edges of your tub.

4—Add a bit, perhaps a few tablespoons, of copper sulphate to the water, and stir. Don't touch this stuff.

5—When the water is adequately blue, attach the red and black alligator clips from your power source to the copper plate-holders. Turn-on/plug-in your wall-wart.

6—Wait 5 minutes. Is your wall-wart warm to the touch? No? then you can add a bit more copper sulphate (we recommend turning off the electricity first). Yes, your wall-wart is warm to the touch? Then you have added enough copper sulphate. Yes, your wall-wart is *really* warm? Then you have added too much. Unplug the electricity, start over with clean water. But that's wasteful, and generally not good. So avoid that.

ETCHING:

1—With the electricity off, put your brass plates onto the copper holders in the water. The plate that is to be etched is placed on the red (positive) holder, and the plate to be plated is placed on the black (negative) holder. If you are only etching, you still need to have a plate to be plated. Fortunately, the same plate can be plated over and over again.

2—Turn the electricity on.

3—Wait. Keep any cats or people away. Don't touch.

4—To check on progress, turn the electricity off and pull the plates out.

INKING THE PLATE:

1—Clean your mask off the plate; with soap, scrubbing, steel wool, whatever.

2—Polish your plate with metal polish (optional, but a good idea).

3—Spray an even layer of black spraypaint.

4—While the paint is wet, squeegee off excess paint with a rubber squeegee or a piece of thin carboard.

5—Wait for the ink to dry (20 minutes or so) and then use a scrubby, alcohol, whatever, to clean off the excess paint and the resultant haze.

6—Spray with clear spraypaint.

DISPOSING OF THE ELECTROLYTE:

1—First, don't bother. Use it again: it's not used up. If you're leaving to go hitchhiking (and thus getting rid of all excess things), getting evicted, or have some other reason to no longer own an electrolyte for brass etching, then find someone to teach, and give it to them.

2—If you're really going to get rid of it, you *can* just dump it down the toilet without beating yourself up too hard about it. Just don't make it a habit. If you have a septic system, then you should avoid this: it might damage the bacteria. But this stuff was manufactured (by evil corporate scum who don't understand organic farming methods, admittedly) to dump down drains, in order to kill plants.

3—That said, dumping it down the toilet still isn't so good. If you add sodium carbonate (also called "washing soda" and reasonably readily available) or sodium hydroxide (apparently used in the making of meth, and therefore unadvisable as well as less available), you can raise the pH balance up to about 7 or 8, and then it's more okay. Filter out the gunk at the bottom (which is mostly copper and zinc particulates, by the way), and dump the rest of the solution down the drain. Take the gunk to the metal recycling dumpster at the town dump.

BIBLIOGRAPHY:

Gootee, Thomas P. Easy Printed Circuit Board Fabrication - Using Laser Printer Toner Transfer, http://www.fullnet.com/u/tomg/gooteepc.htm

Green, Cedric. Green Prints - Etching without Acid, http://www.greenart.info/galvetch/contfram.htm

Slatt, Jake von. The Steampunk Workshop, http://www.steampunkworkshop.com

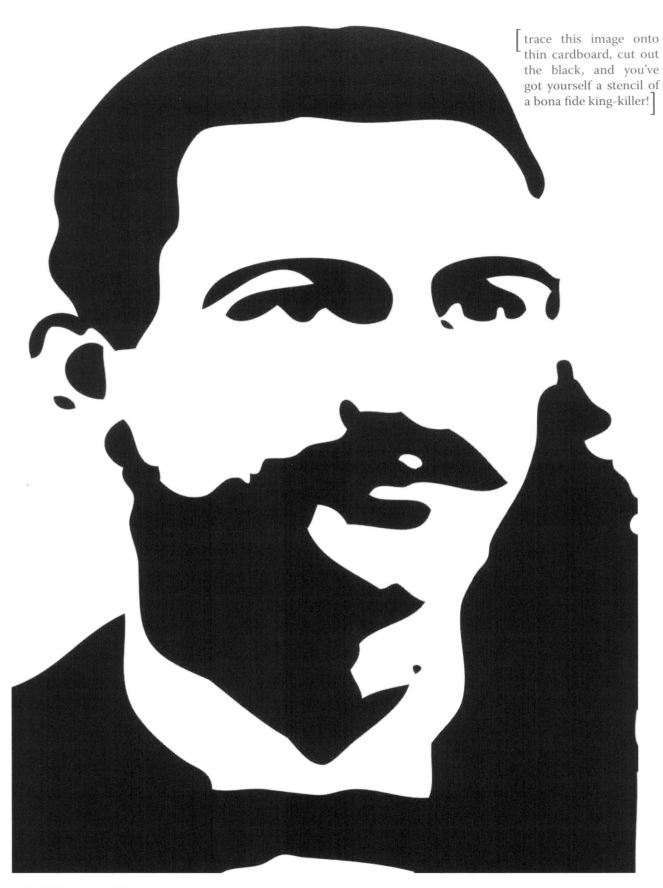

[trace this image onto thin cardboard, cut out the black, and you've got yourself a stencil of a bona fide king-killer!]

GAETANO BRESCI 1869 - 1901

> "…that man who had the courage to kill a king… well, that Gaetano Bresci, who had even come from America, that fantastic country beyond the ocean, seemed, in my child's imagination not a monster, but a great hero!"
>
> — E. Arrigoni, *Freedom: My Dream*

THE COURAGE TO KILL A KING
anarchists in a time of regicide

1900

Gaetano Bresci, an Italian immigrant, was a quiet, sober man by all accounts. A hard working weaver who made a new home for himself in Patterson, NJ as the 19th century drew to a close, he was highly regarded by his peers. He supported a wife and daughter. He helped found and fund *La Questione Sociale*, an Italian language newspaper of Libertarian Socialism, and had no temper to speak of. He bore a fine, full mustache, the ends pulled to slight curls.

Why then did he abandon his family, purchase a pistol and passage to Italy, and gun King Umberto I down in the streets?

Anarchism was a prevalent political trend of the time—despite the dearth of attention paid to it in modern textbooks—and Gaetano was one numerous thousands who espoused a world of social equity without coercive force. What anarchists agreed upon was the end of a ruling class; what they disagreed on was how to see the ruling class ended.

Some advocated that peace would only come through peace:

> The anarchists are right... in the negation of the existing order... They are mistaken only in thinking that Anarchy can be instituted by a revolution."
> – Tolstoy, *On Anarchy*

Others advocated insurrection and revolution. Many felt that only through a combination of education and resistance could liberty be obtained. But one popular trend in the anarchist milieu was that of *propaganda by the deed*.

What was propaganda by the deed, that it shook the world so greatly?

1877

A fellow by the name of Errico Malatesta—who grew a fine beard, but neglected to curl his mustache—was an advocate, and practitioner, of propaganda by the deed. First arrested at the age of 14 for writing a letter to the king in regards to local injustice, who can blame a person born under the yoke of another if they choose to rebel?

Errico and around 30 others marched on two small Italian towns in the Benevento province. They announced the people's liberation from the monarchy and set tax and property records to the torch. A local priest, upon hearing their intentions, announced to his congregation that the anarchists were indeed sent unto them by God.

But the lord of the land felt otherwise, and soon all of the agitators were rounded up and briefly imprisoned. Yet the tales of their action grew more powerful than the brief taste of liberty:

> Take over a commune, introduce collective ownership there,... if attacked, fight back, defend oneself, and if one loses, what matter? The idea will have been launched, not on paper, not in a newspaper, not on a chart; no longer will it be sculpted in marble, carved in stone nor cast in bronze: having sprung to life, it will march in flesh and blood, at the head of the people.
> – Paul Brousse: *Propaganda by the Deed* (1877)

Regicide became the crime of choice and legend, as propaganda by the deed expanded from minor insurrections to attempts on the lives of tyrants. The very next year, Stepniak—a Russian novelist who had also taken part in the Benevento uprising—took the life of the head of the Tsar's secret police; he knifed the man in the streets of St. Petersburg and got away clean. The Tsar himself was soon to follow, along with presidents, kings, emperors and governors.

The anarchists wanted to say to the world, "Hey! You need not play pawn in this life. The state is vulnerable, and the state needs to be held to account. Join us, for liberty!"

Shortly we will return to our humble weaver.

1898

King Umberto I "The Good" was about as popular as consumption. Having turned his attention towards colonizing Africa, he paid no heed to the starvation that grew rampant in Italy. Social unrest reached a head in the first half of 1898, and by May the peasants demonstrated outside the palace in Milan. General Fiorenzo Bava-Beccaris turned cannon upon the crowd, killing between 100-350 and wounding about 1000.

The regal response? Umberto decorated the general.

Back to the great state of New Jersey, where our father, husband and anarchist toiled so vigilantly.

1900

When Gaetano made up his mind to end the imperious reign of Umberto I, he spoke of it to no one. He needed no party's permission to act, no conspiracy to bolster his strength. He just needed some money.

He went to his comrades on the newspaper and requested that they return his loan of $150, but would not tell them why. The paper was destitute, and it was only with much grumbling that they obliged him.

Bresci took leave of his family and returned to Italy. Two months later, on July 29th 1900, he waited for the King to emerge from a gymnasium where His Royal Highness was awarding medals upon athletes. Umberto began to drive away, and Bresci put three bullets into him before being apprehended. With a pistol and courage summoned only from his own convictions, Gaetano had meted out a justice that could have been provided by no state.

The double-edged sword of authority leaves a leader responsible for the actions of their subordinates. It should always be so; indeed, it is perhaps the only justification that can be found for the hierarchical structuring of people. A king should be held accountable for the actions of his general, a general should be held accountable for the actions of his soldiers. When this is forgotten, blame is dispersed so greatly that it allows the soldier to turn the cannon on the people.

The rest of Gaetano Bresci's life was short and nearly formulaic. He was tried and sentenced to life imprisonment on a penal island. Within a year he was found hanged dead in his cell.

His friends back in Patterson who had so misjudged his character chose to adopt his daughter.

But propaganda by the deed wasn't all beautiful rhetoric, murdered kings and martyred militants. The anarchists, by design, had no leaders and no centralized council. The same freedom that allowed Bresci to plot his deed—which the editors of this paper consider indeed praiseworthy—this same freedom meant that horrific actions could be carried out without restraint. There were regicides, yes, but there was also terrorism:

In 1894 a Spaniard by the name of Emile Henry shocked the mainstream populace and radicals alike when he threw a bomb in an upscale cafe. One person was killed and many more were injured. On trial, he was unrepentant. "There are no innocent bourgeois," he declared, as part of his defense to the court. He was guillotined.

And yet, for over 15 years to follow, this was an isolated incident. For every anarchist assassin, there were thousands of working-class unionists, educators and activists. And for every Emile Henry there were a hundred anarchist assassins who would never harm an innocent.

MURDERERS, ONE AND ALL
from left to right: King Umberto I, Stepniak, Emile Henry, Prime Minister Cánovas del Castillo, Michele Angiolillo, Luigi Galleani

In 1897, Michele Angiolillo was about the most gentlemanly killer you could ever hope to meet. Having traveled to Spain from England, he tracked the Prime Minister Cánovas del Castillo—responsible for violent repression and many political deportations—to a resort spa and shot him to death. "Murderer! Murderer!" Michele heard, and the Prime Minister's wife came to the scene of the crime.

Bowing to her, Michele spoke, "Pardon, Madame. I respect you as a lady, but I regret that you were the wife of that man."

The assassin then allowed himself to be captured—so as to minimize the reprisal on his peers—and was executed by garrote in less than two weeks.

And yet *propaganda* by the deed wasn't working; individual kings died, but monarchy did not. The people were not spurred, it seemed, to some glorious revolution, and the attention of the anarchist movement turned back to trade-unionism. Only a few remained convinced of the political righteousness of murder; of these, none were more dangerous than Luigi Galleani. The father of modern terrorism, Luigi advocated large-scale and nearly indiscriminate assaults on the bourgeois, but never practiced as he preached. Instead, the Galleanists did. Never trust someone whose followers describe themselves as someone-ists, and never trust someone who holds the opinions of someone else higher than their own.

From 1914 to his deportation from the United States in 1919, Luigi—who, we must admit, also bore a fine mustache—oversaw or influenced dozens of bombings and poisonings. Yet most of the bombs were intercepted, went off unexpectedly, or otherwise misfired, and it was often housekeepers, bystanders, or the assassins themselves who paid the price.

The name of the anarchism was forever mired with terrorism, and forgotten were the bold folk who fought *against* systematic violence. It takes courage to stand alone against injustice, to stand before your betters, spit in their face, and refuse. It takes much less to leave bombs on the doorstep of their lackeys.

Postscript

Is steampunk anarchist? No, it is not. Ought it be? Probably not. In our ranks there are enthusiasts from all about the political spectrum, to be sure. Yet the punk movement was intentionally one that stood against authority, bravely defiant. The anarchists were among the punks of their era—they stood by their ideals despite overwhelming odds. Although they are mostly lost or misrepresented in the annals of mainstream literature, they had what very few had: the courage to kill a king.

They also had, it can be noted, quite stylish dress and manners despite their lower class.

an interview

MAD SINGER OF MARVELOUS MECHANICAL MUSIC

I know people ask you about your instruments all of the time, but I'm afraid we must. We're quite a bit interested in applied acoustic mechanics, so as much technical information as you can spare would be appreciated by us all. Tell us about the hornicator: how is it built, what can it do? It uses physical objects to create distortion and reverb?

I'm not really an electrician or engineer. I've always liked to build things; I've gleaned a lot of knowledge and experience from my days with puppets and moveable miniatures used in stop-motion animation. That probably also has something to do with the strong anthropomorphic element in my 'instruments'. I really do see them as little beings, bandmates, if you will. We do spend a lot of time together. I also did time working as a prop and set builder for theater and television; that certainly comes into it.

Recently I played a corporate Christmas party—not the kind of gig I usually do—but it paid well and they were all engineers. They offered me a job at their firm afterwards! I said I had absolutely no training as an engineer and they told me that that was why they wanted me, implying that somehow having a proper education in this sort of thing somehow corrupts the inspiration quotient or something.

Anyway what I do is set out to find a way to make an idea happen; it's mostly trial and error, and the fun part is that often I wind up with something completely different than I set out to create. The Hornicator is a good example of that because it was just a nice old gramophone horn from a roadside 'junk' shop that I thought would add a nice visual element when attached to one of my rhythm machines. But aesthetically, it wasn't happening. However, I started tapping on the thing and singing into the big end of the horn (one of my techniques is to always try something backwards) and it dawned on me that it was originally created as an audio amplifier, and had a certain nice tonality of a certain flavor that hadn't been heard in ages by most people. So I attached a microphone element to it and started sticking things in and on it. It's now got fretted strings and springs on it; its structure lent itself to a harp-like set up.

Springs are fantastic; everyone loves 'em, everyone uses 'em. Stretch a spring across almost anything, put a mic or pickup on it and you'll get something as good as coffee in bed. Spring doorstops were endlessly fascinating to me as a kid. I could lay on the floor for hours snapping those things with my ear pressed to the door happily absorbing the reverberation. Once someone came through the door while I was doing this and I've had an injured neck ever since. There's one of those on my instrument 'the Stringaling'. There's a very long spring attached to the small end of the Hornicator, which has a cup-like 'receiver' on the other end. This was something my brother sent me for a birthday present. A 'Space Phone'. When we were kids we'd make these by attaching two plastic cups with a long string between. When you stretched it and spoke into one end, the person on the other end would hear a kind of martian version of the voice of the other person vibrating down the line. This was a marketed version of that, but lucky for me the spring was the exact diameter of the small end of the Hornicator. Pull that spring and it's got this great wobbly sound that reverberates through the horn. Sometimes, as one part of my performance, I sing into one end and listen through the other as if it were a giant phone.

So for me it's not only about thinking up and making

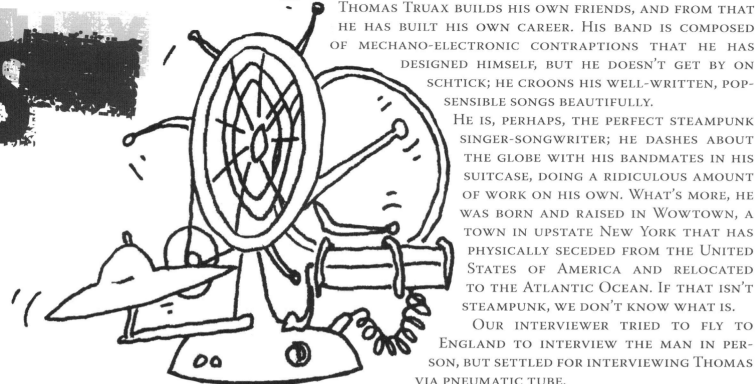

Thomas Truax builds his own friends, and from that he has built his own career. His band is composed of mechano-electronic contraptions that he has designed himself, but he doesn't get by on schtick; he croons his well-written, pop-sensible songs beautifully.

He is, perhaps, the perfect steampunk singer-songwriter; he dashes about the globe with his bandmates in his suitcase, doing a ridiculous amount of work on his own. What's more, he was born and raised in Wowtown, a town in upstate New York that has physically seceded from the United States of America and relocated to the Atlantic Ocean. If that isn't steampunk, we don't know what is.

Our interviewer tried to fly to England to interview the man in person, but settled for interviewing Thomas via pneumatic tube.

instruments for anyone to play in the usual sense, it's really a combination of many different angles. Often an instrument is added to and developed, or even built, to accommodate a specific new song. Sometimes a song is altered or built by some accidental new dimension or discovery with an instrument, so it goes both ways. And I'm always thinking in terms of not only audio but also performance, storytelling, and play.

People have asked me if I can make them a Hornicator or a Spinster, or even tell me flat off that they're going to rip me off and make their own. What they don't get is that what they're seeing me do is an amalgam; the instruments are born of and interwoven with my personal obsessions and fascinations and accidents and experiences, etc. Not to get too highbrow about it, but they are like individual sculptures. It took me a long time to realize it myself, but if you want to do something different, you've got to let your own imagination fly free; these things wouldn't be the same in anyone else's hands. What people really need to do if they want to go in the direction I'm going is find their own direction, let their own imaginations go. Someone more knowledgeable about electronics and acoustics than I will certainly come up with things that are acoustically better than mine, but people would also argue that it's the lo-fi aspects, the shortcomings, that give some of the sound-making contraptions I build their unique personalities. The 'distortion' you asked me about is most likely accidental, but man, it can be nice! Someone better at mechanics could certainly set up a wheel that would turn more smoothly, but then it might lack that tension or unevenness that developed from my shortcomings. I'm constantly and pleasantly surprised by what I get away with.

I'm just a kid at play really. As soon as I get too serious, as soon as my mind goes closed rather than open, the creations get lame. Usually they come together organically, so I don't do technical sketches beforehand. All I can offer are kind of cartoon doodles of my instrument ideas, though occasionally I do sketch out 'Green wire in A to blue wire in B' sort of things when the going gets rough.

Sister Spinster was designed to be a foldable, portable mechanical drum machine. How is it programmed, and how do you control its speed? And why didn't I think of it first?

I had to suffer through a lot of human drummers before I decided I'd had enough and that it was time I built my own. If people don't show up for rehearsals again and again you will eventually be driven to turn into Dr. Frankenstein. I thought how nice it would be to have a drummer that always played steadily, without fancy self-indulgent solos, who would shut up at the turn of a switch, who could sit on a shelf at home and not eat all your food. Who could be folded into a suitcase, and so on. She's built of found objects mostly, though there is a little drum and cymbal that just sounded too good to pass up. There's a piezo mic from Radio Shack glued straight on to the cymbal with epoxy. It's tiny but it sounds like a gong.

One of the drums can be slid along a track to accommodate different settings of the mallets. The mallets are TV arials attached to wheels. The arials can be extended or retracted, in order to set up different rhythm patterns. They are dodgy parts and

break often—they weren't made to play drums, after all—but I carry spares. There's a motor and a speed control. There's a great surplus shop on Canal street in New York City where, if you're lucky, you can find these sort of things. Now that I'm in London I miss it.

There's the internet too, but I shy away from it; if you can't tap on it to see how it sounds, or turn it on and see how noisy it is, you might find yourself with a regrettable purchase. I guess I've also got this kind of dumpster-zen thing going on, where there's a faith that the next thing you need will come into your life one way or another if you keep your eyes open.

I'm not the first person to put a motor on a wheel to make a rhythm, though I think I've taken it further than others. I think that's mostly because I have a limit to what I can carry on planes and trains—that's how I often tour—so I've had to make the same machine do more. Even so, sister Spinster's rhythms are very rudimentary. There are people with computer controlled robot drummers that are much more impressive in a lot of ways. I just feel a lot more comfortable with mechanics and visible physical reactions that I can grasp in my little ball of grey matter than I am with ones and zeros. I think a lot of people feel this way these days, and that's why I've had luck with finding audiences. At the same time I'm no purist. Digital technology has opened a whole new box of tools and possibilities. With some of my contraptions I use a digital looper pedal. But live I never use anything pre-sampled, I always play it live into the looper, otherwise I don't feel like it's really live.

The backbeater is an interesting fusion of form and function, a balance that is quite dear to our hearts. What kinds of limitations did the design impose on the function, or vice-versa?

As far as limitations go, (aside from its irritatingly unreliable in-flight steering mechanism) because it's on my back and out of reach it's pretty much impossible to manually change the rhythm setup (as I would with Sister Spinster) without having to remove it again, which would put a dent in the flow and momentum of the show. So I usually just do a one-off song with the BB. But one of its finer features is that because it's on my back and thereby shielded from a direct line to the monitors by my body, it doesn't cause feedback problems like some of the instruments do, even when it's up real loud.

In a strange way, a one-person band is perhaps the ultimate manifestation of DIY... you build the instruments, the songs, and your business yourself. What's more, you stand as strong evidence that DIY work can be taken seriously. What do you think are the major advantages and disadvantages to doing this work yourself?

Well, the main disadvantage—that I've seen become more and more pronounced as time goes by—is that one person can only stretch themselves so many different ways until they're spread too thin. You can miss opportunities and start losing your mind and run into problems in your personal life when things start expanding. I haven't spent enough time 'playing'—i.e. building instruments, writing songs, etc. these last few years because I've been on the road more and more. I definitely am DIY to a fault; I just don't wanna let go of control, and I'm not very good at asking for help. I'll be the guy that'll put off dying an extra few hours because I want my grave dug just a certain way and won't trust anyone to do it right but me.

But no one is good at everything. The trick is finding people that can do the stuff that you can't, or that are better at things than you, and who want to be involved. Or that you can afford to pay. I've got an

agent, which has been hugely helpful, but I wouldn't appreciate her as much if I hadn't booked my own shows and tours in the beginning and learned what a pain in the ass it can be, and how time consuming it can be. And in fact I wouldn't have an agent at all if I hadn't built up a fanbase on my own first.

So you hail from a small island that recently seceded from the USA? Was the secession politically motivated? Or does the move into the ocean provide better opportunities for fishing?

Yes to both questions. Wowtown seceded in a sort of collective-unconscious psychic joining of the local community immediately following Bush's re-election. The resulting energy field was so strong that it lifted the land—and Wowtown on its surface—like a giant cupcake and floated us out to sea. It wasn't an island when we were attached to the US, but now floating in the Atlantic Ocean, yes the fishing is superior to what we had before, with just the lake.

It's understandable that off-the-beaten-path musicians are wary of finding themselves labeled. It seems inevitable that once a person has been described, the industry and press want to box them in. We at SteamPunk Magazine are of course interested in steampunk, but as a description instead of a definition. What are your associations with the label?

A theremin/violinist that I sometimes work with, Meredith Yayanos, sent me an email and in the subject line it said: "HA HA! You're STEAMPUNK!!" She'd been visiting the Dresden Dolls forum online and there was an argument, or a thread, on there, about what was and what was not Steampunk. Someone brought up my name as the perfect definition. To be honest I was unfamiliar with it at that point, but I liked it and found the associations complimentary and interesting, so I just threw it on the myspace site. But you're right, I don't much like labels, and am quite happy with what I typically hear people tell me after shows: 'I've never seen anything else like it'. That sort of thing is much more complimentary to me than being associated with something or some scene already established.

You've stated before that you build your instruments out of junk, including from the bounty of dumpster diving. What are some of the best things you've found in the trash, aside from musical components? Have you had any crazy experiences while dumpster-diving?

Well, I got into a great deal of trouble with the New York Department of Sanitation when I was putting something back into a dumpster once. It was some dismantled studio pieces when I had to move from my last apartment. I won't go into it because it's mundane but I would warn anyone not to even throw a plastic cup in a dumpster that is not your own in NYC. They are very strict about this stuff, they've got their electric eyes everywhere, and I wound up having to pay a ridiculously huge fine.

It is amazing what people throw away though. I've found functional bicycles, stereo components, a nice bedside table. A coffee mug with Elvis on it, which, when you pour hot water in it, turns into later-period Vegas Elvis. Rock-climbing equipment (handy to find in a really deep dumpster). But it's always the thing you think you'll need or want and *don't* take that you will need or want the very next day, while other things clutter up your corners for years untouched.

And finally, what sorts of instruments do you envision you would build if your space weren't so limited and your schedule so intense?

I don't know yet, but they'll come. I'm going to try and de-intensify my schedule and show us both.

> The next thing you need will come into your life one way or another if you keep your eyes open.

Thomas Truax can be found online at http://www.thomastruax.com

"The smokelung played an accordion, he realized, and the airlung was playing a wooden violin. He was a worldly fellow, but he could barely contain his horror to see someone play on tree flesh. His father before him had outlawed such barbaric practices years ago. And yet the music was powerful, hypnotic even."

The Baron
*A Short Fancy of Airships, Smog, and Questionable Friendship
written by J. T. Hand*

The Baron was not an evil creature, whatever history might claim one day. He ruled a vast section of the infamous Empire, but he was no tyrant. He demanded obedience when he issued an order, but he mostly left people to themselves.

The Baron ruled from his airship high above the land. His skin was as white as pitch is black and his clothes were gray-white and ashen. The oil that fueled his galleon's propeller spat the loveliest pale smog.

The Baron breathed smog as you or I breathe air. He took a deep breath every the morning as he walked out of his cabin, savoring the thick, succulent poison that sank to the deck from the balloons that kept him aloft.

His subjects feared him as they would a dragon and no one spoke to him but when commanded. Even those down below who breathed smog as well, the smokelungs, avoided him, so tremendous was his ill-deserved reputation for villainous cruelty.

Thus the Baron lived in the loneliness known only to the rich, and no amount of reasoning or gift giving would unfetter him from infamy. He spent his days writing, watching the land below, and composing music. In the heart of his metal ship was a calliope, a great steam music box. He would write compositions and then send for engineers to create the studded, mechanical wheels that dictated the pitch and rhythm of the calliope.

It was one day early in his reign that a flock of birds, madly fleeing an oncoming storm, tore apart all of the balloons which kept him afloat. Quickly, the Baron inflated the emergency balloon, but it only served to slow his fall.

He fell through lightning and rain to crash, unharmed, into a vast industrial forest of pipes, silos, fire and smoke. The smog was fresh and the Baron breathed easily, but his airship was dashed and dented beyond any hope of immediate repair.

The Baron was not young, and had been through his share of adversity; he was quite used to taking care of himself.

"I'll just walk until I reach civilization. I will commission a new ship," he reasoned, "and my duties, to be honest, are few, so my land will be alright until I return to the sky."

With only the clothes on his back and a canister of crude oil, the Baron left the bird-and-gravity shattered remains of his old life and

took off through the mechanical wilderness about him. His spirits were high—it had been years since he last visited the wild lands, the lungs which made the atmosphere habitable for smokelungs like him.

It wasn't long before he stumbled upon a camp of travelers, hearing their music long before they became visible in the thick air. Ten or twelve men and women sat in a circle while in the middle a pair of young women played outlandish instruments. To his amazement, a few of those present, including one of the musicians, wore gas masks—the sign of an air breather.

"Stranger!" A man called out, "Come sit with us awhile. It isn't easy to wander." No one else spoke, and the musicians showed no sign of abating on account of him, so the Baron quietly walked over and sat on a half of an oil barrel before turning his attention to the two women.

The smokelung played an accordion, he realized, and the airlung was playing a wooden violin. He was a worldly fellow, but he could barely contain his horror to see someone play on tree flesh. His father before him had outlawed such barbaric practices years ago. And yet the music was powerful, hypnotic even.

Wisely, the Baron said nothing of his station and kept his revulsion for the barbarous airlungs from marring his expression.

The air became dark, as it is prone to do, though the sky was not visible through the haze. The Baron stayed on with the vagabonds. Almost all of them played instruments and those that didn't would dance. He wasn't certain they would ever stop. By the middle of the night, the Baron took off his boots and slept by an oilcan fire with his greatcoat as a blanket. He dreamed tremendous musical dreams.

The next morning most of the revelers were asleep, curled together like a litter of kittens; the only waking soul was an airlung keeping watch. For the first time in his life, he spoke to someone of the old world.

"Who are you people?" The Baron asked.

"Well, I am Ashen. My name, that is," she answered, her voice strangely muffled through the mask, "but as for the rest of us... let me try to explain.

"Last night you heard us play music. Most of us sing, or dance, or play an instrument. Having learned one of these things, the others are easier. Do you practice the arts, Mister..."

"Mister B—," the Baron introduced himself, "and I paint. Sometimes I compose, but I cannot sing or dance."

"Ah, but you could, you could. The painter can dance, the singer can write. One informs the other. In truth, there is no other." She paused before her next point. "The one is the other, the other is the one. Now, here is the secret: this is not some magical solution to anything. Understanding the oneness of the universe doesn't just make everything okay.

"So this is who we are. In the same way all dance and song are the same, so are all living things."

"This metaphor, then, you carry it across..." the Baron began but Ashen finished his thought.

"Everything," she nodded, "but it isn't a metaphor, it is literal. Music is the wild. You have your wild here, and I have my wild..." Through the mask her expression grew heavy. "We are a group of people who have sworn to uphold the balance of the wilds, organic and mechanical."

Throughout all of his life, and certainly throughout all of his reign, the Baron had almost

mindlessly promoted the expansion of the industrial forests at the expense of the organic. Indeed, over the whole of the planet's surface the two worlds battled to control the atmosphere.

Two more long, lazy summer days passed in this way of music, dance and conversation by the fires of the wild. At dusk a guard was posted against the hydraulic creatures of the night.

On the third morning they left their encampment and the Baron chose to join them. He was hooked, and when he discovered that they were going to the organic land he was intensely curious.

So great was his new love for these people that he resolved, during the second day, to swear service to their cause. If by life or death he could promote balance and harmony, then he would do so.

When he told his new friend Ashen of his resolve, she laughed and slapped him on the back.

They arrived at the woods after a three-day trek. Initially he was quite frightened. At all times his smoke-mask was visible from the corner of his eyes, and nothing was sane anywhere about him.

But to his word, he spent five years serving that strange alliance. Owing to the present imbalance, he helped the organics reclaim mechanical land. He learned a great many instruments, although he never could bring himself to play the wooden fiddle or guitar. He cunningly planned and schemed against his own lands, and he grew to love his comrades deeply.

Yet at the close of five years, the kudzu and blackberries had spread too far into his old kingdom, threatening the smog his people depended on.

"Ashen my friend," he said, "we need to stop the spread of organic life to maintain the balance."

Ashen stayed silent. The Baron spun on his heel to the smokelungs of the group, eying them warily.

Only one spoke, the old man who had welcomed him to the fire those years ago. "The mechanical lands, the mechanical people... us... we have oppressed what is natural for too long already."

"But that would mean your death! Our death!"

"All is one. We cannot truly die."

"Madness!" But the Baron quickly mastered his voice, calming down. "I have been betrayed, I have been so terribly betrayed."

With that he left, and when Ashen tried to block his path and speak to him he struck her down with his fist.

He walked straight to the Empire City, to the emperor himself, and reclaimed his post. And thus he became the Baron whose infamy lives still this day. With a song in his heart and fire in his eyes he used violence and concrete to reclaim his lands for his people.

One day, while teaching his young daughter and heiress to waltz, she asked him why he never took his lands past the great river.

"My daughter, my love, all is one. The airlungs and the smoke."

"Yet father, you kill them with abandon on your lands."

"And thus do we kill ourselves. But listen, there is no shame in killing, and there is no shame in mercy."

The Baron is but one of eight short fantastical tales by J. T. Hand that will fill "The Seduction of the Wind", an upcoming publication by Strangers In A Tangled Wilderness.

The Perils of Empire: Steampunk Big Band

Darcy James Argue tells us about his Secret Society, economic empire, culture and jazz.

photos by Ben Anaman

Darcy James Argue is the bandleader and composer for Secret Society, an 18-piece band in NYC. First formed in May 2005, they have played shows at several NYC venues including CBGB, Union Hall, the Bowery Poetry Club and Flux Factory. Darcy graduated from New England Conservatory in Boston in 2002 and commuted to New York weekly for a composer's workshop before moving to Brooklyn in 2003. Once in the city, he started reading sessions to find musicians who were capable of—and excited to be—playing his original and challenging compositions. For two years they rehearsed in various incarnations before they played their first gig.

Argue describes the work as "steampunk big band" and after downloading his music from his website and blog [http://secretsociety.typepad.com] I immediately noticed why; when you listen to the music you are transported to a sinister yet beautiful world, a past that never was.

He agreed to meet with me at a cafe in Cobble Hill, Brooklyn. His face was ageless; had he told me he was 20 or 34 I would simply have nodded and believed him. I drank tea while he spoke of his band-fellows, the political situation of music, steampunk and jazz.

Do you always have the same musicians when you play?

I have a core of musicians, but with 18 people on the gig, it's not always possible to get the same players every time. Usually there's enough carry-over from gig to gig that there is some sense of continuity, but obviously that's one of the challenges of running such a large band—the personality is going to be slightly different every time.

You seem to have a lot of respect for the musicians, and you write about them as being an important factor in the work.

Bless these guys for doing this thing; it's incredibly difficult music that involves a lot of rehearsal time, and they're certainly not making very much money on these gigs. They're doing it because they enjoy the challenge of the music that I write. As a composer there is nothing more gratifying than having musicians at this level, people like Ingrid Jensen or Matt Clohesy, really interested in playing your music. They have a lot of other more lucrative opportunities they could be pursuing.

What is your role as a leader of all of this, how authoritative do you have to be?

Well, I guess the best way of putting it is that it's like the players are voluntary citizens in a benevolent dictatorship. The music is through-composed and pretty finely detailed in terms of the notation. There's definitely room for improvisation from the soloists, but they don't get to dictate the direction of the music. Their improvisation can't just be what they were working on in the practice room the day before, or what they might play in a small group setting—the music has a story to tell and their improvisation has to serve that script. I think that the players in the group understand that; they still find a way to express themselves and be personal and creative but within more narrowly defined constraints.

Do you make your living through what you're doing?

I'm fortunate enough to make a living in music, but I definitely do not make a living on Secret Society. At this point I have to finance my big band habit by other means; I'm a freelance music copyist who prepares music for Broadway and film. The software that I use to notate my music is called Finale and I do Finale clinics in schools and for other professionals. I'm also an arranger and orchestrator.

You currently give away all of the Secret Society music away online for free. Why did you choose do to that?

The challenge for a musician in the age of mp3s is to try to persuade people to listen to your music. I mean, they can download anything for free; what's going to make them want to give your stuff a shot?

The clips that I make available are live performances that I record on my digital recorder, with all the glorious imperfection that a live gig entails. Eventually we'll make a studio recording, where we're going to get to spend more time shaping the sound of the music. I hope that I've built up enough goodwill with the people who've followed Secret Society so far, so that when there is a product that they can buy, they will help support what we're doing. But it just seems foolish for artists to try to control access to their music, because people can always go elsewhere.

You give your scores away on your site so that people can download the actual sheet music. Have you heard from anyone who has used it?

Well, those scores are there mostly for evaluation purposes—if someone has a big band of their own and would like to play the music, then I guess they could theoretically generate the parts for each individual musician from that score, but that would be an incredible pain, and it would be far easier for them to just buy the parts from me. But they are there in case bandleaders want to see what's in the music and whether it's playable by their group.

I also hope that other composers who are interested in my music take a look at those scores, see what I did, and ask me about it. I hope that as the blog grows we'll have more of those discussions online, because I'm definitely interested in talking to other composers about how they solve the same kind of problems that I try to solve.

One of the first things I thought of when I discovered your music is that it is one of the most original things that goes by the name of steampunk. And one of the things I like about it is that it is a reasonably modern style but is playable with old instruments.

First off, I don't want to present myself as some expert on steampunk literature or culture because I'm not. But I couldn't resist appropriating the label because it seemed like an excellent shorthand description of what I was after with Secret Society. We are using an almost archaic instrumentation—when you say "big band" people think of ballrooms in the 30's, [songs like the Glenn Miller Orchestra's] "In The Mood" and that kind of thing. Musically, that kind of thing bears almost no resemblance to what we're doing, but there is something about that instrumentation that is very appealing to me.

In a way I'm trying to use this antiquated music technology, this group of largely acoustic instruments, to replicate the things in contemporary music that I really like. If I'm listening to a record by TV On The Radio or something, one of the more appealing things is the intricate layering of the production. Having so many musicians on stage allows me to have that same layering, that same kind of detail, but I'm able to do it live and organically with acoustic instruments.

I think of the problem-solving you mentioned as relates to mechanics and music...

This is something I got from my mentor, Bob Brookmeyer,

who I studied with at New England Conservatory. He viewed composition as exclusively problem-solving. I guess for me it feels more like storytelling, but of course when you sit down and try to figure out how to structure a story, that requires problem-solving skills.

For a while I was kind of obsessed with screenwriting blogs on the internet because you have a lot of people talking explicitly about the challenges of structuring stories, debating the merits of techniques like the three-act structure, the sequence model... That really resonated with what I'm trying to do musically. I'm trying to get from one moment to another without interrupting the flow; I'm trying to build up a certain amount of musical momentum.

Where did you first run across the aesthetic or concept of steampunk?

Like a lot of people, I'm sure, the first time I heard the label used was in relation to Alan Moore's *The League of Extraordinary Gentlemen*, which I was very taken with, being a huge Alan Moore fan. But the word seemed to also describe things I'd read that I guess aren't normally considered part of the steampunk canon, like Thomas Pynchon's *Mason & Dixon*. That was the first time I had really encountered such an incredibly rich and creative use of anachronism. The entire novel is written in this faux-historical style—it uses the archaic capitalizations and abbreviations and whatnot that evoke the 1700's, but it's more about creating an effect than being a literal facsimile of 18th century literature. It grapples with some of the fundamental questions of modernity and colonialism, the idea of going westward, of literally inscribing the mark of progress on the map. It really highlights the ironies of how the scientific and intellectual advances of the Enlightenment were bound up with the violence and brutality of slavery and colonialism, the idea that we were bringing civilization to "savage" lands through the use of incredible savagery.

The first time I wrote any music directly inspired by literature was after reading *Mason & Dixon*—I wrote a piece after one of the characters, a Chinese surveyor and Fung Shui practitioner named Captain Zhang.

Both *Mason & Dixon* and *The League Of Extraordinary Gentlemen* got me thinking about using an anachronistic framework in order to comment on the modern world. This is exactly what I'm was trying to do musically, taking this old-fashioned instrumentation and making contemporary music with it.

What do you feel we have to learn from a time of empire and colonialism that relates to our present situation, both politically and musically?

Well, when the vice president can get up there and claim, on television, that the Iraqis will greet

us as liberators, and not be laughed off the stage, obviously we still have a lot to learn. It's not really clear to me that we are past a period of colonialism; it just takes new forms. Certainly with the child labor that's happening around the world you've got a really insidious kind of economic imperialism.

You have monopolies and cabals that dwarf the famous railroad trusts of the 1800's. For example, Universal music group just got the go-ahead to buy Bertelsmann [BMG] which will result in 3 major record companies in the whole world that are largely controlling people's access to music. Not just what gets played on the radio, not just what's available in the few actual CD stores that are left, but —because these media companies are vertically integrated— what music gets inserted in TV shows and movies and commercials. Even what gets talked about on the internet. If you look at the music that's illegally downloaded, it follows the pop charts very closely. So it's often very difficult for people to even find out about music that doesn't have big corporate dollars backing it in some way.

So I think that these are issues that everyone trying to do something independent and creative and off the beaten path has to struggle with, whether politically or artistically.

It seems like many of the battles we're facing now, our struggle against preemptive wars and inequality and economic imperialism, are a continuation of the battles that the anti-imperialists, suffragettes and trade unionists fought in the 19th century. These are battles that require constant vigilance and constant participation.

What do you think that you can be doing as a musician, in the music you make, how you make it and how you promote it, to have that constant vigilance?

It's an interesting question whether or not purely instrumental music can be political music. Certainly some of my works have political meaning to me, and I hope convey some of that with the titles. But I also hope that the songs work independently of any extra-musical associations—that they work as pure music.

I didn't mean just through the music itself, but also about staying independent.

Well for a jazz artist, independence is by necessity as much by design. But I also feel that there are a lot of opportunities—opportunities and obligations—for artists to take control of their music. You see more and more people self-releasing records or putting them out through a cooperative venture like ArtistShare [www.artistshare.com] that allows them to own their work, instead of signing it over to a label.

I guess one of the challenges is that, if everyone is independent and self-releasing their records, then how do you engage in some sort of collective promotion? How do you make it seem like what you're doing is part of a movement? Because if it's all just individual people doing their own thing, it's hard for a scene to emerge out of that. It's hard for something like that to develop any momentum, which is why it's important for jazz musicians especially, who tend to be very insular, to try to reach out to other musicians in other genres who are pursuing common goals.

How did the blog come to be?

I was reading a lot of political blogs, and it was through political blogs that I discovered the music blogosphere. I was a little bit jealous of the scene around the indie rock blogs because it seemed like there was a real community there; people were excited. It wasn't that there were that many more people going to indie rock shows than were going to indie jazz shows at Barbès or Tonic, but there was much more of a sense of excitement because people would write about it on their blogs. People would come back from shows at the Mercury Lounge where there were maybe 25 people in the audience, but they would have taken pictures and maybe made a bootleg recording or just written animatedly about what went on. There was a real sense that, okay, so there were only 25 people in the audience, but it was important.

There's nothing really like that on the jazz side. When I started blogging I was one of the very few jazz oriented blogs. My original goal was obviously to promote myself and my own music, but it was also to promote the music of my peers and colleagues, who were playing gigs that otherwise got no notice at all.

I hope to see more musicians, especially musicians in the jazz world, take up blogging, because I think it's a way to try to start a conversation about this music, to get some debate going, some back and forth, some sense that this is vital music that matters to people's lives. ✻

Find mp3s, scores and blogging online at http://secretsociety.typepad.com

Earth Sea and Sky

HUNTING THE OSTRICH.

Here, for our reader's enlightenment, we have excerpted from the excellent tome "Earth Sea and Sky" published in 1887. The following is the faithful reproduction of pages 299-305, which concerns itself primarily with the grotesque "sport" of hunting ostriches.

In the barren wastes of Africa, and also of Asia, the traveller, as he journeys wearily onward, meeting with but stunted herbage and no water, sees from afar something that alarms him. It looks like a body of horsemen scouring the desert, and, as he fears, bent on plunder. There is no way of escape, and as he looks hither and thither the dreaded object approaches. Then his heart beats more freely, and his spirits revive. The band of horsemen, as he supposed it to be, turns out to be birds. And he is not the first traveller by any means who has made the mistake, and imagined the ostrich to be a man on horseback.

In the first place, the ostrich is quite as tall, and as he runs swiftly along there is nothing at a distance that he more resembles. He always feeds in a flock, and the barren wastes have been his home from time immemorial. He eats grass, and grain when he can get it, and does not seem to care for water. There are people who have said that the ostrich never drinks.

Breakfast of Stones and Leather.
However that may be, his appetite is the most curious part of him. He will swallow almost anything he can pick up, and you might wonder where he did pick up the things that have been found in his stomach, were it not for the caravans that now and then come across the desert. Pieces of leather, nails, lumps of brass or iron, to say nothing of stones, all go down his throat with ease.

He has a huge crop, and then a great strong gizzard. And besides these, he has a cavity that might be called a third stomach. So he is well provided. Of course, strong as his digestion may be, he cannot digest either nails or stones; and some people explain this by saying that his great crop

wants so much to fill it, that he is obliged to put in all he can get. And others say that the stones and brass and leather help him to digest his other food, in the same way that grit or gravel helps our poultry at home.

The next curious thing about the ostrich is the pair of wings that nature has given him. The wing is nature's machine by which the bird can support itself in the air, and dart or sail through it as we may see every day. But in some birds the wing fails of this purpose, and is of no use at all to fly with. There are two reasons why the wings of the ostrich cannot bear him into the air. They are very small to begin with, and his great body is too heavy to be raised by such means. And besides, the feathers of the wings are different from those of other birds.

Look how firm and compact is the wing of the swallow or the rook. The feathers fit close together, and the little plumes on each feather hook into each other by those exquisite little catches that are among the marvels of nature. If you pass your finger over the wing it feels like one smooth surface. But in the wing of the ostrich the little plumes are loose, and float lightly about. The ostrich does not use his wings to fly with, though he spreads them out as he runs.

The Flying Camel.
He is in many respects so like an animal, that he forms almost a link between the animals and the birds. Indeed he is so like the camel that he is called the camel-bird. His foot resembles the hoof of the camel. It has only two toes, and both point forward ; and the first is longer than the second, and ends in a thick hoof-like claw. And the habits of the ostrich resemble those of the camel ; they both live in the sandy desert, and are able to go a very long time without drinking. The ostrich does not make any nest, but merely scoops out a hole in the sand. When the proper season comes, the mother ostrich begins to lay her eggs ; she lays about a dozen, and they are very large, and of a dirty white color. In the day-time she leaves them under the burning rays of the sun ; but when the night comes, and the air is cooler, she broods over them.

The natives of the country go out looking for the eggs of the ostrich. One monster egg has in it as much as thirty of our hen's eggs, and is considered quite dainty. But they are very careful how they set about the task of robbing the nest. They choose the time when the mother ostrich is away, and then they take a long stick and push the eggs out of the hole. If they touched any of them with their fingers, the ostrich would find it out in a minute, and go into a great rage. She would break all the eggs that were left with her hoof-like feet, and never lay in that place again. Sometimes a number of mother ostriches will lay their eggs in the same nest.

In some parts of Africa there are tribes of men who eat ostriches, not from gluttony, but because they can get very little else. They keep them as we do cattle, and make them quite tame. The ostrich is by nature gentle, though it is so large, and soon makes himself contented near the dwelling of his master. Sometimes his master rides upon him, and takes a journey.

The beautiful feathers of the ostrich are so admired, that great pains and trouble are taken to procure them. The Arab comes with his swift horse in search of the ostriches. A flock of them are quietly feeding together on the plain. If it is mid-day, they strut about, flapping their wings as if for coolness. When they perceive the enemy they begin to run, at first gently, for he keeps at a distance, and does not wish to alarm them more than he can help. The wings of the bird keep working like two sails, and he gets over the ground so fast that he would soon be out of sight if he ran in a straight line.

But he is so foolish as to keep running from one side to the other. The hunter, meanwhile, rides straight on, and when his horse is exhausted, another hunter takes up the game, and so on, allowing the poor bird no rest. Sometimes, in a fit of despair, he hides his head in the sand.

Another method adopted by the ostrich hunter is to disguise himself in the skin of one of these birds, and, armed with his bow and poisoned arrows, stalk about the plain imitating the gait and motions of the ostrich. Moffat thus describes a hunt of this kind:

A kind of flat double cushion is stuffed with straw and formed something like a saddle. All except the under part of this is covered over with feathers, attached to small pegs, and made so as to resemeble the bird. The head and neck of an ostrich are stuffed and a rod introduced, and the Bushman intending to attack game whitens his legs with any substance he can get. He places the feathered saddle on his shoulders, takes the bottom part of the neck in his right hand, and his bow and poisoned arrows in his left. Such as the writer has seen were the most perfect mimics of the ostrich, and at a few hundreds yards' distance it is not possible for the eye to detect the fraud. This *human* bird appears to be picking away at the verdure, turning the head as if keeping a sharp lookout ; shakes his feathers, now walks and then trots, till he gets within bow-shot, and when the flock runs from one receiving an arrow he runs too. The male ostriches will, on some occasions, give chase to the strange bird, when he tries to elude them in a way to prevent them catching his scent ; for when once they do the spell is broken. Should one happen to get too near in pursuit, he has only to run to windward, or throw off his saddle, to avoid a stroke from a wing that would lay him prostrate.

The Arabs of North Africa puruse the ostrich on horseback ; not at a dash, however—one exciting run and victory decided—but in a deliberate and business-like way. A flock having been sighted, the Arabs put their steeds in motion, and hold them at sufficient speed to keep in sight the fluttering army in advance. When the evening comes, the Arab pickets his horse and rests for the night, and his tired game, finding it is no longer pursued, sinks to the earth and rests too. Next morning the chase is commenced, the clicking of hoofs rouses the still weary bird, and once more he braces his limbs and pursues his hopeless flight. So the game continues, till, tired to death, and with drooping and bedraggled wings, the poor ostrich comes to a dead halt, and the gallant Arab hunter safely approaches and cuts its throat.

The Blow that Ends the Chase.

Toward the approach of the rainy season, when the days are intolerably hot and sultry, the ostrich may easily be ridden down by a single horseman. At the above-mentioned period the protracted drought tells even on this invulnerable bird, and he may be seen standing in a stupefied manner with his wings outspread and his beak wide open. Under such circumstances he offers but little resistance, and though for a few moments he may make hard running, his speed is not enduring ; and presently he is again stock-still and stupidly agape, waiting for the hunter to knock him on the head with his "shambok," or knobby stick.

Our illustration depicts a chase of an ostrich described by Baldwin. Andersson relates that in certain parts of Southern Africa the ostrich is run down on foot. "I have myself seen the Bushmen accomplish this exploit on the shores of Lake Ngami. They usually surround a whole troop, and with shouts and yells chase the terrified birds into the water, where they are, of course, speedily killed." Harris, on one occasion, fell in with a party of caravans chasing an ostrich on foot, and, when they got close enough, "shying" after the fleeing bird, their clubs striking the bird's legs and eventually laming him. "When the ostrich is slain," says the last-mentioned authority, "the throat is opened and a ligature passed below the incision. Several hunters then raise the bird by the head and feet, and shake and drag him about until they obtain from the aperture nearly twenty pounds of a substance of mingled blood and fat, of the consistency of coagulated oil, which under the name of 'manteque' is employed in the preparation of dishes and the cure of various maladies."

Some African tribes take the ostrich in snares, similar to those used in the capture of the smaller species of antelope. A long cord having at the end a noose is tied to a sapling, which is bent down, and the noose pinned to the ground in such a manner that when a bird treads within it the sapling springs back by its own natural elasticity, suspending the bird in the air, only to be released from its sufferings by death. Others again are said to employ ostrich feather parasols, or rather massy plumes—such as adorn our hearses—while hunting wild animals of every description. Thus in case of a wounded beast charging a man, the latter, just at the moment he is about to be seized, whips the big plume off his head, and thrusting the spike to which the feathers are bound into the ground, slips off. While the furious animal vents his rage on the nodding feathers, the wild hunter steals to its rear and transfixes it with his weapon.

Fair Play and no Favor

In hunting the ostrich the mode most favored by sportsmen is to lie in wait at the margins of pools and springs where the birds come to drink. They swallow the water deliberately, and by a succession of gulps. While staying at Elephant Fountain, Andersson shot eight within a very short period. "Lying in wait," however, and taking advantage of your game from behind a wall or hedge, is by no means as a rule a favorite system with the hunter. If an animal has "fight" in it, nothing gives the true sportsman greater pleasure than for it to demonstrate the same to the fullest extent—sharp steel against talons just as sharp and terrible, swift bullets against swift and sudden springs and bounds and death-dealing fangs. Should the animal chased be dependent on its fleetness for safety, again the true sportsman would meet with its own weapons, and stake bit and spur on the issue of the chase.

Andersson relates the particulars of a chase after young ostriches by himself and a friend, and which is none the less interesting that it bears witness to the tender solicitude of the ostrich for its progeny. "While on the road between the Bay and Schepmansdorf we discovered a male and female ostrich, with a brood of young ones about the size of ordinary barn-door fowls. This was a sight we had long been looking for, as

Galton had been requested by Professor Owen to procure a few craniums of the young of this bird. Accordingly we dismounted from our oxen and gave chase, which proved of no ordinary interest.

Cunning Dodge to Save the Little Ones

The moment the parent-birds became aware of our intention they set off at full speed, the female leading the way, the young following in her wake, and the male, though at some little distance, bringing up the rear of the family party. It was very touching to observe the anxiety the old birds evinced for the safety of their young. Finding that we were quickly gaining upon them, the male at once slackened his pace and diverged somewhat from his course ; but seeing that we were not to be diverted from our purpose, he again increased his speed, and with wings drooping so as almost to touch the ground he hovered round us, now in wide circles and then decreasing the circumference till he came almost

AN EXCITING CHASE.

within pistol shot, when he threw himself abruptly on the ground and struggled desperately to regain his legs, as it appeared, like a bird that is badly wounded.

Having previously fired at him several times, I really thought he was disabled, and made quickly toward him ; but this was only a dodge on his part ; for on my nearer approach he slowly arose, and began to run in an opposite direction to that of the female, which by this time was considerably ahead with her charge. After about an hour's severe chase, however, we secured nine of the brood, and though it consisted of about double that number, we found it necessary to be contented with what we had bagged.

SteamPunk Magazine
A Journal of Misapplied Technology
[Lifestyle, Mad Science, Theory & Fiction]

#2

It is too constricting to say that you must always think outside the box; whether you are thinking inside or outside the box, you are still letting the box dictate your thoughts, are you not? What you are not acknowledging is the honest fact that "the box" itself is figmentary, illusory. And as long as one continues to act in reaction to this perceived set of dictates, one cannot be truly original in thought.

— Erica Amelia Smith, *An Address as to the Nature of the "Proper" Uses of Technology*

The cover and facing page were illustrated by Steven Archer

ISSUE TWO:
A Journal of Misapplied Technology

How does one misapply technology? When we asked this question of our friends, readers and contributor-base, a myriad of answers was forthcoming.

Some spoke of the creative misappropriation of technology; there are those who power record-players with bicycles, sew cogs to clothing, contrapt overly-complex machines with which to open their cat door, or tear apart their computers to retrofit them with brass keys. These people are not afraid to significantly demean their efficiency in order to fill their lives with wonder. Others referred to how technology, as is currently applied, serves as a buffer between us and wonder: mono-cropped farms, car culture, omnipresent air-conditioning and heat, etc. The homogenization of technology is indeed a travesty, a pox of our own infliction.

Of course, it is a false claim that technology itself is "unnatural." We must think only of the lens that allows us to peer into the heavens—or at the chaotic dance of single celled critters—to realize that invention need not be evil. But if technology, as it is applied, has separated the vast majority of us from the natural world, then it is time that we misapply it. Let us be diverse and inefficient!

Now let me climb down from the soapbox and welcome you to issue #2 of SteamPunk Magazine. I never could have hoped that so many people would connect with the first issue, and all of us who worked so hard to bring it to you are beaming proud.

As we are still an emerging magazine, we adore feedback of all kinds. Tell us what we've done right, what we've done wrong. Write us letters. Send us clock gears. Submit articles, essays, stories, rants, comics, and fashion tips to us!

— *Margaret P. Killjoy*

LETTERS

write us at collective@steampunkmagazine.com

Dear SPM,

A warning might be appropriate for the sticklers for authenticity who read your glass armonica article. While many of the time believed that the sound of the instrument caused madness, the suspicion today is that the lead was leached out of the glass bowls by the moistened fingers of the musician, and over time built up to dangerous levels. This is still only a suspicion, but readers already teetering on the edge of madness may want to take it under advisement, and satisfy themselves with quartz-glass bowls instead.

-Victorian Radical

Dear Steampunx,

I was wondering about the fate of Noisecore "music" in teh age of steam. Given that residents of this age had to constantly deal with the similar sounds of gear mashing throughout their daily lives, does their appreciation of this music decline, or is it still able to captivate the teeming masses in the same way that it does in the present world? Thx.

-Lord Teh

We've got no idea whatsoever. Anyone care to respond?

What is SteamPunk? What is SteamPunk Magazine?

The term "steampunk" was coined to refer to a branch of "cyberpunk" fiction that concerned itself with Victorian era technology. However, SteamPunk is more than that. SteamPunk is a burgeoning subculture that pays respect to the visceral nature of antiquated technology.

It's about "steam", as in steam-engines, and it's about "punk", as in counter-culture. For an excellent manifesto, refer to the first article in our first issue, "what then, is steampunk?"

SteamPunk Magazine is a print publication that aims to come out seasonally. Full quality print PDFs of it are available for free download from our website [http://www.steampunkmagazine.com], and we keep the cost of the print magazine as low as possible. All work on the magazine, including articles, editing, illustration, layout, and dissemination, is done by volunteers and contributors. To see how you can get involved, see the last page.

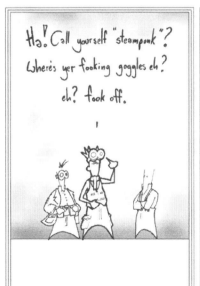

comic by Doctor Geof

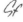

REVIEWS

contact collective@steampunkmagazine.com to get a shipping address for any physical things you would like reviewed.

Short Stories
Jimmy T. Hand
"The Seduction of the Wind"
Strangers In A Tangled Wilderness, 2007
www.tangledwilderness.org

Jimmy T. Hand's collection of bedtime stories for "nights you wish the whole world in flames" is a poignant amalgamation of short parables and speculative fiction. Brilliantly printed as a 28-page zine, Hand's work runs the gamut from simple to complex, and the layout of his leaflet, laced with beautifully stark black ink doodles, reflects this very notion. The characters in his tales are believable and representative of not only their own stories, but ours, the reader's, as well. Approximately half of the stories within the collection can be classified as steampunk. "Anna the Clockmaker" specifically deals with a woman who sets out to reset the time of the dominant clock of her post-apocalyptic city. Her story contains a pro-feminist critique of man's obsession with measure as control. The clock itself stands as a testament to revolution and Anna becomes a heroic and yet very human figure as she attempts to mend its damaged gears. Another of Hand's more steampunk stories is "The Baron", a short story dealing with such diverse subjects as airships, street musicians, and class wars of the organic versus the mechanic. Ending abruptly as many of Hand's pieces do, it is a solid political statement as well as an entertaining fiction.

Perhaps Hand's best written pieces are his shortest—"Of Empire and Village", clocking in at 193 words, and "Of Moth and Flame" (at 278 words) hit hard and fast and leave the reader to salivate and savor the consequences of action, reaction, and inaction. Overall, The Seduction of the Wind is an excellent collection of short stories and comes highly recommended.

Graphic Novel
Jane Irwin with Jeff Berndt
"Vögelein: Clockwork Fairy"
Fiery Studios, 2003
www.vogelein.com

I was bicycling back from mailing off a few copies of the magazine, when, taking a random route home, I passed a used bookstore that I had never seen before. Inside, I discovered a graphic novel with a title I couldn't refuse: *Vögelein: Clockwork Fairy*. I bought it, took it home and devoured it. Metaphorically, that is.

From a SteamPunk point of view, you simply can't go wrong. The protagonist is a clockwork fairy who was constructed by a clockmaker in the 17th century. She lives in the modern world. The social/environmental situation of our world is addressed without falling into the trap of demagoguery. Did I mention that the protagonist is a fairy, made of clockwork? Cause she is. And she's an excellent character, too.

The artwork is beautiful—each panel its own painting—but, I must admit, not reproduced all that well in black & white: it seems like it was made to be viewed in color. But self-publishing is like that: sometimes you do the best you can afford.

The history of the book is quite meticulously researched, and there are amazing footnotes in the back, including one that describes in detail the 17th century method of making clockwork. The world as portrayed is dark, but not dire, and it really does a lot to inject a slight bit of magic into every day life—as much with its portrayals of humanity as its portrayal of true magic.

Album
Abney Park
"The Death of Tragedy"
Self-Published, 2005
www.abneypark.com

Abney Park, for those who are unfamiliar with it, is an impeccably dressed band that sings dark, electronic dance music with gothic sensibilities. But of course, like any decent band of *any* genre, they have a bit more to add: in this case, it is a sort of exotic/world sensibility that appeals to our hopes of finding ourselves lost in the opium dens of our steampunk future. Musically, I find myself remarkably drawn to the voice of Robert, the lead singer, as he sings airily, epically. The harmonies with other vocalists are done quite well, and the myriad of singers helps the album tremendously.

Although I admit that I am not remarkably well versed in this genre of music—my tastes running in less dance-oriented directions—the closest comparison I can summon up is Bel Canto.

If there is a weakness to this album, it is its refined nature. It feels a bit like a dulled blade—the musicians are all quite competent, the songs are well composed, but the music allows itself to fall too easily into the background. It's possible, even likely, that the band doesn't suffer from this problem when they play live.

My favorite tracks are "Dear Ophelia" and "All The Myths Are True." I can't say that I could recommend this to the general SteamPunk crowd, but only because there *is* no general SteamPunk crowd. If your tastes run towards dance music, then it is very likely that you will find things herein that please you greatly.

SteamPunks on the Aetherweb

There are several destinations of choice for the cyber-inclined SteamPunk:

brass goggles **blog**: http://www.brassgoggles.co.uk/brassgoggles/
aether emporium **wiki**: http://etheremporium.pbwiki.com
steampunk: victorian adventures in a past that wasn't: http://welcome.to/steampunk

To Electrocute an Elephant
HOW EDISON KILLED A CENTURY ON CONEY ISLAND

from the Catastrophone Orchestra Archival Vault
illustration by Suzanne Walsh

CONEY ISLAND, THE FABLED *WUNDERCABINET* OF NEW YORK CITY. A PLACE WHERE Astors and nickel-a-day chimney sweeps rubbed shoulders along a mile of mediocre beach and warped boardwalks. It represented progress more than any world's fair, realizing the potential of radical egalitarianism with the newest and most original steam apparatus anywhere in the world. It is fitting that xenophobic status-crawler Thomas Edison would use Coney Island's "crown jewel" Luna Park as a stage to highlight the new—and ghastly—power of electricity. It all began with a 28-year-old elephant.

As the 19th century made way for the 20th, one of the biggest attractions at Coney Island's Luna Park was its free-roaming private herd of elephants. A favorite among them was Topsy, a three-ton tusker whose great strength had been put to use building many of the attractions that made Coney Island so much fun. Topsy had helped move the world's largest steam boiler, a machine that powered no less than three rides—including a steampunk favorite "A Trip To The Moon".

Topsy could work hard, but he could be pushed only so far. One day, a drunken Eli McCathy—an abusive lout of a trainer who had beaten one of his own children to death two years prior—tried to feed a lit cigarette to Topsy. The giant paciderm knocked McCathy to the ground and stomped him to death.

Thompson and "Skip" Dundy—two shady businessmen who were never shy of publicity—publicly declared they would hang Topsy for his "crimes". They claimed the elephant had killed two others, but further research suggests that this was just one of the flamboyant duo's many exaggerated claims. The ASPCA [American Society for the Prevention of Cruelty to Animals] became involved, criticizing the plan to hang the elephant and the newspapers had a field day with the story. Thompson called up the famed inventor Edison to see if he would be willing to do the honors.

For over two years Edison had been publicly electrocuting dogs, cats, lambs, and even a calf to prove that alternating current—a competitor for his direct current systems—was dangerous. It is unclear if any of the more than two-dozen animals executed by Edison had ever committed a "crime".

It was an easy sell for ultimate wheel-dealers Dundy and Thompson. Topsy offered an opportunity that Edison couldn't resist; what better way to demonstrate the horrible consequences of alternating current than to roast a full-grown elephant? Three years earlier, Edison had been "robbed" (as Edison had phrased it in a letter to his teen-age niece) by being denied the right to film the death of President McKinley's anarchist assassin, Leon Czolgosz. He had been limited to filming the convict going from a dingy cell to the death chamber to be electrocuted and the dead body being wheeled out. Edison was not going to be denied again; he arranged for everything and even paid for the execution out of his own pocket.

Edison sent over a crack team of technicians—and his film crew. On January 4th, 1903, Topsy was led to a special platform and the cameras were set rolling. Over 1,500 hundred spectators surrounded the terrified animal. Edison himself spoke to the assembly, which included prominent businessmen and the assistant mayor. He praised the achievements of the "unseen fire", a term he stole from his arch-enemy Nikola Tesla, and proclaimed that "we are entering a new age…" He grabbed the switch with his mink-lined gloves and smiled. It took only 6,600 volts and a little less than thirty seconds to start the elephant's feet on fire and kill the mighty Topsy. Edison later showed the film to audiences across the country to prove his fallacious point.

In the end, it made no difference. AC beat out DC, but the Wizard of Menlo Park still made tons of money.

That wasn't much consolation to Topsy, who was dead, nor to Luna Park, which was eventually destroyed in a horrible fire that was caused by Edison's DC electric light system. Today, nothing remains of either, except for Edison's film. If you ask the folks at the Coney Island Museum, they'll show it to you.

As of this writing, the last season of old Coney Island has begun. There is a large development plan to "sanitize and modernize" Coney Island. Thor Equities was buying up midway turf and will be building a shopping mall/waterpark complex. The new year-round entertainment complex would include a beachfront hotel and spa, apartments, open-air cafes along the boardwalk, arcades, bowling alleys, a pool (yes, a pool right next to the ocean), movie theaters and other non-freak-related attractions. Edison would be proud.

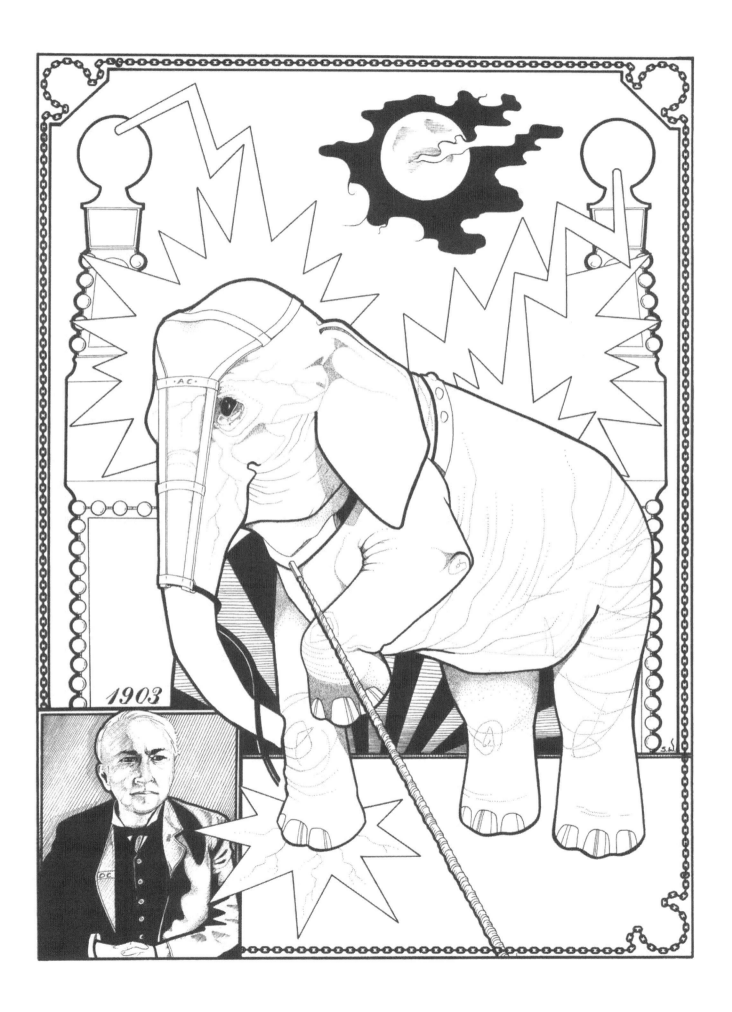

DISCLAIMER: The following is a discussion of what I personally believe is rising as the visual aesthetic and fashionable interpretation of steampunk. My assumptions are not indicative of the entire staff of this fine Magazine nor are they representative of each and every individual who dubs him or herself a steampunk. Steampunk is not a commodity as far as I am concerned—it cannot be outright purchased at the local mall (yet, ahem)—and thus there is no disciplined uniform allotted when you purchase this publication, et cetera. Though that might be somewhat charming... I digress.

Steam Gear
A FASHIONABLE APPROACH TO THE LIFESTYLE

by Libby Bulloff
illustration by Colin Foran

THE FOLLOWING BEGAN AS A RESPONSE TO A THREAD I posted to on the Brass Goggles Internet Forum. I have seen several styles of dress emerging from the steampunk zeitgeist as I have followed its escalation online over the last three years. I have observed that said modes can be cataloged according to social class and function/occupation. Really, the purpose of fashion always stems from these two hierarchies. However, we rotate in circles online that challenge traditional Victorian societal restrictions, so I have endeavored to classify these subsequent modes of dress in a manner that does not restrict any steampunk to one specific assemblage. We, as modern individuals, are allowed the autonomy to pick and choose our garb as we please, and not based upon stringent rules. Yes, I do indeed encourage defiance of these very ideas presented here. Hence, as the pirates say, do consider the following more as "guidelines" to assist in cobbling together the perfect gear.

The Tinkerer / The Inventor

These are the types who do it **for science!** *raises glass* I picture slightly more well-designed garments with straps, pockets, et cetera, some sort of protective eyewear (the ubiquitous goggle goodness or other such spectacles)… perhaps lab coats or clothes that are impervious to spills and grease? I picture the tinkerer in more utilitarian garb, and the inventor in an eccentric amalgamation of cast-off lab wear and well-worn Victorian pieces. Locate yourself a good vest or jacket with lots of pockets—think cargo Victorian. Stitch cogs on or to your clothing. Carry your tools of trade as accessories—make yourself a leather belt with pockets or straps to harness useful implements. The steampunk inventor believes in form *and* function.

Don't forget the wild hair! Or rather, ladies and gents, feel free to forget to comb your hair before you go out. Or build yourself some sort of hairpiece gadget, preferably with amusing mechanized bits. Give yourself a proper fauxhawk with tinted tips and tuck a wax pencil behind one ear or hang aged lightweight clock hands or gears from your pierced lobes.

Look for treasures at surplus stores or see if you can snag an old lab coat or rubber apron online or from a friend. Goggles can be acquired from a plethora of locales, including but not limited to army/navy surplus stores, welding supply stores, antique shops, Ebay, et cetera. Embellish your garb with clock parts and hinges salvaged from dumpstered old tech or the craft store.

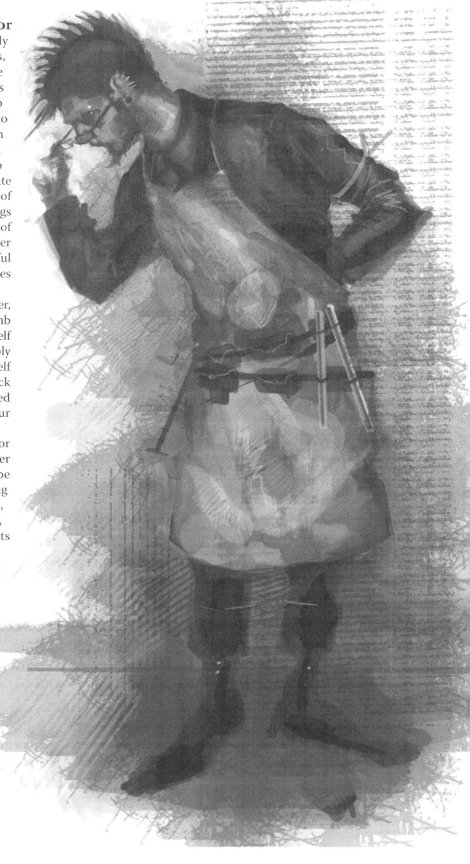

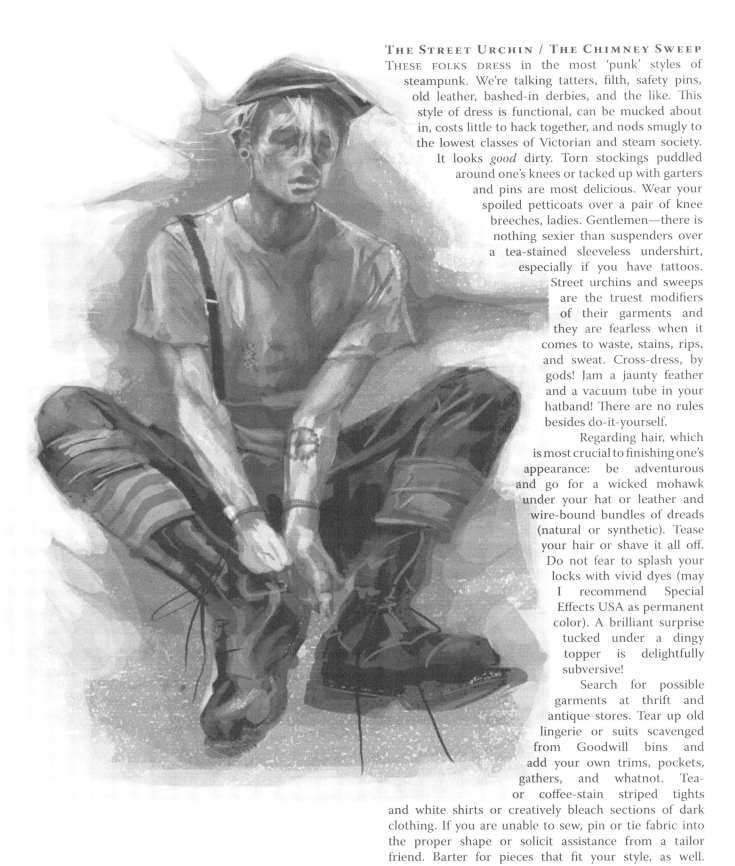

The Street Urchin / The Chimney Sweep

These folks dress in the most 'punk' styles of steampunk. We're talking tatters, filth, safety pins, old leather, bashed-in derbies, and the like. This style of dress is functional, can be mucked about in, costs little to hack together, and nods smugly to the lowest classes of Victorian and steam society. It looks *good* dirty. Torn stockings puddled around one's knees or tacked up with garters and pins are most delicious. Wear your spoiled petticoats over a pair of knee breeches, ladies. Gentlemen—there is nothing sexier than suspenders over a tea-stained sleeveless undershirt, especially if you have tattoos. Street urchins and sweeps are the truest modifiers of their garments and they are fearless when it comes to waste, stains, rips, and sweat. Cross-dress, by gods! Jam a jaunty feather and a vacuum tube in your hatband! There are no rules besides do-it-yourself.

Regarding hair, which is most crucial to finishing one's appearance: be adventurous and go for a wicked mohawk under your hat or leather and wire-bound bundles of dreads (natural or synthetic). Tease your hair or shave it all off. Do not fear to splash your locks with vivid dyes (may I recommend Special Effects USA as permanent color). A brilliant surprise tucked under a dingy topper is delightfully subversive!

Search for possible garments at thrift and antique stores. Tear up old lingerie or suits scavenged from Goodwill bins and add your own trims, pockets, gathers, and whatnot. Tea- or coffee-stain striped tights and white shirts or creatively bleach sections of dark clothing. If you are unable to sew, pin or tie fabric into the proper shape or solicit assistance from a tailor friend. Barter for pieces that fit your style, as well.

The Explorer

Explorers are, by definition "persons who investigate unknown regions". Take a nod from this when dressing yourself, as well. Think tailored garments, but more military-influenced and less I-bought-this-at-the-suit-shop. Leather, silk, linen, tall boots, pith helmets, flying goggles—the list of explorer gear goes on. Try wearing mid-length skirts with the hems buckled up to reveal breeches or cotton bloomers. Billowing sleeves or bustled skirts with tight leather vests or corsets are a definite. Borrow Middle-Eastern and Indian flair from belly dance fashion or take a nod from pioneer garb. Wrap tons of leather belts about your waist and hips or use a piece of rope to tie up your pants or skirt. Ladies—search Ebay or vintage stores for old-fashioned medical cinchers with fan lacing. Gentlemen—tuck your trousers into the tops of your boots and hang a compass and pocketwatch from your belt or rock a kilt and sporran. Mod your own steampunk ray gun from a water pistol and some aerosol paint and wedge it into your belt or your stockings.

Explorers look fine in earth tones, but let a little color peek out here and there. I also recommend investing in a well-fitting blazer of some sort—velvet or wool looks sleek, or choose to don a bomber-style jacket or duster.

Well-slicked hair with a bit of a devilish wave is marvelous for the gents and sleek updos and ponytails look lovely on the gals. If you have the distinct ability to grow muttonchops or a rakish goatee, by all means. Don't feel like doing your hair today? No worries—jam the lot of it under a flying cap and goggles or into a wool beret or helmet from the surplus store.

Scavenge about at your local army/navy surplus store for dress uniforms, footwear, eyewear, and headgear. Make your own skirts and trousers from wool or cotton cloth and decorate them with grommets or buckles purchased at a fabric store.

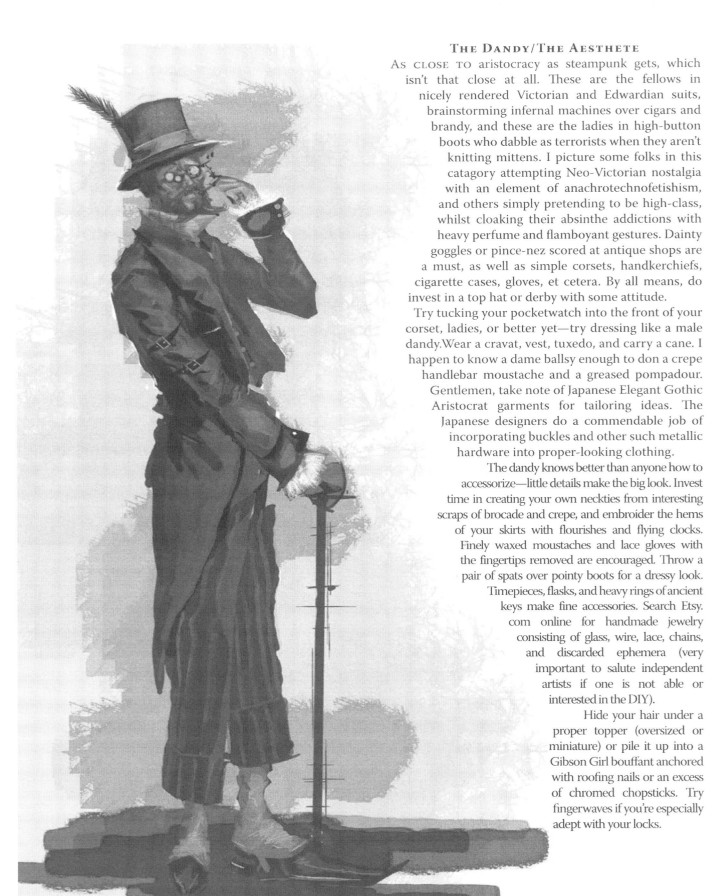

THE DANDY/THE AESTHETE

As close to aristocracy as steampunk gets, which isn't that close at all. These are the fellows in nicely rendered Victorian and Edwardian suits, brainstorming infernal machines over cigars and brandy, and these are the ladies in high-button boots who dabble as terrorists when they aren't knitting mittens. I picture some folks in this catagory attempting Neo-Victorian nostalgia with an element of anachrotechnofetishism, and others simply pretending to be high-class, whilst cloaking their absinthe addictions with heavy perfume and flamboyant gestures. Dainty goggles or pince-nez scored at antique shops are a must, as well as simple corsets, handkerchiefs, cigarette cases, gloves, et cetera. By all means, do invest in a top hat or derby with some attitude.

Try tucking your pocketwatch into the front of your corset, ladies, or better yet—try dressing like a male dandy. Wear a cravat, vest, tuxedo, and carry a cane. I happen to know a dame ballsy enough to don a crepe handlebar moustache and a greased pompadour. Gentlemen, take note of Japanese Elegant Gothic Aristocrat garments for tailoring ideas. The Japanese designers do a commendable job of incorporating buckles and other such metallic hardware into proper-looking clothing.

The dandy knows better than anyone how to accessorize—little details make the big look. Invest time in creating your own neckties from interesting scraps of brocade and crepe, and embroider the hems of your skirts with flourishes and flying clocks. Finely waxed moustaches and lace gloves with the fingertips removed are encouraged. Throw a pair of spats over pointy boots for a dressy look. Timepieces, flasks, and heavy rings of ancient keys make fine accessories. Search Etsy.com online for handmade jewelry consisting of glass, wire, lace, chains, and discarded ephemera (very important to salute independent artists if one is not able or interested in the DIY).

Hide your hair under a proper topper (oversized or miniature) or pile it up into a Gibson Girl bouffant anchored with roofing nails or an excess of chromed chopsticks. Try fingerwaves if you're especially adept with your locks.

In summary, I beg you to use the aforementioned as inspiration, not simply as a set of restrictions. Steampunk revels in the beauty of structure as well as blatant imperfection. Have neither fear nor inhibitions when dressing the part, which I encourage you to do whenever it strikes your fancy.

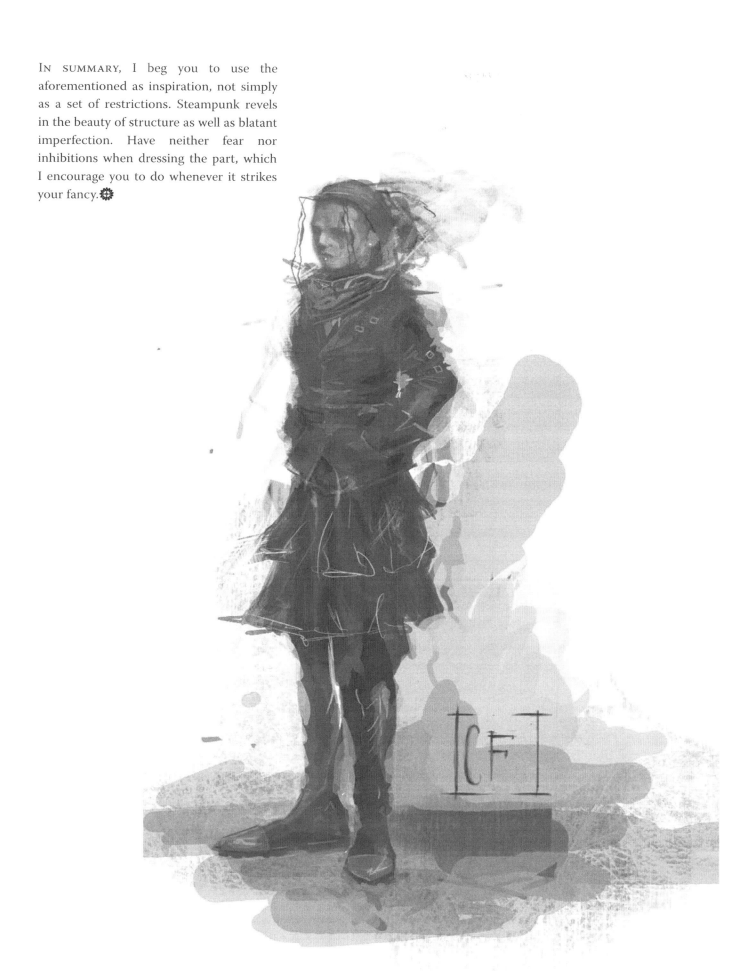

UHRWERK

It was during the latter years of the 1840's (the exact date is still a matter of some debate) that a young Irish railway worker by the name of Culann Thornton stepped into the Lion Tavern opposite Exchange Station in Liverpool with a mind to quench his thirst. This in itself was not remarkable as Thornton often stopped in for a drink before making his way home after a long day's work. He would later recall that the pub was uncharacteristically filled with *"gutter pookas[1]"* that evening and it was with some considerable difficulty that he made his way to the bar. After ordering his ale, Thornton asked the barmaid about the presence of the youths. *"Although many of them were no younger than myself, I considered them childish because of their odd attire and manners."* He was informed that they had come to see a violinist—a German gentleman by the name of Gottlieb. *"I was taught to fiddle by my grandfather but I had no instrument at that period, nor any time to play one,"* Thornton explained, *"so, although I should have supped up and headed on home, I resolved to hang around and hear this Gottlieb fellow do his turn."* It was a decision that was to change the lives of both men. *"When Fritz stepped onto that little stage I thought he looked like a priest, all smart and dressed in black as he was. The pookas seemed to treat him like one too, parting like the red sea to let him through and falling silent in reverence. When he lifted the vilolinophone[2] from its case I almost laughed. I'd never seen anything like it, hardly anyone had of course. But when he started playing I understood. Right there and then I knew that I wanted to be a musician more than anything in the world."* Greatly impressed, Thornton approached Gottlieb after the performance and was surprised to find the German not only fluent in the English tongue but also his own Gaelic (or Gaeilge). The pair drank together and spoke long into the night, chiefly on matters of music and engineering—the twin passions which were to seal their partnership for many years to come.

the incredible steam band

by John Reppion
illustration by Juan Navarro

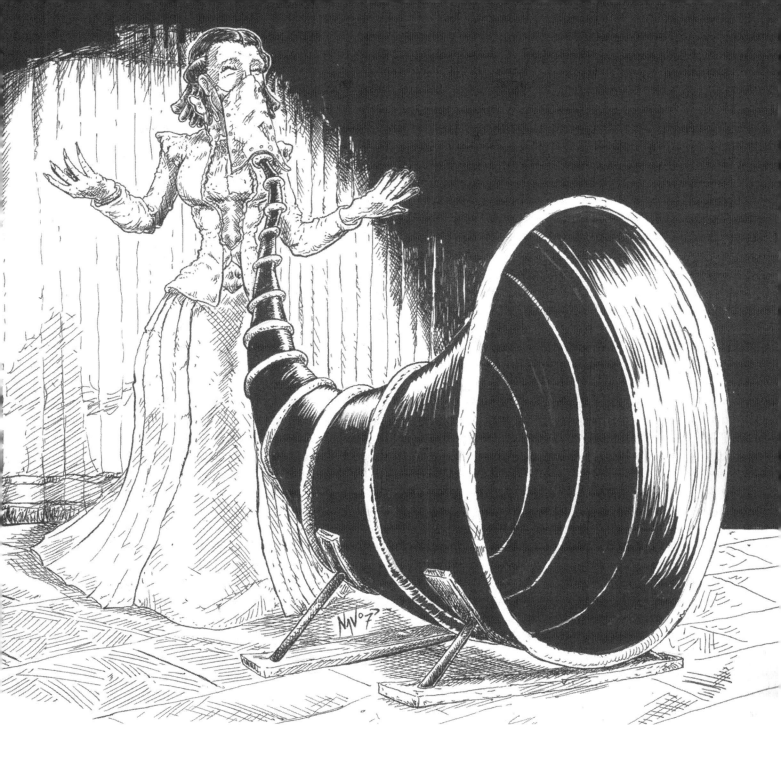

By 1850 Thornton had abandoned his job on the railway and the pair's time was divided between performing their own unique and harmonious compositions and devising and constructing new musical instruments for that purpose. Appearing simply as *"Gottlieb and Thornton,"* the duo began to make use of a somewhat basic but highly compacted orchestrion. The machine provided automated percussion and baroque influenced *"basso continuo"* accompaniment to their duelling vilolinophone and chorded harp[3] concertos. Conceived by Gottlieb, the technicalities of the orchestrion and its manufacture fell to the more mechanically minded Thornton. The device (nicknamed *"der kasten,"* meaning "the box") was no larger than a good sized travelling trunk and was powered by means of a self contained steam engine. It is perhaps not entirely unfair to suppose that some portion of the pair's success came not from the public's love of their music but from the curiosity aroused by the use of such a unique apparatus. After graduating from public houses to small theatres, Gottlieb decided that the duo's funds were now sufficient to embark upon the next phase of their most melodious and innovative journey. Several months were set aside for the design and fabrication of the *"most fabulous and ingenious musical instruments ever conceived"*—the actual process took almost two and a half years and saw the duo living in poverty for much of that time.

Unable to pay the rent on their grand Smithdown Lane house, Gottlieb and Thornton surreptitiously relocated into the property's sizeable cellar. Unbeknownst to their landlord, the subterranean portion of the building extended for some considerable distance beneath, presumably having been constructed by Mister Joseph Williamson's men.[4] Finding that the cellar was connected to nearby Mason Street by means of a narrow tunnel, the pair established that they could come and go from the property relatively easily even with new tenants now occupying the house above. Nevertheless, both men remained fearful of detection, not least because of the value of the materials and apparatus which they kept within their lair. Thornton became ever more obsessive and meticulous—with hardly any concept of night and day (owing to his subterranean lifestyle) he would often cease working only when a state of bodily collapse came upon him. During this period it fell to Gottlieb to raise funds to keep himself and Thornton from starvation which he did by busking around Liverpool. The German's jet black hair and beard had grown long since the days of the duo's notoriety—thus altering his appearance considerably—but Gottlieb, anxious that he might be recognised by persons to whom he and Thornton owed money, remained guarded. He declined to leave the cellar by day and adopted the persona of Grigori, a Russian musician, when venturing out at night. It was on one such evening that Gottlieb first encountered a young Slovenian woman named Pepca Predin singing and begging down by the city's docks. Pepca had a voice that was *"remarkable to the point of otherworldliness"* but intoned her songs so quietly that she could hardly be heard. She was also very beautiful, and it is fair to say, knowing what we do now, that Gottlieb fell in love with her almost instantly. Combining acoustical awareness with an intimate knowledge of the backstreets and alleyways of Liverpool, Gottlieb was able to position the meekly voiced Slovenian in such a way so that the arches and passageways themselves augmented and directed her vocalisations. He himself would accompany Pepca from some considerable distance (sometimes a street or two away), once again making use of the alleyways as a means of carrying the sound. This method of performing soon earned the duo the nickname of *"the Russian ghosts,"* owing to the fact that the optimum position for hearing their combined efforts would often deny the listener the opportunity to visually observe either. Homeless and alone as she was, Pepca gratefully accepted Gottlieb's invitation to join himself and Thornton and reside in the crypt beneath Smithdown Lane. And so it was that the duo became a trio.

It was 1853, the year Brunel began consturction on his Great Eastern passenger steamer down in London, when *"Uhrwerk—the astounding two man orchestra"* finally took to the stage. *"Gottlieb and Thornton"* were still remembered favourably by many of Liverpool's more musically disposed citizens—if not by the city's money lenders—and, after a handful of furtive private performances for some of the port's more discerning and influential individuals, the pair managed to arrange a series of six concerts at the highly regarded Philharmonic Hall. The duo where so convinced of the success of these events they let it be known that all persons to whom they where indebted would receive payment in full at the termination of the very first performance. A contemporary columnist in *The Liverpool Mercury* newspaper described the build up to the concerts thusly *"[...] during their several year's absence from performing publicly Messers Gotlieb and Thornton have apparently been engaged in the creation of some most unique musical apparatus which by virtue of its ingenuity will grant but two men the ability to perform with all the melodiousness of a full orchestra. This is a wild claim indeed but anyone who recalls their performances of old will little doubt either fellow's ability in such matters. Indeed, I for one would not be at all taken aback if those attending next month's performance were to witness the creation of an entirely new approach and method of music".* Articles such as this combined with an exhaustive hand bill campaign (orchestrated by Gottlieb utilising gutter pooka youths as distributors with the promise of free entrance for themselves and their friends as payment) assured that the shows would indeed be well attended. When the evening of Friday, October the twenty-first finally came, talk of Uhrwerk's debut performance had spread far beyond even the North West of England. Numerous persons who had travelled from afar were disappointed and refused entrance on account of the auditorium already being filled to its maximum capacity. And so it was that a hefty throng assembled itself around the hall on Hope Street and strained its collective ear in the hope of catching some stifled melody from the incredible steam band.

The evening's performance began with what one correspondent

described as *"the thunderous blasting of a great many horns whose tone was so low one would expect their size to be monumental"*. The curtain lifted to reveal a stage with three large, concealed objects set out upon it—a tall cloth-covered item stood in the front and centre, a smaller rectangular object (also covered with a cloth) stood to the left of the first and a large, wooden framed canvas screen stood to the right, set back considerably from the other objects. The originator of the *"thunderous blasting"* stood at the rear centre of the stage and was an object some seven feet tall by four feet wide by three feet in depth. This was the heart of Uhrwerk's music—a greatly expanded and improved version of their original steam powered orchestrion der kasten. Again the contraption was powered by an integrated steam engine, but was now large enough for Thornton to have built a sixty one key keyboard and an assortment of pedals and stops into its front so that the device could be played manually. Fritz Gottlieb sat alone on stage with his back to the audience, hammering out ungodly chords and causing steam to belch out of some of the broadest and deepest of the instrument's three hundred and five pipes. As the German's playing reached a crescendo he manipulated a switch causing a mechanism within the orchestrion to engage with a musical roll. This lengthy roll spooled into the apparatus from the rear and controlled the automated percussion and instrumentation—this single reel contained the machine's directions for that night's entire concert. The uninitiated amongst the audience gasped as booming timpanis and crashing cymbals came into play whilst those who had experience of Gottlieb and Thornton's performances with der kasten smiled and nodded agreeably— this was what had been expected from the duo's return. Presently the music grew softer in tone, the percussion dying down, and a smartly dressed Culann Thornton stepped out onto the stage. With a flourish, the Irishman removed the covering fabric from the foremost left object and unveiled his *"clockwork armonica[5]"* much to the audience's amazement. Armonicas had already been around for nearly one hundred years and yet were (and remain) a much underused instrument despite their beautiful sound. Thornton's device had thirty-two purpose built glass bowls— blown by the man himself—mounted horizontally on an iron spindle. This spindle was turned by means of a large pre-wound clockwork motor which was set in motion by releasing a fixed ratchet, thus allowing the mechanism's mighty spring to commence unwinding. Rather than placing a wetted finger upon to bowls to produce a sound, Thornton had created a keyboard by means of which soft leather padded keys could be applied to the glasses, thus opening up a more outstanding range of chords and harmonies. The glasses were enclosed within a metal hood which was formed into a wide horn shape at the instrument's front. This horn acted as a means of directing and amplifying the armonica's somewhat soft tones. The contrast between the delicate, eerie notes of the clockwork armonica and the pulsing grumble of the orchestrion's pipes was emphasised via an elaborate call and response (or *"antiphony"*) arrangement in which the instruments mimicked and duelled with each other. This arrangement eventually built to a climax in which the automated percussive accompaniment once again thundered into play. Soon the orchestrion's musical roll reached a point at which the operation of the device's pipes too became automated and Gottlieb was able to amaze his audience by lifting his white gloved hands from the keyboard in much the same manner as a conjuror might make some elaborate gesture to embellish an illusion. The German was dressed in a slender, well tailored black suit, as was his predilection, and sported freshly barbered locks and whiskers. Gottlieb strode confidently to the front of the stage, every inch the showman, beaming and encouraging the audience's applause and cheers as Thornton continued his vigorous duet with the machine. Then, with swish and a swirl, Gottlieb removed the fabric from the tall, central object. A huge horn stood at the forefront of the stage. The device was of similar design to that which adorned the front of Thornton's armonica though several times larger. This horn was set upon an iron tripod and angled upwards in order to better broadcast sound out into the hall. Stepping out from behind the funnel came the diminutive Pepca Gottlieb (a Predin no longer) wearing a dark flowing dress of velvet and lace. The lower portion of Mrs. Gottlieb's face was obscured by a curious looking veil of leather, covering her mouth and nose and fastening around the back of the head in much the same manner as a modern surgical mask. The mask was connected via means of a lengthy and flexible canvas tube to the vast metal horn as a means of augmenting the Slovenian's faint voice into something more readily perceptible. With several grand staccato stabs, the music came to a halt and Pepca's angelic voice poured out of the great funnel to fill the auditorium. Many in the audience were seen to weep, not at the beauty of her words, for she sang partially in her native tongue and partially in sounds alone, but at the sheer emotion and wonder of her most unique tones. After a time she was accompanied by Fritz upon the vilolinophone, summoning up memories of their time performing together on the streets as *"the Russian ghosts"*. Soon Thornton's instrument could be heard also and the three spectral voices glided in and out of harmony in complex patterns and canons so remarkable as to be proclaimed *"positively mesmeric"* in the next day's *Mercury*. Presently the bass tones of the orchestrion began to build once more, the beaters within the machine struck heavily upon the snare and the cymbal and the symphony thundered onward. Pepca was handed the vilolinophone by her husband and stalked around the stage fiddling and singing like a woman possessed. The flexible canvas tube which connected her mask to the large central horn ensured that her voice was broadcast effectively even when her back was turned to the audience. This portion of the performance was perhaps the most unanticipated of the evening for many people, taking its influences chiefly from Bavarian *"oom-pah"* and fiddle driven Irish folk tunes. This was not the sort of music that one would expect to hear in a respectable arena such as the Philharmonic Hall—this was the music of the lower classes intended

as an accompaniment for dancing and drinking and fighting. And yet somehow, via Uhrwerk's remarkable instrumentation and sublime arrangements the music was given new dynamism and rendered exceptionally palatable to even the loftiest listener. Gottlieb stamped his feet and clapped his hands, urging the audience to do likewise and many obliged. Half a dozen of so gutter pookas actually clambered onto the stage and began to dance a jig in which the German gleefully accompanied them. There were, of course, those who were outraged at such behaviour but even so, very few of those thus offended voiced protest or made efforts to leave the hall—there was after all, still one spectacular instrument yet to be revealed.

After a time the joyous, if off-kilter, jig was brought to a close with the same staccato stabs that proceeded Mrs. Gottlieb's first intonation. The orchestrion continued a slow but steady beat upon its bass drum while all else fell silent. Thornton stepped out from behind the clockwork armonica and assisted Pepca in the removal of her veil. The pair took several bows—to much applause—and exited the stage. Alone now, Gottlieb strode around to the rear of the canvas screen which obscured the final device, his steps keeping time with the solid thump of a drum. The screen was flung to one side with a suitably overgenerous flourish and the final instrument was revealed to the audience. The *"steam flute[6]"* was a curious looking object having twenty four upright sounding tubes arranged in a semi circular manner at its front and a keyboard situated behind. At the instrument's side was a steam engine whose task was to drive water through the device under immense pressure. Warmth from the engine was also used to heat an element which ran through the sounding pipes. Through operation of the keyboard, the flow of water could be redirected so that the liquid made contact with the element, turning instantly to steam. This steam would then travel out through the designated pipe, thus creating a note. Thornton had designed the instrument's keyboard so that each key had several different settings according to how hard it was pressed. These settings varied the amount of water which was directed onto the element thereby giving the device a more organic and supple sound similar to that of a true wind instrument rather than an organ. The steam flute's engine had been running quietly throughout the performance thus far, ensuring that it was now fully prepared for operation. During this break in the music Gottlieb had been counting in his head, keeping pace with the orchestrion so that he knew exactly when the machine would again strike a chord—his timing was always impeccable. As the bass drum pounded like a heartbeat the audience held its breath and waited for the first sound from the German's most remarkable looking instrument, but it was the orchestrion that gave voice first. The vast mechanical organ struck up a beautiful arpeggio bass arrangement, its percussion maintaining the slow and steady pace but embellishing the pattern with dramatic crashes of the cymbals. By and by the percussive elements grew in complexity until the orchestrion's incredible abilities were made most clear—the machine was capable of things that even the most accomplished percussionist (or percussionists) would deem almost impossible. At the apex of the machine's rhythmic interlude the silvery melody of the steam flute finally came into play and, much to the audience's delight, a new movement began. Gottlieb's hands danced merrily across his keyboard, modulating the device's tones with all the control and finesse of a traditional flautist. He and the orchestrion sparred with each other with what seemed like all the spontaneity of two musical equals engaged in some good-natured, if fierce, competition. The truth of the matter of course was that Gottlieb was in fact accompanying himself—the orchestrion's operation being controlled by the roll which he and Thornton had laboured over for months. Presently Gottlieb shifted from playing the steam flute in the manner of a wind instrument to striking chords on its keys. The accompaniment also altered, becoming grander and yet somehow more solemn and melancholic. Fritz's playing grew deliberately mechanical and angular—he stabbed at the steam flute's keys with calculated ferocity ensuring that the maximum amount of water passed through each of the chosen valves. At no point during the evening had the name of Uhrwerk (German for "clockwork") seemed more fitting for the assembled musical group, the composition now bearing a striking similitude to that of some epic and diabolic musical box. This was to be the penultimate movement of the concert, with Culann and Pepca rejoining the German onstage for a final section in which the clockwork armonica and the Slovenian's remarkable voice would once again come into play. Alas, this closing movement was never heard.

Inside the steam flute the pipes which carried the water around the device had grown hotter than ever intended, owing partly to the machine's running for some time prior to its playing and partly to the extreme heat of the packed auditorium. As the German stabbed brutally at the keys of the instrument, the unique rubber seals (or "lips" as Thornton called them) which directed and controlled the flow of water onto the heated element began to stick. At first the effect was merely some sustained notes and chords which Gottlieb remedied by banging and rocking the device—his passion was quickly turning to anger; he clearly had no intention of allowing the contraption to let him down in this, his eleventh hour. Despite Fritz's efforts it was not long before instrument was producing nothing more than a sustained and discordant groan. The German swore and kicked at the apparatus while the orchestrion played on, oblivious. Great gouts of vapour were now spewing from the steam flute's pipes. And then came the explosion.

The build up of pressure within the steam flute's engine was simply too much for the delicate device to take. The machine's boiler ruptured and a considerable burst of steam and energy erupted from within. The instrument was propelled backward with great velocity, taking the enraged Gottlieb with it. The force of the impact combined with flying debris from the steam flute then caused the orchestrion's engine to also split and burst. The twin explosions were deafening, causing even the crowds gathered outside the

building to duck and panic. Steam filled the hall, scalding even many of those seated high in the balconies. When at last the haze cleared there were almost ninety found dead and Fritz Gottlieb, or what little now remained of him, was counted amongst their number.

In the weeks following the concert Culann Thornton found himself in court for his part in the creation of the instruments which had caused the death of so many and such damage to what was then considered Europe's finest such venue. The judge in the case proved to be an admirer of Thornton's and was consequentially as lenient as he could be—spared the hangman's noose, the Irishman was instead sentenced to life imprisonment in Liverpool's Kirkdale jail. Culann's tale does not end there however; he in fact spent only three weeks in the prison before making his escape—his understanding of all things mechanical having also rendered him an excellent lock-pick. The authorities had little luck in locating Thornton and his whereabouts remained unknown for almost two years. In August 1855 a letter professing to be from Culann Thornton was delivered to the editor of the *Liverpool Post* newspaper. In it, Thornton professed to be extremely sorry for the pain that had been caused by the malfunction of his instruments but blamed Gottlieb for the disaster: *"His temper had grown ever fouler during our years together and it seemed strangely fitting that it should be such an outburst that finally caused his demise."* The letter had come from America, where the Irishman claimed to have fled to begin a new life. *"Here I have ceased to be known as Culann Thornton and my beautiful wife is Pepca Gottlieb no longer. I continue inventing and making music and perhaps shall one day know fame by some other name. In the meantime, if there is anything which the people of Liverpool or England or even my own Ireland wish to know about my time as Fritz Gottlieb's apprentice and engineer you have only to print their enquiries in your most highly regarded publication. My replies may not be swift but I give my word that they will always be thorough and honest."*

No recordings of "Gottlieb and Thornton", "the Russian Ghosts" or "Uhrwerk—the incredible two man orchestra" were ever made—the phonograph not being even conceived by Thomas Edison until July 1877. All of Uhrwerk's unique equipment was destroyed or damaged beyond repair in the explosions which killed Fritz Gottlieb and Culann Thornton's notes on their construction have never been found. All that remains of their musical legacy is contained here within this brief article.

FOOTNOTES

1—Thornton's own nickname for the incongruously garbed urchins who proved to be some of his and Gottlieb's most devoted followers. Pooka (or Puca) being an Irish term for a mischievous goblin-like creature.

2—Subsequently nicknamed the "Gottlieb fiddle" for many a year until a countryman of Fritz's named Johannes Matthias Augustus Stroh actually patented its design in 1899.

3—A stringed instrument bearing a striking resemblance to the autoharp commonly used today in much of the folk music of North America.

4—Williamson was a philanthropic gentleman who funded the construction of a huge network of apparently meaningless tunnels beneath Liverpool in order to provide employment during the economic recession following the Napoleonic Wars. Many of these tunnels remain intact—although uncharted—to this day.

5—Thornton's design used Benjamin Franklin and Charles James's device built in 1762 as its basis but it contained many modifications.

6—The steam flute shared some characteristics with Joshua C. Stoddard's *"calliope"* patented in 1855, although the operation of the former was quite different and the subtlety of its sound infinitely superior.

John Reppion lives in Liverpool, UK and has been a freelance writer since 2003. He sometimes tells the truth but mainly deals in fiction.

Interview With
I-WEI HUANG

I-Wei Huang builds the things that the rest of us dream about. A computer-game animator by day and inventor by night, the winner of RoboGames 2006's "Best of Show" & "Kinetic Artbot", I-Wei has achieved a breath-taking (although well-deserved) amount of fame with his remote-controlled, steam-powered gadgets. What's more, he has also blessed the SteamPunk community with a how-to for artists who draw fantastic steam machines. In fact, he illustrated this article!

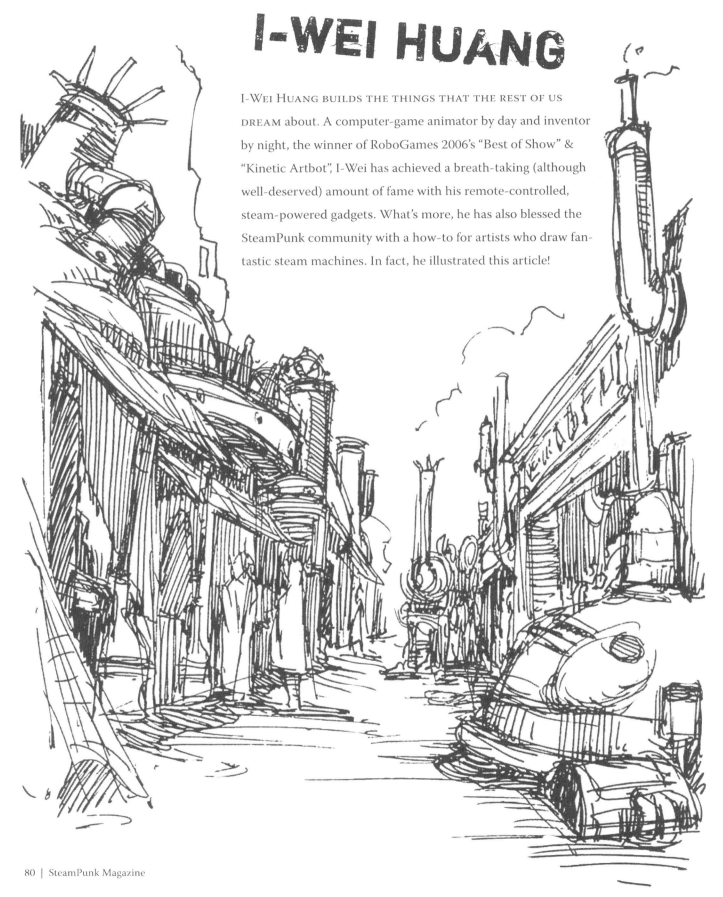

I've read that your dremel tool is the only power tool in your rather limited workshop, and yet you've consistently produced quite amazing machines. What challenges does this limitation present you with? Are there any tools that you often find yourself wishing were available to you?

Since that was written, I've upgraded some tools. Nothing beats having the right tools for the job. Power tool-wise, besides my trusty dremel, I've gotten a scroll saw, a sander, and a drill with drill press adapter. I lack machining skills; therefore I don't have a lathe or mill. I still plan on learning all this machining mumbo jumbo, especially with a CNC [Computer Numerical Control] setup since I'm used to working on the computer already.

What are some of the advantages and disadvantages of steam-power? You've pointed out in the past that steam engines produce a high RPM but a low torque. How does that affect your designs?

Disadvantages:
- The high heat melts plastic chassis and gears pretty quickly.
- Not even including the water it's heavy.
- It's messy & oily.
- It's low power and *very* finicky.
- It can be dangerous if not treated with respect and caution.

Advantages:
- It's an excuse to play with fire.

- It gets you on tv, covered in magazines, and you win shiny awards to hang on the wall.

You've said that you often plan a machine one way during the design stage, only to have the physical limitations require different designs when you are actually building. Are there any consistent mistakes you make when you are planning things out?

Yes, I always go too fancy and start thinking about the bells and whistles (sometimes literally) before the main mechanics are figured out. I also *always* think that an engine has more power than it does. Testing an engine before mounting it to a machine always makes it seem like it's got more power than it needs, but I always need to gear down in order to make it run... slowly... very slowly.

You have a rather impressive resume posted on your website, with work experience as varied as "Double Agent", "Crab Trainer", "Worm Counter" and "Crack Dealer". Do you think that this varied past has led you to the work that you do today?

No. After my double bypass brain transplant, I don't remember much of my past. FYI... there is only one thing true in my resume: I did work a summer counting worms.

You've given the world quite a handy primer on how to draw steam-powered machinery, how to give SteamPunk more authenticity. Do you have any further advice for those who illustrate fantastical machines?

Yes, practice until you drop. Collect as much reference from all of your favorite artists as possible. Look around; the best designs always come from the magic of nature. Lastly, combine all of your influences together to make it your own, and hope that no one notices where you stole your ideas.

Are there any games that (you've done)/(are doing) animation for that are of a particular interest to the SteamPunk crowd?

No, I wish. In the game industry, you don't get to pick to make any game that you like... publishers sink millions into game development, and usually won't fund anything unless they believe it will sell. That is why you see the same games over and over. If any of you readers are gazillionaires, and want to fund a SteamPunk project, let me know.

How do you think that a hacker/contraptor outlook has served you in your day-to-day life? Do you find yourself applying your skills to situations outside the workshop?

Well I look at everything differently now; walking down the aisles of a store, I'm always looking at items from the perspective of whether or not I can use it in some steam contraption.

And finally, how long will it be before I will be able to ride a bicycle-powered crab-device? ⚙

Bicycle-powered, I don't know. Steam powered... 4.425% chance it will happen in my lifetime. I'm too scared of large-scale steam boilers, plus I am still looking for that gazillionaire to fund such a project, along with my steampunk game.

Any prospective financiers are encouraged to contact I-Wei through his website [www.crabfu.com], and any aspiring SteamPunk artists are encouraged to read his tutorial online [www.crabfu.com/steamtoys/diy_steampunk/].

Mining Medusa

by Donna Lynch

illustratration by Steven Archer

"Don't you turn me away. You wouldn't *dare* turn me away."

She wasn't screaming at me, but she wasn't exactly asking cordially either. The woman at the gate was stating a fact. After considering what a nuisance she was likely to become, I let her in.

"I suppose you know why I'm here," she said, trying to sound more professional now.

She was there to speak to Lehmann.

The elevator that took us to the top floor of Chroma Company still worked, but like everything else it was near its end. It rattled and shuddered and moved at inconsistent speeds, but the woman showed no expression of fear.

She did not say another word, in fact, until we reached Mr. Lehmann's study on the twentieth floor.

Then she looked around and whispered nervously, "Oh my stars."

I remembered having a similar reaction to Lehmann's penthouse when I first arrived. It was massive, luxurious, decadent, and utterly torn to shreds. Some poor soul had clearly lost their mind and nearly turned the place on its side. There were expensive broken things: irreplaceable pages ripped from rare books, alcohol-stained hand woven rugs and tapestries from Europe, and most of all, shattered mirrors. In time, every mirror in every room would be shattered into thousands of pieces.

He had eventually fired the servants and staff, shut down the company, and closed his doors to any and all visitors, save for myself.

And since then, it's just been he and I. Patient and doctor. I haven't left his side, and I won't until the end. No matter what sort of man he may have been.

But back to the interloper.

It's unfair—I shouldn't say such things. One can hardly blame her for wanting answers. I know *I* did, and I had far less of an emotional attachment, in the beginning.

"What happened here?" she asked.

But, truly, I didn't know where to begin.

She sat down and produced a photograph from her hand-embroidered bag. It was a picture of an ordinary man, handsome enough, I suppose, if you fancy the blue-collar type. The woman was handsome in a similar way. Not beautiful or elegant, but of sturdy and practical genes.

"This is my husband. His name is Cole."

"And what might your name be?"

She told me her name was Etta Parker. "But I didn't come here for myself," she said, "I came here for Cole. My husband worked for Chroma Company until Mr. Lehmann shut it down. Cole went to work one day and was told to go home. Everyone was just told to go home. No explanation, no nothing. Are you aware, Sir—"

"Doctor," I interrupted, "Dr. Simon Young."

"Are you aware, Dr. Young, that this town only exists for and because of Chroma Company?"

I nodded, though to be honest, I'd never really thought about it before.

"So you can imagine our shock and concern when our husbands came home from the mines that day with the news."

"Of course." I said. But, of course, I couldn't. I am a doctor, my father was a doctor and his father was a doctor. My life has never been uncertain. At least it had never been until I met Lehmann. Now I am uncertain of many, many things, and positively giddy about the possibilities.

Etta continued. "It's been a terribly stressful time, Dr. Young. We have families, you know. We relied on our husband's jobs. We relied on Chroma Company. This tower—it's been our symbol of hope and prosperity since we settled here. And I don't know how well you know our fair town, Dr. Young, but there's not much else around. This land is different. You can't grow normal crops on a serpentine barren. There are no real forests. You can't build sturdy structures—how this tower has even lasted is beyond me! All this place is good for is mining metals. And now that resource has been taken from us."

"And you came here to find out why."

"Well, that certainly *was* the question—until our husbands got sick."

I asked her to explain, not because I really cared, but to be civil. I knew she would tell me either way.

"It started not more than a day or two after the company closed. I thought it was just the stress of being unemployed taking its toll on him, but things just kept getting worse. He coughs. He coughs all the time now, and when he does, a cloud of grey dust comes from his mouth."

Her eyes grew teary and softened a bit. At once she seemed prettier, younger perhaps. I could see the frightened child in her now.

"I made him cough into a handkerchief. Since you are a doctor, perhaps you can tell me what this is."

She took a folded square of cloth from her bag and held it out for me.

I took it, and although I knew exactly what I would see, I went through the motions anyway.

Sure enough, there was a large smudge of grey dust, like charcoal, with glittering green and blue flecks throughout.

"Can you tell me, Dr. Young, why my husband is coughing this up? Can you tell me what to do about it? Is this chromium poisoning?"

I could have lied to her then and there and said 'yes, it's chromium poisoning' and sent her on her way with my condolences. But something compelled me to respond the way I did.

Perhaps I wanted to keep her there. Was I lonely? Was it as simple as that? Perhaps I just wanted some interaction with someone normal. Or maybe I wanted to tell her what I knew. Maybe she would be the only person in the world that could ever believe what I knew to be true. Honestly, I didn't know what to do, only that I didn't want her to go. Not yet.

I sat in silence, staring at the handkerchief.

"It's not the chromium, is it?" she said.

I shook my head. "Chromium is slow. It might have killed them one day, but not now. Not like this."

"Then what? You know, don't you? I can tell by your face."

I did not answer, still unsure of what to say or how to say it.

"Dr. Young, he is dying. And so is our neighbor. And so is his neighbor. And so is every single man in town who worked in the pit. And I need to know why and if there is anything to be done about it!"

Again, I said nothing.

"We've brought in doctors and they are at a loss. Never seen anything like it, they said. And we can only afford so much. But we don't know if this is contagious, if our children are at risk. And there is no one left to help us."

I looked away.

"My husband's tongue is turning green and blue. He cannot eat and is almost unable to get out of bed. His muscles are tight and he is in constant pain. One of his friends committed suicide three days ago because he couldn't take it! And now there is talk that some of the other men are thinking of doing the same. Please, Dr. Young, we need your help."

Tears were streaming down her face now and she clutched her photograph tightly, creasing it across the middle.

I took it from her weathered hands and smoothed it out, staring at the man in the picture. This was a man who was not too good to get his hands dirty. He looked unafraid.

"There is something you should see," I said.

I led her down the hall to a set of giant mahogany doors, behind which was a room made of a blue-green marble-like stone. Of course, she did not immediately take in the beautiful details of the walls and floor or the unusual décor, nor did she take a moment to appreciate the overwhelming view of the pit and the barrens from the colossal arched window.

All she could see as we entered the room was the figure in the bed.

He was little more than a torso and head caught up in a snare of tubes and wires. The contraption that cradled him did not match the room in the least—with its shiny chrome framework and moving gears and parts—but it was practical and could provide what little comfort there was to be had for the poor creature. Had he arms or legs, he might have looked a bit like a marionette, but as he was I likened him to a mangled insect that was cocooned and trapped in a spider's web. I waited for Etta to catch her breath and then made the introduction.

"Etta Parker," I said properly, "meet Klaus Lehmann."

I cannot lie. It was exhilarating, watching her struggle to maintain composure as I revealed part of the secret I'd been guarding since Lehmann's first call. The other part of the secret, of course, was what sort of sickness could lead to such an unbelievable state. I felt a bit like a mad scientist, perhaps because I'd managed to keep Lehmann alive for so long.

"I will tell you what happened here, and when I am finished you will have a choice to make. You can call me a liar and storm out of this place, never to return again. Or you can know that I am telling you exactly what was told to me, and then take that knowledge back to your home. Your men are dying either way. You came here for answers and I shall provide, but I can promise you, they won't be the answers you hoped for."

She didn't speak. I offered her a chair and she sat down, never taking her eyes from Lehmann. It struck me to see her there, for a moment. She looked like a paper doll cut from faded newsprint, with her tousled brown hair and dusty cotton shirtwaist against the jewelled, watery backdrop of the room.

"Mr. Lehmann has always been a betting man. He told me that when I first arrived. He loved a good risk, and never wasted time on regrets. I admire that greatly, having come from a family that leaves nothing to chance."

Still she did not look at me, although she was not really looking at Lehmann any longer. She was staring past him, into nothingness, perhaps a little hypnotized by the rhythmic hissing and sucking sounds of his breathing apparatus. I watched her bony hands tighten and release around the fabric of her bag, which she held firmly against her stomach. I thought it was funny and perhaps a bit heartbreaking that she had embroidered pretty flowers on it, considering there were no flowers anywhere to be found in the barren.

"He called on me when the sickness began. He said he knew my father's name from years ago. So I came, and I must confess, I hadn't a clue what was wrong with him until he told me about the pit:

"Lehmann's story began simply enough; Chroma Company was in its infancy when Klaus Lehmann had come to the serpentine barren with one small rig and only a handful of men. It had been a risky venture, leaving the booming coal industry, but Lehmann had believed there was even more fortune to be had with the Serpentinite soil, rich as it was with heavy metals. There was a new age coming, everyone had been fond of saying then, and metals were certain to be back in fashion before long. They set up camp and blasted the first pit.

"It was sufficient at first, but the deeper the better, Lehmann always said. So deeper they went, and all was well until one day when half of the crew went down and didn't come back. He checked the seismograph; there was no evidence of a cave-in or explosion. It must have been the black damp, he reasoned, and all the men poisoned or suffocated. He sent the remaining crew, with masks, to investigate.

"This time, only one man returned, and when he did, he was nearly useless with hysteria.

"This man—Collins—claimed to have witnessed a most unfathomable occurrence. It was horrific enough, he'd later say once he'd gathered his wits, to find the petrified bodies of the men from the first group, but then—to see it happen right before his eyes, well, needless to say poor Collins was never quite right again.

"But Lehmann pressed on for more information. What could bring about such a thing? Collins was reluctant at first, but after much coercion he told Lehmann what he'd witnessed. He hadn't seen it in the flesh, but only a reflection in the facemask of one of the other men. It was a woman, he

said, but not entirely. She moved like a serpent, and seemed to be made of the same. She was terrifying, yet he could not stop staring at her reflection. He might have peered around the wall of the shaft, too, had it not been for the body of the man next to him, who had frozen where he stood, his flesh like stone: dead and unmovable. There was nowhere for Collins to go but back out the way he came.

"Now, knowing Lehmann the way I do, I'd expected that he might have thrown poor Collins back down into the mine, just to be rid of him in case any questions were asked. But he did no such thing. Instead, he unleashed psychological warfare against the wretched beast—Collins, not the demon creature in the mine—going round and round with him until the poor man no longer trusted his own thoughts. Soon after, Collins left the barrens and swore never to return.

"And he never would. In fact, once he got home, he never went much of anywhere. His family had him committed within a month of his return, and there he sits, raving about pits and demons to this very day.

"But back to our dear Lehmann. He wouldn't have been much of a risk taker if he hadn't gone into the pit to see what all the fuss was about, now would he? And what poor Collins would never know was that his employer believed him after all. Why else would he have taken two mirrors into the pit with him?

"Lehmann said the smell of a pit is indescribable; one can smell the traces of bygone eras and taste the world the way it was a million years ago. I find that to be very poetic and profound for such a superficial man. One would almost think he was in love with his mine, lusting after the soil and darkness.

"When he met the demon, she was just as Collins had said. She gave him a warning in the form of a low guttural sigh. When he called out to her, announcing his presence and business, she responded first with a rattling hiss, then actual human words.

"She said, 'Forge ahead if you care to end up like the others, or stop where you are and use those mirrors like the clever man you are.'

"So he set up his mirrors, catching her reflection, all the while hiding himself behind the stony corpses of his crew. He told me she was hideous, or possibly beautiful; he really couldn't say with any certainly, but he knew from that first moment that he loved her and always would.

"They talked for a full day and night, and when he finally left her he was delirious and near suffocation."

"Wasn't he frightened?" Etta asked. I noticed she was gazing at him with something between longing and bewilderment.

"Perhaps. Were you frightened in coming here, to this strange place?" I thought of how it must have been for her to see such a monolithic tower up close for the first time.

"I was," she confessed quietly, "it was so quiet all the way here. I didn't pass another soul. I heard no birds; not even the wind. I felt alone."

"Then you can imagine how it was for our friend here. He felt alone, too. And although he was frightened, he went to the pit because he knew he had to."

She did not respond, but looked upon Lehmann with great sadness in her heart.

And in a way, his story was indeed one of sadness, and not just abject horror, as it would ostensibly appear.

"So he went to the demon night after night, crawling down into that narrow black void and risking collapse or worse just to hear her exotic voice tell him of great mysteries.

"When she spoke of foreign lands, he dreamed of her words. When she spoke of eras gone by, he imagined himself travelling back through time.

"In turn, he confided in her his greatest desires. More than anything, he wanted to be wealthy enough to see the places she spoke of. He wanted to collect the pieces of history she recalled so vividly. And above all else, with his wealth, he wanted to change the world.

"The demon agreed to help him. She saw that his mine yielded an abundance of useable material, and she agreed to spare his workers, staying hidden while they mined. In return, she asked two things of Lehmann: firstly, that he would continue to visit her whenever he was not travelling, and secondly, that he would give her a mirror of her own as a keepsake. He agreed, and within the year, Chroma Company was on its way to being one of the most successful metal suppliers in the country.

"And Lehmann was on his way to becoming one of the most well travelled people he'd ever heard of. He travelled to the Orient and to the Middle East. He saw Africa's deserts, jungles and plains. He visited Europe and Australia and the South Pacific, and in each nation he purchased keepsakes of his own, amassing quite the collection of rarities and antiques; and in each nation he purchased a mirror of some fashion, to remind him of his true love in the mine.

"But as he travelled and the company expanded, Lehmann had less and less time for the gorgon. His visits grew sparse as he grew less fond of the pit. And while it seemed he was beginning to forget their bargain, it can be safely asserted that she had not.

"When he finally came calling for what would be the last time, she was quiet and distant but she did not question him, and he did not offer any excuse for his absence.

"'I have left the mirror for you,' she said from her dark lair.

"Lehmann saw it lying atop a large stone that had once been a man. 'But it was my gift to you,' he said to her.

"'And it has served me well. But a new day has come for us, my love, and it is time for you to take it back.'

"And so he did. He bid her farewell with an empty promise to return, then left the pit and did not look back.

"You'd think he would have been smarter than that," Etta said quietly, as though he might hear her. "To scorn a woman is hell enough, but a demon?"

"Yes, well, she was scorned all right. You see, mirrors were always safe; they were the only way he could look at her without turning to stone. But that was only the case if she did not look directly back into the mirror, something that Lehmann did

not know until he peered into the cursed mirror she'd sent home with him. He saw her reflection there in the glass staring back at him with a vast coldness and he knew then that his days were marked."

"Why didn't he turn to stone right then and there?"

"That was the nature of the curse. But it didn't end there. Her reflection spread to the other mirrors like a disease. He smashed them at first, but she did not go away. Instead, there were just that many more images of her glittering all around him. So he gathered up the rest of them and threw them into the mine."

"And never bothered to warn our men—"

"I imagine not."

"And now they are slowly turning to stone." She wasn't asking. She was saying it aloud to see if it felt any more real. It didn't. Then she asked me, in a most emotionless voice, what had happened to Lehmann's arms and legs.

"I had to amputate them. Well, I suppose I didn't *have* to, looking back—but before I understood the precise nature of the sickness, I thought I could perhaps stop it from spreading if I removed the affected areas. It's a pity I had to put him through all that unnecessary pain."

"Is it?" she asked as she stood up, approaching the bed. "Why is it different for our husbands? Why is it happening from the inside out instead of the other way around?"

"Because this is Lehmann's curse. Your husband and the others were merely at the wrong place at the wrong time. And believe me when I tell you, the way that Lehmann's suffering is far worse. Your men will go quickly," he looked to his charge, "but he will not."

She left me then, and I did not hear from her again until several weeks later, when she arrived with a cavalcade of wives and children. I met her at the tower gate once more and she told me that the men were all dead, turned to stone. They'd gathered their belongings and set fire to their homes. She pointed toward the east and there, beyond the hill, I saw several great plumes of black smoke rising to the heavens.

"I don't know if the bodies will burn to ashes in the state they are in," I offered, trying to sound sympathetic.

"We considered that. If they do, they do. If they don't, then let that land be their gravesite. They will act as their own monuments. We have no more use of this place."

"So you've come to say goodbye?"

"No, we've come to end what Lehmann started. Our beloved husbands became prisoners of their own bodies because of his greed. And he's had you imprisoned here in this tower, whether you know it or not, since the day you arrived. But there is a whole world out there that is alive and breathing and made of flesh and blood, Dr. Young. We've come to free you."

"But I cannot go. Not while Lehmann is still alive."

"We have a solution for you, Dr. Young."

And with that the crowd swarmed around me, pushing me away from the entrance with such force that my feet did not touch the ground as I was dragged to the fence and restrained there with ropes. I watched helplessly as several of the woman entered the tower and I was powerless to stop them as they returned some time later carrying Lehmann, still entwined in a piece of the chrome cradle as though he were a prince travelling in his litter. Tubes and cords trailed behind the horde as they carried him in silence, their faces like stone, down the path to the mine.

I struggled with the ropes and eventually broke free, but not before the wives of the Chroma Company released the dying remains of Klaus Lehmann into the shaft.

They waited a moment, until Etta Parker said it was time to go.

I asked her why she wasn't going to seal the mine.

"Because no one will be coming out. And I know you won't go in. No matter how badly you might want to."

"And how do you know that?" I asked, vaguely insulted.

"Because Klaus Lehmann was a man who took risks. You, Dr. Young, are not."

And she was right. As she walked away with the twenty-nine other women and their children, I knew she was right. There was an entire world of things I never thought possible at the bottom of that shaft, but I would never know them.

And as the man I admired waits for his last days to come in a tomb and in the company of his demon, I have returned to the safety of the tower, a prisoner of my own making, where I wait for my last days to come, alone and with a heart like stone, living vicariously through the journals of a man who was not afraid of the world.

Donna Lynch is the singer and co-creator of the band Ego Likeness as well as a dark fiction writer. Her first novel, Isabel Burning, will be released in 2008 by Raw Dog Screaming Press. She currently resides in Baltimore with her husband, artist and musician Steven Archer.

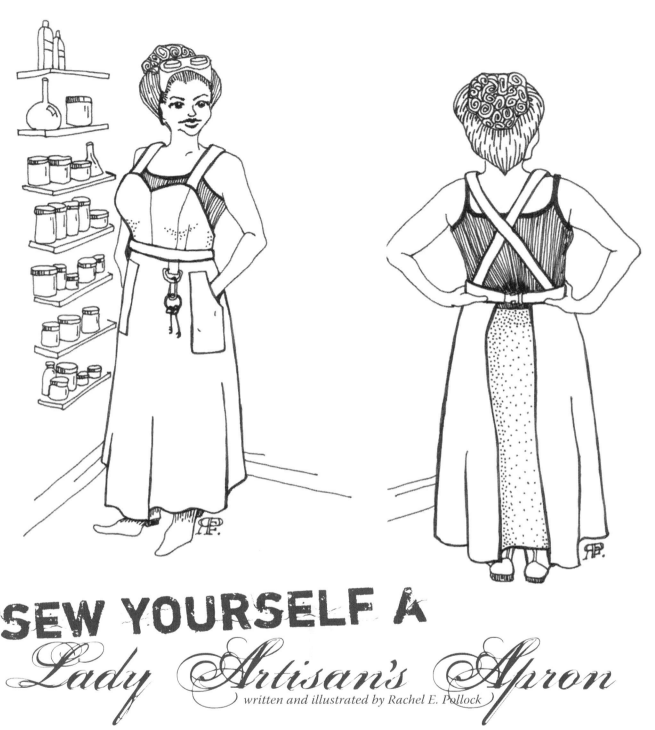

SEW YOURSELF A
Lady Artisan's Apron
written and illustrated by Rachel E. Pollock

Any female who's worked in a lab, workshop, or kitchen can probably go on at length about how much standard-issue bib aprons for any purpose simply don't function for the female form. They are never designed to actually accommodate a bust curve, so they either don't adequately protect your chest area from splashback, or you look like the broad side of a barn. Or both. While I'm not the sort of woman who feels like a fugly waste of space if I don't have a full face of makeup on and cute shoes, wearing utility aprons has always been—for reasons of their design/construction—a necessary evil. But I asked myself: why? Why not instead create a flattering apron, where form follows function follows form? Why not make myself an apron I would be happy to wear all day long, day in and day out?

So, I decided to create my ideal work-apron: a bib style with a full 5-gore skirt modeled on the Edwardian walking skirt, of which the bib is actually both princess-seamed* and bust-darted so it curves *around* the boobal area.

The diagram to your right shows you the basic shapes for your pattern and how to draft them. You need five of the trapezoid shape on the left for the skirt of the apron, and two each of the other two shapes for the bodice. For the smaller-busted lady, you may eliminate the dart and just distribute any necessary fullness with the princess seam. I've got some vague

guidelines on there for how to figure out your measurements on the skirt, but for the bodice, ladies are such drastically differently shaped on top, I am showing you here the basic shapes that the pieces are, and you'll have to fiddle around with some crap-scraps and fit them to your own torso. An alternate means of doing this is to take a bodice pattern that fits you well, trace it off and draw your neckline wherever you want.

The measurements/formulae above make a floor-length apron (the extra 2" give you seam allowance at the top and a generous turn-up for your hem), but you can adjust it shorter as you wish. I made mine ankle length. As for the bottom of the trapezoid, that's somewhat contingent upon your waist-to-hip ratio and how full you want the apron to hang. You may need to fiddle with the dimension to get it how you want it. I used a measurement of 15" on mine.

You can either use wide belting by the yard for your waistband and shoulder straps, or cut widths of your fabric however long you desire. You can also add patch pockets wherever you wish on the apron's skirt. I added two. Other features include a D-ring at the waist for clipping work keys to it, a D-ring on one of the straps (also for clipping tools and other items to), and a pen-loop (since a pen-pocket is pointless on a bust curve).

The 5-gore skirt portion creates a lovely, flattering line, but is also extremely functional, as it protects almost your entire lower body, front and back. The only opening is the small gap at the very back where the apron waistband connects. It doesn't tie like a traditional apron; it buckles together with a tension-clip buckle—like on messenger bag flaps except bigger—so you can put it on swiftly in one quick motion.

This design can be altered to serve a number of different purposes. If you want more upper-body coverage, you can eliminate the sweetheart cut of the top and create a more traditional straight-cut bib neckline. If you intend to use the apron for dyeing or painting, you may wish to make it up in vinyl or neoprene to prevent soak-through. More pockets, cargo pockets, a hammer loop, anything can be added that you might foresee you would need.

*A princess seam is a seam that runs down the length of a bodice or dress, starting either in the shoulder seam or the armscye (seam where the sleeve is set in) and ending either at the waist for a bodice—like in this apron—or at the skirt hem if it is a princess-seamed dress. The princess seam replaces darts and results in a more flattering line for a curvy female figure.

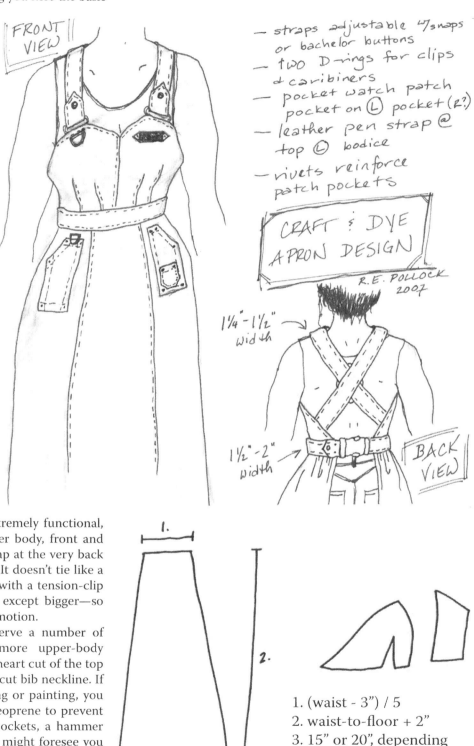

FRONT VIEW

- straps adjustable w/ snaps or bachelor buttons
- two D-rings for clips & caribiners
- pocket watch patch pocket on L pocket (R?)
- leather pen strap @ top L bodice
- rivets reinforce patch pockets

CRAFT & DYE APRON DESIGN

R.E. POLLOCK 2007

1¼" - 1½" width

1½" - 2" width

BACK VIEW

1. (waist - 3") / 5
2. waist-to-floor + 2"
3. 15" or 20", depending

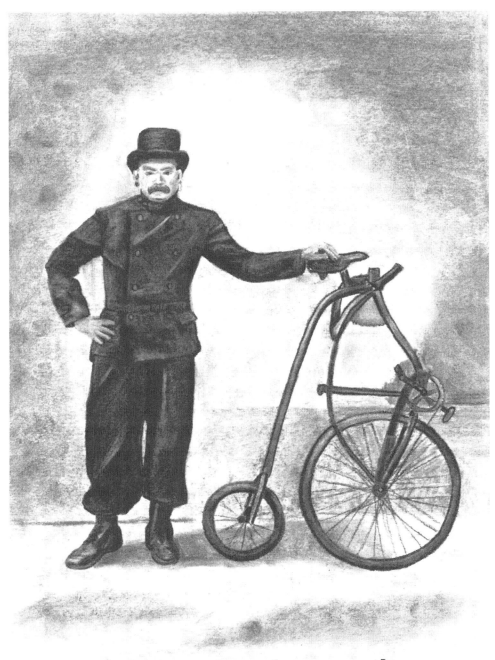

[the author and subject of the article pose together here in a drawing by one "Rachel"]

> "I call my bike Winifred, because once a hipster said to me, 'That's it, you win. You win the game of bike.'"

THE PENNYFAKETHING
the steampunk's bicycle of choice
by Johnny Payphone

What modern appreciator of 1800s technology hasn't admired the pennyfarthing and thought that they'd like to own one? This style of bicycle—called an Ordinary—dominated bicycle design in the late 1800s. The large wheel allowed the rider to go fast, and the height was quite natural in a time of horseback and carriages. Eventually, though, the "dwarf safety" (modern bike) was invented and the Ordinary fell out of favor, owing to its many flaws: a tendency to pitch forward, the inability to touch one's feet to the ground (and thus come to a stop), fixed pedals, and a somewhat bumpy ride.

Vintage Ordinaries can run into the tens of thousands of dollars. Modern reproductions are available but are relatively costly for a bike that is basically a novelty. Given the inherent craftiness of the steampunk, it is only natural that we should make our own.

Sometime around 2002 a Minneapolis bicycle club called the Scallywags decided to build pennyfarthings and become a pennyfarthing gang in order to one-up the local tallbike club. They told me that after one ride on the thing, they decided to go with tallbikes. Ordinaries are quirky, to say the least. They can be ridden as your daily ride (my friend tows his kid in a trailer) but you have to be dedicated to the idea of mastering an entirely different vehicle. Still, with a little bit of period clothing, you will bring a smile to the face of every person you pass.

After a few rides (and a few falls) I wanted one. The problem was—where to find a large wheel? Then somebody showed me a picture from Marin County of a bike that was essentially reversed, so the rider sat on the fork and rode backwards. This gave me an idea—why not just set a bicycle frame upright and use it to replace the large wheel? Given the time and breadth of the bicycle's existence, I am sure that I'm not the first person to do this. But some of my other bike club friends started making them, and the design came to be known as a 'pennyfakething'. It is my unique position as a member of both steampunk and mutant bicycle circles that allows me to introduce this design to you. I would be delighted if it became the steampunk's bicycle of choice and I encourage you all to try to make one. It is a DIY punk twist on a Victorian classic. All of the danger of the original with none of the authenticity!

MATERIALS:

The beauty of this design is that it only takes one bike. Beach cruisers work best because they have big fat wheels and cushy seats and coaster brakes; I recommend a teardrop or cantilevered frame (for looks). You can use a ten-speed and have gears and brakes but I feel the simplicity of a single-speed bike fits more into our aesthetic. Find your bike in a basement or at the dump, in a pinch you can buy one from a second-hand store.

Other materials: One small front wheel. Get the strongest little kid's bike wheel you can—avoid those 8-spoke ones or the ones with latex bearings. This wheel is going to take a lot of weight. You'll also need the matching front fork.

One piece of pipe for the armature. I bent mine with a hand bender (get a muffler shop to do it for you). You could also use any other number of materials (another bike frame, two pipes in an L, etc). Just make sure it's going to be big enough to take your weight. I used a fence post.

STEP 1:

Chop off the head tube (with a little bit of stub) and insert the front fork into the frame. You may have to trim your fork blades or bend your frame a little. Alignment is going to be important here. You want the frame itself to be vertical—pay attention to where your feet will go; you don't want them too high up compared to the seat (or else you'll need a back rest to pedal), yet if they're tipped too far forward your weight will not be behind the front wheel. You're going to have about an 18 inch wheelbase here, so the options for your center of gravity are pretty limited—let the bike tell you where to be. Align the head tube perfectly straight left-and-right, but raked backwards about one degree. This is Secret #1 that I learned from an old pennyfarthing maker that greatly improves the steering.

You may wish to gusset this weld. I've also added a little extra top support so that my head tube is connected on both sides (that joint takes a lot of stress). The bolt allows me to take it apart and service the bearings.

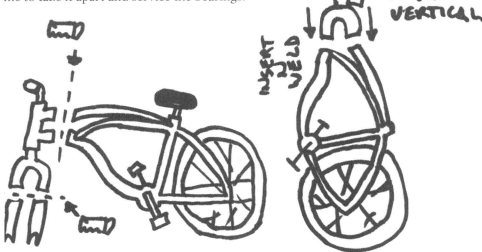

STEP 2:

Bend your armature and attach it to the head tube, aligned perfectly with the bike left-and-right. You will need to weld the fork into the end of it, so maybe you would like to do that first to get an idea of the length. The placement of the rear wheel will greatly affect the bike's handling! Secret #2 is "tuck". On an Ordinary the rear wheel is actually tucked under the curve of the larger wheel, giving a tighter turning radius. Sometimes you will need to turn very sharply to stay on this bike! If the bike is long, it will turn like a barge and you won't be able to do the rapid right turn that is the savior of all pennyfarthings in traffic. The smaller the rear wheel, the better, but it's hard to find quality wheels below 12" (I guess you could use a wheel off of anything).

STEP 3:

ATTACH THE SEAT post right at the point on the armature where your weight is between the two wheels. I just welded mine on but if you wanted to get fancy you could use a seat tube from a bike and make the post adjustable. Then, take the handlebars and flip them backwards, mounting them on the frame below the seat (sit in the seat to find the most comfortable location for your hands—you should dangle your arms, not reach downward). On my first pennyfakething I had them up front (upside-down for that mustache look of course). But every time I hit a bump I'd fly forward and the handlebars would catch my legs and I would land on my teeth and scrape my shins. I think I know why these things were banned in some cities once the Safety was invented.

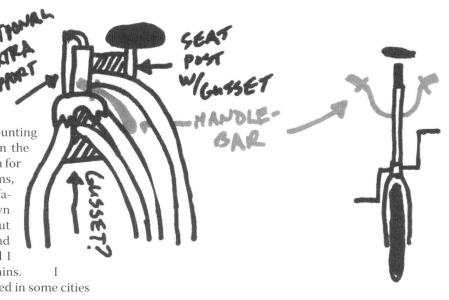

So I mounted my handlebars underneath, and discovered a curious phenomenon—I didn't need my hands at all! You kind of steer with your feet and butt. The handlebars are there for difficult riding but in general they are optional. I can take off my coat, drink tea with a saucer, polish my monocle, do anything I need to while riding. If I were to fall, I'd fly off the front and land deftly on my feet.

The handlebars also serve another function—as a limiter. Secret #3 is that pennyfarthings have a head tube limiter that keeps the front wheel from turning too far. I found out why—once the wheel turns more than about 40 degrees, the entire dynamic of the bike changes, shooting the front wheel backwards and to one side. The handlebars hit the armature and prevent this from happening. If your handlebars don't work this way, you can cut a slit in the head tube and weld a bolt to the fork's steer tube.

Originally I used a handlebar stem and bolted my bars into it, but eventually I just welded the bars to the frame for strength.

THE MOUNT:

FIRST, CLIMB ON something and get the feel of this bike. Become comfortable riding it before attempting a rolling mount. Get used to leaning forwards and backwards to adjust your center of gravity when traversing bumps or grades. The mount is a bit like escaping from handcuffs; step on the peg, give yourself a good push, and throw your opposite leg over the handlebars as you let go with that arm and reach under your leg. Then get yourself situated in the seat. After you've found your balance, bring the remaining leg around and reach under it as well. Stomp on the pedal to keep your inertia and away you go! I've ridden mine thousands of miles and in NYC traffic. You can even give someone a ride on the peg. For a video example of the mount, please see http://www.youtube.com/watch?v=lQH_2kz1H3o

STEP 4:

A FEW FINISHING touches. Cut a small pipe for the mounting peg, and another to match it. The peg goes on the rear armature anywhere you feel comfortable with. The other one goes on the bottom bracket and will function as a bash guard to protect your chainring the first time you try and ride it and it falls forward.

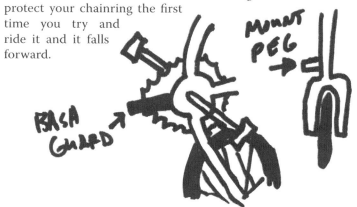

POST-SCRIPT:

YOU COULD, IF you think about it, leave the bike in its original position but chop off everything fore of the pedals, and make a short version of this bike. It would be much more accessible but wouldn't have that Ordinary look.

If you decide to go for the big wheel after all, look for a high-end tricycle with cottered cranks. This will give you the fixed hub you can build up to a wheel (try a round clothing rack), and the crank arms can be replaced to fit you.

" By the time John got to the elevated tracks, they were obscured, like mountains, by clouds of steam. He knew enough about trains to know they must be idling; the grey columns rose then fell, a revolt against the stopped locomotive. It almost pained him to see an engine made for movement contained, trapped like a captured tiger.

Unbound Muscle
by The Catastrophone Orchestra

May Day, 190?, New York City

NEAL PACED IN THE GLOOM OF THE CATASTROPHONE Orchestra's flophouse/free clinic, careful not to ash his cigarette on the wheezing patients who crowded the floor. He had already mopped up the vomit and the blood and tossed it into the gutter last night; today was May Day and he wanted to get an early start. Usually, no one stirred in the clinic before noon, but the Catastrophone Orchestra was playing this afternoon and a few members of the band were already awake.

Covered in soot, Pip looked like a reverse raccoon with his welding goggles hanging around his neck. He was swearing at the reflecting brass tubes of the Catastrophone, the main instrument of the orchestra, as it hissed out steam and drooled boiling water.

The Catastrophone was an implausible instrument, born from the depths of Pip's brilliant mind back when he was still liberating steam engine parts from various under-protected railroad depots. Unfortunately for the orchestra, Pip's skills seemed better adapted to quick disassembly and creative fabrications than the delicate balance of realignments and mechanical assembly; he tended to rely on Neal's brawn when his technical knowledge failed him, which was more often than not. The Orchestra's instruments were more imaginative than functional at times, often leading to explosive effects.

Professor Calamity lay on the faded burgundy chaise lounge, absently kneading his ex-patient—now lover's—frizzled hair, while dreamily watching Pip's fruitless attempts to get the machine working.

"It would seem our poor instrument is a bit under the weather. I do not believe she is supposed to be spitting like an Arabian camel?" the aging alienist sang over the deteriorating B-Flat that oozed from of one of the dented tubes.

"It's the copper crowns. They're not holding their seal. When Mathilda plays her solo, we could lose the whole machine," Pip said, wiping the oily water onto his thick rubber apron.

"Good thing we are not artists. We are simply terrorists who use art." Calamity trailed off, staring at Mathilda's twisted strands.

Mathilda stood up, disentangling Prof. Calamity's hand from her chaotic tresses, and glided towards her instrument. In her dark mourning dress, she looked every bit the dark wraith, purring affectionately as she caressed the heated brass tubes.

"She's fine, she'll play nice this afternoon," Mathilda whispered, pinning Pip with her unsettling, maniacal stare.

"She's not fine. She'll blow, I tell you! I need more time to make adjustments. You'd be crazy—" Pip stuttered.

"*Crazy?*" she spoke, the word dripping venomously from her tongue as she slid towards Pip.

"Oh, this could get interesting," Calamity murmured, looking for his syringe.

"I'm sorry, Mathilda, but this machine is unstable. I can put a binder on those tubes and that might be enough—"

"Corset my machine with your wires? I would prefer to destroy the entire audience than let you— You are afraid of her power and freedom. Never!"

Soon "Screaming Mathilda" lived up to her moniker. The consumptive and opium-sick patients on the floor were awake and making a clumsy but hurried retreat out of the fifth floor walk-up.

"Neal, could you please—" Calamity begged, waving in the direction of Pip and Mathilda, and then pulling one of the threadbare pillows over his head as he gave up the search for words.

Neal shook his head, his freshly-dyed mohawk bobbing; he had played this game at least four times in the past week already. It was always the same: just before a performance everyone got on each other's nerves. They were like a family; they loved each other but still fought every Thanksgiving as they sat around the table.

Any other day Neal would have enjoyed the show but that day he was already late. He moved to intercept Mathilda as she chased the retreating Pip through the clinic, their jabs and ripostes knocking over vials and tools along the way. Neal's powerful scarred arms encircled Mathilda.

"Mathilda, the Doc is sick. Look what you're doing to the poor bastard," Neal said as he released the banshee.

Mathilda rushed to the moaning professor and started snuggling against him, whispering in soft, Slavic tones.

"Neal, give me a hand with those binders," Pip asked, composing himself and grabbing a tangle of filched wire.

"It's May Day, do it yourself. I'm going to check out Tompkin's Square," Neal answered, grabbing his ax handle.

"I guess we'll meet you there for the recital, if I can get this thing working. Be careful," Pip cautioned.

"That's not the point."

"I HEARD FROM MOLLY THAT FLYNN GOT WORK at the Astor Hotel," said Theresa as she flipped the bread in the cast-iron skillet.

John Henry rose from his chair at the table and moved to his wife as she pulled the last of the milk from the pigeon-covered windowsill of their of railroad tenement.

"Let's not discuss this now. It's May Day."

"To hell with May Day, John. What are we going to do? You need a job," she said, her voice breaking suddenly, overcome with desperation.

"I *have* a job. And when this is over we'll all be better off. We just need to see this through. They can't hold out for much longer. The produce in those hulls is already starting to rot, and the bosses are losing their shirts with this strike. Just a little longer. Even the mayor is even on our side."

"I don't care about the mayor. Is the mayor going to put bread on our table? We're your family, John. We deserve better," she pleaded, taking his thick hand in hers.

"I'm doing it for our family. What kind of man would I

be? I'm not one of those damned scabs. Someone needs to walk the line or we'll all just be slaves forever. Someone has to fight. You *do* see that, don't you, darling?"

"I'll tell you what I see, John, every morning when you're on the line. I see your son unable to brush his teeth because his gums bleed too much. I see your daughter without shoes that fit her feet. I see the corner market with less and less in the stands and even less on our own table. I see so much John— our family has seen too much."

John couldn't argue when his wife was like this; anything he said would just make her angrier. But he was angry too.

He burned at night with anger at those who smoked cigars at Gramercy. He wore his hate like a blanket on the cold mornings on the picket line, keeping the scabs from stealing food from his children's mouths. His misfortunes did not blind him; they lit the way to a new and just dawn. These thoughts circled around in his mind, and it killed him that he could not express them to his wife. He had always prided himself on the fact that a real man showed his integrity through his *actions*, leaving fancy words to Tammany Hall. John grabbed his red flag and left his meager breakfast.

His mind was on all the things he wanted to tell his wife as he bounded down the six flights of soot-black stairs to the street. He wished she had accompanied him to the Henry Settlement when Lucy Parsons had set the crowd on fire by speaking of revolution. All those speeches in the smoke-filled halls had made him realize that it was a real war they were fighting—a war between the workers and the exploiters—and he was proud to be a soldier on the right side. John was remembering these speeches when he stumbled on a wino passed out at the bottom of the dark stairs.

John crashed hard on the broken tile of the landing, and the stinking bum on the stairs only registered the incident by turning over and pulling his ratty coat over his grizzled face. Pain flowed into John's leg as blood trickled from his skinned knee. Every day there were more and more drunks in his neighborhood—not just the discarded veterans but also good hard working people who could no longer face the daily humiliations of crushing poverty. He would never be one to hide at the bottom of a bottle or on the tip of a needle; he would fight for himself, his wife, and all the other honest people.

"Hey, Johnny Boy, you alright?" Flynn—John's neighbor—was coming home from his job as a bellhop and reached out his white-gloved hand for John. John stood up, refusing the hand, and brushed the dirt from his torn pant leg. Uncomfortable, Flynn reached down and retrieved the red banner.

"You know, it's not a bad job. I know some of the fellows at the hotel. I can get you an in. No problem, you helped me and Molly when we needed it. I wouldn't mind at all," Flynn rambled, staring at the banner.

Flynn was a good man, and he had been a decent friend on the docks. Strong back and quick with a joke. *Now he can't even look me in the eye*, John thought to himself.

"What are you doing, Flynn? You look like a goddamn organ grinder's monkey in that getup," John said, looping his hand under the man's new leather belt that creased his chest.

"The hotel pays for half the uniform."

"What? They make you pay for your own collar? Take that foolish thing off and I'll wait for you," John ordered, releasing Flynn and shaking his head in disgust.

"What?"

"It's May Day. The rally at Tompkins begins at noon," John answered, pointing to the banner that Flynn still clutched.

"I worked a double and the baby has been crying— maybe I'll catch you over at the Lion's Den afterwards. My treat, 'k?" Flynn said, moving to climb the stairs.

John snatched the banner back and left the tenement. John had once heard a speaker at one of the labor halls say, "Time flows backward here in the Lower East Side; we are now again living in caves. But this time we also have to pay rent." John could never shake that image from his mind.

The tenements were cold in winter, stifling ovens in summer, and were firetraps all year around. The buildings had been constructed hastily by New York and Boston land speculators to profit from the endless influx of desperate immigrants. It was the first time in the United States that housing constructed specifically for poor people had been designed and paid for by the rich. The apartments maximized square footage on the split lots in the Lower East Side; windows, walls, air shafts, and coal chutes were sacrificed in the quest to cram as many souls into them as possible. And, of course, to generate as much profit as possible for the owners. Even the crowded and smoke-choked alleys of the neighborhood seemed life-sustaining in comparison to the lightless mountains of hovels that made up tenement living.

John limped to the only park in this part of the city. The regular May Day crowd half-filled Tompkins Square. John pushed through a throng of long-coated Jewish anarchist tailors. They were pointing to an article in one of their newspapers and arguing loudly in Yiddish. A barefoot blond boy with an oozing sore on his temple was passing out a flyer about child labor in the mines of Pennsylvania. John Henry could tell from his accent that he was one of the Welsh hillbillies from the Appalachian coalmines. He took the boy's flyer and stuffed it into his coat pocket, then unfurled his red banner and moved towards the stage. Hundreds of red and black flags hung in the windless morning like wet towels on a clothesline.

A red-faced man shouted into a megaphone, gesturing wildly as he spoke. The man was a representative of Tammany Hall, pitching some candidate and promising everything from jobs to the moon. John turned away from the stage and surveyed the park. He could remember May Days when both avenues girdling the park had been filled with workers, when a fierce and defiant sea of red flags had stretched all the way to Broadway. He wondered what had happened to everyone, but he only needed to look to his left, at the cops lined up on horseback, to find an answer to his question.

John had been at the great May Day riot three years earlier. The city had had only one police force back then and they had attacked the May Day procession with clubs and the butts of their rifles. They had had a legion of Black Mariahs lined up on First Avenue to take protestors to the Tombs.

He had fought alongside anarchists, socialists and freethinkers as well as his communist comrades. Together they had smashed back the police; they could've stormed City

Hall if they had wanted to. He wished that they had; maybe things would have changed then. In the years that followed the riots, the cops—and sometimes the State's militia—had pounced on the protestors before the first speaker had come to the stage.

John had spent more than one May Day locked in the Tombs, and other people had been less lucky. Certainly, he understood fear. *But a man must still be a man*, John thought, looking over the meager crowd of hardcore radicals. Now, like the flags drooping on all sides of him, it seemed that labor had lost much of its vitality. And yet John was not depressed, because he could see his comrades from the dock waiting for the Tammany windbag to finish up his speech. "Seven-Foot" Sean Sullivan was already looking through some notes as he towered at the back of the stage. Other May Days might have had riots and more people, but this one had a real strike, a strike poised on the verge of winning. The largest strike the city had ever seen. John respected Sullivan; he had heard him speak many times. John knew this once-scrappy Black Irishman could unify the crowd in support of the dockworkers. John forgot the throbbing in his knee and the emptiness in his stomach, for he knew that Sullivan could transform his pain into strength and nourish his soul.

Even the pugnacious laborers from the Brooklyn Brewery moved out of Neal's way as he pushed through the milling throngs in his war-leathers and fierce red Mohawk. Those idiots had just booed the famous insurrectionary anarchist Johann Most when he had started to preach about "propaganda by the deed," extolling the example of an illiterate Italian shepherd who had shot at the ridiculously obese Italian Queen Helene. Most was the kind of man Neal would have actually listened to, and if he hadn't been late leaving the clinic no one would have booed, Neal thought to himself.

Neal was quickly bored by the droning speeches and decided to check out the band shell on the northern end of the park where the Catastrophone Orchestra would be playing later—assuming that they actually show up. Neal was trying to figure out which way the future crowd could run if Mathilda's instrument exploded on stage when a group of Metropolitan police swaggered up to him. He was away from the crowd and the cops had noticed him with his ax handle.

"Hey, buddy, you can't have that here," the top officer barked from his drooping mustache, pointing at the wood handle, as one of his partners spun a hickory club.

"I'm sorry, I can't hear very well. A copper like you busted my ear drum awhile back. Come a little closer so I can hear what you are flapping about," Neal said, slapping the oak handle in his leather covered palm.

The cops slowly started to encircle Neal.

"Which of you has a cigarette, so I know who to put down first? I need a smoke," Neal said smiling. *It might be an interesting May Day after all*, he thought.

Before the cops had decided who was going to try to disarm Neal, a pile of steampunks swarmed up to him. He knew one of them, a skinny girl with unfortunate green dreadlocks; at one time she sported a nice, deep-purple mane.

"Gadget, git!" Neal said, keeping his eyes on the nervous men in blue.

Gadget jumped on Neal, wrapped her skinny legs around him, and kissed him on his unshaven cheeks while the rest of the steampunks badgered the police for change. Gadget whispered into Neal's ear, "We got a real juicy line set up, why don'tcha come with us? 'Sides, there is a row of giddy-up cops behind the band shell."

Neal looked behind the stage to see a group of NYPD cops on horses moving towards the the band shell. They might be after him, or they might be planning on running the Met Police out of the park. Neal couldn't be sure.

"Me and my girl are going to get a drink. I'll catch you around the neighborhood," Neal laughed as he carried the giggling teenager back into the park. The cops yelled something at him as he left, but he didn't bother to hear.

Sullivan did it again, John thought as he waived his red flag in the air. The giant Irishman, a self-proclaimed "Knight of Labor," had whipped up the crowd and had carried them through the wretched conditions of the tenements to the gleaming, golden shores of organized labor. He had moved the crowd like a lion-tamer at Coney Island—calm and assured with enough hint of menace to keep everyone riveted. He was made for labor's stage and he embraced the apocalypse of the class struggle in New York. He turned to catch his breath after whipping the crowd into a frenzy and eyed the police that lined the gathering. The cops' predatory smugness had been completely erased. He took a brief break from speaking, waiting to be "spontaneously" interrupted by his brother-in-law Mikey O'Connor. Mikey nervously crossed the stage, his shirt stained with sweat. Sullivan theatrically moved to talk to him, first feigning anger at being interrupted. The crowd stood in silence watching the great man whisper with his brother-in-law. Sullivan turned from the man and crossed to the very front of the stage.

"It's my brother-in law—you know how in-laws are. Give me just one minute," he called out through his flashy smile.

The men in the crowd laughed, hanging on Sullivan's every move and word.

John had been intently absorbing Sullivan's rhetorical dreams when he suddenly found himself being shoved by a giant sporting a ragged red Mohawk who was talking to and towering over a pack of feral teens. Over the past few years, John had seen more and more of these tattooed and pierced teens hanging on the fringes of the radical political scene just as they did on the margins of the city. He had seen them throwing bricks at customers coming out of a Woolworth's store during a recently failed strike, and John had heard stories about them drinking all of the alcohol at a benefit for arrested steel strikers in Philadelphia. John was aware that some of his comrades had hoped to harness their rage into a fighting force for labor, but he still felt strongly that any real change would have to come from the people. Real people. Honest people willing to both work and fight for a just cause. These kids were just interested in fighting, and the city was already filled with people fighting each other while the rich drank champagne behind their gilded walls.

When Sullivan stopped speaking to consult with Mikey and the other men on the stage, John overheard the conversation between Neal and the kids.

A red-faced man shouted into a megaphone, gesturing wildly as he spoke. The man was a representative of Tammany Hall, pitching some candidate and promising everything from jobs to the moon. John turned away from the stage and surveyed the park. He could remember May Days when both avenues girdling the park had been filled with workers, when a fierce and defiant sea of red flags had stretched all the way to Broadway. He wondered what had happened to everyone, but he only needed to look to his left, at the cops lined up on horseback, to find an answer to his question.

John had been at the great May Day riot three years earlier. The city had had only one police force back then and they had attacked the May Day procession with clubs and the butts of their rifles. They had had a legion of Black Mariahs lined up on First Avenue to take protestors to the Tombs.

He had fought alongside anarchists, socialists and free-thinkers as well as his communist comrades. Together they had smashed back the police; they could've stormed City Hall if they had wanted to. He wished that they had; maybe things would have changed then. In the years that followed the riots, the cops—and sometimes the State's militia—had pounced on the protestors before the first speaker had come to the stage.

John had spent more than one May Day locked in the Tombs, and other people had been less lucky. Certainly, he understood fear. *But a man must still be a man*, John thought, looking over the meager crowd of hardcore radicals. Now, like the flags drooping on all sides of him, it seemed that labor had lost much of its vitality. And yet John was not depressed, because he could see his comrades from the dock waiting for the Tammany windbag to finish up his speech. "Seven-Foot" Sean Sullivan was already looking through some notes as he towered at the back of the stage. Other May Days might have had riots and more people, but this one had a real strike, a strike poised on the verge of winning. The largest strike the city had ever seen. John respected Sullivan; he had heard him speak many times. John knew this once-scrappy Black Irishman could unify the crowd in support of the dockworkers. John forgot the throbbing in his knee and the emptiness in his stomach, for he knew that Sullivan could transform his pain into strength and nourish his soul.

Even the pugnacious laborers from the Brooklyn Brewery moved out of Neal's way as he pushed through the milling throngs in his war-leathers and fierce red Mohawk. Those idiots had just booed the famous insurrectionary anarchist Johann Most when he had started to preach about "propaganda by the deed," extolling the example of an illiterate Italian shepherd who had shot at the ridiculously obese Italian Queen Helene. Most was the kind of man Neal would have actually listened to, and if he hadn't been late leaving the clinic no one would have booed, Neal thought to himself.

Neal was quickly bored by the droning speeches and decided to check out the band shell on the northern end of the park where the Catastrophone Orchestra would be playing later—assuming that they actually show up. Neal was trying to figure out which way the future crowd could run if Mathilda's instrument exploded on stage when a group of Metropolitan police swaggered up to him. He was away from the crowd and the cops had noticed him with his ax handle.

"Hey, buddy, you can't have that here," the top officer barked from his drooping mustache, pointing at the wood handle, as one of his partners spun a hickory club.

"I'm sorry, I can't hear very well. A copper like you busted my ear drum awhile back. Come a little closer so I can hear what you are flapping about," Neal said, slapping the oak handle in his leather covered palm.

The cops slowly started to encircle Neal.

"Which of you has a cigarette, so I know who to put down first? I need a smoke," Neal said smiling. *It might be an interesting May Day after all,* he thought.

Before the cops had decided who was going to try to disarm Neal, a pile of steampunks swarmed up to him. He knew one of them, a skinny girl with unfortunate green dreadlocks; at one time she sported a nice, deep-purple mane.

"Gadget, git!" Neal said, keeping his eyes on the nervous men in blue.

Gadget jumped on Neal, wrapped her skinny legs around him, and kissed him on his unshaven cheeks while the rest of the steampunks badgered the police for change. Gadget whispered into Neal's ear, "We got a real juicy line set up, why don'tcha come with us? 'Sides, there is a row of giddy-up cops behind the band shell."

Neal looked behind the stage to see a group of NYPD cops on horses moving towards the the band shell. They might be after him, or they might be planning on running the Met Police out of the park. Neal couldn't be sure.

"Me and my girl are going to get a drink. I'll catch you around the neighborhood," Neal laughed as he carried the giggling teenager back into the park. The cops yelled something at him as he left, but he didn't bother to hear.

Sullivan did it again, John thought as he waived his red flag in the air. The giant Irishman, a self-proclaimed "Knight of Labor," had whipped up the crowd and had carried them through the wretched conditions of the tenements to the gleaming, golden shores of organized labor. He had moved the crowd like a lion-tamer at Coney Island—calm and assured with enough hint of menace to keep everyone riveted. He was made for labor's stage and he embraced the apocalypse of the class struggle in New York. He turned to catch his breath after whipping the crowd into a frenzy and eyed the police that lined the gathering. The cops' predatory smugness had been completely erased. He took a brief break from speaking, waiting to be "spontaneously" interrupted by his brother-in-law Mikey O'Connor. Mikey nervously crossed the stage, his shirt stained with sweat. Sullivan theatrically moved to talk to him, first feigning anger at being interrupted. The crowd stood in silence watching the great man whisper with his brother-in-law. Sullivan turned from the man and crossed to the very front of the stage.

"It's my brother-in law—you know how in-laws are. Give me just one minute," he called out through his flashy smile.

The men in the crowd laughed, hanging on Sullivan's every move and word.

John had been intently absorbing Sullivan's rhetorical dreams when he suddenly found himself being shoved by a giant sporting a ragged red Mohawk who was talking to and towering over a pack of feral teens. Over the past few years, John had seen more and more of these tattooed and pierced teens hanging on the fringes of the radical political scene just as they did on the margins of the city. He had seen them throwing bricks at customers coming out of a Woolworth's store during a recently failed strike, and John had heard stories about them drinking all of the alcohol at a benefit for arrested steel strikers in Philadelphia. John was aware that some of his comrades had hoped to harness their rage into a fighting force for labor, but he still felt strongly that any real change would have to come from the people. Real people. Honest people willing to both work and fight for a just cause. These kids were just interested in fighting, and the city was already filled with people fighting each other while the rich drank champagne behind their gilded walls.

When Sullivan stopped speaking to consult with Mikey and the other men on the stage, John overheard the conversation between Neal and the kids.

"The whole place is wide open," Gadget said, trying to get Neal to understand. "All the badgers are here watchin' these potatoes. We can get whatever we want. Besides, it's all goin' to rot anyway."

Her crew nodded their heads in agreement. They were talking about going to the closed docks to raid the warehouses and loot whatever they could. Other desperate citizens and a few organized gangs had tried the same thing during the nine weeks of the strike, but they had all been thwarted either by the striking longshoremen or the cops who were protecting the rotting cargo. Mallard Kingston—the main representative of the shipping magnates—had told the *Herald* that "We will let the city starve before we negotiate with these working-class thugs," and the cops seemed more than willing to let Mr. Kingston's apocalyptic vision for the city become a reality.

"Come on, Neal, let's git. Nothing is going to happen. Just some boring *men*," she emphasized this word, "giving boring speeches about some future while our future is ripe for the pickin' right there in those warehouses! Come on, let's go!"

John could barely contain his anger. The working people and the poor of this city starved in solidarity with the beleaguered dockworkers, while this girl—who had never done an hour's worth of work in her life—saw only an opportunity to get something that wasn't hers. He understood that the system itself was predicated on purging all sense of morality, of right and wrong: rich people argued that it was, in fact, right and natural for them to feast while children starved in unheated tenements. No wonder these children had lost all sense of honest work and righteous struggle. He could not just stand there silently; he never could when outraged.

"Listen, listen. You did the right thing at the Woolworth store. You and your pals stood with us. We must stay together on this. I know it's hard," John said, appealing mostly to Neal, who stepped back to let him into the circle of steampunks.

"This is old. We should git before this breaks up," one of the steampunks said, pulling out a crumpled, half-smoked cigarette butt.

"It's not old, it's eternal, it's a thing called solidarity. They won't let the city starve. They can't if we all stick together. The Mayor knows this."

"Damn the mayor," Gadget spat, "we don't trust him *or* you. Neal, lets go."

"Solidarity!" John screamed, incensed by the steampunks' attitude.

"Don't yell at me," Gadget said, stepping up to John. "What you call solidarity is anything but. What have the strikers done for us? What have they done for anyone? I should starve so you can get an extra nickel a week? So we starve and you win. But what do you win? The game is rigged, pal. We are all losers, and if we got to cheat to get a decent hand, so what?"

John took a step back and put his hand on Neal's shoulder.

"You'll stay. I can tell *you* understand the need for us workers to stick together."

Neal took a cigarette offered by one of the steampunks and blew a smoke ring above the crowd. "I'm not a worker anymore. Haven't been for years. I waved the red once with your ilk, but I know the real colors of the future are going to be black and blue. That's why I'm here." Neal watched the steampunk kids moving through the crowd towards the docks.

Sullivan returned to the front of the stage. "Gentleman! Your attention please. I just heard from Mikey that those damn parasites at the shipping offices have found a way to break the strike. As we gather on this day—of all days—they are breaking the back of the strike!"

The crowd erupted with shouts of disbelief while the Tammany Hall hack discreetly left the stage.

Sullivan fought back a smile and raised his hands for calm.

"I know we have all been promised by the Mayor and his flunkies that no scabs would be brought in. The police would even stop them if the bosses tried, that old song and dance. The mayor knows we could destroy this city like we almost did two weeks ago. He knows the power of our resolution. That is why he and the councilmen agreed to the Packard Plan. No scabs at the docks. But these bosses, these blood-sucking parasites, will not be kept from their money. I tell you they have found away to break the strike without inconveniencing their friends at Tammany Hall or the Mayor during his election. They don't need scabs; they are bringing in machines to off-load those ships."

The crowd became silent and sullen. Worry suffocated the recently enthusiastic assembly as they sensed their struggle going up in a whiff of steam.

"Are we going to let those villainous bastards erase our struggle? Are we?" Sullivan knew the answer. "We can stop them. Stop them for good. A train is coming down the Highline now, bringing along these infernal contraptions. Racing right along the Hudson. But we can stop it. We can throw those damn toys right into the river and tell those fat cats that we will *not* be denied what is *ours*. Are we going to

fight? We fought the scabs, we fought the police, and we will fight these machines! To the Highline!"

The Highline was an attempt to relieve the suffering of the poor living on the far west side, which also had the added side effect of increasing the flow of commerce to the center of the city. Trains had flowed through the crowded streets on this side of the Hudson, bringing in all sorts of materials. Even the famed cast-iron pieces of the Woolworth building had wound their way from the manufacturers in Pittsburgh, screaming down from the Bronx to the docks of lower Manhattan. But the trains not only brought resources and steel; they also brought also death, injury and choking, coal-infused fog. There were so many accidents that 11th Avenue had been dubbed "Avenue of Death". In fact, there had been so many nightmarish incidents with horse-carts and elderly returning from the local "bruised" produce markets that the railroads were forced to hire West Side Cowboys to ride in front of their trains with red flags emblazoned with skulls and crossbones to hurry folks out of the way. Reformers had decided that it would be more prudent to raise the rails than to raise the living standard of the poor and so they had moved the trains high above the streets so that now only the bloodless screeches of the steam whistles filled the Avenue of Death. It was through this newest social reform that the company men had hoped to bring in their new machines to break the back of the strike.

JOHN HAD THE DREAM-LIKE FEELING OF EXITING a long dark tunnel; he had never been so clearly intoxicated in his entire life. The swill at McGurk's Suicide Bar was not as powerful or blinding as the energy of the procession heading to deliver the final victorious blow against their exploiters. John fought back the overpowering urge to run to the front and link his arms with Sullivan and the other Knights of Labor. Instead he hung back and balanced on a long neglected trashcan, causing the rats to scatter from their nests, to survey the surging stream of humanity. The heart of the great city. *The heart is a muscle the size of a fist*, he thought to himself. A fist capable of smashing through the whole rotten system. The same system that kept his son hungry and his marriage in turmoil. He was baptized by the sight of so much raw, righteous power. *Where did they all come from?* he wondered. Not daring to blink for fear that it was a mirage formed from the suffocating smoke of the city, deep in this desert of paving stones, John surmised that they must have been coming from the neighborhoods, fleeing the tenements like those ancient slaves from Egypt.

John jumped down when he saw Flynn on the other side of the street. He pushed against the human current, fearful, yet exhilarated by its power, knowing he could drown in their collective anger and purpose. As he made his way through the singing crowd to Flynn, John's earlier hostility towards the other man drained away. He was filled with the nobility of solidarity. Without missing a step, John clasped Flynn's uniformed shoulder and gave him a one-armed hug as they flowed forward. Flynn just smiled back and the two marched towards the Highline and history.

BY THE TIME JOHN GOT TO THE ELEVATED tracks, they were obscured, like mountains, by clouds of steam. He knew enough about trains to know they must be idling; the grey columns rose then fell, a revolt against the stopped locomotive. It almost pained him to see an engine made for movement contained, trapped like a captured tiger.

Though John could not hear Sullivan, he knew that the orator was inciting the men to climb the tracks to destroy the machines. John had perfectly attuned his senses with the mob. He understood without hearing, without seeing, but only by drawing from some universal feeling. He felt the will, the shackled dreams and frustrations of the people. He himself, who had so many dreams, who had listened to so many promises—he was fulfilling something close to fate as he waited his turn to climb the tracks. He shared all of this with the swelling crowd.

He was climbing above the streets, becoming eye-level with the buildings he could never fully see during his daily walks to the picket line. He could imagine those men in their platinum and amber cuff links looking out over their cognacs through the office windows at him. He could now, just this once, look them in the face, eye-to-eye, and show them what it meant to be a man—a man who knew work, who knew suffering, who knew hunger. The type of man who could look those rich bastards in the eye and spit. With one last look out at the blind eyes of the Moloch, he turned to the enemy's structure in front of him: the great and menacing machines tethered to flatbeds.

The coke men had left the train, joining their fellow workers. Rail men, seamstresses, strikers, immigrants, socialists and the rest of the heart of the city had come together, their fury unleashed. John could not deny that the machines were intimidating in their bulk and ingenuity. They had towers of scaffolding with attached pulleys that stretched out like arms from a bloated center. They seemed to be giant steel spiders, just waiting to come alive on the docks and spin their efficient webs to trap, strangle and suffocate his strike. These machines were a pure, cold menace. They were creatures of money, power and condescension. He was not enough of an engineer to understand how these few, though enormous, steam contraptions could replace the thousands of men at the dock, but he could nevertheless detect their obvious threat. All he knew was that if the bosses were bringing them in, he had to try to stop them. These machines without children, without wives, and without dreams threatened him. It was animal; he felt his spine tingle as the steel reflected the late spring's sunlight into his face.

From nowhere and everywhere, wooden levers were unbundled and passed up to the men on the tracks. The crowd was cheering, louder than they would for all the words Sullivan could ever utter. The time for rhetoric, politics and dreams was over; it was time for the backbreaking work of victory. He was proud to be up to the task. He threw his coat—the one his wife had spent two nights patching and sewing—to the crowd and put all of himself into the timber before him. The younger men slid the levers under the machines, knowing the exact point to get the most energy from the unbound muscle of man. He was not the largest,

youngest or strongest of the comrades on the pole but he made up for it with what he hoped was heart. *The heart is a muscle the size of a fist*, he repeated to himself as he strained against the coarse wood.

There was a gunshot followed by a roar. Not the cry of fear or warning but a mighty, barbaric, almost bestial call to attack. Human thunder rumbled through the streets. The men on the track turned to see the crowd smashing back a jagged line of dark blue. In the blink of an eye, a teenaged lathe operator covered in blood was being attended by a group of cooks while a group of enraged trackmen chased the fleeing cops with flagpoles and pipes. John and his comrades cheered the victorious defense and then returned to their work.

The first machine broke free from its moorings and slid silently into the slow-moving Hudson, sinking like an anchor. John only knew this because he heard the crowd two stories below him erupt in ecstatic cheers. That spurred him on. He heard someone shout in German right before the guide-wires snapped free. They split the air and hissed next to John's ear as the next monstrous contraption lurched forward. There was another cheer, and then another splash. John pushed harder when he heard a crack over the din of another jubilant cry from the crowd. The long pole to his left bent and then split. Half a dozen men working the wooden bar crashed, sprawling on the tracks. The monstrous machine seemed to have come alive, striking back at the struggling workers. Some of the less committed dropped their poles and fled from the descending shadow as the machine momentarily blocked the sun. It rocked towards John. A bearded Russian grabbed him and pulled him away from the bar. John felt the machine slide past him as it rolled away from the waiting water to the street below. The crowd, warned by those above, had made a berth wide enough for the dying steel creature to smash down onto the cobblestones. The laborers felt the street vibrate under their worn soles. The last machine had escaped the river, but perished on the street.

The metallic carcass lay shattered on the cobblestone avenue. As the dust settled, the crowd moved back in revulsion; John had a perfect view of the mangled corpses that had been hidden in the belly of this steel Trojan horse. He saw a dozen or more Chinese men submerged in gore, half in and half out of the steel shell. Most were dead, but a few struggled in the tangle of iron and smashed limbs. One man groaned as he slowly slid down a steel shaft protruding through his chest. John realized that the other machines, the ones that were quickly making their way away from the sun to the black bottom of the Hudson, held even greater unseen horrors

No one approached. All of them had seen private deaths— one couldn't help but be familiar with death in this city—but this was something different. A difference in degree and obscenity. The knowledge that a hundred or more men lay trapped in airless machines hidden from view, unaware of their fates. Men like John who had only wanted to find work. Men with families, wives, and children. Men who harbored secret dreams and now even their screams were silenced beneath the quiet flow of the Hudson—silenced except in John's imagination.

He watched the crowd begin to dissipate, like fog on a summer morning. They had arrived unified, but now the masses slunk away alone. Each left to understand, rationalize and deny their role in the disaster.

John numbly climbed down from the railroad tracks. By the time he and the others had descended, the streets had been emptied of the living. He looked for Sullivan but he had disappeared with the rest. John was alone, again.

A RED-HAIRED POLICEMAN HAD GADGET IN A chokehold with his hickory club. She continued to struggle, refusing to let go of the sack. Neal looked around to see if there were other police; it wouldn't have scared him off, he just wanted to know what to expect. Seeing none, he attacked the cop with brutal efficiency. The officer melted into a bloody mess under the rain of blows from Neal's ax handle. Another notch to add later that night.

Neal grabbed the sack from the still gasping Gadget and turned to walk away.

"What gives?" Gadget cried out after Neal, stepping around the beaten police officer.

He felt no need to answer.

AT THE BAND SHELL, NEAL LOOKED INSIDE THE bag; it was from the South Pacific and filled with oranges. He felt the sunshine as he allowed the juices to drip down his chin. He had returned to Tompkins, wondering if the Catastrophe Orchestra had ever shown up. Unsurprisingly, they were not there. Almost no one was there. Sitting on the band shell stage, eating his oranges, he saw John, coatless, trudging across the park. Neal barely recognized him.

John was still gripping his bright banner, but all the color had drained from his face. He looked broken, like a piece inside him no longer fit.

Neal had come across the smashed machine and the human carnage on his way back to the park. He realized that even though it was early afternoon, the day was over.

John recognized Neal from earlier, and approached him. He couldn't bear to bring home what he had just seen. He needed to shed a little of the load.

"Did you see it?" John asked.

"Yeah, I saw most of it," Neal said, tossing a spent orange in the general direction of a trashcan.

"It was— We were doing something—" John stuttered, staring at his ripped trousers.

"Yeah, you guys sure did something alright," Neal said, rubbing his sticky hands on his leather pants.

"No. I mean— it wasn't meant to be like that. We were—" John said, trying to capture his thoughts.

"How the hell did you think it was going to be?"

John wanted to answer the smiling giant but couldn't. He just stared at Neal and then turned away.

"Hey buddy!" Neal bellowed.

John turned just in time to catch an orange.

"For your kid," Neal said as he got up and walked away.

Behind him, crumpled leaflets were swept up by the warm spring breeze that blew through the empty park.

We learn by way of this seasonal a bit of the nature of honeyed words and hasty actions. When John joined the jubilant, angered crowd, he gave little heed to his own reckoning and autonomy.

The Steampunk's Guide to BODY HAIR

illustration by Nick Kole

You can trim, shave or grow your body hair. You can trim, shave or grow your facial hair. Only the brainless clods who buy (quite literally) into conservative mainstream culture need to concern themselves with such antiquated concepts as rules for gender presentation.

Whether it is a dashing, effeminate man in high-heeled boots, sporting a slight mustache and wielding a rapier as he boards the enemy's ship; or a full-bearded scholar who pores over tomes in the skirt of a monk by day and dances in ball-gowns by night—Whether it is a woman in her sleeveless apron who pounds iron against anvil or bakes in a stone oven with her hairy armpits exposed to the world; or a dashing, effeminate woman in high-heeled boots who also wields rapier to foe while sporting a slight mustache—Our concern is liberty. Liberty to shave, to not shave. To glue hair to our faces or grow quite full what nature has endowed us with.

BODY HAIR:

There is unfortunately little to say in the regards of the growing or shaving of body hair, except to note that people of all genders ought to feel free to do either. Consider getting yourself a non-disposable razor, however, if you are inclined to shave. They are significantly cooler than disposables.

FACIAL HAIR:

Growing facial hair, for near half of us, is the easy part. Sparse or thick, dark or light, facial hair just seems to sprout out of our faces. Only a couple of things need be noted about the growing of facial hair:

Contrary to popular supposition, the act of shaving does *not* increase thickness of new growth. What happens is this—hair is thicker at the base and wispier near the end. When you shave, you cut off the hair near its thick base, which then grows out, leaving thick stubble. New hairs grow in over time, replacing the ones that had been cut, and the end-result is a beard of unchanged thickness. This said, someone who shaves often would grow a scratchier beard for a little while until they allow the beard to return to its natural state. And a scratchy beard is often a poor thing to inflict upon a lover.

The most difficult time for those who intend to grow a mustache fit to curl is the awkward period when the hair is long enough to bite by accident but too short to effectively keep brushed to the side. The only advice I can offer is: soldier through. Brush your whiskers to the side before each bite of sandwich, if necessary. It will only be weeks until this problem is behind you, and your mustache will be all the stronger for having persevered untrimmed.

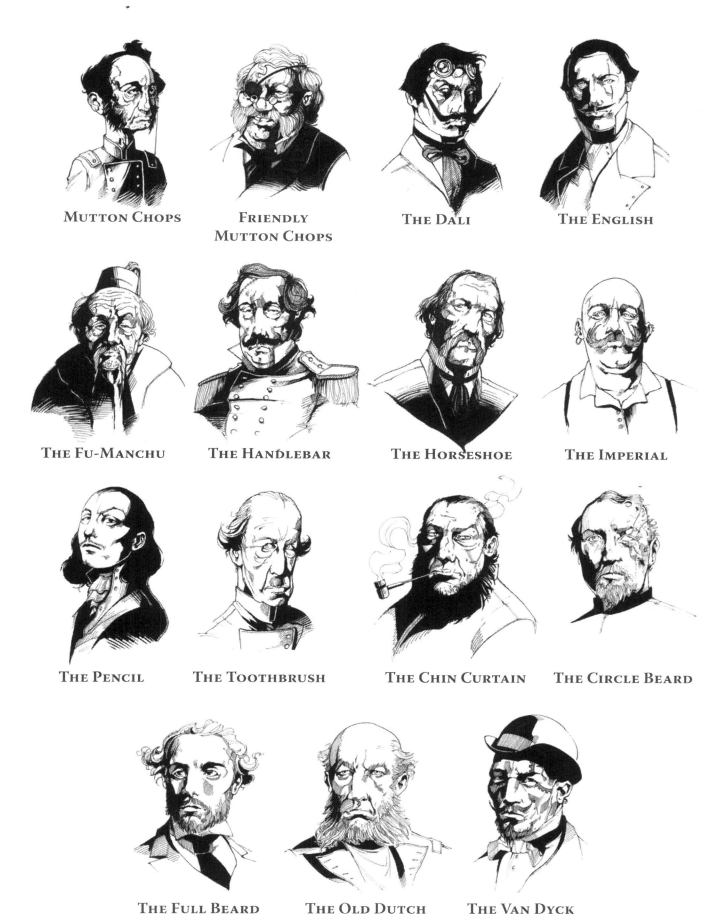

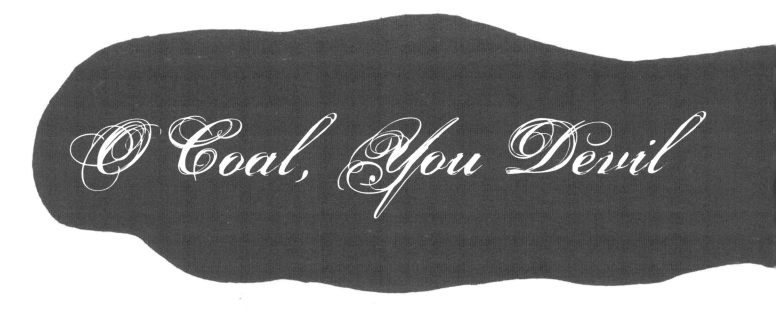

O Coal, You Devil

A REMARKABLY BRIEF & INADEQUATE HISTORY OF A SEDIMENTARY ROCK THAT WE TORE TO PIECES AND TOSSED TO THE WIND

On August 20th, 2004, a half-ton rock crashed through the wall of the house, crushing three-year-old Jeremy Davidson to death as he slept. His parents had made the mistake of living in Virginia, where strip-mining for coal continues unabated; the boulder had come from a nearby work site where miners were widening a road with a bulldozer.[1]

In 1993, criminally negligent workers from Sugar Ridge Coal Company sent a rock flying 225 feet to kill sixteen-year-old Brian Agujar, a tourist.[2]

The coal industry affectionately calls it "fly-rock", and it is often the death of workers. When the coal industry levels mountains with dynamite, shards of flying rock endanger everyone and everything nearby.

Dynamite is cheaper than people, and the accountants of coal have learned that it is more cost effective to level hundreds of feet in mountain to expose coal seams than it is to dig tunnels. The Appalachian Mountains may soon be gone.[3] Excess rock is dumped into nearby valleys, where it is the literal death of communities, the environment, and people. Toxic slurry is held up behind massive dams, and if another one were to break—killing hundreds—it would not be the first time.

The coal-fired cities of the industrial era were an apocalyptic vision, the most foul and toxic manifestation of industrial power. During their time. But today, to see the toll that Industry takes on Earth and Humanity, one would have to go to West Virginia.

Technology lays bare the many faces of humanity; one moment we create wonder and simplify grueling labor, the next we wreak mindless havoc on our air, rivers and lungs. Nowhere is this duality more apparent than in steampunk culture. The traditional fuel for the beautiful gadgets we adore is coal, but we need to know that our fascination is not without cost.

EXTRACTION

The Aztecs burned it. The ancient Chinese mined and burned it. But Britain was the first to grow gluttonous; they developed deep shaft mining in the late 18th century.

Leave it to the United States to develop the mind- and mountain-shatteringly insane idea of Mountain Top Removal(MTR), however, which first took hold in the 1980s and has been growing at an accelerating pace ever since. Estimates range from 700-1200 miles of streams that have been buried forever, and ghost towns are springing up rapidly as entire populations flee the coal-dusty air. Up to a million acres have been mined in Appalachia using this method already, and the Environmental Protection Agency reports indicate that the use of MTR will double in the next decade.[4]

The coal industry paints coal extraction as a temporary use of land. And while a small minority of strip-mined areas has been partially replanted—enough for the photo op—the vast majority are left as death scars upon the wild. The leveled mountains, of course, cannot be rebuilt by humanity.

Mining accidents are less common in the US now then they were a century ago—thanks in part to the tireless work of union organizers and OSHA [Occupational Safety and Health Administration]—but injuries are still par for the course and death is commonplace. Mining directly injures over 11,000 every year[5], and in 2006 47 were killed.[6] This is, of course, ignoring the increased risk of cancer to surrounding communities, the non-potable river water, the asthma rates, and the other human impacts of coal mining.

But to confine our insight to what happens in the United States would be to ignore the figurative elephant that seems to have taken up residence in our sitting room: while China produces only 35% of the world's coal, an astonishing 80% of coal-mining deaths occur within its borders. 6,027 Chinese coal-miners were killed on the job in 2004 alone.[7]

And the mining is dangerous to more than just people. Many coal seams are found near large quantities of pyrite. When pyrite is exposed to water and air, it forms sulfuric acid and iron. As runoff, the acid and metal interfere with the aquatic food chains that many communities depend upon. Areas near existing or long-forgotten mines have an increased risk of flooding as the permeability of the overlying soil changes.[8]

The physical waste from coalmines takes three forms: solid waste called "gob," refuse from coal preparation and washing, and the toxic sludge left over from treating acid mine drainage. These wastes, generated in the tens of millions of tons per year, are stored in vast landfills that can never be used for any other purpose, are highly flammable, and are prone to toxic erosion.[9] *Another* permanent blight.

Some particularly un-clever engineers have used coalmining byproduct as a structural material in the dams that hold back these seas of sludge. One broke in 1971, West Virginia, and the flood of toxins killed 125. In 2000, another broke. In Kentucky this time, more than 75 miles of the Big Sandy River were choked of all animal life, and 1,500 human residences were affected.[10]

All of this, and we haven't even *burned* the coal yet.

COMBUSTION

It takes a light bulb 714 lbs. of coal to stay on 24-hours for a year.[11] (And a quarter of the world's energy comes from coal.[12])

Our hypothetical coal-powered light bulb is doing more than humming away in its benign little corner of the globe, however. Our light bulb is contributing to almost every ecological crisis this planet is currently facing. In that year we kept our light on, it produced five pounds of sulfur dioxide, the main cause of acid rain. It pumped 5.1 pounds of nitrogen oxides into the sky. Nitrogen oxides cause smog

and contribute to acid rain. But the dirtiest secret our light bulb is holding is what it's doing to the ice-caps; our one light bulb has, in its year, caused 1,852 pounds of carbon dioxide to be spewed into the air. [13] Carbon dioxide is the chemical agent causing global warming.

That's not even the start of it. Burning coal actually produces almost every known element—including the radioactive ones. In fact, a properly functioning coal plant produces more nuclear waste than a properly functioning nuclear power plant.[14]

Now, emissions from coal plants, at least in the United States, are subject to the requirements of the Clean Air Act (CAA), are they not? That's right, they're not. Only *new* power-plants are required to meet the standards of the CAA, and those that are grandfathered in produce up to ten times as much pollution, while remaining remarkably inefficient.[15]

Coal does not burn completely, either. Ash is mixed with the liquids used to clean the steam boilers and then dumped. Some of it is sold for use in cement and wallboard, despite its toxicity. And as the standards for cleaner smokestacks go up and the air gets cleaner, more and more of the toxin will be left in the remnant wastes.[16]

As we approach the peak of our ability to produce oil, the global economies intend to rely more and more heavily on the power of coal. And while they can (and ought) significantly improve the efficiency in economic terms, the environmental terms will stay dire.

ALRIGHT, YOU DOOM-PREACHING JOURNALIST, I CAN HEAR YOU say to me now, *you have convinced me that the way our culture uses coal is indeed an atrocity. But I am a simple steampunk, making simple steam toys.* And as I hear you say this to me, know that I am indeed sympathetic. I do not make the claim that steampunks are to blame for global warming, acid rain and the death of thousands. It is the coal *industry* which bears that responsibility.

Instead I wish only to sober myself and my community. Coal makes for beautiful fiction—and for unique contraptions—but we simply cannot allow it to be the bedrock of our culture, lest we make the grave mistakes of the mainstream economic world.

And our alternatives are innumerable. We steampunks have always been proud to be a people plagued by ingenuity. Even using the existing energy technology we have plenty of options; home-distilled alcohol made of fruit (or indeed, any sugar) burns quite readily. Vegetable based oils can be found in the back of every fast food joint, just waiting to be rescued from the landfill. Wood—*used sustainably!*—is a less efficient but renewable source of steam power. In fact, it was the primary source for boilers until about 1850 (although I pity the forest the same as I pity the mountain!). Some Stirling engines have been crafted that can run off of body heat, and bicycle-powered do-dads and hot-breath powered whatsits will abound in our future as we put our gloriously nerdy brains to it.

In fact, coal is kind of a cop-out. Steampunk is about ingenuity, not just stealing the bad ideas of long-dead scientists. We can do better than that!

What's more, we *have* to.

FOOTNOTES

1—Thorton, Tim. "Southwest Virginia family and A&G Coal settle in 3-year-old's death." The Roanoke Times. 8 Sept. 2006. Accessed 9 May 2007. <http://www.roanoke.com/news/nrv/wb/81731>

2—Lydersen, Kari. "Mountaintop Removal Meets Fresh Resistance in Tennessee." The New Standard. Accessed 9 May 2007. <http://newstandardnews.net/content/index.cfm/items/2599>

3—"Mountaintop Removal Mining." Wikipedia. Accessed 9 May 2007. <http://en.wikipedia.org/wiki/Mountaintop_removal>

4—ibid.

5— "Number and Rate of Lost-time Injuries in Mining, 2000-2004." National Institute for Occupational Safety and Health. Accessed 9 May 2007. <http://www.cdc.gov/Niosh/mining/statistics/tables/InjRate.html>

6—"Coal Fatalaties by State." Mine Safety and Health Administration. 24 April 2007. Accessed 9 May 2007. <http://www.msha.gov/stats/charts/coalbystate.asp>

7—Xiaohui, Zhao & Xueli, Zhao. "Coal mining: Most deadly job in China." China Daily. 13 Nov. 2004. Accessed 9 May 2007. <http://www.chinadaily.com.cn/english/doc/2004-11/13/content_391242.htm>

8—Keating, Martha. Cradle To Grave: The Environmental Impacts of Coal. Boston: Clean Air Task Force, 2001

9—ibid.

10—ibid.

11—"How much coal is required to run a 100-watt light bulb 24 hours a day for a year?" HowStuffWorks. Accessed 9 May 2007. <http://science.howstuffworks.com/question481.htm>

12—"World Energy Overview: 1994-2004." Energy Information Administration. May 2006. Accessed 9 May 2007. <http://www.eia.doe.gov/iea/overview.html>

13—same as 11.

14—Gabbard, Alex. Coal Combustion: Nuclear Resource or Danger. Accessed 9 May 2007. <http://www.ornl.gov/info/ornlreview/rev26-34/text/colmain.html>

15—same as 8.

16—ibid.

Yena of The Angeline and the Tale of the Terrible Townies

by Margaret P. Killjoy

illustratration by Laura Pelick

Part Two: Of marvelous Religions, fierce Battles and mythical Androids

In the first part of our tale, recounted in SteamPunk Magazine, Issue #1, we were introduced to our protagonist Yena (a mechanic and musician), her twin-sister Set (who plays a mean cylindraphone), their drummer-boy Fera, an enticing sculptress named Annwyn (who is the object of Yena's unrequited love and is being persecuted by the Terrible Townies for reasons unknown and sinister), a new-in-town young man named Icar (straight from the tribal wastelands), and a bald-headed woman named Suyenne (who has yet to bear any distinguishing characteristics). They belong to a political faction within the city of The Vare, one that is unruly—or, rather, one that refuses to be ruled: the squatters.

While Yena's steam-powered punk band Bellows Again was performing at the squatters' social and cultural center, The Cally Bird, the Townies attempted a raid. The squatters escaped through tunnels, but evaded physical persecution only by means of a rather massive set of doors of stone and steel. Annwyn woke Yena the next day and they sailed a bus out to see the old woman of the mountains, who provided the mechanical support required to lay a trap at Annwyn's squat, which the Townies were expected to raid. Annwyn revealed that the Townies were after her personally, information she received from the spy Gregor, and chose to stay out of the city and lay low.

Expecting a rather run-of-the-mill confrontation with the Townies, Yena and company created a mechanical illusion of occupancy in Annwyn's residence, complete with automated light-triggering and rock-throwing. But the next morning, when the angry mob arrived, the Townies chose not to brawl or parley, but rather utilized explosives to lay the building low. Here we left our protagonist and her allies, with Icar and herself hiding on a nearby rooftop, suddenly rocked by the explosion at Annwyn's squat.

THEIR BOOTED FEET SLAPPED AGAINST THE PACKED EARTH and cobblestone roads of The Vare as they ran.

"I know, I know," Yena panted between her heaving breaths, "'it's all just a game' I said, 'no one is going to get hurt,' I said."

Icar, a born runner, was bounding alongside with enviable ease, and it was clear that he could be sprinting significantly faster than he was. "It's alright. No one was inside."

"But they thought we were." It was all Yena could manage to say as she fought for air, and she turned her attention back to the screaming pain in her abdomen, to her tortured lungs. Born and raised in a coastal city, she was one of Those of The Gear—a people that had evolved, thousands of years ago, accustomed to luxurious underground life—and she was out of her element at such a high elevation.

Fortunately, sheer willpower was enough to keep her going, even as the jeers and yells of the Townies were fading behind her. She looked over her shoulder for just a second to make sure there was no sign of pursuit.

"*Android!*" Icar yelled, but his strange warning came too late. Yena slammed full-speed into 2000 kilograms of steam-driven metal, a four-legged steam-carriage—the sort driven about by dandies with more time than sense or social grace. Her upper body hit the thing's torso, and her legs went out from under her. She was lying under the machine, and only a timely shout from Icar to the driver saved her from being ground into the cobblestone by the thing's hydraulic legs.

"Oh dear, oh dear," the driver—a bespectacled, aging aristocrat—said from his perch on the thing's camel-humped back, forward of the boiler. "I didn't see you there. But indeed, why are you making such haste about my neighborhood, and charging past my alley?" Yena ignored the over-dressed rich man. She had met his kind: distrustful of the poor, distrustful of any who weren't Of the Mountain, and too lazy to walk any great distance. Useless. Instead, she studied his beautiful riding machine while sitting in a daze from the knock on her head.

Icar helped Yena back onto her feet, and none too soon: a few of the Townies seemed to have kept in sight of them and were only five blocks behind. Yena pulled Icar under the machine's belly and the two crawled between its back legs, so that they stood in the alley from which the mechanical beast had emerged. One well-aimed thwack with the crescent wrench that had hung off her belt, and Yena saw the machine's back legs crumple to the ground, useless. The alley effectively blocked, the pair resumed running.

"I say!" they heard the gentleman exclaim from the back of his riding machine, but he must have seen the pry-bar/axe combination-tool that Yena had strapped to her back, for he lowered his voice and began mumbling instead, musing as steam burst out from the exhaust pipe set into his steam-carriage's tail.

Yena and Icar jumped over piled metal scrap and splashed through unsavory puddles as they pounded away down the alley.

"What did you call that buffalo-machine?" Yena asked Icar when they were seated atop a ten-meter junk-hill in the industrial district.

"An *android*."

"What's that?"

Icar picked a piece of a broken clock from the mounded trash beneath him. "This stuff, technology. Where I'm from, it's taboo. A clock, it's okay, just a little bit of evil. But a thing that moves its limbs— 'demon-beast' is perhaps the best translation I can come up with. If a man rode into a Southlakeside encampment on one of those things, he'd be lucky to leave with his life."

"Why?" Yena asked, defensively. Machines were her passion, her calling. Machines gave her power, a power over her own life, which was something rare and valuable indeed.

"I don't know." Icar looked up at the cloudless sky, looked over the city that lay in front of them. "It's superstition, I suppose. It's in our creation story. And I don't think I believe it. Superstition is why I *left* Southlakeside. But when I saw it out on the street, that crazy man perched on its back, I didn't have time to think. I saw it as an *android*."

"It's just a machine, same as another. It's got no life of its own; don't fret. No machine can go for very long without a human to direct it. That's a fundamental law of mechanics."

Icar changed the subject. "Your sister, and Fera, will they know to meet us here?"

"No, but I'm sure they'll be alright. We've got a town meeting tonight at The Cally Bird, and we'll see them there."

Yena's mind turned back to the destruction she had witnessed earlier that morning. Annwyn would have been killed, if not for the warning. The Townies were trying to kill Yena's favorite person. There had to be a reason.

"You're alright by yourself? You know how to find the club?" Yena asked Icar.

"Yeah."

"Good. I'll see you there." Yena stood and faced Icar. "If I *don't* see you there, tell everyone what happened. And tell Set that I'm alright. That I've gone to see a man about some things."

Yena reached a hand out to place on Icar's shoulder, but hesitated. Just yesterday he had seemed like something of a nuisance, a lost little lizard. But by the early morning light, as they perched hidden in the industrial district after a frightful chase, he was someone new. All the same, she pulled her hand back and merely nodded to the young man before walking down the junk-hill to the street below. Icar nodded back, briefly, and then stared out into the sky, his eyes trailing a distant flock of birds.

A strange young man, Yena thought.

She found Gregor, the spy, to be *literally* sitting where she figured he might be *metaphorically*—at the bottom of an iron barrel of rum.

When she had reached Gregor's pub—a modest brick-faced tavern that served the city's elite who liked to slum—she had found the reinforced iron door open wide and inviting, despite the early hour. She had pushed through the strips of wire-screen netting and walked into the empty room.

The lights had been out, and the shutters down, casting the polished brass interior into a rather gloomy light. And quickly, she found Gregor.

"Go away!" Gregor's scratchy voice echoed unflatteringly from the bottom of the barrel where he crouched in fear.

"It's Yena, Gregor. We've got to talk."

"Sounds like you. I'll tell you what. You close the door, give that lock-wheel a twist, and light the lamps. You do that, and I'll come out. But until that door is closed—"

"Yeah, yeah. I get it. You don't want to be seen with me." Yena pulled the poorly oiled door shut with a creak and a slam. Set into its center was a copper-plated wheel, which Yena turned, forcing deadbolts into the floor and ceiling. She pulled flint and steel from one of her many pockets and lit a few of the oil lamps that sat on the tables, casting a harsh yellow glow that reflected garishly on the glistening furniture.

"Out," she said when the room was lit.

Gregor stood, and Yena, so often unfeeling, was filled with pity and sorrow. Most recently a handsome old man, Gregor's face was bruised and cut. He was Of the Mountain, like most of The Vare, and thus he was broad-shouldered and tan, but he looked sickly, his face nearly as pale as Yena's. He wore a brown canvas shirt—quite the luxurious article—but it was stained with blood, presumably his own. His leather bowler was bashed in and it was clear he had been crying, though he was not presently.

"I tried to warn her. But you know Annwyn, she's stubborn." Gregor looked Yena in the eyes for but a moment before looking down at his thick hands that he held clasped in front of him.

"Annwyn wasn't home when it happened."

"No? Then who was inside?"

"No one was inside. We rigged the place. All that's gone is a lot of Annwyn's sculpture." And a lot of innocence, Yena thought.

Gregor unclasped his hands, took his bowler from his head and pushed out the dent before putting it back on and looking up. "Really then? Annwyn's fine? No squatters killed?"

"Nope. Though we had a bit of a sprint to get away after the explosion."

"Well then, well then." Gregor's voice perked right up.

"Now, who mussed you up?"

"This? No one, it's nothing." Gregor clumsily made his way out of the rum-barrel, balancing himself on the nearby bar as he lifted his short, hefty body and stood up on the floor.

"No, tell me. Who did this?" Yena had never been friends with Gregor, had never appreciated Gregor's scheming ways, but the old man had always done right by the squatters, and Annwyn trusted him. Yena wanted to find out who had hurt Gregor, the same as she wanted to find out who blew up Annwyn's house. Violent thoughts of revenge flickered through her head unbidden.

"I'm not joking." Gregor went behind the bar and grabbed a scrap of wool. He rubbed his face lightly and his original reddish tan showed through the pale. "It's paint. I figured that maybe the Townies would get to Annwyn's place, find it empty, and I figured they might suspect me. Wouldn't be the first time. I wanted them to think that you squatters had forced it outta me. Sorry about that. But, you know, it's best to keep up appearances, right?

"Anyways, when the Townies didn't arrive, and I heard the explosion—I think it woke up half The Vare, that little blast—I figured Annwyn had stayed to fight. I thought she was dead." Gregor sounded upset as he spoke, but caught himself and reverted to his jovial, polished charisma. "But, well, she's not, and the Townies think she is, I'm sure."

Gregor laughed, throwing back his head and snorting into the air. "You showed them pretty well, you sure tricked 'em. So, wanna drink?"

"I want to know what bastard was after Annwyn."

"Yes, well, I'm sure it was the usual batch of folks, you know, retired generals and such who resent the civil war. I can't see how it matters now, though. They got what they want, or so they think, eh? Thanks to you and Annwyn, you clever gals you. So, let's drink to that! What can I get you?" Gregor spoke so quickly Yena had to pause a moment to keep up.

"I want to know who. Was. After. Annwyn."

"I'm sure you do, I'm sure you do. Why would anyone hate someone so sweet? That's what I ask." Gregor went back and poured two glass mugs of mead. Mead was pricey stuff, since honey had to be shipped in from the coast.

"Now look Gregor. I'm going to drink this mead, but not because you've successfully changed the subject on me. I'm going to drink this mead because I don't get mead so often, never for free, and because it reminds me of home."

Gregor and Yena silently toasted and drank, sitting on either side of a bar of shining brass. They took long, slow sips, pausing to let the fermented honey tickle their mouths each time before swallowing.

Halfway through the glass, Yena put hers down. "I won't leave until I know, Gregor."

Gregor sighed and chugged the second half of his drink, a nearly heretical action. "I'll tell you. But when I tell you this, I'm trusting you with my life. If that man figures me out a rat, Gregor's Pub here will be next to go. And rest assured, I'm not so clever as you squatters; I won't be getting away."

"We won't let anyone hurt you."

Gregor smiled grimly, rubbing the bar with one hand while he scratched the back of his neck with the other. He was the sort of man to have two nervous habits; it came with being a spy and a charlatan. "So the squatters protect me. Then what? No one will come to Gregor's Pub. After all, he'll be a squatter. And the other squatters? You can't afford mead. What do you think? I'll cast off this bowler, my canvas shirt, perhaps cut my hair into a mohawk? That would be clever. Come see your band play?"

Yena looked down now.

"No, I mean no offense." Gregor stood to refill his glass. "But I'm a bit old for you folk. There aren't so many squatters my age left for me to be friends with, are there?"

"No," Yena said bitterly. They had all died in the war. Yena had barely been born when it happened, and she wasn't even from The Vare, but she lived among grown orphans and felt their elder's absence sharply.

"So there's a man named Keyou. He's old, like me. But he's dangerous, a preacher. He picked up a little bit of the Waste-religion, a little bit of the Coast-religion, and a little bit of the his-brain-is-made-of-bonkey-juice-religion. He thinks Annwyn is up to no good. Thinks she was building an *android* over there in her workshop. An *android*, you see, is—"

"I know what an *android* is," Yena cut him off, "I'm not an idiot."

"Anyhow, Keyou has a lot of sway; he did a lot during the war. He was in here the other night, rambling on about Annwyn, talking her up to be some kind of leader."

"Where does he live?"

"Downtown, Comseye Tower."

"Thanks," Yena finished her mead and set down the glass, "it helps. Say, what did *you* do during the war?"

Gregor scratched his neck and rubbed the bar for a moment, then took Yena's glass and scrubbed it clean with sand and wool. "I, uh, I killed squatters."

Gregor poured himself more mead as Yena unbolted the door to leave.

Outside, the desert air was warming quickly now that the day had begun in earnest. Across the street, crouched in the shade, Yena saw Icar's lanky figure, his shaggy red hair draped in front of his face and his whole tanned body seeming to disappear into his featureless wool clothes. When she caught his eye, he stood and walked out into the sun to greet her.

"You've been following me?" Yena asked, as much amazed by his discretion as she was annoyed.

Icar nodded. "What did you find out?"

"It was a man named Keyou, from Comseye Tower. He figured Annywn was building one of your *androids*. He's some kind of priest."

Icar nodded again, his hair bobbing in his face, looking very much the part of a confused boy. "She won't be safe to come back until he's dealt with… And we will tell people this at the meeting tonight?"

Yena sighed and thought. "We will. But I'm not sure they'll listen. The danger is over for the moment, honestly. Keyou thinks he got her. It's hard to keep people riled up about a threat that has passed."

Icar looked puzzled for a moment, and then resumed his wide-eyed gaze. "Do you suppose that I can sleep at the Cally Bird?"

"I'm sure."

Yena left Icar and walked back to her own squat, hoping to find Set and to get some sleep before the meeting.

The main room of The Cally Bird was packed, and the air smelled strongly of nervous sweat. Over two hundred people were in attendance, and though most of them were young, fifteen to thirty years old, about a dozen elders were mixed into the crowd. A few of these were survivors of the civil war; but most were more recent migrants.

The majority of the people in attendance were Of the Mountain—The Vare's original inhabitants—but there were people from all across The Continent, stragglers who had found their way to The Vare.

There were Those Of the Gear, who, like Yena, had fled Angeline to seek a less repressive world. They were mostly pale or sunburned and peeling, and their bodies were soft and curved. Their life span was frighteningly short; few lived to see forty, thanks to the ravages of cancer that the air itself seemed to bear on the winds.

There were Those Of the Waste, who, like Icar, had fled their tribes in hopes of greater personal freedom. Tall, thin and angular, most Of the Waste were sterile, and many resented their subservience to the fertile minority of their people.

More rare were Those Of the Sea, like Suyenne, a hairless, dark-skinned folk who traditionally plied the seas of the West.

Some sat on benches that had been winched up from the floor, a few perched from platforms that were lowered from the four-story ceiling. Some crouched on the floor, some rested against the wall. Their fashion was diverse, and if there was a unifying theme it was "we are not like you." Some wore antiquated garb: wool vests, trousers and jackets. Others wore leather, in browns and blacks, cut tight to their bodies in bizarre styles. Many were still in the cover-alls and caps that marked them for their work in the gas factories, and still others wore loose, comfortable skirts and little else save for a greatcoat with which to face the desert sun and sand.

There was not a scrap of canvas, not a trace of bleach-white.

Standing guard in the hallway, Suyenne kept track of all these people as they came and went. Fera was on the roof, spyglass in hand, poised near the alarm bells.

Set and Fera had been fine, Yena had been relieved to learn. After seeing the explosion, the two had walked calmly away, disguised as a middle-class couple drunkenly finding their way home from a bar that had closed at first light.

But Icar was conspicuously absent. Arriving after her nap, Yena had combed the building looking for him, but Suyenne hadn't seen him all day.

Set stood behind Yena now, leaning forward and resting her weight on Yena's shoulders. They were near the back of the room, Yena unconsciously guarding the boiler and the steam engine.

When the room could hold no more, a powerfully-built man stood and faced the crowd. He raised his hands and, after a few moments, the room grew quiet. Teyhlo, Of the Sea, spoke with a voice that had at one time crossed the waves, from ship to ship.

"Can everyone hear me alright? Do I need to use the vocal horn?" he asked, and someone from the back shouted that his voice was clear.

"Two nights ago, the Townies attacked us. Once again, without provocation. We got away, and no one was hurt. You all know they do this from time to time. I suppose they think this keeps us on our toes, keeps the gas production high." Teyhlo paused dramatically. "But this wasn't an ordinary strike. This morning, as most of you have heard, they bombed one of our buildings, the workshop of Annwyn. One of us. They thought she was inside."

Those who hadn't heard the news gasped, and murmurs spread across the room until Teyhlo raised his voice once more.

"She wasn't there, of course, and nobody was hurt. But what are we going to do? We have to decide. How do we deal with this?"

Teyhlo moved to his seat nearby and left the floor open. The meeting went as it often did; when there was no immediate threat, the squatters worked by consensus council, and people took turns addressing the crowd. Since everyone in the room would be affected by the decision, everyone in the room had equal say. From time to time, Teyhlo would help to guide the discussion when it strayed too far from the topic at hand, or when disagreements threatened to disrupt

the council, as others had served as guide for meetings past. They would speak like this as long as was necessary, to reach a decision and address every individual concern.

It was a process that was dependent upon the respect for one another they all shared, a process that many of the crowd had grown up with. One took care not to repeat points already raised, and to give due purchase to the views of even those they opposed. Major decisions could mean giving up the better part of a night to come to a consensus, but the squatters were used to it. Anything else seemed like tyranny.

Once Yena had spoken her piece, and people realized that the attacks were unlikely to resume, the aggression quickly drained out of the crowd. The combatants among the Townies were in numbers that neared those of the squatters, but the Townies had the passive support of most of The Vare. If tactics remained escalated past the ritualized conflicts they were used to, it was very likely that the squatters would be wiped out, and their anarchic tradition would be no more.

Just as the crowd seemed to reach a consensus on inaction, the clangor of bells echoed throughout the room and everyone grew quiet.

"About two hundred of them. One steam-ram." Fera's voice echoed through his voice-tube from the roof. "And they don't seem armed. They've got a white flag."

Hushed whispers went through the crowd, and Suyenne spoke up. "Unless anyone objects, I will parley?"

Yena turned and began to power the steam engine. Soon she was shoveling radioactive earth into the gaping boiler and the machine's thrum comforted her. If things got nasty, the squatters would have mechanical support. She would make sure of that.

Without being ordered, the room emptied down into the escape tunnels. Small groups of friends would emerge in nearby buildings in a moment, waiting for the signal to fight, and the Townies would be surrounded. Expressions were grim, but determined.

Yena waited inside with her sister and a handful of others. Weapons were at hand, but if Fera was right, and the Townies were unarmed...

"He says that they've come about our attack on them, about some broken windows." Fera's voice carried down into the main room as he read lips from the roof. "He says that they demand we increase gas production for two weeks to compensate for the damages."

Yena grinned. It was all a game once more.

"He says they won't leave until we agree."

Set started to smirk as well, and she walked over to the steam-drum. She pounded it twice, and the melee began.

At the signal, the squatters emerged bare-fisted from nearby buildings and the two gangs brawled in the streets for a few long bloody minutes.

Yena knew that it was important she stayed by her post, but she couldn't help sighing as she missed the fight outside.

Many hours later, Yena stood in front of The Cally Bird. The Townies had left, and most of the squatters had gone home. After the brief conflict, the parley had resumed and the squatters had agreed to one day's increased extraction to compensate for the mysteriously broken windows.

Now the moon was high and gibbous, and Yena looked out over the dust and cobblestone, so often stained by blood. It was a strange game, to be sure.

A silhouette approached in the moonlight. Icar, Yena guessed by the stride.

"Evening, stranger."

"Evening," Icar said as he came into proper view.

"You missed all the fun."

"Oh? I just woke up."

Yena spoke of the evening's events. "So things are back to normal, mostly. Nothing's been done about Keyou."

"Keyou is dead." Icar looked up to the few stars that were visible through the smog that enveloped the city.

"Yeah?"

"I poisoned him."

Yena was stunned.

"A priest who takes too much power over the people, where I'm from, is poisoned. If Keyou persecutes under our religion, then he can be persecuted under our religion."

Yena looked at Icar and realized that he truly was a stranger to her; she never would have guessed him capable of such action. "Have you ever... killed anyone before?"

"No."

Yena opened the door to the Cally Bird and the two walked inside.

"Then there's one thing I still haven't figured. What about the windows? The Townies came, all pissed to hell over some broken windows."

"You'd best ask your sister and Fera about that."

Yena laughed slightly, and reached her hand out to rest on Icar's shoulder. "I'm glad you came to The Vare."

Icar grinned. "I'm glad too."

Earth Sea and Sky

SEA EAGLE AND ITS CAPTIVE.

Here at SteamPunk Magazine we delight in artifacts, and thus do we present you herein with an excerpt from the excellent tome "Earth Sea and Sky" published in 1887. In the first issue we shed light on the practice of hunting ostriches. In this, the second issue, we instead look at a non-human hunter: the eagle. We make no claim of this dated material's veracity.

The eagle, the monarch of the mountain forests, over which he has reigned since the creation, is still found exercising his dominion in the ancient and remote woods of Europe, Asia, and America, but more particularly in the northern parts. Nuttall thus describes it: Near their rocky nests they are seen usually in pairs, at times majestically soaring to a vast height, and gazing on the sun, toward which they ascend until they disappear from view. From this sublime elevation they often select their devoted prey—sometimes a kid or a lamb from the sporting flock, or the timid rabbit or hare crouched in the furrow, or sheltered in some bush. The largest birds are also frequently their victims, and in extreme want they will not refuse to join with the alarmed vulture in his cadaverous repast. After this gorging meal the eagle can, if necessary, fast for several days.

The precarious nature of his subsistence, and the violence by which it is constantly obtained, seem to produce a moral effect on the disposition of this rapacious bird; though in pairs, they are never seen associated with their young; their offspring are driven forth to lead the same unsocial, wandering life as their unfeeling progenitors. This harsh

and tyrannical disposition is strongly displayed even when they lead a life of restraint and confinement. The weaker bird is never willingly suffered to eat a morsel, and though he may cower and quail under the blow with the abject submission, the same savage deportment continues toward him as long as he exists. Those observed in steady confinement frequently uttered hoarse cries, sometimes almost barkings, accompanied by vaporous breathings, strongly expressive of their ardent, unconquerable, and savage appetites. Their fire-darting eyes, lowering brows, flat foreheads, restless disposition, and terrific plaints, together with their powerful natural weapons, seem to assimilate them to the tiger rather than the timorous bird. Yet it would appear that they may be rendered docile, as the Tartars, according to Marco Polo, were said to tame this species to the chases of hares, foxes, wolves, antelopes, and other kinds of large game, in which they displayed all the docility of the falcon.

The longevity of the eagle is as remarkable as its strength; it is believed to subsist for a century and is about three years in gaining its complete growth and fixed plumage. This bird was held in high estimation by the ancients on account of its extraordinary magnitude, courage, and sanguinary habits. The Romans chose it as an emblem for their imperial standard, and from its aspiring flight and majestic soaring it was fabled to hold communion with heaven, and to be the favorite messenger of Jove. The Tartars have a particular esteem for the feathers of the tail, with which they superstitiously think to plume invincible arrows. It is no less the venerated war-eagle of our northern and western aborigines, and the caudal feathers are extremely valued for head-dresses, and as sacred decorations for the pipe of peace.

Stern and unsocial in their character, yet confident in their strength and efficient means of defense, the eagles delight to dwell in the solitude of inaccessible rocks, on whose summits they build their rude nest and sit in lone majesty, while with their keen and piercing eye they sweep the plains below, even to the horizon. The combined extent and minuteness of their vision, often including not merely towns, villages, and districts, but countries and even kingdoms in its vast circuit, at the same time carefully piercing the depths of forests, the mazes of swamps, and the intricacies of lawns and meadows, so as to discover every moving object—even the sly and stealthy animals that constitute their prey—form a power of sight to which human experience makes no approach. If we connect with this amazing gift of vision the power of flight which enables these birds to shoot through the heavens so as to pass from one zone to another in a single day and at a single flight, we shall readily comprehend how it is that they have in all ages so impressed the popular imagination as to render them the standing types and emblems of power. In ancient times the lion was the representative of kings, but the eagle, soaring in the sky, was made the companion of the gods, and the constant associate of Jupiter himself.

Although in our days the carrying off of Ganymede is not re-enacted, yet the inhabitants of mountainous countries have some ground for accusing the eagles of bearing off their children. A well known fact of this kind took place in the Valais in 1838. A little girl, five years old, called Marie Delex, was playing with one of her companions on a mossy slope of the mountain, when all at once an eagle swooped down upon her and carried her away in spite of the cries and presence of her young friend. Some peasants, hearing the screams, hastened to the spot, but sought in vain for the child, for they found nothing but one of her shoes on the edge of the precipice. The child, however, was not carried to the eagle's nest, where only two eaglets were seen, surrounded by heaps of goat and sheep bones. It was not till two months after this that a shepherd discovered the corpse of Marie Delex, frightfully mutilated, upon a rock half a league from where she had been borne off.

Eagle and Child in the Air

An instance of this kind, which occurred in the autumn of 1868, is thus narrated by a teacher in county Tippah, Mississippi: A sad casualty occurred at my school a few days ago. The eagles have been very troublesome in the neighborhood for some time past, carrying off pigs and lambs. No one

thought they would attempt to prey upon children; but on Thursday, at recess, the little boys were out some distance from the house, playing marbles, when their sport was interrupted by a large eagle sweeping down and picking up little Jemmie Kenney, a boy of eight years, and flying away with him. The children cried out, and when I got out of the house, the eagle was so high that I could just hear the child screaming. The alarm was given, and from screaming and shouting in the air, the eagle was induced to drop his victim; but his talons had been buried in him so deeply, and the fall was so great, that he was killed.

The Abbé Spallanzani had a common, or black eagle, which was so powerful, that it could easily kill dogs much larger than itself. When a dog was cruelly forced into the room where the eagle was kept, it immediately ruffled the feathers on its head and neck, taking a short flight, alighted on the back of its victim, held the neck firmly with one foot, so that there could be no turning of the head to bite, while one of the flanks was grasped with the other, and in this attitude the eagle continued, till the dog, with fruitless cries and struggles, expired. The beak, hitherto unemployed, was now used to make a small hole in the skin; this was gradually enlarged, and from it the eagle tore away and devoured the flesh.

Ebel relates that a young hunter in Switzerland, having discovered an eagle's nest, killed the male, and was descending the rocks to capture the young ones, when, at the moment he was putting his hand into the cleft to take the nest away, the mother, indignantly pouncing upon him, fixed her talons in his arm, and her beak in his side. With great presence of mind, the hunter stood still; had he moved, he would have fallen to the bottom of the precipice; but now, holding his gun in one hand, and supporting it against the rock, he took his aim, pulled the trigger with his foot, and shot the eagle dead. The wounds he had received confined him to his bed, however, for six weeks. A somewhat similar story is related of the children of a Scottish peasant, who were surprised, in their endeavor to take away some young eaglets from the nest, by the return of the mother, from whose indignation they had great difficulty in escaping.

A peasant, with his wife and three children, took up his summer quarters in a cottage, and pastured his flock on one of the rich Alps that overlook the Dranse. The eldest boy was an idiot, about eight years of age; the second, five years old, but dumb; and the third, an infant. One morning the idiot was left in charge of his brothers, and the three had wandered to some distance from the cottage before they were missed; and, when the mother found the two elder, she could discover no trace of the babe. A strange contrast was presented by the two children; the idiot seemed

MARIE DELEX SEIZED AND CARRIED AWAY BY AN IMMENSE EAGLE.

transported with joy, while his dumb brother was filled with consternation. In vain did the terrified parent attempt to gather from either what had become of the infant. But, as the idiot danced about in great glee, laughed immoderately, and imitated the action of one who had caught up something of which he was fond, and hugged it to his breast, the poor woman was slightly comforted, supposing that some acquaintance had fallen in with the children, and taken away the babe.

A Happy Rescue

But the day and the succeeding night passed without any tidings of the lost one. On the morrow the parents were earnestly pursuing their search, when, as an eagle flew over their heads, the idiot renewed his gesticulations, and the dumb boy clung to his father with frantic shrieks. Now the dreadful thought broke upon their minds that the infant had been carried off by a bird of prey, and that his half-witted brother was delighted at his riddance of an object which had excited his jealousy.

Meanwhile, an Alpine hunter had been watching near an eyrie, hoping to shoot the mother-bird, on returning to her nest. At length, waiting with the anxious perseverance of such determined sportsmen, he saw her slowly winging her way towards the rock, behind which he had taken refuge, when, on her nearer approach, he heard, to his horror, the cries of an infant, and then beheld it in her frightful grasp. Instantly his resolve was made, to fire at the eagle the moment she should alight on the nest, and rather to kill the child than leave it to be devoured. With a silent prayer, arising from his heart of hearts, he poised, directed, and discharged his rifle; the ball went through the head or breast of the eagle; with indescribable delight he bore the babe away; and, within four-and-twenty hours after it was missed, he had the satisfaction of restoring it—with wounds which were not serious, on one of its arms and sides—to its transported mother's bosom.

The flight of the bald eagle, when taken into consideration with the ardor and energy of his character, is noble and interesting. Sometimes the human eye can just discern him, like a minute speck, moving in slow curvatures along the face of the heavens, as if reconnoitering the earth at that immense distance. Sometimes he glides along in a direct horizontal line, at a vast height, with expanded and unmoving wings, till he gradually disappears in the distant blue ether. Seen gliding in easy circles over the high shores and mountainous cliffs that tower above the Hudson and Susquehanna, he attracts the eye of the intelligent voyager, and adds great interest to the scenery. At the great Cataract of Niagara, the world's wonder, there rises from the gulf into which the Fall of the Horse-Shoe descends, a stupendous column of smoke, or spray, reaching to the heavens, and moving off in large black clouds, according to the direction of the wind, forming a very striking and majestic appearance. The eagles are here seen sailing about, sometimes losing themselves in this thick column, and again reappearing in another place, with such ease and elegance of motion, as renders the whole truly sublime.

> High o'er the watery uproar, silent seen,
> Sailing sedate in majesty serene,
> Now midst the pillared spray sublimely lost,
> And now, emerging, down the rapids tossed,
> Glides the bald eagle, gazing, calm and slow,
> O'er all the horrors of the scene below;
> Intent alone to sate himself with blood,
> From the torn victims of the raging flood.

Audubon describes a bald eagle pursuing a swan, as follows: The next moment, however, the wild trumpet-like sound of a yet distant but approaching swan is heard: a shriek from the female eagle comes across the stream; for she is fully as alert as her mate. The snow-white bird is now in sight; for her long neck is stretched forward; her eye is on the watch, vigilant as that of her enemy; her large wings seem with difficulty to support the weight of her body, although they flap incessantly. So irksome do her exertions seem, that her very legs are spread beneath her tail, to aid her in her flight. She approaches; the eagle has marked her for his prey. As the swan is passing the dreaded pair, the male bird starts from his perch, and in full preparation for the chase, with an awful scream.

Flight Like a Flash of Lightning

Now is the time to witness a display of the eagle's powers. He glides through the air like a falling star, and, like a flash of lightning, comes upon the timorous quarry, which now, in agony and despair, seeks, by various maneuvers, to elude the grasp of his cruel talons. It mounts, doubles, and willingly would plunge into the stream, were it not prevented by the eagle, which, long possessed of the knowledge that, by such a stratagem, the swan might escape him, forces it to remain in the air, by attempting to strike it with his talons from beneath. The hope of escape is soon given up by the swan. It has already become much weakened, and its strength fails at the sight of the courage and swiftness of its antagonist. Its last gasp is about to escape, when the ferocious eagle strikes with his talons the under side of its wing, and, with unresisted power, forces the bird to fall in a slanting direction upon the nearest shore.

And, again, when two of these eagles are hunting, in concert, some bird which has alighted on the water, this writer says: At other times, when these eagles, sailing in search of prey, discover a goose, a duck, or a swan, that has alighted on the water, they accomplish its destruction in a manner that is worthy of our attention. Well aware that the water-fowl have it in their power to dive at their approach, and thereby elude their attempts upon them, they ascend in the air, in opposite directions, over the lake or river on which the object they are desirous of possessing has been observed. Both reach a certain height, immediately after which, one of them glides with great swiftness toward the prey; the latter, meantime, aware of the eagles' intention, dives the moment before he reaches the spot. The pursuer then rises in the air, and is met by its mate, which glides toward the water bird that has just emerged to breathe, and forces it to plunge again beneath the surface, to escape the talons of this second assailant. The first eagle is now poising itself in the place where its mate formerly was, and rushes anew, to force the quarry to make another plunge. By thus alternately gliding, in rapid and often-repeated rushes, over the ill-fated bird, they soon fatigue it, when it stretches out its neck, swims deeply, and makes for the shore in the hope of concealing itself among the rank weeds. But this is of no avail; for the eagles follow it in all its motions; and the moment it approaches the margin, one of them darts upon it.

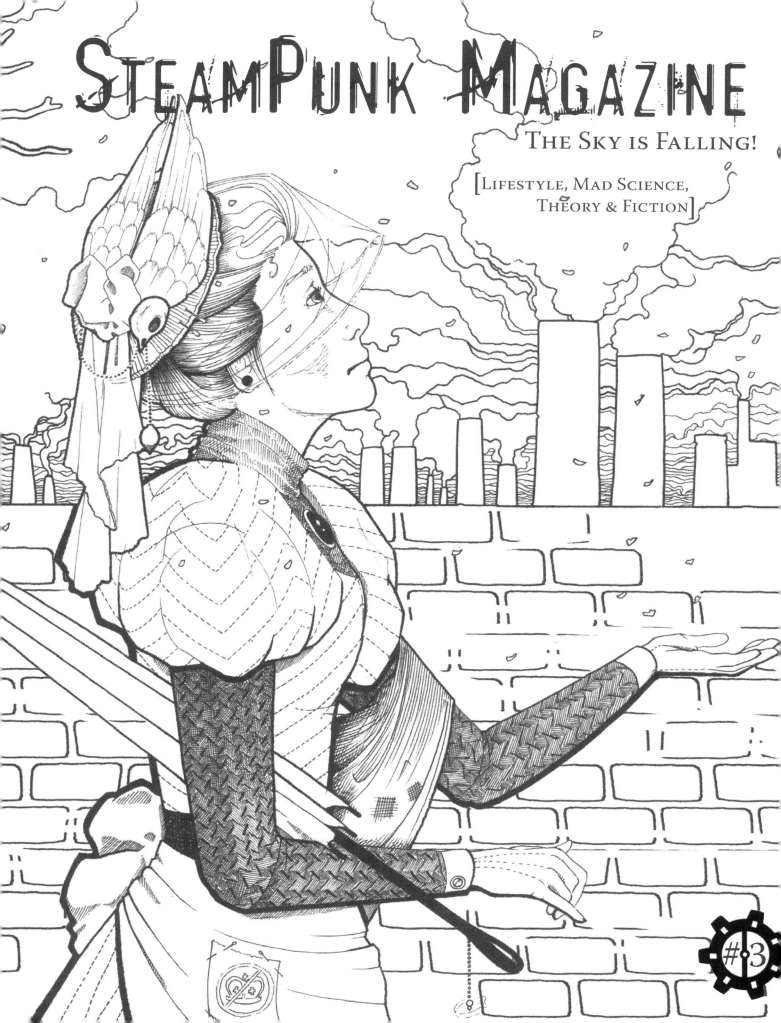

It is an absurdity, it is laughable, to speak of such a pending disaster as "The End of the World." We are discussing the end of Humanity, or we are discussing the end of Civilization, or we are perhaps even discussing the end of some this or that Empire that we mistakenly believe to identify with.

The end of the *world* will come when the sun expands and engulfs it.

Now, is it truly a surprise that our discourse relates economic tragedy with an ecological one? That we actually behave as though a marked downturn in the Market can somehow be compared to the death of Nature? We are so enamored with our vastness and resource that we have forgotten the lark and the sparrow.

So I say, come armageddon. Come, you horsemen. Let us speak these things no more.

—Takici Kaneko, 1934

The cover was illustrated by Suzanne Walsh

ISSUE THREE:
THE SKY IS FALLING!

Another few long months have transpired and it is with tremendous relief and joy that I invite you to read this, our third issue. Our apocalyptic issue.

The growing threat of ecocide and extinction are as real to us Steampunks as they are to anyone else. The water levels threaten to rise, the polar bears drown, and the bumblebees disappear. This affects us because we live in this world, we play in this world, and we hope to contrapt our world into one that better suits us. How can we but think in this context?

With such thoughts do we open the simple discussion: what is our future? The future of our subculture hangs upon the same precipice as the future of our earth. What can be done? At the very least, and let us reinforce that it is the *very least*, we can radically re-envision our lives, our interactions with both people and technology. Both concepts we explore within this issue.

Let it not be said that I seek to scare you! I'm not convinced of impending doom. I'm only convinced that there are many, many grievous errors that need addressing, that there are serious perils directly ahead.

And on a more intimate scale, I inquire again as to our future. Steampunk is growing rapidly, drawing the eye and ear of farflung sources. Let us not lose ourselves, blinded by this limelight. Steampunk is of interest to people because it is earnest, caring, honest. We will not be swept up and carried away by the mainstream, but will instead offer a channel for the clever and curious to escape into.

And the magazine: the magazine goes well, thanks in no small part to the enthusiastic support of so many contributors and readers. Thank you all.

— *Margaret P. Killjoy*

LETTERS

write us at collective@steampunkmagazine.com

Dear SPM,
I predict the makers of this magazine will soon be (if they're not presently) afforded the opportunity to take this fine publication to a "larger audience". I do dearly hope that their principles are where their publication's are. With a small, but growing audience that would shudder at the sight of glossy covers and pages, and full page ads offering steampunks something to buy to help accentuate their culture and express themselves better. I agree with the disclaimer on the "Steam Gear" article. Steampunk is not a commodity, though the article is cute. Do not attempt to make better what is just perfect the way it is. Steampunk can be (and is) everything Cyberpunk wanted to be. It has a tangible essence to it that Cyberpunk lacked in a time of overwhelming superficiality and blind consumerism. It calls out for us to have a place with hand tools in it that we *use*, to make things that we *need*. Things that cannot be bought. It calls for us to re-examine the last hundred years as potentially a "Second Dark Age", a cul de sac where technology and [humanity's] ambitions took a wrong turn. It *should* make us wonder if Nikola Tesla, John Keely, and other such men of their period were right (also Schauberger, Moray, and L. Rota). Steampunk magazine is at the right place at the right time, bearing the ostensible sensabilities to have what it takes to be a fukin PUNK!

Keep it up,
TechnoAlchemist

You may rest assured that SteamPunk Magazine will not be going newstand glossy, and we are dedicated to continuing to keep the Punk in SteamPunk.

In Response to Lord Teh, [See SPM #2],
As an anthropologist who has studied music, I'd have to say that Noisecore is likely to be popular if it had been "invented." My reasoning is that the familiar sounds of a culture's environment tend to get embedded in their music. For example, the Tuvans who respect horsemanship highly have "Bonanzaesque" rhythms which emulate a galloping horse, and industrial (the real gritty stuff) started with working class youth working in factories. Someone who hears gears, steam and clanging metal will try and distil their culture into a representative music, where it all falls together a little more neatly than in the shop.

Cheers,
Cameron

Dear SPM,
Greetings! My name is Albert Bedell and I hail from a small town in the northern reaches of British Columbia (that's in Canada for the unenlightened), I've been reading your zine and finding it quite to my liking. [...]

I have to fight back at your coal editorial, you were fairly accurate with your portrayal of the coal mining/power industry in the US and China, but it should be mentioned that generating power from coal in a clean and efficient manner is not just a wet-dream. Already coal plants are being brought on line which use the heat released by coal more efficiently while, at

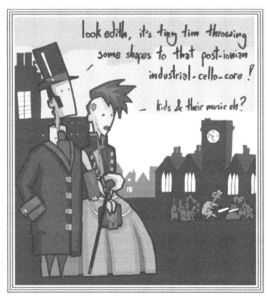

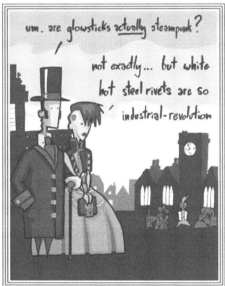

comic by Doctor Geof

the same time, reducing emissions to practically nothing. I won't say that this technology makes coal power a perfect choice, the by-products of combustion still need to be dealt with. Today that means taking sequestered CO2 and forcing it underground in an effort to drive more oil to the surface, which is economical, but not very beneficial for the environment as we are basically substituting coal generated CO2 for oil generated CO2, but it is a start, and eventually all we'll end up doing is putting the vacant pores left by centuries of oil exploration to good use as storage tanks for the by products of coal power plants.

Of course, super high tech coal plants aren't very useful when it comes to building amazing mechanical contraptions.

I have no idea why I wrote this other than the fact that I felt that it should be known that even when the world has gone 'green' many of us will still be relying on our old, grimy friend coal to keep the lights on. Just means that we'll have to find something other than soot to get our hands dirty with.

Thanks for your time,
Albert Bedell

We'll believe clean coal when we see it. So far, these "attempts" have amounted to nothing other than greenwashing. Instead of releasing as many pollutants into the air, they are releasing them into the ground, and we highly doubt that it is possible to burn toxic materials without releasing toxins, or to gut mountains without destroying them; so yes, clean coal is just a fantasy. In the meantime, it is reprehensibly irresponsible to ignore the tragedy that coal—like every other widespread form of electrical generation—has and is inflicting on the world about us.

Steampunk Magazine,
Myself and some friends are working on an interesting bit of software. We intend to craft a steampunk world with just a dash of fantasy. When it is complete enough to be shown to publishers, we hope to sell the project off in order to obtain sufficient resources to bring it to the market.

The setting has grown in fascinating ways. In this steam driven world, coal is even more dangerous and difficult to mine than in the real world. This creates fierce competition between and among petty lords and free townships for that most valuable resource. The high cost of energy creates a division between those capable of mining and affording coal and those less capable. Partially filling the energy gap is the power of magic. Magic in the game is not the tremendous force witnessed in many other settings. It is certainly versatile and a skilled mystic is quite dangerous but there are no grand artifacts, no sorcerer-kings, and a wizard has never felled an army.

As work progresses on this labor of love, we hope to submit pieces to your magazine to showcase our talents and entertain fellow steampunk enthusiasts with tales from and depictions of our world of clever tinkers, conniving despots, and bold explorers.

Unfortunately, we suffer a tremendous lack of resources. Most specifically, our combined artistic talents would be insufficient to render a proper stick figure. My sincere hope is that you could somehow assist us. While I understand you are not looking for ads, we believe the growing steampunk community may be interested in lending their considerable talents to this endeavor. We seek artists, animators, and programmers who are willing to work with us to make our dream of an interactive steampunk world, and our dream of huge piles of money for everyone involved in the development effort, a reality. Any aid you could possibly render would be highly appreciated.

Sincerest regards,
Stephen Burkett
[stephenb.2006@gmail.com]

If anyone is interested, please contact them!

What is SteamPunk? What is SteamPunk Magazine?

THE TERM "STEAMPUNK" WAS COINED to refer to a branch of "cyberpunk" fiction that concerned itself with Victorian era technology. However, SteamPunk is more than that. SteamPunk is a burgeoning subculture that pays respect to the visceral nature of antiquated technology.

It's about "steam", as in steam-engines, and it's about "punk", as in counter-culture. For an excellent manifesto, refer to the first article in our first issue, "what then, is steampunk?"

SteamPunk Magazine is a print publication that aims to come out seasonally. Full quality print PDFs of it are available for free download from our website [www.steampunkmagazine.com], and we keep the cost of the print magazine as low as possible. All work on the magazine, including articles, editing, illustration, layout, and dissemination, is done by volunteers and contributors. To see how you can get involved, see the second-to-last page.

WHAT THEN, IS STEAMPUNK?
steampunk is awesome.
(being a declaration of sorts)
by a Collection of People
illustration by Ikaruga

WHAT IS IT, TO BE STEAMPUNK? STEAMPUNK is a vibrant culture of DIY crafters, writers, artists, and other creative types, each with their own slightly different answer to that question. And this difference is a good thing. Already we are seeing the cross-pollination of ideas among participants; one person creates something cool, then another takes the idea and runs perpendicularly. As each new iteration of the idea becomes more ambitious, the mutations are delightfully limitless and unpredictable. This is how culture is formed, we contend, not by codified law or canonized text.

Take as example, if you will, when a certain Jake von Slatt entered into the field of musical kitbashing with his Steampunk Stratocaster. It featured a beautifully etched brass pickguard bearing a stunning clockwork design. Robert Brown (of the band Abney Park) modified guitarist Nathaniel Johnstone's Ibanez RG-7620 guitar with real clock gears and antique wood trim shortly thereafter. This year, Thunder Eagle Guitars fully hacked a Rhoads Jackson V to create The Villainizer, a music machine coated in copper tubing and inlaid plasma balls. Each of these artists used similar themes and materials as a basis for their work, but the end results were entirely inimitable.

Steampunk art is changing steampunk fashion into its own singular look, as well. Just last year many of us wore simple, sleek, purchased pocketwatches, and now people like Haruo Suekichi drive us to brainstorm and create fantastical wearable pieces that do more than basically tell time. Last year's fashion trends amongst many emerging steampunks borrowed predominantly from neo-victorian and goth clothing, and more recently, the internet has displayed steam fashion hacking at full force. Hand-drawn patterns for aprons, hats, spats, and petticoats are popping up like daisies. It is this organic process, this near-literal blossoming of ideas, that means that DIY maker sites like Etsy.com and train-hopping street vendors will forever be more fruitful sources of steampunk garment inspiration than Hot Topic.

Like so many subcultures before it, however, steampunk is beginning to go through some growing pains. Ought our mini-societies exist as mere spin-offs from the mainstream, our social interactions functioning in much the same manner? For better or worse, we have been socially conditioned and the behaviors ingrained by the mainstream spill over into our proverbial steampunk creek. Many people who are beginning to define themselves as steampunk tend to behave in a fashion that mirrors our icy and judgmental outer world. Elitism and exclusion are two devilish habits that no one knows how to break, particularly on the internet, where steampunk currently flourishes. Even online, we are not mere faceless avatars—as commonplace behavior on message boards and blogs seems to assume—but creatures of flesh, blood, and emotion.

Why do we seem to have this nagging desire to define this culture in terms of yes or no, black or white? What *is* steampunk? What *isn't* steampunk? Why do we keep asking this question of ourselves? In long, looping threads, people attempt to set the boundaries of some steampunk nation.

We believe it is a constructive, curious urge that drives individuals to interrogate steampunk. Steampunk should definitely be questioned, but it should not be systematically restricted. Steampunk is not a pure notion; its inherent mutability and organic inclinations are what keep it beautiful and inviting. When an outsider inquires "What is steampunk?" of an insider, it is the insider's duty to the nature of steampunk to speak in terms that are descriptive rather than definitive. Steampunk can blur into clockpunk can blur into sandalpunk can blur into biopunk can blur into goth can blur into punk can blur into metal, and nobody needs to get hurt in the process! Certainly, we may refine of the idea of steampunk, but we ought not build our own cages. Indubitably, some of steampunk's natural vagueness can be attributed to the fact that it has only recently organized itself subculturally and as of yet there are no serious rules, but it is also intrinsically whimsical. It is fantasy made real.

The main problem with fixating on what *isn't* Steampunk is that the constant nitpicking hinders unbridled creativity. We begin to lock ourselves in brass boxes of homogenized, pre-packaged aesthetic. Steampunk loses its rusty allure when it becomes simple. A major reason as to why steampunk is happening and is necessary right here, right now, is because there is a desperate need to revive the DIY in a time of ossified, shattered, banal iPod culture. Annalee Newitz

paraphrases steampunk culture guru John Brownlee in her article "An Old Aesthetic for New Technology" [http://www.alternet.org/columnists/story/55942]:

> It's also, Brownlee contends, to recall an era when amateurs could contribute meaningfully to the development of science and technology. We live in a time when no single human being can fully comprehend the Windows operating system. No wonder we're nostalgic for the days when beachcombers could be naturalists and tinkerers could invent the telephone…I think the popularity of steampunk also expresses our collective yearning for an era when information technology was in its infancy and could have gone anywhere.

It's also been said, "those who say it can't be done need to get out of the way of those who are doing it." The internet is a powerful communication tool for us as an international culture, but the internet isn't our culture; our culture is in garage laboratories, on our easels, in our quills, typewriters, and word processors. Our culture is on the streets, in clubs, on city rooftops, in suburban parlors.

There will always be the folks who will see steampunk as a successful lifestyle when they can easily buy their faux-vintage goggles and toppers at the mall, and there will be those people who don't want to actually *work* at this, and it will be spirit-dampening. We will press on. We will not back down in fear of judgment or fear of being just plain silly. We will not allow the naysayers to terminate our imaginations.

Banter, debate, and disagreement are certainly encouraged—lest us be a culture of mindless say-nothings!—but so is a tip of your hat when you see a fellow steampunk on the street or at a club. "My," you may think, "I was the first to don a top hat in this town!" But does this give you right to lambaste your fellow, who was so clearly inspired by your bold act? These times in which we wish we did not live in are cruel; let us not be so.

We leave you with a quote from Jake Von Slatt:

"Last year I scribbled a multi-page 'Steampunk Manifesto' in a moleskine notebook. The exercise was valuable in that it got it out of my system, and I lost the urge to pursue it further: Is light a particle or a wave? I don't really care, but I love the way it shines through your hair…"

It Can't All Be Brass, Dear
PAPER MACHE IN THE MODERN HOME
written and illustrated by B. Zedan

Paper has proved its enormous strength by resisting the great power of gunpowder in rockets, cases, and is now used extensively for water-pipes, lined with a bituminous coating. And when, finally, its beauty is gone and its strength is consumed, the refuse still serves in the untiring hands of Industry, and rises once more to renewed beauty and usefulness; for the scanty remains, mere stray bits of paper even, are carefully gathered, stamped into a paste, pressed into shape, saturated with oil and glue, and finally finished off by an artist's hand into the thousand beautiful forms which we call papier-mâché. Tiny boxes embossed with classic patterns, and gigantic house-ornaments rivalling ancient marbles, come forth from the despised fragments; the same past makes the heads of insipid dolls and the works of art that adorn many a lordly hall.

Thus it is that paper is one of the powers that rule the day; giving work to the lowest and to the highest, drying the tears of the poor by easy employment, and enabling the genius of the artist to mould the loftiest conceptions in pliant material.

-De Vere, Schele "A Paper on Paper." <u>Putnam's Magazine</u>. April, 1868.

We live in an age of plastic. From our perspective, the materials available to the Victorians were simple things; glass, wood, metals like brass and an exciting new invention called "vulcanised rubber." In adapting and re-imagining the Victorian era to suit steampunk needs, those materials are what we turn to for historical accuracy and to achieve the right feel to a piece of work. There are, of course, drawbacks—cost and weight being most obvious. That metal, wood and glass could be prohibitive materials was not news to the Victorians.

Enter papier-mâché, which is literally translated as "chewed paper." A favoured substrate for the popular art of black lacquer work, called "Japanning"[1], in the last half of the 1800's innumerable applications for papier-mâché were in use. Of course, there were a multitude of trinkets and decorative objects, ranging from jewelry boxes and dolls to mirror frames, clock faces and architectural ornament. Beyond such fancies, papier-mâché was brought into honest service as a lightweight and portable roofing material[2], tables, and as a key part to an improved process of casting iron type for printing[3]. Papier-mâché could imitate anything, cheaply and easily:

> In the same articles it can be made, if required, far lighter than plaster, terra-cotta, metal, or even wood. Neither heat nor cold affects it; it can be sawed, fitted, nailed or screwed, quickly adjusted or removed, gilded, painted, marbled or bronzed. It can be made as light as cork, or as heavy as stone; never discolours by rust, as will iron; is not affected by temperature or oxygen, as is even zinc.[4]

And it was cheap to produce. Papier-mâché was the plastic of the 19th century.

How a relatively flimsy material such as paper can be made water-proof, fire-proof and incredibly strong is a surprisingly simple process. In sheet papier-mâché, absorbent sheets of paper were layered into moulds with a flour-glue paste. The moulds were then put in a "hot room" and dried at 200° fahrenheit. The formed pieces were then saturated with oil and put back in the hot room until dry. The final step of soaking the papier-mâché in oil waterproofed it. A cheaper method was to pulp paper scrap with water, mix it with paste and press it into moulds[5]. Extra strength for structural elements was added by forming the papier-mâché around wire mesh and a piece could be fire-proofed by adding clay, borax, or phosphate of soda to the pulp[6]. Once formed, sanded and smoothed, it could be decorated after any fashion. Popular finishes were black lacquer and enamel work with embedded shells, bronze painting, and faux marble.

What use now does papier-mâché have for the steampunk practitioner, beyond novelty? For one, papier-mâché can replace the plastic parts that sneak into our work. It's malleable, cheap and easy to use in the home, without the need of specialised tools. It is a fantastic use of scrap paper and old newspapers, is lightweight and a historically accurate material. For every reason that the Victorians chose to employ papier-mâché in Industry, so should we.

> Possibly, as a recent writer remarks, "when the forests of the globe are regarded as curiosities, and the remaining groves are preserved with the same care that has guarded historic trees, the cast-off rags of mankind, and the otherwise useless weeds, reeds, and grasses of the marsh and swamp, will take the place of timber in construction, and many will welcome the change, if for nothing else than it will obviate

much of the nuisance of frequent repaintings.
-"Practical Chemistry and the Arts". <u>Boston Journal of Chemistry and Popular Science Review</u>. August, 1882.

The basic ingredients to creating papier-mâché at home are paper and glue. That's it. For paper, newspaper is most commonly used because it is easily available. Textured or coloured papers work wonderfully as a final decorative layer, instead of paint. Many water-based glues work well in papier-mâché; watered down PVA or white glue, wallpaper paste and flour glue are the most popular options. Pulp papier-mâché is available at most craft stores, but the modified sheet papier-mâché process, using layered strips of paper, is the sturdiest and most malleable.

The overall process of creating an object out of strip papier-mâché is as follows—

1. Decide what you're going to make. A box? A goggle cup? A decorative cane topper? A mask?
2. Build the framework or mould for what you are making. Wire, mesh screen, cardboard of any type, modeling clay and even crumpled newspaper work very well as armatures and frames. Plaster or any non-absorbent shape works well as a mould. Keep in mind these questions: How light do I want the object to be? How sturdy? Will there be moving parts or pieces that need to fit together snugly? Experimentation with different forms is key. Everybody has a different way of going about things, you must figure out what works best for you and your needs.
3. Gather your materials. Paper, glue and a stiff brush for working the papier-mâché into tight spots are about all you need. It can help to take the time now to tear your paper into strips and small sheets. Consider the object you are creating, will narrow strips work best, or larger shapes?
4. Begin layering your paper, dipping or brushing each piece with your glue. Strips of papier-mâché, when layered perpendicular to one another, create great strength; topping a base of such layers with larger, smoothed, sheets can make for a finished look that is very strong.
5. Let the object dry between layers, or every other layer. This allows everything to dry evenly, avoiding buckling and mouldering. A warm oven, around 200°-250° Fahrenheit can be used to speed up the process, but direct heat can warp some pieces, as it dries them quickly, but unevenly.
6. When finished, if the piece needs to be water or weather proofed, brush three or four coats of linseed oil on it and bake the object at 200°-250° Fahrenheit until dry.
7. Uneven spots can be smoothed with spackle, and the object sanded, before applying a primer coat of paint.
8. All that is left now is decoration, a process with as many options as you desire.

A Basic Recipe for Flour Glue

This glue is perfect to use in papier-mâché and decoupage, or anywhere you'll need strength. This is just one version of the many flour glue recipes out there, experiment and look around for what works best for you. The basic ratio is 1 part flour to 2 to 4 parts water, mixed and added to 20 parts just boiled water.

- Something to mix in
- A saucepan
- 2-4 parts room temperature water (1/2 cup)
- 1 part flour (1/8 cup)
- A fork to mix with
- 20 parts water (2 1/2 cup) just boiled

Set the 2 & 1/2 cups water to boil. While it's heating, mix together the 1/2 cup water and 1/8 cup flour, dissolving any lumps. Once your saucepan is boiling, take it off the heat and add the water and flour mix from earlier. Stir well. Do remember take it off the heat when doing mixing the flour in, or you will end up with dumplings.

Simmer your flour glue until it is a thick, almost mucus-like consistency. Let cool to bathwater temperature and use. Flour glue penetrates the paper best when warm, so store any leftover in the fridge and warm it back up in a saucepan when you need it again. Adding oil of cloves, a natural fungicide, will keep it lasting longer.

A fantastic source for those interested in the many applications of papier-mâché is *The Art and Craft of Papier Mâché*, by Juliet Bawden.

Notes:

1- Ripley, George. <u>The New American Cyclopedia: A Popular Dictionary of General Knowledge</u>. New York: D. Appleton and Company, 1860.
2- "Notes and News." <u>Science: An Illustrated Journal</u>. May, 1889.
3- Partridge, C.S. <u>Stereotyping, the Papier Mache Process</u>. Chicago: Mize & Stearns Press, 1892.
4- "Practical Chemistry and the Arts." <u>Boston Journal of Chemistry and Popular Science Review</u>. August, 1882.
5- Urbino, Madame L. B., Prof. Henry Day, et al. <u>Art Recreations</u>. Boston: J. E. Tilton and Company, 1863.
6- Thorne, M.A. Robert. <u>Fugitive Facts: An Epitome of General Information</u>. New York: A. L. Burt, 1890.

THE END JUST WELL MIGHT BE NIGH, ALL TOLD

illustration by Nick Kole

Here, for our reader's fancy, we present ten different scenarios that might bring about the end of the world as we know it. Unfortunately, we cannot present this work as fiction.

PEAK OIL :

In 1956, geophysicist Marion King Hubbert predicted the end of the world as we know it. Or rather, he predicted an end to cheap oil. He said that, essentially, the extraction of oil, or any fossil fuel, would follow a bell curve.

Quite soon now the oil production of the world may enter terminal decline. But it is not the *end* of oil that frightens so many; rather it is the *peak*. When humanity hits peak oil, the results could be staggering.

The oil companies, of course, downplay the scenario. The peak, they say, is forty years hence. But many scientists claim otherwise, and a global economic disaster could be as close as 2010.

Modern industrial agriculture is entirely dependent upon petroleum-based fertilizers. The trucks which transport our plastic-wrapped goods are powered by diesel. And our demand for oil continues to rise. As demand rises and production falls, so may our entire global economy.

But there will be negative effects as well; most industrialized cities only have enough food for a few days, and the shortages might spark deadly riots. If the economic downturn is serious enough, governments may resort to drastic, and fascist, methods of maintaining their power.

Likelihood: Barring the spontaneous invention of cold fusion that would allow our society to continue unhindered [see *status quo*], or ecological collapse [see *ocean acidification*] *some* level of peak oil is essentially guaranteed.

Survival: As Peak Oil is the best-case end-of-the-world scenario, we suggest investing in such guides as "The SteamPunk's Guide to the Apocalypse."

SUPER-STAPH :

Before the 20th century, bacteria-born infection was a brutal, lethal, fact of life. Although a few cultures, notably the ancient Chinese, had developed the use of antibiotics, they remained rare and misunderstood until Paul Ehrlich's 1909 discovery of Salvarsan, an antibiotic cure for syphilis. Penicillin, much more widely useful, was applied to medicine 19 years later.

Unfortunately, the scientists who pioneered the use of antibiotics had not taken into consideration the lessons offered by Darwin and his ilk. Humans, when exposed to diseases, slowly adapt resistances and immunities to those diseases. Bacteria do the same with antibiotics.

Western hospitals, utilizing the medical equivalent of saturation bombing, simply throw antibiotics at any problem that springs up. And for years, this has worked. But these hospitals are now the breeding grounds of new, super-resistant disease strains and doctors have fallen into a desperate arms race to develop stronger antibiotics.

Staph, *staphylococcus aureus*, is our fastest-evolving foe. The first to resist penicillin—in 1947, ten years after penicillin's mass manufacture began—staph has caught up and is currently ahead. In 2003, the first case of this modern super-staph was reported.

Staph is transmittable by touch and lays dormant your skin until a cut appears. It then enters your bloodstream and travels, causing sores to erupt in different places across your body. Eventually, untreated, it is likely to kill you.

Likelihood: Super-staph is here. The only questions are how fast it will spread, and how quickly we will evolve to fight it.

Survival: Keep your immune system strong by eating food from the trash. Avoid hospitals.

THE SINGULARITY :

The technological achievements of humanity, if plotted on a chart, show an exponential rise. We figure things out faster and faster, and these new things allow us to figure out *newer* things faster and faster. There are some who predict that this exponential trend will continue until new discoveries are made at a near infinite rate.

Essentially, these futurists claim, parts of humanity will become gods; much like eugenics, proponents of the Singularity advocate for a breed of super-humans so intensely *capable* that the vast majority of humanity is simply outdated. This may be accomplished by cybernetics, genetic engineering, nanotechnology, artificial intelligence, or any combination thereof.

The tortures of flesh, the world of sin, will be washed away as we become one with machines. Our consciousness will be freed from the prison that is the body. To some, this is the techno-rapture. To others, this is the end of the world. If our technological capacity approaches omnipotence, there is no limit to the good or ill that may result.

Likelihood: The "bell curve" model casts some doubt as to the likelihood of the singularity, but continued exponential "progress" is not to be ruled out entirely.

Survival: Humanity 1.0 stands a rather weak chance when combating humanity 2.0, and the best chance of survival would come from preventative measures or by hoping you are not left behind.

NUCLEAR ARMAGEDDON

When the Stalinist USSR finally collapsed in 1991, when the Cold War came it to its whimpered end, the threat of nuclear winter melted in the warm spring air. Did it not?

There are a documented 20,000 active nuclear warheads in the world today. The USA and Russia top the list, of course, but the United Kingdom, France, China, India, Pakistan, and North Korea have them as well. Israel is widely and profoundly rumored to have nuclear weapons, and South Africa at the very least *used* to have them.

But any industrialized nation could be only a year or two from nuclear testing, and it is a well-rehashed meme that warheads could be obtained from ex-Soviet republics.

The American Geophysical Union has asserted that even a regional nuclear war—such as between India and Pakistan, or Israel and its neighbors—could disrupt global climate for decades [see *Runaway Global Warming*].

Nuclear holocaust is possible. Millions will be incinerated in an instant. Billions will die slowly of radiation poisoning. Soot will blacken the sky, dropping temperature to dangerous levels in a Nuclear Winter. The ozone layer will deplete, so when winter subsides a Nuclear Summer will take over. Far away from the blasts, millions will die as global fallout settles and poisons the waters. Electromagnetic pulses put out by the blasts will destroy nearly all 20th century technology (at least some good will come of it, then!).

Likelihood: At the moment, politics are comparatively stable between the nuclear powers. But as the waters rise...

Survival: Consider investing in a complete, self-sustaining fallout shelter that is mechanically powered and will house hundreds, for hundreds of years. Finally, you'll have the time to finish writing that novel you've been working on.

LARGE HADRON COLLIDER (LHC) :

The work of thousands of scientists from dozens of countries will come to fruition in May 2008, when work is completed on the Large Hadron Collider that sits underneath Switzerland and France. The scientists hope that this 17-mile long circular tunnel, the first particle accelerator of its kind, will unlock the secrets of the universe, but skeptics in the physics community say it risks bringing human life to an abrupt end.

The scientists seek God. Or rather, the "God Particle"—a hypothetical sub-atomic particle that lends mass to the

massless, that, much like Aether, fills the "void" of outer space. Apparently, all of modern physical science is founded on the existence of this unproven particle. Like demonologists of old, the scientists hope that with their fantastic circle they will summon forth the God Particle, or disprove its existence once and for all.

But of course, this summoning bears certain risks. Protons, sped up to 99.9999991% the speed of light, are kept circling by colder-than-deep-space super-conductive magnets. Then the protons are slammed into each other.

The scientists hope that the protons, when collided, will collect with their energy to form the God Particle. Any black holes produced in the process, officials assure us, will be benign: the theory is that any black hole, once created, will be evaporated by *Hawking radiation*. The existence of Hawking radiation is still unconfirmed. The odds of creating an artificial black hole that will devour the earth within minutes are quite slim, they claim, but existent.

And then, of course, there is the chance that the experiments might create strangelets, the things that might be inside neutron stars, and turn our entire world into a different sort of matter.

Likelihood: Neither impossible nor likely.

Survival: We suggest that an old-fashioned diver's suit be converted to black-hole duty.

RUNAWAY GLOBAL WARMING:

So when the average global temperature goes up a few degrees, it will scare humanity into adopting greenhouse gas restrictions and the like to ease ourselves out of the crisis. Right? Possibly. But there's a cliché about "the best of intentions" that just might apply. Quite unfortunately, there's something called positive feedback. Western Siberia, as an example, has seen a 3° Celsius temperature rise—and buried under melting permafrost is a peat bog larger than France and Germany combined. That permafrost—in place since the last ice age—began to melt a few years back and will potentially double the amount of methane in our atmosphere.

And western Siberia is not alone; there are similar *clathrates*—trapped methane pockets—all over the earth. 251 million years ago these pockets erupted into the atmosphere, and nearly every form of life on Earth was wiped out, for 20 million years.

It is quite possible we have less than 10 years to all but stop the human addition of greenhouse gasses if we are to prevent runaway global warming.

Likelihood: A lot of people will tell you a lot of things, for a lot of different political purposes, but at least some of us here at SteamPunk Magazine are nearly paralyzed with fear.

Survival: Survival, if it can be called such a thing, may only be found in subterranean, self-sustaining colonies. We suggest you pack a book to read, since you will be underground for longer than the human race has previously existed.

OCEAN ACIDIFICATION:

The ocean: where life on earth began. The ocean: the bottom of the food chain, on which all life depends. The ocean:

destroyed by the Industrial Revolution?

When we began to spew coal into the air, the oceans began sequestering the excess carbon. But as they did so, their pH began to drop—from 8.179 in the 1700s to 8.104 today. The Royal Society of London—not exactly a group of paranoid environmentalists—predicts that it may fall as low as 7.9 by 2100. Although this may seem negligible, it represents a greater change than the earth has seen it at least 2 million years, and at such a rapid pace that ocean life may not adapt.

Specifically, the change in pH increases the hydrogen ion content of the water, reducing the ability of calcifying organisms—coral to crabs, phytoplankton to mussels—to form their "bones." Even the "higher" life forms of the ocean, such as fish and squid, will find the oxygen content of their blood going down, leading to weakened immune systems or even asphyxiation. It doesn't take much of an imagination to realize what will happen to the earth when the bottom of the food chain is cut out from under it.

And it may already be too late; like so many anthropogenic effects on our greater environment, the acidification of the oceans does not happen overnight. The lag between cause and effect can take scores, if not hundreds, of years. We have no idea what we've gotten ourselves into.

Likelihood: Given the inability of the global powers to sufficiently address the issue of carbon dioxide, and the fact that it may already be too late, we *will* see adverse effects from the acidification of the ocean.

Survival: We recommend the construction of an ark-dirigible, with one of each of every species of plant and animal you would like to eat, and then floating above the earth.

NANOTECH GREY GOO :

Imagine: A creature—seeming innocuous, seeming benign—that reproduces at a breakneck pace and excels at turning organic and inorganic materials alike into machines. No, not humanity [see *Status Quo*]. Nanotech robots.

Nanotechnology seeks to build machines atom by atom, machines smaller than the eye can see. Once created, nanotech robots could change *everything*. From shirts that repair themselves to inorganic "drugs" that confront disease in the body, from holograms to cheap manufacturing, nanotech offers to revolutionize society.

Or, alternatively, to turn society into nanobots. Nanotech pioneer Eric Drexler warned us back in 1986 that self-replicating robots, unleashed, could literally devour our world, breaking down matter and reforming it into their own likeness. The entire planet would be converted to a grey, living goo of robots. This process is called *ecophagy*: the devouring of an ecosystem [fears also associated with *genetic engineering* and *mono-culture*, not covered in this article].

Such a dastardly creature could only be the work of a mad scoundrel, of course, if it were created intentionally. And there is doubt as to whether such a scenario is even physically possible, owing to limitations in energy sources, competition with organic species, and other factors.

But Grey Goo is not the only threat that nanotech brings to bear: consider the ramifications of robots aimed to destroy only one (or all but one) race of people. And the economic and ecological ramifications of molecular manufacturing remain unknown and unknowable.

Likelihood: Unlikely.

Survival: One can only hope to defend oneself from the encroachment of self-replicating invisible monsters by utilizing the same method of defense that the Pope used during the Black Death: surround oneself with flames at all times.

THE END OF THE MAYAN CALENDAR:

THE MAYAN CALENDAR IS CYCLICAL, BEST UNDERSTOOD AS A series of wheels within one another. And the largest wheel, the Long Count, which is 5125.36 years long, is set to come full circle on winter solstice, 2012.

A vast diversity of doom-preachers and new-age welcomers have put a remarkable amount of faith into December 21st, 2012. A major cataclysm will strike. Magic will reenter the world. The magnetic fields of the sun will swap. The sun will enter the dark rift of the milky way, "the road to the underworld". That world-snake, Ourboros, will eat itself. The world will be reborn, whether by fire, revolution, or magic.

Supposedly.

One person I spoke to, reporting back from his extensive travels, said that it will not be a sudden shift, but rather the far end of the pendulum's swing. December 21st, 2012 will represent humanity at its worst, and will mark the swing back towards a saner world, more connected with its landbase. We hope he's right.

Likelihood: Prophecies are best fulfilled by people, not fate. We consider it likely that any upheaval on or around the end of the Mayan calendar will be the result of humanity and not the universe itself.

Survival: Well, if magic is coming back, survival will be most adequately met with the summoning of three-headed hunting dogs. But if the sun's poles swap, we have to recommend the old "hide underground for several thousand years" contingency.

STATUS QUO:

WHAT IF METEORS *DON'T* STRIKE THE EARTH? WHAT IF THE Christians *aren't* summoned up in the Rapture? What if 2012 comes and goes without any change? What if we effortlessly, and voluntarily, shift to cold fusion power, reducing our carbon emissions, and prevent further global warming?

Then the farmers in India will continue to be born in debt to Monsanto, the producer of the terminator-seed genetically engineered crops that undermine the harvest's health and the farmer's autonomy. Then mandatory minimum sentencing will continue to affect the urban poor disproportionately, and one third of black males in the United States will continue to be in some stage of judicial process. Then laws will continue to pass that allow the extraction of wealth and resources from developing countries while banning the movement of people.

Ecosystems will continue to disappear, species will continue to go extinct. Languages will continue to go extinct. McDonalds will still exist, and it will continue

to feed remarkably unhealthy food to a widening global consumer base.

Biodiversity will continue to decline, and fewer and fewer varieties of apples will be grown. Women will continue to be afraid of men on the street—and one third of them will continue to be sexually assualted. Politicians will continue to lie, and factory farms will continue debeaking caged chickens. People will continue to sell their time and their lives to companies they don't respect, working factory lines or serving coffee or shuffling electronic paper.

Religious zealots will continue to smite in the name of monotheism and imperialist nations will continue to pummel the world with bombs.

Is it really any wonder that our society turns more and more of its attentions to the potentials for a disaster to save us from the disaster we're in? ✺

Sources:

peak oil
http://energybulletin.net/primer.php
http://en.wikipedia.org/wiki/Peak_oil

super-staph
http://en.wikipedia.org/wiki/Staphylococcus_aureus
http://en.wikipedia.org/wiki/Antibiotic
http://en.wikipedia.org/wiki/Antibiotic_resistance

the singularity
http://en.wikipedia.org/wiki/Technological_singularity
http://www.aleph.se/Trans/Global/Singularity/

nuclear armageddon
http://en.wikipedia.org/wiki/Nuclear_fallout
http://en.wikipedia.org/wiki/Nuclear_summer
http://en.wikipedia.org/wiki/Nuclear_winter

large hadron collider
http://www.newyorker.com/reporting/2007/05/14/070514fa_fact_kolbert
http://www.exitmundi.nl/vacuum.htm
http://en.wikipedia.org/wiki/Large_Hadron_Collider

runaway global warming
http://www.guardian.co.uk/climatechange/story/0,12374,1546824,00.html

ocean acidification
http://www.royalsoc.ac.uk/displaypagedoc.asp?id=13539
http://en.wikipedia.org/wiki/Ocean_acidification
http://iodeweb3.vliz.be/oanet/FAQeco.html

nanotech gray goo:
http://www.crnano.org/dangers.htm
http://en.wikipedia.org/wiki/Ecophagy
http://en.wikipedia.org/wiki/Grey_goo

the end of the mayan calendar
http://www.greatdreams.com/2012.htm
http://survive2012.com/

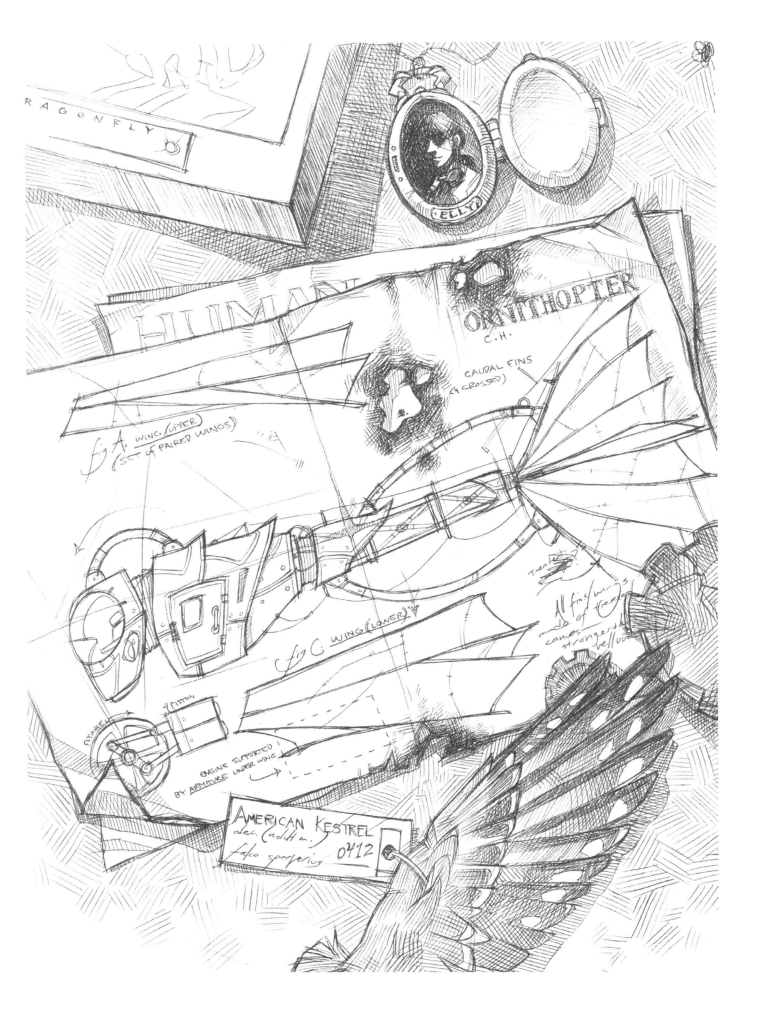

The Ornithopter
by Will Strop
illustration by Claire Hummel

Cyrus wiped a drop of sweat from his brow. After twenty years of saving up and five years of work, and he had only one last bolt to tighten to finish the prototype. The villagers had called him mad for this project, but soon he would prove them wrong. With a final, steady pull, the meter-long wrench slowly came to a stop. He grinned for the first time since he had finished the machine's blueprints, slowly climbed down the ladder, and eased it away from the contraption. He had sunk too much money and effort into the thing to risk denting the hull with a falling ladder.

Cyrus was a tall, gangly man of fifty-five years. He had kept his head clean-shaven ever since an incident involving a rogue cherry from his welder and an unfortunate choice of pomade. His face and hands were blackened with soot, his brass goggles smeared with half-hearted attempts to wipe them clean. He sighed, removed the goggles, and rubbed his green eyes, smearing filth onto his formerly be-goggled skin. His shirt had once been white, but it was now splotched gray with grease and soot around his forearms and sepia from sweat around the armpits, back, and neck. His ruddy brown waistcoat was spattered with engine grease, his grey slacks showing the wear of age and long hours of labor.

It was in this state of apathetic dishevelment that he stepped back to look at the complete device for the first time. It was coppery all over, with a truss protruding from the back of the device tapering from about a meter square at its base to a fine point which terminated in a pair of fins, fanned out like a fish's tail—but at the horizontal as well as the vertical, and covered. Two brass rods connected to the main support of each fin and a pair of cables ran back to the bulbous front end of the machine.

At the junction of the truss and what could only be called the thorax of the machine was the engine that drove the rest of the machine; its driveshaft connecting to a flywheel that was, in turn, attached to a quartet of carefully timed pistons. These were affixed one each to a wing. The wings, like the fins, were covered in laminated canvas, but were about six meters long each and reminiscent of a dragonfly's.

The "head" of the machine was pear-shaped, with the truss sticking out where the stem should. At the front of the mass was a pair of domes arrayed similar to the eyes of an insect and fashioned of copper supports and glass panels. Brass rods not unlike those found on many musical wind instruments seemed to spring from the bottom of the front end of the machine and wind their way to various protruding bits of machinery, their purpose indecipherable at a glance.

Inside the cockpit was a brown leather seat set snugly behind a console festooned with pressure gauges, levers, knobs, buttons, and ill-hidden warning klaxons. A pair of skids held the machine one meter aloft, their supports centered underneath the bulk of the engine at the back of the bulb. A pair of large pipes thrust thirty centimeters upwards and forwards from the engine, only to tilt towards the back of the vessel at an acute angle for a meter.

The ornithopter was done, and soon Cyrus would fly it. Nothing could bring him down now except, perhaps, the snores emanating from a rumpled mass of clothing, hair, and flesh huddled in a chair by the workbench. He looked over to his young assistant, with no small amount of disdain, and walked over to her. She had helped, true, but her work ethic was terrible, and now it was threatening to ruin his good mood.

"Get up!" he said, nudging her side with the wrench. "It's done!"

"Can't it wait 'till morning, dad?" she whined groggily, pointing at the clock on the back wall of the workshop. "It's two in the bloody morning!"

"No, no I don't think it can," He said. "Mankind has waited since time immemorial to fly, and I'd rather not risk the world ending before we finally get around to it! Now get up and help me open the hangar doors!"

She groaned as she got up, but when her father got like this there was no use arguing. She had protested when he first proposed this crazy idea, but that had proved useless. He had kept quiet about the ornithopter for two decades while saving up "for a rainy day", but five years ago he had finally started work on it. Within a month everyone in town had known he was a madman, and from there the strange looks from the townsfolk had grown more pronounced, but had spread to Elly by association, as if some manner of contagion was at work in the family. It had been a natural turn of events to relocate the research to the mountaintop, and ultimately, Elly had been kind of pleased when the move came to pass. The isolation had meant she didn't have to put up with people's pity, and there was always the possibility that the bloody machine might work. In the meantime, she enjoyed the comforts of her semi-forced hermitage.

Her clothing those days, for example, was not so greatly different from her father's. Truthfully, some of her clothing *was* her father's, a fact that would likely further scandalize the family in town, if anyone actually visited.

On that grand occasion, a black waistcoat with one of

her blouses and a pair of grey slacks had to do. And while she used to wear delicate necklaces in her youth, she had long ago replaced them with a pair of goggles, around her neck for easy access. Her hair, once perpetually in intricate braids that ran to her knees, was now a frizzy mess, most of it kept in a ponytail. She had no idea if she would be ever get used to corsets again when she moved back to town. Indeed, aside from her lean physique and her modest assets, the last bastion of her outward femininity was the white ribbon she used to keep her hair up.

She thought of this as she pushed open a ten-meter-high hangar door along its curved track, opening the workshop to a five hundred meter sheer cliff. The town's gas lanterns were only barely visible from the vantage point of the hangar, but she could still trace the outline of the streets from memory and squinting. Her father the madman had decided a cliff would be the best place to launch from, figuring that the fall would help the machine pick up speed for lift. The argument that if the thing wouldn't fly then he's as good as potted meat at the bottom of the cliff seemed to carry no weight with him.

The hangar door locked into place easily enough, as the machinery was fairly well used and maintained. Elly had managed to convince her father that it would be irresponsible to not rehearse the launch every now and then, so every month for the last two years they had gone through the motions. She broke from the plan for the first time in eighteen months by pausing with her hand on one lever of three at a console by the turntable in the center of the room on which the ornithopter was perched.

"Are you ready?" she called to her father. "Are you sure you don't want to at least get a witness or three from town, first?"

"Quite," he said, checking up on the pressure regulators on the ornithopter. "I have nothing to prove to those rumor-mongering doubters… We're doing this for science, not fame!"

Elly sighed and pulled the lever, engaging a pair of engines meant for locomotives. One rotated the turntable to line the machine up with the launch track while the other raised the thirty-meter long launch ramp from the cliff face. Both engines vented surplus steam into a reservoir tank, building pressure that would eventually be released all at once via steam catapult, sending the ornithopter into the air with a running start against gravity. Cyrus, having finished checking the pressure regulators, had moved on to loading the ornithopter's coal hopper and stoking its furnace. Lazily, the wings began to oscillate up and down as the engine built up heat and pressure. The combined chugging of the engines eliminated any possibility of vocal communication, so the rest of the procedure was coordinated with hand signals.

Cyrus opened up the cockpit of the device and climbed in, letting the hatch close behind him with a dull thump. After a couple minutes the turntable and ramp were settled into position, so Elly pulled the second lever, which both lowered the machine onto the track and redirected the full steam pressure from the shop engines away from their pistons and directly towards the reservoir.

She then moved her focus onto the central dial on her console, the pressure indicator for the steam catapult. The dial itself was divided in three parts. The bottom left quarter of the dial was pure white. Releasing the steam at this point wouldn't even drive the ornithopter's mass off the launch ramp. Running clockwise from the white sector, a field of yellow dominated the following five eighths of the dial. This sector marked the launch window of the vessel, the sweet spot that the needle would enter in roughly thirty seconds and exit in one hundred twenty seconds. After that, the remaining eighth of the dial was red. At some indeterminate point after the needle entered the red zone, the reserve tank would likely explode.

That is what Elly thought about as she looked back at her father in the cockpit, waiting for the thumbs up for launch, a signal that arrived with the needle pointing roughly at the three o'clock position. A quick pull of the third lever, and with a rush of steam the ornithopter hurtled into the sky… and promptly dropped. The locomotive engines shut themselves down automatically with the release of the steam tank, and as her ears adjusted once again to reasonable noise levels, Elly became aware of the chugging of the 'thopter, growing quieter with every second. She knew that if they had failed, she would hear the rhythmic swishing of the machine's flapping be replaced by a crash and silence in the next ten seconds or so. She began counting quietly to herself.

"One," Elly whispered. As the puttering of the machine faded from hearing she wondered if she even wanted the thing to work.

"Two." After all, however self-centered or single-minded her father had become while working on this project, she had no frame of reference for what success might do to his psyche.

"Three." She thought it most likely that the proof of his own experience would catapult his already shaky mind into a sort of evangelistic obsession that would not stop until every man, woman, and child alive accepted his achievement as the greatest in human history.

"Four." If they failed, she could at least go back to living a normal life.

"Five." A life without her father, a life in which she could be herself without people judging her by her father's madness—

"Six." But then, that wasn't entirely true.

"Seven." If her father died, she'd have the pity of his tragic death and the legacy of his fantastically complex suicide hanging over her for the rest of *her* life.

"Eight." If the thing flew, then at least she could take pride in her own non-negligible handiwork on the machine—

"Nine." And yet, she still couldn't decide what to hope for when she mouthed the next word.

Cyrus had surprised himself. He had expected himself to let out a yell, some sort of whoop and holler, when the machine lurched forward. He did not. Instead he looked coldly at all the dials and took hold of the levers at either side. On his left was the throttle. On his right, the control stick. He was clear of the launch ramp within a second of the ornithopter's jarring start, putting him exactly five hundred

meters above the base of the cliff. It was only after he felt himself free of external movement that he pulled the throttle as far as it would go and pushed the control stick straight away from him, angling the horizontal tail fin's leading edge down.

What followed was his second surprise: the machine didn't immediately gain altitude. He closed his eyes, looking over the schematic of the craft with his mind's eye, tracing every cog and cam, every pipe and pressure valve on board, and eventually he snapped himself out of the resulting reverie. He opened his eyes and thrust the throttle away from him. Instantly, the engine-stoker began feeding more coal to the furnace, pumping more heat into the boiler and building steam faster.

The fall slowed, but he knew he didn't have long to start gaining altitude before gravity would punish him for his offense against it. Steadily, the vessel slowed its fall, picking up more forward movement as well.

"That's good," he thought. "That ought to buy me a couple more seconds…"

He could feel the craft building lateral speed, and that speed gave it the lift it needed to stop falling. No… The device was not merely "not falling," the machine was *flying*. This marked the first time in mankind's history that one of its own had broken free of the tyranny of the earth, and he had done it with his daughter. His daughter… She had to get a close-up look of the machine in action. *After all*, he thought, *it's not every day Sisyphus manages to get the boulder all the way up the hill.*

With a clumsy fumble of the control stick he guided the machine upwards in a spiraling pattern. He made mental notes on the performance of the ornithopter, on how to improve its maneuvering, its speed, and even its lift as he looked to either side of the device, at the wings as they flexed in-flight. When he was high enough, he looked back at the workshop to see Elly standing at the edge of the ramp. He angled the control stick into a wider spiral at an angle he estimated would allow him to swoop right over her.

Suddenly, a klaxon sounded. Cyrus blinked, eyes checking all of the cockpit's indicators and resting on a gauge to the left of the central dial, the boiler temperature indicator. The furnace was cooling rapidly, and as a result the 'thopter was losing steam pressure. More klaxons sounded as the pressure reached dangerously low levels. The ornithopter lurched, and Cyrus could hear the sudden clank from a wing. The coal hopper chugged as the vibration loosened the clog. Slowly, one by one, the klaxons silenced themselves, and Cyrus snapped himself to awareness of the world around him again. He hoped the "clank" was just the wing tapping the ramp… A cam sticking could damage the machine's gears.

"Ten." The puttering was still there, but still growing quieter. Elly walked slowly towards the edge of the hangar, not quite sure what to expect or hope for when she reached it. She wasn't quite ready to believe what she saw when she did.

The ornithopter was moving forward at a terrific pace, but it was getting dangerously close to the ground. Steadily, it leveled off, and then began to rise. It was flying under its own power, she realized. It took a couple tentative turns, and then started to spiral up parallel to the cliff. She found her feet moving her to the end of the launch ramp as she watched that impossible machine exult in the glory of the loophole Cyrus had found in the laws of physics.

The ornithopter reached the level of the workshop in short order and curved gracefully towards it. *No… not the workshop*, Elly realized. The machine was swerving towards the ramp. She could swear she could hear klaxons going off in her head, but as much as she resented the thing she found she *had* to see it closer and this would give her the perfect opportunity.

Inexorably, the machine approached and as it did, the klaxons grew louder. Intellectually she knew that the 'thopter was too high to hit her or the ramp, but she still thought it prudent to get out of the way. She backed slowly towards the workshop, her eyes tracking the device's approach. Her heart leapt when she saw the vessel begin to lurch. Too late, she began to duck away from the wing.

The clank peeled a chunk of her scalp away from her skull, but it did not knock her unconscious. Staggered, she was wholly unready for the draft in the wake of the wing's upstroke. Woozy and off balance, the air pressure was enough to lift her off the platform. Her thoughts came to her slowly and muddled as she fell, like she was trying to read them through a series of fish-eye lenses off waterlogged newsprint. She had just come to the conclusion she would not survive the fall and was about to tackle the conundrum of how much time she had left, but gravity cut her train of thought short. ⚙

an interview with Alan Moore
illustration by Juan Navarro

Your "League of Extraordinary Gentlemen" has done more to popularize the steampunk aesthetic than perhaps any other book. How did the book come to be?

Oddly enough, it didn't really grow out of a steampunk aesthetic—it perhaps grew *into* one. I'd read some interesting exponents of the steampunk genre, people like Tim Powers, K.W. Jetter, and some of the later exponents—I don't know whether Neil Stephenson's *The Diamond Age* would qualify, or if that's nanopunk—, I'd been interested in a lot of those stories, and I'd enjoyed them. But as for *League of Extraordinary Gentlemen* and where it came from, it grew out of *Lost Girls*. We were having such fun, myself and Melinda Gebbie, doing a pornography upon three established literary characters, that it suddenly struck me delightedly: "hey you could do the same thing with an adventure book." You'd have the invisible man, and you'd have Mr. Hyde, and you'd have Captain Nemo, and eventually, after much thought, arriving at Mina Murray [from Dracula] as the principal female character. Then we sat down to do the book, and we started out with this very simple, even simplistic, idea of a kind of a Justice League of Victorian England. But when Kevin [O'Neill] started to approach the artwork—and started to do things like designing a more faithful and exotic version of the nautilus—he started to feel as if this story was set in a world where various Victorian fantasies and fictions had actually

happened. That tended to color the kind of architecture that Kevin showed, the kind of technology, in terms of motorcars or other vehicles of the period.

I think that it was probably halfway through the first issue where I suddenly realized that I'd got Stephenson's Mr. Hyde murdering Emile Zola's Nana on Edgar Alan Poe's Rue Morgue, that I suddenly realized that there was a fantastic possibility to actually make this book into something pretty unprecedented; if we made every character in the book a character that was taken from previously existing fiction, then the book would suddenly become this mad amalgam of almost every fiction world that ever existed.

With the second volume it occurred to us that we could perhaps extend and undermine that by having this almanac of fictional places in which we tried to tie up and tie together every place in the fictional world. In the next League of Extraordinary Gentlemen (which will be the last one from the hated DC/Wildstorm axis), *The Black Dossier*, we provide a timeline, reaching from before the origins of mankind right up to the present day, in which we give a timeline for the entirety of the fictional planet. Most of it is in the form of the life of Orlando, an immortal character who we date back to the 12th century BC in ancient Thebes. What this does is it builds up this incredible world, very 3 dimensional, in which every fantastic story or non-fantastic story that you may have read about probably co-exists. And this is not a new idea to me; ever since the story of Jason and the Argonauts, people have wanted to think: "what would happen if my favorite fictional heroes all got together?" Certainly in the 19th century, that was very prevalent, with Jules Verne writing the sequel to Edgar Allan Poe's *The Narrative of A. Gordon Pym*. You've got a huge amount of crossovers; all we've done with the league is take that to its ultimate extreme where everything is potentially crossed-over somewhere in the pages of the League. And that's where the idea came from and what it developed into.

Those first two volumes are probably the two that steampunk enthusiasts will most respond to, because with *The Black Dossier*, and with the subsequent volume 3 that me and Kevin are working on at the moment, we move out of the Victorian era. *The Black Dossier*—even though its got material in it which starts in the dawn of time and comes up to the present day—the narrative sections of it are mostly set in 1958, which we found to be a time every bit as distant and peculiar as the Victorian era when we sat down and had a look at it. *Volume 3* on the other hand is comprised of three parts: three 72-page standalone chapters that are each set in a different time period. The first part is set in 1910, and has got various events that revolve around the opera, so we've got Mack the Knife and Pirate Jenny showing up, along with a few other late Victorian, early Edwardian characters. In the second issue its all set in 1958, and in the third one its set in the present day, in 2008 as it will probably be then. So we didn't want to make a fetish of the Victorian era. We may well have other stories set at some point in the Victorian era, and certainly we're going to be setting some stories before the Victorian era, in the past. Although it's an incredibly rich period to indulge yourself in, I think that after *From Hell*, *The League of Extraordinary Gentleman*, and *Lost Girls*, which I suppose is Edwardian, I felt that I was in danger—as much as I love that period—of being pigeonholed as a sort of Victorian Edwardian freak. In fact I'm equally interested in almost every period, they all have something to recommend.

Do you have any thoughts about steampunk as an aesthetic or its potential as a culture?

Well I think that steampunk, if I'm reading it rightly, is a kind of a manifestation of an ethos that is becoming more prevalent in culture today. It seems to me that at this juncture of the 21st century we are more aware of ourselves—we are more aware of our past—than culture has ever been before. Because of the internet, because of our tremendous archives that we've accrued, the culture of the past is open to us. And as we look at it, we can see that it's a fabulous junkyard of ideas that may have been incredibly beautiful—and may have had an awful lot of life left in them—that have been discarded by the relentless forward rolling of culture and our insistence upon new things every day. I think that we're now in a position where we can look back at the wonderful, glorious remains of our previous cultures—our previous mindsets—and we can use elements from that treasure trove to actually craft things that are appropriate to our future.

I think that in many respects that is the definition of "decadence" as it was given by the decadent writer Théophile Gautier who said that the decadent writer should feel free to borrow from the most gorgeous and sumptuous of ancient legends, and at the same time should borrow from technical vocabularies—from the most up-to-date pieces of writing—to be able to bring the past and the future and the present all into a kind of glorious stew. And I think that at its best, that is perhaps what steampunk is attempting. It is taking these abandoned elements that probably got nothing wrong with them at all and were perfectly functional but had simply been left by the wayside, from our previous culture, and putting them together in a new way in order to create ideas that will help us to extend ourselves into the future. I mean that seems to me to be what steampunk, whether consciously or not, is doing.

I think that that art, technology, media, this is all changing the basic way in which we see time. I think that until fairly recently we've seen the progress of time as a kind of conveyor belt where we are dragged through it from the past into the future; there's nothing we can do about it, and the landscape of our past—once the conveyor belt has left it behind—is gone forever. Whereas that's not true at all: all of the ideas of the past, which are the most precious commodities of the past, are all still entirely within reach. And I think that some people, like perhaps the steampunk writers, are realizing that it's possible to embrace the past as a means of progressing into the future. It is not simple nostalgia. That would get tired really quickly. It's essential that there be some progressive, forward-looking aspect to the way that we utilize these bright fragments of previous culture. Looked at from my perspective, where I'm not consciously a steampunk, I would think that that is probably what it's about.

MY MACHINE, MY COMRADE

illustration by Juan Navarro

My Dear Friends,
I'm writing you from New York. The party guests all retired hours ago, leaving a mountain of dirty dishes and half-digested conversations. A winter fog resists the first rays of yet another morn. Despite the deep and oft written-about silence and solitude of this unique hour, I assure you that I'm not without fine company. Below my sofa, the choir of radiators sings praises to the living gods among them. The tidal ticks of the grandfather clock continue unabated, calling out to me. In fact, this entire chamber bristles with the activity and purpose of my mechanical comrades.

I pen this to you, my friends, to share with you the idea of universal brotherhood (and sisterhood) we need to extend to the world mechanical. It is not only for them—but for our own salvation and sanity—that I implore you to indulge me further.

I can already hear the easy dismissals of this sincere call. Many may think that the poor Professor has spent too much time in the company of the needle. Still others, even those I regard fondly as friends, will misunderstand this as

a sly joke manifesting from a bored mind and a malingering nature. While I do not deny that I have an appetite for excess and have been rightfully accused of shirking what passes as work, I assure you there is a truth buried in this missive. A new relationship to machines is not as absurd as you might first imagine, nor is it even a new concept. If it were not for the violent uprisings of communist totalitarianism and national fascism, I am convinced that these first imagines may have been allowed to develop to maturity.

I shall keep you in suspense no longer, and throw my imperfect proposal to your discrete judgments while making good on a promise to those without tongues to speak. In short, *I propose that humanity must reconsider its view of machines. It must make league with them, and accept them, limited as they may be, on fraternal terms.* Equality is not what I suggest we offer, but instead the dignity and pluralism of co-inhabitants of this material reality. This is not a call for altruism, but for actual salvation. I do not think it too melodramatic to say that we, as the inheritors of humanity, are at a perilous crossroads where annihilation dangles off the tines of this historic fork.

It is an ancient idea that, to remake humanity, we must readjust our relationships with the material world. Not all of us are at liberty to jettison this mortal field for the divine and delusional delights of heavenly assurances. I propose that we, as rational animals, seek to draw on our reason to determine our relationships to this maddeningly real world and leave speculation of the spectral to others. I shall not over-tax your indulgence by tracing my ideas to Heraclitus, but start with the birth of the bloody quest to re-make humanity on an immense, even global, scale—the Russian Revolution.

In the bloody nights that followed those shaking days that stunned the world, Russia took the pursuit of re-imagining humanity further than any others since the French drew up that Doctor's gleaming blade. Rodchenko, the artist and philosopher, is today the best remembered of the Constructivists. The Constructivists were a motley collection of artists, engineers, and political-philosophers all stoked by revolutionary fervor. They sought to create a material life that was consistent with Marxism and that would bring art and engineering together, a dream similar to that of Gustave Eiffel (the maker of the famous Parisian tower). They believed that workers needed to approach the means of production in a different way, one infused with art that would inspire as well as ease their labors for the new red dawn. They understood that material things shared a bond with all materiality (which includes you and me). They understood that this relationship was malleable and not predetermined. It could range from the crass commercialism of disposable culture we see today—in the so-called civilized societies—to the absurd animism of the "savage" past. These Russian artists cum engineers rejected both the commodification and divinity of tools and technology. Seeking a relationship of merit built on work, a

rising of labor both human and mechanical. I—an infamous and unrepentant shirker (or Lumpen as they would have it)—can only travel part of the way with these red avant-gardists.

A decade earlier, F. T. Marinetti was penning his famous Futurist Manifesto, where—under his insatiable bloodlust and hatred towards all political progress (e.g. feminism)—he sings the praises of machines. The futurists would go on to suggest that the machine, not the human, is the ultimate creation, superior to flesh, morality and the "uncountable and pathetic weaknesses of man." Futurists take animism to a new and brutal extreme, suggesting that all biological creatures (humans and even dear Fluffy) are inferior to the beauty, speed, and power of the machine. At best, we can seek to vicariously experience true perfection through an obssessional devotion to the mechanical. Marinetti and his ilk believed war to be the ultimate manifestation of the mechanical over the biological, speaking of how easily the "heroes of Roman" could be turned into so much "meat" by the machines of war. I bring the mad impolite ravings of the Futurists to you, not just because they made some lovely art, but because they underline the need to understand and possibly develop relationships with technology.

Both groups tried to invoke their ideals into existence through art. Both were ultimately eclipsed by dictatorial politics of their day (communism and fascism). Both groups despised museums, yet ironically museums are the only places their ideas (or the shadow of their ideas) still reside.

Both groups made the mistake of hierarchical thinking (among other faults). The constructivists sought to make the machine subservient to the noble worker and the Futurists sought the opposite. They both dared to envision a new relationship between machine and *homo-sapiens*, based at their core on inequality and subservience. I sincerely believe, and it is my hope, that steampunk can go some way in addressing this error. That we, as more than a genre of eccentricity, can help remap this primary relationship.

I do indeed believe steampunk seeks to liberate the machine from simply existing as an instrument of work, while at the same time not elevating mechanical forms above all else. From these ideas a synthesis is born. Steampunk seeks to find a relationship with the world of gears, steel, and steam that allows machines to not only co-inhabit our world but to be partners in our journey. To be born, age, and die like we all must, that is not only true of humans, plants, rivers, animals but also of machines. This may be a crucial realignment of our relationship to the world, man-made and natural.

Humans are confronted with a plague of crises, ranging from climate change to the demise of capitalism. We currently inhabit a planet fraught with mass extinction of biological species and the beginning of colonial resource wars. The problem is not with technology, but with our relationship to it. We sit in our cities as tsunamis of mass-produced commodities rise around us, threatening to drown all of us as it suffocates the planet. Mass production, war, and the factory farming of animals all suggest a worldview positing that everything is disposable. This barbaric callousness even extends to our fellow humans on the other side of the globe.

Steampunk seeks, like the constructivists, to rediscover the inherent dignity of created objects. All machines, mechanical or otherwise, come most originally from the physical world—as do all of us—and thus are imbued with inherent profound existence that requires respect, be it a river, a child, or a steam-powered thrasher. There is a price for each of the world's creations, and each existence is responsible for that inherent debt. Without that debt being paid, this planet cannot hope to survive and it will attempt to expel the free-loaders before self-destructing. How could we expect anything less of such a complex entity?

There is a beauty that can be found in the idiosyncratic nature of the lumbering, clanging machines of the past that we now get but a glimpse of in the high-tech gadgetry of today. The difference between the machines of then and now is the same as the difference between an old-growth forest and a soulless tree farm. While it is true both are made up of trees, one strikes us as missing something: a spirit, or will, which speaks to us of intention. Intention that demands to be respected and understood, not for what it can be (or do) but for its simple existence. This intuition should enlarge our humanity, not reduce it. We should feel free to promote it in unlikely domains, including the mechanical.

I can already hear the complaints of my friends, leveling the charge of anthropomorphizing machines. Dear friends, this could not be further from the truth. We should not seek to recreate our humanity in our machines any more than we do in a gently swaying glade or a spiraling hawk. They can be respected on their own, in terms outside the limited cage of humanness. The technology that sits by our side is too complicated, too swift to serve, too abstract to engage our senses. There is a nauseating sameness found in most of today's technologies (like the tree farm). Replication has replaced revelation. To know one is to know all, thus the value of one is none. We treasure uniqueness in ourselves and others; why would be satisfied with the numbing and pointless replication of other material inhabitants? High-tech mass production has sought to erase all identity from our machines just as the captains of commerce attempt to erase animalness from our meat nuggets. The so-called machines of this era seek the cleanness and sleekness of thought, platonic forms unsullied by the earth from which they come. Floating beyond us in mathematical ether far above us and the golems of iron. These abstract replicated technologies ultimately seek in their purity a Nirvana of emptiness. If I were to choose comrades, fellow-travelers in the truest sense, I'll seek those machines with clay feet, and that breathe the air I do. Whose actions are as unpredictable as the mouse that feeds upon my neglected dishes or my dear Mathilda's moods. Even if I do not comprehend my boiler's song, I know it sings for its own purpose in its own time. It has been with me for years, and as I gray, it rusts. We age together, besieged by the forces of the world. It is my comrade on this long road of existence.

Even if my feeble wit and uninspired prose has failed to convince you of the truth of my proposal, I trust you shall seek out a new understanding, if not friendship, with the machines that populate your life.

Your loyal servant,
Prof. Calamity

FIVE BUTTON SPATS

written and illustrated by Rachel E. Pollock

A QUICK AND FAIRLY EASY PATTERN FOR A COMMON accessory suitable for both ladies and gentlemen: spats!

"Spats" is a shortened form of the term "spatterdashes," which alludes to their original function: to protect the wearer's shoes and shins from spattered street muck. I developed this pattern with reference to two resources: the *Tailor and Cutter System* published in April of 1890, and the *Cutter's Research Journal*, Summer, 1989. Unfortunately these resources came from unattributed photocopies which I found in a drawer of old patterns in a house in rural Utah, so the original authors of the articles are unknown to me. Whomever they were, I am grateful for their contributions.

This pattern presumes a basic familiarity with sewing conventions, though it shouldn't be too hard for the careful and diligent beginner. It is for a fully-lined pair of above-ankle spats with a five-button closure, though the skilled stitcher may alter it according to her/his wishes: double the number of buttons, replace them with a zipper or laces, snaps, or galoshes-hooks, lengthen it at the top to reach further up the shin, etc. You will need standard sewing equipment (scissors, thread, etc.), and while it is entirely possible to make the pattern up without a sewing machine, I do strongly suggest you use an iron where directed. Proper pressing is an invaluable element of skillful sewing.

The finished spats will fit an ankle measurement up to 9 1/2". If you wish to make them to accommodate a larger ankle, read through the directions completely to familiarize yourself with the means of construction—alterations are discussed at the end.

The pattern requires 1/3 yard of 45" or wider fabric, 1/3 yard of 45" or wider lining, and ten 3/8" buttons or your choice of alternate closure. If you choose to use larger buttons, don't forget to lengthen the buttonholes. I recommend shank buttons; if you choose to use flat buttons you will likely need to make thread-shanks for them when stitching them on. If you are using a fabric with a nap (such as velvet) or with a directional pattern, you will need twice as much fabric: 2/3 yard. The pattern is drafted for woven fabrics, though I reckon they could just as easily be made up in a stretchy knit and the closures foregone entirely.

Remove the page containing the pattern from the magazine and cut out pieces A,

B, and C. These are your three pattern pieces and have *no included seam allowances. You will need to add seam allowance around the edge of the pattern when you trace them onto fabric and cut them out.* Commercial patterns often have a 5/8" seam allowance included, so if you are used to sewing with commercial patterns, you may wish to add 5/8" to all sides. When working on a small garment like this, I prefer a smaller seam allowance: 1/4" or 3/8".

Lay the pattern out on the fabric thus:

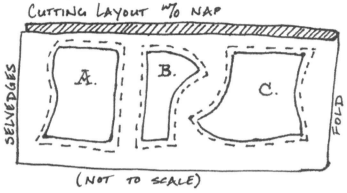

If you are using a fabric with a nap or directional pattern, you will need to lay it out thus:

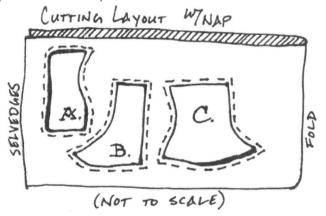

Cut out your pattern pieces, making certain to note the position of the notches and closure placements and paying attention to the grainline arrows. There is a single notch on the center front (CF) seam, and a double notch on the center back (CB) seam, as well as two single notches on the button edge of pattern piece A. The grainline arrows indicate which direction your straight of grain should go—this means, they run parallel to the selvedge edge of the fabric. (If you are confused about this, google or wiki it—grain orientation is important to the construction of a garment and if your spats are cut off-grain they may turn out woodgy and fugly-looking.)

Stitch your CF and CB seams for both your fabric pieces and your lining pieces. Clip the curves—slits for concave curves and pie-slices for convex ones—and press the seam allowances open. You will then have four vaguely-spat-shaped things.

Now is a good time to put on a pair of shoes and check for fit; you can pin one on along the button markings and get a rough idea of how it will look when finished. If it's too big or small, don't worry! Alteration suggestions follow at the end.

Pin each lining to each fabric spat, right sides together, matching seams. Stitch them together around the outside edge, beginning at one end of your notched-opening on the button edge of pattern piece A and continuing all the way around to the other. You will now have two inside-out lined spats, each with an opening of around 4" along the button-end. Again, clip and notch your curves, then turn the two spats right-side-out and press them flat. Sew the openings closed using the stitch of your choice: slip-stitch by hand, or run a narrow top-stitch by machine, or whichever other means you desire.

Put in your buttonholes, sew on your buttons, and voila! You have a natty new pair of spatterdashes!

Alterations suggestions:
—You may wish to topstitch around all edges for stability or aesthetic reasons.

—If you wish to make unlined spats, I recommend French seams at CF and CB for a nice interior finish.

—Should you desire a stirrup-strap to hold the spats down firmly to your shoe, you may wish to stitch it in the appropriate place before attaching the linings to the fabrics.

—To accommodate a larger ankle, you will need to add circumference to the ankle opening. To take the pattern in for a smaller ankle, you will need to subtract it. The easiest way to do this is to slash pattern pieces A & C from top to bottom down the axis of the grainline arrows. For larger-ankle spats, add equally to both sides (i.e., if you need to add two inches to the circumference of the ankle, add an inch to the slash in pattern piece A and an inch to the slash in pattern piece C). Or, if you really want to get fancy, slash piece B as well and add 25% to piece A, 25% to piece B, and 50% to piece C. For smaller-ankle spats, subtract from the slashed pieces in the same manner.

If you intend to alter the pattern, I recommend first making a "mock-up" of it in some crappy fabric to test your alterations before cutting into your fashion fabric or lining.

TURN THE PAGE FOR THE PATTERN!

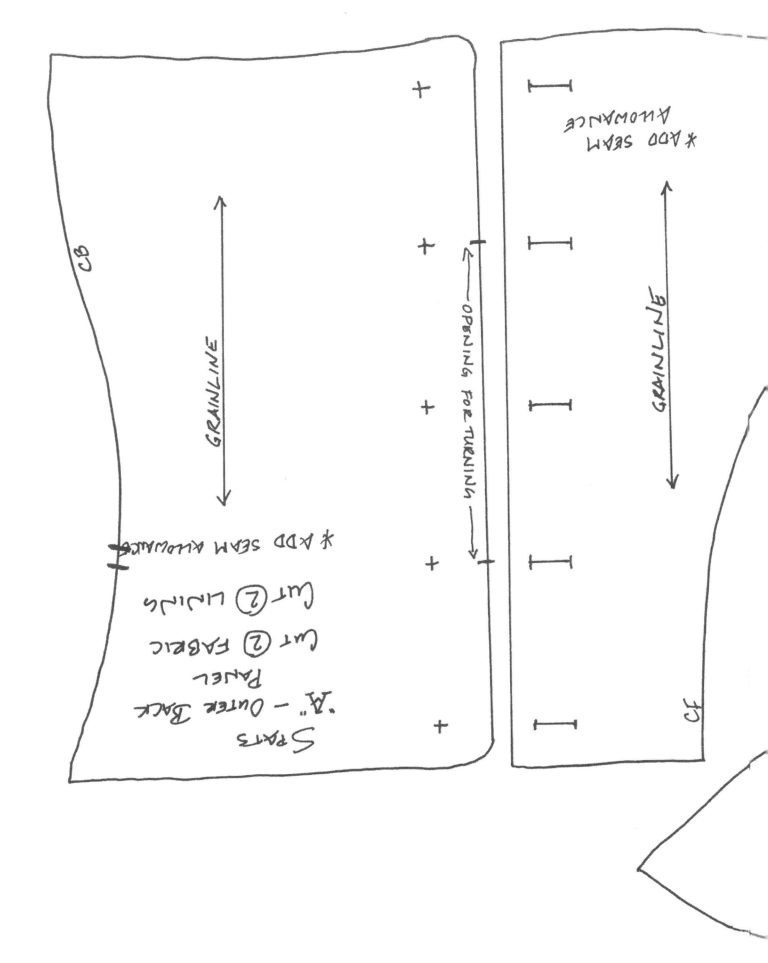

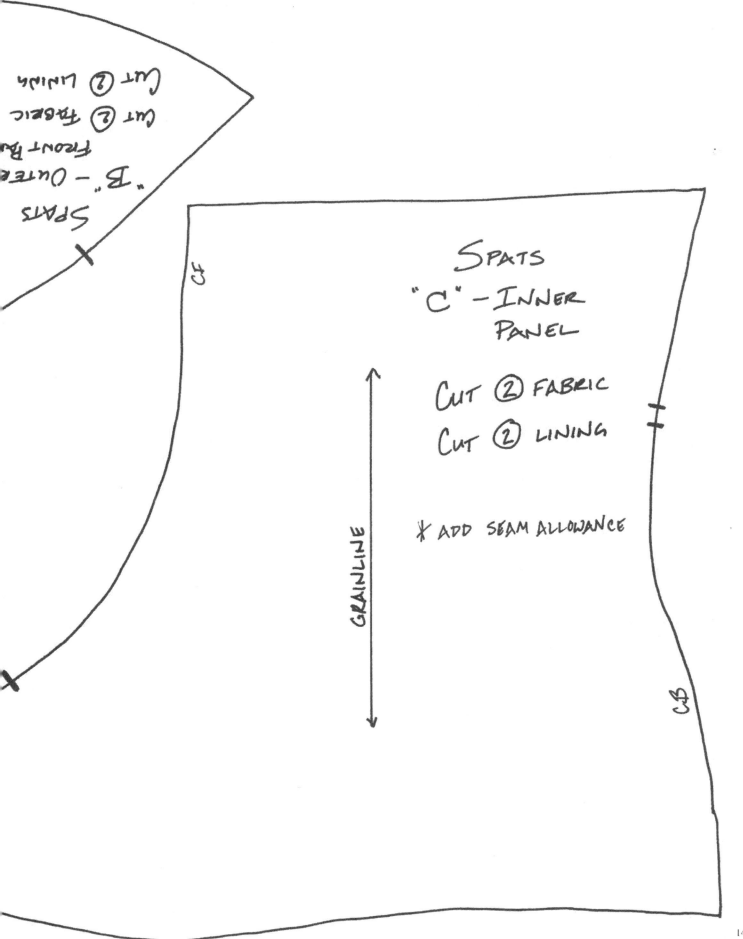

Reflected Light
by Rachel E. Pollock
illustration by the Author

Nicquossee Artifact Collection: Vick Flinders record diary, wax cylinders 1-4
Reference subject: Fardelle "Della" Dicely

Archivist's note: Cylinder condition is denoted "fair," as some minor scratches have obliterated short sections (3 seconds or less) of playback quality. Cylinders will be demoted to "degraded/discard" status after 10 known playback instances. Please confine perusal to attached transcript unless granted playback permission by sanctioned government agency. Current number of known playback instances: 7.

Cylinder 1

THEY SAY DELLA DICELY'S RUN MAD. UP AND WALKED OFF the job two weeks past and none know whence she's gone. Nobody's ever walked off the job, not in our shop, not that I've ever heard. They say when she returns, if she returns, Nonnahee's set to kill her slow. Puts my mind at unrest, that prospect.

Me and Della, we worked side-by-side in this smithy since we was wee younglings, she a piece longer than I. I don't know as I'd call her friend; don't know if Della rightly has friends. Don't know as any of us do. Perhaps she'd be my comrade, my collaborant or fellow or helpmate… something indicating the closeness grown by common labor, the community of the machines.

See, me and Della… But now I reckon I ought to say only "me." I'm a leatherworker; not a carcass-skinner nor a hide-scraper nor an oil-tanner, but a leathersmith proper. I assemble the hides into whatever is requested each morning by the Nonnahee jobman—mostly working-gear. I make toolbelts and knife-sheaths, heavy gloves and cartage pouches.

Della's favorite thing to make was the welders' leathers—long-sleeved backless shirts and the front-sides of trousers, customized exact to fit the bodily shapes of the men and women they protected. Some say she was the best in the business, and I believe it. Would you feature? Jack-a-Ron Dantsy himself brought his entire gang of welders in, had Della kit them all out, even he himself! Jack-a-Ron Dantsy! I like to have died just to cower in the corner of the same room as the man, but Della? No sir. Walked right up to him, shook his hand just as cool as you please—*shook his blamed hand!*—then whipped out the twine and began to measure him off. She's got brass, Della does.

Not me though, I'm as dull as the dishwater. I just keep my head down and my shoulder to the wheel. Jack-a-Ron Dantsy aside, I'm not much for the high geometry of custom work, even for [*section lost: flaw in wax surface*] sit with a stack of stock patterns, bags and pouches and spannermen's toolbelts, and crank them on out. Leathersmithing, it's hard work, but we're grateful for it. Beats other work, that's for true; at least at the end of the day I've got a pile of things I've made, me with my own hands. What can the railman say, or the stoker? He's moved cars around the yard, shoveled how many piles of fuel? Necessary jobs, honest work to be sure, but I wonder: for the railman, for the stoker, where's the satisfaction in it? Or perhaps they need no sense of accomplishment in their work, care for none. It's possible; but me? Give me leathersmithy any day.

Cylinder 2
They tell us we're at the bottom of the chain of progress, leathersmiths, working with hide instead of metal, but Della, she figured out that was a lie. That's something she told me before she ran off to wherever: *We ain't the bottom at all. We're an integral part of the cycle.* We make the leathers that protect the welders that build the machines that form the basis of the world of the Hollowland. And what do we use to make those leathers? Machines. And what must the welders have in order to build machines? Our leathers, to protect them from the flying slag and swarf. We may be small cogs, but remove even one tooth of one gear and the machine won't run properly. We, Della told me, are *important*.

I've been a leathersmith all my life, ever since I was tall enough to reach the foot-pedals of the stitching machines. Even before that, [*section lost: flaw in wax surface*] belting through a strap-cutter, finished ornamental edges with the crank-pinker, and traced out patterns to be cut upon hides with bits of colored wax.

It was as a youngling learning the trade from Della that it happened, that which I can never myself forgive, the horrible happenstance that rendered me forever in her debt, [*section lost: flaw in wax surface*] chasing the smoke of atonement.

Hap you ever to see a strap-cutter? It takes two working in tandem to operate, and I worked it that day partoned to Della, both of us green young things but I far the greener stripling. She was showing me how it worked, what my business was and what was hers, when the accident happened. She had the blade and I the hide, and as she pulled the cutter-handle toward her, slicing through the leather so swift and smooth, I got excited and gave the hide a quick little tug, a fillip that sent the cutter through the end and oh! Her hand was caught and the world swung round and I tasted the bile of horror at what I'd done.

At first I cried far more than she—so much blood on the floor and the sight of Della's finger lying there like some cave worm grubbed up from the depths. It shook my teeth a-rattle and no mistake. Della though made neither sound nor weepage until the foreman cauterized the tiny nub with a fire-iron; then she screamed but good, and then the tears came, big and trembly.

"No, Vick, no guilt," she said. "It was not your fault."

That Della could say a hundred-thousand times, but it would always be a lie.

[*three-second pause in the recording*]

Two weeks in the shop without Della have seemed two years at least, mayhap two lifetimes, as we've not only lost her skill and turnout toward the workload, but we've lost her stories as well. Me, I haven't a head for spinning of yarns and no matter—that lies in the province of talekeepers. Della, she's talekeeper for Dicely Clan.

Della knows more tales than hairs on a hide fresh-skinned, and not just Dicely Clan stories neither, nor just those of our people, the Nicquossee. She even knows Sallagee legends and Geriyan epics and oh! Great Builders, but I love the tales she tells of the Lunjinfolk. (She learned those from Dantsy Clan, some first-hand from Jack-a-Ron himself!) I never thought about how swiftly passed our days when the work sped through the machines in the nimble hands of Della's stories, but now she's gone, the melody and rhythm of her tale-telling has been replaced with naught but the steady repetition of chunking machines, their whirring flywheels and laboring treadles punctuated only by the occasional startling arrhythmia of an explosive burst of let-off steam. Our minds are left to occupy themselves, and mine seems only able to caper and slog an ever-tightening spiral around the central figure of lost, mad Della.

I miss her.

In her presence, I, dull Vick, shone with reflected light.

Cylinder 3
Today the world has changed.

My world has changed, at least, for today, my goodman Lundy brought home a piece of godwork, a contraption that has sparked in me a fire, for it flings wide a door that leads to my salvation!

My Lundy's a manufactor—he assembles small machines that do breadbasket-sized tasks in a shop equal-scale of our smithy. He doesn't design the machines, only puts them together according to schematics drawn by the Nonnahee engineers. (The Nonnahee would never allow us to create abstractly, not in any official capacity.) But Lundy, he's a bit of a secret contraptor, bringing home broken parts of things salvaged from the refuse, which is of course forbidden, trashpicking is, but he's friendly with some of the rustmen and slagworkers at the manufactory, [*section lost: flaw in wax surface*] other way when he pockets a broken flywheel or a crushed oilcan. He's a good fellow, Lundy is, and careful about keeping his bricolages hidden from Nonnahee eyes, so I don't begrudge him his devotion to tinkerage; it trumps a fleshly mistress certain.

Twice before Lundy's brought home nigh-fully-functioning machines gifted to him by Garl Spitshine, his particular slagman friend. In what repugnant rotting heap or chemic sludge Garl finds them, I don't know and do not wish to; I fear perhaps he steals them, and I prefer to remain ignorant of that for true. I only know the glee they bring my dearheart Lundy, and, admittedly, a-times myself as well.

The first such contraption was an odd thing with a crank and a stamper-plate and a drawer of tiny lead shapes, neatly

arranged. Lundy replaced the bent crankshaft and showed me its true purpose: printing small paper tickets with words in the Nonnahee language. What use this is to Lundy is a mystery to me—he cannot parse the symbols, but he does love cranking out reams upon reams of those gibberish-tickets and I must admit, there is some satisfaction in building up a rhythm turning its crank, watching the little papers move through and emerge with their rows of neat marks. We burn them—often before their ink's dry—for fear of their discovery.

The second such requisition ran off with my heart, however—the device upon which I set down these thoughts: the wax cylinder recorder. It was housed in a splintered wood case (replaced by Lundy), the gears inside missing teeth like oldsters. Its horn was crushed, its mandrel bent, the stylus crumpled like a stomped reed. As with the ticket-printer, Lundy scavenged and repaired and fiddled around with the odd little thing until he coaxed it back to life.

I'll never forget the night he brought it to me, showed me the means by which it worked. There was the machine, hunkered on our rustic table, and there was Lundy, grinning like a new father as he produced a brownish waxy tube, held on the spindle of his own two fingers. He cranked the handle, placed the cylinder on the mandrel, positioned the reproducer, and set it a-running. I couldn't believe my ears when, out of the mouth of the machine, came Lundy's voice:

"Please know this, love: I taught these gears to speak that they might convey the contents of my heart. You have all of it, always." Then the machine laughed in Lundy's peculiar arpeggio.

I stood there, my jaw hanging open, catching flies. Lundy's laugh came echoing out of his own mouth and I, too, couldn't stifle my... oh dear, I've digressed a whole cylinder away.

Trifles aside and I must rush to the point: today Lundy brought home a mechanical hand.

Archivist's note: Though this diary entry at first may seem spontaneous, the voice that speaks the dialogue of Lundy Flinders "through" the machine is in fact that of Flinders himself, leading this scholar to believe that Vick Flinders planned the entry in advance and coordinated its recording with her husband. An alternative possibility is that Flinders replicated the wax cylinder recorder in toto, and Goodwife Flinders utilized a second phonograph to play Flinders' original recording on cue. The clarity and volume of the dialogue however leads this scholar to discount that hypothesis,

.
Cylinder 4

IT IS NOW several days since, as Lundy and I like to say, the Advent of the Palm, and oh! More to relate!

The poor hand, as the ticket-press and phonograph before it, arrived a wretched mangled thing. As per usual, Garl is the means of its shady deliverance; but I don't care if he stole it off a one-armed Nonnahee while he slept. Looking upon it fills every twitching corner of my mind with soft light and cool salve. Lundy has been tinkering with it each night since, well into the wee hours, and I, though I have no head for contraption, help him with what tasks I may—matching cogs from his collection to the broken ones he extracts and cleaning those he salvages intact. I do not shirk from elbow-grease, no, not I, diligent Vick.

Lundy's prognosis is grim for the sad twisted mitt, but he is often a raincloud to my sun. He claims preference of the shadow's view, but truth-told he is buoyed by my brightsiding. I knew the moment I clapped eyes upon the little wreck, if any tale of the world is written by any people's gods, Garl was meant to give that hand to Lundy, and Lundy is meant to make it work again.

Oh, but I cannot keep it to myself: I have news of Della Dicely!

Hap I may have been too bold, but yesterday after half-shift I went to the dockyard, where Della's sister Spondee works as a braider and a knotsmith. I found her easy enough—Spondee is tall and mannish-built—but spent a long while loitering, looking for my courage. I am so poor at conversing! Not so Spondee, for she shot me a narrow glance and stalked right over, demanding my business on the docks. Certain I seemed a halfwit for I feared to speak her name aloud, but [*section lost: flaw in wax surface*] managed to convey with gesture and lipshaping that I worked in Della's smithy. Spondee's eyes flew wide at that. She hissed me silent, grabbed my hand and stalked the length of the nearest pier, pulling me stumbling behind her.

At pier's end, with only ships' timber and hull-iron and a few wheeling sea-birds to eavesdrop, a fire-eyed Spondee favored me with crypticism:

"You'll find [*section lost: flaw in wax surface*] railyard at night, in the broken glass among the cinders."

Her eyes went flat and cold, and then she stalked away, leaving me shivering in the rank, oily spray of the sea. I though, I could dance I was so full of joy! Della must be hiding in the railyard somewhere, and I count the days until I shall go and find her.

As soon as Lundy and I have repaired the clockwork hand, I shall take her a lamp, beckon her forth from the dark cavern of madness, if mad she be, with the crook of a shining brass finger.

Archivist's note: The cylinder diary ends here. It is well-documented fact that Fardelle "Della" Dicely possessed only nine fingers, having lost one to an accident in her youth, but she was never known to wear any type of prosthetic. Though multiple sources recount "Della" Dicely's return to the Hollowland and her subsequent coup to overthrow Nonnahee domination and emancipate the Four Peoples, the fate of Vick Flinders beyond the scope of these recordings is unknown.

SEW AN AVIATOR'S CAP
by Juli(A)

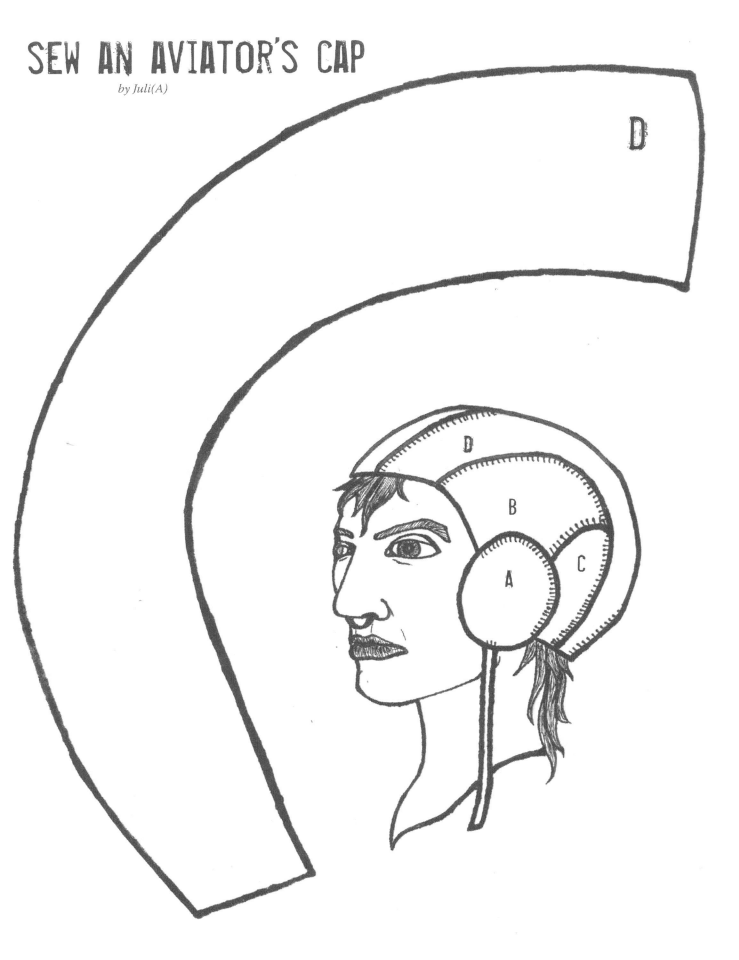

NOTES:
—cut two of each piece.
—piece A overlaps both B & C, B overlaps C, and B & C overlap D.
—D and its match form a normal seam. (as may the intersection of B & C with D.
—a lining may be created by, after sewing together A, B, and C, cutting an equivalent shape from a softer, warmer fabric.
—to measure the cap to your own head, experiment with scrap fabric.
—while this hat is best sewn of leather, we implore you to use *used* leather: go to a thrift shop and buy some ugly old skirt to cut up. The leather industry is obscene.
—sew with upholstery thread, artificial sinew, or dental floss.

THE UTOPIAN PLAYGROUND OF Dr. Steel

interview by Cheshire S. Grin
illustration by Dr. Steel

Your music has been described as "Hip Hop Industrial Opera" and "If Danny Elfman and Trent Reznor's music had a baby and it was raised by Ella Fitzgerald, you'd get Doctor Steel". An accurate description?

Ah, delightful. Indeed I am flattered by both descriptions. I rather enjoy demanding such eloquent and creative categorization, as I would never wish to fall into an existing genre of music.

If one were attempting to understand your influences, what works would you recommend, be they literary, musical, artistic, theatrical, or otherwise?

My influences are greatly varied as I find inspiration from many sources. Though might I suggest beginning to understand my madness by reading a biography on P.T. Barnum while peering over a model of Walt Disney's initial EPCOT design, listening to Pink Floyd's The Wall and running vintage cartoons in the background. You may also want to be wearing spaceman pajamas and a top hat while doing so.

The reason for your music and all your creative endeavors is to generate funds and recruit Toy Soldiers to help you to take over the world. Why quest for the title of World Emperor?

My vision for a world make-over would certainly be most easily attained with such a status. However, my true interest in becoming World Emperor hinges on the realization that one creates their own reality. Once I became privy to this information—through a rather mystical experience involving a floating shape shifter from a parallel universe—I realized that one's power is great. From this I have set my sights above and beyond what the average human generally considers to be a "reality" and I continue to encourage others to do the same.

Fan art and flash movies among other things have sprung up in your honor. One of your more notable fans has even dedicated his wrestling career to you. Having been such a loner in your younger days, how has it been to suddenly get these accolades?

I do not consider these grand initiatives so much as accolades as a brilliant representation of what many of us are capable of when we are encouraged to do what we enjoy. Building a Utopian Playland begins with the vision to make fun the top priority. To see these creative minds bubbling with such vision brings me great pleasure. I have lived in this world, a world where our interests and creativity are smashed by a stifling System. To this I turn my back on such lack of vision and open my arms to those looking to create. I maniacally throw gasoline on the creative flames of my dedicated Toy Soldiers and I am honored to have been a catalyst to spark such smashing talent.

One of your calling cards is the delightful marriage of past and present. It's evident in your Victorian wardrobe constructed in modern materials to the jazz age style samples in your music and the wartime propaganda influence in your posters. Are you

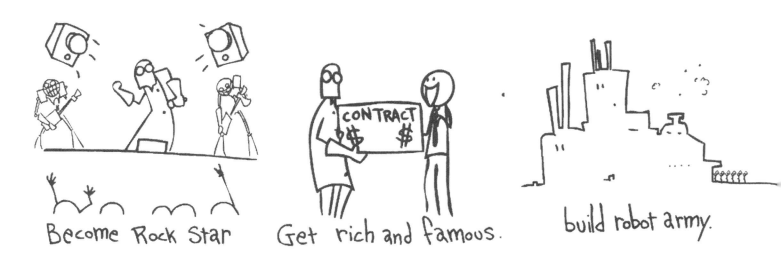

Doctor Phineas Waldolf Steel is known primarily for his music, but to anyone who is a fan, he is so much more. Artist, fashion plate, mad scientist, historian, aspiring world emperor; he really does it all. At first glance, in his goggles and white lab coat, he is immediately written off as a crazy person, and that suits him just fine.

trying to usher history to repeat itself? Or is it more of a play on the nostalgia associated with the eras? Or do you just think they're pretty?

In all that is ever created, in all that we experience, the most important and powerful element is the element of contrast. Without contrast, things are stagnant and dull no matter the subject. To this I enjoy experimenting with contrasting elements from visual to aural creations. Likewise, my interests range from the distance past to the recent present and I enjoy pulling inspiration from various sources.

What are your favorite apocalypse scenarios, both societal and planetary?

I don't know that I have a favorite Apocalyptic scenario, other than perhaps turning the White House into a miniature golf course. I would, however, be delighted to renovate many major metropolis cities with the use of giant robots with large crushing arms and laser eye cannons... all for the greater good of course.

Would it be the best-case scenario for the Utopian Playland society to flourish in a post-apocalyptic setting, or are you more prepared to use the resources and failings in the current day?

I term my plans for world domination as less of a world take-over and more of a world "make-over." With that, I do believe that there are many elements in place currently which could certainly be retrofitted with a new agenda. 'Tis the element of fear and control which must be bled from the veins of the System. To this end, it is a state of mind which shall first take place... the giant robots and flying saucers come second.

Society in general considers it's aberrant members to be crazy, and steampunkers are often regarded as aberrations. As a madman, do you have any advice for those who have recently found that they're completely insane?

Enjoy it. Embrace the madness and continue to look at the world in a completely different way. The perspective we have been conditioned to experience is only a widely accepted opinion based on misinformation created by the reality engineers whose aim it is to keep us under control.

Thank you so very much, Doctor. And, so far, your famous last words have been "penguin" and "carnauba wax". Any others that you'd like to share with your now adoring masses?

Ah yes, indeed. I would suggest spending at least five minutes each day hopping about like a chimpanzee if at all possible.

Doctor Steel's work and aspirations can be found at http://www.doctorsteel.com

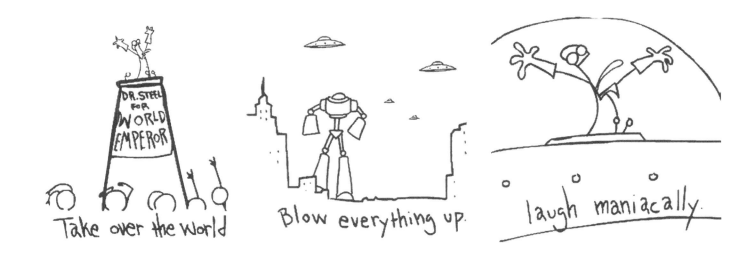

A Spark From the Rails
by Olga Izakson
illustration by Rob Powell

"Where'd you say the break was?"

"Out a mile that way—" The shorter man pointed to the left of the glimmer of sun on the horizon. "Maybe a mile and a half. Isn't much, just some old rail needs fixing up."

"Let's go, then." The taller man's voice floated out unnaturally loud into the early morning mist. He hoisted one of the knapsacks onto his shoulder and tossed the other to his companion. They set off through the slick grass, each lost in the thoughts that always come in the hush before dawn.

The only sound for three-quarters of a mile was the rhythmic thump of their boots, tough and stained with engine oil and grease, much like the men themselves. The taller one began to whistle half-heartedly, but hesitated and stopped. It didn't feel right to wake the woods. Times like those seemed to him the true reason for the world's existence—just him and one or two of the others walking in silence, with nothing around but the mute trees and sleeping birds, with nothing weighing him down but the tools and sandwiches, and the pleasurable feeling of one foot after the other in unending sequence.

"We should be coming up on it soon," said the other man.

"Mm."

A rustle in the undergrowth beside them made them stop. It was too loud and clumsy to be an animal, and a shoe was clearly visible under a bush.

"Who's there?" demanded the shorter man. "Show yourself! You're trespassing on Company land!"

There was an irritated sigh and the sound of someone smashing through the tangle of low branches towards them. The shorter man tensed his shoulders, ready to fight, but relaxed when he saw the intruder.

She was skinny and ragged, about sixteen or so, with smooth dark skin under the grime covering her face and a pair of goggles perched atop a wild curly mass of hair. She carried a cloth bag in her hand and an odd-looking metal object strapped to her back. Her scuffed leather boots made soft squelching noises on the wet grass as she limped toward them.

"You're trespassing on Company land," the shorter man repeated. "You're not supposed to be here."

The girl stared at him, then at the taller man, then back at him again.

"The railroad company?" she asked at last.

"Yes," said the shorter man. "It owns the railroad. You're not supposed to be here."

The girl looked thoroughly bewildered for a moment, and then her expression cleared and she smiled at the taller man, ignoring the other man completely. "The Company doesn't own the railroad. The railroad owns the railroad."

Privately, he agreed with her, but before he could work out what to say to her statement, the shorter man spluttered, "Of course the Company owns the railroad! Look, who are you, anyway?"

"Who am I?" repeated the girl softly, lost in thought. "I am the singing of the rails... I am the beam of the lantern passing in the night, and the trail of smoke behind the train. I am the clatter and the joy of the rushing wheels. I am the soul of the railroad. I am the train's whistle. I am the gleaming iron and the engine's heat. I am the cogs and the wheels that keep the engineers awake at night and the source of the oil on your faces and I am the place you are going and I am the place you have left and I am a spark from the rails..."

She trailed off absentmindedly and rooted around in her pocket. At last, with a triumphant look on her face, she discovered a pocketwatch, and flipped it open.

"Ten to six," she told the two men. "I have to go now. Can't be late." With a small grin, she added, "Never Late—Passengers or Freight"—the Company's motto—and went limping off into the underbrush again.

There was a long, shocked silence.

"Come on," said the taller man finally, "We need to go fix the break. Looked like her foot was hurt."

"You can't possibly believe all of that crap!" the shorter man said furiously as they walked on. "'Singing of the rails'? 'Gleaming *iron*'? Iron doesn't gleam! She's not the soul of the railroad, because the fucking *railroad* isn't fucking *alive*!"

The taller man shrugged.

"She was just some kid!" the shorter man raged. "She had apples or something in that bag—didn't you see? What the hell does a railroad need apples for, huh? Railroads don't fucking eat! And that brass leg—"

"The—what?"

"The brass leg! That thing on her back was somebody's brass leg, I swear it was! You could see all the machinery inside the knee—it was a *mechanical* leg—what the hell does a railroad want with a fucking brass leg?"

"I'm sure she could find some use for it," said the taller man calmly.

The shorter man threw him a disgusted look. "The break is right up that way, anyway. We're going to have to—what in fucking Hades are you doing? That's a perfectly good apple, you can't just throw it on the tracks like that—"

THE AIR SHIP OF TOMORROW!

An essay on the improvements needed to keep the mighty air ship queen of the skies before the ensuing threat of flimsy paper and wood aircraft

by Lord Dr. Richard von Tropp
illustration by Swizec

Dear reader, if you, like me, feel that the humble air ship has not spoken her final word in spite of recent events, then please read on. But if you feel yourself to be situated amongst the fixed wing aero craft slime then please feel free to put this writing back whence you took it, help yourself to a fine cup of tea, and let the true visionaries to their business.

If you are still with me, you will, please, have to excuse me for the above paragraph, but I feel such introductions are sadly needed in today's state of affairs; I have been driven from my home country of Germania for propagating that the air ship age must continue. You will also excuse me that I make this writing in British for, unfortunately, such is the only way of making it publishable.

First, I feel obliged to tell you a bit about the state of affairs aviation has found itself in for the unfortunate occurrence that my prediction be correct and this writing lay forgotten in some dusty archive for a century before anyone cares giving it a read. Even if that be the case I hope, dear reader, that you take the advice contained herein to heart and revive the air ship for all its advantages and glory.

A year ago the great Burghindia suffered a terrible case of crashing during a landing after a successful transatlantic voyage, resulting in the unfortunate deaths of five and twenty people. The crash being immortalised on celluloid tape and relived via projectors all over the world fuelled the death of the air ship age and sparked the revolution that resulted in what many feel is the future of aviation—the paper skinned, wood framed, fixed wing aero craft.

There are a handful of engineers trying to open the world's eyes and make it see the truth, but the fact of the matter is they have lost not only the battle, but the war already, if they don't make some improvements in their designs. Right now, though, they are proving too stubborn to change anything.

The fixed wing monsters, even though quite useless, do have some advantages over air ships, especially once the petrol engine reaches a stage of life advanced enough to power steel-made vehicles. The air ship must be refreshed, improved and bettered until that point in time, by which it will be too late.

I believe that in endless experimentations with scale models I have come upon the solution to all the issues at hand and more. So peruse on if you too would like to change the world for the better.

The biggest advantage dirigibles have over fixed wing aero craft is their size and stability in the air. Air ships follow similar size rules as regular water ships in that the bigger they are, the more efficient and completely better they become. It is because of this I suggest we build a 1200ft long dirigible with a 270ft diameter, which would make her a bit fat in appearance, but wouldn't affect streamlineness.

Her belly would be filled with helium so as to provide buoyancy while preventing a catastrophe like the one that destroyed poor Burghindia. The gas could even be used to put out fires were they to occur. Gas bags would be positioned around the ten large boilers for heating up water.

There would be ten boilers because that way it takes less time to get the engines running from a stationary position and also prevents running out of steam if a boiler was to malfunction. Fires would be fuelled by coal gas instead of coal itself because coal burns too inefficiently and is in general too heavy for use in flying ships, even though it was used extensively in the past.

Because of this the ship could carry a lot more fuel and thus having a much longer range; she could probably fly right around the world without even having to stop for provisions. Now, dear reader, you might be wondering why on earth wouldn't she have to stop for water? Let me tell you.

She would not need to ever refuel water, especially if there were no unfortunate leaks, because once the boilers were filled the steam would always pass through highly efficient engines, condensers, and then right back into the boilers to be reheated again. The two triple-expansion reciprocating double-acting high-pressure steam engines would drive a large crankshaft to which several canvas drive belts would be connected.

The belts would transfer rotary motion to sixteen propeller systems by means of turning a shaft connected to a gearbox that would in turn run two propellers in a cylinder. Each system would have its own gearbox so that different systems could turn at different speeds and aid in the manoeuvrability of the craft. The reason why the propellers would be in a cylinder is that the first one would accelerate the column of air a little and the hind one would accelerate it even more, producing great thrust.

These cylinders would be positioned in two rows of four on each side of the body, each on a simple system of two large cogs each positioned at 90 degrees to each other with their shaft containing the drive shaft for the propellers. This would enable the cylinder to turn into any position, making the air ship very manoeuvrable, perhaps even more so than the evil fixed wingers.

To produce even more power and have greater efficiency steam turbines could be used—if Dr. von Battenbug ever manages to develop them into a usable state. I reckon we will just have to wait for that one. Also, my friend Lord Matternich has been developing a technique for stripping the aether from beyond the Earth's atmosphere. If that ever succeeds we

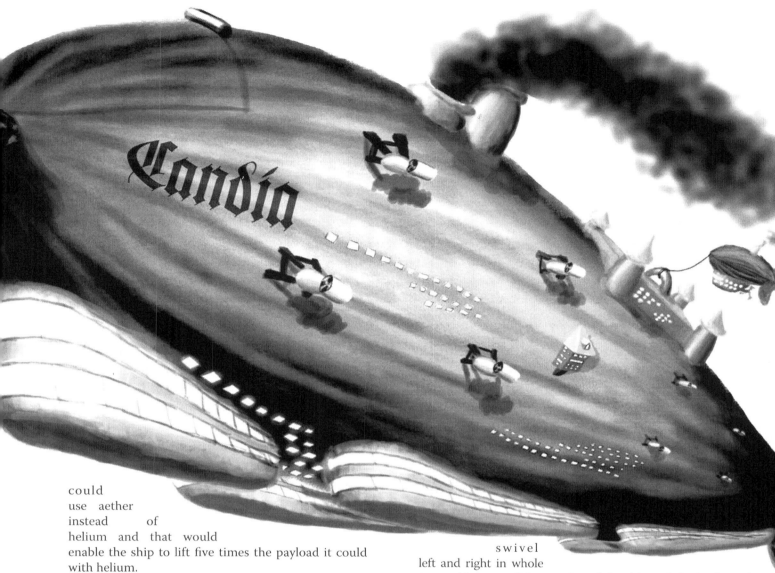

could use aether instead of helium and that would enable the ship to lift five times the payload it could with helium.

Payload would be, in part, stored in the five gondolas attached to the bottom side of the dirigible. They would be configured in a geese flock configuration and would each be 250ft long by 50ft wide. The reason for having five of these and not one very large one is segregation of crew, passengers and, possibly, weaponry.

The whole thing would be wrapped in a sheet of aluminium instead of canvas so that different cabins and towers could be attached all over the hull wherever needed. Crow's nests, for example, or Gatling gun turrets for war versions of the ship.

The interior of the hull would contain at least one hangar for a smaller dirigible or a few war fixed wingers, once they become enhanced enough for use as quick agile escorts for the ship at war. The hangar could be accessed through a large chute in the front and could be used to transfer crew, passengers, or anything else to the air ship without landing, thus enabling her to stay in the air forever.

It would of course be much easier to land a dirigible in an air ship if it was moving away from you instead of towards you, but the hind side would be taken up by the two large tail fins, each 400 ft tall and 100 ft long, which would in fact make her about 1273ft long, rather than the previously stated 1200ft. The tailfins could swivel left and right in whole to provide most of the steering of the ship and the horizontal flap that would be positioned between the fins would provide up and down steering.

Civilian versions of the ship would provide a great deal of luxury for its 1500 passengers, who would mostly be bedded in the hull between the storage tanks, gas bags, fuel tanks, and other important things. The higher classes would be put in larger suits in gondolas, with the crew having the front gondola completely to themselves. This is also where the bridge would be positioned.

All cabins would enjoy magnificently bright electrical lighting powered by the Siemens dynamo that would also power Mr. Siemens' electric engines for turning propeller cylinders, change gears in the gearboxes and everything else that needs moving and isn't a steam powered propeller.

I believe that every nation would be proud to father such a project and I am simply giving it away to the London Gazette in hopes of somebody worthy noticing it. Hopefully my earlier prediction of it laying forgotten for a century or two will not come true, and the skies of our tomorrow will not be filled with aero dynamical flying.

September 1875, London
Your Dr. von Tropp

Yena of Angeline in "Sandstorms by Gaslight"
In which is explored the Creation of the World, among other Subjects
serial fiction by Margaret Killjoy
illustration by Laura Pelick

"You had a lover, back in Southlakeside?" Yena asked her new friend, perched on the highest platform above The Cally Bird.

Icar nodded his boyish nod, his unkempt red hair bobbing in the still air. "I did."

"What was her name?"

"His name. His name was Carin."

Embarrassed, Yena turned to look out over the wasteland that surrounded her adopted city. A lesbian herself, she was surprised by her own assumptions. "I'm sorry—" she began to mumble.

"Don't worry about it," he cut her off.

Out near the horizon, storm clouds loomed. On the Wasteland—where the dust and sand could strip a person's flesh—the rain never fell and dark clouds meant only winds.

"What was he like?"

Icar smiled sadly, bringing crow's-feet to his bright eyes, and joined Yena in staring out toward the darkened horizon. "He was older than me. Six years. Age differences are a bit strange for my people, but nothing exceptional. He played music, bowing the glass tines, and he hunted.... His muscles would tense and relax as he held a spear. It was hypnotizing. He loved me, I think."

"What happened?"

"He was content with what our tradition offered him, us. The *izet*, the sterile. He trained and he played music and he never touched a woman," Icar said then paused, tugging absent-mindedly at his soft leather boots. "I knew that I would leave, as soon as I was ready."

"How old are you, anyway?"

"17. You?"

"22."

The ominous clouds were closer now, and the wind picked up. A few kilometers out, Yena saw the blurry haze that could mark a sandstorm. She pulled on her leather skullcap, wrapped her scarf once more around her neck, and began to stand.

"You know what's not fair?" she asked while she rose to her feet.

"What's that?"

"I'm 22, and I've got less than half my life ahead of me. You're going to live to be eighty." Those Of the Gear died young of cancers and ills that seemed to ignore most everyone else.

Icar stood as well. "You're right. It's not fair."

"The world's never been fair though, has it?"

"No, I suppose it hasn't."

"That sandstorm going to hit, do you know?" Yena asked Icar.

"Not yet. Not until pretty late tonight."

As the winds tossed Yena's scarf about, the two of them walked back to the ladder that descended into the building.

"What are your plans for the night," Icar asked Yena.

"I'm going out with Set. Twins' night out."

Icar looked disappointed as Yena climbed down.

As twilight fell, the twins walked along under skies still bright with the vivid colors of polluted air. The western horizon, just barely visible between the buildings, glowed with an eerily beautiful array of blue-greens and pinks.

Just as the last of the evening light dispersed, Yena and Set walked into the namesake yellow-glass glow of the gaslamp district. Crazed papaver laughter met their ears, mingled with the crystal music of the bowed tines.

"So where are we going?" Yena asked her sister, her mood still fatalistic as she stood on the lamplit cobble.

"I met a man," Set began, "simply gorgeous. And he …" Her voice trailed off as her eyes were drawn to the beggar prostrating himself at the entrance to a cramped alleyway. His long, thin, gray hair was matted and tangled with blood, his bare back a patchwork of cuts and bruises.

"Who did this to you?" Set asked, choking softly with emotion.

But the beggar gave no response, his empty hands open before him.

"This is just what I had hoped to escape, you know." Set was controlling her voice with effort as they continued to walk.

"I know."

"It's simple cruelty. It's economic cruelty."

"If that man wanted a different life, he could walk thirty blocks to The Cally Bird and join us." Yena spoke almost absent-mindedly, her eyes darting to balconies above where drunks and madfolk gibbered happily.

"Oh and do what? It's not as simple as that. It's really not. Do the squatters take just anyone?"

"They took us, didn't they?" Yena lowered her voice. "Instead of lying down in defeat, he could learn to do for his own, with us. In Angelina, it was different. But here? It *could* be as simple as that."

Set, as usual, let her twin have the last word, and Yena, as usual, felt guilty about it. Up ahead, the music was louder and small gouts of flame illuminated the street.

"Here we go," Set said, and then raised her black hood, hiding her shy face. She took Yena by the hand and led her to the source of the music and flame.

A band of street performers was splayed out around the entryway to an abandoned building. Around them, their fellow poor and the slumming bourgeois stood rapt.

A small woman Of the Waste sat, playing the tines of her crystallaphone, her bow of bone and hair sweeping gracefully around the glass instrument. Its resonating belly was shaped like a gourd, from which nearly twenty finger-thick stalks rose up, each a different note. Its voice, while soft, cut through the silent upper registers of the street and sang like a choir of opium ghosts.

Two drummers kept time. One—a woman Of the Gear like Yena—beat a deep, ponderous rhythm on a massive steel drum with a mallet, gazing out into space, clearly intoxicated by papaver. The other, a short, round man Of the Mountain, snapped complex fills and overlays on a series of hide drums with his hands, grinning with mad sobriety.

The lowhorn of the sea, a massive copper horn overflowing with complex mechanical switches and gates, shuddered across the lower register. A sturdy, tall woman Of the Sea blew occasional resonating notes through it that shook Yena's ribcage softly as she watched.

Two ragged, happy children took turns spitting fire on either side of the performance, grinding flammable soil between their teeth and blowing it forth onto gas torches.

But in front of it all was a belly dancer, a giant of a man, skin as dark as the deep of the ocean, who captivated the crowd with his gyration. Ostentatious black plant-fiber veils were draped from his neck and forehead—hiding his eyes— and gold chains encircled his waist, chiming in time to his undulating muscle.

"That him?" Yena asked, staring at the man's exposed belly that glistened with sweat in the firelight.

"Yeah."

Yena put her arm over her twin's shoulder. "Why aim shy of the sun, that the idea?"

"Yeah."

Solid slow minutes progressed as the pair stood hidden in the crowd, watching the band. Yena took to staring at the crystallaphone player, alternating rapidly between a romantic infatuation with the stranger's musical prowess and a deep jealousy of the same. Set, for her part, rarely let her eyes waver from the veiled man.

A hideous shout and a tormenting cracking of bone broke the song into silence, however, as it echoed down from the nearest alley. Shortly after followed a deep, drunken guffaw.

Certain that ill was at hand, the crowd split immediately into two uneven parts: the majority slunk backwards— affecting the look of the unconcerned—while Yena, Set, and the musicians strode without hesitation into the alley.

At the midpoint of the alley lay the bleeding mess of a second beggar, beaten into silence. Surrounding her were five sons of the upper class, resplendent in their cotton and lace. Three held the gold-handled walking sticks affected by The Vare's rich, clearly converted for use as cudgels, and all looked laughing down at the wretch they might have just murdered.

Grumbling a curse at having left her tool-belt behind, Yena ran forward, bare-fisted and enraged. Set at her side, she dodged a clumsy, surprised blow from the first man she encountered and disarmed him with practiced ease.

On Yena's left, Set had taken an unarmed man to the ground, grappling his throat with her legs and sending him quickly into unconsciousness.

Right behind the twins came the street musicians, each armed with a long, knapped glass knife, each with a face contorted into calm ferocity as they prepared to revenge the murder.

Seeing their companion on the ground and the small mob charging forward, the four standing drunks took flight toward the far end of the alley and into the crowded street beyond. Yena stood triumphant and held her new cane aloft as she watched them run.

The belly dancer stopped and helped Set to her feet while the crystallaphone player checked the beggar on the ground.

"She's not dead," she said, in a voice every bit as musical as her instrument, "but when she wakes up she's going to realize that her ribs are broken."

The woman ran her hands gently along the beggar, checking for blood, and Yena watched her calm, professional manner with a further sense of awe until a gathering wind took her attention.

"Sandstorm!" Yena yelled over the quickly howling wind. Somewhere, hidden behind the buildings, a seemingly solid wall of radioactive sand approached.

Yena tucked her new gold-headed cane under a shoulder and helped the medic lift the beggar and carry her out to the street, casting only a brief glance at the unconscious young man they were leaving behind.

The two children—having stayed behind to watch the instruments and beg change and food from the crowd—were madly gathering together all of the group's personal effects. All the people on the street were dispersing quickly as the storm approached, and the sober drummer kicked open the door to the abandoned building behind them.

Yena and the medic brought the beggar inside while the rest of their companions worked to barricade the door, and the dust storm howled its approach.

"Well of all the Wastes and Seas," Yena exclaimed lightly when a gas torch illuminated the hall, "a theatre."

The torchlight flickered off of the nearby stone stage, and was lost to shadow before it saw the roof above them. Rows of plush seats spread outwards from the raised stage, all the way back to the entryway in which they stood, and empty balconies overlooked.

Giggling, the two children chased one another to the stage and leapt onto it with a remarkable grace. "Unto thee!" exclaimed the younger of the two boys.

"And through thee with blades!" shouted the second, repeating the words from a popular play of the time. Their voices carried through the hall to the waiting ears of the band. The two drummers smiled deeply and proudly, and Yena assumed them to be the children's parents.

"Are these seats *velvet?*" Set had wandered into a row of chairs, and pulled lightly at the cushion of one. When the fabric of it came away in her hand, weak as a spider's web, she looked disappointed. "They *were*, at any rate. Just imagine."

And Yena did imagine. A thousand years before, when the train-line had first run across the whole of Tudines and the Empire had first formed, this must have been a wealthy district. She imagined the grand plays that must have been performed, the operas and recitals. But as she tried to lose herself in such pleasantries, she remembered the beggar they had carried in with them and she fingered the head of the cane that might well have killed the poor woman.

"It's an utter shame, you know," Yena said, turning to the crystallaphone player who stood beside her.

"'Bout the woman? She'll survive."

"No. Well, yes, it's a shame about the woman. But it's a shame on this town that you have to play out in the street for your food when there is a stage like this in here, waiting for you."

The small woman ran her hand up to the back of her head, scratching lightly under her crimson-red hair, and Yena smelled her underarm musk, sandy as the wind outside. "Yeah, I suppose it's a shame," the crystallaphone player started, "but there's something so … so lovely … 'bout playing out on the cobbles, ya know?"

"My name's Yena, by the way," Yena said.

"Yena? Yena is a lovely name." The crystallaphone player smiled, relaxing Yena. "Name's Erecura. Not as pretty, I suppose."

"Where are you all from?"

"Most of them met a few years ago in Bamore. But me? I'm off the low wastes."

"Low wastes?"

"Yeah, over east. We're up on the high wastes now, but the low wastes lie between us and the coast."

"Oh," Yena said, trying not to feel stupid. She had only a shadowed conception of the world east of The Vare.

"Where're you from, then?" Erecura turned from watching the children to look up at Yena, smiling with endearing crooked teeth and the crow's-feet eyes that reminded Yena of Icar.

"Angeline. Capital of Angelina."

"Out on the west seas, is that right?"

"Yup." Yena looked down.

"Well, I like your mohawk, Yena of Angeline. Makes you even taller, yeah?"

"Yeah," Yena laughed, "I suppose it does."

From the stage, the play-acting children interrupted their conversation. "Oh doth the rapture await?!" announced the older child as he fell down, run through by an imaginary spear. He quivered dramatically on the stone before flopping to stillness with a final, over-acted sigh. The room burst forth in applause, and the previously-dead child jumped to his feet and bowed graciously, extending his too-big top hat in front of him.

Hours later, the storm still raged and its screams kept most of the company awake. Set snored atop a pile of decayed, pink velvet seat cushions, and the papaver mother lay curled with her boys in a dark corner of the auditorium.

Yena, Erecura, and the others sat cross-legged on stage, the gas torch turned down to a candle's flicker. Yena had met the rest: Lir, the lowhorn player; her husband Braygan, the bellydancer; and Raka, the pot-bellied drummer and father of the boys.

After introductions, silence dominated the conversation for nearly an hour before Raka spoke up. "How, then, about a story?"

Everyone nodded lightly, drowsily, in the soft glow of the torch.

"A story for the dust storms, then, a story Those of the Mountain used to scare their children from climbing down to the wastes."

"My story begins more years back than there are years in front of the whole of humanity. It begins when the wastes

were not the wastes, when they were verdant grasslands. When the seas were not the seas, when they were crossed with bridges of glass. When humanity was not newborn, but when it was not so far gone as now. My story begins when the city we sit in this very night was younger than my sleeping sons. And of course, my story begins with the romantic whimper of fate.

"There was a young man from Bamore, scarcely more than a boy, who loved the stars more than he loved himself or his people. His name was Nigel, and it is for this boy that the mountain range to our west Monnigels is named. Nigel spent most every day of his life hard at study and most every night with his eyes to the heavens, studying more. He studied so greatly that he never slept.

"Far across the seas, a month-long walk across the bridge of glass, was a woman, a full-grown woman whose vigor had passed but whose mind and beauty remained. Her name was Abigail, and she was the queen of a small tribe. It is for her that we have named Queen Peak, the tallest and most majestic of the Monnigels Mountains. It had been her dream since childhood to walk upon the surface of our moon.

"And when Abigail heard tell of Nigel the Sleepless she sent a summons to him on the wings of a gull, a summons Nigel received with joy. He had few friends, so lost was he in the night heavens, and so it was with great happiness that he set out across the glass bridge.

"For four weeks he strode bravely in solitude, and although his mind required no sleep, his tired and weak body forced him to lie for hours at a time on the clear deck of the bridge. Every time he slept, great fish leapt from the water and spoke to him.

"Let me be clear when I say this: the fish did not speak metaphorically, as they might today. The fish of those times were quite articulate, and they spoke in the words of Ihguls, the tongue of those days. They told him to return to Bamore, and they told him that the queen ought not walk on the surface of the moon.

"But Nigel was well-studied and believed not the words of fish. He had faith in his own reasoning, a reasoning that saw no possible fault in the Queen's ambition. So it was that when he reached Abigail across the seas that he did not confide in her the misgivings of the fish, but instead worked night and day to allow her to walk on the moon.

"He fell deeper than science and deeper than magic, into the darkness of alchemy. He learned to craft the combustible soil we travel across today, and he learned to silence the voices of the sea, so loud were they in exclaiming their dissent. Yet Nigel was not an evil youth, merely a young man in love with knowledge and, increasingly, with Abigail herself who spent many hours in his company.

"After less than a year at her side, he announced to the world his greatest discovery, a discovery that would allow Abigail to walk upon the surface of the moon. Thousands of people, collected from all of the tribes on the land east of the glass bridge, came out to watch the proceedings. A great rock would be hurled by magic and science, Nigel proclaimed, and he and Abigail would ride it.

"The fish of the sea and the fish of the lake stood on their tails above the water, screaming silent dissenting pleas, but the festival air drowned out their silence, and Nigel and Abigail stepped onto a glorious pedestal of rock and metal, decked in the finest of cottons and even silk. Abigail announced that the pair would be wed upon their return, a return that would be effected by the simple means of gravity.

"So the great sling hurled the great stone, and the two fled upwards at fantastic speeds, until they were soon perched on the very peak of the moon itself. 'Glorious,' Abigail shouted, and she danced in the gray clay soil. 'Just imagine what a castle we may build here,' she told Nigel, as she began to mold the clay into a simple pillar.

"But Nigel was distracted, for his rock, built too roundly, began to roll off from the curved peak of the moon. He must have cried for help, but gravity cannot be stopped, and his rock crashed back down through the heavens, splashing into the sea with such vigor that the glass bridges shattered the world round. The fish, who used to rescue humans with admirable grace and remarkable friendliness, turned a cold, scaled shoulder to his plight and he was forced to swim for the whole of a year before landing upon shore.

"Nigel became a broken man, but he held onto his genius, even if his sanity had drowned in the cold blue ocean. Once more, he began to build a rock and sling so that he might come to the rescue of his beloved Queen, although any rational person might have known with morbid certainty that she must have starved, alone on her moon.

"For one hundred and seventy years he built—for the lifespan of a person is quite shortened by the toxic act of sleeping—until he had a castle of stone and fire, prepared to be slung to the moon to rescue Abigail. Once more, the people gathered, for none had been alive to witness his first journey, and once more the fish stood on their tails in silent protest. The castle went up in a massive arc and then exploded, a fireball the like of the sun, and Nigel became, for a brief moment, such a star as those he had studied so raptly in his youth. But a star ought not be so close upon the earth, and the entire land was unforgivably scorched.

"Only the mountains, above the exploding castle, remained unharmed, and it was to the mountains that the few survivors turned. And it was in the mountains that my people grew both young and old, never venturing to the poison-scorched earth below."

The narrator laughed deeply, a guffaw that echoed throughout the theatre. "And here, if this were a thousand years ago, I would admonish you to stay above the level of the snow, and tell you that land below is filled with cruel monsters."

Erecura looked significantly at the gold-headed cane that Yena bore as trophy, and it occurred to Yena that there might be truth in Raka's tale of wasteland monsters.

The evening thus concluded, Raka reached forward and tightened the gas valve on the torch, throwing the room into perfect darkness.

"C'MON, LADY, WE'VE GOT BAND PRACTICE AT NOON." Set's voice first seeped into Yena's jumbled dreams and then roused her properly.

"Er…" Yena managed to rumble. She was curled up on her side, and Erecura's arm was draped lightly across her. Yena looked pleadingly up at her sister, but Set was unmoved.

"What would we tell Fera? That we didn't feel like coming?"

Erecura sat up, and Yena followed suit. They were still on the stone stage, a thin blanket lain out beneath them as a mattress, the mid-morning sun casting the room into sharp relief.

"I didn't know you played in a band," Erecura said, as she lay on her back to stretch and Yena tried not to stare.

"Yeah," Yena mumbled.

"I suppose there's plenty I don't know 'bout you, then."

Yena smiled weakly.

"Maybe sometime I'll get to know you a bit better." Erecura stood, smiling, and began to gather up her various belts and pouches.

"You going to be in The Vare long?" Yena asked.

"Got a sailbus out of here in a few hours, I think. Heading up to the trainline and out to Angeline, matter of fact."

"Yeah," Yena said, "be careful out there. And if you ever come back…"

"I'll see you then."

Yena reluctantly said a general farewell to the band and walked out of the building. In the daylight, the Gaslamp district smelled of sewage and drunk, as though the whole quarter had suffered a hangover and had induced vomiting.

Walking back the way they came, they nearly stumbled upon the sandy corpse of the beggar man that they had discussed the night before. His flesh was stripped off in spots, with glinting clean bone exposed, and he still lay prostrate, submissive.

Biting down guilt, Yena defended her callousness: "He could have gone in to any of these buildings. Most of them are abandoned. He could have taken care of himself."

"It's not as simple as that," her sister replied, crying softly as they walked on, "it really isn't."

Earth Sea and Sky

Welcome, gentle soul, to our third installment of "Earth Sea And Sky", excerpts from a 1887 natural history tome of the same name. Here we present you with a realization of the immense philosophical ramifications of the modern universe.

From the discoveries of astronomy it appears that our earth is but as a point in the immensity of the universe—that there are worlds a thousand times larger, enlightened by the same sun which "rules our day"—that the sun himself is an immense luminous world, whose circumference would enclose more than twelve hundred thousand globes as large as ours—that the earth and its inhabitants are carried forward through the regions of space at the rate of a thousand miles every minute—that motions exist in the great bodies of the universe, the force and rapidity of which astonish and overpower the imagination—and that beyond the sphere of the sun and planets, creation is replenished with millions of luminous globes, scattered over immense regions to which the human mind can assign no boundaries.

Where are the souls to whom the spectacle of starry night is not an eloquent discourse? Where are those who have not been sometimes arrested in the presence of the bright worlds which hover over our heads, and who have not sought for the key of the great enigma of creation? The solitary hours of night are in truth the most beautiful of all our hours, those in which we have the faculty of placing ourselves in intimate communication with great and holy Nature. The orb of day conceals from us the splendors of the firmament; it is during the night that the panoramas of the sky are open to us. At the hour of midnight, the heavenly vault is strewn with stars, like isles of light in the midst of an ocean extending over our heads.

Orbs of Amazing Brilliancy.

In the midst of darkness our eyes gaze freely on the sky, piercing the deep azure of the apparent vault, above which the stars shine. They traverse the white constellated regions, visiting distant realms of space, where the most brilliant stars lose their brightness by distance; they go beyond this unexplored expanse, and mount still higher, as far as those faint nebulæ whose diffused brightness seems to mark the limits of the visible. In this immense passage of sight thought is carried away by its flight and wonders at these distant splendors. It is then that thousands of questions spring up in our minds, and that a thousand points of interrogation rise to our sight. The problem of creation is a great problem! The science of the stars is a sublime science; its mission is to embrace all created things! At the remembrance of these impressions, does it not appear that the man who does not feel any sentiment of admiration before the picture of the starry splendor, is not yet worth of receiving on his brow the crown of intelligence?

Of all the sciences astronomy is the one which can enlighten us best on our relative value, and make us understand the relation which connects the earth with the rest of creation. Without it, as the history of past centuries testifies, it is impossible for us to know where we are or who we are, or to establish an instructive comparison between the place which we occupy in space and the whole of the universe; without it we should be both ignorant of the actual extent of our country, its nature, and the order to which it belongs. Enclosed in the dark meshes of ignorance, we cannot form the slightest idea of the general arrangement of the world; a thick fog covers the narrow horizon which contains us, and our mind remains incapable of soaring above the daily theatre of live, and of going beyond the narrow sphere traced by the limits of the actions of our senses. On the other hand, when the torch of the Science of the Worlds enlightens us, the scene changes, the vapors which darkened the horizon fade away, our mistaken eyes contemplate in the serenity of a pure sky the immense work of the Creator. The earth appears like a globe poised under our steps; thousands of similar globes are rocked in ether; the world enlarges in proportion as the power of our examination increases, and from that time universal creation develops itself before us in reality, establishing both our rank and our relation with the numerous similar worlds which constitute the universe.

If we imagine the terrestrial globe suspended in space, we shall understand that the side turned towards the sun is alone illuminated, whilst the opposite hemisphere remains in shadow, and that this shadow presents the aspect of a cone. Moreover, as the earth turns on itself, all its portions are presented successively to the sun and pass successively into this shadow, and it is this which constitutes the succession of day and night in every country of the world. This simple statement suffices to show that the phenomenon to which we give the name of night belongs really to the earth, and that the heavens and the rest of the universe are independent of it.

This is the reason why, if at any hour of the night we let our minds soar above the terrestrial surface, it will follow that, far from remaining always in the night, we shall again find the sun pouring forth his floods of light through space. If we carry ourselves away as far as one of the planets which like the earth, revolves in the region of space where we are, we shall understand that the night of the earth does not extend to those other worlds, and that the period which with us is consecrated to repose does not exert its influence there. When all beings are buried in the stillness of silent night here—above, the forces of nature continue the exercise of their brilliant functions—the sun shines, life radiates, movement is not suspended, and the rein of light pursues its dominant action in the heavens (as on the opposite hemisphere to ours), at the same hour when sleep overcomes all beings on the hemisphere we inhabit.

Space Has Neither Beginning Nor End

It is important that we should know, first of all, how to habituate ourselves to this idea of the isolation of the earth in space, and to believe that all the phenomena which we observe upon this globe are peculiar to it and foreign to the rest of the universe. Thousands and thousands of similar globes revolve like it in space. One of the most fatal delusions which it is important we should get rid of at once, is that which presents the earth as the lower half of the universe, and the heavens as its upper half. There is nothing in the world more false than this. The heavens and the earth are not two separate creations, as we have had repeated to us thousands and thousands of times. They are only one. The earth is in the heavens. The heavens are infinite space, indefinite expanse, a void without limits; no frontier circumscribes them, they have neither beginning nor end, neither top nor bottom, right or left; there is an infinity of spaces which succeed each other in every direction. The earth is a little material globe, placed in this space without support of any kind, like a bullet which sustains itself alone in the air, like the little captive balloons which rise and float in the atmosphere when the thin cord which retains them is cut.

RELATIVE SIZES OF THE SUN AND PLANETS.

REVIEWS

contact collective@steampunkmagazine.com to get a shipping address for any physical things you would like reviewed.

EP
The Dust Collectors
"Music for the Scrapyard Dancehalls"
self-published, 2007
thedustcollectors.net

Let it be said: The Dust Collectors is my favorite SteamPunk band. And I say that not to disparage the other SteamPunk innovators who populate our small and growing world, but that, simply put, this is a band that lives up to every hope I have had for steampunk music. With their four song, 22 minute EP, they have covered it all: "out-dated" instrumentation performing a more modern, punk-influenced style; creepy lyrics centered around machines that tell a remarkable story; male and female vocals both; and a hand-stitched zine as part of their packaging.

Track 3, "a big machine," being entirely ambient, there are properly three songs on this album. The first one, "Jack Cannonball/Like Lung," is my least favorite, and perhaps a poor indicator of what is to come—I shall describe it as a sort of "weird jazz", with harsh vocals and electric guitars. I do not doubt that there will be many among you who will enjoy it to its fullest, but it pales in my eye after hearing the entire album. Soon enough, we get to "Our Lady of the Flowers", a well-composed, spooky, seven-minute track that relates to us a portion of their strange Industrial Inclination mythology.

And after our track 3 interlude, we are presented with "The Men Without Eyes," a bizarre and entirely listenable confoundation of jazz, punk, and gothic.

I can only imagine their live performances.

There is no doubt in my mind that The Dust Collectors ought be heralded proudly by those of us of the steam inclination as innovators and creators of the utmost quality.

—*Margaret*

GRAPHIC NOVEL
Jane Irwin
"Vögelein: Old Ghosts"
Fiery Studios, 2007
www.vogelein.com

This book is sweet. It's sweet in that slang way, meaning "really damn cool," and it's, well, emotionally sweet. I'm not sure I've read a fantasy book more earnest and compelling, and earnest is a welcome thing in these dire times of irony.

For those who haven't read the first book [reviewed in SteamPunk #2], Vogelein is an clockwork fairy given life, surviving in the care of successive guardians who wind her every 36 hours. The first book tracks Vogelein as she first learns to live alone in modern, urban America, and the second finds her well adapted to city life. Her survival needs fulfilled, she turns her energy inward.

The characters radiate warmth, unabashed hope, and a refusal to fall into cynicism. While not glossing over the horrors of the world—indeed, we are presented with long-forgotten atrocities as well as the insanity of the modern era—this story makes one happy to be alive. Even the antagonists are viewed compassionately, as portraits of obsession.

Every panel in this 150+ page book was painted individually. Every historical fact was researched, and this attention to detail is part of what breathes life into this book.

The book overflows with DIY in all its best, and it is clearly the kind of work that could only come from someone with no regard for the needs of the mainstream comics world: the back brims with footnotes, photos of the body models, and a gallery of guest artists. The plot itself pays little heed of mainstream methodology, moving gracefully between scenes in an understated, often un-dramatic way that is refreshingly realistic for fantasy.

Perhaps the biggest drawback to the book is that it is printed in black and white, when the paintings so clearly long to seen in full color. But it seems that the artist has learned from the first book and the artwork in the second is more intentional.

—*Margaret*

artwork by Steven Archer

STEAMPUNK MAGAZINE
our lives as fantastic as any fiction!
[Lifestyle, Mad Science, Theory & Fiction]

TSA
please remove all metal items from your person

#4

One thing I have faithfully observed and noted about punks: they're all legends, each and every last one of them, in one circle or another. Even if you never see them in the elements of their renown, even in a mere courtesy-handshake between friends of friends in a parking lot, you cannot help but feel an immortal vibrancy, a comic-book kind of costumed exuberance like that parking lot is host to a historic summit or a scene in ten thousand movies we're living right now…

Inevitably I reach the understanding that this word 'punk' does not mean anything tangible like 'tree' or 'car.' Rather, *punk* is like a flag; an open symbol, it only means what people believe it means.

—Michael Muhammad Knight,
The Taqwacores

The cover was illustrated by Claire Hummel

ISSUE FOUR:
OUR LIVES AS FANTASTIC AS ANY FICTION!

Welcome back, fellow time-travelers, artists, vagrants, engineers, pirates, bookworms, performers, and other such folk! For that is who we are—we are all wearers of multiple hats (see Molly Friedrich's article on how to create your own! ;). Issue Four of SteamPunk Magazine is a tribute to the multiplicity of our culture. Steampunk is fantasy made real, filtered through the brass sieve of nostalgia, vehemence, curiosity, wonderment, and apprehension.

Our culture is not based only in story—it's about action. Contrary to what we often see on blogs and in forums, steampunk is inherently political. Daring to wear what we want and creating communities in our image is rebellious. Popular or no, steampunk is not commonplace. It is anti-establishment. It is dangerous to pluck our dreams from muddy scribblings and coax them into existence in three dimensions.

Let us not speak only of ages gone by, of retrofutures and fantasy worlds. Let us talk about change in our time. Let us talk about going to protests or shows in our garb and performing on the street to let people know we exist and passing out free food and literature to anyone who might hunger. Let us talk of the environmental impact of mainstream culture's technofetishism and of civil rights. Let us talk about doing great and wondrous things, not just what other people are doing elsewhere. And then let us do. Let us make real what we hallucinate on paper or online.

Sometimes, in our giddiness to participate in community, we forget that steampunk *does* exist outside of our laptops and personal computers. We waste our nights furiously bantering over theory and semantics when we could be gathering together to create. Not everyone is a maker, but we can certainly be more conscientious consumers. Steampunk is in our coffeehouses and alleys and parks, thriving just as wildly as it might in any internet forum. We must remember that our stories may be told online, but we must take our ideas off the computer screen and into the streets.

Steampunk Magazine would, however, like to offer our readers a chance to gather together in the ether to formulate our futures perfect. Understanding a need for a mechanism that allows friends across continents to share projects and philosophies, we are proud to announce the opening of The Gaslamp Bazaar, which is located at **http://www.steampunkmagazine.com/forum**. We hope that such a place will encourage activism amongst our ranks and solidify us as a society. Please stop on by! We would love to see what you have been doing.

— *Libby Bulloff*

LETTERS
write us at collective@steampunkmagazine.com

An open letter to Jake von Slatt and Datamancer

Gentlemen,

A hearty congratulations on the attentions paid to you by the press of late. Fear no "selling out", for all such trends wax and wane, with only the true devotees remaining (witness the continued perpetuation of metalhead culture long after society has considered metal to be dead). Attention from the mainstream will draw more good people (who will linger long after the trendseekers move on) just as well as it will manufacture a cheesy, store-bought version of your trend available to all who wish to buy-in without effort. So now you may play a skateboarding video game if you are too lazy to actually skateboard, and so on.

Yet something disturbs me about this coverage, and I assure you it's not your fault at all. The media seems to portray steampunk as a trend in prop-making and case-modding. Their reasoning is obvious; this is the most marketable aspect of it and larger society understands nothing that cannot be bought or sold. Of course this has benefitted you in the short term and I think neither of you wish to become wholesale manufacturers of keyboards. Let's treat it as a fortunate happenstance— for Jake, you seem all too devoted to your various projects to become a full-time propmaker, and Doc, you are hopefully using this as a springboard to pursuing your dreams on the west coast. I am happy for your success and hope you wring as much from the buzz as you can. The media, after all, is trying to wring what they can from you.

So this is what bothers me: Steampunk is not some non-functional ray-gun to be painted and polished and put on a shelf, it is a revolution in personal behavior and industrial design! It means making an *actual* ray-gun! Or, barring that, a ray-gun case for your TV remote... for are not these objects merely props in a larger lifestyle? If we are making our computers look old-fashioned, isn't it just so they match the rest of our house? Isn't someone who collects skateboard decks and hangs them on the wall a *fan* of skateboarding, rather than a skater?

I know already that both of you feel the same way about Steampunk. You've both worked hard to emphasize that the product is not the point. We are all three, after all, merely at the right place and time. None of us can make anything that cannot be churned out en masse by some factory full of third-world craftsmen, were some investor to see the profit in it and start importing "von Slott" keyboards. We have what the cool-hunters want, an understanding of a nascent trend. After all, the beauty of our projects is that a determined-enough individual could make them by themselves. Ideally each Steampunk craftsman would be supported by the idle rich who don't wish to bother with the effort, or, in trade between steampunk costume-makers, case-modders, engineers, etc etc. Perhaps we're witnessing the early stages of the Neo-Victorianism as described in *The Diamond Age*, where mass production has leeched the value from everything that is not handcrafted. Still, I have a friend who is a maker of very fine, very expensive, and very labour-intensive wooden clamps which he sells to Home Depot; he has recently lost that client to someone who is making the same product with slave labor in China.

And now I will tell two stories:

I have long been struggling with the balance of technophobia and technophilia in Steampunk. I like to say that Steampunks are far from

comic by Doctor Geof

Luddites, but appear so, where in fact we are obsessed with technology but we are "techno-suspicious". I was discussing this suspicion with Guru Stu, trying to pin its specifics down, and he told me a story: After Hoot Gibson's NASA astronaut career was over, he became the CEO and head test pilot for Benson Space Company, a fledgling private-rocketeering firm. As the company started to design private spacecraft, he asked for the unthinkable: Spaceships that were user-serviceable. He'd been in space, risked his life, and he wanted future astronauts to be able to pull off a panel and fix whatever was going wrong. This is, by modern design standards, ridiculous—but it's what saved the Apollo 13 mission, a mission planned and built by the slide rule instead of the computer simulation. Unfortunately, however, the era of the shade-tree mechanic is long gone and you cannot even fix a toaster anymore. You just throw it out and buy another one. Mass Consumerism (which I trace back to/blame on the "wonderous conveniences of the future" from the 1893 Columbian Exposition, the tipping point when Consumerism began) has bred a generation unable to fix any appliance or tool they own. Conversely, it has often been pointed out that 1900 or so was the last point at which a high school graduate could grasp the basic concepts behind all human knowledge.

The second story: When LeChat Noir (who has synthesized old and new in his craft in a way I've seen no other steampunk builder do, starting with a base of blacksmithing and then developing ways of making a plasma cutter produce work that looks like it was cast) was building his "Contraption", he was pulling apart an old tobacco setter, and he wrote:

> "When I broke apart the guides that held the axles for the discs, I found that they contained wood bearings. I suspect worn-out babbit bearings were replaced at some time by an industrious farmer who needed to get this thing going again. They were well made, as if turned on a lathe and were built as a two piece assembly complete with holes for oil access. Its weird, but I swear I feel echoes of the past in stuff like this. Like the vibrations of the lives that counted on this piece of equipment were recorded in the grooves worn into that wood like a groove in a record."

When I heard the story of Hoot and his user-serviceable spacecraft, it dinged the dusty memory of LeChat's wooden babbits, and that's when I realized why I don't like modern technology: no user serviceability! Just like the label says: "No User Serviceable Parts Inside". Those who've circuit bent have pulled out a toy's circuit board and found resistors and circuits they could mess with and replace, but know of the black synthesizer dot and its impenetrability. User Serviceability can involve modern technology by being modular, so at least the unserviceable part can be yanked out and replaced when neccessary. Perhaps this is all obvious to you both. But to me, it finally provided me with a guideline for allowing technology into my life: I'll use any machine that I can fix!

But I'm no re-creationist living in dreams of the past. It's not that I want to go back to the 1800s, it's that I've spent too much time in the third world to not realize that *now* is the 1800s, and you can be plunged into that level of survival at any time. While an absolute collapse of society is unlikely (an I'm not sure I'd want to live long afterwards), there are plenty of likely scenarios for *temporary* social collapse, such as the aftermath of Katrina. Those possibilities are much more possible and realistic than some end-times scenario. To me, living a steampunk self-reliant life of minimal technology is about preparation for those possibilities. I don't want to survive an earthquake only to die because I don't know how to grow corn, or fix a generator, or suture. And thus I only involve user-serviceable technologies in my life.

See how drastically this interpretation of our lifestyle differs from the media's fixation on the casemod entrepreneur. Of course there is room in our world for both. I only hope that your own creations remain accessible, and I have faith that they will. Let's use this peak of popularity to bend the world just a little bit towards our own vision.

Fondly,
Your Servant,
Johnny H. Payphone

What is Steampunk? What is SteamPunk Magazine?

The term "steampunk" was coined to refer to a branch of "cyberpunk" fiction that concerned itself with Victorian-era technology. However, Steampunk is more than that. Steampunk is a burgeoning subculture that pays respect to the visceral nature of antiquated technology.

It's about "steam", as in steam-engines, and it's about "punk", as in counter-culture. For an excellent manifesto, refer to the first article in our first issue, "what then, is steampunk?"

SteamPunk Magazine is a print publication that comes out erratically. Full quality print PDFs of it are available for free download from our website [http://www.steampunkmagazine.com], and we keep the cost of the print magazine as low as possible. Most all work on the magazine, including articles, editing, illustration, and layout, is done by volunteers and contributors. To see how you can get involved, see the last page.

The End of an Era

After a great deal of consideration, we are no longer planning on publishing seasonally. We feel that we have played our part in giving Steampunk culture its feet. We now intend to publish a slimmer volume every summer and a thicker volume every winter. This seemed to us to be the only way to keep the volunteer spirit of the magazine alive amidst the beautiful maelstrom of steampunk activity that we now find ourselves in.

For Freedom
BEING THE REMARKABLE LIFE OF ONE ISABELLE EBERHARDT (1877–1904)

by Esther
illustration by Colin Foran

adventurer, cross-dresser, sufi, author

I

IN A SENSE, ISABELLE EBERHARDT WAS BORN ON THE run. Her father, Alexandre Trophimowsky, was a Russian Orthodox priest who converted to nihilism and left the church to be with a married woman. Isabelle's mother, Nathalie Moerder, was that married woman, and she ran off with Alexandre with her two children in tow and soon gave birth to the illegitimate Isabelle.

Isabelle was raised by the stern hand of her father, who provided her with an extensive education. He taught her Greek, Russian, and Latin, and later, at her insistence, Arabic. Isabelle worked hard alongside her brother, doing "men's work" and often wearing trousers. In the late 19th century, this was not the accepted way for a young woman to live, but then, Isabelle was not being prepared to live an ordinary life. It was quite possibly this unconventional upbringing that gave Isabelle the fortitude to embark on the epic adventures of her life. *Vava* (uncle), as she called her father, left a bitter taste with Isabelle and she longed to leave his brutal regiment behind.

Throughout her childhood, her closest friend was her half-brother Augustin. They shared everything, including the dream of total liberty. Her love for her brother was the first of Isabelle's bouts of mad love, a love completely outside the bounds of convention—though it would not be her last. It is lost to history what the exact nature of their relationship was, but she wrote often of it. Augustin and Isabelle longed for a life outside the walls of the compound where they lived, and spent much of their time exploring the urban wilds of Geneva, entangling themselves in unknowable adventures.

What *is* known, however, is that the Swiss authorities were keeping tabs on the family, and eventually Augustin fell into trouble. It may have been his anarchist affiliations, his gambling debts, or his uncontrolled love of opium that led him to desperate measures, but he felt his only escape was to join the French Foreign Legion. Later, he would marry a woman that Isabelle found to be intolerably boring and sensible. As Augustin drifted into predictable mediocrity, Isabelle, devastated and betrayed, hatched plans of her own.

...but the moment of danger

II

Springtime, 1897. At the age of nineteen, Isabelle departed for Algeria, having convinced her ailing mother to join her. Shortly after arriving in the city of Bône [now known as Annaba], Isabelle made her preferences clear by taking up residence in the loud and raucous Arab quarter. This rejection of the French quarter was her first affront on colonial sensibilities, but it was certainly not her last.

Both Isabelle and her mother officially converted to Islam shortly after their arrival in Africa. Her mother, however, soon died and was buried on a hillside. At last, Isabelle was alone and adrift. Although her mother had married into the noble class, Isabelle's illegitimacy made inheritance impossible, and she was destined to a life of poverty.

Vava had heard of his wife's failing health and set out across the sea, only to find her dead and their child in suicidal despair. Isabelle, deep in grief, told her father of her desire to die. Vava, with his typically chill calculations, handed Isabelle his revolver.

Perhaps he knew that Isabelle's will to live was too strong, and that by pressing his gun into her hand he would force her to confront the pain of a life lived fiercely. Isabelle, having long since determined to leave her life in the hands of fate, chose not to pull the trigger.

III

Isabelle threw herself into an abyss, but not that of suicide. Instead, she descended into a debauchery previously unimaginable for such a young woman. Since it was unacceptable for a young woman of European descent to walk the streets alone in Bône, Isabelle became a man. She took to wandering the cacophonous Arab quarters in the long white burnous of traditional Arab men, having realized an identity for herself that allowed her to pursue the adventures she had long dreamed of.

She drifted through the winding alleyways, sniffing her way into dark kif dens where she smoked herself into oblivion time and time again. Through clouds of smoke, Isabelle wrote constantly in her journals, keeping record of the social and mental frontiers she explored. She embraced her new life lustfully, and spent hours in small cafes conversing with young Arab men or wrestling in the dust with spahis [native soldiers recruited by the French occupation]. Often, when desires arose, one of these young soldiers would spend a night in her quarters.

If her choice of neighborhoods was a source of scorn for the French occupying society, then her new habits were a scandal of legendary proportions.

And yet, while it was unheard of for a young woman to behave in this way, the Arabs allowed her as a young *man* to act as she pleased. So was she reborn as Si Mahmoud Essadi. She rejected the predictable life spelled out for her in the role of a proper European woman by transgressing the gender sphere of both Arab and European societies, all the while violating the boundaries of the colonizing culture by living amongst, rather than above, the Arabs.

This was a lonely path, of course, and being neither male nor female and neither Arab nor French left Isabelle out of all communities. This was a road that Isabelle envisioned herself to be on, in one way or the other, for many years. She wrote time and again of the long white road, the lane that stretched out from Villa Neuve. It was a road to autonomy and freedom for her in her youth, but it later came to represent the path of the isolated wanderer.

In Bône, Isabelle could drink and smoke her way into a stupor, and find an abundance of lovers, but that was not the complete autonomy she longed for and wrote of. There were other roads for her to take.

Isabelle embraced sufism, a mystical and largely tolerant form of Islam with an emphasis on personal experience of the divine. Though profoundly devout, Isabelle wrote very little about her spiritual practices. She prayed daily and attended mosque. In time, she was initiated into the ancient sufi order The Qadiriyyah. Associating with an order was not an uncommon thing among the Algerians at the time, and although the affiliation would prove useful in her years of wandering, it also predicated a cataclysmic twist of fate.

IV

It was in the endless sea of sand that Isabelle found the autonomy and freedom she had always dreamed of. She took on the persona of a Tunisian student, and traveled alone on horseback. Although not everyone she met believed she was a young man, or a "Tunisian student," there was a tolerance for difference that did not abide in Western Europe at the time. For years she wandered, exploring the deserts she loved. Sometimes it was just her and her horse, other times she joined long winding streams of camels driven by nomads through the dunes. She visited lands and met peoples that no other European of her time had the courage or desire to seek out—except to subject or exploit.

Her initiation into the Qadiriyyah had become a scandal in the eyes of the French authorities, who suspected her of inciting the natives to revolt against the colonial occupation— as members of that order were prone to doing. With these accusations, it was a challenge simply to make ends meet.

One noonday, sun high above her, Isabelle sat down in a remote village to translate a local man's letter. While deep in translation, a man rushed her from behind, sword

is also the moment of hope.

held high and glinting. He was a poor man from a rival sufi sect. Perhaps he was manipulated into the act by the French authorities, perhaps it was merely their opposing sect loyalties. By chance, his sword hit an unseen clothesline directly above Isabelle's head, and his sword missed her skull and tore into her shoulder instead.

Later, Isabelle successfully advocated for her would-be assassin in court, helping him to escape the death penalty.

Before and after this encounter, Isabelle wrote maniacally, at times making a living as a journalist, and hoping to become a published author. She reported, for European audiences, on North Africa in the throes of colonial conflicts. Much of her vast collection of writing chronicles her explorations and wanderings through the vast Sahara, living among nomads and common people. Her journeys were both physical and philosophical, and she recorded with as much detail the cultural traits of various tribes as she did her own conclusions on what it meant to be a risk taker in this world:

> "I wasn't made to whirl through intrigues wearing satin blinders. I didn't construct for myself an ideal: I went for discovery. I'm quite aware that this way of life is dangerous, but the moment of danger is also the moment of hope. Besides, I have been penetrated by this idea: that one can never fall lower than oneself. When my heart has suffered, then it has begun to live. Many times on the paths of my errand, I asked myself where I was going, and I've come to understand among ordinary folk and with the nomads, that I was climbing back to the sources of life, that I was accomplishing a voyage into the depths of my humanity."
> *Reflections in a courtyard, diary entry.*

One starry night at an oasis, as she was sleeping alone under the velvet black desert sky, Isabelle was awakened. Her rouser was Slimane Ehnni, a native Algerian soldier. The two quickly fell into mad love.

Eventually, the French authorities succeeded in deporting Isabelle from the colonies, and it was only by way of marriage to Slimane that she managed to return to Africa.

Never content to be settled, Isabelle departed her husband for months at a time to wander the deserts alone. Their once mad love turned into an enduring dedication, one that left her freedom wholly intact.

V

ISABELLE'S LIFE WAS marked by an unwavering spirit of adventure and wanderlust. In her endless self-evaluations, recorded in her diary, she constantly challenged herself to push further into spiritual realms, deeper into the desert, to be more self-sufficient, to be more free. She was hard on herself in a world that was hard on her, and Isabelle battled addiction and illness. It's likely that she suffered from syphilis in addition to the injuries she sustained during the assassination attempt.

After a particularly difficult bout of illness, Isabelle planned a reunion with her lover. They had been apart for a long time, and she missed him sorely. Slimane had found a small mud hut for them in the Algerian town of Ain Sefra, near the Moroccan border, and it was there that the lovers were reunited. They spent one last night together, when their home—and Isabelle's life—was destroyed by a flash flood. As strangely as her life had begun, so it ended: Isabelle Eberhardt drowned in the desert at age 27. Her body was found crushed under a beam and buried in the mud. The year was 1904.

> "A while ago the enlightened Aissawas were singing their Asiatic ballads, celebrating the blessedness of non-existence. And now the black Africans are singing, unthinkingly, a great hymn of love to eternal fecundity. As for me, I know music stranger and stronger, music that would bleed the heart into silence, songs that lips have murmured, absent lips that will drink other breath than mine, that will breathe another soul than mine, because my soul could not give itself, because it was not in me but in eternal things, and I possess it finally only in the vast, the divine solitude of all my being offered to the southern night.
>
> In the morning, the west wind suddenly arrived. This wind, which could be seen coming, raised spirals of dust like tall plumes of dark smoke. It advanced on the calmness of the air, with great sighs that soon became howls; I lent it living accents, I felt myself carried up in the huge embrace of monstrous wings rushing to destroy everything. And the sand fell upon the terraces with the incessant small sound of a shower."

Isabelle embraced a strange dream of freedom, insisting on living life on her terms alone. She overflowed with creativity, debauchery, loneliness, and mad love. Eberhardt left us the writings of a vagabond, a wanderlust rebel, but at the same time she chronicled a deeply examined life. Her journey was based on an unwavering dedication to total self-liberation. While she accepted the suffering and loneliness this long white road brought, she threw herself wholly into the passionate excess it afforded her. ✺

The Good Doctor is puttering about in his workroom when Igor dashes in.

"Doctor!" gasps Igor.

"What is it, Igor?"

"It's the peasants!" Igor gibbers, gesticulating in the general direction of the front of the castle and the road leading up from the village below. "The peasants are revolting!"

"And what else would the peasants be if not revolting?"

"Doctor, unless you think it likely that the village populace are heading up the road en masse and prepared for a nocturnal hay harvest, then I suggest we quickly pack your work and head out the back way!"

"What? Oh, it's another 'torches and pitchfork' parade, is it? Fear not, I have a plan!"

"I'll bring the carriage around back!"

"Not necessary, Igor! First, switch the nameplates on two rooms: swap "Conservatory" for "Laboratory" and we're halfway there. Then, go down to the storeroom and return with whatever old jars and vials you may find handy, and bring up the 'Jacob's Ladder' apparatus".

"Doctor, what are you talking about?"

"The good people of 'Shtuppstein' are looking to inspect the laboratory of a 'mad scientist'. We can help them find it by displaying a Jacob's Ladder, as I believe that few Shtuppsteiners could read the nameplates, could they? They'll sniff around in the 'lab', look at some vials of colored water, pet that basket of kittens we rescued last week, and find nothing to shock their delicate peasant sensibilities... provided they don't get touchy-feely with the Ladder, that is. In the end they'll be apologizing for their intrusion and then all go back home, and we can get back to our more sinister work... in peace!

BUILD YOURSELF A JACOB'S LADDER
WITHOUT BURNING YOUR HOUSE DOWN IN THE PROCESS *(one would hope)*

written and diagrammed by Prof. Offlogic
illustration by Molly Crabapple

A "Jacob's Ladder" is essentially a set of electrodes with an electric arc cycling from the bottom to the top. Since electric current is lazy, the arc will start at the point of least resistance, near the bottom where the electrodes are closest. Once the arc starts, the air conducting the arc is both ionized and heated by the current. Ionized air is more conductive than non-ionized air, and heated air tends to rise, so the arc will rise with it. The electrodes slope away from each other, so eventually the gap is too wide to support the arc. It re-forms at the bottom again, where the going is easier, and the cycle repeats. It is truly a wonder to behold, like watching the Devil's own yo-yo!

Although a Ladder serves no direct scientific purpose, having one is a requirement for recognition as a "mad scientist" (the preferred term is "ethically-undaunted science worker") and it is the internationally recognized symbol of "forbidden science in progress." Having one in operation greatly facilitates engaging the services of reliable resurrectionists, infernal device contractors, and members of the International Congress of Hunchbacked Henchmen.

YOU ARE WARNED! YOU ARE WARNED! YOU ARE WARNED!

This project involves high voltage and AC line power. This how-to isn't intended to be a college course so **beware!** These directions do cover making two types of Ladders. Be careful, and stay safe by following some minimal precautions:

— Never work on any mains-powered device with power applied.
— Make solid electrical connections and insulate them.
— It is a good idea to work with a friend.
— Evaluate both your level of expertise and your karmic burden before attempting this or any other electrical project.
— If you have any doubts at all regarding safety **stop immediately** and get help from a technical expert.

Remember these three primary points when building or operating a Jacob's Ladder:

— High voltage **really hurts**! Think 'bug zapper', and remember that you are the bug! Probably not enough current to stop your heart outright, but the arc will definitely burn you and make your thrash in an uncoordinated way, subjecting you to other injuries as you collide with walls, floor, other equipment, and people.

— High voltage **burns** and **ignites stuff!** This is a big spark plug, so do not power it up around flammable vapors (paint fumes, natural gas, anything that smells like airplane cement, nail polish remover, gasoline, spirits, etc).

— High voltage **kills electronics!** Many modern appliances, from coffee makers to cellular phones to I-pods, contain delicate circuitry, and one taste of the Ladder (even filtered through your body), will like as not render them "food for the land-fill."

YOU ARE WARNED! YOU ARE WARNED! YOU ARE WARNED!

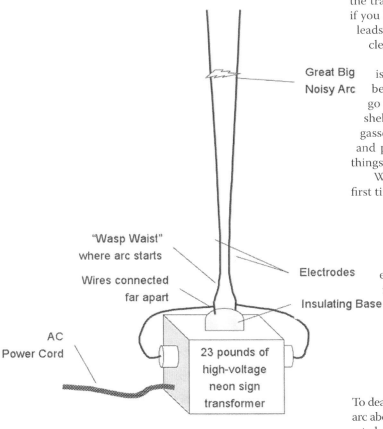

Neon Sign Transformer Scheme

THE PRE-PACKAGED SOLUTION (ABOVE)

The easiest, most basic system requires only a neon sign transformer and some insulated mounting blocks. It's so easy it's almost cheating, but it is a bit bulky.

eBay has a couple of neon sign supply sellers at any given time, but you will need a "neon sign transformer" *not* a "neon sign power supply". If it says "UL-2161" (a safety requirement that, among other things, keeps it from making an arc) it is of no use for Ladder makers.

I managed to score three Transco #4B15N3-02 transformers weighing over 20 pounds each on eBay. Caveat emptor: "removed from working equipment" doesn't mean they were careful when doing it, and they all had damaged insulators. It was nothing a couple of 2 inch PVC couplers filled with Bondo couldn't fix (a whole other article in itself).

Next you'll need some electrodes and an insulating base to hold them. I used ceiling tile hanger wire for the electrodes. For the base, I was lucky enough to have a weird looking chunk of cast urethane lying around, but a block of wood will work nicely (dry wood, varnished is best). Attach the electrodes to the base in a manner that makes it easy to adjust them for maximum effect (with the power off, remember!). Connect the output leads from the transformer to opposite electrodes using high-voltage wire if you have any; I didn't, so I made due by keeping the output leads short, separated from all other conductive objects, and clear of probing fingers.

For proper operation, a Ladder requires a location that is level, dry, and sheltered from drafts or breezes. Level because the electrodes need to be where the arc wants to go (up), dry to keep you from frying yourself or other, and sheltered because drafts and breezes will try to carry the hot gasses in the arc away, spoiling your fun. You might keep kids and pets out of the area as well, since they tend to lunge at things.

When you switch on the power to the transformer for the first time, one of the following will likely happen:

— No arc at all.
— A continous arc that just stays put between the electrodes.

Remember how the electrode mounting needed to be easily adjustable? Here's where that part comes in. You will need to iteratively:

— **Remove power to the transformer.**
— Adjust the distance/angle between the electrodes.
— Reapply power and observe outcome of adjustment.
— Repeat until the desired results are achieved.

To deal with the first problem, a rule of thumb is that electricity will arc about $1/10^{th}$ of an inch for every 1100 volts. For my transformer, rated at 12,500-16,000 volts, I positioned the electrodes just a bit further than the arc would theoretically jump, by drilling two holes about 2 inches apart, attached the wires at the base of each electrode, then bent the electrodes in to form a "wasp-waist" configuration. I dealt with the second problem by adjusting the angle of the electrodes above the "wasp-waist" more and more toward the vertical until the spark began to rise up between the electrodes.

My neon transformer Ladder throws off a very noisy 3-5 inch arc at the top of a pair of 4 foot electrodes. I christened it "Herr Baron" (it just seemed fitting).

Unfortunately Herr Baron is just too much power for use inside. For that niche, we can turn to the second, more accessible design...

IT CAME FROM THE SALVAGE YARD... AND THE HARDWARE STORE (FACING PAGE)

I came across a very simple means of producing a Jacob's Ladder, built around an incandescent lamp dimmer (600 Watt, like you'd replace a lightswitch with) and an automotive ignition coil (mine was from a 1990 Ford Escort, your mileage may vary). The dimmer is wired to an AC cord in a manner identical to its normal use. The output of the dimmer is connected to the ignition coil through a capacitor (details below). The capacitor blocks direct current, but allows pulses from the dimmer through, giving little kicks to the primary of the ignition coil, which multiplies the primary voltage hundreds of times and puts it out to the electrodes.

The capacitor needs to be at least 1uF with a working voltage of at least 220 VAC. The capacitor must be non-polar, rated for

an AC voltage of at least double the AC voltage in your area (triple even better). Since I'm in the US of A, standard mains power is 120 VAC.

Now, you can spend $50 on a big motor start capacitor, or $10 ordering a 4.7uF/600VAC poly cap from an electronics distributor, but if you are lucky enough to have a real hardware store (not any kind of "depot", but a dusty old independent store) in your area, you might be lucky enough to find "ceiling fan speed control capacitors". I think mine cost $6, cash and carry.

Ceiling fan caps are usually two capacitors in one, with one input wire shared between a 1.5uF and a 3uF capacitor, each with separate output wires. These are perfect because you can connect the two output wires together to make a 4.5uF capacitor rated at 250VAC.

I built this smaller Ladder inside some 4" diameter PVC drain pipe.

Most electrical connections were made using "peanuts" (or "wire nuts"), though the Ford Escort ignition coil did require some crimp-on connectors to make connections. The high-voltage output from the ignition coil was a socket close to 1/4 inch in diameter, so I coiled a bare copper wire around a #10 machine screw and forced it in. The other end of the high voltage lead and a connection to safety ground were attached to two "banana plug" terminals I'd mounted through the square wrench-end of a 4 inch PVC clean-out plug cemented inside a 4 inch-to-3.5 inch PVC reducer. The smaller end of the reducer fits nicely inside the 4 inch PVC body of the Ladder.

For added protection against internal arcing I enclosed the high voltage lead in a good packing of "Bondo" glass-filled body putty, which also anchored the ignition coil to the underside of the clean-out plug.

Once the base assembly was complete, I made electrodes with 3/32 inch bare brass welding rods. A 90 degree bend about an inch from the end of each of them allowed them to stand upright after being screwed down into the banana plug terminals. A 4 inch diameter glass candle chimney picked up from a resale shop for $1 completed the ensemble.

The completed assembly was finished in hammered bronze using Rustoleum "Hammered Paint for Plastic".

OTHER OPTIONS

IT IS POSSIBLE TO CONSTRUCT A SMALL LADDER POWERED by a "flyback transformer", but the process is somewhat involved for those not already electronic tinkerers.

Using the flyback as a source of high voltage makes for a very compact unit, though bulky heat-sinks are required for the driving electronics. Due to the high resonant frequency of a flyback (15-16KHz), I found the audio appeal of these lacking when compared to the 60HZ models… just not enough *crackle* to suit my taste. ✺

REFERENCES

Sam Barros (the mac daddy of high voltage) self-resonant flyback driver (and lots of cool other stuff): http://www.powerlabs.org/flybackdriver.htm

Don Klipstein has one of the most comprehensive collections of high voltage information out there: http://members.misty.com/don/igcoilhv.html

The dimmer/ignition coil idea came from Snock's High Voltage Page: http://www.geocities.com/capecanaveral/lab/5322/simpleign.htm

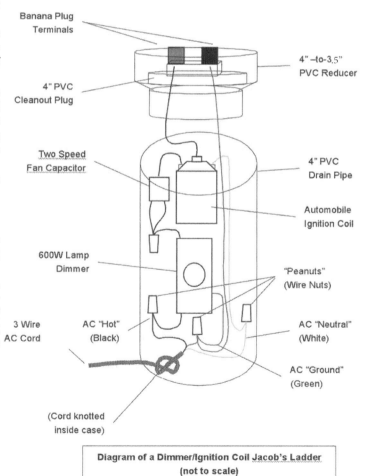

Diagram of a Dimmer/Ignition Coil Jacob's Ladder (not to scale)

A Fabulous Junkyard
by David X. Wiggin
illustration by Fabiola Garza

Contents of Exhibit C (Burnt journal):

Feb 15, 2037

I DO NOT KNOW IF THESE WORDS WILL SURVIVE—ANY MORE than I can be assured of my own survival—but since I find myself with the time and the need to record these final thoughts and confessions, I shall take pen to page and do just so. My name is Philip Pirrip—though that is not the name I was born with it is, nevertheless, my name—and this is the story of my birth, education, and the induction into the Fraternal Order of the Cog that was both my undoing and my salvation.

I was born into the wrong place and—most tragically of all—the wrong time. Somehow, even in my infancy I knew that there was something wrong with this pale, antiseptic world I occupied. According to my mother, my persistent colic could only be calmed by the sound of whirring clockwork held close to my ears. When I became old enough to walk, I set about disassembling whatever devices I could reach to see inside them and investigate their workings. More often than not my efforts were met with disappointment, as the circuitry of even our toaster was microscopic. I loved the smell of my uncle's illegal tobacco cigarettes and would follow him around while he smoked—until my mother finally shamed him into quitting in favor of foul marijuana. Who is to know what made me so? Perhaps there is something to reincarnation and I was born with a sentimental soul: one that longs for its past.

It was the books that finally told me who I was. Not long after I'd turned eight, I was bedridden with the enigmatically named chicken pox. My grandfather gave me a few H.G. Wells and Jules Verne paperbacks to pass the time while my Gamestation was being fixed. I remember the crinkle and crunch of cheap yellow paper, the smell of times long gone. It was a revelation for someone who'd until then only read words from a screen. The faded cover boasted a thousand thrills and chills beyond my wildest dreams, and the stories within did not disappoint. Even before I started to read, I knew that I had been given an answer. Though the science described in these stories held little resemblance to the real thing, I was fascinated by the possibilities they offered. It was not merely the applications of technology that awed me—for miraculous devices can be found everywhere in this age—but the romance of discovery and the pleasure of seeing beautifully crafted devices in motion. Gears and cogs and pneumatics and steam made me weak in the knees. Science that was not beautiful did not interest me. I wrapped myself in the novels of Jules Verne, H.G. Wells, Conan Doyle, and Poe; in artists and musicians from the Victorian era. I asked my mother for a Prince Albert frock and took to wearing it regularly. In short, I awoke to nerdhood at an early age.

I graduated high school early and wasted no time in packing for college. I attended MIT with the intention of majoring in AI psychoanalysis like the rest of my class. I drowsed through my first semester of classes much as I had sleepwalked through most of my life: making friends I did not care much for and studying things that only tangentially interested me. Professor Pappas, with his overly enthusiastic lectures on bland, invisible microchips, failed to excite me the way the Verne had. I began to wonder if I should have studied the arts instead.

It was not until I had consigned myself to a second semester of soullessness that I encountered the Order. I was sitting at a table in the quad, drinking my Darjeeling and staving off boredom with a tattered copy of Edward Bellamy's *Looking Backward*, when a shadow suddenly appeared to block my reading light. Irked at this intrusion of my private space and time, I looked up and the sharp words I had readied dulled on my tongue. The woman who stood over me wore a billowing dress nearly as red as her flaming hair and at least a century out of fashion, with a poesy-weighted tea-hat on her head and a collapsed parasol in her hands. She leaned over—seemingly oblivious to her uncomfortable proximity—and squinted her green eyes at the title of my book.

"I didn't think anyone read actual books anymore." She spoke with an elocuted British accent, the sound of which sent a thrill down my spine. It was a businesslike way of speaking, cold and measured—and yet there was a sort of music to it that delighted me. She introduced herself, gloved hand extended, as Estella Haversham, Senior Deacon for the MIT chapter of the Fraternal Order of the Cog. I was nearly too tongue-tied to introduce myself. She was part of a Culture, I realized. There were many such groups on campus, like the Minutemen who patrolled the walks in revolutionary war garb, or the *animorphs* who surgically altered their facial features to resemble those of Japanese cartoon characters. Cultures were frequent targets of ridicule amongst more acceptable members of campus society. I had never heard of the Fraternal Order of the Cog before, however.

"We are a chapter of steampunks," she explained. "Anarchists, socialists, and other political revolutionaries with a love of true science—the soot-blackened and steam heated kind. We bow to no one but common decency and the laws of the universe, and even these serve us as much as we serve them. We are holding an open demonstration of science outside of Tesla Hall tonight. Attend if you are interested." And would you believe, unknown reader, that I was?

I saw her again at the demonstration, this time clad in goggles and red leather to protect her from the billowing flames that issued from the thousand-heads of monstrous organ she and her fellow Cogites had built. It was a massive instrument, the size of a van, squirming with brass tubes, each of its iron keys shaped like a different animal, capable of mimicking any music instrument. They played the best of Brahms, Bach, Beethoven, and boogie to a small but enraptured audience. As I danced for the first time in my life, I realized that these people were like me: souls pining for a world denied, singers of a song only they could hear. I made up my mind at that moment to join them. No matter the mockery of my peers. If their dead, grey world was reality, then I wanted no part of it. These were my people. This was my reality.

COUNTER-TERRORISM DIVISION UNIT #42A
TRANSCRIPT 2/15/37
15:23-15:25

"How many of them are in there, Clyde?"

"Twenty hostages: scientists and technicians, and a pair of feds who slipped up. Eight to ten terrorists in the cell, all heavily armed."

"Armed with what?"

"Mostly pistols and rifles. I think one of them has a sword cane. Nothing post 20^{th} century."

"Jee-zus. What are they, Harry Potter nuts?"

"Not sure. Got some social anthropologists looking into it. Theory right now is that they're steampunks. Basically, people who wish they were still living in fancy-pants Victorian times."

"Kee-riste. Modern primitives, you mean."

"Yep. Which means we can't hack 'em. Hell, we don't even know if their tech is stable. That bomb they got planted under the building could go off at a sneeze."

"Give it to me straight, Clyde. No rocks, no mixers. How bad is this going to be? Waco? Sears Tower '22?"

"I'd say it's a whole new class of bad, Carl."

Mr. Know-it-All's Virtual Guides Vol. 8: Recognizing Culture Terrorists, Scholartastic Educational Enterprises, 2029.

"What's wrong, Timmy? You don't seem to be enjoying your banana nut sundae. What's on your mind?"

"Mr. Know-it-All, what's a Culture Terrorist?"

"Why, Timmy, where'd you learn such big words?"

"The newsfeed, sir. And my mama said the other day that she's scared the Culture Terrorists are going to destroy America. Could that really happen, Mr. Know-it-All?"

"It just might, Timmy, it just might. A Culture Terrorist (or CT) is a kind of person who just isn't right in the head, the kind of person who's so twisted that he or she can't see how wonderful the world is right now. He or she hates our modern life and products, like your Gamestation IX."

Timmy gasps.

"The CT wants to go back to a time when people were crude and cruel like him. In the old days, terrorists were religious fanatics or communists, but now… Well, now they have all kinds of wacky beliefs!"

"Like what?"

"Like the Furries who took over three floors of the Sears Tower back in 2022."

Images of men and women in colorful cartoon animal suits using tasers and AK-47's to herd terrified hostages into an elevator. One fox, with googly blue eyes, has a bomb

strapped to his back.

"Or the cross-country bank robbing LARPers in '27."

A snarling elf holds a teller at crossbow point. In the background a twelve-year-old boy in star-covered robes and a fake beard waves his hands and yells nonsense words.

"Wow, Mr. Know-it-All, those terrorists sure are funny!"

"They sure are, Timmy, they sure are. Funny but dangerous. So it's important that you keep an eye out for people you think might be CTs. If you know someone who collects comic books, dresses up in chain mail, or likes to pretend that he or she lives in any time other than the present, report them to your local CTD unit straight away. Because the next Culture Terrorist might be in your very home. Or yours! Or *yours*!"

Accusing finger. Menacing music. Fade to black. Cue national anthem and credits.

JOINING THE ORDER was a more complicated matter than simply renting an overcoat and showing up to weekly meetings. I was to foreswear use of all twenty-first century technology. Writing my school papers with an old pen and inkwell was d—n near impossible, but a revelation. Without an AI to organize and compose my thoughts for me, I was forced to think carefully about my ideas and the language that contained them before committing them to paper. My first few efforts were dreadful, but as time passed I learned to write—and think—with a degree of clarity that I had never been capable of before.

Further rites of passage took the form of assisting in the building of the group's inventions. I was dubbed an apprentice, and through hard work and initiative I was expected to work my way up to a Journeyman. The Order of the Cog was an anarchist group, however, so though I was considered a junior in my understanding of science, I had no less a voice at our meetings than our own chairperson.

The chairperson of our Order was its founder, Mr. Abel Magwitch: a quiet, kindly old man who, with his long white beard and sad blue eyes, resembled no one so much as Sir Charles Darwin. When he spoke it was with a raspy whisper, the voice of a man who had spent his younger years yelling over the clank of heavy machinery. Mr. Magwitch was a master of mechanical engineering—in his past life he had held an advanced degree in robotics—but he was interested in every aspect of the world and knew something about nearly everything. He was shy and never joined in our raucous revels, but he would often take us aside to offer advise or encouragement of such quality that it was impossible not to admire him as we all did.

Second in experience was Mr. Jaggers, who—with his iron teeth and perpetually soot-blackened features—frankly frightened me. His face was always clenched in a scowl and he spoke to us apprentices as though we were children. But he taught me to smoke a pipe and judge good tobacco, and his understanding of political philosophy was second to none, and in this manner he quickly earned my respect.

Life in the Order was non-stop excitement. I had little time for classes and soon stopped attending altogether. Stella taught me to fire old-fashioned firearms and gave me one of her homemade air-pistols; which were, of course, inspired by those featured in the Sherlock Holmes stories. We raised money by performing in concerts with our steam-powered instruments. We demonstrated the wonders of science to passersby on city streets. We flew over towns in a hot air balloon and dropped pamphlets that decried the government onto the sleeping houses below. I can't count the hours I spent in the darkness with my fellow Cogites, sipping absinthe and watching old science fiction films projected silently onto the wall with Drummie's homemade cinematograph. The futures that those movies promised didn't seem so distant anymore. Watching them, I felt as though I were peering into the true world that this veil of solids only hid. We knew the truth.

When we weren't doing all these things, we worked on the Order's master project: the construction of a steam-powered automaton of Mr. Magwitch's design, inspired by the works of Mr. Lewis Carroll. It was dubbed 'the Jabberwock.'

The night of the Jabberwock's celebratory animation, Mr. Magwitch and Mr. Jaggers had an altercation. The exact nature of their furious debate is unknown, as it was held behind closed doors. But we could hear the timbre of their raised voices and made out the occasional non-sequitor through the muffling wall. At the conclusion of their debate, Mr. Magwitch stormed out of the room and the building, his shoes and cane pounding out every step to the doorway.

Our fears could wait for tomorrow. There was science to witness tonight. Shivering in anticipation, we watched as Mr. Jaggers threw the switch and brought the Jabberwock to screaming life.

COUNTER-TERRORISM DIVISION UNIT #42A
TRANSCRIPT 2/15/37
18:41-18:43

"DAMN! THE OPTICS went out. What the hell got our hunter-seekers?"

"Looked like a giant steam-powered robot to me, Carl. With scythe-sized claws."

"But where did it come from?"

"Keep in mind that we're dealing with Abel Magwitch here. MIT whiz kid back in the 1990's. Passed on hot fields like String Theory and New Quantum to study antiquated Newtonian physics with a focus on steam-based technologies. Guy puts the 'gee' in 'genius.'"

"First they somehow neutralize the dustcams, now they take out the Hunter-Seekers. What's left?"

"I dunno. Give into their demands? Shut down nanotech research like they ask?"

"Or we could send in everyone. Forget the hostages."

"Some of the most brilliant scientific minds of today are in there, Carl."

"There isn't a single one of them that we won't be able to replace with an AI next year. I'm sick of these freaks popping up every other week, Clyde. Let's just take 'em out. Make the rest of 'em think twice. Let's send in everyone."

"What do you mean by everyone?"

"Come on. You've seen 'The Professional.' What do you think I mean?"

Mr. Magwitch no longer attended Order meetings after that night, but a week later, he asked us all to come for a special lecture at his house. There would be wine and cheese—and food for the mind as well. Naturally, we were all very interested to attend. Everyone was already there when I arrived—with the notable exception of Mr. Jaggers. Mr. Magwitch was a meticulous host and a wide selection of cheeses and wines was spread out for us to sample on his dining table. He took time to speak with each of us, making sure that we were comfortable and well fed. He showed us some of his latest creations: tiny mechanical doves whose clockwork mechanisms doubled as music boxes, exalting the room with beautiful hymns as they flit about.

When he was certain of our elegant sufficiency, he took off his shoes, stood up on a chair and, with a slight cough, begged our attention. Our minds a pleasant buzz from the wine, we gave it gladly. None of us expected him to start his speech the way that he did:

"Pornography," he said. I confess that I may have spat up some of my Shiraz.

Pornography was the credo for the world we lived in now, he explained. Modern humanity's surroundings were a vast buffet of instant gratification for the basest of senses with no real truth or beauty to nourish its greatest parts. We lived in an empty utopia where nearly anything could be obtained with ridiculous ease but nothing could satisfy. Science had brought us one miracle after another, but these miracles had not transformed the world into heaven. Rather, they merely made heaven mundane. Kitchens were laboratories where food could be synthesized and all care or art was excised from cooking. Sexual intercourse mostly occurred in the wireless worlds, in digital love motels where lovers never touched. An endless variety of entertainment was available online for free. Nearly everything was mass-produced by automatons. Fewer people left their homes with every passing improvement to virtual reality. Life itself had become a masturbatory fantasy.

"This world has given us everything," he announced, "and it has destroyed us."

He called for change. Not a return to the past. Science was progress, life was change, to deny these things was to deny reality and embrace madness. Rather, Mr. Magwitch dreamt of another future (a dream that he suspected had brought all of us together), one where humanity was self-reliant and separate from and master of the tools that enhanced him. A future where every man and woman was a scientist, artist, or explorer. And since it seemed that our fellows were too comfortable to change, it was our responsibility to drag them into that future, kicking and screaming if need be.

Of course, this would require our participation in illegal activities that would be judged antisocial and insane by society—as all truly meaningful activities were—and he understood if we did not wish to participate. He himself would never have suggested this if he did not feel that revolution was necessary. I think he was genuinely surprised by the applause that greeted the conclusion of his speech. I clapped until my hands were red as strawberries. He had described the world as I saw it, had captured the feelings I'd had since I first became aware.

We started picketing the nanotech research lab and sabotaging the local wireless grid. We set up a steam-powered grinder/percolator outside JavaBucks and offered free coffee. We wrote our congressmen and we begged them to reconsider Proposition 444.

And then we moved on to bigger things.

Accessing GonzoFeed™: Your Source of Music, Movies, Pornography, Spirituality, and News Customized to Your Personal Tastes! Reality As You See It!

"The standoff has gone for eighteen hours," the SimReporter announces [*to some eyes it's a dead ringer for Marilyn Monroe, to others Edward R. Murrow, and for the vast majority, a giant talking penis*]. "The last of the hostages was released nearly an hour ago but the terrorists have not evacuated the building. It looks like the CT team has decided to make the first move. They're sending in a battering-bot to knock down the door… Oh my God!" [*This blasphemy is censored for those who have enabled the 'censorship' option.*]

Hissing and smoking like the devil himself, an iron monster bursts through the barricaded front doors of the laboratory and knocks the heavy battering-bot aside with a disdainful swipe of its massive claws. [*Heavy metal music begins to play as*] The monster tromps down the steps in tune with the giant key spinning in its back. Trained soldiers back away in terror. They are used to enemies that are functional, who lack imagination and passion. They have never seen something so beautiful and horrible as this Moreauian monstrosity. Twin blue flames burn in the hollows of the monster's eyes. Its curved claws stretch all the way to the ground, scraping grooves in the stone. It is a marvel of engineering and craftsmanship. It looks almost alive.

A moment later the spell breaks. Their training recalled, the soldiers open fire and their high-powered bullets shred the Jabberwock like paper [*on sale at FleurMart now! High-powered acid bullets! Real men only buy bullets from Marksman!*] What's left of the iron behemoth crashes down the stairs, bursting and steaming. The Jabbwerwock has been slain with no need for a vorpal sword. There follows a silence broken only by the hiss of the robot's cracked boiler and the sobs of an officer whose sanity trembles.

With the doors broken down, a crack Counter-terrorist team of soldiers cautiously enters the house. A moment later, the building erupts into a smoking column of dust and brick and flame and noise. Officers and robots standing nearby are tossed aside like toys before the sweeping arm of a giant malevolent child. [*Rewind/fast forward- the image is shown again and again. A different angle, now in reverse. Guitars wail.*] A pit filled with rubble is all that remains of the historic building and the living anachronisms that occupied it not a few moments earlier. Officers stand back with guns at the

ready, their ears still ringing from the roar of the blast. A minute passes. Five minutes. Still no one emerges, and at last they give the signal for the medical technicians to approach. There won't be much work for them tonight. An officer lights up a celebratory joint [*buy Rasta Joints, mon! De're da best on de market!*] It looks as though the situation has been resolved.

[*Next up! Stay tuned for an analysis on the Naked News! News got you down? We'll help get you up!*]

COUNTER-TERRORISM DIVISION UNIT #42A
TRANSCRIPT 2/15/37
20:07-20:10

"Boom! Did you see that Clyde? We got 'em! We got 'em good!"

"We sure did, Carl. Looks like our job's done here."

"I'll say. Nothing left of the manor or the terrorists. Nothing left to do but go home and fill out the paperwork. Might even be back in time to catch the game. Wanna join me, Clyde, you old dog?"

"I'm an old man, Carl. I'll probably just drink some milk, read my book here, and go right to sleep."

"I see… All right then. Good night, Clyde."

"Good night, Carl."

And now I find myself crouched in the darkness, cowering under a desk like an animal cornered in its hole. Police lights flash through the window, turning the room blood red for an instant every other instant. Half of us are down, injured or dead by CTD attacks—Mr. Magwitch, our wise, kindly leader suffered a fatal heart attack during the first exchange of gunfire. The air is muggy and thick with the heated vapor we have been using to neutralize their nanotechnology. It is difficult to breathe, almost impossible to see these words as I write them. I can hear sobbing somewhere—either one of the hostages or our own number. It has not even been a whole day and already we are exhausted and frightened and ready to surrender.

Despite the desperate situation I now find myself in, despite the terrible mistakes that we have made, some mad part of me still has hope. Not for our survival or freedom, but for our cause. It is a mystery, this unfounded naivety that infects me. What cause could I have—in the face of humanity's apathy, in the lure of its unthinking laziness—for hope?

A memory. The memory of a sick, happy little boy, curled up in bed with a book and a smile. He travels across a vast and impossible universe of robots and dinosaurs, wise heroes and monstrous villains. It is a world unlike his own, and he knows that once he has been there he can never leave.

For as long as there are Doc Savage pulps and Jules Verne stories and little boys and girls to read them, our struggle will never die. The revolution will continue silently in the imaginations of men and women who go to work and live their simple lives. Though they may look like bankers, constables, and tax-men to others, in their hearts they are warriors and wizards, kings and queens in a world that can never be sullied. Someday that world will pour out into this one, through these men and women, and what we have started here—what others started millennia before us—will be complete.

We have decided to release the hostages. They may call us terrorists, but we are not. We are revolutionaries, and we will fight with honor to the bloody end. Father, mother, whatever they may tell you, know that your son died a man. I have no regrets, save that I did not spend more time dreaming. Good-bye.

The lights go out—all but one anyway. The old army-man reaches under his desk and pulls out a tattered and dog eared book. A slight smile crosses his weathered face. He opens it to the first page and the smell of molding pages ushers up a memory from childhood. Soft cartoon sheets wrapped tightly around him, his mother's voice transmuting the blocky printed words into music.

"Chapter 1," he reads quietly to himself, "Down the Rabbit-Hole…"

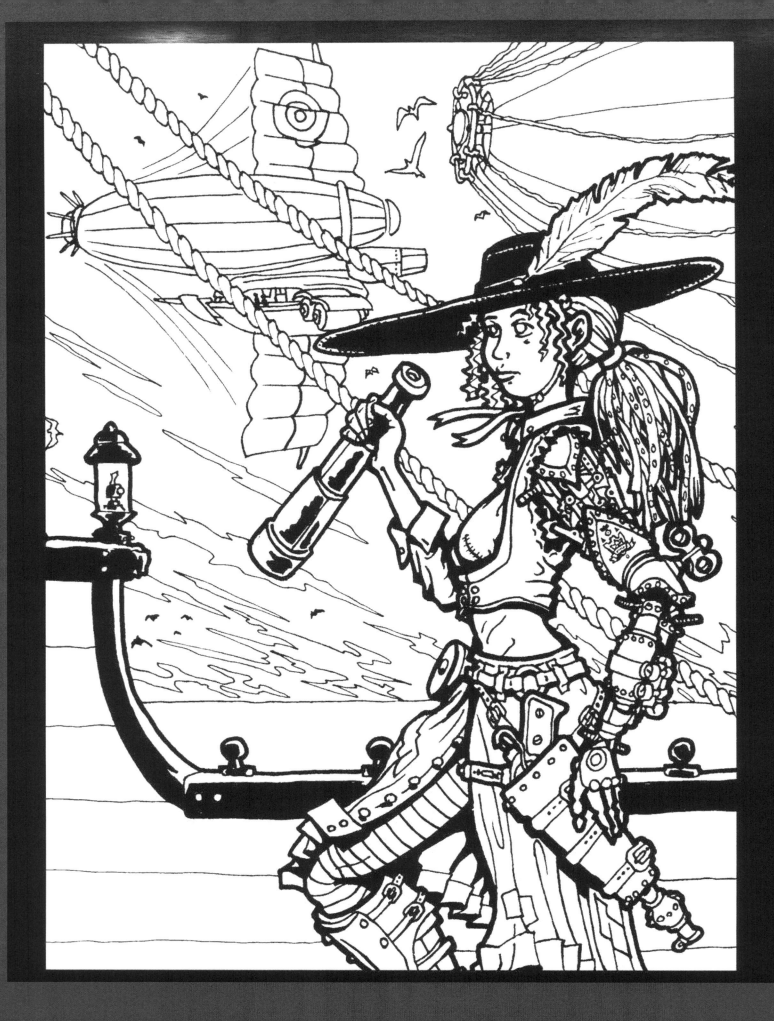

sometimes life calls for AN UNEXPECTED HAT
(BEING THE GUIDELINES FOR THE CONSTRUCTION OF SUCH A HAT)

written and illustrated by Molly Friedrich

Ladies and gentlemen, welcome to this primer on scratch building custom hats. I will be your guide into the world of inappropriate millinery. I am not a professional hat maker and I don't own a block to save my soul. So you might be asking at this point, what qualifies me to be teaching people how to make hats? A most excellent question!

Let's ignore for a moment that I get lots of compliments on my hats from strangers. Let's pretend that working on a project like this isn't a total blast to do. Foremost, I wrote this article because I want to put the spark of creation in people!

I believe in looking to the past for inspiration, but that we also must move forward with that inspiration to craft a new world for ourselves. I believe that most of what you can buy in a store today is boring and unimaginative. And above all else, I believe that it's time to start this project!

I *Research and development.*

The most important step! While each step in creating something original matters, the way you approach this is going to colour the whole project. It really helps to have an idea of the outfit or at least a general concept of your target style in mind while doing this. One really good way to research this is to get a couple books on Victorian and Edwardian fashion. Check used book stores, the library, and the internet (through online bookstores, or sometimes just an image search will do the job). The more pictures the better obviously, and there are numerous good books out there on the subject. We are lucky in that it was the first fashion era fully photographed and documented for us to look back on. Just keep in mind that the everyday wear was much less photographed, so the pictures you find are going to be skewed towards the upper crusties.

It doesn't matter if the book focuses on hats; they were so much more common back then that you will find plenty of inspiration. I am personally drawn to Edwardian fashion, so I decided to make myself a picture hat, and that's what this project is. However, the instructions I will be giving you are highly variable, and please feel free to experiment and try new things. You can use these steps to make a bowler, a bonnet, a top hat, a sunhat, or just something crazy and new (and please do!). I will do my best to make suggestions and point out places where adjustments can be made for taste.

Pay attention to trim, as what you put on a hat can really make or break the whole concept. If you don't have any ideas jumping out at you at this point, you can always go with the standards: goggles, cogs, or feathers. The more creative you are though, the better. Try to put some of your personality into it with an old keepsake or something that represents the kind of person you want to be. Maybe use bits of hardware you find on the ground, or cut a design out of a sheet of brass. Build something out of copper or brass pipe, add a gauge or a dial of some sort. Perhaps you could build a small model of an airship or a steam engine? Don't be afraid to have some fun with it and be bold! This is not fashion for the tame of heart.

II *Materials.*

Gather as many of the materials you can before starting work, because nothing vents the steam out of a project more than having to run out for more parts. I don't feel there can be a strictly limited list of parts, because only you know how you like to work, but here is what I use to build these hats:

Supplies:

Material. What you choose to use will have a huge effect on the final look of the hat. If you are building a hat with a very wide brim, try to use something stiff, strong, and without a lot of stretchiness to it. I use a high quality artificial leather due to personal values, although obviously real leather would work just as well, although it is harder to work with and you may need other tools. Also good would be a strong wool, denim, or upholstery fabric. I always try to recycle something old into a project like this, so maybe look at the jackets hanging in the closet that no one wears anymore.

Ribbon. This will form the hatband that goes around the crown, and the chinstrap if you decide you need one. Again, your choices here are many. Check out a local craft or sewing shop; you'll only need one spool.

Wire, snips, and **electrical tape**. Optional! If you make a hat with a huge brim, you'll probably want a thicker gauge wire to keep it steady. Make sure you have snips handy that can cut the wire, and the tape will be used to connect and

protect the ends. You can get a bail of thick wire at most hardware stores for a couple bucks. To test if it will work, make a loop with it and hold it out horizontally. If the wire bends under its own weight, it's not strong enough. The wire I used in the picture hat was about 1/8th inch thick.

Thread. I use button or embroidery threads because they are thicker and stronger than most machine threads. Oh yeah, I should mention this project requires mostly hand sewing. I will mention the places where a machine can come in handy, so if you are going to use one, you'll need regular thread for that too.

Lining Fabric. Optional. If you want something inside the crown to give it a more 'finished' look. Acrylic or cotton might be best here.

Decorative trim. Optional. Lace, something smaller (1/4th to 5/8th) to subtly trim the outside of the brim might be nice? Grommets if you want to add venting. Rivets if you like them. Rope, if you want to run it through the grommets to make a chin strap from it.

Tools:

Scissors. The sharper the better!

A **measuring tape**. A ruler won't be very helpful here!

Marking pencil/pen. Use something that will make a mark on your fabric without disfiguring it. For example, my picture hat was made of black fake leather, so I used a fine point sharpie. Most of the marks can be made on the wrong side of the fabric, so don't worry too much about this.

Pins. You'll need a bunch.

III *The brim.*

WE START WITH the brim because it sets the shapes of everything else into motion. First, place the measuring tape on the part of the head that you want it to lay over. Note the size, and then lay out the fabric, wrong side up, on the workspace. A large flat area like a table or tile floor is perfect for a workspace (try to avoid carpet). Draw a dot in the center of the fabric that will become the brim. Place the loop of measuring tape (still the size of your head) around the dot as evenly as you can. It doesn't have to be perfect, and heads are usually oblong, so try to match your shape as best you can for greater comfort. Use the marking pen to draw a circle that is the size of your head on the fabric. Next draw a slightly larger circle around that one about 1/4th to 1/2 of an inch bigger, depending on how thick your fabric is. You will want this to be a little larger than your head because we sew the brim to the crown (the part of the hat that covers your head).

Now we do the outside circumference of the brim. Stick a pin into the end of your tape measure and stick that into the dot you placed at the center of the brim. Now, lay the tape flat, radiating out from the center and find the width you'd like the hat to be. For my picture hat, I chose 10 inches, so the full width of the hat is 20 inches. For a bowler, you'll only need an inch or two outside the crown. For a victorian sunhat or bonnet, you might try 8 inches. Play around and maybe even make a few practice brims on paper to see what you like before you start cutting fabric. So, to draw the brim, simply follow that measurement with the pen as you pull it around the hat in a circle. If you can get someone to help you hold the pin down, it will help greatly!

Finally, draw another circle outside that big circle, slightly larger by 1/4th to 1/2 of an inch. Cut the brim on the largest and smallest of the four circles. Then, put the brim down on another bit of fabric and copy the inside and outside dimensions. You won't need to recopy the seamlines; just cut the second piece out on both circles. Pin the two matching brim shapes with right sides together (for those with no sewing experience, this means the sides of the fabric that you want to see in the finished product will be facing each other). If you would like to have a bit of lace trim going around the outside edge of the brim, now is when to place it between the two pieces of fabric with the part you want showing on the inside.

This is where a sewing machine will come in handy. Sew around the outside of the brim on the seam line we drew earlier. Turn the brim right sides out. You'll want to re-pin and sew around the outside of the brim again to make the hat look less floppy. Try to make this seam run up the middle of the overlapping edge fabric inside the brim.

If you are doing a hat with a small brim, say less than 5 inches from the crown, then go ahead and zip a seam down on the smaller circle that attaches to the crown and skip to step 4.

If your hat is looking floppy, don't sew up the middle circle just yet! You are going to want to reinforce the brim with wire. Cut a circle of wire to fit inside the outer edge snugly, and then wrap electrical tape around the tips to make a complete loop. Slide the loop into the hat through the center hole. This can get tricky! One trick I use is twisting the loop once so it is thinner in the middle and then untwisting it once inside the brim. After the wire is in place, you'll want to lock it into position by laying another seam just to the inside of it.

Voila! You've just made a fabric frisbee! Go ahead and play with it, just try not to bend the wire too much. Then move to the next step when you get bored.

IV *The crown.*

THE TRICKY PART! The crown of the hat also has a lot of control over what the end result looks like, so it's good to know about how high and how wide you want the top to be at this point. If you want a tophat look, make a circle on the fabric the same size and shape as the first one that started the brim out. If you want a slightly tapered top like a bowler, make it 1/4 to 1/2 of an inch smaller. If you want a bonnet, make it 3/4 of an inch or more smaller. The taller the top is, the less it will taper, so for a short hat you'll want to keep the size close to the measurement of your head.

Draw another line, slightly bigger (1/4 to 1/2 inch again), around the outside of the top measurement. Cut along this outside line.

So here's when it gets a little harder. The sides of the crown might take a little practice, so use paper to test out your design first. The more tapering there is between the inside of the brim and the crown, the more the shape will look like an acute rainbow. If the two sizes are equal, it will look like a long rectangle. If the top is larger, it will look like an oblique rainbow.

Here's how you can figure out this shape from scratch: just cut a piece of paper so that it fits comfortably around the inside of the brim with the ends overlapping slightly, then cut it to the height you'd like the top to be. Place the top on it and make any tapering happen to get the sides to meet the top, then snip the overlapping ends of paper in one stroke so they line up. You may want to re-cut the top to make it totally level if there was a lot of tapering. It might need a little tweaking here or there to get it perfect, but that's basically it.

Once you have the side shape, trace it down on the fabric and then draw another line around it, slightly bigger by the standard 1/4 to 1/2 inch. This outer line we will again cut along. Put the shorter ends together (right sides facing together) and sew on this line to form a loop of fabric. Keeping the loop wrong sides out, pin on the top of the hat wrong side facing out as well. When pinning the top down, you'll want to mind how tight it is across the sides. I start with pinning the 8 cardinal directions first so it's evenly distributed around and looks flat. If you want the top of the hat to bowl out a bit, pin the top looser and closer to the outer edge of the top piece.

You might be able to use a machine here to sew the top on, but I prefer to do this part by hand. It allows for an even placing of the top along the seam with the sides. And this is important to the hat looking clean and professional. If you want to add any decorative rivets or venting to the sides, like grommets or such, now would be the time to pop those babies on. Be careful to leave room for the ribbon hatband.

Now, if you want a rounded top, you can pin the overlap fabric from the last seam we made to the side of the hat and sew it down. If you want a more flat type of top, pin the overlap fabric to the top of the hat and put a seam there. Now pop the crown right side out and move to the next step!

V Hey, is that a hat?

CAREFULLY PIN THE inside circle of the brim to the bottom circle of the crown. Use the technique from the top to make sure the crown meets the brim as evenly as possible. This is another seam that really needs to be done by hand. Make sure it's strong, maybe do it twice if you're not sure.

If you want to have some kind of lining inside the hat, make a copy of the crown out of your lining fabric and place it inside now. Once you've attached the pieces together, fold the overlap fabric up inside and pin it down tightly against the side of the crown. This is why we left a little extra room in there. Add a seam on the overlap to lock it in place. Don't worry; we'll cover this seam up with the hatband. If you want to have a chinstrap on the hat, add it now by sewing it on the inside rim of the brim. Usually two 2-3 foot long lengths of ribbon will suffice. Place them right in front of where your ears are on the hat.

VI Egads! You made a hat!

LAST PART OF the hat is the hatband. While they do make hats look distinctive, they are more than decorative. Hatbands help the hat keep its shape and size from warping during wear. Simply make a loop out of ribbon that fits snugly around the base (maybe even have a friend help you do this while you wear the hat) and sew the ends together. Then take a small length of ribbon and place it vertically over the seam in the loop. It should be long enough to fold the top and bottom over to the inside of the loop. Sew the second loop to the first one where the upper and lower edges meet the big loop. Slide the hatband down onto the hat and if the sides taper a lot you might need to sew it down in a couple places evenly around the crown so it doesn't fall off.

That's it! Add decoration to your heart's desire and enjoy!

the Egos: DONNA LYNCH & STEVE ARCHER

Donna Lynch and Steve Archer are two artists who have "made it," which is to say, they make a majority of their modest income from their artistic output (which, combined, is quite formidable) and have freed up enough time to explore their artistic visions. Steve's artwork graced the cover of SPM #2 and the interiors of others (including the self-portrait in this article!). Donna's piece "Mining Medusa" also appeared in issue #2. This fall, I was invited to join them as a live drummer on tour with their band Ego Likeness, and I used the opportunity to interview them about living their lives, steampunk, and their roots.

SPM: If you could introduce yourselves, and some of your various projects?

D: My name is Donna Lynch, I am the co-writer and singer for Ego Likeness and The Trinity Project, and I am a horror writer. I have a novel coming out this summer called *Isabel Burning* on Raw Dog Screaming Press, and I have a couple of poetry collections as well.

S: My name is Steven, I am a painter, I make stuff. I make visual art, paintings, music, I do a teeny tiny little bit of writing. I am half of the band Ego Likeness and I've got a solo project called Hopeful Machines. I play drums with a couple of powernoise bands, and I've got a children's book being published next year on Raw Dog Screaming Press called *Luna Maris*.

SPM: The theme of this issue is "Our Lives As Fantastic As Any Fiction," and I'm interviewing you because you live quite interesting lives. Was this a conscious choice?

S: I don't think that we have a lot of choice. Neither of us function well in a day-job environment. There are too many ideas, and you just have to learn how to get them out. Turning those ideas into our business is the only way that makes sense to us to survive.

SPM: How did you set up your life around your work? What is your lifestyle?

S: Well, it happened in increments... you find one way that you can utilize a talent to help you survive, like art sales. People becoming aware of our bands helps a great deal, and then writing... it all begins to cascade, and all work together. One thing influences another thing, and another, and another.

SPM: How have you sustained yourselves in the meantime?

S: We've both had a wide variety of odd jobs. I was a bike courier for a long time, I worked at the Kennedy Center for the Performing Arts, I've DJ'd...

D: I worked in retail, I bartended, whatever.

S: We both did artist modeling...

SPM: What do you think is the difference between an odd job and career then?

S: I don't want to be an artist model for the rest of my life.

D: I didn't want to be doing any of the jobs I was doing.

S: A career, by nature, has potential to grow. There's not a real high ceiling for bike courier or bartender or whatever.

You can make a lot of money doing those things, but they are what they are.

SPM: What would your advice be to aspiring artists, writers, musicians be?

S: You have to want it more than anything else. Otherwise you're not going to take it seriously enough to make it work.

D: You have to sacrifice a lot of stability if you want to do it full time. That's too scary for a lot of people, which is understandable. It's scary for us too. But, like Steve said, you have to want it so much that you're willing to give up pretty much anything else, and that you're willing to pay whatever price you have to pay in order to make it work.

S: And that includes being very uncomfortable for a very long period of time. Eating ramen noodles for years. It takes infinitely longer than it feels like it should take. There's never a point where you're like "oh I made it, I'm rich." We know a lot of people in the art and music industries and it doesn't really work like that. At least not at this level of the game.

D: I think a lot of people want to know what the magic formula is to getting an art show, to getting your band signed, to getting a book published, and there isn't one. There are no magic tricks, there is nothing that someone is going to tell you that will make that happen for you. You just have to keep making stuff, whether anyone is paying attention or not, and you have to keep doing it until people *start* paying attention.

> It makes the world a much more interesting place, if you just do what you want, and be committed to it. Don't do it, and if someone calls you out, start backpedaling. Do it, and say: "This is why I did it, and if you don't like it, you can fuck off."

S: And a lot of times you have to be prepared for negative attention. One of the things that I always tell people about being in bands is that you have to be willing to suck in public. You have to put your music together and put it out there, because it's not doing you any good waiting to become perfect. It's *never* going to be perfect. The moment we finish an album and it goes off to be mastered, three seconds after it's out the door, I realize something I should have done differently. It's never going to be as good as you would like it to be. And if you continue to try and make it that way, it will never go out into the world. You have to let there be rough edges. If someone calls you on it, you have to just say: "Well, next one will be better."

SPM: A lot of your work is about the interaction between humanity and science, humanity and machinery, the medical sciences, etc...

D: It's easy to fit these things onto opposing sides, but they're not. Humanity and science, technology, machinery, it's all the same. We have technology because we made it. It's part of us, whether want to admit that or not. I think people want to think of humans as these very natural beings, but what if it is in our natures to make things that have the capacity to destroy? That's part of who we are, and there are a lot interesting and dark places you can go with that.

S: Part of being human, something that we pride ourselves on, that we use to set ourselves apart from the rest of the animal kingdom (even though it's not technically true), is the ability to use tools. A lot of the work that I do is about the interactions between humans and themselves, looking at people as meat, how technology plays with that.

SPM: Would you make things if there was no audience? If you were on a desert island?

S: (laughs) I used to make things with no audience. The fact that we have an audience now is really wonderful. I think that is something that people don't get all of the time: the amount of stuff that you see, out in public, in the real world, is the tip of the iceberg compared to things that get rejected or put aside because they aren't done or ready. There is a ton of work that gets done that the audience never sees. But the stuff you *do* see wouldn't be there without the stuff that you *don't* see.

SPM: You mentioned that the public work is the tip of the iceberg, and one of the things I wanted to talk about is building things from the ground up, about your roots in DIY, and the punk aspects of steampunk.

S: What you make, music or art or whatever, it's your kid. And nobody else is going to love your kid or have faith in your kid as much as you do. So you can wait around and tell people all your brilliant ideas and hope that someday someone will fund you, without actually having seen you do anything. Or you can do it all yourself. When we put an album together, we do all of it ourselves and then it goes off to the record label as a finished product. It's not dictated to us.

In order to survive, we've had to do as much in house as possible, making the buttons and making the t-shirts. It's amazing that we're in a place now where we actually have to look at outsourcing a lot of that work because there's enough of a demand, but without having done everything ourselves we wouldn't be able to get where we are. We have a booking agent because we spent *years* booking every show on our own. Now we're fortunate to have enough of a fanbase that we don't have to do that. It's the same kind of thing.

As for steampunk, I think there's the roots of any of the – punk movements… steampunk, cyberpunk, my own personal favorite, biopunk—mostly because I think I invented that, or at least I'm going to claim I did. The punk part is taking ideas from multiple sources and… the journal of misapplied technology. What a wonderful tagline by the way! [editor's note: Steve suggested the theme for issue #2.]

It's about taking things that already exist and manipulating them in such a way that that manipulation becomes art. Trying to look at technology in less obvious ways.

Much of my artwork is about taking technology and changing the original application of it. Using a lot of turn-

of-the-century source material... back when everything was still solid-state. Things that, if you knew enough about it, anybody could build in their backyard. I find that very appealing.

D: One of the things about punk rock that always appealed to me was that you could pretty much do whatever you wanted. If you wanted to stick a safety pin through your cheek, go ahead. If you wanted to rip your clothes up, go ahead. If you wanted to have a mohawk, paint your face, it wasn't wrong, it was fine. You just needed to do it, and be committed to it. In the underground culture these days it feels like everything is much more uniform. Like you have to wear the specific uniform if you want to call yourself a specific thing. And you have to use things the way they were meant to be used. And that's crap. Why do you have to do that?

It makes the world a much more interesting place, if you just do what you want, and be committed to it. Don't do it, and if someone calls you out, start backpedaling. Do it, and say: "This is why I did it, and if you don't like it, you can fuck off."

S: I think it's a sad state when subcultures that define themselves as not being part of the status quo have just as much of a uniform as the rest of the world. The entire reason this scene exists, and I'm talking about counter-culture going back to the 70s, and modern art and all of that, is people deciding that you can be whoever you want to be as long as you accept the consequences of those actions.

I think that people get wrapped up in the *idea* of being rebellious as compared to actually being rebellious and actually being who they are.

SPM: A lot of your roots in the punk/goth scene were back when they weren't so divided between the two, you just had multiple labels for different aspects of something. With steampunk we're hoping to not be "you must be the following."

S: Way back in the day, industrial was still punk, and goth was still punk. You would go to Skinny Puppy shows and all the punks would be there, and you would go to Minor Threat shows, and you've have goths over in the corner. It was always coming from the same place.

Then it got subdivided and subdivided and subdivided, and now you have people who say, only listen to Amazonian powernoise, and think that everything that isn't Amazonian powernoise is bad. By making it about you, instead of about the music in general, you kill it. Everyone has their own niche and no one is supporting the group as a whole, which is a major problem. I don't know how to get beyond that.

Steampunk, Cyberpunk, it's all punk. And the punk part is the important thing. The rest of it is just aesthetic variation. The punk is the part where you step up to the plate and actually take control of your life and how you look, and make those choices. The rest of it is just dressing.

To find out more about Steve & Donna's projects, go to www.egolikeness.com

Doppler and the Madness Engine
Part One of Three
by John Reppion
illustration by Juan Navarro

Extract from Doppler's Journal No. 27.

November the 16th [1865] (morning)

I awoke earlier than usual this morning with an overwhelming urge to escape the confines of my hotel room. Hearing that Grober was still snoring in the adjoining room, I decided to venture out alone. I find that the early morning is often the easiest time for me to risk such a journey as the opportunity for confrontation is at a minimum. I dressed hastily in yesterday's clothes, pulled on my hat and coat, and headed toward the lobby. Once outside, the thick London fog served to further preserve my anonymity. Wrapping my scarf around my mouth so as not to inhale too much of the noxious vapour, I set off for a short stroll around the area. The hour meant that the streets were all but deserted and my footsteps seemed curiously amplified as I walked. As time passed the sound began to grate upon me, setting my nerves on edge, making me feel rather conspicuous and ever more conscious of being alone. I stopped and stood silent for a moment, trying to settle my breathing and regain some composure but it was then that my imagination turned upon me. The encircling fog became a mere cloak behind which a host of nameless horrors watched and waited. I felt a nauseous wave of panic rising within and soon I was in the grip of a waking nightmare; my stinging mind reduced to a mere passenger of a frantically stumbling body. In the midst of my terrors I observed a body slumped in a shadowed doorway and in that instant I knew it was but one of the many slain by the things which lingered just beyond my sight enshrouded in smog. I forced myself to slow a little and called out to the figure. The weary drunkard responded with a slurred curse which momentarily cheered me until I was struck by the idea that he might give chase.

When I arrived back at the hotel's lobby I was anxious and greatly out of breath. As I struggled to free myself from the suddenly oppressive closeness of my hat and scarf, a concerned looking porter approached. Vexed as I was, I could not even gather my thoughts enough to correct the boy when he addressed me as "Miss". Eventually, having caught my breath and assured the fellow that I was simply exhausted by the briskness of my early morning walk, I ascended the stairs and returned here to my room.

My worries were quelled as soon as I heard the rumble of Grober's snores once again. I remind myself that these panics, upsetting as they are, are something of a necessity; they present me with the reality of what a life without Grober would be. They allow me to see the world as I would without his guidance and assurance and therefore understand the immense benefit his companionship affords. It is also fair to say that they provide me with occasional bursts of exercise which I should certainly benefit from. I have undressed and returned to my bed, ensuring that my friend shall have no knowledge of my venturing out alone.

November the 16th (evening)

At eleven o'clock this morning Grober and I met with a gentleman named Shandon in a Soho café.

As usual I made a few brief notes about our client during the meeting so that I may refresh my memory as to his personal details at a later date. My notes were as follows:

Mr. Jeremy Shandon is a gentleman in his middle forties, slightly overweight but seemingly in good health. He dresses well, though not in the manner of one who has any real interest in clothing or fashion per se. He is a man of reasonable wealth, having worked for many years as a jeweller here in London, but is now retired.

Mr. Shandon contacted Grober and myself concerning a recent change in the temperament of his lady wife. He asserted that this change began only two months ago, after a visit to a séance held in a private residence. Shandon confided that his wife had attended several such events previously, and whilst he holds no particular beliefs on the matter of spirits or life beyond the grave, he had no objections to her doing so. Her experiences were quite typical of those commonly reported to occur at such events; she saw objects lift from a table in a darkened room, felt drafts, heard noises, etc. However, upon the night of October the twentieth, Mrs. Shandon arrived home in something of a daze. She told her husband that she had seen "something" at the séance and feared that she may have been followed. Assuming that her nerves had merely got the better of her, Mr. Shandon reassured his wife as best he could and had their housekeeper put her to bed. In the days that followed Mrs. Shandon's anxieties dwindled; she even joked with her husband about how silly she had been. She was however, keen to attend the next such event.

"Partly, I think, in an effort to prove to herself that there was really nothing to be afraid of", Mr. Shandon told us.

Sadly, this was evidently not a wise course of action, as when his wife returned home from the next séance she was, once again, somewhat anxious. On this second occasion Mrs. Shandon insisted when pressed that all was well but declined to say much else. Her husband felt that she regarded him and the staff with an air of suspicion and over the following weeks she became increasingly introverted, speaking only when addressed directly. Their only detailed discussion arose when the eve of the next séance was at hand. Mrs. Shandon expressed her desire to attend the occasion and Mr. Shandon explained that he did not

think it would be prudent to do so in light of how she had been affected by her previous visits. At this, she apparently seemed hurt and confused, "as if my words were a betrayal of some kind," and said nothing more on the matter. Mrs. Shandon's temperament has remained bleak since that time; she speaks less and less and her husband fears greatly for her sanity. He is a kind man and obviously cares a great deal for his wife as he has resisted having her committed to an asylum in favour of enlisting our help. It is his wish that Grober and I should investigate the gentleman responsible for these so called séances and expose him for a fraud. I should say that I do not anticipate that we will have very much trouble in doing as he asks, but whether or not the proving of this will return Mrs. Shandon to a sensible state is another matter entirely. Nevertheless, I am a great believer in the importance of putting a person's mind at rest and, in this instance, though he did not say as much, I believe that Mr. Shandon wishes to be certain of the medium's fraudulence as much for his own sake as for that of his lady wife.

November the 17th, 1865 (afternoon)

After much to-ing and fro-ing, Grober and I are to attend a séance tomorrow evening. The event will be presided over by Mr. Sam Thonlemes—an American spirit medium from California. He and his staff have lived in the house for some ten months and have given bi-weekly private séances for the duration of that time. These are the very events which our Mrs. Shandon had been attending these past months. We sent an errand boy to Thonlemes' address this morning, with the instruction to purchase two tickets for the evening's event in our names. However, these séances are evidently very popular as we received word that there were no places available. We were advised that, in a little under one month, Thonlemes would be staging the first of many proposed larger events which may be attended by as many as fifty persons and that a few seats were still vacant. Logically, we can not afford to wait so long and so, handing the matter over to Grober and his methods, we eventually secured our place at tomorrow's table by offering a sum of money to a member of Thonlemes' house staff. Her request that we should arrive slightly earlier than the allotted time makes me assume that we must be taking some unsuspecting couple's place. Grober assures me that all is well, but I do hope they are not too greatly inconvenienced by our attendance.

November the 18th (evening)

We have returned to our hotel after having been somewhat prematurely ejected from the home of Mr. Thonlemes. Nevertheless, the evening's events have provided me with much to think upon.

We arrived at the residence at a quarter to the hour as instructed by our girl and it was she who met us at the door and took our hats and coats. Our associate took care in exclaiming stridently that she had taken our tickets, though we had no such vouchers to give, before showing us into the parlour where we waited for the other attendees to arrive. The walls of the room were decorated with a great many framed photographs, chiefly showing Mr. Thonlemes himself in various states of mediumship. There were images showing the man festooned in the curious substance which is referred to as "ectoplasm" whilst others showed figures or disembodied faces hovering about his person. All looked wholly unremarkable to me; not at all mysterious or captivating as one might imagine such things should appear. They seemed somehow too well defined, too deliberate to be genuine glimpses of another realm. Grober seated himself by the blazing fireside in a creaking oxblood chair while I paced around the room with interest. My eye was caught quite suddenly by a most curious-looking device that sat on its own small wooden stand at one side of the fireplace. The machine had a small metal cone or funnel sticking out from it which reminded me very much of a hearing trumpet. Upon closer inspection the contrivance resembled some form of clockwork musical box, though it seemed to be missing some of its parts.

My examinations of the object were interrupted by the entrance of some of our fellow séance attendees. Three slightly nervous-looking women, all apparently of an age with Mrs. Shandon, and of similar social standing, came into the room whispering to each other. They seemed quite taken a back by the presence of Grober and myself and one actually let out a little squeal as he rose from his seat to greet her. Whilst his size does sometimes cause a certain degree of shock to those who have not met him previously, in this instance it seemed to me as though the women were already somewhat on edge. Of course, in anticipation of an evening communing with the dead, heightened responsiveness to such a surprise is perhaps not altogether unexpected. Apologising, Grober introduced himself as, in turn, did I. The women seemed suspicious and reluctant to talk to us; they gave their names, nodded with the merest façade of politeness and then retreated to a corner where they resumed their frantic, hissy whispering. Soon, we were joined by other paying guests; two young couples (newlyweds by their age and attitudes, the gentlemen having evidently had a little to drink), who seemed greatly excited and evidently presumed that the séance would prove an entertaining evening's diversion. These were followed by elderly, bearded gentlemen and two more furtive looking ladies in their fourth decade of life. All were ushered into the room by a well turned out young gentleman who I at first took to be a butler but who introduced himself as "Mr. Thonlemes' assistant, Gerard." After a few brief introductions (Grober making a point of politely enquiring after the names of as many people present as possible) Gerard moved around the room gathering tickets. When Grober informed him that ours had already been collected, he appeared puzzled for a moment but seemed to accept his word.

"Some of you," and here he glanced briefly towards the huddled ladies in the corner, "will be familiar with how the events of this evening shall proceed. However, for the benefit of our new guests, and to refresh the memory of those who have visited us previously, I ask you to please give your full attention to Mr. Thonlemes' speech." Here I expected our medium to enter the room in the manner of a stage conjuror, the crowd having been sufficiently primed for his appearance. Instead, Gerard moved over to the device which stood by the fireside and set it in motion somehow (his body obscured the machine at the crucial moment so I could not make out exactly how he did so). A crackling sound came

from the trumpet of the apparatus followed by a peculiarly accented voice which I took to be that of Mr. Thonlemes himself. Although I suspected some trickery at first, I soon deduced that the device somehow held an impression of the voice and was able to broadcast it just as a musical box does. I managed to get close enough to the machine to observe a little of its workings and saw that a thin needle-like arm touched upon a rotating shiny cylinder (which looked to be of wax or perhaps rubber). The impression was evidently upon the cylinder and "read" somehow by the needle. The message itself was rather dull; Mr. Thonlemes welcomed us and gave a set of rules about the need for quiet and calm during a séance, not breaking the circle which we would be seated in, not attempting to touch himself or any of the spirits, and so on. Despite the mundanity of the speech, a palpable sense of dread descended upon the room as the machine whirred away. I noticed that even the newlyweds appeared suddenly sombre and quiet. I am quite accustomed to such dark turns in my own temperament but it was odd indeed to see this happen to all those assembled as one.

Even Grober, whose expression usually gives very little away, looked suddenly rather uncomfortable. Gerard had left the room quite abruptly after activating the machine and we were alone with our disembodied host. Thonlemes' communication was quite short but the machine continued to broadcast a scratchy murmur after his words had ceased. I made some comment about the device being very clever but my companions, evidently feeling ill at ease, seemed reluctant to engage in any conversation. Studying the appliance a little closer I found a small handle on the needle arm and, with a neat click, disengaged its point from the cylinder. The crackle and hiss of the impression halted abruptly and, after a few seconds, the mood seemed to lighten somewhat.

Unhappily, I had little time to reflect upon this as at that moment Gerard entered the room accompanied by two sickly looking gentlemen and the girl whom we had bribed. It was apparent that our game was up. Observing my proximity to the machine and the lack of sound coming from it, Gerard reproached me for "interfering with Mr. Thonlemes' property." The two gentlemen who accompanied him had evidently arrived late but each held his ticket in hand. Gerard pushed the girl forward; she had clearly been crying and proceeded to do so again. She confessed all, and myself and Grober were asked to leave. Under the circumstances there really was very little to be said; we apologised and left to catch a cab.

During the journey back to the hotel I asked Grober what he had felt whilst the cylinder played. He was reluctant to answer at first, claiming he hadn't felt anything but then, staring out of the carriage window, I heard him mutter "Foolish".

November the 19th (morning)

I cannot sleep and so find myself jotting down thoughts here in my journal. We were imprudent to trust the girl and our obvious error of judgement has now jeopardised the whole case. The next such séance is two weeks away and, even if we were able to obtain tickets, it was made abundantly clear that we should not be allowed to return to the house. Concealing our identities is, of course, out of the question; I am recognisable enough but Grober is positively unmistakable. Perhaps, if we were to wait until the number of guests was greater and a few weeks had passed, then we might be able to attend less conspicuously but, regrettably, we do not have the time. It seems that the only thing to be done is to try to contact some of the others who were in attendance last night and enquire about their experiences. I believe that speaking with the newlyweds would be most advantageous as it was in them that I perceived the largest change of character. After that we shall call upon Mr. Thonlemes and speak with him directly, if he is willing. This has been a poor start indeed but I hope that the new day will afford us a fresh beginning.

November the 19th (afternoon)

As expected, Grober had committed the names and details of all those to whom he spoke yesterday evening to memory and we had little trouble in tracking down the address of one of the newlywed couples. It is just after noon now as we travel towards their home. As always, I am amazed by Grober's skill in these matters; I have great difficulty remembering names, indeed I often forget faces too. If a person speaks then I know them instantly, but their features are somehow less distinct, or at least create less of an impression upon me.

November the 19th (evening)

We called upon Mr. and Mrs. Jonathan Peterson just as they were about to leave for a trip. A carriage stood outside their home and several members of their staff were loading luggage onto it. Mr. Peterson greeted us at the front door, recognising Grober and myself as "the chaps who were thrown out last night". Before I could correct him we were ushered into the parlour where a fire was already burning in the grate. After offering us a drink, which we declined, and pouring himself one, Mr. Peterson asked what he could do for us. I explained that we were curious to know what had occurred last night in our absence. He shuddered and took a healthy gulp of his drink "Yes, terrible business". When I asked what was so terrible about it, Peterson sucked air through his teeth and looked pained.

"You mean you haven't heard? I assumed …"

He was interrupted by a terrific crash and a shattering of glass from somewhere above. A shadow passed the front window of the parlour followed by a dull, wet sound as something struck the ground outside. We rushed as one to the front door and, as we rounded the corner, a girl among the staff who had been helping with the luggage began to scream hysterically. An older woman, a maid by her dress, lay on the ground amongst the splinters of glass, her body twisted and broken and a look of terror upon her face. She was dead. I turned my gaze toward her point of origin and there, framed in the jagged remains of a window, saw Mrs. Peterson glaring down at the corpse with the eyes of a lunatic.

To be continued.

EDITOR'S WARNING AND DISCLAMATION:
Clearly, many things are illegal. But this is not our concern. In the words of Ammon Hennacy: "good people don't need [laws] and the bad people don't follow them." Our concern for our readers is, instead, one of mental health. There are severe and unpredictable dangers involved with the experimentation with drugs. Addiction and schizophrenia come to mind. We do not, **cannot** *advocate most of the activities in the article below. Some doors, once opened, can never be shut.*

Victorians & Altered States
Green Fairies, Witch-Cradles, and Angel Tongues

by Professor Calamity
illustration by Ika

The role of consciousness is too often overlooked in steampunk, both as a genre and a subculture. Steampunk should seek to incorporate the purposeful manipulations of the mind as much as it does technology, politics, fashion, and music if it is to be a proper subculture. The Victorian period, an era of inspiration for steampunk in both style and technology, was also a heyday in the exploration of mind-altering methods and technologies, many of them forgotten. The idea of "storming heaven" with the aid of drugs, technology, and science was a cornerstone of various Victorian subcultures ranging from the psychology circles of Vienna to the nitrous oxide salons of Manchester. We hope to resurrect some of these unique substances and practices so as to fuel the boilers of the imagination of today's steampunks.

ALIENISM AND THE TECHNOLOGY OF TRANCE

The mind has fascinated people throughout the ages, but it was the Victorians who took to changing the mind using the new science of psychology. Most people know of Breuler, Freud, Jung, and James and their attempts to cure lunacy and various psychological ailments. What is less known is that they all shared a fascination with altered states of consciousness. Breuler transformed hypnotism and somnambulism from parlor entertainment into a science. Freud not only dabbled in cocaine but was fascinated by the power of dreams and their ability to open new realms of understanding and experience. Jung was fascinated by the paranormal and the realms of the imagination. He studied "primitive" techniques to induce trance-like states that he hoped "would unfold the secrets of magic and miracles". William James, the father of pragmatism, was fascinated by ecstatic states and wrote an entire tome on the "Varieties of religious experience" while "alienists" (early psychiatrists) in New York sought to unlock the secrets of the dead using science and psychology. Below is a sampling of some of the techniques these alienists developed.

Trance Devices were popular in Victorian times for their ability to unlock the imagination. Poets, artists, and thinkers of all fields dabbled in the varieties of trance. Trances were commonly induced by hypnotism, among other methods. One of the more inventive trance-inducing devices was called the "witch's cradle". It was a swing-like device in which a person hung from a series of ropes balanced in such a way that it was impossible for the person to reach equilibrium. The individual was put in the harness in a darkened room and left to sway, turn and spin about in complete darkness, never coming to rest. Soon the person was "freed of orientation" and started to hallucinate like in a dream.

Another interesting device was called the **Kinetic Shell**, which is very similar to a magic lantern or the more modern dream machine. The shell had bars of primary colors painted on the inside, and when spun a tiny gaslight or candle would illuminate the shell. The individual would stare through one

"The head is a machine. Even though we did not build it, we own it and thus have a right to tinker with it."
— William James

of the windows on the side of the shell and be bombarded with colors. At certain rates, the flashing colors caused cognitive hallucinations (or epilepsy) in the user. There were literally dozens of such devices employed by Victorians to switch off the conscious mind and cross the threshold to other realms.

Somnambulism is most known as a sleeping disorder where sleepers walk or act out their dreams. However somnambulism actually covers a range of sleep-like states. Automatic writing and drawing were popular forms of induced somnambulism during the reign of Victoria. There were a number of techniques to achieve this, but the use of oracle boards (e.g. the Ouija board designed by Fuld) was the most popular. People, alone or in couples, placed their hands on a planchette or marker—either a pencil or a spyglass—that spelled out words and messages. Another trick was to have a person do a repetitive task, like counting back aloud by 3 from 100, while another person read poetry in their left ear. The individual then took a pen and, without looking, started writing or drawing, producing images/messages that they were not conscious of.

"**Nerves**" was a catchall term for a variety of emotional states that apparently no longer afflict modern people. Some of these nervous ailments were believed to have special powers to make people more sensitive to the imagination. Melancholy, exhausted nerves, acute sensitivity, and uncanniness were sometimes induced to allow the experiencer access to the secrets of the fantastic realms of the mind. *The Sorrows of Young Werther* by Goethe was one tool to achieve melancholy. The book was so efficacious that it was banned by four countries because of its "detrimental effect on the mind". Goethe's book was just one of many tomes believed to be able to infect the reader with temporary nerves. Music was another way to achieve these states of hyper-arousal. The music of Edgar Elgar was also believed to do damage to the nerves and cause one to experience "opium-like fevers". Later, the Hungarian composer Rezso Seress wrote "Gloomy Sunday," which was supposedly responsible for a spate of suicides throughout Europe. Others believed it produced a hypnotic trance in the listeners.

Art wasn't the only way to inflame the nerves: physical techniques like **double ducking** were used by Victorians as well. Double ducking involved two barrels of water, one with freezing water and one with very warm water (scents were also added, mostly menthol). The person dunked their head in the hot water, counted to five, and then dunked into the cold bath. A black towel soaked in warm water would then be wrapped around the whole head (this was called "turbaning"), covering the eyes and ears. This treatment was believed to cause an outburst of emotions ranging from deep depression to feelings of elation.

Some alienists sincerely believed that by breathing in the last breath of a dying man one would re-experience his feelings at the time of death. This technique, called **Grave Vapours**, was used by Victorians to have novel, if morbid, experiences.

The **Psychograph** was another device used by some alienists to put a person in a trance state. The psychograph was a copper and leather crown that fit on the head and could send "magnetic pulses" to various parts of the head, "activating" parts of the mind. Psychographs were used by some artists and writers in an attempt to wake the muse by spinning electrically charged magnets around their shaved head.

NARCOTICS AND DRUG TECHNOLOGY

THE RISE OF commercial chemistry and the widespread use of steel allowed Victorians to precisely and easily navigate the furthest regions of the mind. Below is a small sampling of the "artificial paradises" available to the intrepid Victorian drug user.

Opium is probably the best known of the Victorians' insatiable quest to expand the mind with drugs. But opium flowered alongside many other psychotropics. The use of drugs to alter one's consciousness has been with humans since the earliest days, according to recent paleo-botanical discoveries. Victorians did not invent drug use, but they endowed it with the power of industrial technology and science. Even age-old opium was transformed in the mid-19th century into morphine (named after the Greek god of dreams). Not only was industrialization brought to bear on the poor poppy, but an arsenal of personal technologies were developed for its administration. The glass-and-steel syringe (also called an "angel's tongue") complete with delicate measuring instruments was first devised by Victorians to administer precise amounts of the drug directly to the blood stream, bypassing the less efficient process of smoking. Opium was added to various substances to create new and powerfully addictive blends like laudanum. In addition, the use of morphine-derived ointments became popular in the 1880s on both sides of the Atlantic. The pressurizer was an ingenious device constructed by a mad Englishman to "vaporize and pressurize" opium, creating a powerful mist that worked much like a modern day inhaler would, if it were powered by steam. Heroin was also first synthesized and used recreationally in the Victorian era, mostly by injection.

Absinthe, known as the "cocaine of the 19th century," was a distilled liquor with additive wormwood. The distillation process involved many steps, and complex technologies were used in the process including a "steam valve-turbine" that made the wormwood oil dissolve in alcohol and other substances. Wormwood, when combined with alcohol, becomes a narcotic producing a variety of disturbing physical and mental effects. Known as "the green fairy," "the plague," "the enemy," and "the queen of poisons," absinthe was described as mind-opening and hallucinogenic, and most commonly induced a state of "lucid drunkenness". Prohibitionists believed it to cause anti-social behaviors, "turning good people mad and desolate" partly because it was associated with inspiration and freedom and became a symbol of decadence—characteristics counter to Victorian sensibility and propriety.

First synthesized in 1832, **chloral hydrate** was the first depressant developed for the specific purpose of inducing hypnagogic hallucinatory sleep. Marketed as syrups or soft gelatin capsules, chloral hydrate takes effect in a relatively short time (about 30 minutes) and induces sleep-like trance in an hour. In Victorian England, a solution of chloral and alcohol constituted the infamous "knockout drop" or "Mickey Finn." It was used to create highly-charged visual landscapes similar to the state before falling asleep. Chloral hydrate was even added to fancy French and Swiss chocolate in the 1870's. Another popular way to administer the drug was through a pressurized enema device called the "shooter" which could deliver precise amounts of chloral hydrate to the porous mucous membranes of the anus.

Though **nitrous oxide** was first synthesized in 1775, it took the era of Queen Victoria for it to catch on as a recreational drug. It took nearly two centuries for the technology to develop in such a way so the odorless drug could be properly administered. Large canisters of nitrous oxide were set up in parlors and "sweet gas" salons became a popular (and legal) form of entertainment during the late Victorian period. In fact, a cottage industry of designer nitrous masks was started in the 1870's for the fashion-conscious drug user.

Ether (a potent mixture of chloroform and ethanol) was popularized by free-thinking women of the 19th century. It was considered improper for women to drink, smoke, or use other drugs; yet "angelic vapours" were strangely not frowned upon by the sexist Victorian society. Ether produced a similar effect on these women as nitrous oxide had on the men, creating a sense of euphoria and eliminating the suffocating social restrictions of the time.

Perhaps the strangest of the drug fads that swept through Victorian England was the dabbling in **Orangutan adrenaline**. Adrenaline from various apes and monkeys (all branded as "Orangutan") from across the empire was distilled into an injectable form used by a variety of bohemians and decadents in England. The users claimed to gain "primal energy and insight" from the injections. Newspapers of the time claimed the shooting up of "jungle animal blood" created scenes of rapt primitiveness in otherwise civilized people. It is suspected that Poe's *Murders in Rue Morgue* may have been inspired by an infamous (though fictional) tabloid account of a murderous Orangutan adrenaline party in London.

WITH THIS PALTRY SAMPLING OF VICTORIAN TECHNIQUES for bending and expanding the mind, we hope to provide steampunkers food for thought to enrich their art, literature, and lives.

on Writing: Ann & Jeff Vandermeer

illustration by Fabio Romeu

Ann and Jeff Vandermeer are a power couple of speculative fiction. Ann is the editor, Jeff is the writer. Together, they have delved into publishing both DIY and mainstream, and they are compiling an upcoming steampunk anthology. Having just finished Jeff's City of Saints and Madmen, I tracked them down and spoke to the pair over speakerphone about punk rock fiction, steampunk, and carving out a life for oneself. All things dear to my heart.

SPM: Perhaps you could start by introducing yourselves, mentioning something about your projects?

A: I'm Ann Vandermeer. I ran a publishing company for almost twenty years called Buzzcity Press. I published the surreal magazine "The Silver Web" and also published Jeff's *Dradin in Love* and Michael Cisco's *The Divinity Student*. Now I am the fiction editor for Weird Tales Magazine as well as editing various and sundry anthology projects with my husband.

J: I'm Jeff Vandermeer, and my first love is fiction writing; that includes both novels and short fiction, but I also do a lot of reviews, essays, editing a lot of anthologies with Ann. Eight anthologies next year actually. In addition to that I ran a publishing company—and now run a publishing company again. Ministry of Whimsy Press has been resurrected and is coming back next year with a project called *Last Drink Bird Head*, which is a charity anthology for literacy that includes everyone from Gene Wolfe and Peter Straub, to Henry Kaiser who scores all of the movies for Werner Herzog. The project may also include a CD, and in addition to the offset book there will be a print-on-demand accompanying volume that isn't fiction but is a series of interviews with the authors about their relationship to books called *Love Drum Book Head*.

SPM: The two of you have been editing fiction for a pretty long time. What could you say about the history, and growth, of steampunk?

J: I first encountered it because of K.W. Jeter. I think he was

the first one to popularize the term for people like me, even if it existed before that. I know that Michael Moorcock had been doing stuff in the late 70s that is all steampunk, and of course it goes all the way back to Jules Verne. I think what is interesting to me is how it has become not just a literary thing, but also a cultural phenomenon.

There was actually a debate about this on my blog [www.jeffvandermeer.com]: Cat Valente, another writer, was guest-blogging, and she was talking about how steampunk has come to mean a lot of things that she doesn't believe are steampunk. The thing about any term or movement is that where it begins and where it winds up are two vastly different things, and ultimately it's not up to critics or reviewers who decide that, but readers and people who pick up the term and make it their own. That's what is most interesting to me, and that's why our steampunk anthology isn't all strictly speaking what you would call 'core' steampunk. Some of it is Victoriana type stuff that is kind of steampunk, some of it is the missing link between cyberpunk and steampunk. I just like the fact that the term has come to mean a lot of different cross-pollinating influences.

A: What brought me first to steampunk were comics—Alan Moore's *League of Extraordinary Gentlemen*—and movies. I looked at it from a different starting place than Jeff. I think that that made the anthology what it is, because there are all kinds of different influences stemming from steampunk. Like Jeff said, it's not just a literary movement; it has become so much more than that.

SPM: In a post to your blog, Jeff, you mention that a lot of short fiction has been falling short of late. Specifically, you say

that you "...keep coming back to words like rough, wild, pushing, punk, and visionary" but aren't finding that. What do you, either of you, think that it would take for fiction to be punk?

J: Someone responded to that post, pointing out that the word punk has been so commercialized that it doesn't mean anything anymore, but I meant it in the original sense. Punk music got past stylized arrangements, and ways of doing things that weren't really related to real life, by doing away with the idea of nuanced musicianship, in a sense. Anyone can pick a guitar.

For fiction, I think that it's similar in that we are perceiving the world with too many layers between us and what's actually outside. I'm not anti-technology, but I do think that the commercialism in our society, and the ways that we use technology without thinking at all about the implications of what it means for our context of ourselves as human beings, means that a lot of writers are seeing the world through a veil. There are a lot of stories that come into the slush piles of various projects of ours—and a lot of other published fiction—where the writer doesn't seem like they live in the real world. It doesn't feel like they're connecting with anything real. That's what I meant by the *punk* comment.

> I would rather see a writer just do what they want to do, put it out there, shake it up and see what happens. I am seeing too much formulaic stuff.

Writers are supposed to be receivers of what's out there. They are supposed to soak it up; they are not supposed to have a filter to begin with. And there are so many ideas out there, coming in through the internet, through the media—and we allow ourselves to be hemmed in by those things that give us creature comforts—that I think its doing a lot of damage to our ability to write good fiction.

I wasn't just posing this as an 'I'm doing all this great stuff and you guys suck" comment; I posed it as something that I ask myself all the time. What a good writer should do too is be constantly recalibrating how they see fiction, and constantly challenging themselves to be better.

The other thing that makes it difficult is that genre fiction came out of the pulp tradition, came out of the situation of pennies for words, where writers were writing a lot of schlock to fill pages. It was a very commercial thing. There's still this tension in genre fiction between being a little suspicious of art for art's sake, of still valuing the commercial over the literary. So anytime you bring up these topics, people begin to get upset about it, because for some, their view of fiction is still too much on the commercial side.

But what I was getting at with punk is to get rid of this veil that is over a lot of writers eyes, in my opinion.

A: I come to this question from a different perspective. I spent four years of my life playing bass in several punk rock bands—this was back in the late 70s, early 80s—and the way that I look

at that word "punk" is that it is something that is pretty much open to anybody. Let anybody give it a try, but be true to yourself. That was the way that we approached everything. The different bands that I played with, we were just doing what we wanted to do, to hell with what was out there, what was popular, what was commercial. We were just doing what we wanted to do, and maybe we connected with people and maybe we didn't, but at least we were true to ourselves.

I see the same type of thing in a lot of the fiction today, not just in my slushpile but also in what's published. I see people being very, very careful. It's almost like they are censoring themselves in a way. I would rather see a writer just do what they want to do, put it out there, shake it up and see what happens. If they have to go back later and do something else with it, then fine, but the initial spark, that initial creativity, is what is missing in a lot of the fiction that I read. I am seeing too much formulaic stuff. One of the things that the punk movement brought to the music industry was to question this tendency. It shook things up and got us—thank god—away from disco and stuff like that. I'd like to see more of that kind of reaction in the fiction world as well.

J: Just to follow up, I don't want to misrepresent the fact that there is a lot of really good stuff being done out there too. Obviously there is, or we wouldn't be editors, we wouldn't be readers. I mean, *I wouldn't be a writer*. That was something that was also lost when I posted that… the preconceptions of the foundation of where I was coming from—which I just assumed people would realize—is that there is a lot of great stuff out there as well.

SPM: One of the things that really struck me about [Jeff's novel] City of Saints and Madmen *is that when I first picked it up and was looking through it, I felt like I'd picked up a zine anthology—like a Cometbus or Doris zine anthology—because it was all these different self-published bits, even if they were completely fictional self-published bits, all strung together with seemingly-random page numbers. That was definitely one of the things that drew me to it—although the book actually works as a novel as well.*

J: I thought one of the best ways to make a place real was to present facsimiles of things that were actually published in that world. I like the idea of a mosaic approach, as a view of reality, because the fact of the matter is that the way we get our information in the real world is very fractured. We build up our view of events or people or whatever else from a lot of different sources, and I liked the idea of putting everything together in such a way that the reader would have to go through all of it and make up their own opinion on vastly different views of the same person from one story to another.

SPM: As a bit of an aside, I recently interviewed Ursula K. LeGuin for a project of mine, and I asked her why so many short-fiction markets today intentionally avoid work of a political nature. Her response was, essentially, one of surprise and sadness. "But maybe this is one of the reasons why I'm not reading much SF any more. I pick it up, then I put it down. Maybe I just o.d'd on it. But it seems sort of academic, almost, lately. Doing the same stuff only fancier, more hardware, more noir… I may be totally wrong about this." It reminded me of what you two were talking about with what was happening with fiction.

A: One of the reasons may be that a lot of publishing companies are going the safer route. They're looking for the lowest common denominator that's going to sell the most books. Perhaps the reason why Ursula K. LeGuin is having a hard time with some of what she is picking up nowadays is that a lot of what you're seeing in science fiction is more for the effect of "wow, isn't that cool, isn't that neat," and there's really no connection to the people.

When I pick up a piece of fiction, I have to have a connection to the people, whether they're aliens or humans or whatever. There has got to be something there that grounds me and has something to do with my reality for me to engage in it. And it's not just in fiction, it's everywhere. Everyone is being a lot more careful, a lot more politically correct, and looking for things that are in their comfort zone and they are afraid to get out of that. But I see that as part of a pendulum that is swinging back and forth. I think that we are going back in the other direction now, that we're going to see a lot more cutting-edge, meaningful fiction.

J: I go back and forth on this, on the political thing, because one thing that bothers me—even though I'm finding science fiction that I like and a lot of fantasy that I like too—is that there isn't enough of it—SF especially—that seems to me to be engaging the situation that we're in right now, like extrapolating forward from this. It might be that it seems too painful, because we're actually living in a time when there are so many dangers to the earth in general that there are serious scientists saying that civilization could collapse within 100 years. I know that this is painful, and I know that it is also painful to have had all of these horrible things happen in the wake of 9-11…

On one hand I think that there aren't enough writers who are willing to engage it because they don't yet know how

> It's not that I think that people should have to write didactic pieces of fiction that reflect their political point of view or stuff about the environment, but when I read a near-future SF novel that has some throwaway line about "oh, we solved global warming 20 years ago," I just don't buy it.

to engage it since they're still absorbing what's happening, on the other hand I think it's a way an abdication of responsibility. If you are supposed to absorb the world and give your reflection, your view of what the world is all about, even if it is on a very personal level, then some of this stuff should come into play. It's not that I think that people should have to go out there and do didactic pieces of fiction that reflect their political point of view or stuff about the environment, but when I read a near-future SF novel and it has some throwaway line about "oh, we solved global warming 20 years ago" or something I just don't buy it, because then the novel goes on with the same kind of fairy tale crap. It strikes me as being a failure of the imagination to some degree.

Of course, there are books out there that do deal with this. Even something like Robert Charles Wilson's *Spin*—which I thought was a good book, not a great book, but a good book—where it's not global warming, but it's outside alien interference, but it acts kind of in the same way; here's a crisis that we have to meet. Even that strikes me as more realistic than a lot of the stuff that's out there which is just pure escapism that might as well be fantasy.

It doesn't have to be overt. [Jeff's latest novel] *Shriek*, which is kind of the sequel to *City of Saints and Madmen*, has a war in it that incorporates a lot of the stuff that I've read about the war in Iraq, incorporates an event kind of like global warming transformed into a fantasy setting. No one has really noticed those aspects of the novel, which in a way is a good thing because it means that I was able to internalize these things in such a way that they didn't just seem as though they were stand-ins for stuff in the real world. But that's what I mean when I say that writers really have a responsibility to engage in this stuff. The more writing we have like that, the more relevant it is—not relevant in the sense that fiction has to be like non-fiction and has to have a purpose for being—the more alive in some way, more complex it will be.

SPM: *On a personal level, I'm curious about the working relationship and marriage between two people involved in the fiction world. The theme of this issue is "our lives as fantastic as any fiction", about how we can learn to create our lives to be what we want them to be. And I thought that the two of you might have some insight into that?*

A: Let me just say that I love my life. Every single day, new stuff comes up. I'm never bored, and I'm often surprised with things that happen. I've had the opportunity, from being married to Jeff, to travel all over the world, to meet all kinds of different people, to make friends everywhere, and to try different things.

Yeah, it's a lot of work, some of the projects we work on, sometimes we scream and yell at each other and all of that, but overall I feel truly blessed by the life that I have, and the things that we're able to do.

> Sometimes it's a real battle to get a book out, and not just get a book out, but to get it out the way that you want it to be. And it's good to have a partner in that.

J: I think that first of all we compliment each other very well. It was different when we had two separate publishing companies; we had all these separate projects, because we wanted to keep a wall there. We didn't really combine our talents in the way that we are now, so it's been kind of revelatory over the past couple of years.

We compliment each other editorially because Ann is a great general editor; she'll read a story and say "this is what doesn't work here, here, and here," and I can do a good job using specific comments to give a general idea of what your strengths and weaknesses are as a writer. That line is kind of blurred now, because we've been working more closely together. For example, when we taught at [fiction workshop] Clarion, the past summer, we found out very interesting things about ourselves. Ann was offering these very specific, very incisive comments about the manuscript, and I was offering more general comments. We were able to mix and match our talents. But I think that one thing that holds true is that Ann is always a very clear and grounded person, and that helps me a lot… I get very passionate about things in a way that can be good but can also get me off track in directions that aren't productive, and Ann helps keep me grounded. We both push each other to do the best possible job we can on the project.

It's been good to work more closely together because it means we can get more done. I remember when I was doing the fake disease guide; Ann was helping with that but she had her own editorial projects. It was a great project, but I can remember working 16-hour days for 6 months to get that thing done. Now, even though we have more projects, we're working on everything pretty much equally, so there's more of an ability to not only do more but to keep the level of quality at the same high place that we want it to be.

I think that it's interesting that your issue is devoted to imagining your own lives, getting to that place to where you can have the realization of what you want to do or be. That's something that we've kind of been moving towards in the last few years. In February I went fulltime doing the writing and editing, and that was kind of the culmination of what you're talking about, having the belief, I don't know, not really the courage, but to throw yourself off a cliff and see what happens. Because for years I'd always been under the impression that with my personality type I needed to have a day job as an anchor and that I needed to be around people in the workplace. But what I found is that I could have done this much earlier and I would have been a much happier person.

In terms of our relationship and our marriage, we just compliment each other so well. I do have to say this though: I think that it's really good that I'm not married to another writer. One area in which I'm very competitive is that aspect, and I think that if I was doing poorly and my wife was doing very well it would be very difficult for me, and vice versa. It strikes me that people who are married and they are both writers have to be extraordinary people. While I try to do very well with the writing, I know my limitations when it comes to personal things like that. I think that is part of the equation of a successful partnership like this. Even if you don't always get it right, at least knowing what your limitations are, knowing what the things are that you do that aren't productive, helps you keep that under control. Like she said, we do argue from time to time, but most of the time we don't. If you think about it, being under the pressure cooker of all these deadlines all the time, it's kind of amazing that we don't yell at each other more often. By accident of timing we have 8 anthologies coming out next year, which is absolutely ridiculous, but somehow we've survived so far.

A: I think that the bottom line is that we really respect each other, and we respect each other's talents and skills. Regardless of the love and the friendship, we have that respect as well, which carries us through anything, I think. As long as we've been together—Jeff and I have been together for almost 20 years—, every morning I wake up and he does something new that surprises me. It's wonderful, because it's always new and fresh to me. I love being around his playfulness, his creativity. And I'm sure he loves my computer skills, because if something goes wrong, "Ann, come here..."—because that's my day job. And I think what Jeff said about me not being a writer is very true, I think we compliment each other because our skills are very different.

J: We also have basically the same sense of humor, which is very useful. We both have kind of an absurdist point of view. As a reader on the outside, reading the anthologies, you don't see the scar tissue that builds up. Because although there are great people in genre—there are great people everywhere—there are also all these roadblocks and obstacles and gatekeepers and people that you have to deal with who aren't so great. So each book has all of this scar tissue behind it, of frustrations and irritations and things that didn't go right or could have gone better...

A: But we do it so well that you never see that...

J: And we have that shared history of that, of all of those battles over the years. And they really are battles; sometimes it's a real battle to get a book out, and not just get a book out, but to get it out the way that you want it to be. And it's good to have a partner in that.

A: The two of us are in the same foxhole.

For more information about Jeff and Ann's projects, see Jeff's blog at www.jeffvandermeer.com

paint it brass
THE INTERSECTION OF GOTH AND STEAM
written and illustrated by Libby Bulloff

Many people who self-identify as or are actively involved in the goth/industrial/punk scenes are currently taking an intense interest in steampunk. The reasons for wanting to be a part of an emerging subculture when one already takes part in a previously established community are varied—some latch on to steampunk simply because it is seemingly trendy thanks to Boing Boing and Wired.com, and others develop interest as steampunk is an amalgamation of a vast number of cultural areas. Still others seem to be exhausted by regulations implied by their personal subcultures and find steampunk to be a breath of fresh air, so to speak. Having been subsumed by the mainstream by way of pseudo-goth chain stores in small-town shopping malls and pop bands masquerading as deathrock, current dark culture seems mass-produced and tired on the whole.

Not simply doom-and-gloom, goth's original modus operandi asked participants to seek out nontraditional beauty and venerate it through music, literature, decorum, and community. Steampunk culture functions under similar guidelines, making it seem very attractive to old-school goths who pine for the days when the dark lifestyle was more than just a withering club scene. Right now, gothic venues, on the whole, play EBM and synthpop more often than post-punk or deathrock. The dark community is dominated by the 21+ bar or pub atmosphere as the main place of physical meeting, and that means that a lot of people cannot even experience the culture until they may be past the point of needing/wanting it. There are young steampunks, however, and because steampunks hang out online and on street corners and tea shops, not just in dark clubs, it seems like there is more of a place for a young, curious audience.

Once upon a time, if one wanted to dress in a gothic style, one did not have the ability to buy complete outfits off the racks of boutiques or from the ridiculous number of goth fashion sites online. One had to make one's own look from scratch. Goth borrowed the anti-establishment do-it-yourself attitude from 1970s punk and post-punk culture, married it to the lush and forbidden hedonism of glam rock, and swirled in a liberal dose of Romantic fashion stolen gracefully from the Victorians. However, the average punk, indie rocker, rivethead, or spookykid

Once upon a time, one could not purchase one's lifestyle—one had to grow it.

these days is more accustomed to easy access to subcultural simulacra. Once upon a time, one could not purchase one's lifestyle—one had to grow it. There was a certain sense of duty to one's individuality rather than one's scene.

Steampunk is the first subculture in years that invites this same sort of organic behavior. Because steampunk as a lifestyle is "new", members have not yet decided on a specific dress code, attitude, type of music, et cetera (and we're hoping it will stay that way!). There is a lot less self-justification amongst the ranks, and steampunks on average seem to be quite fine with the notion that one can be steampunk and goth, or steamrivet, or cybersteam, or geekysteam. Steampunk as of yet is less of a scene and more of a community, a notion that appeals to a large range of outcasts, academics, garage engineers, eccentrics, and other such delightfully unique members of society. Its D.I.Y flavor captivates and welcomes, resulting in an ever-mutating heterogeneity. Steampunk "cred" is not achieved based on who one knows or how many records one owns or where one hangs out—rather, it is earned through positive participation and amelioration of the steampunk zeitgeist.

In April 2007, a LiveJournal thread was started in the steampunk community "anachrotech" in which a user inquired "In light of recent postings, when/why did the goths, of all people, take over Steampunk?" The replies erupted in a tempest of emotion, ranging from the personally offended to the equally curious. User "hollow_01" deftly wrote: "Let's look at goth. Roots in 70's punk rock? Check. Fascination with Victorian fashions and style? Check. An introspective subculture overpopulated by artist personalities with a love for industrial imagery? Check. Anyway, next time I meet with the Grand Council of Darkness and Cure Albums™, I'll let them know that the great and evil plan to take over Steampunk has been leaked to the public by an outsider. Expect people to be moping on your lawn by midnight in retribution." Goths and non-goths alike similarly (and cheekily) stood up for both steam culture and goth culture in tandem, explaining historical comparisons as well as implying that exclusivity was not going to be tolerated.

Some users, however, felt that steampunk and goth could not exist hand-in-hand, or that steampunk was just shaping up to be a brass-coated fourth-wave goth. Though goth and steam seem to have sprouted from the same desire that educated individuals possess to both fit in and stand out, steampunk is certainly a distinct community with its own aesthetic and unbridled behavior. One illustration of the two subcultures mingling in the same space but still maintaining their own diversity occurred in May of 2007 in Portland, Oregon, at Convergence 13. Convergence is the largest goth meet-up in North America and it takes place yearly in different cities. Saturday evening of the event this year became an unofficial steampunk party, likely brought on by the planned appearances of Abney Park on the mainstage and Vernian Process behind the CD decks. The dissimilarities between goth garb and steam gear worn by participants were obvious, though both groups were dressed to the nines in jewel tones. The steampunks wore clothing they had predominantly manufactured themselves or purchased from small businesses online, and many of the unaffiliated goths dressed in classic neovictorian gowns and suits with few modifications, or typical Lip Service and Tripp NYC outfits. Noticeable as well was how fluidly the steampunks gravitated toward each other—for one, the entire participating company of SteamPunk Magazine managed to congregate on the stairs for photos, having never met before and with little advance warning! The goggled community at C13 seemed relaxed and polite, and pressed up against the stage eagerly during the performances, shying from the bars in order to dance.

Sunday brought the second major appearance of steampunk subculture at Convergence 13—an impromptu busking session outside the event's hotel. Paul Mercer of Faith and the Muse and The Ghosts Project played viola side-by-side with Nathaniel Johnstone, violinist/guitarist for Abney Park. They were joined by Magpie Ratt on accordion/vocals and a small company of doumbek-players, bellydancers, photographers, and other such individuals. The event was nearly unorganized and none of the musicians had practiced together before. However, there was absolutely no debate about what might constitute proper music—they simply unpacked and performed for the gaggle of goths waiting for the bus and unrelated bystanders. This exhibition of pure D.I.Y amusement is exactly why steampunk is so alluring: whimsically, it existed for its own sake within a larger cultural space.

Despite events like C13 and steampunk's current popularity, the emerging community often seems a bit divided and confused. Some of those following the culture closely consider themselves lifestylers in one way or another; others want only to adopt a steampunk-flavored persona to use during play. Everyone seems a bit unsettled, as if no one knows quite what to do next. No rules means creativity blossoms with wild abandon... as does naysaying, backpedaling, and neovictorian flouncing. Individuals looking to join the goth scene are lucky in that it is broken-in like a comfortable black velvet couch—it is easy to find a mentor or someone to emulate. Steampunk newbies usually seem to be squirming in their proverbial wooden chairs, not quite certain where to begin, expecting to have their niche neatly parceled out, and finding themselves lost. Lifestylers quickly tire of the same curiosities from the uninitiated, and there can be a fair bit of tension in online forums over politics and protocol—no different from the goth or punk scene, truly.

Still, steampunks of all kinds press on. By no means is the steam community a superior subculture to goth, punk, indie rock, et cetera—it is still a child and will need much nurturing. People from all other walks of life are more than welcome to assist in its growth. Come what may.

The Duel
by Nicholas Cowley
illustration by Emily Trow

Once there was a city.
In this city there lived a Man and there lived a King.
The Man did not know the King was a king.
The King knew very well the Man was a man.
The King had taken with ease what the Man had worked hard to earn.
The King had stolen the affections of a lady. Namely, the Man's True Love.
The Man did not like this at all…

"Nine-and-forty hands high this's some balloon."
It wasn't the sort of crowd you saw at the lighter-than-air fair. First, well, there was me, all but done up in a bow, aristocrat and made more fool with my need. Secondly the legions like me; all whiskers and waistcoats, a flurry of high-order and little compassion, we knew what we wanted, we bought it often, we sold it oftener. This air-business had a transference out of the normal realms, near the wasteland; nobody knew what was going on, all you could sell in a sack with a ribbon on top. Long gone from the spheres of churchyard blasphemy and into what we knew how to build with our good two hands, we knew how, we could fly, suffer that you fucker…

The Man challenged the King to a fight because he was very cross. This was not a fight like you would have with your brother or sister, because it was a fight with very strict rules that had to be obeyed (but otherwise it was it was much like what you would have with your brother or sister).

The King accepted the challenge because above all things the King was vain and the vain often do silly things.

The Man asked the King where he would like to have the fight (the Man used the word 'duel,' a word which is used to make fighting sound much nicer than it actually is). It was one of the rules of a duel that he should.

The King answered the Man that he would like to have the duel in the air, in hot-air balloons.

She was… Well… She was all that I did it for. I had adored her for so long, under so much grief of waiting; across crowded halls and laden tables my desire made the air thick with potential. Just to speak to her.

Say anything, anything at all, you coward.

And I did, for all my worry I didn't fall on my intent; my heart melted at her attention and poured out my mouth. Words and words and words, all there ever was to be had I gave to her in the shape of those tiny, ugly little constructs. And in turn I was all but broken by the fact that she paid any heed to them at all.

It's easy in retrospect to say when it was that you knew; it was there and then, I won her at the first.

Well, at least that's what I thought at the time.

Among all the dancehalls and all the masques that the city bled like blood there was no one competing for her, they had all repented and resigned to me. My method was slow and ferocious, I would suffer no fool to waste her time but me.

But then, that was my weakness. Too slow, I waited too long. Then he came along.

Bludgeoning his way through our society; two clubbed feet, he was a disaster waiting to happen that never did—he blockaded and starved her to the death of my adulations.

Named on account of all his victory, he was the sort who knew no bounds; all he could fetch (and was worth fetching) was his for the game. A game indeed, for competition, a hunt: Ashbury Paralda.

It was all I ever needed to know about him…

THE MAN AGREED to the King's idea because those were the rules, and if you don't agree to the rules then the game isn't fun anymore. The Man also agreed to it because the King took a lot of pride in balloons, and the Man felt if he could win a contest involving balloons, then the King would be quite shamed.

And so the Man and the King agreed to fight with pistols, in the air, in balloons…

And suffer is just what I did. Paralda knew his way around those blessed, bloated man-lifters in a way that made us seem the ignorant meat-weights we were. His knowledge was supernatural in precision; those that didn't greet his gospel with open arms took it for sacrilege. I counted him heretic alone…

THE KING WAS sure he could win the duel because, for one thing, he was very, very good at flying balloons, but above all he knew that he was a king, and he knew that kings always win. This, of course, was in the days before the French Revolution.

The Man was not quite so sure he could win the duel, but he tried regardless. He wanted to win back his True Love. He knew that he fought for love and knew that those who have love in their hearts must always triumph. This, of course, was in the days before people knew what they were talking about.

The King did have the upper hand though, for he was a special sort of king. Not the king of France or Spain or Africa, he was the king of the air and the wind; his throne was all the sky[1].

THE DAY HAD been arranged and both the King and the Man had arrived. The Man had studied long and had studied hard about what he needed and had found himself a balloon in a hurry, for he had spent most of his time building two exceptional pistols.

The King had spoken to the winds and told them what he wanted. He had ordered a balloon to be made for him because he knew exactly how it should work. And though I do not think his pistols were nearly so fine as the Man's, he did carry a very peculiar sword.

THE KING AND the Man stood a long way from each other, near their balloons: the Man had a very serious expression on his face, while the King looked unconcerned. And this made the Man more upset than he already was…

Set, we meet, I'll mince him good.
Ferocious
And
Savage
And
Brutal
And so filled to bursting with all the grief of all the love I have the way I do. If… if he even grazes me, I'll break open at the seams like this heaven-rising bell above me (like it creaks—the way it wants to). But no! No, I'll break him down on the anvil of all I know.
(But what if what I know is wrong?)
It isn't!
(What a pathetic child I make, what if you die?)
Then I'll die in love.
(Ha! What if he loves her more?)
He doesn't!
(What if she doesn't love me?)
Shut up!
(Can I know? Can I prove how she feels?)
Shut up!
(What if all you've done is for nothing?)
Shut up…
(Because whether you win or lose, you can never, ever know, not really.)
(It will be a tragedy.)
(And I will be the only one to blame.)
(And I will be the only one the tragedy touches.)
(And it will be a tragedy.)
(Such a tragedy.)

(Stop your sniveling! Harden your face! Make ready! Are you ready?)
…
("Are you ready?")
…
"I say sir, are you ready? It is about to begin."
"Yes, yes of course I am ready" *I say, I am not so far robbed of my tenacity and desire, or the providence of my reason to forego this struggle. This will be decided in the traditional*

[1] Do not imagine an actual chair that comprises the entirety of the sky. This is what we call a metaphor; it is sometimes very useful and sometimes very confusing.

way: *I will murder him through the body to stop his murder through my heart, and we will do it in the air.*

We rise aloft, so high the laws of the city don't touch us, can't. We'll make our own, filled with lead and hate and our wretched resolves. So far away, but blowing ever closer; these pistols with their grinning, toothless mouths are the heft and the heave of all my heart's will.

So still,
The world down there is so still up here.
I can hear the beat of my heart. In my throat. And in my temples. It is a tattoo, it is wild and hungry. It is blackening me. But I see, I see the range, I gauge it right—these searing wolves in my hands leap, cocked and made ready I let them loose.
 ONE.
 TWO.
Misses both; what're the chances?
"Feed us! Feed us!" *They howl.*
But I see him aiming now, and I am afraid. Now, now it all ends.
He fires
…
Wildly and carelessly, I think. I think I feel empty humility swelling in me; this is not compassion I have known, I…
No!
He is coming closer and I see the malice in his bearing, I see something in his hands. That gleaming, glimmering twist of metal, what is it?
My god. It's so beautiful…
His clubbed feet are no encumbrance here; his hair is gold in the sunlight and his coat billows in the wind.
He is a bird (so fair shaped)
And an angel (so cruel of eye)
He is the king here.
That sword, oh god, that sword is his name made steel. And it is so powerfully beautiful.

"Feed us! Feed us!" *I try, I scream in effort. Jesus save me from this interminable, fumbling wait.*
 Fed,
 Cocked,
 Steady hand,
 Look up,
 Aim!
 Where…is…he?
There! Along the wind—stepping toward me, with nothing but sovereignty in his eyes and that sword in his hands.

"I'll not give her up to you!"
I do not care what he is or where we are, and so let loose a wolf at his face with all my intent. Blood breaks ranks along his head where an ear used to be. But all the same he falls toward my seat here and we fight. And we fight for all we're worth and that sword moves like a song but it can't move here *and it can't move* there *because it'd cut us well from this perch and all the wind-walking you can do wont save you from a great big basket this size gripping you all the way down.*

 His extra ballast brings us ground-ward but not fast enough to stop this violence, so I bite and throw my limbs at him and cry and scream. And scream. And watch my hand fall, severed. Four fingers and a thumb. So unlike the bird it imitates…

AND SO BOTH the King and the Man fought. It was not nearly as nice as the word 'duel' made it seem. And though the King was peerless in the sky, the man attacked him in the manner of the creature that his love made him—this made the duel almost, but not quite, even.

But, the Man's balloon was poorly designed, and so failed as the two fought, and all the powers that the King had could not save him whilst dooming the Man and so he called to the winds to help them both live[2].

And when they landed in a tangled mess, both rose to find a crowd about them, but not one face there looked remotely like the Lady they fought for, because in fact, she wasn't even there.

YOU SEE, THE Lady was truly flattered by the attentions of both the King and the Man, but just as much, she was sure she was not a prize to be won or lost. She would no more favor the winner for his martial prowess than she would tend to or mourn the loser for his masculine failings. Her mind and heart were her own; the passion that drove them to violence was not one mirrored inside her. Indeed, rather than watch the skies, she had decided to attend the playhouse instead.

And when the two duelists discovered this, neither cared particularly for her afterward…

This passion that drives me is far from gone.
After so much work, my hand is returned, but of new design. Glimmering and glittering now, an echo of old defeat. Hand of my hand, built in the shape of the flesh but finished in metal; turning by knowledge and gear-knuckle, gibbering electric. It channels the output of my lusts as voltage through the very air. The air I know that lives in him.
I will find him.
I will make him return the love that I lost. ✺

[2]This is what we call Irony, which is very complicated, and never very useful, but tends to happen in stories like this.

Kitchen Alchemy Conference, 1909

Brass Monkeying

by Prof. Offlogic
illustration by Suzanne Walsh

While meditating amidst scraps of copper, strong chemicals, and the Internet one day, I chanced upon a classroom demonstration of turning a penny into gold.

Okay, so it's not really "gold", but *brass*, specifically cementation brass (akin to calamine brass, for the research-oriented). Few metals scream "steampunk" the way that brass does. Chemically inlaying a brass design into copper, or simply turning those goggles you made from copper plumbing into brass, is nothing short of alchemy—and is fairly easy to accomplish in the average kitchen!

MATERIALS:
- Copper: sheeting, plumbing fittings, etc.—as long as it is in a form that can be cleaned.
- Zinc: harvested from alkaline batteries (using a tubing cutter, see the website), roof flashing (if you live in a wet climate), or from a marine supply or stained glass shop.
- Household lye (sodium hydroxide): available in hardware and grocery stores, or from the neighborhood meth lab.
- Hot water: nothing fancy here.
- Resist material of your choice for imparting a design: see Steampunk Magazine #1.

TOOLS AND SUPPLIES:
- Personal protection equipment (goggles, rubber gloves).
- A glass dish: a stove-safe Pyrex pan is best, but a baking dish will work.
- Tongs or chopsticks (depending on the size of your project).
- A clean scouring pad and cleansing powder.
- A stove or hotplate.
- Paper towels.

STEP 1

Wearing clean rubber gloves, get that copper as clean as you can get it with scouring pads and cleanser. You want bare, clean metal with no grease or fingerprints. Rinse it in hot water until it is free of any cleaning agents. You can give it a wipe down with rubbing alcohol if you want. The end result should be copper with no varnish, grease, nor oxides left.

STEP 2

If you want to put a design on your copper, mask off everything that you don't want "brassed". Choose a masking material that can withstand a hot alkali solution for at least one minute, because we're going to be boiling it. In some cases you might reverse Step 1 and Step 2, depending on how tough your masking agent is.

STEP 3

While wearing your eye protection, place a bit of zinc (battery paste, small bits of flashing, etc) into the glass dish. You need only as much zinc as you'll be plating on, so a few grams will suffice on all but the biggest projects. Add some household lye crystals and enough hot water to the dish to completely cover your copper item. I use about a tablespoon of lye to a cup of boiling hot water. This solution is quite caustic, so don't drink it, get it on your skin or mucus membranes or eyes or hair or anywhere on your clothes, your pets, etc.

The hotter the solution is the better it will work, hence my preference for the stove-top Pyrex dish (be warned: a baking dish will shatter if placed on open flame!).

STEP 4

Place the squeaky-clean copper into the dish of the lye/zinc/hot-water, and watch in amazement as a silvery coating of zinc gets deposited over all exposed surfaces. Pretty neat huh? The longer you leave it in there—and the hotter the solution is—the thicker the zinc plating will get (up to a point, anyway). After 1 to 5 minutes it'll probably have all the zinc it's going to need.

STEP 5

Remove the zinc-plated copper from the solution with chopsticks or tongs or a plastic spoon, whatever works for you. Treat it a little gently so as to preserve that lovely zinc coating. Rinse the piece off in running water until all that nasty lye is washed off.

STEP 6

Time to make brass happen! Note: Depending on the masking material used you might want to remove that now. Depending on the flammability of the mask, it may emit vile/toxic vapors when heated, and surface discoloration can result from heating/burning it. If you used a lacquer to mask your design, you can probably apply the appropriate solvent to remove it before heating, but be sure that the solvent has completely evaporated before heating the copper. If you've used wax you should probably remove any excess by gentle heat before holding the copper over a stove (flaming wax=fire hazard).

You will heat the plated copper piece on a stove or hotplate (or, used carefully, with a torch or heat gun). The recommended method is to hold with tongs and pass it rapidly and repeatedly over the flames to get it evenly heated. You don't want it red hot, but it does need several hundred degrees for the zinc to diffuse into the copper. Keep an eye on your work, and you will see the brass magically appear as the zinc oozes into the copper. Once the surface zinc is absorbed, *immediately cease heating*! Too much heat makes the brass go away again (that darned zinc just keeps diffusing into the deeper regions of the copper and the air itself).

Set the piece aside to cool on a trivet or drop it into a pan of water. **Congrats, you just made brass.**

LEFT-OVERS

THE LYE SOLUTION can be stored in a glass or plastic bottle for use on your next creation (just be sure to label it clearly). You won't need to add more lye, but you should replenish the zinc as it is consumed. Use care when reheating the lye solution though: I discovered that microwaving it in a mason jar is a very bad idea, since lye collects on the side of the jar creating a very hot ring, and the jar will break (my jar broke cleanly above the level of the lye solution, but you may not be that lucky). Again, a Pyrex pan is the best way to go for reheating the lye solution.

On the other hand, the household lye is cheap and designed (nay, destined) to be poured down the drain: it is sold as a drain cleaner. Dilute it with lots of water and carefully pour it down your kitchen drain. This may sound very, very mean to Mother Earth, but the action of household lye on the greasy sludge in your kitchen drain is very benign: it reacts with fats and oils (in a process called saponification) to make soap, a very low impact effluent. Alternatively you could just decide to make some soap (seen "Fight Club"?), or the diluted lye can be neutralized by carefully titrating with acid (hydrochloric acid + lye = salt water + heat), though this could actually increase the total energy/chemical footprint rather than reduce it (e.g. the grease in your drain is already there).

GET GROOVY WITH ETCHING

SAY YOU'VE JUST made a nice brass cog design on a square of copper. Want to jazz that up a bit? How about etching the outlines of the cog, or adding a background pattern? You may do so, whether using acidic or galvanic methods. For galvanic etching, see SPM#1. For acidic, refer to the nearest internet.

PATINA NEVER SLEEPS

YOU COULD MAKE a drinking game out of "The Antiques Roadshow", downing a shot every time you hear the word "patina". But seriously, patina (corrosion) on your copper or brass handiworks adds a nice air of historicity (props to Phillip K. Dick, wherever you are).

My all time favorite ageing treatment is "Liver of Sulfur", AKA "sulfurated potash", available from craft supplier or jewelry supply shops (I found mine at a funky place called "The Bead Merchant"). Available as a limited shelf-life liquid or in storable dry crumbles, you put just a pinch of the dry stuff into a cup of hot water then dip or brush it on copper, brass, silver, etc., and it darkens the metal dramatically. Copper can be aged from a pinkish ochre tint through deeper shades of chocolate to a dark bluish black in just a few seconds. "Liver" is a very striking, permanent, and fast acting surface treatment.

Some other patina suggestions:
- A mixture of equal volumes of household ammonia and salt is good for a blue/black patina. The usual method is to bury the work piece in a plastic container filled with sand, pour in enough ammonia/salt mixture to moisten the sand, then close it up for 2-5 days. The longer it sets, the more pronounced the effect.
- A strong solution of Miracle Grow and water will produce a green patina overnight. Use the sand method above, or just brush it on around the areas you'd like to show their age.
- I've noticed that the brass electrodes in my glass enclosed Jacob's Ladder (infernal device) turned green after one night's use. This lends me to suspect that ozone would be an inexpensive source of green patina. Ozone generators, anyone?
- Some swear by using urine, *human pee*, but I don't. It's nasty and I won't go there. I don't think you should either.
- Man's oldest and dearest friend, fire, can produce interesting effects and on most metals (and the people that they touch). Polished copper shows off wonderfully colorful heat distress. Be careful, though, not to bleed your brass away: too much heat can turn your latest cementation brass design into plain copper faster than you can say "NOOOOO!!!!"
- The www.finishing.com website has a lot of information on patinas, plating, and that kind of stuff.

FINISHING UP

EXPERIMENTATION IN OPEN air metal transmutation, etching, and surface finishes can be used only for good or evil, but be careful. I've not covered all the usual safety warnings (ignored them for the most part, I have), but you hear them all by watching a few "Beakman's World" re-runs, consulting MSDS sheets on the materials involved, and so on. Of the chemicals discussed, the muriatic acid, the lye, and the "Liver of Sulfur" are probably deserving of the most respect, though the ammonia is no treat to spend time with. Use personal protection equipment, common sense, good ventilation and, if possible, work with a friend.

Good luck, and go make something interesting!

(see http://offlogic.wordpress.com/2007/09/20/steampunk-and-the-golden-penny-effect/ for some background on this.)

> *"Then I heard every creature in sky and on earth and under the earth and in the sea, every beast in the universe, cry out: 'To the one who sits on the throne who will answer our cries?'" (Revelations 5:13)*

Antonio's Answer
by The Catastrophone Orchestra

New York City, October 3rd, 189?

THE HOWLS OF THE CATASTROPHONE EXPLODED through the cluttered free clinic, sending musical shards flying out the door onto Delancey Street. Columns of roiling steam poured from two of the instrument's many cannon-like pipes, engulfing Professor Calamity and hampering his search for a makeshift cricket cage.

Neal List, knowing that his voice would not be heard over the roaring and clanking of the instrument, threw his recently pilfered copy of the *Herald* down and marched through the artificial fog towards Pip, the instrument's caretaker. Through his welding goggles, Pip saw only the white of Neal's mohawk, not the heavy meaty hand that cuffed him so hard his teeth clattered. Pip turned one of the brass valves, smarting from the ex-steelworker's blow.

The instrument shimmied, sputtered, and finally became silent.

Neal flopped back down onto his orange-crate and picked up the funnies again, while Calamity continued to search, stepping over a murky puddle of discharge.

"It's madness, this cricket idea of yours," Pip said, turning a few more knobs and locking a lever in place.

"Madness?" the Professor asked, turning to gaze down at Pip, "What would you know about madness? Do not forget, my young Pip, with whom you are conversing. I have not only studied madness, I fell in love with it."

The professor gave a slight bow in the direction of Mathilda, who was applying arsenic to her face on the other side of the room. Calamity had worked for years in the screeching bedlam of Bellevue as an alienist before moving to the Lower East Side, squatting the free clinic, and forming the Catastrophone Orchestra. His lover and main operator, Screaming Mathilda, was certifiably insane.

Pip knew all of this, but he also knew that the Professor's idea was nothing more than sheer lunacy.

"Look, the catastrophone operates at ninety-five PSI, minimum. Those pedal steel drumotrones we just built? They had to be increased just so they could be heard above it. I had to double up the chains to get enough velocity…" Pip trailed off as he tried to re-zero a cracked gauge.

"Yet an angel's sigh can be heard across the world. We need something else, something subtle … a sound to add to your wonderful machines. We need something *organic*. To fully capture the music, to transform the listeners…" Calamity said, now searching his empty opium vials for an appropriate cricket receptacle.

"Listeners would be nice," Neal said from behind his paper. The others paid him no mind.

"It's just not mathematically possible, Calamity," Pip said, retrieving a mop to slop up the mess from the machine.

"Mathematics! That is exactly the point! Barbs divide the length of the golden cricket's back leg. With proper breeding, an individual with enough foresight may breed crickets that play notes. Specific, separate, and discrete notes. There is an exact and well-known formula; high temperatures produce specific leg rubbings. This is why men who work the land can determine the temperature in the fields on the basis of the crickets' song. Don't you see, my boy? We can heat up our specially-bred crickets to play anything we like! Think of it … think of it as the first organic organ!" Calamity exclaimed, knocking a tin of twice-used coffee grounds onto the threadbare rug.

Mathilda checked her midnight-blue lipstick and rose from her razor mirror. She ducked under one of the Catastrophone's vents, crossed over to Calamity, and gently touched his bony shoulder.

"These plebeians have no understanding of art, but you, you believe in me, my dear Mathilda," he said, pulling her into his trackmarked arms. She purred and reached past him, lifting down a black beribboned hatbox and handing it to him.

"I don't want to keep the Society waiting."

"Brilliant!" Calamity said as he took the box, "I'll go fetch some rolled oats for our little insects; I'll meet you on the corner." The doctor dipped into Neil's vest pocket and removed a few tattered dollars.

"Mathilda, you know he'll never make it to Canal Street. There are at least three poppy parlors on the way to the Chinaman's pet shop," Neil said, without looking up from his paper.

"How much did he take?" Mathilda asked.

"Most of the tobacco money and a bit of the food too," Neil answered.

"Then you make sure he comes back with at least half. You know that the Doctor sometimes forgets that the rest of us need to eat."

Mathlida navigated her way past the urchins sharing a cigarette on the stone steps of the Henry Street Settlement. Inside, the foyer smelled of unwashed diapers and five-cent cigars. She stole a glance at a bulletin board advertising English classes, a lecture by the infamous anarchist Johann Most, and free tuberculosis testing. She walked past the kitchen where sincere reformers worked to prepare the evening's turnip stew. The library door was open, and through it she heard the voices of the Society debating.

"Greetings, Mathilda! We were just speaking of the incident at Coney Island, with the butcher and that poor elephant," Father Martin said, as he rose from the table.

If the Society had wanted a leader it would have undoubtedly been Father Martin. His duties caring for the poor as one of the Franciscan order had allowed him to move in many circles. It was from these different spheres he first drew together the Society for the Enrichment of Animal Welfare, which was commonly referred to as "the Society." When the Society had first begun three years previously, many more people had attended the monthly soirées and lectures, but it had in recent months dwindled to a monthly gathering of no more than a handful of like-minded folk.

"How much electricity does it take to kill an elephant anyways?" Mathilda asked a rotund man who sat by the window eating a cookie.

Along with Mathilda, the pot-bellied Dr. Tarr had been there since the beginning, when the Society was still idealistic and fired by dreams of action. Dr. Tarr, ever the martyr, had continued to put out the society's gazette long after the subscription rates had dropped. He was always the first to arrive to the meetings and he always brought lemon-seed cookies that his wife had baked the night before. Clearly, Tarr had married a woman who could indulge in his love of both deserts and stray cats. The man was a hard worker and he was the last remaining full-time animal doctor in Manhattan.

"Mathilda! That is dreadful! Who cares how much electricity? It's terrible," said Mrs. Halsworth, "and it's in all the papers and, why, no one's lifting a finger. I heard the mayor was even there!" Mrs. Halsworth was the wife of an investment lawyer. She used as much of his money as she dared to care for ex-racing horses on their property in Tarrytown.

"Do you think they ate it, after they cooked it?" Mathilda asked, folding her hands in her lap.

"I must say! The things that pop into your mind." Halsworth shook her head, "You know, meat-eating is criminal. It ought to be a crime."

"Or at least a sin," Mathilda replied, looking at the priest.

The conversation died as Antonio—the society's newest member—entered. All eyes were on the balding Italian, who quickly took his seat opposite the Franciscan. Silence filled the book-lined room.

"Antonio, I was very sorry to hear…" Halsworth broke the silence.

The rest nodded in agreement. As if on cue, Antonio started uncontrollably hacking into his stained handkerchief.

"Thanks, it's alright. So what were you all talking about?"

Father Martin recapped the discussion and the news article on the electrocution of Topsy, the elephant at Luna Park.

"So it would seem, Mrs. Halsworth, that technology is *not* going to be the savior of animals, as you have so often suggested," Dr. Tarr said.

"Nonsense, Edison is a lunatic, an aberration. In the future there will be no need for animals to be eaten or worked to death," Halsworth replied.

"There will always be a need for animals to aid man in his labor," Tarr said.

"How can you say that? Why, it goes against progress! You already see the mule teams on the Eerie being replaced by steam engines. And last summer in London, I rode in a steam carriage. It was such fun to whiz about the streets in it. The museums were also very impressive … you should really go sometime. Now where was I?"

"Whizzing around London." Mathilda smirked.

"Yes. No. Oh yes, I believe the twilight has already begun for beasts of burden and the animals of the field. Steam tractors will liberate the draft horse and the tired donkey," Halsworth said, building a head of rhetorical steam.

"I don't believe all of that, but you must admit there will always be a need for meat," Dr. Tarr said.

"Need! Meat is a murderous abomination. Soon, we will all be like the Japanese, eating only healthy vegetables. When I was in Tokyo on my honeymoon, the food was simply amazing. They *did* eat fish, but most of it was rice and vegetables."

"Murder? Father, have you ever heard such nonsense? The study of nature is the study of violence. The lion eats the gazelle, because food is food. We must eat to live. I cannot agree that there is anything wrong with eating meat, so long as the animals are treated humanely. Let the chicken have a good life before she is put in the pot, I've always said. And that has been my work for all of these years. No one loves animals more than me."

"Do you *often* eat your loved ones?" Mathilda asked.

Halsworth continued to protest against meat and for the redemptive power of technology while Dr. Tarr offered up a lackluster defense between bites of cookie. Mathilda half-listened, tossing in a verbal bomb every now and then.

Father Martin had heard it all before: the conversations,

the debates. He longed to free animals, and he had once hoped that his little society could be an agent in that struggle to advance mankind. His faith had always given him comfort. He thought fondly of Saint Francis. How that holy man had extended his love to all the beasts, how he had reached communion with both God and His creations. Yes, that would be an excellent beginning for his sermon, he thought. Martin had yet to write his sermon for St. Francis' feast, which was the following day, and had hoped that the society would bring him inspiration.

"I am sorry my friends, but I must go, and prepare a sermon. You are welcome to continue your conversation. We have the room for another hour," he said.

Before he left he looked over at poor Antonio. He had known the man for perhaps six months at most, but he knew that Antonio was a good, solid friend of the animals. He was more than a little sad that the Italian stagehand was dying. He wondered how many more meetings Antonio would be able to attend as he looked over and found him trying to stifle a cough.

"Antonio, would you like to accompany me back to the rectory, for some fresh air?" Martin asked.

None of the others heard Antonio's response. He simply rose and followed the priest out; the sounds of the society's argument followed them down the hall.

Father Martin was feeling good about himself. He had told Antonio all the right things, given him a speech he had honed in his years of visiting hospitals and sick beds. He had done his good work for the day and had more than a start on his sermon. It was always the most interesting sermon of the year.

"Well Antonio, I trust we will see you next meeting."

Martin shook the hand of the dying man, who would not let go.

"Father … there is something weighing on me. I am confused."

"I believe that is natural, Antonio. But you must not fret; you are in God's perfect grace."

"Thank you. But what I am confused about is how to make a real impact. You started the society; it must be a disappointment to you. For two years, nothing has changed, even fewer people come now. Even Professor Feather hasn't been around," Antonio said wringing his well-worn hat.

"An impact? What kind of impact? I'm afraid I don't understand."

Martin felt something behind the man's words, something dark that made the hairs along his arm rise. He could not quite grasp the source, but something made him terribly uneasy.

"What are you planning Antonio?" Martin whispered.

"I have a bomb."

The priest instinctively took a step backward, almost slipping off the curb.

"Not with me, Father." The Italian smiled.

Placing his cap on his head and standing straighter, he continued, "The theater may have killed me with its chemicals but my life will not be wasted. No siree. I got most of it worked out."

"You can't be serious," Martin said, grabbing Antonio's sleeve and pulling him closer.

"Deadly serious, I assure you. There is nothing you can do to stop me. I have already let my room go and I'm going to get my bomb. The only question I have is where I should go."

"Go? Perhaps we'll go inside and talk."

"The cruelty is out there, Father," Antonio said, waving his arm to the city. "There are so many wrongs. Helpless beasts who never asked for any of this. You have been involved in the struggle longer than I have. Longer than all of them. I am not looking for your blessing Father, just point me in a direction where my death will have the most meaning. Relieve the most suffering. That's what we all want, we all do it in our own ways. The doctor, with his practice helping mend poodles and Mrs. Halsworth with her crippled racehorses, Mathilda … well I'm not sure what she does. You with your words. And me with…"

"A bomb?"

"Yes."

Martin didn't know what to do. If he went to the police, Antonio would surely be gone before he returned. He might even be forced to do something dangerously foolish. It was true, Martin didn't know this man well but he believed he could change his mind. He just needed more time with him.

"It is clear you will not help me." Antonio began to walk down the street.

"Antonio, wait. Where are you going? Let me come with you," Martin pleaded.

If nothing else, Martin thought, Antonio wouldn't blow himself up with a priest at his side.

"I kept notes, you know. Don't say much at the meetings but I hear."

Antonio pulled out crumpled articles from the Society's bulletins.

"What is that?" the priest asked.

"Places you all talked about. I'm going to check them out. Find where I can do the most for the animals. If you want to come, you can, maybe you can help me pick the best one."

"Or none," Martin silently added to himself.

"It's too bad Dr. Tarr isn't with us," Antonio said, stepping carefully to avoid a half-congealed puddle of blood.

Martin's response was drowned out by the steam horn which bleated loudly from the frigate sliding out from the Chelsea piers.

From twentieth street all the way to the forties, snaking along the river was New York's ever busy "meat-packing district." Cows from Chicago were chased down chutes on the piers bumping into guinea fowl from St. Lucia. Slick urine and feces-covered ramps crisscrossed the waterfront, connecting dark windowless sheds. The animals were herded into these perverse arks, most often at night, their last earthly communications echoing across the water to the Palisades. A few blocks further, towards the interior of Manhattan, were the meathouses. Horse-drawn trucks dropped off full carcasses to be alchemically transformed into dinner chops. It was through these gory alleys that Antonio searched for

the LaFontainne Brothers.

"Where are we going?" Martin asked, horrified by two strays pulling at an unidentifiable piece of forgotten entrails in the gloom.

"Here we are," Antonio said as he pulled himself onto a loading dock.

A man with the body of an ape and the face of child met Antonio on the deck. He casually carried a fifty pound block of ice on his toweled shoulders; his bare chest was streaked with blood. The butcher dropped the ice and held out his hand to help heave the priest onto the slippery deck.

"You are very welcome, Father," the man said in a heavy continental accent.

"You are French?" the priest said, trying not to stare at the man's bloody torso.

"Belge actually," the man replied, following the priest's eyes with his own. "Sorry. Aprons soak up too fast and they cost ten cents a cleaning. It's easier to just wash off. So you come for the Cevaux piggies? Yes, men of taste. Better to prepare it yourself than to have it at some mangy restaurant, no?"

Antonio and Martin ducked under the leather flap separating the dock from the interior. Martin was shocked by the number of laborers moving around in the gray-tiled hall. Gleaming knives, powerful cleavers, and flexing saws moved in silence like the choreography of a Bosch scene. Martin followed the hulking Belgian across the well-lit slaughter floor to a metal staircase. The Belgian stopped and grabbed a sputtering hurricane lantern.

"Watch your heads, yes?" he smiled, descending the wrought-iron stairs.

Martin grabbed Antonio's arm and pulled him close whispering, "What are we doing here? I have read the article too, you know?"

"Have you ever seen it? I mean not at a restaurant with orange sauce, but actually seen it?" Antonio answered.

"No," Martin admitted, watching the glow of the lantern dance further away into the depths of the building.

"Neither have I. Let's go."

The cellar was low and the men had to crouch to avoid banging their skulls on the exposed beams. The sound was disturbing—whirling gears and crushing noises filled the low basement as if a giant was grinding the bones of unlucky Englishmen to make his bread. The temperature in the cellar was at least twenty degrees higher than on the ice-covered cutting floor.

In the back were rows of small cages filled with bloated piglets. Their heads tethered upwards as if they were singing in a ghastly choir, though no sound escaped their throats. At first Martin thought the animals were dead, that strange copper birds of prey were picking at the succulent bodies. As his eyes adjusted, he began to see the clunking contraptions with flapping bellows, the spinning gears crushing glass, the tangles of copper tubing that extended to an iron shelf of upturned bottles with French labels. The entire mechanism was powered by a small glowing boiler that sat like a burning egg under the mechanical vulture.

"The light is bad for the meat, yes? Many others take shorter cuts, keep them exposed. Many shorter cuts, but we are Belge. This is the real Cevaux piggies," the Belgian said, like a proud parent showing off his son's trophies to a houseguest.

Martin knew what those tubes snaking down the pigs' throats were for; they were filled with some type of liquor, usually anise-flavored but sometimes something more exotic like chokeberry.

Martin could no longer stand the sight. He turned, looking for the stairs, toppling something that clanked and smashed on the stone floor. The huge Belgian bent down and picked up a brown shard of glass.

"Yes. See we only use brown or green glass. You know why, yes?" he said smiling his idiot's grin at the priest.

"I think we have seen enough," Martin said searching for the stairs in the suffocating darkness.

"You feed them broken glass so they bleed internally, so the liquor saturates the fatty tissues," Antonio answered, from behind Martin.

"Yes. But why do we use colored glass? It's more expensive. Take a guess," the man said, grabbing Martin.

"I assure you I have no idea."

"So the cook can find them. It wouldn't do any good to serve you a plate of Cevaux A L'Orange with bits of glass would it?"

Outside, Martin drew in great shaking breaths of the cold air. Even the putrid river air felt refreshing after being in the basement. He watched as Antonio shared some final words with the butcher and handed him a few coins. From where he stood, Martin could see the meat merchant was confused and trying to convince Antonio to at least take some sirloin for his money.

Antonio finished his transaction and rejoined Martin.

"Seeing is indeed different from reading about it," Antonio said offering a cigarette to the shaken Martin.

"Yes. It was worse than even Ms. Halsworth's article about it. Just to see it … no wonder she is a vegetarian."

"Yet our comrade Dr. Tarr probably has no compunction about sitting down at Marlowe's and ordering the special," Antonio said, spitting out a stray piece of tobacco.

"That's not entirely fair. Dr. Tarr has always maintained that animals, even those we eat, should be treated humanely…"

"What is humane Father? A cow living in the pastures of Illinois, beaten, forced on a train and then loaded into the bottom of a steamship to be run up a chute to have its throat cut? How is that humane?"

"It's different, and you know it. That is why you came here as opposed to any of the other meat houses. It is why Halsworth wrote that article. It is unconscionable what they do to those piglets. But that is the perversity of the rich. I doubt any of the Society could even afford such a cruel indulgence. It would be foolish to … do something here. What kind of impact would that have? The rich are so decadent they will find some other perversity. I am no longer shocked by the callous cruelty of the patrons of this city."

Martin watched as his words sank in. Antonio looked back at the meathouse and threw away his cigarette. Martin knew that Antonio had told him about the bomb because

he wanted to be stopped. He wanted a reason why his destructive, suicidal act woud have been simply folly. Martin settled himself in for a long night. He knew that at each Dante-esque stop he would need to find the words, the arguments to stop Antonio. He would get this friend of the animals through his dark night of the soul and perhaps even save it before it was too late.

Martin could tell Antonio was lost. The Five-Points was not an area that strangers could easily navigate, and that was the point.

"We need to ask someone," Antonio said, checking the article.

"We should not be here. It is dangerous. Just last week two metro policeman were–" Martin began to say.

"There." Antonio interrupted the priest's tabloid tale, "I'll ask those punks."

Antonio handed the priest his wallet and timepiece and darted across the street to two punks playing Mumbley-pegs with a rusty fish knife. Martin noticed that Antonio kept a safe distance from the girls. The youngest, in a pair of oversized fireman's boots, sloshed over to Antonio. He handed her an article and she gave him a few simple directions while her older sister kicked a rustling cloth sack.

"It's just over there," Antonio yelled back to Martin, handing the girl the rest of his pack of cigarettes.

O'Malley's was the type of bar sailors went to for a fight, followed by regulars who cleaned up the unfortunate losers' pockets. It didn't have a sign, and even though Old Man O'Malley had been beaten to death by his wife years earlier, it was still named after him. Since O'Malley's time little had changed except for the addition of a four-by-eight foot zinc-lined pit in the basement. Some rummies even joked the pub was so much the same, that the warped bar hadn't seen a wash rag since the old man ran afoul of his wife.

The upstairs was filled with half-drunken men; it was too dangerous of a place to get completely sloshed. Martin had seen these men before—they came to his church looking for handouts. They were the type that had never known an honest day's work, or any other honesty, in their lives. A gaggle of pierced adolescents pushed past him to the end of the bar where an ogre-like bartender was carefully counting out stacks of pennies. One of them, with a padlock and chain around his neck, began furiously arguing with the bartender, shaking a handful of filthy potato bags.

"According to Mathilda's article the pit's downstairs," Antonio said, carefully folding the tattered piece of paper.

"This is a prime place to get pick-pocketed. Be careful, and don't drink anything," Martin whispered to Antonio.

Martin was a priest but he had also worked and lived on the Lower East Side his entire life. The Five Points was worse, but he was familiar with both the place and the people. He could see that Antonio was determined but a little afraid. Martin realized he knew little about his fellow Society member except that he worked on Long Acre, and that he was out of his depth. Martin was just about to drag him out of the bar, when he changed his mind. Let him see rat-baiting, let him revel in the cruelty of man towards the beasts. He needed to see it, and Martin would play the part of companion if only to keep him from becoming completely unraveled. He had seen others burn with righteous anger in the cause of animals and seen them consumed by the frightful indifference of their fellow man. He had seen the cold cynicism in Mathilda's eyes and he would not let that happen to Antonio if he could help it.

Antonio said something to Martin but his words were swallowed by the shouts of the bookies and the yelps of the dogs. Martin managed to finagle a spot for them near the edge of the reflecting zinc-lined pit. The regulars preferred the higher up benches to get a bird's eye view and to be close to the beer kegs.

A pockmarked man jumped into the pit and lifted a tawny pit-bull up for the crowd to see. The betting frenzied into a crescendo as the bookies wormed their way through the sweaty throngs making coded marks on slates that hung around their necks. The handler set the dog into the pit and untied the kerchief that held the muscular dog's jaws shut. The animal's white teeth snapped viscously in the smoky air. The owner announced the dog was named Willy's Trick and had previously dispatched 50 rats in 38 minutes.

A rugged man with a shaved head struggled with a squirming undertaker's bag almost twice his size. He worked to untie the bag and brusquely pulled his hand out with a large rat latched onto his thumb. He shook the rat off to the ground and stomped it to the delight of the crowd. The bag exploded into the pit, with a swarm of ferocious river rats slipping on the metal. The owner could barely hold his dog back at the far end of the pit. Sensing the killer dog, the crazed rodents desperately scrambled to escape the pit and piled into the corner. An elaborate clock was lowered. A bell rang and the pocked face man released his pride, fleeing the pit.

The dog slipped once before careening into the frantic mound of terrified vermin. The pit bull's mouth ran red with blood as it shook three kitten sized rats in its spine-pulverizing jaws. The rats regrouped, understanding that escape was impossible, and threw themselves on their attacker. For a moment only the back legs of the dog were visible under the gnawing blanket of rats. The pit bull's yelps were muffled by the mounds of rodent flesh held in its vice-like jaws. The rats' yellow teeth tore at the front paws and ears of the pain-frenzied animal as it tried to find more room to attack. Moments later the pit bull escaped the corner but the rats had already chewed off one ear and blood streamed down its front legs. The mob was on their feet, nearly crushing the shouting owner as he hung over the wood railing encouraging his Willy on.

A bell rang, and the judges in derbies moved into the pit. The men solemnly checked to determine that the rats were indeed dead, while the owner tried to revive poor Willy. Martin could see by the way the animal struggled for breath, its muscular frame shaking with each inhalation, that the dog would not live the night.

Martin led Antonio out of the basement as the slate-men shoved money into their pockets while winners and losers cued up for more warm beer and awaited the start of the next fight.

Martin watched the pit's nightmare etched across Antonio's face. He waited for a moment before speaking.

"Antonio, even Mathilda could not describe it accurately. As you can see, cruelty begets more cruelty. Perhaps it is a mistake to think that people, people like this, who experience cruelty and death every day in these alleys and streets could muster anything resembling compassion. They are ever as much victims as those animals in the pit. It is difficult to see, but it is true: Mathilda made a mistake in her article when she ignored that simple truth. What we saw is … the result of poverty, of dehumanization. Cruelty is learned and these streets are the universities of pain."

"But the bastards enjoyed it. How could that owner let his dog…" Antonio tried to find the words for the sickness he felt.

"They're not the problem. Cruelty is these men's inheritance. Killing them, wiping out every pit, would accomplish nothing. Absolutely nothing, my friend. Some day when cruelty ends—the cruelty of man to man—the pits will be empty. That is the way. That is our hope," Martin said, putting his arm around Antonio.

Martin felt relieved turning off Broadway onto Longacre Square. The theater-goers were exiting their hacks, rushing home after the shows. The square was filled with people from all over the city, from top-hats to scarf-wearing babushkas. The one unifying thread of the metropolis was the need for entertainment and Longacre Square was its home. Antonio had remained silent nearly the entire long walk north to the theater-lined square. Martin had allowed Antonio the silence, letting him ruminate on his words and what he had seen. Martin was tired from the walk but he still felt the subtle energy he always experienced when retrieving a lost soul.

"I really should get back. I have a sermon I must prepare," Martin said, clasping Antonio's shoulder in a fraternal way.

"I want to show you where I work, it won't take long. Will you come?"

Martin nodded. The two men crossed the wide avenue towards a mountain of pseudo-Baroque architecture. A forest of plaster Greek statues and reliefs covered the nearly block-long edifice. Edison's crackling electric lights still lit up the Hippodrome Theatre's thirty-foot banner.

Martin felt small inside the empty auditorium, a feeling he had when he was a seminary student visiting the great cathedrals in Europe. The stage rose in the back, like a tall ship, full of glistening hardwood and innumerable coats of wax and oil that shone in the gloom.

"18 years I worked for the Sheinbergs here at the Hippodrome. I worked here before it was even called the Hippodrome. I've seen thousands of people pay their two bits and enter this hall," Antonio said, mainly to himself as he walked like a somnambulist towards the stage steps.

"How many people does this place hold?" Martin asked, his voice hushed with appreciation.

"5,500 men, women, and children. 8 shows a week. Come up here," Antonio said, his voice echoing from the stage.

The Italian pulled a Lucifer from his pocket and lit one of the gas footlights, casting a thin stream of illumination across the vast stage. The light ended on the side of a huge glass aquarium.

"That board is forty feet up, even though the posters say fifty," he explained, pointing out the tall, extra-wide diving platform stretching high above the still water. "I know because I ran the cables, almost a hundred feet to the back. What you and the audience can't see, is that the wood is connected to a steam generator in the basement. You may ask why but first, let's go up. You can only understand from up there. Don't worry, there's an elevator."

Antonio didn't wait for a reply but disappeared into the darkness backstage. Martin had no choice but to follow.

Antonio called to Martin from the edge of the board. Martin grasped the iron of the catwalk until the coolness of the metal disappeared. The priest was not afraid of heights, but there was something disorienting about the long ramp leading up to the board. It was terrifying.

"Of course with the lights the Duke wouldn't be able to see anything from where you're standing. This is for obvious reasons. But come here," Antonio said, beckoning him.

Martin screwed up his courage and made his way up the ramp, careful not to trip on the smooth wooden ribs.

"Are you sure it will hold both of us?" Martin questioned, trying to keep his voice steady.

"Dukes, all of them, weigh a lot more than the two of us. Trust me." Antonio said, sitting down, letting his boots hang stories above the darkened stage.

Martin made it to the board and immediately stopped. His chest tightened like a screw and he fought back his vertigo.

"You said Dukes? There is more than one?" He asked, staring at his feet and not to the sides.

"Of course, dozens over the years. When a full grown horse hits the water from this height, many terrible things can go wrong. In fact we always had a spare Duke just in case the shock of a bad flop killed the horse right away. That's why there's the trap door you passed. Now look over the side from where I sit," Antonio said.

Martin tried to will his legs forward but couldn't. Something about being so far above the stage made the huge tank seem ridiculously small.

"I won't, I can't," he said, with more anger than he felt.

"No, of course not. It takes a lot of getting used to. So you can imagine how hard it was to get a horse to the edge. You know this is safe, you see me on the edge and you know every day, and twice a day on Saturdays, a full-sized horse trotted off this platform but your body refuses. It's normal. Look down at your feet."

Martin hadn't even noticed the bare copper wire grid on the platform until now. He could see the black outlines of the wire where it had singed the wood.

"They put copper-lined shoes on the horse and when they came up the ramp it was my job to throw the switch. You see, a horse won't run to the side or backward when in pain, but will always go forward. That is how we make stars here at the Hippodrome."

"You should write an article. If people knew…" Martin started, taking a step back from the edge.

"An article to teach the people. Do you really think even the children believe a horse would jump into a tank of water, on its own, from here?"

"You have to believe that if people…"

Antonio jumped up and moved towards Martin.

"Belief is your occupation; I already told you what I did. I know the audiences. I have seen—" Antonio's violent coughs cut off his sentence. He hacked so terribly that Martin believed he could feel the board shake.

"Let's get down," Martin said, retreating back to the catwalk.

Antonio directed the priest with hand gestures, his powers of speech stolen from him by his coughing, to the other ladder leading to the backstage. Martin was so relieved to be down from the diving platform he hadn't even noticed Antonio fiddling with a lock by a trunk marked "Fireworks! No Smoking!" Antonio removed a large leather bag from the trunk and set it down carefully by his feet.

"That's it?" Martin whispered.

Antonio nodded and said, "It took me six months to make it. It's delicate, but will do the job. I got the recipe from an anarchist pamphlet last May Day."

"Antonio, I see what this is all about. Just because of what you saw—I don't mean tonight, I mean the past 18 years. You feel guilty and now at the end of your life you want to do something to make up for it somehow."

"Maybe I do. Shouldn't we take responsibility? Doesn't someone have to take responsibility?"

"No. That is, yes, but not this way. Who is responsible? You? You were doing a job. It was a job and maybe jobs like that you had should not exist … but they do. If you didn't do it someone else would."

"But that can't be an excuse."

"No, of course not. You want to find someone to blame. Maybe you even blame yourself but everyone is to blame. Look at my shoes. I have dedicated myself to helping animals, like St. Francis, and yet my shoes are no better than the pit we saw or the board we were on. The leather, the glue made from horses and even the laces … do you know where they come from? I'll tell you: cats … kittens actually. Their stomach linings are used to make these laces. Tonight I'll take a cab home because I need to work on a sermon on how we all must respect God's creation, animals included. Yet I know just as you do, how hack horses are treated in this city. I have wept to see old, wise horses, whipped bloody when they no longer can see which way to turn. I have even been to the so-called stables on 17th Street. These prisons are enough to make you sick. Yet tonight I'll ride back to the rectory. You want to blame the five thousand average people who come to this theater and hundreds other places like it to escape their lives. How dare you judge them! How dare you judge yourself? That is for God only. So who is to blame?"

Martin stared at Antonio, who looked down at his bomb. Martin waited for his answer but there was none. Sure he had made his point, and now having a theme for his sermon, he was eager to return to the rectory. He was convinced he had saved Antonio from seeking his a misguided and sinister vengeance.

Martin did not feel the fatigue of having missed an evening's rest. He had worked through the night on his sermon, convinced it was the best he had ever written. He would open with Revelations 5:13.

Martin was pleased that the church pews were filled elbow-to-elbow. He began the benediction and looked out over his kneeling flock. In the back row, Antonio remained standing. Martin locked eyes with the Italian as he lifted the leather case above his head…

Neal was slurping noodles from a paper box on the corner of Mulberry as Mathilda in her mourning dress glided between the screaming fire-wagons across the street.

"The good doc didn't make it to the pet store," Neal said between mouthfuls of Cho Pai.

"Most of us never do, and that's probably for the best."

"Do you want me to go fish him out?"

"I'll do it," Mathilda said, heading for the opium den.

Neal threw the empty box in the gutter and followed the fire-wagons rushing towards St. Francis.

The world of our dreams exists to the exact degree that we behave as if we're already living in it.

THE FUTURE

an excerpt from Expect Resistance, *by CrimethInc.*

The world is coming to an end. Make no mistake about it, the days are numbered. Where you are, you can't even imagine what it will be like when the bottom hits.

Or, to put it differently, the world is *always* ending. What comes next is up to us. Every morning we wake up and sweat and bleed to put an exact duplicate of the previous day's world in its place. We need not do this, but we do, out of fear, or despair, or psychotically deluded petty ambition, or sheer stubborn lack of imagination. At any moment we could all stop paying rent and going to work—nothing could stop us if we all deserted together—and rebuild society from scratch without landlords or loan payments. Heaven knows we've all had that daydream at least once. It's not police or politicians that keep the wheels turning and the bodies burning, it's our own compliance and complacency, not to mention lack of faith in each other.

Yet even if we insist on keeping at it, the Disaster is not sustainable. Capitalism as we know it is not going to be here in five generations—any environmental scientist can tell you that. Likewise no one has to argue for the destruction of the middle class—it's already destroyed: it is the class of people laid waste by their own materialism and duplicity, suffering emotional and psychological consequences to which any psychiatrist can attest. It's no longer a question of whether the system we grew up in has created the best of all possible worlds—everybody knows the answer to that question by now—but of how we're going to handle the mess next time the terrorists get through the checkpoints, the fuel supply runs out, the computers and power plants break down. Considering other options, trying them out, that's not radical—it's just common sense when the writing is on the wall.

But are we really going to live to see anything else? Do we dare hold our breath for another world?

Despite the seriousness of our situation, the future isn't one of monolithic, inescapable doom. There are several futures ahead of us, just as today there are people who live side by side but inhabit different worlds; which one you live to witness will depend largely on what you do in the meantime. This nightmare exists precisely to the extent that we invest ourselves in it—every day we work for it, buy from it, and stake our lives on it, we are buying into the protection racket that keeps it the only game in town. Correspondingly, the world of our dreams exists to the exact degree that we behave as if we're already living in it—there's no other way it can come to be. The turning point for each individual is the turning point of society, in miniature. Don't ask when or whether that point will come, but how you can reach yours; if you can get there yourself, everyone else can too.

When you really start to go for it, when your actions open a bona fide portal to another way of life, others will come out of hiding and join in. What, did you think you were the only one going crazy here? It takes an entire subjugated nation to keep things running, and there are plenty of others among that number who know how little they're getting out of it. They are the millions who don't get consulted for newspaper polls, who might pick you up hitchhiking but never appear on television. Ten thousand sleeper cells wait for the point of critical mass to arrive, ready to spring into action with their own yearnings to breathe free and private scores to settle, desperate for a war to fight in that really matters, a love to fall in that can command their attention—killing time and themselves in the meantime with anorexia and alcoholism, dead marriages and deadening careers. Every day each of us puts off taking the risks we know we need to take, waiting for the right moment to come or for someone else to make the first move or just feeling too beaten to try, we have the blood on our hands of every suicide who couldn't hold out any longer, every ruined love affair that couldn't endure in the vacuum, every sensitive desperado artist buried inside the corpse of a miserable service industry employee.

Next time the end of the world comes, we won't be paralyzed watching it on television. We'll be out there deciding for ourselves what comes next…

It's not too late to live like there's no tomorrow—all hope for the future depends on it. Say your last words now, and start from there with whoever joins in. **Dreams do rebel and come true.**

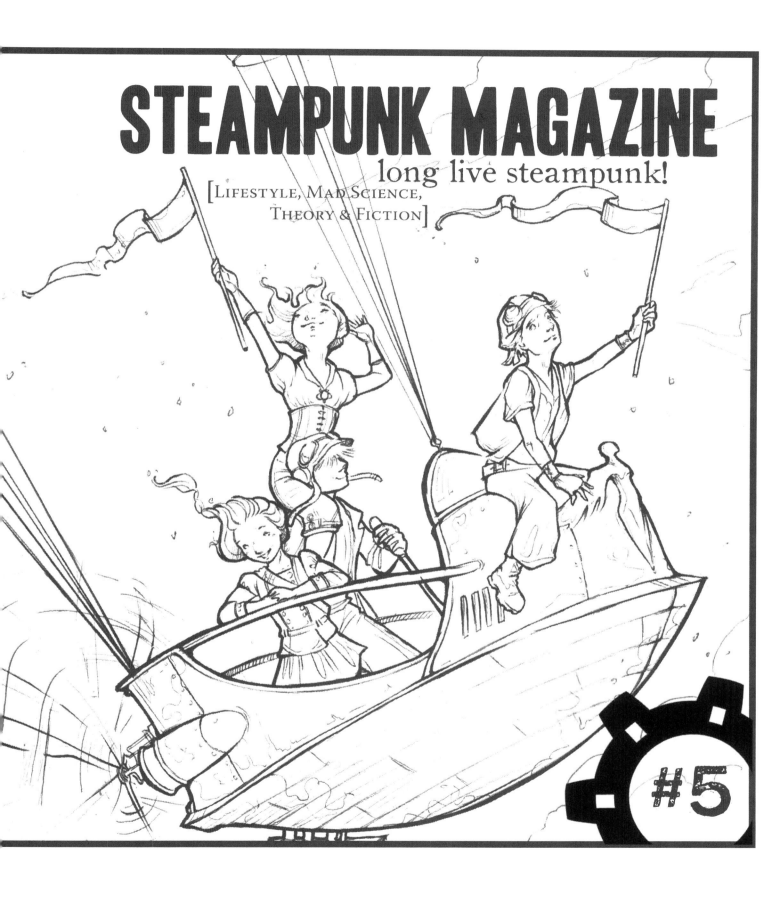

I don't know the key to success, but the key to failure is trying to please everybody.
—*Bill Cosby*

You want steampunk to be a novelty, a LOLcat, a meme. I want it to be my life. Which of us is going to fight harder for it?
—*Dimitri Markotin*

The cover was illustrated by Fabiola Garza.

Dear Reader,

Long thought to be lost in the post, it is with great pleasure that I welcome you, dear reader, to the fifth issue of Steampunk Magazine.

Much has changed in the twelve months that have passed since our last issue, and it would be foolish of us not to attempt to address at least some of those changes. The last year has seen our culture exposed to an ever-increasing tide of scrutiny and popularity. With articles turning up everywhere from Newsweek to MTV, steampunk has attracted more and more attention from people who make it their business to keep up with the latest trends and fashions, as well as from those people who would seek to commercialise us – producing aviator caps and goggles for a few pennies far abroad and selling them back to us in high street stores.

It is unavoidable that many of us will see this increased popularity and attention as an incursion, a threat to those of us who dared to be airship pirates (or anarchist ink-devils, alchemists and spiritualists, adventurers and inventors of great and terrible machines) long before such things became commonplace.

Indeed, it would be easy for us to see the increased attention as something which compromises the unique set of beliefs and aesthetics by which we steampunks define ourselves. However, it is important for us to remember that many of the people who are now discovering our way of life may be attracted by our cogs and Tesla coils, but may find a home for themselves in the earnest dedication that we show to our values, whatever those values may be.

So it is true, then, that many things have changed since we released issue four, and Steampunk Magazine itself has not been immune from those changes. However, we would like to take the opportunity to reassure you, that we here at SPM fully intend to remain committed to putting the punk back into steampunk, while at the same time offering articles and stories to delight and entertain all.

That said, we could not do any of those things were it not for the continued support of you, our readers. So here's to each and every one of us in all our varied creeds and colours, and with all our beautifully conflicting beliefs and opinions. Long may it last! And long live steampunk!

–C. Allegra Hawksmoor

Correspondence

direct any letters to COLLECTIVE@STEAMPUNKMAGAZINE.COM
letters may be trimmed for space reasons and/or edited slightly for "proper" grammar.

on electrical safety

I WAS VERY PLEASED TO DISCOVER YOUR WEBSITE. I'm fascinated by the (sometimes) inefficient but marvelous creations of "steampunkery" ever since seeing the film "Brazil", albeit that may be a different flavor. I've even dabbled in Second Life to play around with the steampunk toys people make.

In the section labeled "Build your Own Jacob's Ladder", I would like to point out a possible FATAL encounter that your readers may experience. VAC was mentioned in looking for a capacitor. "VAC" when marked on a capacitor is usually "Volt-Amps Capacitance" and not "Volts AC"
HTTP://EN.WIKIPEDIA.ORG/WIKI/CAPACITANCE
HTTP://EN.WIKIPEDIA.ORG/WIKI/CAPACITORS

It should be noted that any current put to a capacitor can be stored for (what can be calculated) for a period of time. Touching a capacitor before that time can and may cause death by heart fibrillation.
HTTP://EN.WIKIPEDIA.ORG/WIKI/ELECTRIC_SHOCK

Warmest regards, and thank you for such a creation.

–X. Ordous

RESPONSE FROM PROF. OFFLOGIC, THE AUTHOR *of the article in question*: I will in no way argue against any electrical safety precautions. There are many good reasons the article featured a banner reading "You are warned! You are warned! You are warned!".

(Full disclosure: I am not a doctor, but electrical shocks do run in my family: my father was electrocuted via an aluminum ladder contacting a feeder line; my uncle was struck by lightning and had all his filling melt, and electronic watches still die when he wears them; my great-uncle was an electrician that routinely tested light sockets with his fingers).

The electrical "killing factor" is current density through the right atrium of the heart. Any flow of current through the body that causes a sufficient flow of current in that section of the heart could induce fatal ventricular fibrillation (or ViFib). As regards AC (alternating current, like from one of those sexy lamp sockets):

"In general, for limb contact electrical shocks, accepted rules of thumb are: 1-5 mA is the level of perception; 10 mA is the level where pain is sensed; at 100 mA severe muscular contraction occurs, and at 100-300 mA electrocution occurs. Keep in mind that those figures are approximate, and are not to be taken as guidelines to approximate 'assumed risk'. Death can occur under certain circumstances with considerably lower levels of current. For example, when you have been sweating or are standing in salt water, all bets are off. In medical situations, the level of current that can kill is considered to be in the 20-150 microampere level, because the current is induced directly into the body".

"Safety For Electronic Hobbyist", Joseph J. Carr, Popular Electronics, Oct. 1997
HTTP://YARCHIVE.NET/MED/ELECTROCUTION.HTML

At 120 volts, the capacitor could carry (assuming you disconnected it from the circuit at the very peak of the AC sine wave) a total energy of approximately $.338 \times 10^{-1}$ Joule. For the UK and points east, it's closer to 1J, due to higher voltage (see HTTP://HYPERPHYSICS.PHY-ASTR.GSU.EDU/HBASE/ELECTRIC/CAPENG.HTML#C1). One joule is equal to 0.2391 calorie (defined as the amount of energy required to raise the temperature of one gram of water one degree Celsius at 20°C), so this is basically one metric dog fart (best case).

If discharged through the oft-cited 500-20,000Ω skin resistance, you'd get a single pulse (.00235 to.094 seconds) of between 6 and 240 mA. These are fairly optimistic figures, though: my own body's skin resistance between dry hands with firm skin contact measures about 500,000Ω; across my saliva moistened palm (the left one) it's closer to the 20,000Ω level. These figures would give a single pulse (between .094 and 2.35 seconds) of current between 0.24 to 6 mA, counter-respectively.

You might get a minor jolt (with wet hands, are ye daft?) or just be able to barely perceive it, but either way the discharge is no more likely to cause cardiac arrest than when Ripley the cat jumped out in "Alien".

> "The current world record for a healthy person is a seaman electrocuted standing in saltwater by a 32 volt DC submarine battery. And of course, it generally takes a lot more voltage than that".
> Steve Harris M.D.
> HTTP://YARCHIVE.NET/MED/ELECTROCUTION.HTML

The 4.5-ish uF capacitor cited, if charged to line voltage, might conceivably be fatal to a *Drosophila Melanogaster* [fruit fly –Ed.] but not to a human if applied externally. Certainly you wouldn't go poking bare conductors with your fingers, licking the terminals of any capacitor or impaling the walls of your chest cavity with the terminals of a charged capacitor, large battery, power lines, etc., lest you succeed in doing something really, stupidly "FATAL", though unless you try, you'll never know (there I go again with that results-oriented thinking!).

> "You can't reliably kill anybody with 20J of electricity. For example: your standard electric chair delivers 2000 Volts A.C. for about 10 sec, followed by 500 V for maybe 120 seconds. You figure a body resistance between two patches of moist broken down (fried) skin of 200 ohms (a realistic figure), and that gives you $[(2000^2/200)* 10\ sec] + [(500^2/200) * 120\ sec] = 350,000$ J. And it doesn't always work on the first charge, at that".
> Steve Harris M.D., op. cit.

Most telephones (the old fashioned "land line" types, with wires connected to them) use about 90 volts (at 20 Hz over here) to ring, yet I've read of exactly *zero* phone ringer electrocutions (not counting those involving lightning strikes, foul play, or similar strained credulity). It's because they just don't happen.

In regards to the meaning of VAC, Ordous is incorrect though perhaps well intentioned. "Volt-Amps" is used to specify the "apparent power" of reactive electricals in reference to the "power factor" of motors, transformers, UPS units, and capacitors. This is separate and not easily confused with the "rated working voltage" of non-polar (or AC) capacitors, which (in the case of a ceiling fan speed capacitor) is stated in "volts alternating current" or VAC (at least in the US-of friggin'-A). I've never heard of "volt-amps capacitance" or seen any such marking on any capacitor in 20-something years in the electronics industry.

Google "volt-amps capacitance" and you will get *zero* hits for good reason

As for the storage of electricity in a capicator, always with these negative vibes, Moriarty! Duly noted (fer sure!), but this is like saying "Whatever you do, *don't use the salt-water etching process!!! That makes chlorine and it may kill you!!!!*", which, though technically true, is totally irrelevant and a disproportionate level of alarm.

I am glad that someone read my article but wish this Gentle Reader would get real, pull his/her head out and quit finding justifications to go on doing nothing. S/he needs to get off the duff and do something amazing, astounding, or even tangible, instead of wallowing in fear, uncertainty, and doubt.

"Didja see that? That apple could have killed me!!! Good thing it missed!" (Isaac Newton, "My Life as a Hair-Model", 1721).

More fun, fewer suits.

–Prof. Offlogic

on facial hair

In the second issue of Steampunk Magazine is a very interesting article on facial hair, "The Steampunk's Guide to Body Hair." While I did enjoy reading this article, there were a couple of points that I would like to comment on.

The assorted facial hair styles illustrated by Nick Kole have their roots much further back into history than just the Victorian era. Many of these styles have been documented in the early Renaissance, while others seem to have come into popularity much later. The style that is of particular interest to me, perhaps because I'm currently sporting it, is the Friendly Mutton Chops.

The Friendly Mutton Chops is more correctly known in the competitive beard growing circles as the Franz Josef. Before I get much further; yes, there are clubs where men gather to compare beards and moustaches, exchange information on trimming, maintaining, and using wax, as well as holding contests on who has the most impressive facial fluff. Here in the northwest, there is the Whiskers Club in Bremerton, WA. Internationally, there is the World Beard and Moustache Association, known more commonly by their acronym, WBMA.

The Franz Josef beard takes its name from the style of facial hair worn by Franz Joseph I of Austria (1830-1916) [pictured]. This beard is essentially the combination of both Mutton Chops and an Imperial style moustache. Instead of trimming the mutton chops, as many men do, to stop just before the corner of the mouth, they are allowed to grow and blend with the moustache. Whiskers on the neck, up to and just over the edge of the jaw, are shaved away, leaving a well-defined lower edge to the mutton chops. The chin, between both corners of the mouth, is also clean shaven. The mutton chops are then allowed to grow out, and are trained to curl upwards.

This style of beard gained popularity in the mid 1800's and into the later Victorian era, as many men found it a convenient way to combine both a moustache and beard. In Victorian times, as it is today, a well-trimmed Franz Josef helps give the impression of the wearer having a square jaw, while allowing them to maintain a flamboyant military-style moustache, combined with a very populist look of well-trimmed mutton chops. This style of beard was very popular among European nobles, as well as with the common working-class craftsmen. In the United States, this look was commonly associated with the socially established—but politically progressive—merchant working class.

Today, the Franz Josef beard has been separated into two competition classes by the WMBA: the Imperial Partial Beard, and the Freestyle Sideburns categories. The difference being that the Freestyle Sideburns class requires that the neck be clean shaven up to and just over the jawline (as in the original style of the Franz Josef), whereas the Imperial Partial Beard class allows beard growth from below the jawline.

For the male steampunk, these classifications are offered only as a matter of course; each beard wearer is, of course, free to interpret beard and moustache styles for himself. Many gentlemen combine different aspects of beard and moustache growth, creating personalized looks that set them apart from their peers. This is a fundamental part of the steampunk culture: being who you really are, fanatical face fuzz or not.

Note: The next International WBMA Championships will be held in May 2009, in Anchorage, Alaska. As in past events, the vast majority of competitors sport their favorite costumes, from vintage clothes to, turn-of-the-century military uniforms. As for myself, I'd like to show up at this event in my steampunk finest—vest, pocket watch and goggles. I see no reason why our steampunk culture should not be represented on the International scene.

–*Christopher delaMaison*

The Handlebar Club
http://www.handlebar.co.uk

The World Beard and Moustache Association
http://wbma.whiskerclub.org

World Beard and Moustache Championships
http://www.anchorage.net/worldbeard

Thank you for the clarification, and I'm pretty certain I speak for most everyone in the Steampunk community when I wish you luck and success at the WBMA championship!

on other things entirely

I wanted to say thank you for your magazines. I found them useful, and nice to read. I was always left wanting more in the DIY department, but I don't need a zine to show me how to make everything I want. I am grateful enough, that you left me with such nice things to read.

What I really wanted to say, was I was struck by how much I liked the articles that were written within. It really struck a chord within me. In issue four, I was reading the back, and I noticed the mention of anarchists, and crimethinc. Suddenly, it was very clear why I had found so much in this little zine that I liked. I have always been a fan of crimethinc's endeavors. I should have noticed it before, but didn't.

I wanted to say, I especially liked the article by Johnny Payphone, in this issue. He managed to verbalize many of my own frustrations at modern technology. Between my husband and I, I am the builder, the tinker, and the fixer. I work on the cars, pull apart broken appliances, etc. I have for many years been frustrated at how difficult it is to repair the things I own. I hate throwing things away. I want to fix them. I just recently bought a solder gun, in the realization that I my mechanical skills won't fix circuits. I refuse to let the industry dictate that I can't fix my belongings. I will just have to learn how, and am purchasing several books on circuit bending to do just that. Corporate PR folks might prefer I chuck my old and broken things, but I will not be swayed by that. Instead, I will be fostering new skills, so that I can have the last laugh. I found Mr. Payphone's article heartening, in light my my recent activities.

Thank you again, for putting your zine out. I appreciated it. I will miss the frequency with which they are published.

–Sage

I enjoyed reading Mother of the Dispossessed [SPM #1]. Though I didn't quite see the connection to the conclusion at the end that "truth is over rated", nor do I agree with it. I believe that a common vein in steampunk is about a search for knowledge, using the unconventional means to acquire the said knowledge. The mad scientist who works by gas-lamp light to gain the knowledge ahead of his time that others would label "devilry" and is cast aside from society. Truth to many is the highest ideal to be obtained and is far from over rated.

I have been enjoying the magazine so far, and look forword to issue 5.

–Mason

Knights of the Road

THE DAWN AND THE RISE OF THE TRAMP PRINTER

by Charles Eberhardt
illustrated by Colin Foran

an expanded version of this article will be released in book form by Eberhardt Press in 2012

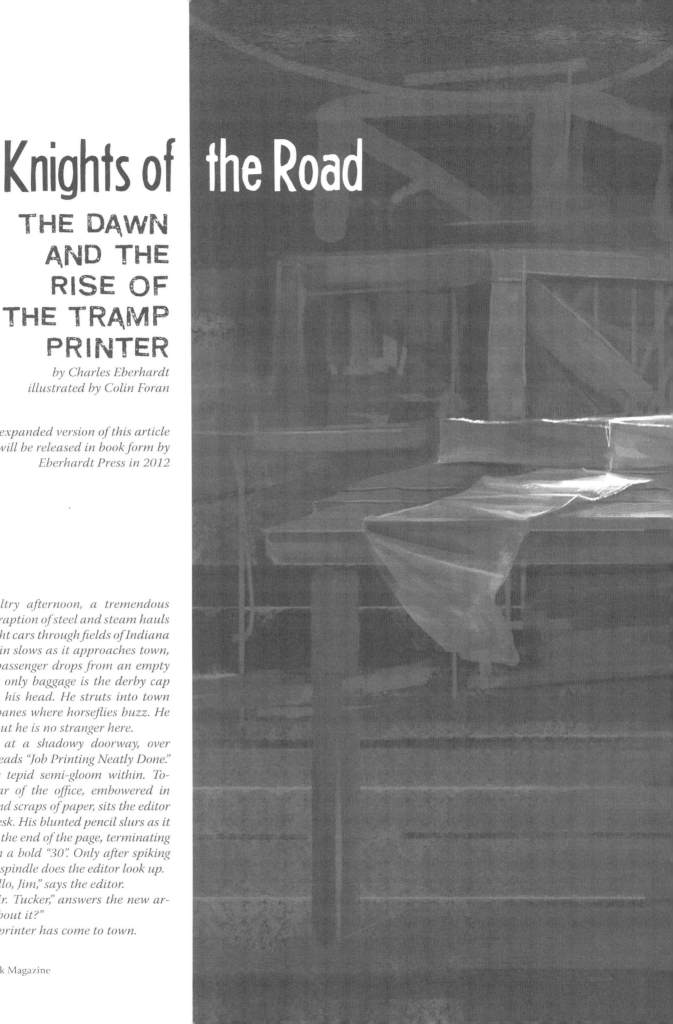

Late in a sultry afternoon, a tremendous chugging contraption of steel and steam hauls a train of freight cars through fields of Indiana grain. The train slows as it approaches town, and its lone passenger drops from an empty grain car. His only baggage is the derby cap perched upon his head. He struts into town past windowpanes where horseflies buzz. He is not home, but he is no stranger here.

He stops at a shadowy doorway, over which a sign reads "Job Printing Neatly Done." He enters the tepid semi-gloom within. Towards the rear of the office, embowered in newspapers and scraps of paper, sits the editor at his small desk. His blunted pencil slurs as it races towards the end of the page, terminating its marks with a bold "30". Only after spiking the sheet on a spindle does the editor look up.

"Why, hello, Jim," says the editor.

"Hello, Mr. Tucker," answers the new arrival. "How about it?"

A tramp printer has come to town.

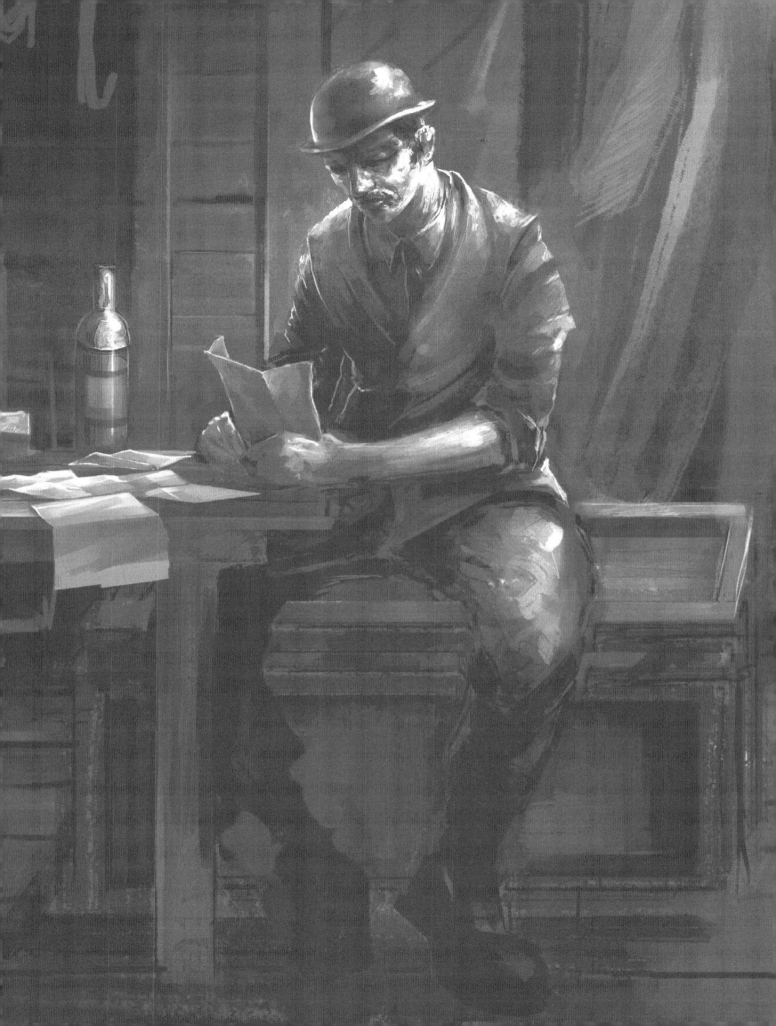

The tramp printer's only certain and indispensable possession was the International Typographic Union (ITU) journeyman's card, or "traveling card," a simple piece of yellow paper that entitled him to obtain work at any union shop. With nothing more than the ITU seal and the assurance "that the bearer was a union member in good standing," this little slip paper represented a hard-fought and victorious campaign of solidarity and resistance against the wicked forces of greed.

From the early years of moveable type up until the dawn of the computer age, tramp printers promulgated the craft of printing and knowledge of the written word as they wandered from shop to shop in search of work. At a time when most "country" people didn't move very far from home, the tramp printer was a well-traveled individual who carried with him far-flung and worldy experiences.

These hobo scholars, Hicks writes, "could discuss politics, religion, art, music, history, literature of the most modern and ancient cultural subjects with such erudition that frequently the editor would be found sitting at their roundtable discussions by the office stove after work hours in the dim light of a flickering coal-oil lamp."

The tramp printer was a salty character, "an individualist, sworn to personal freedom of action ... He was rough and ready, rude and often profane. He drank hard liquor and enjoyed life to the fullest."

Many went on to become newspaper editors; Horace Greeley, the famed publisher and editor of the New York *Tribune*, started out as an apprentice and worked as a journeyman printer for 14 months before making his way to New York City. Samuel L. Clemens, better known as Mark Twain, worked as a printer's devil on his brother's weekly newspaper, the Hannibal *Courier*, and spent several years as an itinerant printer.

"Perhaps he was never an essentially heroic figure," writes Lampman. "His annals lacked the refinements, as we consider them now, of preferable romance and the larger excitements of big-time drama. But in other days he was not without significance to the plot." Indeed, if life were a book, then the itinerant printer might be the ink and the letters which tell the story.

The Birth of the Union and the Fledging of the Printers

From the colonial days in America, printers were an obstinate, militant bunch. It is no coincidence that the first labor strike in the United States was carried out by printers in Philadelphia. As skilled, knowledgeable and literate workers, they faced a great deal of pressure from bosses and capitalists, who sought to undermine them for the sake of profit.

As publishers increased pressure on the back shop, local unions took steps to defend themselves, such as exchanging "rat lists" of those who had committed severe transgressions. In shops where their activities were forbidden, union members organized clandestinely, using secret signs to identify each other without words. Although they faced prosecutions for conspiracy, "the typographical unions continued to move steadily toward the all-union shop—in which all employees were union journeymen or recognized apprentices," according to Rosemont.

A series of conventions organized by militant journeymen printers led to the creation of the National Typographic Union in 1850, which later became the International Typographic Union. Over the following decades, the ITU established legal defense funds, funds to support strikers and traveling journeymen, and benefit systems to support its members, including a retirement home for union printers. These efforts made the militant ITU strong and resilient.

The union, not the bosses, quickly came to control hiring in union composing rooms. Itinerant printers simply wrote their names down on slips of paper and placed them on the "slipboard" to indicate that they were available for work. There was no need for an interview with the boss or to even speak with a foreman; the tramp printer merely presented his ITU card and waited to be hired. And he was free to come and go as he pleased.

In turn, tramp printers played a crucial role in strengthening the ITU. "The practice of tramp printing helped cement the hundreds of locals together into a cohesive whole" instead of isolated, solitary groups. The tramp printer was very knowledgeable about the ITU's system of laws and zealously saw to their observance. Their itinerant way of life was good for the craft as well, as what was learned or innovated in one shop was carried to all other shops. The tramp printers formed an indispensable network of knowledge and communication which had at its heart a love of the craft, and a deeply ingrained self-protective instinct.

And the Capitalist Resistance

Against this strongly rooted bunch, unscrupulous publishers contrived to divide and conquer the well-organized printers with Technology. The introduction of new Devices, such as composition rollers, powered presses, and typesetting machines, was intended as a wedge to split workers apart. But the militant printers did not back down. Any technological innovation that increased production by reducing the role of the human hand was vehemently resisted, until it was undeniable that such innovation would benefit, not disempower, the worker.

In 1807, printers successfully resisted "the substitution of rollers for the hair-stuffed inking balls that printers had used since Caxton's time." And for good reason: their inventor, Hugh Maxwell, was notorious for refusing to pay union wages, and openly advertised that his rollers would allow employers to replace half of their pressmen with "green hands earning less than half of journeymen's wages." Because of militant resistance to Maxwell's devices, the use of rollers was discontinued and nearly forgotten.

But as the century wore on, the industrial revolution dropped into high gear. As the first powered presses were developed in England, new composition rollers were created that could survive the rigors of mechanical printing. Even though these new ink rollers did away with the disgusting chore of treading on urine-soaked pelts to clean them, English journeymen refused to use the "rolling pins" until their

manufacturer made contributions to their pension fund. These new rollers were imported into the United States, but this time, their use spread through the craft, allowing printers to do better work at higher rates of productivity, thus empowering them.

Printers had a deep-seated distrust of new machines and innovations, as did small proprietors who lacked the capital necessary to adopt them. The old skills were becoming obsolete, as unskilled and semi-skilled workers were brought into the shop to operate the new equipment. When the new Treadwell presses were installed in Boston print shops, workers fought hard against them. Even Josiah Warren, called by some "the first American anarchist," was targeted by repeated acts of sabotage in 1840 after he constructed a self-inking cylinder press.

Following the introduction of powered presses, the next quantum shift in printing technology was hot-metal typesetting equipment, such as the Linotype, invented by Otto Mergenthaler in 1883. At first, "the idea that a machine could set type was considered ridiculous," writes Hicks.

Prior to the Linotype, printers all the way back to Gutenburg had laboriously plucked pieces of type by hand, one by one, from type cases and arranged them in lines of type with a composition stick. When finished, each piece of type was carefully returned to its case. The new typesetting machines, equipped with keyboards, could set whole lines of type, thus doing the work of six or seven men. Understandably, printers initially condemned the Linotype as a "job killer."

Their fears were unfounded, though: the new machine spawned hundreds of industries and millions of jobs. According to Otto Schultz, "It revolutionized not only letterpress printing but journalism itself by its capacity to move massive amounts of information.... It was one of the most effective machines of all time."

The Linotype soon became the most crucial piece of equipment in the shop, even more important than the printing presses. But although effective, the Linotype was a vastly complex machine composed of thousands of parts. Rather than being undermined by this technology, tramp printers and other union workers gained a great deal of power in the workplace by mastering the Linotype, which the publishers and bosses had no idea how to operate or repair. Very soon after its introduction, the Linotype came under ITU control. As the twentieth century dawned, the emphasis in the "back shop" shifted from the printing press to typography and composition. A printer became more than a mere pressman; "printer" came to mean one who was a master of all the skills required for the print shop, not simply the operator of the press. And golden days lay ahead for the tramp printer.

The Path of the Printer: From Printer's Devil to Journeyman

FROM THE EARLIEST DAYS OF PRINTING, AN aspiring craftsman would complete a five or six year apprenticeship, emerging fully trained with the title of "journeyman." At this point, he was expected to make room for a new apprentice by leaving to wander the countryside in search of his place in the world. Thus, the tramp printer was born.

Every journeyman started out as a "printer's devil" around fourteen years of age. He began his apprenticeship by laboring in the hellish heat and lead-laden fumes of the casting room, where he dumped damaged type into the "hell box" to be melted down into "pigs" to be re-cast into new pieces of metal type.

The printer's devil built the shop fire early on winter mornings, hauled water from the village pump, swept the office, washed the rollers and forms, folded newspapers and delivered the papers at dawn on Thursday morning. From such grueling and menial tasks, the young apprentice moved on to learn the location of each letter in the type case by "dissing"—distributing handset type back to the case after printing.

As a final step before receiving an ITU card, an aspiring printer would often get a permit from the union's local secretary to work "in the toughest shop in town" to prove his competency before applying for membership. If everything worked out, the new journeyman was allowed to join the ITU, draw a travelers' card, and finally set out to satiate the burning urge of wanderlust.

Living on the Road

FOR A UNION JOURNEYMAN, IT WAS EASY TO GET work. "An itinerant printer had only to walk a block or two in any city, anywhere in North America to find a good job," write Howells and Dearman. "If you had an apron, a makeup rule and a pica-pole (and knew how to use them), your future was assured."

Tramp printers could travel throughout North America to Alaska, Hawaii, and points beyond, following the ebb and flow of the seasons like migrating birds. "Some tramp printers, frustrated by the Pacific's limiting shoreline, hopped aboard ships and headed for even more distant, western climes," write Howells and Dearman. "The Publishers Auxiliary offered jobs on steamships, in the Fiji Islands, Guam, Puerto Rico, the Philippines and South Africa."

The ITU card was interchangeable with European printing unions as well. Some printers used their cards to work in England, and several English-language newspapers in Europe hired traveling printers.

Mobility was always key to the success of the tramp printer. In good economic times, it was easy to get plentiful work by moving around. In bad economic times, it was possible to get scarce work by migrating to where the jobs were. During a bitterly prolonged strike, a union printer could draw a traveler and get work on the road. Printer Don Cleary recalled, "At one time I was on strike in West Palm Beach, locked out in Detroit, and working in Washington, D.C.!"

When on the road, a tramp printer might "carry the banner" at the "jungle camp," where transients rested and shared food while awaiting the next freight train. Linafont Brevier recalls one such camp: "It was on the beautiful Kootenai River, and there were several natural springs with pure cold water constantly bubbling up. Pots and pans were hanging from wires strung between two trees. They were spotless, evidently having been scoured with the clean, white sand near the river."

John Edward Hicks recalled various establishments that formed a loose support network for itinerant printers, such as "Jack" O'Brien's pool hall in Chicago, where the generous proprietor would allow transients to make a bed of one of the billiard tables, although if any cash customers came in to play pool they were obliged to sleep underneath the "bed". When nothing else was available, a pile of newspapers on the shop floor often made a suitable mattress for tramp printers who showed up too late or too early for work.

The Price of Freedom

ADVENTURE AND FREEDOM ALWAYS BEAR CERTAIN risks. The tramp printer's preferred mode of transportation, the freight train, was convenient but dangerous. "Learning to catch a fast-moving freight required experience," wrote Brevier. "We would each choose a freight car, and keep our eyes on the lowest rung of the iron ladder going up the side of the car. We would run fast, and as the rung came past, grab it tightly and leave our feet simultaneously.... A leap for the grab iron that missed could very likely mean death under the wheels. ... If we had to be secretive on any freight train, we would ride the bumpers between cars. All tramps learned, sooner or later, never to straddle the bumpers. If the train separated at that particular coupler, a hobo's chance of remaining alive was nil."

Tramp printers were sometimes obliged to "ride the rods" by climbing underneath a boxcar. This is what John Edward Hicks and tramp printer "Dad" McGinley were doing one frigid, fateful night while riding to New York City. "It was cold under those boxcars and our fingers and hands were almost numb," Hicks wrote. "'Dad' suddenly relaxed his grip and fell, grabbed wildly for some sort of support, and the next instant was underneath the wheels of the train, being ground to pieces. ... I became deathly sick and was vomiting all over myself, but was compelled to hold on for dear life to avoid suffering the same fate...."

And the trains were fraught with other dangers. Railyard "bulls" were a pernicious menace. "Gulf Coast" Guy Foley, a famous tramp printer who drew nearly a thousand ITU traveling cards during his career, was badly handicapped after being severely beaten by a Tennessee cop. His injuries curtailed his travels and hastened his untimely passing.

Beyond the hazards of road and rail, there was the tendency towards alienation and social decay that sometimes accompanies a transient lifestyle. "The oldtime printer was a product of his environment and time, which were not exactly conducive to producing angelic characters," Howells and Dearman write.

Tramp printers were able to resist personal disintegration through their community with other tramps. The sharing of information was a crucial survival strategy. In the West, it was customary for print shops "to keep a record book wherein itinerant printers might write their names, whence they hailed and whither bound," Hicks wrote. "So far as tramp printers were concerned, it was a better method than that universally used by tramps in general, the writing of similar information on water tanks and other conspicuous places along railway rights of way. The printers, of course, used both methods, the one supplementing the other. I always wrote my name in the books."

Widely-traveled tramps would often keep a "little black book" to record details about each place they worked, such as dates; names of cash-in men, chairmen and foremen; whether they had been fired or barred for six months; and anything else they might forget during their travels.

Sharing of resources was also crucial. "They helped each other over the hard places, loaned each other money, advised each other," wrote Howells and Dearman, "regarding working conditions, the foreman's stoolies in shops, availability of work, cheap hotels, bars that stayed open after hours, and other information vital to the traveling printer.... They traveled together ... and took care of each other wherever they might go."

Uncertain and Dangerous Equipment

IF THE LIFESTYLE DID NOT BRING INJURY OR DEATH to the journeyman printer, than the equipment was almost as likely to. From the 1800s well into the 1900s, printers worked long, hard hours in extreme heat and cold, laboring with "uncertain and dangerous equipment" in poorly lit, ramshackle buildings. One never knew when some mishap might cause grievous injury.

Mark Twain almost crushed his hand while working on his brother's newspaper. Peter Baxter tells of another near-miss fiasco: "We had a fly-wheel that came loose one time from our old Babcock single-revolution press, made about 1890. The wheel—it weighed about 200 pounds and was 20-22 inches in diameter—slipped off its shaft and promptly took off, going south. It sailed right through our concrete-block wall and straight into a tavern that was located back-to-back with our newspaper office. Made quite a big hole in the wall, too. That wheel could have maimed a whole generation of bar-flies if it had been aimed just a bit differently." Fortunately, no one was injured, and the newspaper made the best of it. "We decided it would be appropriate to put a door in that space so we wouldn't have to walk all the way around the block when we needed refreshment."

The environment of a print shop was traditionally unhealthy, from the leaden fumes of the hell-box to the use of urine by early printers to clean the wool pelts of their hand presses. Although health conditions in print shops steadily improved after the organization of the International Typographic Union, the average life expectancy for printers was estimated at 28 years during the early part of the nineteenth century.

The average press was 75 years old, thus they outlived most printers. There were Cottrells, Babcocks, Campbell "Grasshoppers", and machines like the Little Giant 12 x 18, which "used gas burners to cut static and to dry the ink. If the paper jammed up, a job printer had to act quickly to put out the fire," according to Robert Shaw. The Miehle Vertical job press also used flames to dry the wet ink; if there was a paper jam, "the oil-based inked paper would drop right on the delivery end of the press and a burst of fire would go right up to the ceiling," Shaw writes.

Printers survived such working conditions by being adept. "Your typical tramp printer was at his zenith in an emergency," wrote Lampman. "He delighted to come to grips with problems that baffled the best minds."

One of the stranger tales ever told of ramshackle equipment was related to John Edward Hicks by a tramp printer named "Dixie." Hicks crossed paths with Dixie, a Confederate army veteran, in Atlanta, whereupon he spoke of a most unusual print shop indeed. The equipment at this place had consisted of nothing more than a big shelf covered with a scattered assortment of old wood type, a rack of primer, a dilapidated composing stone and two composing sticks. There were not even any galleys for storing composed lines of type; the editor instructed Dixie to tie them with string and hang them from nails that encircled the empty room.

"I asked the old man when he went to press," Dixie related. "He told me, '"Whenever you get all the nails filled."' Eventually the old country editor "picked up the form and said he would put it on the press. There was a contraption on the outside of the back door that I had seen but had never thought of in connection with a printing press. … He let down the slab of wood, set the type form upright against the back slab, held a piece of news print in front of the form and pulled the front slab up against it…. As the editor got the contraption set, he emitted a shrill whistle and here came bounding the biggest buck sheep I had ever seen. The old man said, 'Okay, Buck,' and the sheep's head struck the press with enough force to shake the whole building. After which he pranced away, while the editor pulled off the printed sheet and reached for the ink brayer."

Hazardous Conditions: Printing on America's Western Frontier

THE ITU WAS A TENACIOUS AND CALLOUSED creature, bred on harsh conditions and adapted to thrive in them. It is no surprise, then, that one of the "golden ages" of the tramp printer was the bloody period of westward expansion that followed the U.S. Civil War. Tramp printers came by foot and by rail to the raw territories of the American West at a time when street shootings, vigilante lynch mobs and riots were not uncommon.

Hicks' recollections document the widespread corruption and graft that existed at the intersection of gambling, alcohol, prostitution, law enforcement, and government. He writes frequently in his memoir of blackmail, bribery and jury tampering, of city political machines entwined with corruption, of syndicates enriched from the indulgences of vice. When the independent press clashed with these nefarious forces, the matter often came to violence. Hicks wrote of one newspaper publisher in Denver who vigorously opposed the gambling syndicates and their allies. "Several attempts had been made to burn his home and shop, causing the printers to work with revolvers buckled on and shotguns leaning against their type cases. Once the rowdies fired into the building and one of them was killed by the answering fusillade of the printers."

Despite the bloody carnage, there were good times also in the Wild West. Hicks spent some time amongst the renowned Missouri River Pirates, a loose-knit group of itinerant printers. "The Pirates were never formally organized, the name merely being given those who tramped the Missouri River valley and lived off the country."

One of the early Missouri River Pirates was "Judge" Grigsby. "I ran across him near the little town of Knob Noster," Hicks recalled. "He was dressed in a frock coat, white waistcoat, striped trousers, immaculate linen and patent-leather shoes—all topped by a silk hat. He was one of the most picturesque of the old tourist printers" who preferred to travel on foot than on rail, in keeping "with his philosophy of a leisurely and gracious manner of spending one's life. As we walked along, he told me something of his theory of life: to live fully and richly, to acquire the greatest delight for the mind in the joys of intellectual curiosity. He would study, he said, the text of nature and the book of life, learning from things about him. He quoted Rousseau to the effect that the only way to travel was on foot while one reveled in the freshness and harmony beside the little streams. Railroads and steamboats, he said, had robbed the pilgrimages of journeymen workers of their poetry, thereby shortening their journey of life."

THE CHRONABELLE
an interview conducted by Libby Bulloff
illustration owes apologies to Dr. Geof

The Chronabelle Crew is a group of people I met last year at MAKE Magazine's Bay Area Maker Faire. They immediately stood out as they drifted about the exhibits in their steampunk finery, but what really drew me to them was the fact that they were quite possibly the youngest but most mature steampunk crew I'd met in my cross-country travels. The Chronabelle is comprised of a number of high-school and college-age students from the West Coast of the United States. They marry cosplay personas to punk philosophies. Their dedication to the genre through fashion, lifestyle, and intellect convinced me to interview them regarding their experiences with steampunk.

I asked the following questions of three individuals: The Grand Duchess, Lady Almira, and Captain Mouse.

Libby: *Tell our readers a bit about the Chronabelle crew. How did you meet? Did you come together with a shared interest in steampunk or did this develop over time?*

Capt. Mouse: I discovered steampunk somewhere… I suspect Boing Boing, but I couldn't say for sure. The next day I came to school and told Lady Almira. It turned out that she has been reading *Girl Genius* for a while now, and it was simply a matter of evangelizing to our friends to develop the Chronabelle crew. So our conversion to steampunk, in name, was abrupt, but like most people, we had a long history of liking steampunk things without knowing they were steampunk.

Lady Almira: We started wearing "steampunk-esque" clothing, and then it just integrated into our everyday lives. The rest of the crew members were friends that expressed curiosity and a desire to learn about the subculture. Eventually, it all culminated in the creation of the Chronabelle.

Libby: *Relay a few details about your experience at the Bay Area Maker Faire, please.*

Lady Almira: Maker Faire has been, and will probably remain the highest point in my experiences as a steampunk. [It] really inspired me and made the entire crew feel as though we were a part of something real. As nice as the internet steampunk community is, getting to interact with flesh and blood folks was a nice change of pace.

Capt. Mouse: Meeting practically all the hyper-talented steampunk makers in one place was… well, some kind of highly positive adjective. Great for name dropping too. Also: fighting robots. I think that is all I need say.

Libby: *What about steampunk do you find most attractive? Why do you think steampunk is so popular with both young and older folks?*

The Grand Duchess: I really appreciate the detail and depth that has developed in steampunk culture. It has taken the literature and used that as inspiration for art, clothing, weaponry, and lifestyles, and has also managed to not become dependent on it. I think this has given steampunk a shared core, but also allows for its development and change. This flexibility is one of the things I like most about the culture, and is why I think it appeals to such a wide range of people.

Lady Almira: I think that it's probably the combination of good standards from across

different eras. I feel as though the heart of steampunk lies in its ability to grasp at what works in a set of moral and societal values and bring them to the forefront. For example, the DIY culture of anti-mass production is truly inspiring. I love holding something in my hands that I know a lot of time and thought went into. I think this is a feeling that connects to both older and younger people, and probably something that really goes a long way into making the age range of steampunks so broad. We're all just a bunch of mad scientists looking for a place to show off our latest toy.

Capt. Mouse: The DIY aspect really clinches it though, even if I'm not terribly good at it, I love creating things and having the sense of ownership that can only be achieved through making.

Steampunk can be taken on many different levels—it can be very exhibitionist or very subtle. From the limited experiences I've had, the older steampunk crowd tends to be more on the building things side of the spectrum—they are much more likely to have space, money, supplies, and skills—and the younger tend to be more fashion oriented. There's something to appeal to all ages.

Libby: How do you feel about steampunk's growth from simply a genre of science/speculative fiction into a subculture? Do you feel personally responsible for this adaptation, at all?

Lady Almira: I think it was inevitable. Honestly, if something so aesthetically oriented as steampunk is written about, illustrated, and discussed, wouldn't it also have the tendency to eventually jump off the page?

Libby: What bothers you about the steampunk subculture or about how the media has treated its popularity over the last year? How would you try to ameliorate these things?

Lady Almira: I could really get into the nitty-gritty of the matter, but honestly it would just offend loads of people and potentially start a few drunken fist-fights. I will say this: Just because you stick a few gears on it does *not* make it steampunk.

Capt. Mouse: There is so much that I don't agree with in steampunk subculture that I don't even know where to start. But I don't mind; it would be a bit unnerving if this wasn't the case. I take different things from steampunk than many others, but I don't really feel the need to proselytize or convert people to my way of thinking. Hey, if people want to be wrong, that's no problem of mine.

Libby: *What is your favorite piece of steampunk art, music, and/or literature, and why?*

Capt. Mouse: I'm not sure that Neil Stephenson's *The Diamond Age* is technically steampunk, but I adore that book, and really liked the way that Victorianism was reinterpreted. *Girl Genius* is brilliant—it's one of my all time favorite comics. I love seeing steampunk creations that have utility and quality in equal measure—I think that's one of the most valuable things we have to offer—so pretty much everything Jake von Slatt has made.

Lady Almira: Alan Moore's *The League of Extraordinary Gentlemen*. Hands down. However, in terms of contributing to the subculture, I feel as though Abney Park really brings the community together in a lot of ways. Music can bond people like nothing else can.

Libby: *What is your advice to emerging steampunks or steampunk crews?*

Lady Almira: Don't go into it to become important or well-recognized. That's really not enough motivation to keep you going. Do it because you think walking around in a bustle skirt in public is a blast.

Capt. Mouse: Resist the urge to tell everyone about the first few things you do; hold off and make a dignified entrance once you've got something polished to present.

Libby: *How can we keep steampunk punk?*

Lady Almira: Balance is everything. Steampunk is not Victoriana. It is a combination of two styles. Don't be afraid to add a personal touch to everything. Just because the Victorians didn't wear it doesn't mean that you can't. Take liberties.

Capt. Mouse: Bimonthly checkups and up to date immunization?

Libby: *How do you think living a steampunk lifestyle contributes to a better existence all around?*

The Grand Duchess: I think a steampunk lifestyle encourages people to think creatively. One thing specifically is that steampunk culture places a high value on the work you can do with your hands, and I think that making art or constructing a catapult and the skills and enjoyment that come from these kinds of practical activities are too often overlooked.

Lady Almira: Do you know the joys of wearing a corset? Yes, men, this includes you.

Capt. Mouse: Steampunk has a valuable reminder to take pride in all the aspects of one's life—a rejection of the disposable culture, built in obsolescence, and dime-a-dozen, cheap plastic junk for the handmade and modded, real wood, metal, fabric, and a sense of quality and individuality.

steampunk AD-LIBS!

illustration by Juan Navarro

We are proud to bring you a modern take on that traditional Victorian parlour game, the ad-lib! In order to play, you gather round a group (any size will do!) of friends and enemies. Then, without reading any of the story aloud, you have the crowd suggests words to fill in the blanks in the story, given only the clues that appear below the blanks. After all of the blanks have been filled, you read the story aloud, and laugh heartily with your compatriots at the strange lack of context to your choices of words!

On the Construction of the Tesla Coil
by Margaret Killjoy &
Usul of the Blackfoot

As the evening sun set outside the laboratory windows, I found myself immersed in the task of creation! No simple machine was scheduled to be constructed that _____ night, but
_(over-wrought adjective)
rather, the _____ Telsa Coil.
_(adjective)

Many nights over glasses of _____, my
_(liquid)
colleagues and I had discussed constructing this, the greatest of electrical devices, but not a one of us had ever set out to actually construct such a _____. But at the last gathering of
_(noun)
_____, I was insulted so _____, so
_(name of made-up organization) _(adverb)
_____, so _____, by that _____
_(adverb) _(particularly superlative adverb) _(19th century insult)
of a fellow I dare not consider a gentleman, that I set it into my mind as though into stone that I would complete this task and show them all my _____ intellect.
_(adjective)

My _____ in hand, _____ determina-
_(object) _(adjective)
tion in mind—for a genius such as mine, once set in motion, can no more easily be stopped than the 8 o'clock locomotive bound for _____—I went to the trunk and withdrew
_(city)
my _____ as well as a bottle of ground
_(noun)
_____. I pulled a _____ from the
_(ingredient) _(tool)
pocket on my _____ and went about to
_(article of clothing)
my task.

After clearing my inventory of _____ (plural noun), _____ (plural noun), as well as _____ (plural noun), I finally had everything I needed. I connected the _____ (part of device) to the _____ (source of power) and set off to spend some time at _____ (diversionary activity) to allow the device adequate time to power up.

"_____ (distraught exclamation)", I declared upon my return, "my _____ (contraption) is not so complete as I had begun to hope!" I _____ (past-tense verb) my _____ (body part) for a solution, but to no avail. "_____ (affirmative exclamation), perhaps I need to replace the _____ (part of machine) with _____ (number) _____ (plural of item found in kitchen)."

Of course, I can assume that the _____ (adjective) reader is acutely aware of the mistake inherent in such a haphazard workaround. For instead of alleviating the problem, I had only exacerbated it! I had no choice: I decided I must visit the _____ (victorian profession) and impose upon them to borrow their _____ (tool of above-mentioned trade).

Three hours later, I had what I needed. Having installed the _____ (same tool) into the contraption, I threw the switch!

Oh, dear reader, let me tell you how _____ (adjective) and _____ (adjective) the electricity was as it shot around the room and through my very _____ (body part)! Never had I felt so _____ (mood)! This is truly why we are alive.

That _____ (19th century insult) of a _____ (lowly profession) will never again be able to say such things about my creative prowess! I look forward to when next we meet, for I shall _____ (verb) him soundly until his _____ (body part) is _____ (color).

And thus ends the first of our Steampunk Ad-Libs! If your party still requires additional merriment, we suggest you move on to the second!

D.A.R.B.A., the Automated Machine-Man
by Usul of the Blackfoot

When I was a young lad, I had the immense fortune to visit the Great Exhibition of 1851, held in Her Majesty's Crystal Palace. My uncle, a creator of the most _____ (adjective) and _____ (adjective) widgets in all the Empire, was off to the Exhibition to demonstrate his wares. When he extended an invitation to me, I _____ (past-tense verb) with fervor before exclaiming, "_____ (exclamation)!"

My stomach swam with _____ (plural animal) and my heart pounded like a stampede of _____ (plural noun) when I first caught sight of the Crystal Palace. The front facade was a Classical motif depicting fauns chasing after elusive _____ (color) _____ (plural noun). The crowd amassed around the building sported their finest formal dress, accented by opulent _____ (plural noun) and embroidered

_____. They were a sight to see in
(plural noun)
their own right.

However, nothing outside the building could begin to compare to the wonders that bombarded one's senses upon entering the Palace. As far as I could see, men stood _____ their creations
(participle [-ing verb])
to life, hoping desperately to impress the _____ spectators. When their
(adjective)
machines failed they threw great tantrums, cursing like furious _____
(people who yell)
and shouting, "_____, you blasted
(exclamation)
contraption!"

The highlight of the Exhibition was called D.A.R.B.A., whose name was an acronym for _____ _____ _____
(adjective starts w/ D) (adjective starts w/ A) (adjective starts w/ R)
_____ Automaton. Why it was
(adjective starts w/ B)
named this eludes me, but despite its tawdry name it was truly the crowning achievement of scientific endeavour.

D.A.R.B.A. was a humanoid machine-man that stood _____ metres tall
(number)
and weighed around _____ mil-
(number)
lion pounds. Its primary functions were _____ _____ and _____
(participle [-ing verb]) (plural noun) (participle [-ing verb])
_____, though it was proficient at a
(plural noun)
number of other tasks.

Although it was clearly the most accomplished invention of the day, D.A.R.B.A. was also the source of a tremendous disaster. When _____ _____
(military or noble title) (haughty 19th century name)
started up their _____-powered
(noun)
flame-retardant cannon, D.A.R.B.A. was accidentally doused. Consequently, D.A.R.B.A.'s _____ steam-motiva-
(power tool or machine)
tor went haywire, causing its Æthereal _____ motor to malfunction. The
(power tool or machine)
marvel became a monstrosity.

Perhaps due to the glint of her _____
(adjective)
diamond necklace and matching earrings, D.A.R.B.A. ran over and snatched

Her Majesty right off her officious seat. Those who were not too _____ (adjective) to speak screamed "_____!" (exclamation) and "_____, (exclamation) you foul beast!" Rather than waste time talking, I knew I must act to save Her Majesty.

As D.A.R.B.A. hurried toward the door, it destroyed everything in its way with its shoulder-mounted _____ (noun) launcher and malevolent _____ (noun) laser. I rushed to gather supplies necessary to stop it. I fetched up a _____ (noun), a _____ (noun), and _____ (number) _____ (noun), and hastily threw them together. After mere minutes of toil, I had created a potent _____ (noun)-blasting power-_____ (noun). I took aim at D.A.R.B.A. and fired. The shot whizzed through the hall and struck the terror in its clockwork _____ (noun) activator, felling it in an instant.

D.A.R.B.A.'s creators were devastated by their loss, but as relieved as everyone else to see the Queen in perfect health. For my bravery and cunning I was rewarded _____ (number) _____ (plural noun) and a _____ (color) _____ (noun), in addition to memories that shall last my life through.

To be certain, your party must now have had its fill of mirth. If you require still more, might we suggest the excellent games "throw rocks at one another" or "drink excessively and vomit!"

On Progress, On Airships

by Carolyn Dougherty
illustration by Fabio Romeu

LORD DR. RICHARD VON TROPP'S EXCELLENT ARTICLE IN STEAMPUNK MAGAZINE ISSUE 3 moved me to share a few thoughts on the vagaries of technological change. We tend to describe it as an almost predetermined progress, a fairly straightforward evolution from less complex to more complex and from less efficient to more efficient. If we look more carefully at how technologies are chosen, however, we discover anomalous narratives that refute this model.

In order to capitalise on his invention of the incandescent light bulb, in the early 1880s Thomas Edison developed a power network in New York City that distributed direct current (DC) electricity. As Edison considered electricity an urban technology, the fact that substations every couple of miles were required to transmit the current was not a drawback. At about that time, after witnessing a demonstration of Edison's inventions, George Westinghouse decided to invest in electrical distribution. As he couldn't infringe on Edison's

patents, he developed an alternating current (AC) distribution system based on two patents held by Nikola Tesla.

Unlike DC, AC could be transported long distances. But it required transformers to be used safely, a point which Edison stressed in a relentless publicity campaign, known as the Battle of the Currents (as you can read about in SteamPunk Magazine issue 2). Although JP Morgan and other financiers backed Edison, Westinghouse's system prevailed after he was awarded two major projects—the production of electricity at Niagara Falls and the supply of electricity to the 1893 Columbian Exhibition in Chicago. AC had become the new standard by the early 20th century, but DC remained in use until 2005, when Con Ed announced that it would cut off DC service to its remaining 1,600 customers (all in Manhattan) by the end of the year. New technologies have since been developed that allow DC power to be transmitted over long distances; such technologies are used to transmit electricity through undersea cables, or when connecting power systems between countries. However, since AC now is the standard for power distribution, this DC power must be converted back to AC.

Technological determinists explain the adoption of AC in technological terms—AC current can be transmitted over long distances and DC current can't. While this is true, it is simply a statement of fact, not an objective measure of superiority; the actual explanation is due to cultural factors. At the time of

the Battle of the Currents, industrialists were in the process of creating monopolies, including regional electrical monopolies, and consolidation was the word of the day. The decentralized and localized system of DC transmission was at odds with the business philosophy of the time. AC also conforms to our society's current values and priorities; if we use AC we can build power stations far from where the power is used. This way we can remain unaware of the extent of their pollution, and we don't seem to object to the defacing of the landscape with transmission lines. If we'd adopted DC, urban form and culture could have been very different. A power station on every block may have caused us to consider less polluting sources of electricity. Small-scale power might have encouraged communities to be more unified and integrated. Power produced locally might have led to electricity being used more appropriately, and to more diversity and a better balance among power sources.

Everyone knows now that gasoline powered cars are far superior to electric or steam-powered vehicles. Electric cars are slow and heavy and have only a limited range of travel. Steam cars are slow to start, complicated and dangerous. But our culture didn't seem to know that 100 years ago; in 1900, American car companies made 1,681 steam, 1,575 electric and 936 gasoline powered cars. And in a poll conducted at the first National Automobile Show in New York City, patrons favoured electric cars as their first choice, followed closely by steam.

The steam car is of course the oldest of the three competing technologies, the first reported example built by Nicholas Cugnot in 1769. The electric car also predates the petrol car; in 1839 Robert Anderson of Aberdeen built the first electric vehicle, and an electric taxi was running in England by 1886. In the United States, Pedro Salom and Henry Morris founded the Electric Vehicle Company in New York City in 1897, expanding to other cities including Boston, Chicago, Philadelphia and Washington, DC. At that time it was the largest vehicle manufacturer—and the largest owner and operator of motor vehicles—in America. The cab model was chosen because the vehicles needed trained drivers, and because it was similar to that of a livery stable in which the owner feeds and maintains the vehicles and power sources. The Electric Vehicle Company saw itself as selling mobility rather than vehicles, and planned to operate the electric cabs as part of a network including electric streetcars and buses. Significantly, this idea of selling a service rather than an object developed at the same time that electrical utilities began to sell power rather than motors.

Electric cabs found a niche in the horse-based transport system. They were quicker and quieter than horsedrawn cabs, and could do more miles in a day than horsedrawn vehicles, particularly in adverse weather. In purely technical terms the electric car was clearly superior to the internal combustion vehicle for both cab and commercial service. Before the introduction of electric starter motors, internal combustion engines were difficult to start—and expensive to keep running while idle—and thus weren't suitable for stop-and-start operation. Electric vehicles were more reliable, and their lower top speeds kept drivers from abusing or damaging them. The drawbacks of limited operating range and of the high cost of batteries were being addressed by the development of a network of battery exchanges by several city utilities.

But despite all the factors in its favour, and despite the support of electrical utilities, the electric car lost ground to the internal combustion car between about 1900 and about 1920. David Kirsch, in "The Electric Vehicle and the Burden of History", suggests many reasons for this, including the poor business practices of utilities and electric vehicle manufacturers, uncertainty over the market the electric vehicle manufacturers were targeting (luxury, touring, or commercial), bad press (the reasons for which are still unclear), and the general economic instability of the time. Other factors included the

demand for internal combustion trucks during World War I due to the military's prioritization of speed and range over reliability and quiet operation, and the identification of electric cars with women. Internal combustion vehicles began to dominate long before Henry Ford's assembly lines began producing them in quantity in 1913; by 1914 of the more than 568,000 motor vehicles manufactured in America, more than 99 % were gasoline powered.

Such stories help us understand that choice among competing technologies has less to do with the objective efficiency of the victor than with the ways in which it conforms to the values of the culture within which it is embedded. Which brings us to the airship and the airplane. As we know, the first primitive one-person airplanes were falling out of the sky at the same time airships were transporting hundreds of passengers safely across the Atlantic and around the world. But the reasons for the former's current triumph over the latter seem fairly clear: the airplane appealed to the American's (particularly the American investor's) sense of individualism and adventure (Charles Lindbergh was not only a record-setting pilot but an ardent advocate of the airplane and of airport construction) and the airplane proved to be more useful in war.

But if we can come to recognise how certain technologies mesh with certain cultures and institutions, is it not possible for us to reassess our current choices, and to consciously choose technologies that conform to our cultural values? **What sort of culture, for example, would choose the airship over the airplane?**

A culture, perhaps, that values the physical environment. The infrastructure required for an airship is a fraction of that required for an airplane; one needs only to stand on an empty airport runway (something I've done on occasion in my professional capacity) to appreciate the fact that millions of acres of our planet have been covered with more than a foot of concrete just to provide a smooth and safe surface for these machines. An airship terminal? Grass, maintained by flocks of sheep. Airships can transport people and freight without roads, railways, bridges or airports, avoiding the destruction of habitats or the damaging of wilderness environments.

A culture that values the wise and restrained use of resources. Aside from the savings in the construction and maintenance of infrastructure, an airship uses a fraction of the amount of fuel that an airplane requires just to keep aloft. Airships can even power themselves, producing enough electricity from solar cells to meet their minimal energy requirements.

A culture that values safety. It is instructive to ask strangers how many people they believe died in the Hindenburg explosion (the answer is 35, out of the 97 people on board, and one person on the ground). Despite the popular misconception arising from this incident, airships are far safer than airplanes. They are very unlikely to crash, even in the event of an engine malfunction or any but the most serious compromise of its lift cells. Many airships did crash—the United States Navy managed to destroy four of its six airships, and one of Britain's two first airships, the R-101, crashed on its first voyage. However, analysis of these accidents indicates that the most significant factor was adverse weather, and our satellite and communications technology do a far better job of predicting the weather than even the most experienced airship captain of the 20th century.

Is this our culture? It seems not. Do we want it to be? I think some of us may. Could it be? Perhaps. We don't need to adapt our culture to our technologies. We don't need to accept the technologies we have today, with the unconscious cultural baggage attached. We can think consciously about the values we prioritise, and the values we wish to prioritise, and adopt technologies that are in line with these values.

THE USER'S GUIDE TO STEAMPUNK
by Bruce Sterling

illustration by Leah Moore

Steampunk's key lessons are not about the past. They are about the instability and obsolescence of our own times.

Every year, a group of multimedia artists and various malcontents put together the GOGBOT festival in The Netherlands. 2008 was Steampunk themed. Bruce Sterling, author of the landmark book The Difference Engine, *wrote a thought-provoking essay for the event, which we are quite pleased to reprint here with permission from both the author and GOGBOT organizers.*

People like steampunk for two good reasons. First, it's a great opportunity to dress up in a cool, weird way that baffles the straights. Second, steampunk set design looks great. The Industrial Revolution has grown old. So machines that Romantics considered satanic now look romantic.

If you like to play dress-up, good for you. You're probably young, and, being young, you have some identity issues. So while pretending to be a fireman, or a doctor, or a lawyer, or whatever your parents want you to be, you should be sure to try on a few identities that are totally impossible. Steampunk will help you, because you cannot, ever, be an authentic denizen of the 19th century. You will meet interesting people your own age who share your vague discontent with today's status quo. Clutch them to your velvet-frilled bosom, because you will learn more from them than you ever will from your teachers.

Stretching your self-definition will help you when, in later life, you are forced to become something your parents could not even imagine. This is a likely fate for you. Your parents were born in the 20th century. Soon their 20th century world will seem even deader, weirder and more remote than the 19th. The 19th-century world was crude, limited and clanky, but the 20th-century world is calamitously unsustainable. I would advise you to get used to thinking of all your tools, toys and possessions as weird oddities destined for the recycle bin. Imagine starting all over with radically different material surroundings. Get used to that idea.

If you are European, you may further realize that you are surrounded by an ever-growing European "museum economy" that sells your heritage as a "heritage industry." Familiarity with steampunk will certainly help you here. The heritage industry does not sell heritage, because heritage is inherently unsellable. Instead, it sells the tourist-friendly, simplified, Photoshopped, price-tagged, Disneyized version of heritage. Steampunk is great at mocking and parodizing this

> If you meet a steampunk craftsman and he or she doesn't want to tell you how he or she creates her stuff, that's a poseur who should be avoided.

activity. That's what makes steampunk a thoroughly contemporary act.

This dress-up costume play and these subcultural frolics will amuse and content 90 percent of the people involved in steampunk.

However, you may possibly be one of those troublesome 10 percent guys, not just in the scene but creating a scene. Frankly, the heaviest guys in the steampunk scene are not really all that into "steam." Instead, they are into punk. Specifically, punk's do-it-yourself aspects and its determination to take the means of production away from big, mind-deadening companies who want to package and sell shrink-wrapped cultural product.

Steampunks are modern crafts people who are very into spreading the means and methods of working in archaic technologies. If you meet a steampunk craftsman and he or she doesn't want to tell you how he or she creates her stuff, that's a poseur who should be avoided. Find the creative ones who want to help you, and who don't leave you feeling hollow, drained and betrayed. They exist. You might be one.

Steampunk began as a literary movement—for some reason no one understands, it started with young Californian fantasists writing about Victorian Great Britain, specifically James P. Blaylock, Tim Powers and K. W. Jeter. This guy Jeter made up the term "steampunk." He made no money doing that, and you've likely never heard of him before now. I doubt this much bothers Jeter. Jeter was a major disciple of Philip K. Dick, so he always understood the inherent limits of bourgeois mundane reality.

Nowadays steampunk is not about historical pastiche with a sci-fi twist, because, although that's interesting, there's not a whole lot of room for literary maneuver there. Steampunk has become popular now because it is no longer just fiction. It is an international design and technology effort. Steampunk is a counterculture arts and crafts movement in a 21st century guise.

If this idea makes your heart beat faster, I can save you a lot of trouble by recommending one brief essay called "On the Nature of the Gothic" by John Ruskin, the greatest design critic of the original steam era. Go read it. Read this manifesto with great care because it was the seed of the Pre-Raphaelite Brotherhood, Jugendstil, Art Nouveau, William Morris wallpaper, Aubrey Beardsley Yellow Book decadence, romantic-nationalist architecture and about a thousand other things most steampunks would consider very cool.

Ruskin wrote an extremely influential and important essay which changed the world. Everything Ruskin says in that essay is wrong. The ideas in there don't work, have never worked and are never going to work. If you try to do the things Ruskin described in the spirit that Ruskin suggested, you are doomed.

However. If you try to do those things in a steampunk spirit, you might get somewhere useful. Steampunks are equipped with a number of creative tools and approaches that John Ruskin never imagined, such as design software, fabricators, Instructables videos, websites, wikis, cellphones, search engines and etsy.com. Successful steampunks are not anti-industrial as Ruskin was. They are digital natives and therefore post-industrial. This means that they can make their own, brand-new, fresh mistakes—if they understand the old mistakes well enough not to repeat them.

Steampunk's key lessons are not about the past. They are about the instability and obsolescence of our own times. A host of objects and services that we see each day all around us are not sustainable. They will surely vanish, just as "Gone With the Wind" like Scarlett O'Hara's evil slave-based economy. Once they're gone, they'll seem every bit as weird and archaic as top hats, crinolines, magic lanterns, clockwork automatons, absinthe, walking-sticks and paper-scrolled player pianos.

We are a technological society. When we trifle, in our sly, Gothic, grave-robbing fashion, with archaic and eclipsed technologies, we are secretly preparing ourselves for the death of our own tech. Steampunk is popular now because people are unconsciously realizing that the way that we live has already died. We are sleepwalking. We are ruled by rapacious, dogmatic, heavily-armed fossil-moguls who rob us and force us to live like corpses. Steampunk is a pretty way of coping with this truth.

The hero of the funeral is already dead. He has no idea what is happening. A funeral is theater for the living.

Steampunk is funereal theater. It's a pageant. A pageant selectively pumps some life into the parts of the past that can excite us, such as the dandified gear of aristocrats, peculiar brass gadgets, rather stilted personal relationships and elaborate and slightly kinky underwear. Pageants repress the aspects of the past that are dark, gloomy, ugly, foul, shameful and catastrophic. But when you raise the dead, they bring their baggage.

There's not a lot we can do about the past; but we should never despair of it, because, as Czeslaw Milosz wisely said, the past takes its meaning from whatever we do right now. The past has a way of sticking to us, of sticking around, of just plain sticking. Even if we wrap the past around us like a snow-globe, so as to obscure our many discontents with our dangerous present, that willful act will change our future. Because that's already been tried. It was tried repeatedly. Look deep enough, try not to flinch, and it's all in the record. So: never mock those who went before you unless you have the courage to confront your own illusions.

The past is a kind of future that has already happened.

On the "Validity" of Steampunk

by Heather Pund

I'VE STARTED SEEING A GREAT DEAL OF GOGGLE-RATTLING about how Steampunk is dead and oh noes, it's been co-opted by the masses and is no longer cool.

To which I wish to say, in brief: Get stuffed.

Let me tell you something about being co-opted; I am a belly dancer. My art form, my chosen passion, has been adopted by both Disney and Fredericks of Hollywood. You can find coin belts at Hot Topic, zills in the mall, and harem pants are required as part of the standard Halloween costume. Every single person on the Earth can hum that "nee ne nee ne neee" song and mime headslides. Little Sorority girls tell me gleefully that they've "done bellydance" or have a tape or took a class that one time; so they know all about what I do.

And that's just the civilians. I go to workshops, conventions and performances and there's always a Belly Bunny to be found—all dressed up in something expensive, not knowing good posture from her posterior. There are infinite people who flock to the banner of dance to be sexy, seductive or sensuous, all the while not knowing one damn thing about the God Technique. They flail on stage, look for quarters, or start dropping names as if holding them in their mouths will burn a hole. Tip of the iceberg, folks. We won't even go into the confusion about belly dance and the sex industry.

And you know what? Who cares?

My choice to be a dancer isn't lessened or impacted by some ditz in a fringe belt who doesn't even know there are different styles of dance, let alone different styles of belly dance. (Tribal what?? *hairtoss*) The work I've put into learning the art and

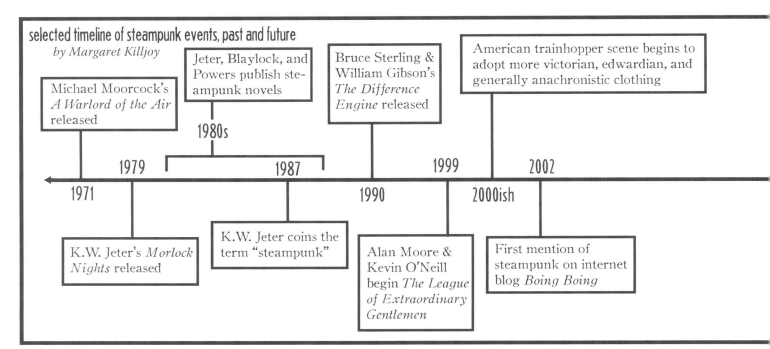

performing, the hours of practice, costuming and gaining my chops aren't suddenly moot just because that person over there has decided to try on the "persona" of a belly dancer. I'm not in this for them, or you, or what you think of me.

I'm in this for me. Because it's something I love. Because it's something that matters to me. Because it's something that I feel is worthwhile and something that satisfies me on a deep level.

And as surely as you get the N00bs with the endless questions, sometime shallow interest, and assumptions—you get the Crusty Old Grump who Has Been Here Since The Start and bitterly resents all the new interest. "Why, when I crawled out of my Daddy's Vat in the Mad Scientist Lab" they start, "no one even knew what Steampunk was! You whippersnappers!"

Great, fine; Get stuffed.

There are a lot of people who dance and there are a lot of people who are interested in Steampunk. Some of these people will stay and some will go but deciding that something is over or invalid just because a lot of people are talking about it is not only shortsighted but a huge slap in the face to those of us who are passionate about it. I don't care if I can walk into Kmart and find bustle skirts with gears hanging off—they still won't fit me because I have a huge butt and a pot tummy. So I'll still go home and make my own. I don't care if I can go into the mall and find things with gears stuck on or tea-dyed or with excessive amounts of brass. That kind of stuff is pretty—but not the totality of what I personally think of as "Steampunk".

My point being: just because someone borrows the trappings of your art or passion does not cheapen or kill that thing you are passionate about. And if it does—well then. Maybe it wasn't the right thing for you after all?

As for the newcomers—we all started somewhere. Ask questions, challenge assumptions, combine new stuff, but absolutely learn what's already here. In the world of dance, things are a little more laid out and set because it's so physical. You have to learn good posture or you'll hurt yourself. You have to learn the rules before you can start challenging or breaking them.

We learn by asking and we learn by doing and we learn by teaching. If the Belly Bunny bothers you, teach her good posture. If the N00b with gears glued to his face annoys you, start up a conversation and teach him something. Share your passion, share your fire because that only makes it grow. And yes, absolutely, you'll find people who won't understand it but you'll also find people who will. And they are worth the time, effort, and occasional disappointment hands down.

This art, this movement is what we make it. It's as simple as that. And this particular artist has decided that her interests are still quite viable, thank you.

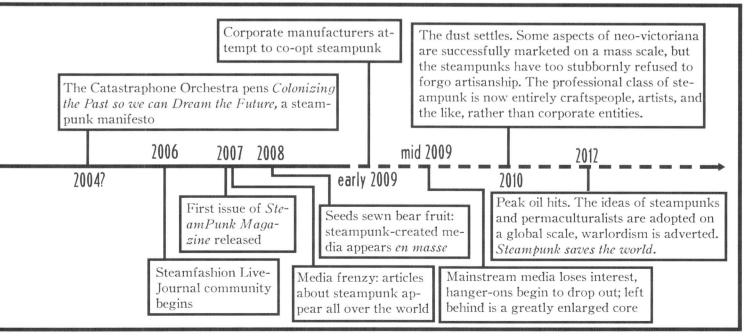

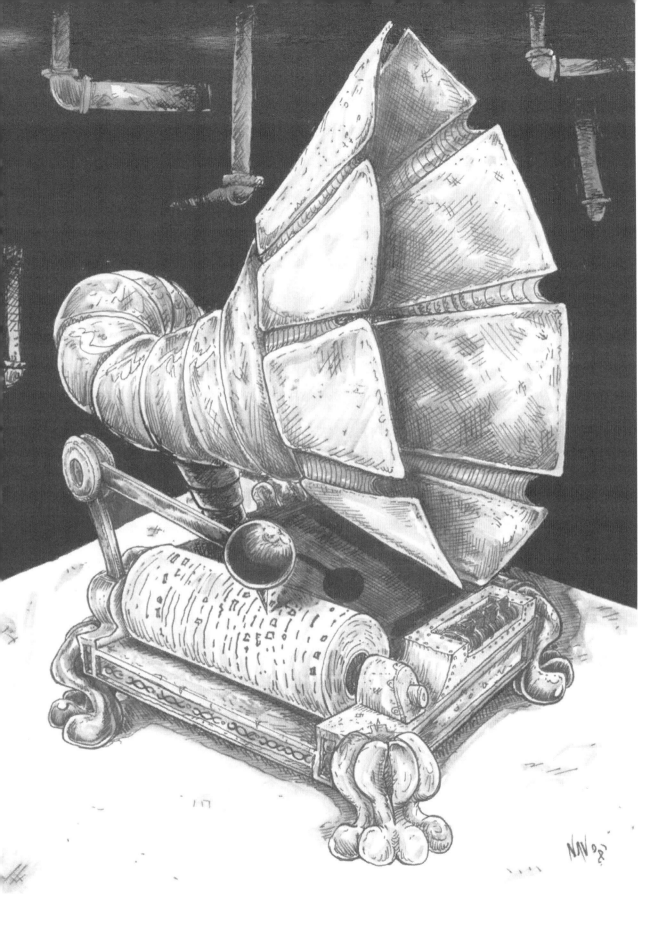

Doppler and the Madness Engine
Part Two of Three
by John Reppion
illustration by Juan Navarro

Extract from Doppler's Journal No. 27.

November the 19th [1865] (evening)

I write this by the light of a streetlamp at the junction of Edward Street where the American spirit medium Mr. Sam Thonlemes formerly conducted his trade. Grober is watching over me as I do so, ensuring that I am not disturbed. We find ourselves surrounded by a chaos of queasy familiarity to me. It is as if my own madness has somehow infected the world at large. I have seen those affected stumble like drunken babes in a terror [words rendered indecipherable by much crossing out] I must start at the beginning. I am having trouble gathering my thoughts. It is difficult to think even at this distance from the house and the hum [words crossed out].

We have moved yet further from Thonlemes' dwelling and once again I write by the glow of a streetlamp. I must record this day's events as thoroughly as possible before I can begin that which needs to be done.

Following the death of the Peterson's maid this afternoon, Grober and I found ourselves in the company of a thoroughly unpleasant Detective Inspector. The fatality was naturally sufficient cause to summon the police and though I felt uneasy at the prospect of being questioned, it seemed only proper that Grober and I should remain at the house to give our version of events as we had seen them. Any other course of action would certainly have been considered suspicious on our part. Mr. Peterson was, of course, distraught at the thought that his lady wife may have caused the woman's fall and begged to be left alone in her company. A family physician by the name of Sloane was summoned—arriving shortly before the police—and it was he who made swift arrangements for the servant's body to be removed. It was all too soon after that Mrs. Peterson was also escorted from the house and into a waiting carriage, the straight waistcoat she wore leaving little doubt as to her destination. All the while Grober and I were kept at a distance from the proceedings, having been instructed to wait in the parlour as soon as the police ascertained that we were mere visitors who had arrived at the house only moments before the death.

It was at least three quarters of an hour after Mrs. Peterson was taken that Detective Inspector Leeche finally entered the room and introduced himself. Though Grober and I have had many meetings with the law during our time here in England, we had not previously encountered Leeche and he was tediously curious about our affairs. I have no wish to record all the unpleasantness that occurred, all the innuendo and thinly veiled threats that were levelled at us both; suffice it to say that they were of the same asinine nature as always. Was I a child in the guise of a man? Or perhaps a young lady thusly attired "for a lark"? Was I the slave or lover of the "great, ugly beast" Grober? All just as I have encountered and written of countless times. Leeche's persistence was unrelenting however, his baiting of Grober so incessant that I began to worry that my faithful companion would lose his temper and commit some act of violence which would lead to our arrest. Happily, any such occurrence was prevented when a young messenger burst into the room with urgent news. It was obvious that the boy was in some considerable distress and he blurted out his message before Leeche could make protest or direct him out of our earshot. The child spoke of a disturbance at an address which I recognised instantly as belonging to Mr. Sam Thonlemes. Cursing, Leeche pushed the boy out of the room and closed the door behind him. Though I strained my ear I could not properly follow their conversation. A few moments later the messenger entered and told us that we were free to go. Leeche and his men had already left for the address. Grober asked what had happened but the child merely shook his head and said, "I must get home now. I must get home," before rushing from the house. Following a short debate, we elected to follow the officers to the home of Mr. Thonlemes. After all, I reasoned, if some grave misdeed had been perpetrated by the gentleman or his staff it might have some bearing upon our case. A genuine spirit medium—if there could be such a thing—would logically have little or no association with crime. Therefore, I further postulated, this as yet unnamed offence might well expose Thonlemes as a fraud, just as our employer Mr. Shandon had hoped. We found little difficulty in hailing a hansom cab and as dusk descended we began the short trip towards Marylebone and Edward Street.

We were almost at our journey's end when the horse pulling our cab suddenly halted and reared up violently. As a child I recall seeing a horse react in a similar manner at the sight of a nest of adders. The carriage rocked so violently that I feared for one moment it might overturn. Grober and I half jumped and were half flung from the cab as the driver, having already leapt from his place, struggled with the beast's reins. I felt a familiar prickling around my temples and knew instantly that the shock of the situation had triggered one of my attacks. Looking about I realised that there was no obstruction upon the street and no obvious cause for the horse's distress. Even so, the beast continued to buck and thrash wildly, chomping and foaming at its bit. Grober took a few steps forward as if to assist the cabman in his wrangling but then, quite uncharacteristically, hesitated and turned his gaze towards me. He wore a strange expression of bafflement mixed with betrayal. At that very moment the reins where jerked from the driver's hand. The horse galloped away with the empty carriage rattling along behind it, the cabman hollering in disbelief as he tore off in pursuit. Grober's eyes however, remained fixed upon me.

"It is the same. The very same thing again," he said, almost accusingly.

Beyond, I saw our carriage lift onto a single wheel as it struck a curb. Its top collided with a streetlamp and the buggy twisted onto its side, the horse whinnying in terror as it was dragged down by the force of the clash. Turning my gaze back toward Grober I found him with his head bowed

and his palms pressed to his eyes as if trying to collect his thoughts.

"Can't you feel it? It is the same as last night when that damned machine was in action."

There was, I realised, a barely perceptible hum all about us. The sound was faint and low but could be felt through the ground itself, just as one experiences vibration through the platform when a steam locomotive approaches its station. This curious sensation confirmed to me that something very real was happening—something that could be, and was being, experienced by people other than myself. Hesitantly, I asked Grober if he felt able to continue. A few wordless moments followed during which my companion took several slow, deep breaths. At length Grober raised his head and, looking somewhat more composed, gave a single nod. I suggested we proceed toward Thonlemes' residence, feeling I must confess, quite unable to think of any other course of action. As we walked it seemed to me as though each successive step upon the throbbing ground required a just little more concentration and effort than the last. Behind us, the cab driver's cries mingled horribly with those of his lamed horse as it thrashed feverishly upon the ground. I admit that I could not bear the thought of venturing anywhere near the stricken animal; my mind buzzed like a hornet's nest and simple self preservation told me that I must shift my thoughts away from the accident at all costs. Their cause was a bleak one and it seemed to me at that moment that hopelessness was a dangerously infectious thing. Though I cannot be sure of Grober's thoughts on the matter, he seemed somehow oblivious to the ghastly sounds at our back.

As we staggered towards Edward Street I became conscious of raised voices ahead. Two police carriages stood at the far end of the road, their horses visibly restless even at such a distance. From our viewpoint, Thonlemes' house stood approximately one third of the way along the street. A small, disorganised crowd were gathered at the building's front and as we drew nearer I realised that the mob was in part made up of some of the officers we had previously encountered at the Peterson's home. Clouds of what appeared to be smoke rose from the ground around the group, making it difficult to ascertain exactly what was occurring. A number of policemen seemed to be engaged in attempts to calm their fellow officers, and there were also members of Thonlemes' staff wandering around as if dazed. Much to my distress I became aware of an object laid flat upon the cobbled road which, viewed through the murk, looked to me very much like a body. The sounds around me grew muffled, the people seemed to fade and I found myself drawn to the shape in the gloom. In what seemed like the merest instant I found myself standing over the corpse of Mr. Sam Thonlemes. His head rested in a pool of blood which much to my horror appeared to be still increasing in volume. His eyes were open and staring blankly at the night sky, his expression eerily calm and sober. Entranced by the awful sight before me, oblivious to the chaos all around, I stooped to examine the medium's body more closely. His clothing was just as I had seen in his photographs—though his frockcoat was torn at the shoulder and his tie ragged and undone. What caught my attention most however, was the bizarre apparatus that he wore upon his chest. It bore a marked resemblance to the contraption that I had observed yesterday evening in his parlour that had somehow held, and had been able to transmit, the sound of Mr. Thonlemes' voice. The machine was whirring still and, almost without thinking, I reached out and flicked a switch marked DISABLE that brought an end to its progress. It was as I bent to examine the contraption that I first became aware of an unseasonable warmth and of a dampness clinging to my face and hands. That which I had earlier taken to be smoke was in fact a warm vapour which rose from the sewers and grates close to Thonlemes' former residence.

It was then that I was seized roughly under the arms, hoisted to my feet and flung back into the chaotic reality of the situation. I found myself unexpectedly face to face with Detective Inspector Leeche, who seized me by the lapels of my overcoat. He looked outraged beyond all reason and demanded to know what I thought I was doing there. Before I could gather my thoughts enough to even attempt an answer, Leeche was sent sprawling by a slap from Grober's massive hand. Whether my companion ran to my aid or had been standing close by all along, I am at a loss to say. The fact that the blow was dealt with an open hand—and indeed that Leeche remained conscious after its delivery—assured me that Grober's judgement was now not too greatly impaired. The Detective Inspector was, quite understandably, shocked and sat upon the ground gaping at my companion. A policeman shouted something largely unintelligible in Grober's general direction but, instead of coming to Leeche's aid, tore away from us towards the waiting carriages at the opposite end of the street. I realised that the people in the vicinity were now clamorously stumbling along a similar bearing.

"What has happened here?" I asked the still bowled over Detective Inspector.

Leeche blinked incredulously for a few seconds as if struggling to come to terms with the unexpected reversal of our circumstances. Grober extended a hand to the man which, after some little hesitation, he took and was hauled to his feet. Dusting himself off and regaining his composure somewhat, the Detective Inspector suggested that we move away from the house if we were to converse. I enquired why our proximity to the building should make any difference and Leeche let out a short, nervous laugh.

"Because otherwise one of us will end up like him," and here, with a jerk of his thumb, he indicated the body of Thonlemes.

It was clear that Leeche wished us to follow the others towards the carriages but I objected, fearing greatly that we would be arrested when we reached the other officers. Sensing my worry and perhaps thinking something similar himself, Grober placed a heavy arm about the officer's shoulders and we escorted him to the opposite side of the street. Leeche spoke reluctantly and guardedly at first but his inhibitions were soon forgotten as he lost himself in the telling of the tale. I shall do my best here to give the key facts of the matter as he related them:

The police received a complaint last night from a woman, a widow by the name of Derby, who claimed to have been

attacked by Mr. Thonlemes during that evening's séance. Though no great bodily harm was done to the woman she was most emphatic that the medium should be arrested. She repeatedly referred to Thonlemes as a demon or devil (as he imparted this detail Leeche glanced furtively at the medium's body across the street from us). Officers arrived on the scene to be told by Thonlemes' assistant Gerard that Thonlemes was unable to speak with them owing to extreme fatigue resulting from harrowing spiritual happenings. Insisting still that they must see Thonlemes, the officers were shown to his bedroom were he was found to be unconscious in his bed. Given the deepness of his sleep and his insensibility when eventually waked, the officers suspected that Thonlemes had been dosed with laudanum or some other soporific. Short of carrying the anaesthetised gentleman to the nearest police station, the offers were left with little choice but to postpone their interview of Mr. Thonlemes until the following day. Gerard assured them that his employer was anxious to clear the matter up himself and that he would make sure that Thonlemes call in at the station as soon as he was able.

When this afternoon arrived and the medium had not yet presented himself, the same two officers who had called previously returned to the house. One of these officers is yet to be located. The second, a Constable Sheridan, was the catalyst for this day's panic. Sheridan was seen stumbling from the house at approximately three o'clock this afternoon by a house-maid who was engaged in cleaning the upper windows of a residence opposite. The Constable was seen to sit dazedly at the curb-side for some minutes. Presently, two gentlemen came strolling along the road and approached Sheridan, presumably concerned by his attitude and condition. Quite without warning the Constable attacked these men with such ferocity that one found his arm broken and the other was throttled into unconsciousness. Had the servant not raised the alarm as quickly as she did, there can be little doubt that both men would have been viciously murdered by the officer. Constable Sheridan was subdued by a mob made up mostly of staff from the adjacent houses. As her colleagues were engaged in restraining the officer the house-maid first noticed the steam rising from a number of drainage gratings close to Thonlemes' building.

By the time additional officers reached the scene, something approaching a riot had broken out on Edward Street, Constable Sheridan having been beaten badly and many of those assembled now fighting amongst themselves. It was noted that horses became restless as soon as they neared the area and refused to enter the street itself. Messengers were sent immediately to gather reinforcements from the surrounding area and this was where Detective Inspector Leeche and him men had become involved.

When Leeche arrived, no one had yet been able to gain entry to Thonlemes' premises; it seems that the front door had been barred sometime after Sheridan's egress. The Detective Inspector confessed that he became aware of the unpleasant atmosphere surrounding the area as soon as he approached the street but made no mention of it to his colleagues. "I could see by the looks on their faces that they felt the same thing." Those who had been on site for the greatest length of time seemed the most affected and many had grown confused and fearful. Most of the earlier violence had subsided now and it seemed that corralling the remaining residents and officers into the Black Mariahs waiting at the end of the street would not prove overly difficult. Three carriage loads were already taken when the front door of Thonlemes' house burst open. Several members of staff came running from the building, all of whom appeared stupefied and in fear of their lives. These were soon followed by Thonlemes himself who pursued them "as a dog goes after a rat." Leeche was close to the house at this point and saw Thonlemes catch the leg of a young maid and send her sprawling on the ground. He looked on in horror as the medium bit down hard upon the woman's arm. Leeche pulled Thonlemes from the maid and the two men fought. The Detective Inspector's description of their struggles was disjointed and he grew ever more uneasy in its telling until he stopped quite abruptly and stared silently at his own hands. Though unsaid, it is quite obvious that Leeche was responsible for the death of Mr. Sam Thonlemes.

Our current situation is as follows: Leeche has now left us and joined his colleagues. After removing the machine from the body of Sam Thonlemes, Grober and I proceeded away from the police towards the opposite end of Edward Street. It is clear to me that the source of this most peculiar disturbance must lay inside the former residence of Thonlemes. I believe that the affected area is now widening as we continue to witness persons leaving their homes in a state of confusion, some of whom are beginning to act in a violent manner. It seems logical to me that, since we have previously witnessed a similar atmosphere of unease generated by the action of one of Thonlemes' speaking machines, this current situation might well be the result of some broadcast from another, or perhaps many, such contraptions. If this is the case, I need only enter the house and deactivate these devices in order halt this madness. It does indeed seem that the closer one's proximity to the house, the more intense the influence and disorganisation of one's thoughts becomes. For this reason, it is safe to assume that journeying into the building will be disorienting in the extreme. It is my belief however that I am one of the few persons—indeed perhaps the only one—capable of making such a journey owing to my intimate knowledge of insanity and its effects upon my person. My plan is to use the contraption which we removed from Thonlemes' body to create an audible record of my progress which, should the disorientation be so great that I am unable to remember the events clearly and in order, I hope that it may help me to make sense of my journey after the fact. I shall now take a few minutes to familiarise myself with the operation of the machine, after which I will explain my intent to Grober. I have little doubt that he will do his very best to dissuade me from my cause but I am convinced that this is the only proper course of action. If I were a person who believed in such things as providence or destiny I should probably read some higher meaning into my being here, in the midst of these events. As it is, I can only see that if I do not attempt to do something there may be no other who can. ✹

To be concluded.

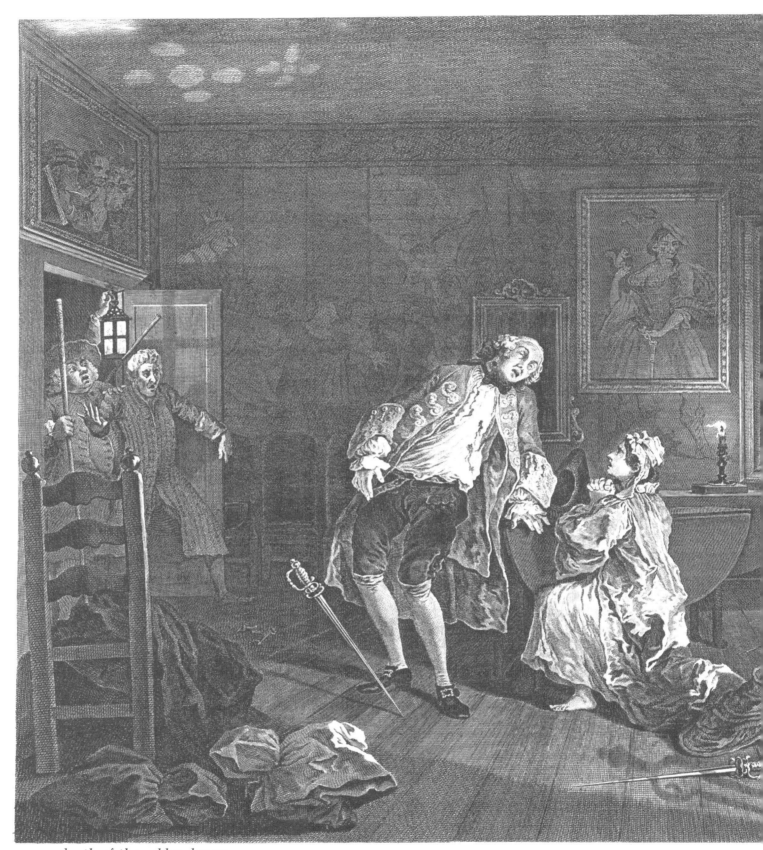

death of the robber baron

VOLTAIRE
as interviewed by Margaret Killjoy

Voltaire is a renowned musician, writer, artist, and ne'er-do-well. He's been involved in spooky culture of all sorts for decades, and he's always gone at it with a style that us steampunks will quickly recognize and appreciate. I had a chance to interview him last fall about his steampunk-est album to date and about steampunk in general.

Margaret: Alright, for those readers who are unfamiliar with you and your work, could you introduce yourself?

Voltaire: I'm a person who makes things. Most of the things I make have a decidedly dark slant and simultaneously a wry or outright humorous bent. In other words, I make things that are dark and funny, spooky but cute. Once upon a time these things were stop-motion animated commercials and station IDs for MTV, The Sci Fi Channel, etc... Then I started making comic books (*Oh My Goth!*, *Chi-Chian*), then I started making music and was signed to a record label (Projekt) and these days I make a lot of toys and still do all of the above. People are always asking me which of these things I enjoy doing the most; music, comics, animation, toys? I generally tell them that I don't do many things. I just do one. I create. Or I throw my hands in the air and tell them I'm an evil clown.

Margaret: I had a whole slew of questions I was set to ask you, but then I heard your latest album, "To the Bottom of the Sea" and well, I kind of had to drop them all and start again. To the Bottom of the Sea seems like a real de-

velopment for you, with a clear theme and focused songwriting. What spurred this?

Voltaire: I knew that would happen when you listened to it. That's why I decided not to answer the first batch of questions you sent me! heh heh. To answer your question... I don't know. This CD, I dare say, sounds like a musical to me. And yes, it does have a linear plot line. But I should tell you that it was not planned that way. I simply went about writing a handful of songs for the next CD. When I started putting them in order, I realized that it formed a narrative. I was rather stunned. It's as if I had the story in my head all jumbled like pieces of a puzzle, and then when I had them all in front of me, they formed a picture. At that point, I supported the story by adding a lyric here or there to connect them further, but honestly, the story was already there. I feel like the CD is a sign of the times. Frustrations with the economy, the growing rift between the rich and the poor, our government's dubious activities, all of the these things I think seeped into my mind. It is the best of times, it is the worst of times (depending on whether you're privileged or poor) so I guess it's no surprise I've subconsciously written a musical about a revolution against a tyrannical robber baron.

Margaret: *You've been something of a gothic troubadour for essentially your entire career, focusing on songwriting and performance. What can you tell us about the tradition of entertainers? It seems like nearly a lost art these days...*

Voltaire: To be honest, when I first read this question, I wasn't quite sure how to answer it. I closed my computer and I figured I'd get back to it later. Then I went to Spooky Empire's Horror Weekend in Orlando to play a show. The next day, I was approached by an old punk rocker in the cafe of the hotel. He said to me, "Back in the day, I used to go to see industrial bands. And I had a blast at those shows. Eventually I stopped going to concerts because the shows got lamer and lamer. Eventually it would just be a couple of guys in their blue jeans fiddling with a laptop. What ever happened to being entertained at a show? Well, let me tell you sir, that last night, you entertained the fuck out of me!" Well, I was sort of taken aback and flattered, of course. I honestly, while standing there talking to him, tried to think about what it was that did it. I don't have pyrotechnics, I don't have a fancy light show, or big props or anything like that. I honestly tried to figure out what the connection was between me and the old-school industrial bands that he felt entertained him so much. And I couldn't think of anything tangible that we have in common. And then it sort of hit me. I think it's about engaging the audience. Not just yelling "Hello Detroit!" every once in a while, I mean, somehow letting the audience know you see them and that you are there for them, not for yourself. And my show is nothing if not audience driven. I think storytelling has a lot to do with it too. For centuries all you really needed to entertain a group of people was your mouth and an ability to weave a yarn. That's still true today. No amount of computer graphics and explosions can compare to a story that pulls you in and gets all of your emotions involved. All you really need to accomplish that is a understanding of what it means to be human and a whole lot of honesty. That's what comedy is at its core. It's being honest in the face of what we are all pretending to be. It's admitting you farted a little while talking to the president or that you sort of checked out your mom's tits when she bent over. When my grandmother died, my son and I were going to her funeral. It was his first and I felt I should prepare him. I told him that "Grandma is going to be in a box". It took everything I had not to bust up laughing when I heard those words come out of my mouth. I cried my ass off at my grandmother's funeral but I still burst out laughing when I say, "Grandma's going to be in a box." When I'm on stage, I'm not someone else. I'm me, warts and all. And it's the warts people appreciate the most. Because it reminds them of their own.

Margaret: *A lot of our readers are firmly of the opinion that acoustic music is pretty important in steampunk. To me, it certainly seems natural that anachronistic songwriters like yourself belong in our midst. What's your take on steampunk, and on steampunk music?*

Voltaire: I've been making the kind of music that I make for over ten years now. Over the years people have called it Goth, Acoustic Goth, Dark Cabaret, Folk, Apocalyptic Folk, Gypsy Punk and now with the popularity of Steampunk, they call it that too. Unlike other bands, I don't strive to fit into a category. I think that's a trap. The moment you say that you are a Deathrock or a Ska or a Polka band or any other genre for that matter, chances are you will never grow any further. You might try to make the very *best* polka song ever, but that's where it's going to end. It's not my goal to be easily labeled. It's my goal to make good music that moves me and hopefully others as well. Now, as it happens, I'm a big fan of the past and classical instruments and of Victorian fashion and I'm a big fan of Steampunk so I'm delighted that fans of the genre can relate to what I do because I've been a fan of Steampunk since I first laid eyes on *Chitty Chitty Bang Bang* and Harryhausen's *First Men in the Moon*. That was over 30 years ago. So feel I'm in good company. And I'm glad they welcome me aboard. But I think it makes a lot of sense that Steampunk music, like the aesthetic, should be firmly grounded in the Victorian era. And that to me means that ideally, a "Steampunk band" should only ever use instruments that were in existence during that time... and maybe steam and mechanical devices (and by this I do not mean electronic devices, but rather machines that are either wound up, cranked, spring powered or powered by steam). Aside from those elements, I think everything else is at best a stretch and at worst, posturing.

I think that when it comes to the music of the genre, the bands can be separated into three groups: 1) Bands that sing about steampunk issues but use modern instruments. 2) Bands that dress steampunk but make modern sounding music. 3) Bands that make steampunk music.

The first category is, I believe, populated by well meaning, ardent fans of the genre. The second category is, sadly, riddled with people using Steampunk as a marketing tool to make whatever it is they do seem somehow mysterious and special. In my opinion, those bands are to Steampunk what Disneyland's Haunted Mansion is to paranormal investigation. Now, I *love* Disney's Haunted Mansion, but nobody's fooled. We all know it's fake. And in the third category, I can only think of very few bands that fit the bill. Amongst them Thomas Truax and Tom Waits. And I'm fairly certain neither of them strived to be a Steampunk act. I'd say Rasputina (of which I'm a big fan), but while they have the turn of the century underwear and cellos, they lack the steam.

I'd put them in a 4th category (along with myself). 4) Bands that have elements that appeal to Steampunk fans.

> No amount of computer graphics and explosions can compare to a story that pulls you in and gets all of your emotions involved.

an introduction to casting
(which, by the way, is dangerous as hell)
written and diagramed by David Dowling
art by Fabio Romeu

The alloying and casting of metal is as old as industry, even defining "industry" in the broadest of terms. Whole fields of academic research have been dedicated to tracing the history and origins of the technology, which pre-dates the written word—libraries penned on the cultural impacts and social conditions generated by metallurgy.

I'm not going into that.

If you want to learn about the marvelous and fascinating history of molten metal, get a library card. The subject is beyond the scope of this article. The objective of this article is, quite simply, to put that earth-changing technology, the foundational pillar of civilization and industry, into as many amateur hands as possible. Hands that can then go on to pattern their own machine parts, jewelry components, sculptures, or ammunition. Hands that can fumble a flask of molten metal and accidentally set alight entire neighborhoods. Your hands.

The metal casting is far too vast and complicated a subject to be encompassed by one article and covers a dizzying scope of scale and material, from tiny gold jewelry pieces to multi-ton iron machine parts. The process we'll be focusing on is one of the simplest, oldest, and most versatile methods of turning a lump of metal into a beautiful or functional what-have-you, commonly known as sand casting. The process is simple enough to be done with readily-available equipment in your basement, garage, backyard or driveway, flexible enough to produce anything from a bronze replica of that 19th century bevel gear you wish you had ten of, to a necklace pendant, to a functional cannon (though the author does not recommend this unless you intend to turn it on your corporate masters, and even then accepts no responsibility). At its simplest, the process consists of taking a pattern (prototype), packing damp sand around it much like you would when forming a sand castle, removing the pattern, and pouring metal into the void. Of course, it's not really that easy. In fact, it's rather difficult. Let's have at.

Before diving into melting your mum's good silver down to make lycanthrope defense devices, a friendly Warning: The following procedure involves extremely hot fires, potentially dangerous fumes, and molten pools of liquid ranging up to 2,000 degrees F and beyond. You will burn at a much, much lower temperature than that, and your lungs are fragile things. Take care.

Metals

The metal you choose to work with is obviously going to be dictated by availability and application—jewelry castings are most commonly done in silver and gold, and sometimes bronze or brass. Machine parts are most well suited to brass, bronze, aluminum and iron.

Copper may not suitable for casting without processes beyond the scope of this writing, as it tends to oxidize badly and produce porous, brittle, ugly castings. Feel free to experiment with it, however, as it is readily available in the form of scrap plumbing pipe.

Silver (either fine or sterling) is widely available in the form of serving ware and cheap production jewelry. It casts well and is comparatively inexpensive as scrap and easy to scrounge.

Gold casts very well, but is prohibitively expensive for most of us. If cost is not an issue for you, gold is an excellent metal for casting due to its high resistance to oxidization and smooth flow at molten temperatures. Also, please contact me if you can afford to frivolously experiment with gold as I could use a wealthy steampunk benefactor to fund my attempts to save/ruin civilization.

Supply list:

- Wood or steel to make a molding flask.
- Metal to melt.
- Something to melt metal with (instructions for building a furnace or gas torch not included).
- Something to melt metal in (instructions for making crucibles not included).
- Borax.
- Casting sand (see section on sand for details).
- Talc or chalk and an old, thin sock or nylon stocking for pounce bag.
- Protective clothing—nothing synthetic, close toed shoes or boots, shaded glasses or a full face shield.

WARNING: The following procedure involves extremely hot fires, potentially dangerous fumes, and molten pools of liquid ranging up to 2,000 degrees F and beyond. You will burn at a much, much lower temperature than that, and your lungs are fragile things.

Brass and bronze are both alloys of copper, tin, and zinc (mostly), and are an excellent choice for machine parts and art casting due to high strength, fairly clean casting properties, and low cost. Brass, love it though we do, contains a large quantity of zinc which produces toxic fumes when melted. I cannot recommend casting brass unless you have an excellent ventilation system and the correct respirator. Bronze comes in many alloys, but unless you have a highly specialized application in mind whatever you can find will be fine. Both are commonly used in decorative hardware and can be found in many yard sales and rummage shops.

Iron can be cast by this method, but due to its high oxidization rate and sluggish flow when liquid, it's troublesome and isn't recommended without further instruction. But go ahead and try if you like! Never let almost certain failure be a deterrent! If you can get it hot enough to melt, you can pour it.

Additionally, you can choose to work in any of the wide variety of soft alloys referred to commonly as "white metals", most commonly pewter, Britannia, or "pot metal". This whole family of metals is utter crap in terms of longevity and strength and not really suitable for anything other than experimentation and decorative objects. And they often contain lead, so don't eat it. On the upside, they're only slightly more scarce and costly than dirt, and cast at very low temperatures.

Models

THE FIRST THING YOU'RE GOING TO HAVE TO DO ONCE YOU have some metal to destroy is figure out what you want to make it into. This is where the model comes in. Models can be made out of anything rigid enough to withstand sand being packed hard around them. I've used carved wood, forged metal parts, found plastic parts, closed cell foam, clay—anything, really can be a pattern. One of the most common and easiest thing to make a pattern out of, if you aren't just making a copy of an existing object, is wax. There are special carving waxes available for this purpose, but anything hard enough to hold its shape will do. A good trick when using wax not intended for carving is to work it with heat to keep it soft, then cool it in the fridge to harden it before casting. Wax can be filed, cut, sculpted, welded with heat and even sanded and polished if it's hard enough.

Whatever you choose to use for your pattern, the one requirement is that it have no undercuts, by which I mean there are no spaces where the form folds in on itself in such a way that it would trap sand packed around it (*See Figure 1*). The pattern needs to be able to come out of the mold without disturbing the sand around it. Undercuts can be done with self-evacuating processes, wherein a combustible pattern is left in the mold and burned out by the addition of hot metal, but we aren't covering that here. See your nearest art student, tinker, or internet for details on lost wax and lost foam casting.

Some authorities maintain that sand castings must be done with flat-backed models, that being a model that only has dimensional stuff on one side and is flush on the other. This isn't true, but it is easier and more likely to produce consistently good castings. In many cases, the easiest way to get a dimensional object out of flat backed models is a two-part model, wherein your initial model is just sawn in half lengthwise to produce two halves that will be packed into the sand molds separately such that the impressions they leave in the sand will match up (*See Figure 2*). Trial and error will tell you what needs to be a two or more part model and what can be cast in one piece.

Molding

THE BASIC SAND MOLD (OR COPE AND DRAG) IS COMPRISED of two rectangular (or square, or round, whatever) frames, like boxes without a top or bottom, which key together and allow some orifice through which molten metal may be poured. These can be fabricated from steel, cast from iron or aluminum, or just nailed together from wood. For very small castings, a couple of tuna cans work well enough, but don't tend to last very long. A better bet is to find a piece of big pipe, three or more inches interior diameter, and saw rings off of it (*See Figure 1*). Molds can take many forms and, while there are some very fine and nigh-indestructible commercially produced cope and drag frames, people have been making them out of whatever was at hand for thousands of years. If you can't figure out how to build a box, you're probably not up to casting your own steam-driven death machine parts. For inspiration and more in-depth instructions on flask making, refer again your nearest library or internet. A link to an excellent instructional website has been provided at the bottom of this article.

Once you have your mold and model, whatever they may be, you'll need to acquire the crucial casting medium—sand. "Sand" is a rather ambiguous term in foundry, as it refers to an endless variety of earth-like substances comprising in different quantities clay, silica, sundry particulates, resins, and moisture in the form of water or oil. There are sands commercially available to the caster, as well as natural sand available free to anyone with a bucket.

Green sand (which is not really green at all) is a mixture of clay, silica, moisture and various additives that can be purchased commercially or made at home out of clay cat litter, masonry sand and/or silica sand, and motor oil, mineral oil, or water. Really, you can make it out of almost any consistently fine sand and clay mixture: this is one of the places where trial and error come into play. There are no universal rules for making/collecting green sand, but these guidelines should help:

• Don't use beach sand. The salt content seems to keep the molds from sticking together, perhaps because it dissolves when moistened. I don't really get it, but it doesn't work, so don't bother.

• Sift whatever sand you use (be it from a playground or construction site or the nearest post-apocalyptic desert) to produce a uniformly fine grain free of dirt and unwanted rubble. The finer the grain of your green sand, the finer the detail of your castings. Sand with too coarse a grain won't want to hold it's shape or will produce rough castings.

• Add moisture slowly, it's easy to overdo it. You want your sand to have enough moisture that it will bond into a dense ball when you squeeze it in your hand that can be gently tossed and caught without falling apart. When broken in half it should come apart cleanly, not crumble away to nothing.

• If your sand isn't bonding it probably doesn't contain enough clay. Natural sand dug from the earth will usually have enough clay in it to work, refined sand may not. In either case, the addition on kaolin (fireclay) or bentonite clay in small amounts should fix the problem. You want your sand/clay ratio to be about 10 to 1. Good luck figuring out how to ascertain that, I just guess.

Making or finding your own sand is a great skill to survive the inevitable industrial collapse with, but if it's too much of a pain or you just can't make it work, your local foundry, art center, or internet should be able to guide you to a resource for buying green sand already made.

Another option, more practical for small scale castings, is a sand-like material called delft clay. It can be found at jewelry, sculpture, and some industrial suppliers and produces very fine castings and comes pre-mixed. I have no idea what's in it but it's easy to use and maintain, and I prefer it for small machine parts.

Both green sand and delft clay are reusable—just remove and discard the badly bunt parts after de-molding you castings, grind anything that heat has dried hard, and add moisture as needed.

Making the mold itself can vary widely in complexity depending on the complexity of your model. For our example, we'll assume you have a fairly small, simple shape with a flat back. Start by laying one half of your flask on a sturdy, flat surface, and packing it with sand. Tamp the sand down with a hammer or stick or something to make sure it's packed tight into all the corners and provides a dense surface. Using a straightedge, scrape any sand that may be above the lip of the flask off, using the flask's edge as a guide. Repack the surface is needed, repeat until you have a suitably smooth surface that comes flush to the edge of the flask. Take a sock or old nylon or bit of cheesecloth filled with talc or crushed chalk and gently bounce it on the surface of the sand. This should deposit a fine layer of powder that will keep the halves of the mold from sticking together. Lay your model on the sand, flat side down and reasonably close to the center of the flask, and again dust with release powder.

A note on sprues and vents: When packing the mold is complete, you will need a sprue through which to pour your metal. A sprue is a channel that runs through the mold from the outside of the flask to the void created by ramming sand around and removing your model. In some cases, the sprue can be scraped out of the sand manually after the mold has been formed. In others, you'll want to pack a length of pipe or rod into the mold along with your model to act as the sprue. Which to do when is a matter of preference and is dictated by judgment and experience. Generally, in very small castings, scraping the sprue out is fine. In larger castings, ramming a sprue into the mold will help the sprue from breaking apart

Figure 1: A model with and without an undercut.

Figure 2: The two part model.

under the pressure of molten metal and expanding sand. In some cases, you will need to add vents as well. When you pour molten metal into a mold, the air inside said mold will immediately be superheated, causing the release of steam, smoke and all manner of vapors at immense pressure. Since sand is porous, most of these vapors will be able to evacuate through the mold. In many cases, such as where there are fine details that may not fill before the metal cools, or in the case of large castings that generate a lot of heat and gas expansion, you'll need to include vents that allow gas to escape and ensure the flow of molten metal. The placement of vents is another mater of judgment and experience, but generally, more won't hurt. Don't overdo it though, as you'll have to cut all these off later when they're metal (*See Figure 4*).

Once you've figured out what to do with your sprue and vents, lay the other, empty half of the flask on top of the sand-filled flask and model and fill it with sand, tamping it down as you go, careful not to disturb the position of your model. Once the second half of the flask has been rammed down and struck off, you're ready to separate your mold. Tapping the side gently with a hammer will help to release the mold without breaking apart its contents. Remove the model and any sprue and vent fillers you may have used, and you will be left

with a mold nearly ready for pouring. All that's left is to make sure you've left a big enough opening on the outside of the mold to pour metal into and to bind the halves together. Scrape and form a cone shape into the outside end of your sprue that will channel any metal you don't pour quite right into the hole instead of dumping it on your feet, and use whatever's handy to firmly hold the two halves of the mold together—if you were clever in the flask making phase, your flask may bolt together or something neat like that. If you weren't, just use wire or a couple of c-clamps.

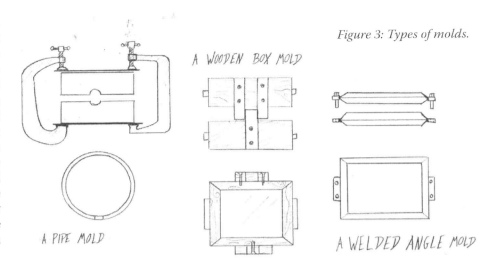

Figure 3: Types of molds.

Melting/Pouring

The fun part, wherein all the dangerous dramatic stuff happens. Your melting needs will vary depending on what and how much you're planning to melt. White metal, pewter, and aluminum can be melted in a coffee can over at hot fire quite readily in small quantities. In small amounts, silver, gold, and some bronzes can be successfully brought to pouring temperatures with a MAPP gas torch of the type commonly found in hardware stores. Larger masses of metal or metals with higher melting temperatures will require more dramatic measures which can range from primitive ground forges to furnaces made from steel buckets and concrete to your welder friend's oxy-acetylene torch. There are no end of DIY how-to articles and YouTube videos for building a furnace if you want to. Otherwise, just find someone with a torch.

You'll also need a crucible, a vessel that can withstand the high heat of molten metal to transfer your 2,000 degree puddle from flame to flask. Steel is a common choice for this, a length of solid pipe with one end capped with welded plate works fine, or any heavy steel vessel. A more common and probably better choice is a fireclay or refractory (referring to any number of heat-reflective ceramic, plaster, and fiber materials) crucible. You can find instructions for making these, but considering that commercially made crucibles aren't expensive, last through a number of pours, and are less likely to explode than home-made varieties, you should probably start with buying one.

Weigh out your metal so you know you have enough to fill the mold but not so much that you'll be left with tons of molten metal cooling in your crucible or on the ground. If you like math and SCIENCE!, you can do this by multiplying the weight of your model by the difference in specific gravity between the model material and the metal you're using. You can also use the fluid displacement method that this guy Archimedes's came up with back in the day—it still works fine. Fill a clear container with enough water to submerge your model. Drop the model in and mark the water level. Remove the model and add metal until the mark is reached again. This, plus however much you'll need to fill all the voids left by your sprues and vents, is how much metal you'll need. Remember that a little too much makes for extra cleanup, but too little ruins your castings. Err on the side of caution.

From here on, it's pretty straightforward—add fire to metal until liquid, flux, pour in hole in your mold. Specifics may vary if you're using a specific type of furnace, follow whatever method is recommended by the instructions you find on furnace building.

Wear eye protection, closed-toe shoes, leather gloves, and natural fiber clothing. Seriously. You will not look tough when you're on fire or pretty when you have hideous scars from synthetic fibers melting to your flesh. If you work cautiously but confidently, you will be fine. As in all dangerous situations, proceed without caution, not fear. Keep plenty of water handy to douse flames or quench molten metal if a mishap occurs. And remember—fire is fun!

Pre-heat whatever vessel you'll be melting metal in with a torch or a brief firing in the furnace to make the melting quicker and easier, begin to add metal when the crucible is hot. Adding your metal in small amounts will help it melt more quickly and reduce the risk of burning part of the metal while the rest is still solid. When your mass of metal begins to get sluggish and runny, add a generous pinch of borax. This substance, sold as a cleaner in most markets, is a naturally occurring salt used in everything from detergents to cosmetic and insecticides and is a handy thing to familiarize yourself with. It also works as a flux in casting, acting to draw impurities out of molten metal and break its surface tension, making it flow more easily. As a handy side effect, it leaves a glassy residue on crucibles that will in many cases help preserve them. Metal is ready to pour when it is consistently liquid, has a shining and flowing surface (a boiling surface means you may be too hot—this will not ruin your castings outright, but should be avoided), and flows freely when the crucible is jostled. Think of mercury broken from an old style thermometer—mercury is molten metal, it just has a very low melting temperature. It should behave like that.

The critical moment—pouring. Carefully remove your crucible from the furnace or forge or, if using a torch, keep the flame on it while you position it over the mold. Pre-heating the mold itself can help in keeping the metal from

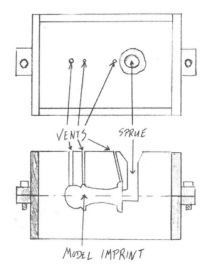

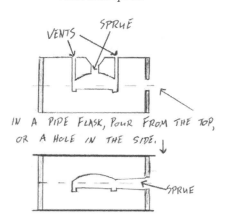

Figure 4: A finished mold with vents and sprue

cooling prematurely, but is often not needed. I like to heat the mouth of the sprue just before pouring when working with a torch to preventing sudden cooling during the pour. Make sure your mold is on a stable, nonflammable surface, and dump the pool of metal into it with one smooth, even gesture. Try not to miss. Expect smoke, steam, and flames. Flare-ups are normal, but if the mold is still burning after the initial few seconds, it's on fire and should probably be smothered or doused before it spreads.

Congratulations. You've just stolen fire from the gods.

Finishing/Conclusion

COOLING OF THE METAL MAY TAKE ONLY A FEW MINUTES for jewelry and small parts, hours for larger pieces. If the mold is too hot to touch, leave it alone. When you feel it's ready, break apart your mold on a clean surface so you can save the sand for re-use. If it came out right, your casting will be a replica of your model, plus sprues and vents. Cut these away with bolt cutters or a saw, then grind or file off the remainder. The oxides on the surface of your casting can be removed by sanding, grinding, sandblasting—whatever you have access to—or they can be left there.

Common problems you're likely to encounter:

• Parts missing from the casting can be caused by a number of problems. If the bottom cast correctly but it didn't fill all the way and there was no metal left in the funnel at the top of your sprue (called the sprue button), you didn't have enough metal. Use more next time.

• If the top filled but the bottom didn't and you have leftover metal in the sprue button or spilling over the mold, then it cooled too quickly. Make sure your metal is hot enough before pouring, and try to avoid making either your sprues or casting models too thin. When metal flows into thin spots it will want to cool more quickly. Sand casting is better for chunky, solid objects than thin, delicate shapes. Pre-heating your mold will help with this as well.

• If the mold mostly filled but details are missing, the metal either cooled too quickly or encountered air pockets it couldn't fill before cooling. Use more or better placed vents to prevent this and be sure your metal is hot enough.

• If the casting has pits or porous areas in it, there were likely impurities in the metal or it was over-heated. This happens a lot, especially in DIY casting setups and with scrap materials. Don't overheat, sort and clean your metal carefully to remove things that might impart impurities or occlusions if you want to remedy this. A pitted casting can be saved by filling the holes with an appropriate material, if you can weld or braze, or with resin, or concrete, or whatever you want.

BE CREATIVE. FIND unexpected success in your failures. And don't expect this to work out for you every time—it took thousands of years for people to master the working of molten metal. Patience, resourcefulness and tenacity will be rewarded with mountains of metal stuff. Good luck, oh dear reader.

References

- http://en.wikipedia.org/wiki/Sand_casting
- http://www.gizmology.net/index.htm

Tim McCreight, *The Complete Metalsmith*. Portland: Brynmorgan Press, 2004

Sean Ragan's casting flask via MAKE:Blog:
- http://www.seanmichaelragan.com/html/%5B2008-05-21%5D_Welded_steel_flask_for_green_sand_casting.shtml

Congratulations.
You've just stolen fire from the gods.

Funny Thing About Horizons
by Jimmy T. Hand
illustration by Suzanne Walsh

In which the reader is introduced to the use of "they" as a singular pronoun

Far, far from where I pen these words, there was once a small continent in a large sea. Most likely, the sea was on a planet entirely removed from our own, but that's not particularly pertinent to the story.

On this continent there lived people made of clockwork. They were as tall and wide as a human, had two arms, two legs, a head with a mouth and eyes and a nose; they were, more or less, what you expect people to look like. But in the center of each person's back was a keyhole, and each carried a key as unique as an iris to allow themselves to be rewound by their fellows, as they could not reach to wind themself. If a person went without winding for two days, they would wind down and die. If a person was overwound—by intention or mistake—they would die.

Many, many years ago, their society split into two: the Ikli and the Nopal. The Ikli (pronounced, if you're curious, *Ick-lee*) lived on the eastern shore of the continent—which, by the way, neither people had a name for, since it was the only land they knew—and the Nopal (*No-paul*) lived on the western shore. The two groups knew of the other only as legend.

This, then, is the simple tale of Dexa, an Ikli who took it upon themself to cross the wasteland and jungle, to walk rarely-traveled roads, to reach and explore Nopalia. Dexa didn't simply decide to throw themself to fate on the spur of the moment, of course. It was a long time coming.

Dexa was a non-builder—a person who never studied the trade of person-construction. They had instead studied the oceans and the ponderously large creatures of flesh that dwelt within. Most of their peers instead studied the wild ornithopters, the self-winding badgers, and other metal animals. The salty ocean breezes, after all, wreaked havoc on Dexa's iron skin and they were often in need of repair.

But this professional isolation alone was not enough to drive Dexa across five hundred kilometers of danger. Dexa had fallen in love with Kaxis, another non-builder, and society had turned a disapproving eye to them.

"One of you must take a break from your research to study person-construction," society said most bluntly.

"I've heard of a place," Kaxis told Dexa one night, "where we'll never need to listen to Ikli society again. Nopalia."

I expect it surprises you little that it was love which drove Dexa onto their journey. With little preparation but a great deal of trepidation and exhilaration, the pair set off down the lonely, ruined road, out past the settled lands.

They hiked through jungles, waded streams—careful to apply oil after the crossings. They climbed the high pass of Ereckal and stopped to witness a meteor shower. The sparks descended from the heavens as though a great wheel ground against the sky.

Every two days they stopped and carefully, lovingly, rewound one another.

After nearly a month, three-quarters of the way across the continent, they reached the salt flats.

"Odds aren't great we'll run into an oil spring in there, are they?" one asked the other rhetorically. By this point, after all the two had been through, the pair felt little need to distinguish who exactly had said what.

They sidetracked for days to the south, following the edge of the great desert of salt, but saw no end.

"We've come this far, I suppose."

They re-oiled one another and filled their cans to brimming before setting out across the salt and sand. Two weeks' walk and they were through it, but the days without oil had rusted Kaxis beyond what Dexa could repair.

Sorrow in their eyes, Dexa disassembled their friend and buried the pieces, returning the metal to the earth.

Dexa ran across the final stretch of plains that separated them from Nopalia, heedless to the damage that reckless running wrought on their joints. Their gears stripped, their belts snapped, their bolts unbolted, but still they ran on.

With six hours to spare, Dexa sprinted ragged into a small mining town on the outskirts of Nopalia. Their left arm half-off, they limped to a group of strangers gathered at the market. "Help me," Dexa spoke, "or I'll be dead."

Confused and frightened by the half-apart stranger with the bizarre accent, the villagers turned away and cast no gaze upon them.

Disheartened and frightened, Dexa ran westward out of town. An hour later, they reached another town, with the same result. They continued in blind panic through another two towns before they reached a city, a city of low, skeletal buildings without walls, a city of hustle and of course of bustle, a city that did half its businesses belowground.

"Please," they pleaded, falling on their knees before the first stranger they saw, "please, I will die if I'm not rewound soon. Why will no one wind me?"

The stranger, a street vendor of optics, demurred. "Where's your family? I can't wind you. What if I slip? Your death will be on my hands."

"I'll die at your feet if you don't."

"No, I simply can't risk it. I have business to see to."

With only minutes left to live, Dexa lay at the vendor's feet. But of course, if they had died then and there, this story would not be so extraordinary, for people wound down unattended to in Nopalia

every day. Each person's death, of course, was their own tragedy, but this was not to be Dexa's fate.

A person broke free from the nearby crowd and approached. "Oh my," they said, "I've been looking everywhere for you!" This, of course, was a lie. The stranger was pretending to be a friend, for the sake of social graces.

Dexa, grateful, reached into the box on their hip and withdrew their key. The stranger wound them, erring on the side of safety, and helped them to their feet. The two of them left the optics vendor to their business and joined the busy market crowd. Dexa introduced themself and thanked their savior.

The stranger introduced themself as Yatal and led Dexa to the emergency repair room. Hours later, once Dexa was bolted back together, Yatal asked them: "What were you doing on the street, so nearly unwound?"

And so Dexa told them their story, of Iklia and of Kaxis, of their ill-fated journey.

Yatal whistled in amazement.

"Why would no person rewind me?" Dexa asked as they walked the stone streets of Nopalia. "Is it because I am foreign?"

As if explaining the simplest calculus to a young child, Yatal told Dexa that it was unheard of to wind a stranger.

"In Ilkia," Dexa said, "you would not think twice about it."

"But that's horrible! What keeps them from overwinding you?"

"Why would a stranger overwind me?" Dexa asked.

"Well, to steal from you, or perhaps for revenge."

"Is that sort of behavior common here, in Nopalia?"

"No, no, of course not. But surely, you could be overwound by mistake? Left dead in the streets?"

"Occasionally. But I would have been dead in the streets if not for you."

"Well, I'm an honorable person, and well practiced at winding."

"Others are not?"

And in such a manner the two argued until they were quite good friends. Yatal invited Dexa to live with them, in their modest flat overlooking the sea.

"You'll have to pardon the salty air," they apologized, "but the rent is much lower here, and it's quite close to my work."

It came out that Yatal was a geologist who focused primarily on tidal soils, and soon the two had a new bond, that of fellow scientists of the seaside. For several weeks, Dexa accompanied and assisted Yatal in their study, and through the joy of co-discovery and the pleasures of re-oiling and rewinding, the two fell swiftly in love. Dexa missed Kaxis still, of course, but life has an unstoppable forward motion that cannot be ignored.

Dexa though, never came to accept the Nopal culture, and their dislike rubbed off onto Yatal. They considered a return to Iklia, but since Yatal was a non-builder, they knew they would find no acceptance there.

"Where can there be for people like us," one asked the other, "who love each other so deeply and yet desire a basic trust in all people?"

"Nowhere, of course. There is nowhere for us."

"Then we must keep looking."

Yatal spent their entire earnings, and the two built a boat. They stockpiled it with oil and iron and bolts.

"You won't last long out there in the salty air," society said to them. "The ocean is made for creatures of flesh, and we are people of metal."

"I don't care," they both said.

Yatal said their farewells to their family, who shuddered in sadness, resignation, and hope. "If you find someplace better than this," Yatal's builder said, "you come back and you let us know."

"I will," Yatal said.

But Yatal never came back. The boat went over the horizon, Dexa and Yatal aboard, and was never seen since.

EMERGENCY WELDING MACHINE
or, how to weld with a car battery, a pair of jumper cables, and a coat hanger

written and illustrated by Zac Zunin

WARNING: Welding is dangerous when done with proper equipment. This article covers how to do it *without* proper equipment, which is just downright crazy. Furthermore, this article is not intended for first-time welders.

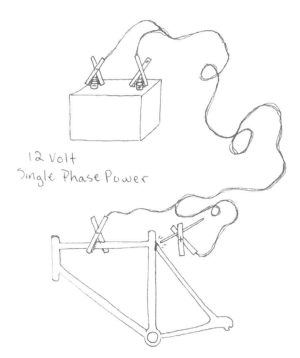

This emergency welding system isn't for long term welds, though if you're in a weld or die situation it'll do the trick.

MAKING THE MACHINE

Basically it works like this: you take a 12-volt car battery, a pair of jumper cables, and a coat hanger (or substitute mild steel scrap of appropriate size, 1/8" round or smaller). Attach the cable's negative lead (black handle) to the car battery's negative terminal, then to the piece you want to work on. Next attach the positive lead (red handle) to the coat hanger or substitute. *It's rather important to do it in this order to prevent **untimely death**.*

So now you're ready to weld. *With a single car battery you run the risk of blowing up the battery.* While this is an extremely unlikely occurrence, pulse welding is your safest option. Holding the red handle, touch down with the rod, making contact for one to two seconds with short intervals in between. Stack your welds, overlapping one atop the other.

Be aware that your rod is going to heat up fairly quickly; so wrapping the handle in rubber or leather to give you more insulation is not a bad idea. I recommend patching welds thats have to stand up to extended stress or vibration. Bikes and autos for example.

Eye protection is highly recommended, so if you don't have an auto-darkening visor or welding goggles, don't think you can pull off welding with a pair of shades because your eyes won't react properly and the damage to your retinas increases. If you don't have any proper protection available, set your workstation up in such a way that you don't have to hold what you are repairing. Set your rod up an inch above where you want to make contact and look away as you make the welds. Wait a couple seconds until the repair piece stops glowing to

check your weld. Keep doing this after every pulse or two for a better weld.

UPGRADING THE MACHINE

It's fairly simple to upgrade the basic machine to get some extra juice. All you need is a second 12-volt battery, an 18-20" section of insulated copper cable (i.e. telephone cable), or another set of jumper cables. This creates a much safer and more reliable machine. It virtually eliminates the possibility of explosion due to putting to much stress on the battery and uses much more efficient 2-phase power. The output is 24 amps as opposed to 12.

The output of the average commercial Mig welder is between 36-40 amps DC, so you can see you are reasonably approaching the necessary power to do most any weld. 24 amps (two car batteries) allows you to do continuous welds or fill in small sections.

I've built a three-battery system that puts out 36v. This system seems to burn through everything up to about a 1/16 inch thick. Also, it's possible to carry the gear for a more advanced setup; a few arc welding rods found very cheaply at any hardware store go a long way. The machine can be expanded infinitely.

Use level 6 or better replacement lenses ripped out of a Mig helmet. Usually, they're 1 by 2 inches and you can make "goggles" by creating frames out of a cardboard box and fit the lenses right in—instant visor. By using arc welding rods or "sticks" you get far better penetration on your welds, making them much stronger.

I've pushed this machine to its limits many times and never caused an explosion. Regardless, use common sense, and be careful!

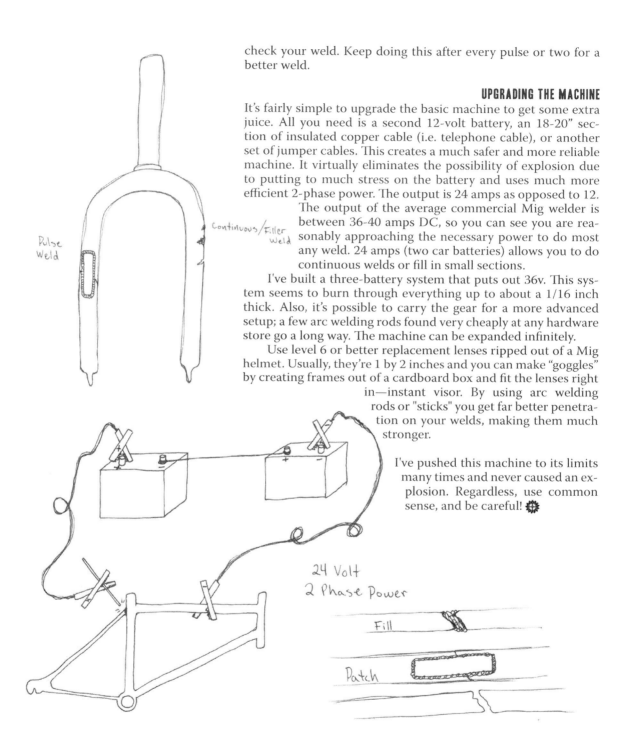

REVIEWS

ALBUM
Life Toward Twilight
I Swear By All The Flowers
Bottle Imp Productions, 2007
ltt.bottle-imp.com

THE SIMPLEST WAY TO SELL YOU ON THIS CD is to tell you that it was created entirely of antique sources, sampling music boxes and wax cylinders to great effect. The entire album is restrained, soft, and pretty. As atmosphere, it's nearly perfect.

That said, there is not so much that is *intensely* beautiful about the album, nothing to really draw you in, nothing that will haunt you hours later (with the possible exception of "Sunrise", the final track, performed on a lovely out-of-tune piano). But while this is to say that the work is not a masterpiece, it is certainly well executed and well worth multiple listens.

ALBUM
Abney Park
Lost Horizons
2008
www.abneypark.com

IT'S POSSIBLE THAT THERE'S NO MUSICAL ACT more invested in steampunk than Abney Park. Their latest album shows this; it's the first of their releases that speaks intentionally to steampunk. Musically, it's gothic-electronic-rock, and it's their best work to date.

The first song, "Airship Pirate", is probably the quintessential steampunk pop song: tongue firmly in cheek it introduces the Abney Park concept: Abney Park are airship pirates. There's even a song, "Virus", that I'm pretty sure is comparing the spread of religion to the zombie apocalypse.

Other highlights are the European-folk-influenced "This Dark & Twisted Road" and the waltz-beat "Herr Drosselmeyer's Doll". Probably the biggest disappointment on the album is "Post-Apocalypse Punk", which well, isn't punk. Or if it is, it's the kind of punk I've always shied away from and always resented.

The work is definitely a maturation for the band, as though they have finally found their voice.

ALBUM
Crow Tongue
Ghost:Eye:Seeker & The Red Hand Mark
Hand/Eye, both 2008
www.lostgospel.org

CROW TONGUE IS WEIRD. LIKE, THE SKY HAS GONE GRAY AND purple weird, like death-vapors weird, like early Pink Floyd weird. This is a good thing. Most of the time, music described as weird—or associated with hallucinogens—isn't my thing, but both of these albums are clearly listenable.

The first release, *Ghost:Eye:Seeker*, is a drone of occult chanting, noise, and guitar/sitar. Traditional song structure is functionally non-existent. But the album refuses to fall into the trap that so many noise/experimental albums do: this music conveys emotion, and it refuses to sit in the back of your mind. This album would do well played at the climax of your next evening at the opium den in a ghost town's Chinatown, if you ask me.

The second release, *The Red Hand Mark*, seems at first to be more traditional; there are songs, after all. But it breaks into quite interesting territory. Imagine acoustic doom metal. With banjos (well, homemade bass-banjos). And no screaming. Hard to wrap your brain around. Just listen to this CD. Unfortunately, while The Red Hand Mark has moments far more powerful than Ghost:Eye:Seeker, it has more disappointments as well. Thus is the curse of traditional song structure.

Lest you fear that your opium den will go without soundtrack, pick up *Prophecies & Secrets*, which is The Red Hand Mark in dub. Even weirder. Better? Apples and oranges, my friend, gears and flywheels.

The packaging for all of these CDs is beautiful. It's DIY done right. I for one will not mourn the death of the jewel case.

BOOK
Greg Broadmore
Doctor Grordbort's Contrapulatronic Dingus Directory
WETA Publishing & Dark Horse Comics, 2008

AS A FULL DISCLOSURE, MY COPY OF THIS BOOK didn't survive my most recent move and I no longer have it in front of me, much to my displeasure. This thing made for near-perfect steampunk bathroom or coffee table material: something easy and fun to browse. The art it in is absolutely top-notch.

It's a fictional catalog of rayguns. And WETA, the publishers, they know rayguns, better than pretty much anyone outside the department of defense. I'm a sucker for this format, the fictional catalog. I love little descriptions of various fictional trinkets and creatures and people. I've loved them since I first discovered RPG books over fifteen years ago. The book is, of course, steampunk as all get-out, hamming it up without ever quite tipping over into mockery. There are mad scientists and mad colonialists off on their imperialist hunting missions, all well-executed.

Call me a curmudgeon, but I remember some of the humor in this book as a bit off-color in a way I'm not prone to appreciating. And while the book is large, full-color, and beautiful, it's quite pricey for a mere 32 pages of content. Those things aside, makes for a perfect gift to give someone: even if you tell them what they're getting, they won't be able to remember the title!

BOOK
Paul Marlowe
Sporeville
Sybertooth Inc, 2008

SPOREVILLE IS A FANTASY NOVEL SET IN A SMALL town in Nova Scotia in 1886. It follows two new residents in the town who begin to notice how strangely the entire population is acting. In traditional young adult novel fashion, the protagonists learn to overcome challenges without the help of their elders.

The main characters are clearly and colorfully portrayed, forming a vivid picture of their world, but this reviewer was able to discern the path the book was going to take after only a few chapters. That said, it was certainly readable and I will happily pick up any future books in the series.

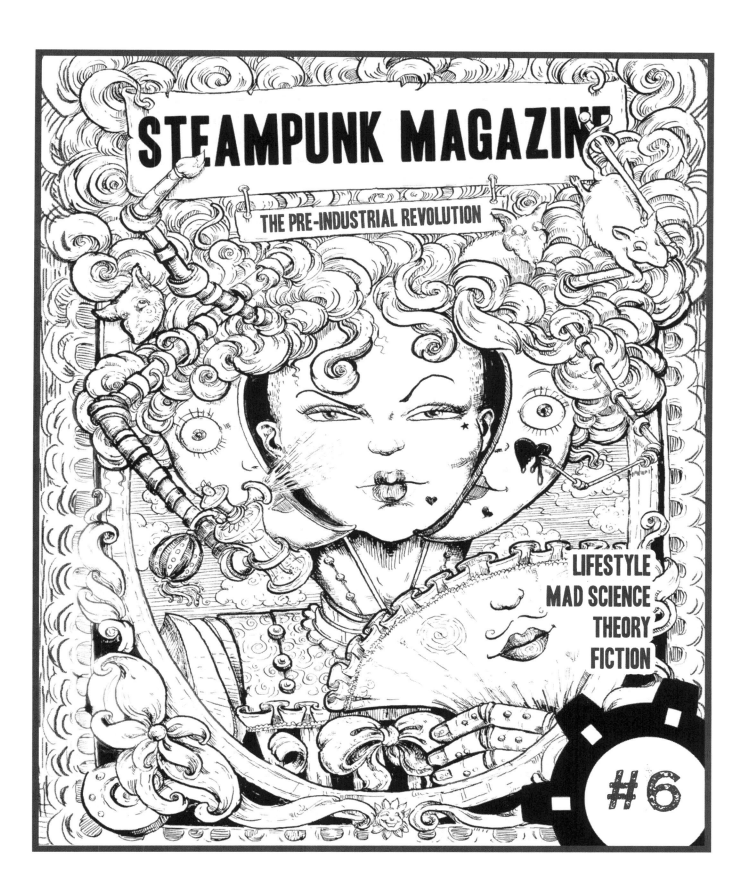

As the Liberty lads o'er the sea
Bought their freedom, and cheaply, with blood,
So we, boys, we
Will die fighting, or live free,
And down with all kings but King Ludd!

When the web that we weave is complete,
And the shuttle exchanged for the sword,
We will fling the winding-sheet
O'er the despot at our feet,
And dye it deep in the gore he has pour'd.

Though black as his heart its hue,
Since his veins are corrupted to mud,
Yet this is the dew
Which the tree shall renew
Of Liberty, planted by Ludd!

–Lord Byron
Song to the Luddites

The cover was illustrated by Molly Crabapple.

O Dear Reader,

THE VICTORIAN AGE IS SLOWLY BECOMing to steampunk what the Dark Ages is to sword-and-sorcery. A certain amount of this is inevitable: as steampunks, we are in love with Victorian technology. We adore the machines that come from an age before endless replication reduced everything into soulless copies of itself—lacking any sort of individuality, and plastered with labels warning us not to interfere with machines whose workings we cannot possibly understand. However, beyond the factories of the late eighteen-hundreds, whole centuries lie unexplored; waiting for us to ask that question which lies at the very heart of steampunk: what if?

It is only when we ask ourselves this question that we can find out just how much that we have in common with the ethics of the Romantic poets, painters and musicians of the early nineteenth century—people who rejected the values of increasing mechanization to live in harmony with technology, with Nature, and with one another as friends and lovers, as companions, and as equals. It is only by asking 'what if' that we begin to look at ancient sacred science or the political uprisings of the French Revolution and Waterloo, and begin to take what we can learn from all these things, and use them to build a better future for ourselves.

Steampunk has always been a melting pot of ideas, where the present and the past intertwine with the fantasies of our own imaginations—and too often are those imaginations restricted by the silent rule that, in order for something to be steampunk, it has to be Victorian.

In fact, we should reject that seemingly unbreakable connection just as thoroughly as we reject suggestions that steampunk should be nothing more than historical re-enactment. We should expand our horizons before the Victorian age becomes the rope by which we hang ourselves—until we become little more than the meme which our detractors claim us to be.

Let us study our relationship with technology anew. The Industrial Revolution may have brought us the smoking, seething, rumbling machines that we all love so much, but steampunk is not an industrial revolution in and of itself. In fact, in our rejection of mindless commercial consumption (in loving the machine, but hating the factory), and in our desire to use our contraptions in harmony with Nature instead of against it, steampunk is often a non-industrial, if not a pre-industrial revolution.

By no means should we forget about our steam engines, or cast aside our corsets and our top hats, but these things are not all of what we are. And, while we should continue to embrace them, we should also make sure that we don't stop ourselves from asking that irresistible little question …
"What if?"

–C. Allegra Hawksmoor

Correspondence

Direct any letters to COLLECTIVE@STEAMPUNKMAGAZINE.COM. *Letters may be trimmed for space reasons and/or edited slightly for "proper" grammar.*

on steampunk in brazil

Dear SPM,

I am part of your new Brazilian audience, those who have found the magazine at WWW.STEAMPUNK.COM.BR. What is Steampunk to me? After reading some comics and mangas (Wikipedia's list of Steampunk works), I would say that Steampunk to me means your magazine, the Steampunk Magazine, please never stop writing it. I just read issue one, and even decided to start writing some melancholic Steampunk, using your excellent work like source material and inspiration, since this genre is non-existent in Brazil.

–Leandro Bonatto

two missives on formatting

Are you likely to release issues 3 and 4 in imposed versions?

–Alex

I've just started downloading and printing your fantastic publication. I'm absolutely loving it, wonderful work. I was wondering though, how long will it be before the 11x17 imposed formats for issues 3 and 4 are put on the site? Also, as I'm Australian, A3 imposed would be a lovely addition to your range of formats.

–Frazer

Allegra responds: Hopefully, we will be releasing issues #3 and #4 in 11x17 imposed format very shortly, however we are only able to do this because of assistance from our readers. Unfortunately, we simply do not have the time that we need to offer the magazine in as large a variety of formats as we would like. That said, should anyone take the time required to convert SteamPunk Magazine into other formats that are useful for our readers, we will happily reward them with a copy of their favourite issue of the magazine.

on utopia and infernal instruments

I came upon a few copies of your publication at the Portland public library and have been reading them with some fascination. Having constructed some relatively simple musical instruments myself, I was particularly interested in the articles and stories which talked about the construction or use of experimental or otherwise interesting musical instruments. In one of the very few stories written by Clark Ashton Smith that does not

take place on some distant planet or some ancient, long-disappeared continent, but rather in northern California in the 1920s or thereabouts (not too late for steampunk, I hope), "The Devotee of Evil," a musical instrument intended to call up the essence of "metaphysical evil" is described. Not believing in "metaphysical evil," I have thought it would be fascinating to try to create an instrument fitting the description (check out the story on the website www.eldritchdark.com). Unfortunately I do not currently have the means to build it.

Along the lines of experimental musical instruments, I plan to construct a few sculpture/instruments using (among other things) parts from a broken typewriter and a broken alarm clock (misappropriated technologies) ... This also fits in with the sort of critique of technology that I have (and that seems to share some affinity with the steampunk ethos), in which I would like to see the massive technological apparati dismantled and individuals and small groups using the pieces in a bricolage manner to create what they want ... Though I do see certain machines as a complete disaster (the internal combustion engine and the things that require it to operate), I think that people freed of pre-constructed technological systems and the governments which impose rules on their lives, could create all sorts of lovely gizmos and gadgets to make their loves more enjoyable and adventurous ... Utopian dreams of course.

Along those lines, have any of you read William Morris' revolutionary utopian novel News From Nowhere? He was a Victorian era utopian, anti-authoritarian communist. His novel is interesting in that it doesn't try to give you a description of precisely how this society is run (this reflects Morris' anti-authoritarian sensibilities), but rather tries to take you into the daily lives of people in the society, and talk about how a revolution might lead there (through the central character, a Victorian socialist who dreams himself into the future, talking with an old man whose parents had lived through the revolutionary period). In any case it is interesting on a lot of levels. My main criticism is that Morris has little critique of the dominant gender roles of his time.

Reading the magazine also caused me to think of the comic artist, Rube Goldberg. I would assume that you have seen comics of Rube Goldberg machines, those overly intricate contraptions, all completely mechanical (no electronics or electricity involved) for doing the simplest tasks. All very surreal machines, the utility of which is simply an excuse for making a hilarious contraption. The game Mousetrap is based on Rube Goldberg's machines. I have dreamed of working up similar things. Along these lines, I recently learned from a friend that the US surrealist, Robert Green, has been making steam engines that have no use, but operate on "surrealist principles."

In any case, I have enjoyed your magazines so far and am wondering where someone who only has computer access at the library (where printing out copies is 10 cents a page, and they now have machines to prevent scamming) and would like to get his own copies might find them in Portland (I checked out Powell's, but they are all out).

–Apio

Margaret responds: There are a few stores around the world that carry SteamPunk Magazine, and most of them are in Portland, Oregon. That's where the magazine is printed and mailed from, at the moment. Your best bet is probably the anarchist bookstore Black Rose Books, on Mississippi in North Portland, or Reading Frenzy in downtown, right near Powell's. However, none of these stores are guaranteed to have it in stock, so we do suggest ordering it directly from our publishers online at www.tangledwilderness.org.

REVIEWS

We are quite happy to review whatever it is that you feel counts as steampunk enough to warrant review. We will, however, only review physical submissions (rather than pdf books or mp3 albums). Contact us at collective@steampunkmagazine.com *to find out where to send things!*

BOOK
Jonathan Green
Unnatural History
Abaddon Books, 2007
www.abaddonbooks.com

A dashing adventurer with a butler who would make Bruce Wayne's Alfred flush with pride; a beautiful damsel in distress; dinosaurs in London Zoo and the grand, world-spanning empire of Magnus Britannia preparing to celebrate Queen Victoria's 160th jubilee. All of this leaves little room for complaint in the first in Abaddon Books' *Pax Britannia* series.

Unnatural History opens with Ulysses Quicksilver—gentleman thrill-seeker and secret agent—returning from his presumed death and being sent to investigate a break-in at the office of Professor Galapagos: foremost authority in the field of evolutionary biology. Enter Genevieve, the professor's innocent and beautiful daughter, imploring Ulysses to find her daddy.

Taken on its own terms, the book is a fantastic whirlwind of larger-than-life characters and spectacular scenes which would bankrupt any Hollywood studio that tried to recreate them. Steam-powered policemen and steam trains chugging over the streets of London, cravats and gas lamps provide the steam. Meanwhile, the broadly-painted, diseased slums of London, and the revolutionaries fighting for the downfall of the corrupt Monarchist system provides the punk.

But all of that comes second to the fast-paced story which, by the end of the first act, sees our hero single-handedly take down an escaped megasaur with nothing but his swordcane and bare hands. The over-the-top action comes so fast and furious that it feels a little like being thrown from a waterfall.

The occasional pause to catch the breath would be welcome, but that minor grumble aside, this is a great way to spend a few hours. Especially for all those of us who grew up with *Indiana Jones*, *Jurassic Park*, and *James Bond*, who bought the first *Pirates of the Caribbean* for our nephews, but ended up keeping it ourselves.

EP
Ghostfire
Drunk Lullabies
www.myspace.com/ghostfire

Proudly flying the flag for British steampunk music, Ghostfire's debut EP is a cracker. Next to Abney Park's Romantic airship pirates, this group of Londoners is the silver-tongued opium storyteller and sideshow carouser.

The music is driven by the drums and bass guitar, with competent lead guitar showing touches of Iron Maiden and electric folk, and organ from a mid-sixties blues band. It sounds like it's coming out a sweaty pub of ledger clerks and coal men drinking hard to escape their day's toil in the crowded streets of Victorian London.

The lyrics imply a story without ever telling it, following threads of what might be metaphor, might be mythology, or might be the free-association of the freakshow peddler as he stands in-front of his crowd.

The opening track, "Vaudevillian," is a burlesque number which ties the heroine to the train tracks while twiddling its moustache. "Masters of the Sea" and "Ghostways of Paris" are full of that rhythm section, making a deep engine throb with lead guitar and organ highlights and lyrics which are both sinister and pleading. The closing track, "Barrio," is a dark but charged wil o' the wisp, promising enlightenment if you stray from the path.

Unmistakably British and unmistakably steampunk, the only complaint one could raise would be the length of the EP: four tracks is enough to whet the appetite, but leaves you wanting so much more.

ILLUSTRATED CHAPBOOK
Steven Archer
Red King Black Rook
Raw Dog Screaming Press, 2009
WWW.RAWDOGSCREAMING.COM

By very definition, a short story has a limited amount of time in which to establish a world, a mood, and a storyline. They have to claim our attention from the start, and here *Red King Black Rook* succeeds admirably.

A dark and claustrophobic tale of royalty, family, greed, and war, with the sense of a morality tale from several hundred years ago, the story of *Red King Black Rook* echoes throughout history, but leaves us free to chose whether to draw parallels with modern or ancient history. It is not an attractive tale, but it encapsulates a universal truth of human (and corvid) nature.

The characters are well written, in that the characterisation (or lack of it) matches well with the characters being written about: the King is bloodless and horrific; the Rook pleasant, obedient, and a cipher. It is not a book in which we are likely to feel any sympathy for those being written about, but the writing is such that curiosity about the people and the situation keeps the attention focused.

The language is stylised and always evocative, while the book design itself is excellent: the typeface, the layout, and the illustrations beautifully compliment and enhance the story. Well worth a look!

ALBUM
Imaginary Airship
Where Dreams Take Flight
Sound Ghost Recordings, 2007
WWW.MYSPACE.COM/IMAGINARYAIRSHIP

Imaginary Airship's *Where Dreams Take Flight* is an album with something of an identity crisis: with vocal and guitar tracks that are reminiscent of Elliott Smith mixed in with synthesizer instrumentals that sound like a combination of Brian Eno and the Flaming Lips. The lyrics themselves are sometimes romantic, sometimes introverted, and sometimes resentful, and the whole album has a hazy, dreamlike feel to it which can sometimes cross the line into sounding slightly uncommitted. The album's best (and most identifiably steampunk) track is "Mr. Wonderful" with its glockenspiel instrumentation, which sounds almost as though it could be a response to the Dresden Doll's "Coin Operated Boy."

All in all, *Where Dreams Take Flight* is an enjoyable album to listen to. Although it isn't entirely what we'd call steampunk, it is certainly worth keeping an eye on how their sound develops in the future.

TWO DEMOS
Trousseaux
Self-released
WWW.MYSPACE.COM/TROUSSEAUX

We do like to find something original in a demo. Whilst Brighton based Anglo-French outfit Trousseaux's armory (guitar, drums, piano, cello amongst others) may not be anything particularly new (think electronically tinged gothic-post-rock) it's their unique approach to writing songs that immediately impresses.

The little things like the intro to the modern day Hammer Horror sound of "La Nuit" which stands out. Or, the crashing waves throughout "Absence" which would be lovely and calming, were it not for the haunting piano and bass which follow. Granted, the earlier tracks on these two demos show some teething problems—the rhythm guitar on "Even Jane" being noticeably (and hopefully not deliberately) awkward, but their sound progresses in the later tracks and singer Virginie's voice is beautiful throughout, especially on the French Language tracks.

Trousseaux may have a long way to go until their sound is perfected, bit it'll be interesting to see where they can take it—because there's certainly some potential in these two self-releases.

THE LUDDITES

by Carolyn Dougherty
illustration by Benjamin Bagenski

The winter of 1811-1812 was particularly hard for the poor in England. Food was unusually scarce due to the deprivations of the Napoleonic Wars, the meager harvests of 1810 and 1811, wartime trade blockades, and a rapidly increasing population—14% between 1800 and 1810. A substantial number of people were facing a precarious existence.

In Nottinghamshire, stockingers had been producing stockings and

other small articles of clothing for nearly 200 years. At that time there were about 30,000 knitting frames in operation in the region, mostly in workshops with a master and two or three apprentices. Hosiers managed the trading end of the business, arranging for the clothes to be sold and often renting knitting frames to stockingers who couldn't afford to purchase them.

At that time, stockingers used small frames to knit clothing in single pieces which gave them finished edges on each side; around 1803, however, a few hosiers began to encourage stockingers to use wide frames, originally used to make pantaloons—making sheets of fabric which were then cut up to make gloves and stockings. These garments, which did not have finished edges, were of poor quality and frayed quickly. Wide frames required less skill to operate, so non-apprenticed workers could operate them. Skilled and apprenticed stockingers were outraged at this use of wide frames—not only were they now expected to compete with unskilled workers for lower wages, the poor quality of the goods produced in this way caused frame knitting to become a dishonourable trade.

A few incidents of sabotage and mob gatherings took place in early 1811. In November of that year, a group of men led by "Ned Ludd" (the name had probably originated a generation before, when an apprentice who had been unfairly beaten destroyed his stocking frame) attacked a workshop in Bullwell. The rate of sabotage escalated until the "Luddites" were breaking 50 frames a week; before the attacks ended they had destroyed more than 1,000 frames. The groups who undertook these attacks were orderly, organised and armed, distinguished by their thoughtfulness, deliberation, and orderliness—traits the elite generally prefer not to ascribe to workers. They were also careful to focus solely on enforcement of quality and employment standards; General Ludd went so far as to return personal property stolen in an attack on a workshop in February 1812. By the end of 1811, most workshops had halted their unacceptable business practices, posting signs stating their compliance with the rules. Attacks in Nottinghamshire had all but stopped by early 1812.

As the Luddite movement was dying down in Nottinghamshire, it spread through its delegates to other regions and other trades, with different backgrounds, grievances, and targets—wool croppers in Yorkshire in early 1812 and cotton weavers in Lancashire and Cheshire in early 1813. While the original Luddites were not fighting the mechanisation of their trade, the Yorkshire and Lancashire Luddites destroyed machinery designed to automate skilled labour. In contrast to the guerilla tactics against small workshops in Nottinghamshire, the Yorkshire and Lancashire Luddites, due to the size and concentration of the machinery they were attacking, staged major battles. The scale of the latter two movements and the political leanings of their participants made them more consciously insurrectionary and directly threatening to the national power structure.

The Yorkshire Luddites were more secret, more paramilitary, and more violent than the Nottinghamshire group; while the Nottinghamshire Luddites had been committed to non-violence, the mood in Yorkshire changed after a manufacturer killed two Luddites in an attack on Rawfolds Mill. In late April, George Mellor (a leader of the group) declared that "the Masters must be shot"; as good as his word, he and a colleague later ambushed and murdered a local mill owner. After this assassination the movement in Yorkshire lost its focus, becoming embedded in revolutionary factional politics. Raids were organised not to break machinery but to steal arms and money, and looters used the Luddites as a cover for their activities.

The national government at that time was entirely occupied with the war against Napoleon; it was investing so much in the land and sea war in Europe that little was left for internal affairs. Despite the pleas of overwhelmed local forces, the Luddite protests did not receive national attention for nearly a year, and when the government finally took notice they overreacted; a bill making frame-breaking a capital offense, and increasing the police powers of the state, was proposed in Parliament in February 1812. Lord Byron, who lived in Nottinghamshire and who had been new-

ly appointed to the House of Lords, wrote to Lord Holland:

> By the adoption of a certain kind of frame one man performs ye work of 7—6 are thus thrown out of business. But it is observed that ye work thus done is far inferior in quality, hardly marketable at home, and hurried out with a view to exportation … we must not allow mankind to be sacrificed to improvements in Mechanism.

His speech on the bill pointed out that the "mob" they were so afraid of were the same men who did the country's work and who had fought against Britain's enemies. But Byron lost interest when *Childe Harold* was published shortly thereafter, and the bill (with the support of William Wilberforce, among others) passed later that year. Parliament requested Wellington to send troops from Spain to control the rebellion in the north; in the summer of 1812, 35,000 soldiers were sent to Yorkshire and Lancashire. Luddism as a distinct movement had dissipated before the notorious trials at York Assizes in January 1813 in which Mellor and two associates were hanged. Fourteen more were hanged a few days later, the largest number of people ever hanged at once in Britain, ostensibly for robbery and "oath taking" but in reality for challenging the power of the state.

IT SHOULD BE noted that the Nottinghamshire stockingers had had actual legal rights, as specified in guild and corporate charters as well as statutes, concerning the employment of apprentices and the length of their required service, the number of pieces of equipment controlled by one person, the use of particular kinds of equipment, and the quality of goods permitted to be sold. These rights had been challenged in London in the early 18th century and in Nottinghamshire in the 1770s, and stockingers had retaliated by breaking frames. In the early 19th century stockingers had fought to enforce these protections through legal means to no avail; in 1809 these legal protections were repealed, leaving them with no alternative but direct action.

It should also be noted that the actions of the capitalists that prompted the Luddite protests are the same as those Naomi Klein describes in *The Shock Doctrine*. Manufacturers took advantage of the disruption caused by war, inflation and scarcity to introduce such inimical economic practices as new uses of technology, the factory system, unrestricted competition, undermining of traditional standards and practices, and undercutting wages and prices. Industries and regions in which capitalists did not take advantage of the social disruption to institute these changes suffered no unrest. The tactics the government used against the movement—infiltrators, spies, *agents provocateurs* and torture—are also still used by governments today; agents had no qualms about extracting wild confessions from suspects under torture, then using them to stir up fears of a mass uprising controlled and funded by foreign (French or Irish) terrorist governments.

The Luddite movement should be considered in the context of the British tradition of popular uprisings against imposed authority, from Boudicca to the poll tax riots. Such protests have been organised not only among the industrial proletariat but also agricultural workers (the Swing riots) and even small landowners and professionals (the Pilgrimage of Grace) and aristocrats (the Barons' Rebellion). Luddism merged into later protest movements resulting from the dreadful conditions caused by the spread of the factory system, described by Friedrich Engels in *The Condition of the Working Class in England in 1844*. Protests and uprisings eventually led to some Parliamentary reform and increases in suffrage throughout the 19th century.

The quotation below seems to encapsulate the typical modern response to Luddism:

> Invention, once made, is as permanent a part of civilisation as the DNA of a gene of a human embryo which becomes a permanent part of the individual. Once the characteristic it represents has been encoded, it is inevitable that

eventually it will be expressed. ... The arrow of time moves in one direction only. ... New stages can be added to the progress of invention. But it is not possible to uninvent.
–Robert Reid, *Land of Lost Content*, 279-280).

Most people seem to think the lesson of the Luddites is "progress cannot be stopped"; in reality what cannot be stopped is the use of economic power by elites, particularly when it is rendered invisible by the language of technological progress. Production processes are not mechanised because mechanisation is inherently "more efficient" and therefore better; if that were true, why is it that while our machinery is produced by mechanised labour our clothing is still produced by poor women? It is clear that there is no such thing as "technological progress." Some people may object to this statement, pointing out that people cannot be kept from inventing and improving; this is true, but there is a difference between the invention and the dissemination of a technology, and the latter only happens if someone can profit from it. The idea that technological change is autonomous is a dangerous myth which advantages economic elites by making their influence invisible. The technological changes of the Industrial Revolution were based on the forced acquiescence of the men, women, and children whose ability to survive was eliminated by the "enclosure" of common property in the late 18th and early 19th centuries; the majority of England's inhabitants were left with no choice but to submit or starve. It is a common misapprehension that technological "progress" increases living standards; the living standard of the English working class did gradually increase over the 19th century, not because of technological change, but rather because England's population began to benefit from exploiting African, Indian, and Asian people.

I believe the following "lessons from the Luddites" are both truer and more useful:

TECHNOLOGY IS NOT the same as machines, and technological change doesn't necessarily mean a change in machinery. The most significant technological innovations—the factory system, the wide frame (or to take a current example, the shipping container) may have nothing to do with new inventions, though other social or technological changes (e.g. enclosure, changed methods of distributing goods, computerised record keeping) may increase the benefits of their adoption to groups with the power to effect change.

As Kirkpatrick Sale points out, "technologies are never neutral." However, he is incorrect when he goes on to say "and some are hurtful." Technologies reflect the economic and social system in which they are embedded; any change in technology will disrupt the balance of forces in this system and create winners and losers. A technology is never adopted unless it is perceived to benefit a potential winner—in our culture, this invariably means unless it is perceived to economically benefit a group that already has enough power to bring about the change.

Workers acted against a few unscrupulous and greedy hosiers who forced the majority to follow their practices in order to compete; there is always a "race to the bottom" when even one individual cheats without facing any legal or social consequences.

Centuries before our current non-violent activists, the Nottinghamshire Luddites understood the importance of fighting the system, not the people. They did not dilute their message or give the "other side" the moral high ground by harming people. In Yorkshire the community initially supported the movement when it conformed to this social norm but was unwilling to condone assassination even in response to violence on the other side.

The decision of groups other than those currently in power to influence the pace and direction of technological change is, far from being a misguided and ultimately pointless attempt to stop the inevitable, a reasoned and legitimate mode of participation in an open and democratic society.

Of Mice and Journeymen
by Dylan Fox

Carter Brown sat in the gloom, staring into his mug of dirty water. He stank of horse and he was sitting in a bar, sober enough to notice it. The day could only get better, he mused, using his identification card as a coaster. Three days riding in a mail carriage and a day-and-a-half on foot, and the oligarchy knew where he was before he'd even finished walking. He took a sip from his mug.

"Corporal Brown."

The voice was firm. It didn't ask questions, it made statements and expected not to be questioned.

"Card," the voice said. Carter stood, and handed it over.

The hisaab took it and studied it carefully. His eyes lingered on the wet ring the mug had left. In the dirty yellow light, his white robe seemed artificially crisp and clean.

"Defamation of official documents is a chargeable offence, Brown."

"Yes, mawla," Carter answered, his eyes focused on a point over the hisaab's shoulder.

"Count yourself lucky it's not worth my time extracting the fine from you," the hisaab said. "See me tomorrow, three o'clock in the afternoon. Don't be late."

"Yes, mawla," Carter answered.

The hisaab's skin was pale and his eyes bulged. The clusters of men drinking away a day spent breaking their back for pittance didn't look. They sat in silence, staring at the centre of their tables.

The hisaab dropped Carter's ID card on the table, turned and left. Carter made his way to the bar.

"I don't want trouble," the barman said.

Carter leaned heavily on the bar. He took his union travelling card out, and showed it to the barman. The barman looked at it suspiciously.

"Got a room?" Carter asked.

The barman didn't answer.

"He's from out of town," the barman said. "Oligarchy doesn't send them sorts down here unless it's for something special. You're from out of town, too."

"I assure you," Carter said, "that he's nothing to do with me."

"Corporal, is it?"

Carter shook his head. "The hisaab was just winding me up. Ain't been in uniform for years."

The barman looked at him.

"Horace Farrow," he said, offering his hand.

"Carter Brown," Carter said, taking it. "*Mister* Carter Brown."

Horace Farrow nodded, satisfied. "Never trust a man who won't give you his name. But I'm tight up this month, I'm afraid friend. Rooms are a dollar a night, and I'm going to need that dollar."

Carter bit back on his anger. He didn't have a dollar and if he did, he wouldn't be drinking filthy stable water.

A coin slipped across the wet counter, pushed by a calloused forefinger. Carter looked around and saw a lined face under thinning grey hair partially hidden in the gloom.

"Can't have you sleeping on the streets," the man said with an empty look in his eyes. Horace took the money.

"My credit good for a drink?" Carter asked.

The stranger laughed.

"If you beat up the sandboy, you can dig through the shit on the floor and look for nickels."

"If my name's still on the slipboard tomorrow, I'll be taking you up on that offer."

The man melted back into the gloom and after another hour, Carter made his way up to the room, balled his coat into a pillow and fell asleep on the floor. Without the feeling of movement or the sounds of men shouting and marching, he slept uneasily. Memories poked their icy fingers in and made him shiver and whimper. He drew his knees up to his chest as if he could somehow find the peace of the womb.

Despite the night-ice lingering in the dawn, the print room was already hot and stinking like hell. Carter hung surreptitiously at the edge, working the lid of the empty ink bottle he had in his pocket.

"Brown?" a man asked, emerging from a back door. The printer's devil and runners made their way around him.

Carter took the travelling card out his pocket, and showed it to him. The man nodded, and made a tiny gesture with his head. He looked different in the half-light of the print room, but that look in his eyes was the sort of thing to stick with you.

"Stirling," he said, without offering his hand. "You okay with announcement sheets?"

"Yeah," Carter said without enthusiasm. "Someone's got to do it—"

Stirling slapped him across the cheek.

"You watch your mouth," he said, calloused finger breaths away from Carter's nose.

"I just thought—"

"You be careful what you *think*, road-rat," Stirling said. "Announcement sheets are regular work with a good return, guaranteed, every day. We ain't losing the contract because some drunk couldn't keep his head to himself and him upstairs fancied he heard something he didn't like when he's transcribing. You know those quarizimi pick up on things. Stray thoughts. I've got two small-time shops willing to kill for the contract, if they could get away with it."

Carter exhaled slowly through pursed lips.

"This isn't an oligarch shop, then?"

Stirling shook his head.

"We're independent," he said. "Runner brings the cable sheet over from the office, prophet upstairs turns it into words and sends it down to us, and we print it up in time for service. If we're late, runner brings the cable sheet to another shop."

"Why don't the oligarchy have their own shop here?"

"History," Stirling said. "And we don't want them thinking they need to own us."

Carter understood.

"Sorry, boss," Carter said. "Long time on the road. Long time sober."

Stirling nodded, and the moment passed.

"That's Laura," Stirling said, gesturing to the selftype machine, sitting in the middle of the room like a spider in her web.

Carter looked, and took the time to appreciate her. She was as big as a mail coach and, if she could speak, would talk as plainly as a fishwife.

"Dyler fourteen, isn't she?" he asked.

Stirling nodded. "Bit temperamental."

"The fourteens have a square-cut balance arm, which means it jams if you don't pull the stamp at an angle."

Stirling nodded.

"Can I get to work?"

Stirling nodded again. "Sure."

"Runner'll bring the sheet down in about an hour," he added. "Make yourself at home until then. There's a batch of posters and ads that need printing up, silver tray over there. Work through them so Laura can get to know you."

Stirling patted her side firmly.

"Good girl," he told her.

He went back through the door, and Carter took a deep breath. He'd repay Stirling's dollar the next time he was in a bar, had a dollar to spare, and a journeyman came off the road looking for a bed. That was what you signed up to when you took a union travelling card.

The silver tray had become black long ago. Everything in the print room was black from ink and soot, including the air. As Carter took an advert for hair tonic out the tray, he heard the sound of the printer staggering into life in the next room. Carter sat down at Laura's keyboard, snapped the ad into the holder, and ran his fingers over the keys. The heat of the furnace was already making him sweat. He could smell the molten lead.

As he pressed each key, an individual metal matrix fell from the magazine towering above him, and Laura arranged them into a neat line. Each matrix was embossed with a letter and together, Carter and Laura turned them into sentences. When a line was done, Laura swiped it away and poured the liquid metal over it. The sentence slug quickly solidified and was whipped away, dropped into line and waited for the runner to take it to Stirling at the printer.

Carter's fingers were quick over the keys and almost perfect. Occasionally, a letter would drop out of order and he'd

take the matrix out the line before he gave Laura the nod to cast it.

He remembered arranging each letter by hand when he was an apprentice learning his trade. He remembered marching in protest and smashing shop windows when they tried to bring in the selftype. It was an unholy concoction of hot metal, ringing brass and persistent, whirling rods, wreathed in steam and smoke from the moment the printer's devil lit the furnace before dawn. It made the seven year apprenticeship he took useless. It made him useless. The army was waiting for him.

When the army spat him out and he came back to the print room, the selftype was waiting for him. The union had adopted it with all its heart, and it was only when he'd learned its art that he understood why. He learned on an Errington Axis, like a schoolboy learning how to make love. Then the Dylers had brought out the Mark-3, and he'd learned from them. Each new machine brought an impossible set of complications and flaws which had to be worked around, worked with and cleaned up after. It took him another apprenticeship to learn how to listen to the selftype. A print shop couldn't function without a selftype, and the selftype couldn't function without a union journeyman.

As the morning got late, the silver tray emptied and Carter got typeblind. The outside world stopped existing for him. At the end of the last advertisement, he hammered out three lines of nonsense and left them for the printer.

Stirling tapped him on the shoulder, and handed him the announcement sheet.

"Needs to be done by half-two," he said.

Carter looked over the neat, carefully drawn handwriting. He didn't see the carefully-chosen news the oligarchy was choosing to tell the world. He saw lines of type that needed setting, odd punctuation marks and awkward spacings. Half-two—ready for to be consumed at the attendance-expected six o'clock announcement.

"It's going to be a ball ache," Carter opined.

"Worried about getting your pretty fingers dirty?" Stirling asked. His face was serious.

"'Time is a trick of the mind, a trap for lazy souls. All the time in the world is in this moment now.'"

"'Lay me out a day of sun and a stream of spring water, and I'll show you where eternity lies,'" Stirling added, finishing the quote. "If it's not done by half-two, the guy upstairs will have your balls on the anvil."

"Name?" the hisaab asked.

"Carter Brown," Carter answered.

The hisaab nodded, and used the long, thin finger of metal to operate switches on his quarizimi. In the daylight he looked young. His short black hair was waxed back and stuck his skull, making his angular face look almost inhuman.

"Occupation."

"Travelling journeyman printer."

More switches were touched. The quarizimi sat on the desk by the hisaab's right hand, an irregular box the size of a house cat. The cogs, gears and springs inside let off small pops, clicks, and sighs as they moved.

"Unique identification number."

Carter reeled it off. He'd had it since the day he was born, so it wasn't hard to remember.

The hisaab nodded, and entered it into the quarizimi. The machine let off a cough of steam, and the hisaab paused to pour water from a glass jug onto a matte black square on its surface. The water bubbled, and then sunk inside. Its clicks became more regular, more gentle.

It was remembering, thinking, analysing. The hisaab touched its brass keys, and somehow the insides of the machine mulled it over and came to conclusions. It was turning the world around it into the teeth of a gear and manipulating them. Carter tried not to look. He tried to look at a point over the hisaab's left shoulder, and to keep his eyes carefully sober and neutral.

"I am going to ask you a series of questions," the hisaab told him. "You will answer them honestly—you will gain nothing by attempting to lie. Do you understand?"

"Yes, mawla."

The hisaab nodded, and the quarizimi sighed and clicked. Along the top of it, there was one-hundred-and-thirteen tiny brass rods which rose and fell like lovers or waves. The hisaab never took his eyes off them.

"Carter Brown," the hisaab said. "Served in the governmental army, but brought yourself out half-way through your first tour. Six more years left to serve in the reserve militia. Numerous arrests stemming from a dependence on alcohol—"

"I just like a drink once in a while—"

"And nothing more of note since joining the printer's union six years, eight months ago," the hisaab finished, ignoring Carter's protestations. "Slowly making your way from the east coast to the west, working in union shops and drinking yourself into a stupor whenever you can."

The hisaab touched the keys. He stared at the rods, his mind turning their slow, hypnotic movement into information without him noticing. The quarizimi knew the facts of his past. Somewhere, there was one which had predicted the facts of his future with disquieting accuracy. That's how the oligarchy knew he'd be here, now. It gave another smug burst of steam, sounded like it was shifting gears and a bell rang. The hisaab poured more water onto it.

"Now, Corporal Brown—"

"Just Mister Brown, if you please, mawla."

The hisaab coughed. "You are to be interviewed as part of the consultation I am undertaking for this town. Your answers will be compiled with those of the permanent residents and other transients in order to inform a suitable growth strategy for this region. If you lie to me, I will take it as a deliberate attempt to manipulate the expansion model. I will punish such an act. Is that understood?"

Carter understood the important part. "I've no reason to lie to you, mawla."

"Plans have been tabled to build a wagonway station here, Brown," the hisaab continued. "As someone who uses the wagonways as a primary means of transportation, you above all people should appreciate the profound impact a station here would have in the region. This … economic and social backwater would be put on the map. An individual

who thought they were smart might try and manipulate the results for their own benefit."

"A wagonway station?" Carter frowned. "There's no point in that. Survey was done here in seventy-three: there's no ore; no rivers; not even particularly good farming land. There's nothing here worth transporting."

"Not *yet*," the hisaab said.

Carter knew when to shut up.

"I won't lie to you, mawla."

The hisaab nodded, and touched more keys. The quarizimi let out a gentle hiss of air and Carter could hear the sound of a spring winding itself up. The brass rods continued to rise and fall.

Carter stared at a point on the wall. The hisaabs always smelt of gunpowder and mud and shit. Their voices always sounded like the cries of horror that death reduces a man to. In Carter's theatre, the hisaabs sat safe and warm, giving orders as their pawns dug holes in the desert and slaughtered strangers.

Part of Carter's mind was aware that he was talking, that he was answering questions and the hisaab was relaying everything to the quarizimi. The quarizimi was thinking, and coming up with more questions. The hisaab was relaying them to Carter.

He'd once heard that the quarizimi couldn't talk because while everything had to go through a human being, the human being stayed in control. Maybe the oligarchy hadn't heard the same rumour. Maybe the quarizimi had convinced them it was a lie; the less the human being interfered, the more efficient the quarizimi could be, and that was good for everyone. Right?

Every time Carter looked the hisaab in the face, he saw a mask of soft tissue, muscle and bone with charred flesh sticking to it. Yeah, it was good for everyone. Except the nobodies. The foreigners and footsoldiers and the people history would never remember.

He stared at the wall and answered the questions.

Carter sat in the gloom of the bar, getting drunk. He used the money the hisaab kindly gave him to pay for the room for another few nights, and put the rest behind the bar. It was all going to end up there anyway, so what was the sense in reaching into his pocket every time he wanted a drink?

The first few shots started to make him feel human again. The next three or four started to calm him down. After a dozen fingers of rough whiskey, he started to feel like himself again. Then he got down to the business of getting drunk.

"You eaten, Cater?" Stirling asked, emerging from the gloom and hovering by Carter's table.

Carter looked up, and tried to focus on him.

"Sure," he said.

He tapped two of the up-ended glasses on the table. "Starters."

"Main course," he tapped another two, and then a third.

"With gravy," he tapped another.

"And desert," he added with a grin, showing him the glass in his hand.

Stirling nodded, put his drink on the table and sat. Carter knocked back his desert and whistled. The barman understood, and the sandboy brought him more whiskey.

"You ever ridden on a wagonway?" Stirling asked.

"Sure," Carter said with a shrug.

"Amazing machines, ain't they?" Stirling said more than asked. "Did you know that, per tonnage, they can move almost twice as much as a regular carriage? It's the tracks, you see. The tracks distribute the weight of the cargo over a much, much larger distance. That means that the wheels of the wagon are put under less pressure per ton, and the road is put under less pressure per ton. The tracks, you see, they take the pressure. That's why they're tearing up the wooden ones, and putting metal tracks down. Metal's stronger than wood."

"It kills the wheels," Carter said, taking a sip of his whiskey. "Them old wheels need a bit of give on the track. All that weight on them and no give, the constant movement shakes them to pieces. So they have to refit all the carriages with new axles, 'cause the new wheels don't fit on the regular ones."

Getting drunk was just as easy to do with company as it was alone. And talking helped him not to think.

Stirling stared at him for a few moments, his eyes nurturing a weak flame.

"That's why we had all that rioting in Coldbrooke last year—the Baxley yard refused to modify their designs, so the government took their business somewhere—"

"I was up in New Lay," Stirling said, the flame in his eyes brightening. "Tail end of last year. They're not reporting it in the announcement sheets because it's still under development, but I blagged my way in and had a wander around the transport trade show. You know what I saw?"

Stirling knocked his drink back and waited for Carter to answer.

"They've finally made a working wishbone mail cart?"

"No, oh no, you won't believe this ... my drink's empty." Stirling pursed his lips and gave a high-pitched whistle. "No, try to image a wagonway, without horses."

Stirling stared at Carter like he was imparting some universal truth.

"Not hard. It would just sit there on the tracks, not moving ..." Carter said, uncertainly.

The sandboy came back refilled Stirling's glass. Carter held up a hand, knocked back his own drink, and the boy filled his glass, too.

"That's because you're doing it wrong, you see," Stirling told Carter. "What I'm talking about is a wagon that doesn't *need* horses. One that *pulls itself*."

Carter shook his head. "Never going to happen. Oligarchy wouldn't allow it."

"Ah, but you're wrong. It's already being used by the army to move supplies."

"It's not possible. No way the oligarchy would let anyone else use a quarizimi. Hang on, it's an oligarchy thing, then. Military hisaabs driving them, right?"

Stirling shook his head. "It's about the size of a freight wagon, and then half again. It's too heavy to sit on regular tracks, which is why they're replacing them all come hell or high water. It's a huge boiler on wheels. Uses the steam to

drive the wheels."

Carter leaned back in his seat, studying Stirling's face. The pitiful candle on their table quivered, making Stirling's well-lined eyes seem almost maniacal.

"That doesn't sound like any quarizimi I've ever heard of," Carter said. "Not that big. Wouldn't happen."

"No," Stirling agreed. "It wouldn't. Because it's not a quarizimi. The guy who built it was there. The guy who designed it. *The guy who designed it.*"

Carter studied Stirling's face carefully. He saw nothing but raging earnestness.

"The quarizimi design themselves," Carter told him. "One generation designs the next. It's been like that for centuries. Human hand would interfere with the harmonies of the universe the quarizimi are tuned into. Come on, Stirling—my mama sung this shit to me when I was still sucking on her tits."

Stirling knocked back his drink, and shook his head.

"You're not listening. Some mad bastard actually dreamt this thing up," Stirling insisted. "A human being, just like the one who dreamt up the first selftype a dozen years ago. I watched a team of people strip it down to parts, and rebuild it. Moves as fast as a good pair of nags, and so long as you keep the boiler hot, never needs a rest, never needs changing."

Stirling glanced around, and lowered his voice.

"They're forming a union." He put his finger to his lips. "Journeymen drivers and engineers. Some of our boys are helping them organise it."

"And the oligarchy are letting them?"

"Alls they can see is how much money they're going to make once they get the steam wagons rolling all over the country. Unions mean everything's coordinated, don't they? Short-term, it's efficient, right?"

Carter nodded, and knocked his own drink back. If you could move people and materials where ever you wanted, you weren't held ransom by geography and weather any more. Those towns on rivers and the established roads lost their bargaining power.

The candlelight flickered, threatening to go out. Stirling cupped it in his hands, sheltering it for a few moments.

Carter whistled, and their glasses were filled again.

"Here's to the future," he said, smiling.

Stirling picked up his own glass, glanced it against Carter's, and they both emptied them.

"Corporal Carter Brown," the judge said, stifling a yawn.

"Mister, if you please, your honour," Carter corrected him.

The courtroom was dry and full of dust. When the hearing was over, everything would be packed away or re-arranged, and some official would take possession of it for counting tax returns. There was the smell of ink and the acidic twang of ledger paper.

The judge scratched his chin, and pushed the hair back out his face.

"Hm," he opined.

The large windows let far too much sunlight in. Carter held onto the rail in-front of him like a sick man at sea. His eyes were bloodshot and skin the colour of sun-weary paper. His fingers twitched.

The judge picked up Carter's rap sheet, hastily transcribed from the cable sheet which had followed Carter to the small town. Everything the oligarchy felt needed to be recorded about him, on a single, spooling piece of paper—his arrest record, service record, tax returns, date of birth, date of death … everything the oligarchy thought made up a person.

"You are charged with lewd and drunken conduct in a public place, Mister Brown," the judge said, still looking over the sheet. "What is your plea?"

"Guilty, m'lord."

It was all routine, and Carter was well used to it.

The judge nodded, put the sheet down and looked at Carter. Carter waited.

"You served in the Fifth Company Guards, Mister Brown?"

"Yes, m'lord." Carter's voice became tight.

"Did you know a young lieutenant called Michael Joesph Frontuine?"

Carter paused before answering. "Yes, m'lord."

"What happened to him?"

This wasn't part of the script Carter was used to. He glanced around, looking for a way out. His fingers gripped the edge of the rail.

"He died, m'lord."

The judge snorted. "We all die, Mister Brown. I am asking if you know the manner of his death."

Carter took a deep breath. "Yes, m'lord, I do."

"Then say it, Mister Brown," the judge told him after another pause.

Carter took another deep breath. "The company was to secure Bridge Point from rebel natives. In … some part of Africa, I forget where, m'lord. Never really mattered. When Point was secured, we were to use military force to facilitate supplies to the friendly natives at Hughtown. We were then to lay tracks to secure mineral resources from the region. Payment, from the friendlies. Bridge Point was rigged, m'lord. Lieutenant Frontuine was leading house patrol, and was ambushed by rebels. He suffered a cut to the thigh, and two rebels held him to the floor while a third eviscerated him, m'lord."

"Did he suffer?"

"Yes, m'lord. We heard his screams across the village. They went on a long time."

"Hm." The judge nodded, and picked Carter's rap sheet again.

"Are you aware of the damage that excessive alcohol consumption does to your body?" he asked.

"Yes, m'lord," Carter answered after a pause.

"Then why do it, man?"

Carter didn't answer.

"The human body is an artefact so complicated, it takes a dozen quarizimi working in harmony to imitate it," the judge told him. "We have but one chance, Mister Brown, to enjoy the wealth of beauty that this world and our fellow men offer us. And you're content to destroy your vessel by a lazy habit of drunkenness. Not only that, but your sloth brings chaos and upset into the lives of all those who are unfortunate enough to have contact with you. What kind of selfish

impulse drives you, man?"

"My body still belongs to the government, m'lord," Carter said. "And will do for the six years I have left to serve in the militia. If the government wishes me to stop destroying their property, they should provide me with the means to do so."

The judge sighed. Carter looked straight ahead, not seeing anything.

"In view of your repeated offences and transient lifestyle, I do not believe that a sentence of jail time would serve any purpose but to further drain local authority's resources, which can be better spent elsewhere," the judge said. "Therefore, Mister Brown, you are to pay a fine of four dollars to cover costs relating to your apprehension and detainment, and a further two dollars as punishment. You have 28 days to make payment. Payment can be made at any governmental office."

He banged his gavel, and the clerk recorded the sentence. Carter nodded to himself.

Generous, really.

"Lieutenant Frontuine was my godson," the judge said.

Carter nodded, but didn't say anything.

"Dismissed," the judge said wearily, stood up and left.

CARTER SAT WITH Laura, jabbing at the keys with his calloused fingers. The furnace whined. He pulled the casting lever, she juddered into loud and flailing life, and he moved on to the next line. He took the old ink bottle from his pocket, took a slug of whiskey to stop his fingers twitching, and slipped it back. He had to be discreet. He'd be fired without by-your-leave if he was caught drinking on the job. But Stirling understood. Stirling would be easy with him. The whiskey was cheap and burned his throat. It sat in his gut like food poisoning. He took another slug.

He'd left the court and spent the last of yesterday's money on the drink, decanted it from the bottle into his improvised hip-flask, and come straight to the print room. He'd found three long slugs of random letters waiting for him. He memorized them quickly, and threw them into the hell bucket to be melted down and recast.

Whoever had devised the system was smarter than him. Or maybe just luckier. The typographical union had members who had to move the length and breadth of the country to work. Members who might occasionally press a bad line of type and leave it to be printed by mistake.

Laura's machinery beat an arrhythmic tattoo, and Carter wondered if the oligarchy knew. The quarizimi could predict the weather, the people, the tides, the crops … Surely they could predict their own downfall. Surely they knew the working men of the country were scheming against them. He thought, sometimes, that the whole alliance was being organised and run by the oligarchy. Let some smoke loose and see where it went.

He took the bottle from his pocket, tipped the liquor down his throat until it burned, and slipped it away again. Drinking made everything vague except the thick pillar of hate he'd woken up one day to find inside himself. Laura coughed sympathetically. The keys juddered under Carter's fingers.

They thought the printers were just mules, dumbly carrying coded messages from town to town. Letters did funny things when you were married to them. They shifted and made themselves into words. They formed order out of the chaos, like a cloud becoming a well-loved face. He pulled the lever again, and Laura got to work casting another line of type. Strings of letters became adverts, news from the rich east coast, politicised victories from foreign lands. Coded messages started to unravel themselves.

The quarizimi were precision instruments, tuned into the harmony of the universe that only ever beat out of time when the universe did. Whatever lost race had designed them didn't believe in mistakes and human error. Laura was a huge, human cacophony of melted metal and pistons. She had over five thousand moving parts. She had her own ideas, and she surprised you sometimes.

"Corporal Brown," a voice behind him said.

"Five minutes," Carter said without turning around, his hands still moving.

"I don't believe you heard me—"

"*Five minutes*" Carter insisted, not turning.

Five fingers dug themselves into his shoulder, and pulled him out of his chair. He sprawled onto the floor, skidding through the spilt ink, charcoal and burnt paper. He rolled to his feet, fists clenched and ready to swing. Laura moaned, his sudden absence causing a vacuum.

"What—" he began, and bit his tongue.

The hisaab stared at him from his pale, harried face. The quarizimi on his belt hissed and clicked, and the hisaab's hand cradled it. His fingers moved, reading the quarizimi's tiny movements as it talked to him.

Stirling appeared from the adjoining room, took the scene in with a sweep of his eyes and went to Laura. Carter bit his tongue, and she gave an angry screech of hot air.

"Your arrogant lack of respect leaves me speechless, Brown," the hisaab said, his voice quivering. "You will—"

His eyes darted to the quarizimi on his belt as the words died on his tongue. The scowl melted from his face, his expression becoming cold. His fingers caressed the machine.

"You're lucky I'm a busy man, Brown," he said, his voice calm, distant. Laura moaned again, and Stirling kicked her furnace and pulled the stamp lever.

"Your answers produced anomalies," the hisaab said.

"I answered honestly," Carter told him, panic starting to edge in the sides of his mind.

"No," the hisaab said flatly. "No, you didn't. You concealed something. That's what's causing the anomalies. I've seen enough of you people to understand that this may not be your fault, so I've designed a second set of questions for you to answer. That should clarify your position. You have one hour to make suitable arrangements. I must stress, Brown, the need for you to be open and honest. Do you understand?"

Carter's eyes flicked to Laura as she moaned again, a deep sound which made her whole body shake. Carter didn't dare look away from the hisaab.

"Carter!" Stirling shouted, wanting to run but not willing to leave him.

"I asked if you understood, Brown," the hisaab said.

All Carter knew—knew for sure—was that someone wanted him to memorize strings of random letters, take them to a particular shop, and let someone else know what they were. He didn't know who the someone else was. He didn't know who gave him a new set of letters to memorize. He didn't know what the letters meant, not for sure.

And if the hisaab did get to the truth? He was drunk beyond sense in a bar one night, he couldn't even remember where. There were four? five? maybe three people at the table with him, buying rounds and letting him curse out the army. They listened to his stories about tortured natives, broken promises and broken flesh, and listened to him explain the pointlessness of it all.

One of them asked whose fault it was. It struck him as strange—he'd never thought of it being anyone's "fault," just stuff that had happened to him. They asked where his orders had come from, and who was benefiting from them. He was drunk enough to jump to a conclusion.

Then there was a ... blank patch in his memory. He'd started memorizing the strings of letters, and leaving them to be found. That was eight months ago.

He looked at the hisaab. The eyes looked watery and dead.

"Brown?"

Carter looked at Laura again as she shook. She was sick, he suddenly realised. If he didn't fix her *right now*, she was going to—

"Carter!" Stirling shouted.

Carter looked back at the hisaab, who was still staring at him.

"I understand—" he began. There was a cracking sound and a rush of air. Carter knew. He dropped to the floor, rolled and scrambled to the door. Stirling was already three steps ahead of him.

Laura moaned, a final breath of air to buy them a few seconds. And then, she let go. Arms, legs, matrices, liquid metal, flaming coals suddenly filled the print shop. The stacks of paper quickly caught and the flames licked hungrily at the wooden walls. Noxious chemicals began to vaporize. Carter was out the door before he could smell the burning flesh of those too young to know what was coming.

He stood next to Stirling, blood running down his cheek and dripping onto the ground by his feet. His hand felt twisted, the flesh hard. His breath came in wheezy gasps. Something in his lungs didn't feel right.

He glanced at Stirling, who looked back. Stirling's face was black with coal or ink, his clothes torn. The escapees from the shop wer being quickly joined by spectators. Glass from the window exploded onto the street, and flames began to crawl up the side of the building. Everything in the shop burned hot and fast.

Carter looked at the crowd. They took a step back as the other window exploded and a wave of heat crashed over them. He blinked, and double-checked. There was a scream from the building and a glimpse of the hisaab's face through the window, muscle and soft tissue bubbling and burning. There was the smell of burning flesh.

"You got any of that ink left?" Stirling asked him.

"What?" Carter asked, the smell suddenly throwing him back in time to when he stood in a smouldering military uniform, watching helplessly as his friends burned.

"The sauce, Carter. You empty the bottle already?"

"What? No, Cap—," Carter stopped himself and shook his head. That was a long time ago, another world ... The memory disappeared like paper ash in the wind.

"Help yourself, boss," Carter said, handing Stirling the bottle. They had to make ink bottles to last.

"You get the message this morning?" Stirling asked.

"Yeah."

"You know where to take it, then?"

"Twenty miles north. Barlyton. Shop named Burley's Press."

"You're a good lad, Carter."

Stirling knocked back the last of the whiskey, and handed the empty bottle back.

"You think they'll remember it started like this?" Stirling asked, staring into the flames. "Two drunks who let an accident happen at the right time?"

"Couldn't say. History remembers odd things."

"Doesn't matter," Stirling said with a shrug. "'When the day ends and night has run its course, dawn gives bloody birth to a new day and there, there is where eternity lies, where life is in flux and tied not by the past, and not by the future.'"

The flames mushroomed as the roof began to collapse, and the spectators took a step back.

Carter's future would involve a lot more well-timed accidents.

"Carter," Stirling said, and Carter turned to look at him. Stirling's eyes were alive.

"Let's have a drink to wet the baby's head, hey?"

"Sounds like a good idea, if you're buying." ⚙

The Second Great Fire

The Catch-Valve Journal
by Austin Dyches
illustration by Paul Ballard

Nicholas,
You will find enclosed herein the journal excerpt of which we spoke. I must remind you that I have not sent this to you as a peace-offering. I feel it only proper that you should see the remaining pages of our father's journal, and the words contained within—you may take them as you will.

August Malcombe
March 15, 1796

June 12, 1723
 Jack visited me again tonight. I swear that one of these days that man will do for me, running about in the dark. He again asked me if I had contrived to get the key for the Inner Chamber. I will write this, as I told him not three and twenty minutes past, so that if my transgressions are discovered, I shall have a full and complete record before Almighty God and man. I was forced at my great displeasure to tell him that I was again unable to convince Darien to let me borrow it, even only for a minute! Jack seems different these days. No longer does he haunt the old pubs of our youth, but spends his night god-knows-where, planning and scheming things which, even to my semi-educated mind, are certainly too complex to grasp. He rattles on that we must take a stand against the King. I don't know what he wants me to do, and besides, I need more sleep tonight.

June 21st, 1723
 Mariana lost her child, my nephew, this morning. I can have no doubt as to the reason that God saw fit to take such a lovely babe: London now is no place for a child; the lawlessness and filth that sit on wobbly legs all around us will surely smother us. The doctor, arrogant as he is, was still sympathetic. He said in no uncertain terms that it

was the damp and the wet that took the child within a week. We paid him a small sum not to report the death to the constables, so that we might bury him in peace. It is too damnable wet in this house! The rain pours in through the rotted planks, running down the walls and pooling on the floors before dripping down on the heads of the Lilybren's beneath us. I do not know what to do. I sit here useless, day in and day out. I spend the mornings at the roundhouse, but it is such a small wage—not enough to live on. No one has work, and tomorrow we will gather around the rookery and sing a burial song.

July 4th, 1723

I saw that vile man Quilt Arnold down at the laundry today. He was washing clothes with his filthy children. I swear that if it were not for the little ones, I would have walked over there and drowned the man. He is a bully, and a thief, and last week he split the lip of Henry Conner, the old man that lives with his simple daughter, because Henry tried to stop him from leering at the voiceless woman while she was finishing her errands, such as they are. He was so arrogant as to offer her a bottle of Gowland's Lotion as some sort of bait-hook! That man will get what needs done to him, if there is any justice. Oh yes, and some idiot ran down the street today wearing the colors of the Regrettable Colonies. He was arrested for indecency, and it was a good thing, too—the fool could have been killed.

July 18th, 1723

I had an excellent idea this morning, and this afternoon I have seen it come to fruition. My previous attempts to gain access to the key in Darien's charge had been completely without success, and so today I (having come into an extra bag of old potatoes for some work I did on the Weatherton's window and door), decided that if my old friend would not have his honor sullied by my intrigues, perhaps his wife would have her kitchen table sullied by a bag of hard-to-come-by potatoes. Thus I now have the key. Henrietta has a friend whose husband can fashion a replica in a little discreet shop he keeps barred up on Oxford Street.

July 22nd, 1723

Some men were by this afternoon. They loitered around the corner for some hours, asking people questions that all

seemed to point to Sheppard. Two of them were constables from up-town, but the other two, Sykes and Rorchard, we've all seen before. They will never catch him. They wouldn't even want to, if they knew what was good for them! Wild is such an arrogant bastard—he thinks that if he finds Sheppard before Sheppard gets a hold of that valve, he can claim credit for himself. But they'll never let anyone know what it really does! Do they think Georgy-Peorgy will let us modify our own engines? Ha!

August 14, 1723

That idiot Whitefield is shouting in the street again.

August 15th, 1723

Sheppard has the valve, and has given it to the Non-Royal Engineering Society. They are pleased as can be at the contraption. Apparently it allows steam to travel omni-directionally in a closed valve system, by some order or another. It's a bit above me. But now we have it, and we're going to use it.

October 29th, 1723

It has been a long time since I have written. Things have changed. For those of you who read this in the future, remember only one thing: you cannot destroy the will of man. You may rend the flesh from his bones, but he will march on, through fire and steam. They bombed St. Giles two weeks ago. It came without warning. My dear Eliza was killed, buried beneath that horrible slum I had made her live in for too many years. Mariana has disappeared. I have been alone for the last three days, trying to flee from George's men. After the Non-Royal Engineering Society successfully re-created the valve, it was found that we could not only heat all of our homes with half the energy, but we could build cranes that would re-build them completely. We tried to keep it a secret, but someone let someone else know of our discovery and we were lost. I write this in a hole that was made by a bomb, launched from Knightsbridge, no doubt, by their giant steam-guns which are most likely using the same valve we were trying to rebuild our homes with. It is a sad time indeed.

November 3rd, 1723

It has been a wonderful day. King George is dead! His son is of course using the opportunity to divert the forces outside the city to attacking the castle, and we are using the lull in the violence to make our escape. I had been hiding in this hole for almost three days with no food. I was awoken with a shake this morning, and who was it? It was Jack Sheppard, come to visit me once again while I was so peacefully asleep. I jest, but it was a great surprise, and I was very glad to see him. He had most of the Harod family with him, and together we stole away from the city, using the darkness as our ally. There were flames coming from over the further buildings. What fool starts a war after a war? Is the weight of gold so worth the price of blood? Give me my pneumatic hammer and a pint, and I'm a happy man. And I am a happy man tonight, as we sit here. I have lost my family, and the grief that wells within me when I think of it is too much to bear. So I will follow Sheppard. He told me yesterday as we waited in the darkness, "A file is worth all the bibles in the world."

December 14th, 1723

London is burning. They're calling it The Second Great Fire, but we call it The Greatest Fire. Yesterday, with the help of the Engineering Corps of Cornwall, we repealed the attack on our Northern Flank and pressed men into the city. I am an observer, now. It is out of my hands, but I know that it will end well. The Prince has been killed, his body taken to the Circus and hung on the snowy rafters of our scorched nest. Jack has disappeared again. It is rumored that he is seeking some treasure, but who can say? When this is over, people will say, "They stood up for themselves." I hope they say that. I hope they never let the Rule of Law vanish from the earth. Through fire and steam, we march.

STEAMPUNK SCULPTURE

an introduction to creating works of art in three dimensions, by three adventurers in the field of sculpting.

facing page, illustration by Allison Healy
parts 1 & 2, illustration by their authors

Keith Newstead has been making automata (moving figurative sculptures) for the last 20 years, and draws his style from a wide source of influences. His work has been exhibited worldwide, and is on permanent display at the Eden project, the National Gallery, and the Natural History Museum, to name but a few.

You can find pictures documenting the construction of this work on his Facebook group, "Mechanical Adventures," and can see more of his steampunk creations on his website: www.keithnewsteadautomata.com

Part 1 - A Steampunk Romance
by Keith Newstead

Recently, I discovered Steampunk. I felt that the style lent itself particularly well to automata, and I was inspired to create a new work.

I made a small drawing of a very elaborate vehicle which would appear to be powered by a steam engine. The driver would be dressed in a suit of black rubber, and behind him would be a rusty tin compartment containing a small clockwork heart. The heart would vibrate very quickly and be revealed when the heart compartment door opened. I designed the automata to rest on rotating rollers which would be driven by a handle. The rollers would then turn the wheels which, in turn, would power all the movements in the automata.

I took my original small sketch and enlarged it to the finished size. I did not want to lose any of the freshness of the original drawing by re-working it.

The first parts I made were the wheels. I used wooden beads for the hubs which were then drilled and glued in the spokes. I then made a jig and soldered the spokes to the wheel rims; then I made rubber tyres from the large rubber rings used in vacuum cleaners. It took one day to make the 3 wheels.

Next, I made the chassis from galvanised fencing wire: first, sanding the wire so that it would rust, and then making two wooden jigs (one for each side) and soldering the wires for each. I soldered the two sides together and made brackets for the wheels and other attachments, referring to my drawing.

The heart compartment was made from an old tin oil drum [*see inset illustration*]. I found that the easiest and neatest way to cut the tin was to clamp it between two sheets of thin plywood (I wrapped masking tape tightly around the outside) and cut it with an electric scroll saw. The plywood stops the tin catching in the saw blade and jumping, and a very good and detailed cut can be achieved this way. The roof of the heart compartment was dome-shaped so I made a card roof first. When I had achieved the correct shape, I folded it flat and used it as a template for cutting the tin. When it was finished, I rusted it using sea-water and then painted it using acrylic paint. Then I re-applied more sea-water so that the rust would break through the paint.

I added a window to the heart compartment door using a small magnifying lens held in place by a wooden surround. I painted the surround in metallic paint, which I then sprayed with vinegar. The vinegar attacked the metal in the paint and produced a pleasing aged effect. This is a good technique to use to make wooden parts appear to be made of metal

To make the clockwork heart, I took some thin brass sheet and cut out a small heart shape. I removed the small hammer from the ringing arm of an old alarm clock, soldered the heart onto the arm, and made a wooden pulley to fit onto the winding mechanism of the alarm (having first removed the spring). This pulley was then connected to another on the front wheels, so that as the front wheels turned, the heart was activated. The heart compartment door is opened and closed by a crank on the back wheel.

The driver (or Romancer, as I like to call him) was made from lime wood. For the hands I first made the shape, without fingers, from the wood, then drilled holes and glued in pieces of wire for the fingers and thumbs which were covered in heat-shrink tubing. By heating just the ends of the tubing I achieved a tapered finger effect.

The hair was made by gluing small lengths of parcel string around the circumference of the Romancer's head. This was then unraveled using the point of a cocktail stick to produce thin strands. Later, the hair was dipped in thin black paint which stiffened it and allowed it to be styled.

The body parts were then dressed in rubber from an old inner tube. This is a very nice material to use as it is easy to cut, can be stretched around shapes, and sticks well with super glue. Other small details such as buckles were then added. The Romancer is activated by a bent metal rod which passes through his body and rotates, giving him a nice fluid movement. This rod is driven by the front wheels.

Some control levers were also added. These were made from beads with brass shafts, and are worked by cams attached to the front wheels. As they pull, they give movement to the Romancers hands and arms (which are attached to them).

The steam engine was made from tin, wood and found objects. I wanted to achieve the look of an old boat, with varnished wood, rust and polished brass. The boiler was made by first covering a small length of 1" diameter dowel with thin strips of hardwood that was then varnished. The firebox was then fabricated from tin and then rusted; the chimneys and pistons were made from brass tube and polished. The dome on the front of the engine is the bell from an alarm clock, and the governor is made from an expanding wall plug decorated with brass beads.

The gauges were made by wrapping and soldering very thin brass sheet around wooden dowel, leaving a small hollow in the top. I then painted small circles of card with a thin rust solution (steel wool dissolved in vinegar) and drew on the hands. These were glued into the tops of the gauges, and a resin called "Liquid Water" was carefully poured into the hollow. The first ones I made were a disaster as the resin leaked out of the bottom, so on my second attempt I sealed the gaps at the bottom with wood filler first.

Once finished, the gauges were strategically placed around the machine.

Next, I made the wings from galvanised wire which was covered with a very fine black fabric, stuck on with super glue. I splattered them with some rust solution to give an aged effect. The wings are operated by the back wheel and not only flap but fold into themselves.

The seat is made from hardwood covered with foam and finished with velvet from a ladies shirt brought from my local charity shop. I studded the cover by sewing on small brass beads and pulling them tight. The brackets which hold the seat together are made from aluminum and were cut by clamping the metal between two pieces of ply as with the tin. I then added small gear wheels and levers to finish.

In total, the automata took one month to complete and was a journey of discovery for me. The biggest problem was finding all the small gear wheels I needed, but in the end I solved this by buying a few new alarm clocks and dismantling them. The clocks I used are made by Acctim, and cost £3.99 each.

Another good source of supply for the materials needed in this piece was Hobby's. They stock brass tube, brass gear wheels and the liquid water that I used for the gauges.

Part 2 - Making Friends
Being a Study in the Construction of Steampunk Art Dolls
by Robin Martin

Practicalities

MATERIALS AND INSPIRATION ARE, TO ME, interwoven. I might imagine a Victorian gentleman astride a gallant mechanical steed, but the components I'm able to find, adapt, or as a last resort purchase, might dictate a gallant horseless carriage instead. Limitations imposed by the materials and the scale challenge me to find new uses for unlikely objects, and it is always best to adapt ideas around the things that you can scavenge to tinker with and be led by the materials that are available for you to work with. One of my machines required a way of conducting imaginary steam from the engine to the control panel. Its small size precluded using something as large, and obvious, as a garden hose. While wracking my brain, I happened to undo my ponytail in order to play with the elastic: The narrow, tube-like elastic. Eureka!

Some of my preferred playthings include:
- polymer clay

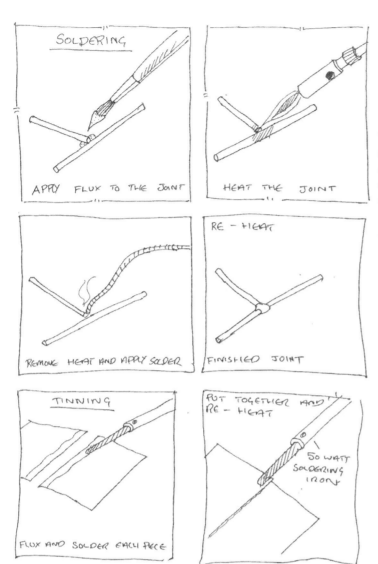

- fabric, yarn, lace, leather
- wire
- beads, bits of jewelry, chain, charms
- cogs, watch parts, gears, springs
- pliers, super glue, wire cutters, and other such tools

The Amicus Somes

With a vague idea, some wire, and a crumpled ball of aluminum foil, I begin to build the armature—a sort of stick figure skeleton to which the polymer clay flesh will adhere. There are books dedicated to the anatomy and sculpting of dolls, such as *Fantastic Figures* by Susanna Oroyan and *1/12 Scale Character Figures for the Dolls' House* by James Carrington, but I've always found imagination, observation, and experimentation to be my most trusted instructors; never be afraid to try.

Because I'm constructing the art doll's clothing at the same time, and from the same material as the body, anatomical exactitude is less important than the shape of a bustle and shirtwaist, or the drape of a frock coat left unbuttoned. Remaining aware that I'm not creating an exact historical representation, I might make a miniature cameo for them to wear, but I won't go so far as to insist upon the accuracy of every shoe button. In any case, I imagine my steampunk dolls to be so eager to work on their inventions that the state of their clothing is of secondary importance to them at best!

The position of the body (and how it will interact with the soon-to-be-created machine) must be decided now, while the clay is still soft. The figure will never stand on tiptoe to reach for something if I've sculpted and baked it into a permanent sitting position.

Although it is created from simple shapes, the face can take as long as all the rest combined, for this is where the personality comes through. Is she concentrating? Is he agitated, or eager? The face is where it will show. To me, the expression is more important than the precise and coldly arithmetical placement of each feature—or, to paraphrase Terry Pratchett, "'Taint what a horse looks like, it's what a horse be."

Once I'm happy with the homunculus and the polymer clay has been baked (in a common household oven, not a kiln, and definitely not a microwave) the details are added. Lips are painted, watch chains or spectacles set in place, hair firmly attached with super glue. Now it's time to give my friend something to do.

Behold the Machine

The impossible contraption is what truly makes an art doll a steampunk—but what other accoutrement will be required? The manikin on which I've been working as I write this is standing, leaning forward, with one hand raised and the other forward, as though peering into a crank-powered telescope. Not just any telescope, though; this one will be operated by so many gears, levers, and other devices that it must be placed on a sturdy, and rather tall, framework. This, in turn, necessitates a stepstool for the convenience of the miniature astronomer.

Robin Martin is an artistic explorer who enjoys nothing more than delving into new methods, materials, and schools of thought—ready to share her oddly tilted point of view with friends old and new. Since her serendipitous discovery of steampunk late last year, she has made a number of delightful friends: academicians, aviatrixes, and adventurers among them.

Bits of thin cardboard rolled into tubes form the basis for the telescope, wrapped in polymer clay and nested one inside another. After the telescope is baked, I'll build its scaffolding from copper wire. The crank mechanism will be constructed from small gears, a round toothpick, and a gold-colored bead for the handle.

The stepstool is also made from copper wire, with steps built from thicker cardboard wrapped in black drafting tape. Bracing is required to support the weight of the art doll, as it is comparatively heavy for its size. The steps must be wide enough to accommodate the feet, the eyepiece must be positioned as though it's being looked through, and the crank must be where the hand can reach it. There's little point in constructing a machine that looks as though it bears no relation to its supposed inventor, after all!

In Conclusion

So, dear reader, our friend is decently attired and suitably occupied with a mechanical diversion. What else is there to do? A moment, please; how are we to make polite introductions without a name? The christening, so to speak, is one of my favorite aspects of making an art doll, the point at which all my efforts come together. I love names that sound like who they're meant to be: A Celtic warrior's name should sound as though it belongs to a Celtic warrior and a steampunk aviatrix's name should make it clear that she can fly with the best of the men and still be home in time for tea.

Our astronomer is a man of leisure, able to afford both the funding to construct an elaborate telescope and the freedom to stay awake until all hours to use it. He's intrigued by the stars, revealing him to be of both a scientific and a poetic bent: "Newton" for the science, perhaps "Coleridge" for the poetry. I'll add a whimsical middle name, hinting at his parents' fecundity just for fun: "Octavius." And rather than settling for the commonplace "telescope," I'll play with Latin translations until something more interesting emerges: "Proculastravisopticon."

My lords, ladies, and gentlemen, allow me to introduce my new friend and his amazing invention, Sir Newton Octavius Coleridge and the Coleridge Proculastravisopticon!

Part 3 - A Victorian Flea Circus Chariot
by Andy Clark

Andy Clark is researching the history of the flea circus and has an interest in animation and anything mechanical. For the last couple of years he has been living in North London making and repairing things in a shed at the bottom of the garden.

Flea Circuses became popular in Victorian times when the travelling performer L. Bertolotto displayed his industrious fleas to the world. However, the ideas and techniques evolved much earlier from the skills of watchmakers and jewellers.

A few years ago, a Mr. Boverick, an ingenious watch-

maker, of London, exhibited to the public, a little ivory chaise, with four wheels, and all its proper apparatus, and a man sitting on the box, all of which were drawn by a single flea. He made a small landau, which opened and shut by springs, with six horses harnessed to it, a coachman sitting on the box, and a dog between his legs : four persons were in the carriage, two footmen behind it, and a postilion riding on one of the fore horses, which was also easily drawn along by a flea. He likewise had a chain of brass, about two inches long, containing 200 links, with a hook at one end, and a padlock and key at the other, which the flea drew very nimbly along.

—*Jamieson't Modern Voyages and Travels*

I started wondered if it was possible to make such a tiny vehicle as this using simple techniques such as would have been available in the 1800s. Although there were no detailed illustrations of the props used in the early days of the flea circus, I had seen some later ones in videos. Therefore, I based my design on those from Elsie Torp's Danish flea circus and those seen on the British Pathe Newsreels. [*See figure 1*].

The chariot is approximately 10mm long by 7mm wide and made from brass, the wheels are 5mm in diameter. The wheels and axle were turned on a lathe and the other parts were made by hand with hacksaw and files. Mostly the chariot was made without needing magnification but I did use a magnifying glass for the filing and fitting. A digital camera was also used to check some of the details.

The mounting is an old Victorian era French coin about the size of a 2p; the chariot is secured with a small magnet and a tiny piece of steel glued below the axle (brass is not magnetic).

It was a fairly straight forward project with a nice range of different skills including turning and brazing as well as some manual metal working. The design for the wheels was spokeless because of the difficulties given the size and because I did not really have any ability to drill holes around a circle. I used a 3D modelling tool (Carrara Studio) that allowed me to visualise the results. I then created some rough sketches of each of the components that I required and finally added some measurements.

Tools and Materials

Given that this was my first project using brass, I decided to make some soft jaws for the vice. Soft jaws are simple aluminium sheets bent around the jaws of the vice to stop them from scratching or marking the materials. The size of the components I was working on meant that I had to hold some of them in some small toolmakers clamps.

I also used a junior hacksaw, standard files (for rough shaping), needlefiles, and a magnifying glass. I've been given recommendations to always use your sharpest files and saws for dealing with brass but I did not have any real issues with that.

I also used a variety of clamps for the brazing and a selection of tools/materials for polishing the parts before assembly.

I used a small, manual metalworking lathe. The Victorians would have used a treadle or belt driven lathe; mine was driven with an electric motor. I used high speed steel tools whereas the Victorians would have used carbon steel, for this kind of work there is not a lot of difference between the two; their tools could even have been sharper than mine.

The materials were fairly simple, some brass strip in two different thicknesses and some 4mm brass rod. The design actually called for thinner rod so I had to machine it down from 4mm to 2mm.

Machining the Parts

The axle and the wheels of the chariot needed to be turned to a smaller diameter in the lathe. However due to a lack of appropriately sized material, I also ended up machining the hook at the front of the chariot.

To turn the 4mm brass rod down to 2mm for the axle, I needed to support the rod at both ends to stop it bending when being cut. I did this using a female centre to support the tailstock end of the rod. The middle section of the rod was then turned down to size. [*See figure 2*].

Once this was complete, the ends were sawn off. The rod was replaced in the chuck and the ends were carefully turned down to 1mm. [*See figure 3*].

The towing hook of the chariot the rod needed to be even thinner; I wanted it to be 1.5mm. I started using the same technique as above, but the rod was bending as it was machined. This meant that the middle was fatter than the ends which were supported. The solution to this was to run more passes with a finer feed. Keeping the tool clear of swarf (dust) and additional cutting fluid seemed to help with this too.

The wheels were machined from the same piece of r o d using a small parting tool. [*See figure 4*].

The holes in the wheels were first spotted with a very small centre drill and then drilled to 1.2mm to give clearance on the axle. Because the drill was so small I needed to

Here illustrated are the crafting of hands, the stepping on stools, and the peering through scopes.

use a small drill chuck mounted in the larger chuck of the tailstock. The wheels were sawn from their support with a junior hacksaw and then filed smooth.

An offcut from the axle was also used to make the washers that held on the wheels. These were thinned/smoothed by rubbing them on some emery cloth.

Manual Jobs

The base of the chariot was sawn from a piece of brass strip and rounded with a file. Then using a magnifying glass and a needle file, the stepped edge was added. The front of the chariot was made from a slightly thinner brass strip and filed to shape. I had wondered about using some kind of tool for bending this to shape but it turned out that it could easily be done by hand. I simply bent the strip around the base of the chariot. A photo with the digital camera showed where it did not fit properly and it was coaxed into line with a bit of rubbing.

Because the parts were so small I kept them in a plastic container to avoid losing them.

Brazing and Soldering

The first thing I did was to clean all of the parts using wirewool and checked that they fitted correctly.

As there were many parts, it was not possible to clamp them all in place at once. The parts are in close proximity, so it is also not possible to silver solder them in multiple steps. Doing so would mean that the later steps would melt the first joints and the model would fall apart.

The solution to this issue is called step soldering. This requires solder with two different melting points. The higher melting point solder is used first then this is followed by a lower melting point. For complex models this can be extended to even more steps but there is a limit to how many different solders can be used. I only had one type of silver solder but I also had some soft solder so I decided to use those two. I used a cotton bud to apply flux to the joints and heated the components with a mini gas torch.

The parts need to be held firmly together, do not use too much force as the brass softens when it is heated. I used crocodile clips as they provided just the right force for clamping.

The body was then soldered using soft solder (and appropriate flux) and an electric soldering iron usually used for soldering electronic components.

For the wheels to rotate I needed to protect them from the solder. I wetted the wheels/axle with WD40 and then fluxed the washer and tip of the axle before soldering. While the solder was cooling I checked that the wheels still rotated.

Finish

I was thinking about "aging" the brass but when I cleaned it up with a minidrill and wirebrush it turned a nice dull colour. Hence I left it that way.

I wandered around a few coin shops in London looking for a cheap coin 1820-1870 and finally settled on an 1857 French coin with a relief of Napoleon III.

The chariot is secured with a small cube magnet glued to the coin. A tiny flake of steel glued below the axle of the chariot to allow it to be lifted off.

Summary

The investigation part of the project has been going on and off since the summer and I've had some rough designs in my head since then. The build process took about 12 hours spread over several days between Christmas 2008 and New Year.

It's been a learning exercise making the flea chariot. There were some small mistakes, but I'm happy with the end results.

Thanks to the chaps from Model Engineering Clearing House the for their tips on drilling with very small drills. Thanks to Mike Freeman for his tips on silver soldering and cleaning flux.

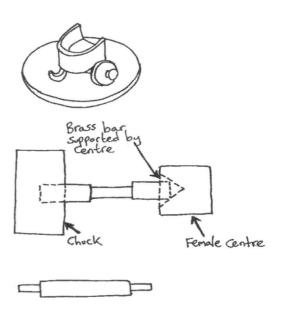

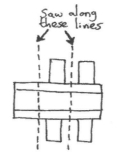

Figures 1-4 (from top to bottom): the completed chariot; the turning rod supported on both ends; the finished axle; machining the wheels.

La Lotería de San Leonardo

by Joshua Gage
illustration by Sarah Dungan

The foreman says the shackles keep us
from skipping on our contracts. We count
the days until the lottery, the hours
until the shaft swallows us whole
into the mountain's belly. The ore blisters
the skin, steams the sweat and carves
the carbide light with dust and shadow.
The advertisements begged for men
strong enough to throw their weight
behind a pneumatic drill. The pay
they promised was enough to feed a family,
buy a house and woo a wife
to keep it. After a five year stint,
a man who saved could earn enough
to set up shop in San Eloy
or a farm outside of San Ysidro.
Up to $500 a day!
The chance of a lifetime! Join today!
We are paid in candles and the chance to dig
every thirty days. They cut the steam
that moves the hoist, then let us down
on ropes and saddles. One bell down
into the black, and just enough light
to walk by. What ever ore we can pack
into our tent cloth sack is ours
to keep or sell. We bet away
our lives, twenty-nine days at a time,
giving Newt Bagley everything
our bodies can beat out of the seams.
For twenty-nine days we break ourselves,
chains and hammers calling through
the darkness, filling our lungs with a rattle
of rock against rock, the wheeze of a seam
just before it snaps. The blood
we cough is black and tastes like sin
upon the tongue, nectar sweet
with an edge of salt to remind a man
of what he's done. Twenty-nine days
is the time it takes for a man to die
a thousand deaths. We count the ways—
loose stope, mine gas, fire, cave in.
We leave the names of the dead behind,
but feed the ghosts. Plates of food
tucked into the shaft house corners
appease the spirits that keep the mine
safe and bring the miners luck.
The ghosts guide the men to rich
seams and keep their candles lit
long enough to dig. A ghost
well fed will keep a man alive,
but ghosts are ever hungry, and no one
ever lives his full five years.
When Death arrives, it will be in darkness.
A single bell will sound, then the smell
of smoke from a candle sputtering out.

Freedom

by A. M. Paulson
illustration by Benjamin Bagenski

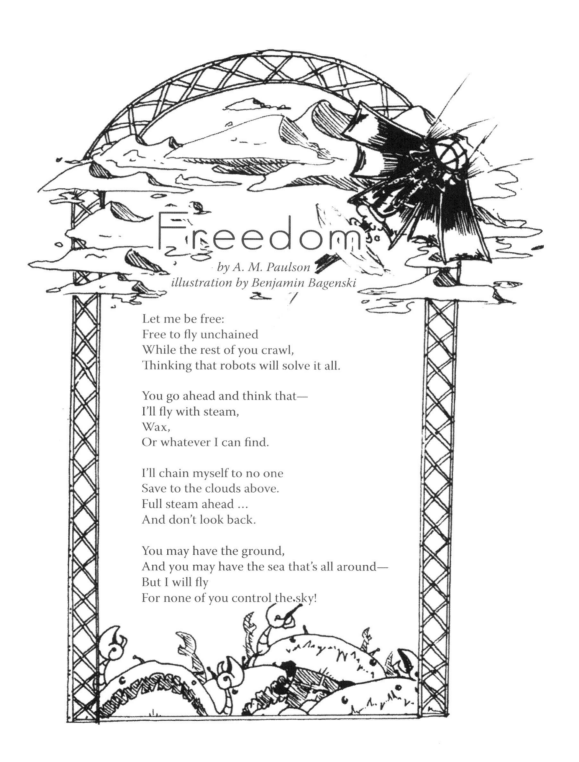

Let me be free:
Free to fly unchained
While the rest of you crawl,
Thinking that robots will solve it all.

You go ahead and think that—
I'll fly with steam,
Wax,
Or whatever I can find.

I'll chain myself to no one
Save to the clouds above.
Full steam ahead …
And don't look back.

You may have the ground,
And you may have the sea that's all around—
But I will fly
For none of you control the sky!

ON ALCHEMY

being a study of ancient science and sacred psychology

illustration of alchemist's lab by Sarah Dungan

As Above - The World of Outer Alchemy
by Benjamin Bagenski

Outer Alchemy, also known as Weidan, Real Alchemy, and Practical Alchemy, is the practice of using the properties of the world around you to achieve wisdom and power. Over the course of history, our understanding of what this esoteric science involves (and what its ultimate goals are) has changed, but there is always a distinct aspect of it that lures people into its complicated riddles—no matter which corner of the world, or day and age that it is in.

The first thing to set straight is that, contrary to popular belief, alchemists do not try to turn lead into gold. As a few people (who believe they have stepped past the point of ignorance) will calmly correct, it was cow dung, not lead. However, I would like to make the point that neither is an accurate image. There are various goals to pursue in alchemy, and yes, one of them is the pursuit of turning various elements into others—perhaps Pb into Au if that is the case—but this is definitely not alchemy in its purest form.

The true essence of Alchemy is to understand the relationship that all things have with each other, which is to have true wisdom. Alchemy is also about utilizing the degree of wisdom that one already has. Another good way to view the artform is to describe it as a sort of synthetic magic, formed from a combination of chemistry, physics, biology philosophy, psychology, and religion.

As tempted as I am to say otherwise, alchemy is not always congruent with the romanticized visions that neophytes have when they stumble upon this science: Saint Germain mysteriously charming high society every century or so; Nicholas Flamel defying the laws of physics as he performs great wonders and even achieves immortality; Hermes Trismegistus, a being of great power, bestowing the

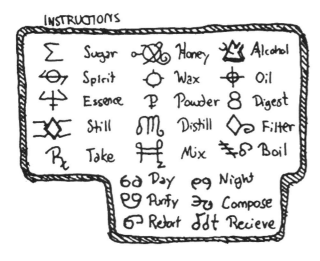

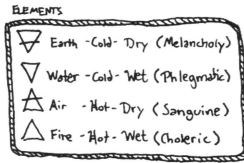

Emerald Tablets for future generations to one day unlock all of the regions of knowledge. Germain was just a great teller of stories (and an even better showman), Flamel most likely a regular scientist of the era, and good old Hermes probably did not even exist. But that does not matter. For an alchemist, it's not about summoning vast wonders from your flask, or about checking off which natural laws to defy from your list. Every single thing that the alchemist does can be influenced by his or her power. That is when you've completed your Great Journey as an alchemist.

First, we will discuss two different types of alchemy: Chinese Alchemy and Classical Alchemy. Chinese Alchemy, or Weidan, is an ancient practice that dates back as far as AD 35. In that day, people held the general belief that life could be extended or augmented by minerals and natural herbs combined into potions and other strange concoctions. To accomplish this, first the resources would be refined—such as gold or cinnabar (mainly the second, as gold was not a common resource in ancient China). These compositions were put into vast tomes, listing all sorts of wondrous effects that were now at the fingertips of the alchemist … or at the mouth, as we shall see. Yes, elongated life, infinite wisdom—and living forever, for the truly enlightened!

The only flaw with this is that, in order to create the Asian equivalent of the Elixir of Life, the Chinese ingested mercury (cinnabar is just mercury in another form). This would, inevitably, lead to death, which would (to those who are centered around the more traditional beliefs or even the Western Alchemical principals) appear a bit off aim. The masters of the art (the smart ones who did not seek eternal life through poison) would excuse this by explaining what eternal life truly entailed. Some forms of eternal life would be measured by what state the corpse was in—things like body preservation or a vanishing of the body altogether.

The other kind of alchemy is known as Classical Alchemy, which embraces the more traditional views of the art. The main idea is pursuing "the Great Work," which is different for each individual alchemist. The two classic quests to occupy the Great Work are, in most cases, the Elixir of Life and the Philosopher's Stone. However, the Great Work's purpose (and what drives the alchemist), is not so much creating or finding these artifacts as it is finding the wisdom and understanding—the intrinsic power within—and the ability to find an outlet for it from the subtle to the gross. In other words, turning thought into action.

This is the kind of alchemy that you will more than likely be familiar with. Just look for those enigmatic symbols and pictures of naked people with the heads of suns and moons, covered with all sorts of queer and quaint runes and emblems. It will seem like somebody was trying to make sense of a child's doodle. On top of that, you have what will seem like mediocre poetry that hints at what to do by way of the procedure, but is lacking enough information to duplicate the feat. It's plaguing, but it is also extremely fulfilling. You'll find yourself addicted to decoding these writings and making some of your own, in time.

Because each alchemist of note has generated their own world-view, we can only really look at the basics of philosophy. We begin at the beginning of time. Many alchemists hold the belief that God, or whoever has the patent on the universe, did not really create this world. The world was merely set in motion by this being. Now, in practice, this doesn't make much difference, but saying it makes us feel good about ourselves and it provides incentive for shaping the world further through our mastering the outer and inner worlds of alchemy.

After the when comes the why. Why is everything happening that is happening? You would struggle to think of a broader question, and so therefore if someone could answer it, wouldn't that be wonderful? Just a simple answer, and suddenly the universe makes sense. Well, Hermes Trismegistus' impressive Emerald Tablets provide that answer: "As Above, So Below."

Right now, you are probably thinking "What? Here you claim that you hold all the secrets of the universe, and you just say something like 'Up, down?' I want my money back!" But contrary to what you may be thinking, if this is the first time you've heard these words, it could be the best, most sincere advice you will hear in your life. It applies to religion, physics, philosophy, dating, cooking, darning socks: everything. It

means everything is, in essence, a repetition of what is above it. Just think about it, and figure it out yourself, that's the point of it.

If I've had the honor of piquing your interest, by now you could be off on your alchemical journey. If so, then I recommend that you begin at once.

The first thing in order would be a basic experiment. After that, you'll be all on your own.

Below, there is a short alchemical experiment derived from John French's, *The Art of Distillation*:

> To keep fire in a glasse, that whilest the glasse is shut will not burne, but as soone as it is opened will be inflamed. First extract the burning spirit of the salt of tin in a glasse Retort well coated; when the Retort is cold, take it out and break it, and as soone as the matter in it, which remains in the bottome thereof after distillation, comes into the aire, it will presently be inflamed. Put this matter into a glasse viall, and keep it close stopt. This fire will keep many thousand yeares and not burne unless the glasse be opened: but at what time soever that is opened it will burne. It is conceived that such a kind of fire as this was found in vaults when they were opened, which many conceived to be a perpetuall burning Lamp, when as indeed it was inflamed at the opening of the vault, and the letting in aire thereby which before it lacked, and therefore could not burne. For it is to be conceived that there is no fire burnes longer than its matter endures, and there is no combustible matter can endure for ever. There may be many uses of such a fire as this, for any man may carry it about with him and let it burne on a sudden when he hath any occasion for fire.

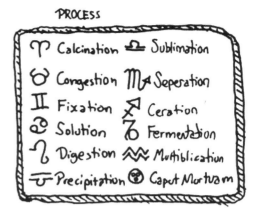

Imagine if one could completely understand each word that French was saying. Wouldn't that be a wonderful power to behold? And furthermore, if, like a true alchemist, all the talk of this is making one's mouth water by thinking of other applications to this method, the temptation to try and decode this work is irresistible. Well, be my guest.

However, not everything is as complicated as the example above. Plenty of modern day alchemists have created all sorts of new experiments. On that note: no, adding sodium hydroxide and phenolphthalein to a glass of water and making it appear to turn into wine is not alchemy. It has chemicals and does something tritely amusing, but a true alchemist would want the water to really become a drinkable substance that tasted like wine. Neither is alchemy about knowing how to blow up various chemicals. It can be, when applied right, but generally speaking, that's just explosive chemistry. So watch out for what you research, and with that disclaimer out of the way, apply all of your knowledge to one general science and art, and you'll find alchemy.

You can experiment with turning wine into pure vinegar, altering the color of glass, and all other sorts of step-by-step wonders. Don't be discouraged.

Decoding the text that I have provided you with will be a challenge, but even if you don't create any sort of wonder, the journey will be worthwhile. I promise you that.

Hopefully you have found all of this interesting. Remember, that Outer Alchemy is something you can see and believe. It's really there, because it is you who chooses to create it. So what are you waiting for? We have chemists finding elements and transmuting them into others through radiation, and physicists researching the fabrics of time and space, so don't you dare say you can't do it, you're probably a lot more interesting than they are! This is your formal invitation to join the technicolor fray of alchemical chaos in this world.

As above so below, so in this note:

Outer Alchemy, also known as Weidan, Real Alchemy and Practical Alchemy, is the practice of using the world's properties found around you to achieve wisdom and power.

You've already learned more than you knew the first time you read those lines, so finish up this magazine and then go learn more!

So Below - The Alchemy of the Spirit
by C. Allegra Hawksmoor

The cryptic nature of the alchemical texts recorded over the centuries means that alchemy has often found itself imbued with a spiritual, as well as a physical, interpretation. Through time, this interpretation has led to the development of a distinct and separate tradition—a form of psychological alchemy which sometimes works in harmony with the physical alchemical tradition, but is often entirely independent of it.

One of the most integral principles of alchemy is, "that which is below is like that which is above, and that which is above is like that which is below," written more commonly as, "as above, so below." This simple statement expresses the idea that all things are linked together. That the macrocosm and the microcosm effect one another on even the most basic and fundamental of levels. It says that what is true of the outer, physical levels of existence must also be true of the inner, spiritual dimensions too—and in that it provides the cornerstone of the whole discipline of internal alchemy.

The fact that Newton's Third Law of Motion is so often misquoted as "every action has an equal and opposite reaction" (and thereby used to illustrate the laws of Fate and karma) can be seen in a new light when you consider the fact that Newton himself was an alchemist, and would have understood only too well that what is true without is also true within.

In China, the discipline of inner alchemy is referred to as neidan or nei tan. At its core, neidan is the same quest for immortality and the understanding that is also the goal of physical alchemy. However, while the ancient physical alchemists tried to understand universal truths through chemical experimentation and their understanding of physical matter, the practitioners of neidan formed the other half of the equation: they turned inwards in their search for truth and practised meditation, yoga, breath control, and visualisation.

Just as the physical alchemists believe that they can understand the soul if they can only understand the universe, so the practitioners of inner alchemy believe that they can understand the universe, if only they can understand the essence of the soul.

Spiritual Alchemy of the East

One of the great quests of physical alchemy is the attainment of the panacea—the elixir of life that would cure all ills and make the alchemist immortal. Inner alchemists hope to achieve eternal life (either physical or ethereal) through their ongoing quest for an internal transformation, which will transmutate the spirit into a golden body of light that can overcome even death. In China, the practitioners of neidan tried to obtain this secret knowledge through the transcendence of time and the cultivation of life-force (or chi), which would be driven up the spine towards the brain in order to bring about this transformation they desired. Evidence of this can still be seen today in the practice of kundalini meditation and yoga.

A World of Opposites

Chinese alchemy draws its roots from Taoism, which sees the whole universe as divided into pairs of opposing forces. These two forces—commonly referred to as yin and yang—represent the two extremes of everything that is: female and male; Heaven and Earth; water and fire; darkness and light; cold and warmth; and every other pair of opposites between which the world exists.

In Tao cosmology, "Tao gives birth to one. One gives birth to two. Two gives birth to three. Three gives birth to ten thousand things."

In the West, the gnostics were developing a similar belief: the idea that the universe was not created *by* God, but *from* God, that the process was imperfect, and that it was the purpose of the alchemists to help the world refine itself back into its original state of perfection.

Many ancient Eastern and Western alchemists alike believed that the world was ultimately created from one energy and one spirit. Shortly before this one energy divided to create everything that is, it divided into the two opposing forces which the Taoists called yin and yang and that Westerners represented as Sol and Luna, the sun and the moon. These two forces then became three, just as man and woman (and therefore also the god and the goddess) create the divine child. Western alchemy represented these three elements as Mercury, Sulphur, and Salt, while the Taoists called them Jing (Essence), Chi (Energy) and Shen (Spirit). These three things created everything that is. And, just as alchemists in Europe sought to reunite Sol and Luna to create the Philosopher's Stone, so the Taoists attempted to "rise through the hierarchy of things," returning to the three basic elements of creation and then the two opposing forces of yin and yang. From there, they hoped to combine the opposites and return to the original material of the universe—thereby gaining enlightenment, and with it, immortality.

At this point, it is interesting to note what modern scientific investigation has discovered about the human brain. In a series of tests and experiments carried out in the nineteen-sixties and seventies, scientists discovered that the natural state of the brain was one in which one hemisphere was dominant over the other. (Which hemisphere was dominant varied depending on the situation the subject was in, and the task that was being carried out). However, they also discovered that in states of sleep and meditation, the two hemispheres began to operate equally. Not only that, but they discovered that in the deepest states of reflection the two hemispheres actually began to fall into sync with one another, and that the result was the sense of peace and oneness with the universe that mediators and alchemists alike had been reporting for centuries. While this article does not purport to have unlocked the

secrets of the universe, the similarities between the process through which the two hemispheres of the brain begin to function together and the alchemical concept of combining yin and yang (or the sun and moon) in order to attain oneness is certainly interesting.

In internal alchemy, the body becomes a laboratory where these experiments are carried out, exploring the three basic elements of creation and combining the essences of Mercury (or Jing, which represents essence), Sulphur (or Chi, which represents energy) and Salt (or Shen which represents the spirit) just as the outer alchemists experiment with their tangible counterparts in the physical world.

The Alchemy of the Mind

THIS KIND OF internal experimentation was not limited to the Taoists of the Far East, and while alchemy was slowly replaced by science throughout the Age of Enlightenment (and, as a result, alchemists enjoyed a reputation as charlatans throughout the nineteenth century), alchemical beliefs and practices can still be seen in the emergence of the Celtic Revival, as well as in institutions such as the Freemasons and the Hellfire Club. However, it wasn't until the dawn of the twentieth century and the works of Swiss psychologist Carl Jung, that alchemy once again began to be accepted as something other than the pseudo-science of con-men and self-styled spiritualists.

Jung became interested in the alchemists while he was developing his work on the collective unconscious and universal symbols. In antiquity alchemy had been the art exploring physical matter and chemical processes (therefore the alchemists' own imaginations, perceptions, symbols, and images). However, unlike people who followed a particular religion, they were not bound to a particular bias, viewpoint or doctrine. In this way, Jung saw alchemy as providing him with a "pure" sort of access into the collective subconscious.

His theory held that there were certain symbols and ideas that formed a sort of ancestral memory for everyone, and that the same symbols, thoughts and myths reoccurred independently of one another across the world. Therefore it was inevitable that alchemy (which itself seems to have developed independently and in isolation on at least two separate continents) would fascinate him as he gathered information to support his theories.

The more that he investigated it, the more that Jung discovered that alchemy was not just useful for its representation of universal symbols, but that it could also aid him in his work as a psychologist. He began to unearth evidence that even the earliest Greek alchemists had been aware that their physical experimentation had corresponding processes which occurred in the human psyche. In essence, he discovered that alchemy was not only an early physical science, but also a living form of sacred psychology that could be interpreted symbolically in the search for personal transformation. In doing this, he confirmed the "as above, so below" concept, which alchemists had been using for hundreds of years to understand the world around them.

Jung thought that the physical goals of the alchemists were "unconsciously reflecting an internal developmental process of 'wholeness' and health in the individual human psyche." He called this "individuation," a process by which the transformation of lead (or cow dung, or mercury) into gold became symbolic of a process of psychological and emotional refinement. This helped him to develop methods of treat-

ing the psychologically disturbed, but it also led him to further develop the individuation process itself, and not just for the mentally ill. In fact, the practices he developed could not have been used by someone who was emotionally unstable (at least, not until they had overcome the most destructive aspects of their own minds). Instead of treating the sick, Jung's individuation process taught people to confront the workings of their mind in order to achieve emotional and psychological growth. Or, as the alchemists would have put it, it demonstrated that "only that which has been tried by fire is strong."

As alchemy has again attracted interest and developed as a field of physical experimentation, many modern alchemists have accused Jung of belittling alchemy or reducing it to a "mere psychological process." What they fail not notice is that alchemy has *never* been about pure physical experimentation. Since its earliest days, it has focused on the purification, not only of the physical world around us, but of the soul, and Jung was drawn to it just as the major religions of the world have been drawn to it throughout history.

To the practitioners of internal alchemy, there was never any such thing as mere psychological process. The alchemy that Jung helped to revive was never intended simply to understand the outside world.

All Things are One Thing

THE ALCHEMISTS HAVE been teaching for centuries that everything is interconnected, and that nothing exists in isolation. And while the external alchemists draw correspondences between all of the phenomena of the physical world—connecting the planets of the solar system to the major metals and days of the week—so Jung understood (as the Taoists and spiritual alchemists do) that each of these physical processes is also a representation of something that occurs within. Since its infancy, it has been the goal of alchemy to understand the wider universe by focusing intensely on just one part of it—whether that part is the visceral, physical compounds, or the more diffuse workings of the soul, it barely matters. In the end, alchemical teachings tell us that all things are one thing.

The fact that physical matter and the mind affect one another is one of the inevitable truths of existence. To alchemists, this means that ultimately the physical sciences and the science of the mind are inseparable. Jung said that, "sooner or later nuclear physics and the psychology of the unconscious will draw closely together … psyche cannot be totally different from matter for how otherwise could it move matter? And matter cannot be alien to psyche, for how else could matter produce psyche? Psyche and matter exist in the same world, and each partakes of the other," and that, "it is only today, when we know that the assumptions of the observer decisively precondition the total results, that the question is becoming acute."

Today, people are beginning to understand the fact that physical reality is only evident through our abilities to perceive it, from George Orwell writing, "if I think I float, and you think I float, then it happens" in *1984*, to recent scientific theories presented in journals like *New Scientist* proposing that physical reality is a holographic projection of three-dimensional space onto a two-dimensional surface—creating an illusion which our minds detect as physical matter.

Suddenly, the alchemical teaching that the physical and the psychological are profoundly interlinked no longer seems so fantastical. Perhaps, then, this ancient, sacred science (which has been relegated to the table-rappings of mediums and the ritual dogma of secret societies for so long) has something more to give humanity, after all.

Yena of Angeline in "Lizard Town Woes"
In which our Protagonist learns Nothing, accomplishes Nothing
serial fiction by Margaret Killjoy
illustration by Amanda Rehagen

The fire didn't really *roar*, per se. It was much too loud for that. It didn't *crackle* or *hiss*. No, the fire screamed and it shattered and it deafened. Hot air forced through narrow holes in the library's roof and whistled a cacophony that could be heard clear across town. No one in The Vare slept the night that the library burned down.

The whole town gathered in the public square near the building, close enough to the fire to silence conversation, far enough away to avoid being hurt. The townies stood side-by-side with the squatters for hours, but no blows were thrown and few glares were traded. In that simple moment of awe and disaster, the crowd was of one mind. A simple mind. The kind of mind that lives in every human being, the kind of mind that delights in fires and forgets the consequences.

Of course, no one there seemed to know how the fire started.

Yena stood near the back of the crowd, with several thousand people between her and the spectacle. Her jumpsuit was half-buttoned, revealing her nightshirt below, and she held her crowbar-axe slack at her side. Sleep, or the lack thereof, formed dark circles underneath her eyes.

The fire calmed down, its fuel consumed, and the crowd began to murmur. Factions formed, slowly at first, but then with increasing speed. The squatters grouped beside the stonework fountain — the one that none of them had ever seen run — with its mythical beasts and imaginary birds and unclothed people of every gender. The nightshift gas-workers stood with their signature oversized wrenches, dressed in workclothes, while others stood in their patched woolen union-suits, bare-fisted but awake, and angry.

The townies took the small amphitheatre on the other side of the square. They wore their plant-fiber nightgowns. A few bore canes, but most bore only grimaces.

Obviously, the fault was with the other side.

As the last of the fire died, another disaster began.

"Listen to this," Yena said, three days before the fire. "'The first priority of the musician, much like that of an engineer, is to learn efficiency. If a concept may be better stated in whole notes than 64^{th} notes, it behooves the musician to know this. Complexity may later be built of necessity or ornamentation.'"

"Maybe," Annwyn said, "but I'm not convinced. I think the first priority of the engineer is the creation of things that are useful,

aesthetically or otherwise. Efficiency? Efficiency can be developed, I suppose. I mean, maybe it's more true for music."

The two of them were in Yena's workshop. Yena was reclined on a lounge chair, reading, while Annwyn worked on one of her scrap-metal automatons. Ever since Annwyn's workshop had been bombed out by the townies, she'd been using Yena's. There wasn't really enough space for the two to work side-by-side, but Yena certainly didn't mind being in Annwyn's company so often.

"Where you getting this, anyhow?"

"It's called *From The Aether With Love: The Art Of Pyrophonic Composition*."

"Huh. Quite a title. Kind of goes against what the book is saying, being all long like that."

"Suppose so."

"Where'd you get the book?" Annwyn asked. Books were not a common commodity in The Vare, where paper had to be imported from the coast a thousand miles away.

"The library."

"Weird. I've never actually been. Good place?"

"It's lovely there," Yena said. "After my workshop, there's nowhere that I'd rather be. When I first came to town, I think it was my salvation."

"What do you mean?" Annwyn asked. She turned her attention back to her shears, cutting out sheet metal.

"You all are wonderful, of course," Yena said, "but it was pretty crazy first showing up here. I didn't know who to talk to, and I'm not as social as my sister. I think every day I moved back and forth from excited to overwhelmed."

"Huh."

Yena went back to reading when she realized that Annwyn was lost in work. Once again, Yena felt overwhelmed by how hard it was to express herself. That was why she liked reading, engineering, and music. Much better than trying to talk.

"I figure, if I write a book, someone can just stop reading if they don't want to pay attention. Much harder with conversation."

"What?" Annwyn said, confused.

"Nothing."

The evening of the fire, Yena went to return the book. The library was out on the edge of the old downtown; a part of The Vare that was covered in rusted trash and was occupied only by a strange, symbiotic assortment of loners and orphans. The alleys were filled with scrap metal all the way to the tops of the three story houses that surrounded them. The smaller children were often seen emerging from cracks between rusted appliances and building refuse. Lizard Town, it was called, for the reptiles that sunned themselves on top of the junk and nested within it.

Every time Yena went into Lizard Town, strange noises greeted her. The children there had developed their own culture—some say even their own language—and they played games which were quite incomprehensible to outsiders. Screams of delight were indistinguishable from screams of pain, and there was literally no way for an outsider to understand what was play and what was torture. Not well enough to intervene. But the evening of the fire, something seemed wrong to Yena. The sobs seemed to overpower the shrieks.

She thought nothing of it. Not until the fire. Or rather, not until after the brawl that followed it.

After the fire—and after the fight—the sun rose on Lizard Town. The soft morning glow showed cinder and ash in the air, falling lighter than snow on the bloody, earthen streets. No one had been killed, at least not that Yena saw, but the fight had been one of the nastiest in years. Tensions were high, and weapons had been drawn. Yena herself had taken her crowbar-axe to a Townie's forearm, a matter she didn't even try to justify to herself, not anymore. The Townies had tried to kill Annwyn. They were trying to wipe out, or control, the squatters.

Unhurt, Yena stood on the fountain's carved ledge and let the adrenaline wash through, cleansing her. Beside her, Set sat treating Icar's wounds.

The superficial cuts along the side of his waist weren't bad enough to take him to the overcrowded clinic, so they had remained in the courtyard.

A stranger sat smoking papaver on the far side of the fountain; a sun-faded top hat perched on his head, a stripe of ash across his eyes as a mask. His suit was patched wool, marking him as a rare sort in The Vare—one who had once been able to afford fine clothing, but had found a new and lower place in life.

Three orphans ran counterclockwise around the adults, calling out numbers and turning somersaults. Blood covered their faces, and it took Yena a minute or two to realize that the blood was not their own, that the children had painted their faces from the muddy, red pools that were left after the fight.

Once Icar's wounds were treated they tried to talk about the fire, but Icar began to sob and soon Yena followed, curling her head onto Set's lap.

"So much knowledge," Icar cried.

"Who would do this?" Yena asked. She hadn't felt so powerless in years, not since leaving Angeline. The brawl was no catharsis. "Who would do this?" She might have asked the question four or five times between the bouts of tears.

"Enough of your wailing!" the stranger said, leaving his seat and walking clockwise around the fountain to face them. "I set the building on fire. Are you happy to know that? Does knowing it was me solve anything for you?"

Yena was too stunned to react.

"I was paid to do it, much better than I'm paid in this wasteland hell to light the gas lamps. So I lit all those books instead. They paid me, and there's no more library. Write your own damn books if it's so important to you! Just quit your gibbering!"

Somehow, the stranger's emotional outburst brought Yena into a ghostly calm that prevented her from thinking about harming him.

"Why?"

"Blasted if I know, maybe they want you to fight. Maybe they want you to just run at them with axes and die. Or maybe they just like fire. Doesn't matter much, now does it? There's nothing you can do about it, there's nothing you're *going* to do about it. Good morrow." With a sardonic doff of his cap, the arsonist walked away.

Yena let him. She didn't know why.

"Well, what are we going to do about it?" Yena asked Annwyn, back at the workshop that night.

"I don't know," Annwyn replied.

"If we hunt down that man, that lamplighter, and break his arms, that's not going to fix it, is it?"

"No."

"If we hunt him down and make him tell us who paid him, if he even knows, and we hunt *them* down and break their skulls against the cobbles, that's not going to stop the Townies from trying to kill us, will it?"

"No."

"Who would destroy half the books in The Vare just to piss us off?"

"I don't know."

Yena sat in an uncomfortable silence while Annwyn went about her work, tightening bolts on a small clockwork doll.

"If I wanted to track that man down, would you help me?" Yena asked.

"Yes," Annwyn replied, her voice still devoid of emotion.

Another silence, then a pop as a spring wound its way into place through the mouth of the automaton.

"What do you think we should do?" Yena asked.

"I don't know."

"What *can* we do?"

"I don't know."

Yena stopped asking questions. Annwyn finished the doll. The moon rose gibbous over the slum's dark streets.

Eventually, the two women went to their respective beds and tried to sleep. Yena lay unsettled for hours, but no answer ever came to her.

Some questions have no answers, and some problems can have no solutions.

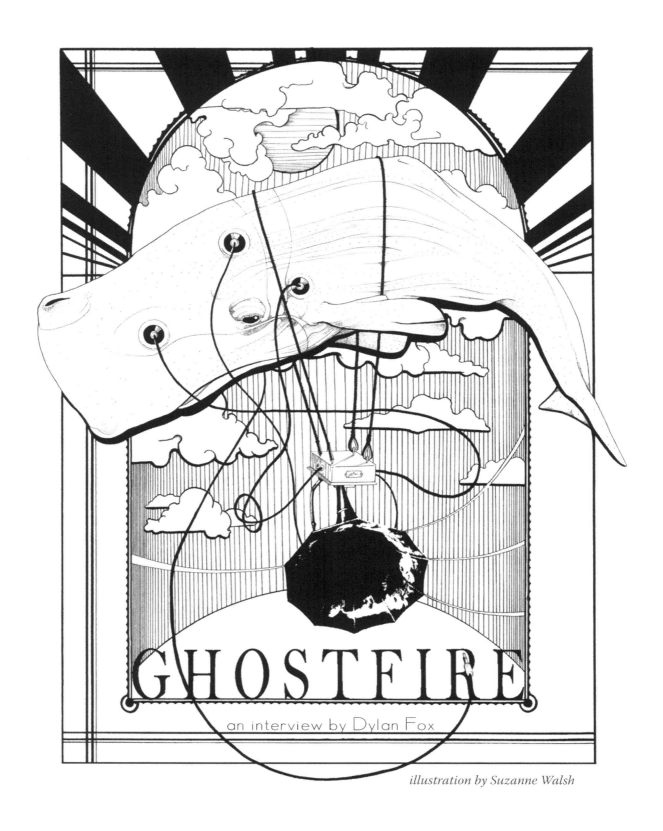

illustration by Suzanne Walsh

Ghostfire are a London-based steampunk rock band who coalesced around their guitarist, Andii. Foregoing the lure of airships and lairs of mad scientists, they instead shuffle down the dark and ill-lit side-streets of the Victorian slums, plucking beggers, murderers, and lost souls from the doorways and casting them in menacing melodramas, opium-tinged fairy tales and alcoholic ballads. Andii kindly agreed to answer a few questions while we sat in a Tyburn doorway, sharing some jellied eels while the rope was being tied.

Dylan: *You have a couple of inches on the playbill to sell yourself to passing trade. How would you encapsulate everything that Ghostfire is?*

Andii: A day trip to Olde Paddington Fayre.

Dylan: *Say we're in some dead-end tavern, with poor lighting and sawdust on the floor. You've managed to coax us into one of the gloomier, danker corners and brought us a drink. What's in that battered old box you're trying so hard to sell to us?*

Andii: Absinthe, opium, laudanum, forged copy of Psalm 51, daggers, alchemist's gold. … Copy of the Times.

Dylan: *I do hope it's a copy of a pre-Rupert Murdoch Times. Or, if not, it's wrapped around some fish and chips …*

Andii: It's a perfectly preserved copy from the infamous "Thunderer" days—artfully concealing a copy of The Sun (which we only buy "for the sport" of course …)

Dylan: *Your music and your lyrics sound different to most other self-confessed steampunk bands—for example, there's a distinct lack of synthesisers, drum machines and airship pirates. Are you purposefully trying to define a different sound for yourselves?*

Andii: Definitely! We're trying to represent the darker side of steampunk. Within our songs there's always been a strong lyrical focus on tales from the underbelly of English history—Victorian and beyond—and steampunk is a great way of getting these stories out to a historically astute audience. While the more whimsical side of steampunk is certainly important to the culture—probably best encapsulated by Abney Park—the English have a reputation for grit and that's where Ghostfire are coming from. In terms of using "real" instruments, we believe in the rock and roll ethic—we're a loud, rude band when we play live, and people seem to respond to that.

Dylan: *What's your greatest triumph?*

Andii: The Triumph Stag—a work of art. I'm also quite keen on the Herald.

Dylan: *Can you recall a time when you wished that the lights would dim and the guy with the hook would hurry up and pull you off stage?*

Andii: Several of the small pub gigs we played in the early stages of our live career. The absolute worst was just before Christmas last year—some hole in the backstreets of Camden, nobody there, and a useless soundman who wouldn't soundcheck us, listened to the whole gig through the mixing desk, and cut our set short. Which was a blessing actually, Steve was ready to hit him …

Dylan: *What is your preferred method of transportation? Airship, paddle steamer, or something more exotic?*

Andii: Peppercorn class A1 Pacific steam locomotive 4-6-2. "Tornado."

Dylan: *Do you think that the UK steampunk scene is different to the scene in the US?*

Andii: The US scene seems more defined and developed. Over here, currently, steampunk seems to be regarded as the latest offshoot of the gothic scene. I've heard it described as "goth for engineers," for example. I'm not saying I subscribe to that opinion, but in the UK steampunk is still very much an emerging scene and the associated bands (not that there are too many of us), are if anything even more diverse that those in the US.

Dylan: *Do you think that diversity is going to be maintained as the scene grows, or are some artists going to split away and find a different path?*

Andii: My personal feeling, based on years of experience of the UK music press, is that they will attempt to pigeon-hole steampunk via a few bands, then a load of inferior copyist bands will jump on the bandwagon. It happens over and over again and it's depressing because it usually ends up destroy-

ing scenes that were initially vibrant, unique, and musically exciting. I really hope this doesn't happen with the emerging steampunk music culture, but there's not much anybody can do if the mainstream decides to gatecrash … The bands and artists who split away from any established genre in order to find their own path are often the proto-scene innovators anyway, which is something of a paradox I guess.

Dylan: *Your EP,* Drunk Lullabies, *came out in October last year. You've had a couple of personnel changes since then and plenty of time on stage. We hear that you have an album due out in early 2010. How will it compare to* Lullabies?

Andii: It will be better recorded! When we made Drunk Lullabies we'd never gigged as a band. Rob, our keyboard player, had only been in the band for two weeks and I didn't have a decent functioning amp. The past 12 months of gigging/rehearsing has established our sound and this time we know exactly what we want and how to get it. We want the new album to be more powerful and dynamic than the EP, but we also want it to crystallise the Ghostfire sound while retaining the essential sonic elements that many people seemed to like about our first endeavour. We're working on some great new songs at the moment, and we're very excited about recording them—hopefully in October.

Dylan: *When the apocalypse happens, what skills are you going to bring to your rag-tag group of survivors?*

Andii: We will have caused the apocalypse—too much curry and beer! Like a very flatulent form of Skynet.

Dylan: *Where do you as a band, and you as people, expect to be in five years time? Will there be cake?*

Andii: We will be living in France: owners of our own personal vineyard, producing the infamous Ghostfire Chablis and drinking all the profits. There will be a shoe-cake.

Ghosfire have promised to entertain the crowds at The Asylum, the UK steampunk convivial, in September. In the meantime, their music can be enjoyed through their aether-net site at www.myspace.com/ghostfire, *where one can also make purchases of their EP and other sundry items.*

A CORSET MANIFESTO

by Katherine Casey
illustration by Allison Healy

For us, adventure knows no gender, and possibility knows no bounds.

Contrary to the honeyed words of gentlemen, this Age of Empire is a pestilence upon every continent and soul. Rich men from stone buildings wade blindly through the penniless on their way to the opera, and though these gentlemen are excellent at imposing a world order, they are equally adept at colonizing the women who maintain their homes.

—Erica A. Smith, *On The Political Situation Experienced In Our Era*, Steampunk Magazine #1

WERE YOU TO SEEK AN INTERNATIONAL measure of a woman's value, you would need look no further than her appearance. Across history, women have been treated as china dolls in glass cases, judged only for their beauty, and no era is more guilty of this than the one we build upon; the smog-choked alleys of Victoria's Empire that are our inspirations hid women trapped in parlors and kitchens, bound in gilded cages of silk and steel.

The costumes we create from ruffles and tea-stained lace summon images of the garment-restraints worn by the women we claim as our inspiration. Their identities were bound in laces criss-crossing up their spines; their creativity and passions were labeled hysteria and locked away, leaving them with musty parlors and parasols to keep their delicate skin from the sun should they, God forbid, find the need to step outside. Their young daughters were dressed like dolls in heavy skirts, and quickly learned that the price of a stain or tear outweighed any wish to climb a tree.

We imagine a world of endless potential, where anyone could invent a flying machine, discover a country, or overthrow an empire. We do not see the women whose husbands locked the library door and left for work, leaving their wives to flip through catalogs selling penny-farthings for gentlemen and tricycles for ladies.

And so we come to steampunk, re-creating the Duskless Empire. For us, adventure knows no gender, and possibility knows no bounds. As we create our future from the past, how are we to cast ourselves? Shall we throw aside our petticoats, accept the chopping off of our braids as prerequisite to liberation?

No! This world we make for ourselves exists at the juncture of fashion and function. Our mad scientists' sketches are annotated with lines of poetry, our steam-spitting inventions play stirring symphonies, and our dirigible captain's hair is tied with satin bows.

No longer trapped by standards that crushed ribs and spirits, we are free to define ourselves as we choose. We do not measure ourselves by the dresses in our closets or inches pulled from our corsets; instead, we draw beauty in the margins of our stories and embroider it on the sleeves of our blouses. We refuse to be display pieces, our skirts and curls confined to the frames of sepia-toned photographs. We are not mere dolls to be costumed—we are explorers and inventors, philosophers and madwomen. The women of the Empire gave us computer programs before the computer, cross-dressing surgeons before women could even attend medical school, and volumes of writing under names given and assumed, detailing adventures never imagined for a lady of the day— we take *them* for our inspiration, casting aside the assumptions of docile submissiveness assumed by "proper" ladies. Our goal is not to return to a time of oppressive morals, but to challenge the assumptions sewn in long hems and high necklines: no longer are our dresses a uniform of domesticity (or our trousers a pass to play with the boys). We define ourselves creatively, in ribbons that hold our goggles, and frills that hide dangerous gadgets.

Steampunk will never be a mere revision of Victoria's long-gone London. The walls of tradition (which long held women cloistered) have crumbled, the first cracks made by the brave women of bygone eras. Let us take the stones and build a world of equality and possibility, the likes of which was unimagined just a century ago. We stand before women who broke their ribs for beauty. Now, we shall lace our corsets only as tightly as we want to, able to breathe deeply as we prepare for adventure that will take our breath away.

an expanded version of this article will be released in book form by Eberhardt Press in 2012

the zenith and decline of the tramp printer
CHASING THE WILL O' THE WISP

by Charles Eberhardt

THE TRANSIENT PRINTER WAS MASTER OF every piece of equipment in the shop, and this mastery came from traveling. "If you had not traveled, no matter how good you thought you were, you were only good in one shop." The International Typographical Union traveling card allowed the tramp printer to work in any union shop, to spread their knowledge and chase their dreams—or try to outrun their demons.

The tale of Peter B. Lee is particularly poignant. "Known throughout the craft as 'king of the tramp printers,'" Hicks writes, Lee "was a fine figure of a man, usually wearing a spike-tailed coat and a wide-brimmed hat … He wore an unusually heavy watch chain and never was without it. He came and went in a quiet sort of way and little was said of his coming or going, how he arrived or what mode of travel would take him away. … Lee was welcome because of his entertaining conversation, his courteous demeanor and gentlemanly bearing.

"The legend of Peter B. Lee was that upon the outbreak of the Civil War, he joined the Union army and marched away, leaving a young wife behind. The war over, he returned home, but was unable to find the wife or any trace of her. The rest of his life, it was said, was spent in wandering up and down the earth, seeking the vanished one. The year after I met him in Cedar Rapids, wearied of his fruitless search, he sank to eternal rest in Lincoln, Nebraska, and was buried there. Later, at the instance of the local typographical union, his body was reinterred in the 'old' cemetery at Beatrice, Nebraska, where it rests under a modest marker:

> And thus we die,
> Still searching. …"

Sometimes, tramp printers were not seeking to find something, but to escape something. According to Thomas W. Holson, a printer known as the Duke of Wellington tramped through Arizona during the 1920s. Everyone always assumed "Duke" was just a nickname, until he was outed as the real Duke of Wellington and brought back home to England. In fact, he was the youngest son of the Wellington family. He had accompanied his father to Arizona, where he learned the printing trade and hit the road as a tramp printer. He never expected that his father and all the other heirs to the family estate would die, leaving him the title of Duke. Upon returning to England, he found that the family estate had been mismanaged into utter insolvency. After guzzling the family's sole remaining asset, a few decanters of whiskey, the Duke scammed one last loan out of the estate to cover his passage back to America and renounced his title. "The Duke said goodbye again and walked away into the night, his boots scuffing gravel," Thomas Holson wrote of his final encounter with the heir of the doomed duchy. "Somewhere he would find work as a printer. He was sure of that. We never heard of him again."

In New Orleans, Hicks writes that he "became acquainted with one Newell, a printer on the *Times-Democrat*, whose father had befriended an old seafaring man and had been given a map to show where Lafitte [Jean Lafitte, "The Gentleman Pirate of New Orleans," 1776-1826] had buried his golden doubloons. The father died, and the son devoted his whole life to the search for the gold, it becoming his only interest. Having little money, he would set type until he had earned enough to fit out an expedition, when he would go in search of the treasure. But alas, the winds and the tides were so constantly shifting the sandy islands that he could never be sure which one his chart called for. … Half a dozen times he returned penniless to his printer's case, saved, and left again, keeping up the search for twenty years, finally being drowned when a tropical hurricane swamped his sailboat. Don't we all chase some sort of will o' the wisp?"

Often Unpredictable, and Frequently Ludicrous Behavior

THE HARSH AND unforgiving lifestyle of the tramp printer ensured only those of almost indestructible character survived. And the characters which thrived were those who were eccentric even among their peers.

Gene Thieme recalled a tramp printer "who carried a .22 pistol in his tool box. Pigeons would fly in through the open windows and sit on the rail above his [Linotype] machine. The first time we heard his gun go off—we didn't even know he had one—we were surprised, but pretty soon we got used to it. One night he shot three or four birds right off the top of

his machine. Never damaged the machine. Next morning the printer's devil just scooped up the dead birds and put them into the garbage."

According to John Edward Hicks, the local townspeople of Hannibal remembered Samuel Clemens as a practical joker. Hicks wrote about a joke Clemens played "on Sam Snell, a tramp printer, when he had placed a skeleton in Snell's bed. The tramp printer slept peacefully with the skeleton all night and the next morning had sold it for seven dollars and got cock-eyed drunk on the proceeds."

Hicks writes of one larger-than-life tramp known as "Muskogee Red." "For more than half a century he saw the inside of more print shops and jails than any other man in the trade," Hicks wrote. "On one occasion he burned down a jail of which he was an inmate." To encourage Red toward sobriety, a friend once advised him "that he should, when feeling the desire for strong drink coming on, eat an apple. 'Who the hell,' inquired Red, 'wants to run around with a bushel of apples on his shoulder?' He became a great friend of Jay House, writer on the *Topeka Capital*, and in his early days himself a tramp printer. When the word came up from Oklahoma that 'Muskogee Red' had been found dead with a half-empty whisky bottle in his pocket, Mr. House wrote a touching tribute for his paper ... A few months later 'Red' drifted into Topeka and gently reproved House for the premature obituary. 'You might have known it wasn't me,' he chided; 'didn't the report say the bottle was only half-emptied?'"

Booze, Booze, and More Booze

PERHAPS UNSURPRISINGLY, AUDACIOUS drinking habits were customary among tramp printers. Alcoholism was prevalent among editors, reporters, and typographers alike; tramps were only fired for drinking when it interfered with their work. And even if they were fired, there was another job waiting for them in the next town over, if not across the street.

"Tramps drink little, if any, booze when on the road," notes Linafont Brevier in his memoir *Trampography*. "A tramp has to struggle to keep from going hungry; he has little or no money for alcohol. He knows, too, that he must be in possession of all his faculties when he hops a fast freight—or he may be killed or crippled for life."

However, once off the train, a dry tramp was likely to quench his thirst at a local watering hole. Tramp printers frequented burlesque houses like Gilmore's Zoo and bars like Doc Zapf's Washington Hall in Indianapolis, and gigantic dance halls like the one in Leadville, Colorado, "where from five hundred to fifteen hundred men would gather." Other establishments catered to the tourist printer particularly, such as John Jakle's saloon in Terre Haute, Indiana, "where it was only necessary to lay a printer's rule on the bar to get a drink," according to Hicks. "This jovial old German, known to the printers as 'Jake,' would stake a traveler to a meal ticket and a room until work could be found. He told me he never lost a cent on a tramp printer, for as soon as they got work, they would come to him on their first pay day and repay the money advanced and in many cases pay the bill of some pal who had failed to get work."

While on the job, there is no subterfuge that drunkard printers would not seize upon in their quest to conceal alcohol. One tramp printer claimed to have "a chronic medical condition which required that he take frequent doses of different colors of medicine, which he kept on his work frame in plain sight," write Howells and Dearman. "Not surprisingly, it proved to be mostly alcohol ... with various food colors added."

Printer Howie Schuneman recalled, "At Miller Publishing in Minneapolis there was this pressman who actually hid his bottle in an ink fountain. We had a big Miehle press with ... an inkwell about six inches deep. This pressman would bring his bottle in the morning, slip it into the well, and then—when nobody was looking—fish it out, take a swig, and submerge it again in the ink. He was very precise: never got ink on his hands. He wore rubber gloves—all pressmen had to—and he'd take them off, put on another pair, fish out the bottle, wipe off the neck of the bottle carefully with a rag, take a swig, and sink the bottle in the fountain again. The boss never did figure out where he hid the bottle."

Naturally, all this drinking led to some inevitable antics. "A tramp named Rigsby was slugged up on the Chicago Tribune," recalled Jack Reuter and Frank Graham. "After belting away a few

drinks at lunch he forgot where he was working. He entered the Sun-Times composing room and was pounding away on the keyboard for about half an hour before the foreman … told him that he was working on the wrong rag."

Nevertheless, according to Gary Thieme, "If anybody tries to tell you that alcohol 'dulled their minds' or interfered with their work, don't believe it! They were sharp, particularly the [Linotype] operators. Alcohol improved their work."

The Fairer Sex and Fair Dues

THERE WERE WOMEN typesetters in North America from the very beginning. The wives and daughters of printers regularly worked in the family business; two of Ben Franklin's nieces set type in his shop. During John Peter Zenger's famous censorship trial in 1735, it was his wife who kept his little weekly newspaper going during his imprisonment. When he passed away a few years later, she became the publisher.

So we must wonder why the annals of trampography are so devoid of women's stories. There were relatively few women printers, so there would have been fewer women tramp printers by default. Women typesetters also faced chauvinistic discrimination in the workplace, which prioritized the economic needs of "men with families to support." Because of this, "when a woman gained a regular situation by way of her priority, she was more likely to hold on to that job for life" rather than sacrifice her hard-earned priority on the slipboard to carelessly tramp across the countryside. We must also wonder if the history of women tramp printers has not been overlooked for the same reasons that so much of women's history has been ignored and forgotten within the context of a patriarchal society. We do know that much of the equipment, as in other trades, was designed for use by burly men; generally speaking, they would have had an easier time loading a Linotype magazine, for example, which "fully loaded with mats weighed about 80 pounds and had to be hoisted about five feet in the air and slid diagonally upward on the machine."

Nevertheless, as Howells and Dearman observe, "There was no reason why female typesetters couldn't match production standards expected of male workers.." This did not escape the cognizance of shop owners and foremen at the time. They began to bring women into the composing room during the mid-1800s in an effort to undermine the growing but almost exclusively male unions. Women typesetters were hired at lower wages, which inflamed resentment among some of their male co-workers. They were also perceived by capitalist interests to be "more malleable" than their male counterparts. However, after a short time in the back shop, they found the women to be just as stubborn and militant as the men. "In 1869, the Typographical Union finally agreed that women should be admitted as full-fledged members" and that "women printers must be paid the same as men, and there could be no discrimination against them."

"The thing I especially liked about working in union shops," wrote female tramp printer Le Hanesworth, "was that women's wages were the same as men's wages, not always true in non-union places. Although women were not always welcome at first, once you proved yourself as a worker, you'd quickly earn the respect of all."

Thus, women eventually became somewhat freer to take to the road, and there are a few whose stories are known to us. Tramp printer Lydia Avery entered the printing trade before she was twenty and held an ITU journeyman's card for 75 years. She did a fair bit of traveling before settling down to a permanent situation in New York City. "We took no nonsense from any foreman," she recounted at nearly a hundred years of age. "We developed an independence that remained until the end."

Then there was Big Marie Emory, a true tramp printer through and through. "She was a loud, brash individual who enjoyed bragging about her exploits," write Howells and Dearman. Once she was jailed after throwing a beer mug through a stained glass window in an attempt to get the attention of the establishment's bartender. Another time, when a foreman questioned what kind of work she could handle, Big Marie "went over to him and poked him a couple of times on the shoulder, and said, 'I can do anything a goddamn man can do except piss in a bottle.'" Big Marie continued tramping into the 1970s; the FBI came after her at age 72 because she was drawing checks for a Navy pension from a

deceased husband, social security off two other dead printer husbands, her own social security check, and full union wages as a proofreader—and using her food stamps to pay an undocumented worker to clean her trailer. A first-class tramp to the end!

Technology Finally Kills the Dream

For decades, innovations in printing technology had either created more jobs and empowered the workers, or were rejected by the back shop. The computer dramatically reversed this pattern.

The shift began with an adaptation to the Linotype called the teletypesetter (TTS). Instead of operating a keyboard, the operator punched a perforated paper tape by hand and fed it into the machine. The TTS actually increased the amount of labor required and ultimately failed, but it was a hint of things to come.

The introduction of the computer changed everything. At first, it was only used to calculate the justification and letterspacing for each line of type based on the operator's output from the Linotype keyboard. Suddenly, an unskilled TTS operator could set type with punched tape as rapidly as the fastest "swift" of the old days. Consequently, "newspapers were able to effect reductions in their workforce instead of a steady increase." Traveling became more difficult for tramp Linotype operators as job opportunities began to dry up. Faced with looming insecurity, many itinerant printers began trying to secure permanent positions.

Soon thereafter, TTS punch tapes were adapted to operate the new phototypesetting machines, and before long hot metal was done away with for good. Computers and software became more powerful and sophisticated by the month. Optical character recognition (OCR) software was developed that allowed anyone to scan typewritten pages and convert them into teletype tape to operate either a Linotype or a phototypesetting machine. Printers were soon bypassed entirely by the new digital technologies, which also eliminated TTS jobs, cutting off yet another job opportunity for tramp printers who were trying to adapt.

As the pace of technological change continued accelerating, video terminals linked the newsroom directly with photocomposing machines, allowing reporters, editors, and anyone else who could use a typewriter to become typesetters, entirely bypassing the composing room. Computers could store articles and ads in memory, and layout software allowed editors to compose pages themselves. Tramp printers were no longer needed to get the paper out on deadline. In fact, no printers were needed at all. Linotypes were cast away for scrap metal; machines that cost $50,000 each a few years earlier were given away to anyone who was willing to haul them off. Non-union composing rooms were liquidated without further ado. The ever-tenacious ITU held strong in solidarity, sometimes fighting back with wildcat strikes. But publishers and commercial interests fired the strikers and farmed out the work. They used fear to lure workers away from the ITU, knowing that this was their opportunity to finally do away with the troublesome, militant typographical union once and for all. Deeply wounded, the ITU limped into a merger with the Communication Workers of America (CWA). Soon, unskilled workers were laboring for longer hours at about half the wages previously enjoyed by skilled typographers.

"Tramp printing didn't die a slow death; it happened suddenly," write Howells and Dearman.

They Come No More?

A few tramp printers clung to their way of life, vanishing into lonely, anonymous fates. Bill Taylor got stuck in Denver's skid row as work for tramp printers dried up to nothing; bitter and disillusioned, he managed to escape Denver and move to Montana, where he died of a heart attack, alone, in a cheap motel in Bozeman.

Most tramps attempted to adapt to the new systems and took permanent jobs. Eddie Hayes settled down at the *Santa Cruz Sentinel* for a while but was unable to let go of his wanderlust. He eventually drew a travelers' card and was last heard of heading for Atlanta.

"We tramp printers felt such a deep attachment to the union and the craft that it represented that we mourn its passage like a person who has lost his entire family in a fatal accident," write Howells and Dearman. "The end of the composing room closes an era that began centuries ago and will not likely ever return."

Yet I think of friends and old-time musicians who hitchhike and hop freight cars all over the country, stopping for a while before they are dragged away by the irresistible call of wanderlust. I think of all the youth who cast off worldly possessions and travel from town to town in search of adventure, crossing paths with vagabond friends, comrades and collaborators, sharing their stories and recording their ideas and dreams in music, zines, and journals. And completing the circle, many folks are re-discovering the beauty and utility of letterpress as a means of conveying their words. In all of these things, the spirit of the tramp printer lingers on.

Further Reading

The Tramp Printer: Sometime Journeyman of the Little Hometown Papers In Days That Come No More, by Ben Hur Lampman, Metropolitan Press, 1934.

Adventures of a Tramp Printer: 1880-1890, by John Edward Hicks, Midamericana Press, 1950.

Trampography: Reminiscences of a Rovin' Printer 1913-1917, by Linafont Brevier, 1954.

Tramp Printers, by John Howells and Marion Dearman, Discovery Press, 1996.

A Catfish in the Bodoni: And Other Tales From the Golden Age of Tramp Printers, by Otto J. Boutin, North Star Press, 1970.

Life in the Back Shop: Printers Tell Their Stories, 1900-1965, by Robert MacGregor Shaw, Superior Letterpress Company, 2004.

American Labor's First Strike, by Henry P. Rosemont, Charles H. Kerr Publishing Company, 2007.

IN DECEMBER 1893, A CRIME WAS COMMITTED which sent shockwaves around the world. Readers of the monthly publication *Strand Magazine* were the first to learn of the offence, but news spread fast, and soon the tragic facts of the case were common knowledge: Sherlock Holmes was dead.

After six years of recording his exploits, Arthur Conan Doyle had grown tired of the Great Detective and decided the only way he could be truly free of the character was to kill him off in *The Final Problem*. Doyle's intention was to send Holmes out in a blaze of glory so magnificent that his fans would be more than satisfied. This, however, did not prove to be the case. In 1903, after a decade of pressure from Sherlockians the world over, Doyle finally acquiesced and Sherlock Holmes was resurrected in *The Adventure of the Empty House*. Reports of the Great Detective's demise had been greatly exaggerated, it turned out—Holmes had merely pretended to have toppled over the Reichenbach Falls in an effort to escape would-be assassins. But how did he do it? Struggling for his life, grappling with his arch enemy, Professor Moriarty, at the edge of a precipice, what was it that saved Holmes from certain death?

> We tottered together upon the brink of the fall. I have some knowledge, however, of baritsu, or the Japanese system of wrestling, which has more than once been very useful to me. I slipped through his grip, and he with a horrible scream kicked madly for a few seconds and clawed the air with both his hands. But for all his efforts he could not get his balance, and over he went. With my face over the brink I saw him fall for a long way. Then he struck a rock, bounded off, and splashed into the water.

However, as exciting and dynamic as the preceding passage might be, it should be pointed out that Doyle (or arguably Dr. Watson who is the author within the tale) was incorrect on at least two points. Firstly, though published in 1903, *The Adventure of the Empty House* is set in 1893, yet the martial art referred to in the text was not actually developed until the late 1890s. Secondly, it is not "baritsu" but Bartitsu.

There can be little doubt that Arthur Conan Doyle would have read *The New Art of Self Defence: How a Man May Defend Himself Against Every Form of Attack*, which caused quite a sensation when it was published in *Pearson's Magazine* in March 1899. Evidently the article made some impression upon the Scotsman—though not quite enough to allow him to remember the correct spelling of the art in question. Its author, Mr. Edward William Barton-Wright, was every inch the Victorian gentleman: born in 1860 in Bangalore, the son of a British mechanical engineer and Locomotive Superintendent, he was educated in Europe and went on to travel the world as a civil engineer and surveyor. It was while on these travels in the early 1890s that Barton-Wright found himself living in Japan. There, in his spare time, he studied several different styles of Jujitsu including Shinden Fudo Ryu ("immovable teachings transmitted by the Gods") and Judo ("the gentle way"). By combining these techniques and further incorporating aspects of oriental stick fighting, English pugilism and French kickboxing, Edward soon formulated his own mixed martial art which he dubbed Bartitsu—a portmanteau of his own surname and Jujitsu.

Having left Japan and arrived in London in 1898 Barton-Wright found himself in a rather unique position. Crime was rife in the post industrial revolution cities of Europe and its colonies, and the contemporary newspapers' reporting of muggings, garrotting, chloroforming, beatings, and the like were sensationalist to say the least. So severe was the media hysteria that the humorous magazine *Punch* (1841—1992) satirised the over-the-top reporting of

BARITSU, BARTITSU, AND THE JU-JUTSUFFRAGETTES

by John Reppion
illustration by Juan Navarro

other publications by running mock advertisements for items such as the *Patent Antigarotte Collar* ("*warranted to withstand the grip of the most muscular ruffian in the metropolis [...] highly polished and elegantly studded with the sharpest spikes*"). In reality, sword canes, pistols, knuckle dusters, and other concealed weapons were being carried by an increasing proportion of the population, all in the name of self-defence. People were desperate for a way to protect themselves from the thugs and "roughs" who roamed the streets and Edward Barton-Wright, it seemed, had the solution.

The Bartitsu Club opened its doors on London's Shaftsbury Avenue in 1899, offering classes taught by Japanese Jujitsu masters, French walking-stick fighters, Swiss wrestlers, English fencing champions, and much more besides. Many of those who taught at the club also became students of the other disciplines in accordance with the eclectic ethos of Bartitsu. Barton-Wright's model for the business was that of a Victorian gentleman's club, meaning that prospective members were voted on by a committee before being allowed to join. Once accepted, new members were required to take private lessons before they would be allowed to participate in group classes. Whilst this system may have been quite ideal for keeping out the "riff-raff" it did not prove to be a very sound business model, and in 1902 The Bartitsu Club closed its doors for the last time.

Though the club itself was short-lived, Barton-Wright's ideas unquestionably had a huge impact on the new Edwardian society (Queen Victoria having passed away in 1901). Though Jujitsu was not entirely unknown in England prior to 1889, there can be little doubt that Bartitsu helped to popularise the martial art in the west. Three Japanese jujutsuka had originally travelled to England to become part of Barton-Wright's permanent staff: K. Tani, S. Yamamoto, and Yukio Tan. K. Tani and Yamamoto returned to Japan after a short time, but Yukio Tan stayed, and was soon joined by a young jujutsuka named Sadakazu Uyenishi. After the collapse of The Bartitsu Club, Uyenishi remained in London and was soon teaching Jujitsu at his own dojo, The School of Japanese Self Defence, on Piccadilly Circus. Some readers may be surprised to learn that one of Sadakazu Uyenishi's star pupils was a young woman by the name of Mrs. Roger [Emily] Watts who later went on to write *The Fine Art of Jujitsu*—the first English work to record Kodokan judo kata. It is however worth noting that there were a number of female members at The Bartitsu Club—boxing being the only art women were forbade from participating in (Barton-Wright having deemed it unladylike).

When Sadakazu Uyenishi eventually returned to Japan in 1908, teaching at the Piccadilly Circus school was taken over by husband and wife team William and Edith Garrud (with the former schooling men and the latter instructing women and children). William Garrud went on to pen *The Complete Jujitsuan* (published in 1914) which remained the standard English reference on the art for many years. Edith's fame however was altogether more controversial. A series of photographs published in the *London Sketch* in July of 1910 depicted Mrs.Garrud escaping from the hold of a male attacker and using the art of jujitsu to gain an advantage, ultimately twisting his arm up his back and forcing him into an awkward crouch. Though it was by now accepted that many women across the country were practicing martial arts, the fact that the gentleman in the photographs happened to be dressed in a police officer's uniform gave the piece a somewhat more political slant as did the caption which read, "*Mrs Garrud, a well-known Suffragette, demonstrates the methods of jujitsu she has taught the W.S.P.U. 'bodyguard.'*" The W.S.P.U (Women's Social and Political Union), founded in October of 1903 by Emmeline and Christabel Pankhurst at their family home in Manchester, was by 1910 the leading militant organisation campaigning for Women's suffrage in the UK. The "bodyguard" mentioned in the caption was comprised of both women and men who were sworn to physically protect Suffragettes during their public protests should they erupt into violence. Mrs. Garrud wrote an article, also published in July 1910,

which appeared in the periodical Health & Strength under the title *Damsel v. Desperado*. The opening paragraph of the piece read as follows:

In proportion as the Suffragettes increase in number and in power, so also do the JU-JUT-SUFFRAGETTES. (I believe it was Health & Strength who first coined that latter phrase.) The daily papers, by their witticisms, smart or otherwise, at the expense of the Suffragette who goes in for ju-jutsu in order that she may foil her supposed natural enemy, the man in blue [e.g., police constables attempting to stop violent women's rights demonstrations], has certainly helped to popularise that mode of self-defence we owe to the Japanese amongst our women, whether they clamour for the vote or not.

Punch was one such paper which responded to the phenomenon of Ju-Jutsuffragettes with characteristic irreverence. In response to the *London Sketch* piece they published a cartoon showing a young lady—complete with Votes for Women placard—intimidating a crowd of uniformed policemen, two of whom had already been hurled over some nearby railings. The caption beneath the image read "*The Suffragette That Knew Jui-Jitsu—The Arrest*."

Unfortunately for Edward Barton-Wright, after the demise of The Bartitsu Club, public interest in his own mixed martial art was soon eclipsed by an enthusiasm for Jujitsu itself. Though undoubtedly responsible for the martial arts craze which swept across the UK and much of the Western world during the early 1900s, Barton-Wright was soon watching from the sidelines as others grew wealthy. Edward is thought to have continued teaching Bartitsu up until the 1920s when, struggling to find paying students, he eventually changed his career. He became an inventor and established "electrotherapy" clinics around London where ailing customers were treated with Thermo-Penetration Machines, Ultra-Violet Ray Lamps and other curious contraptions. The clinics were not hugely lucrative however and, when Edward eventually passed away in 1951, lack of proper funds saw him buried in an unmarked pauper's grave.

In 2001 the *Electronic Journal of Martial Arts and Sciences* began re-publishing some of Barton-Wright's (now out of copyright) articles online. Interest in the long lost art of Bartitsu quickly grew, and soon a group of online enthusiasts calling themselves The Bartitsu Society began searching libraries and newspaper archives for further information on "The New Art of Self Defence." Today The Bartitsu Society draws a clear distinction between what they term "Canonical Bartitsu"—the art as described in material contemporary with the life and times of its creator—and "Neo-Bartitsu"—the art as it may theoretically have developed since its foundation had the public maintained their interest. As well as organising demonstrations, workshops and meetings the world over, the society succeeded in 2007 in locating the spot where Barton-Wright was buried. The grave site is in Kingston Cemetery in Surrey, roughly ten miles from central London. The Bartitsu Society has produced two books: *The Bartitsu Compendium, Volume I: History and Canonical Syllabus* (2005) and *Volume II: Antagonistics* (2008), proceeds from which will go towards the erection of a monument dedicated to the memory and the legacy of Mr. Edward William Barton-Wright. Perhaps the inscription could read "*In memory of the man who saved the life of Sherlock Holmes*." ✺

Reference:

EN.WIKIPEDIA.ORG/WIKI/BARTITSU

WWW.BARTITSU.ORG

WWW.VICTORIANLONDON.ORG

WWW.FSCCLUB.COM/HISTORY/JUDO-HIST-E.SHTML

MARTIALHISTORY.COM/2008/01/JUJUTSU-SUFFRAGETTES

The New Annotated Sherlock Holmes edited by Leslie S. Klinger (W. W. Norton & Company), 2005.

"The Cane Mutiny" by Anton Krause—The Chap #41, Oct/Nov 2008.

Doppler and the Madness Engine
Part Three of Three
by John Reppion
illustration by Juan Navarro

Extract from Doppler's Journal No. 27.

January the 12th [1866]

Almost two months have passed since those dreadful happenings at the home of the late spirit medium Mr. Sam Thonlemes. My time since has been divided between recuperation and working toward a proper and complete record of those occurrences—the latter indisputably delaying and increasing the need for the former. The transcription of those sounds committed to the cylinders of the remarkable machine taken from Thonlemes' body has proven a far greater task than I first imagined. The broadcast of those resonances having something of the same influence as that which caused the whole terrible business. Before I go any further it is necessary that I describe the device and its workings as briefly as possible.

The apparatus is mounted upon a wooden breastplate which is fastened to the wearer's chest via a system of leather straps. The device has three curved horns; two of which are angled towards the face of the wearer and the third (central) of which curves forwards. The machine is equipped with six cylinders which hold the impression of sound. The cylinders—made of some substance beyond my knowledge which is very much like (but considerably tougher than) hardened wax—are mounted together upon a larger revolving drum in much the same manner that the firing chambers of a revolver pistol are arranged. A single needle-like arm connects with the cylinders, one at a time. The needle's application is controlled by an automated mechanism rather than the operator manually placing its tip upon the surface. The parts of the machine which are key to its operation are clearly marked with small etched plaques, indicating that the contraption was created by some professional maker. For example, the marker above a small, neat crank attached to the device's clockwork motor reads WIND FORWARD UNTIL BELL SOUNDS. A small domed bell with an internal striker, similar to those commonly seen upon shop counters, is mounted a little way below the handle. The switch which controls the application and withdrawal of the needle has three positions marked DISENGAGE (this withdraws the needle from the current cylinder), BROADCAST (this enables the needle to read from the cylinder) and INSCROLL (this enables the needle to record upon the cylinder). There is one final switch, again with three positions. This time, they are marked DISABLE (this halts the mechanism which turns the cylinders), ENABLE (this activates the same mechanism) and AUTOMATE (this allows the device to move automatically to the beginning of the next cylinder once it has reached the end of the last).

To minimise the risk of the sounds affecting others, I have had the machine altered somewhat. A binaural stethoscope—a device used by physicians for the monitoring of their patient's heart—has been fixed in place of its central broadcast horn. The forks of this apparatus fit into my ears, allowing the sounds to be transmitted to me alone. Having made copious notes over the intervening weeks, and listening to those fearful cylinders a number of times, I feel I have now reached the stage where I may at last make record of that night's happenings here in this journal.

There beneath the streetlamp at the far end of Edward Street, having completed my previous diary entry, Grober assisted me in strapping Thonlemes' apparatus to my chest. It took me no more than a few minutes to understand its workings sufficiently to create an impression upon its cylinder and to then broadcast that impression audibly. Satisfied that the device would serve in creating a record of what lay ahead, the time came for me to put my plan to my companion. Grober was, as I had expected, wholly opposed to either of us venturing anywhere near the house. I explained my theory that, since we had previously witnessed a similar—though much less powerful—atmosphere generated by the action of one of Thonlemes' speaking machines, the resonance which filled those around us with such dread might well be emanating from a device, or devices, inside his former home. Our exchange grew gradually more heated until Grober blurted out that if I was mad enough to enter the house then he must patently do likewise. There was a moment of silence. Though merely a figure of speech, my companion's mention of my mania jarred us both.

As I struggled to gather my thoughts, my temples throbbing, I became aware of the sounds all around us once more. I heard the crash of furniture and mingled cries of fear and anger from several of the buildings in the area. Those who had escaped the confines of their homes were wandering about us, some dazed and bloodied, others gnashing their teeth like wild beasts. The scene was eerie and otherworldly, the fog of steam which rose from the street's drainage gratings clinging silent and low to the cobbled road.

My own memories of precisely what occurred next are vague, as of a dream only half remembered upon waking. I know not if I took flight out of terror, or if I determined to sprint back up Edward Street for some other reason, but somehow I found myself standing within the hallway of that fearful house. The first sounds I recorded upon that foremost cylinder were those of my own laboured breathing followed by my stating of my name and, after a pause to glance at my pocket watch, the date and hour. Listening back to that first impression now, a fearful clamour of shouts and screams can be heard drawing near. I stood with my back to the open front door, but turned at the commotion and saw Grober with a mob about him. I cannot say exactly how many there were—my memories of the sight being distorted through terror and the influence of that dread drone which emanated from the house. The horde was surging toward the house in an orgy of anger and violence—Grober was all that stood between the crowd and myself. I know now how the Viking Berserker must have looked when in his battle frenzy, for Grober was the very embodiment of rage and devastation. I stood in horror at the scene, certain that my companion's rage would not be spent until he had killed every last living thing which approached. I called out his name, but as he turned—his eyes meeting my own—I feared for one terrible moment that his fury might be directed toward me.

Grober's words are loud and clear upon the cylinder:

"I will hold them back for as long as I can. Do what you must!"

Whether I nodded with any kind of understanding I cannot say. If I spoke, my voice was drowned out by the commotion. The next sound upon the cylinder is that of the house's heavy front door slammed by my hand.

The hum I had felt beneath my feet out on the street was more obvious within the residence, the sound—like the buzz of some monstrous hive—seeming louder in the relative quiet of the hallway. I decided I must speak stridently in the hope of making myself heard upon the cylinder. I did my best to narrate my short journey through the hallway into the parlour where we and the others had gathered the evening before. All around were signs of struggle and confusion; furniture and other items overturned or broken, many of the pictures which once adorned the walls lying shattered upon the floor. All at once I became conscious of a voice other than my own—soft and scratchy and coming from within the room.

"Must not break the circle—Must not break the circle—Must not break the circle" The words, though quiet, are easily discerned upon the cylinder.

I found the speaking machine lying upon its side beneath a chair. The contraption had sustained some damage which caused Thonlemes' assistant's message to become jammed—Gerard's calm voice repeating the sentence over and over. I lifted the needle, silencing him at last.

As I crept further into the house, the pulsation grew ever louder; the floor, walls and ceilings shuddering all around me. My voice as impressed upon the cylinder is soon lost behind the drone. Almost ten minutes of utter cacophony follows, an appalling, nauseating crescendo toward its end. I admit it is this portion of the record which has caused me the greatest distress, for the listening of those sounds has a terrible, almost hypnogogic effect. Within that tumult I have fancied I heard many things—things impossible to describe adequately upon any page. It is as if all sound that has been, and that ever will be, is condensed into those brief yet harrowing moments. When next my voice becomes audible upon the cylinder I speak thusly:

"I have returned to the parlour at the front of the house. I do not know how long I have been gone. The house is in a state of disorder … there is blood … but I have encountered no other living person. I have made as thorough a search as possible of the ground floor. The humming grows maddeningly loud toward the rear … vision and reason becomes distorted … I found a great circular theatre which I could not bear to enter … it shook fiercely … I could see no machines there. I am certain of that."

This room, it is now apparent, was the auditorium which Thonlemes had been constructing in order that he might conduct his séances before a larger audience in the future. I shudder to think of what might have been had he succeeded in his goal, though it is hard to imagine any outcome worse than what occurred.

I remained in the parlour for several minutes, collecting my thoughts. Though the machine was not deactivated during that time, I began my next deliberate address by once again stating my name, the date and hour. I was now convinced that the sound must be originating from below the building rather than within. From the doorway of the theatre I had observed what I believed to be a trapdoor at the rear of the stage and this, I decided, would be a likely entry point into whatever cellars or passageways lay beneath the house. Although the sheer volume and uncanny reverberation within the auditorium had prevented me from entering the room previously, I decided that if I approached at a run, heading directly to the trapdoor, I may be able to gain entrance before being overcome with disorientation.

At this point, my speech upon the cylinder is interrupted by the sudden sound of shattering glass. Whether the man leapt, or was thrown toward the parlour's front window I cannot say, but his blind fury as he struggled to free himself and scramble into the room was—and is—obvious in his wordless screams. Upon the cylinder his cries fade quickly; the sound of my own breathing and the fall of my running feet soon enveloped once again in that near-deafening, maddening drone.

The din was eventually silenced by the closing of a substantial, lead-lined trapdoor above my head as I found myself in cramped space wholly without light. Once I had caught my breath and gathered my thoughts, I was struck with the fresh terror that I might have merely entered a storage space of some kind. After a few moments groping in the blackness however, I found what I took to be the topmost step of stone staircase. Though I could still feel the echoes of the terrible sound in the floor and walls around me, its volume was lower within the space even than it had been out on Edward Street. I took a few moments to explain my situation into the contraption. I could not say if the man who came through the window of the parlour had followed me, but I imagined that it would not be long before others, similarly affected, made their way into the house. My only hope, I reasoned, was to continue on my course. Cautiously, I made my way down that steep, gradually winding stairway which led I knew not where.

When at last I reached the bottom of the stair, I found a heavy, lead-lined door standing slightly ajar. Passing through the door, I found myself in a circular room of immense height and realised at once that the stairway I had descended must wind around the exterior of the space. The room was lit by several gas lamps set into niches around the walls, but their light did not extend far enough to see anywhere near where I assumed the ceiling must be. The space evidently served as some kind of workshop—its walls being lined with curved shelves and benches on which various tools and curious-looking machine parts stood. From the centre of the chamber there rose a great metallic column some ten feet or more in diameter which towered toward the room's unseen apex. Set against the column on one side was a small, stout furnace or boiler which was evidently in use. The dreaded drone was all but gone down there in the crypt, and only a faint whirring can be heard upon the cylinder at this point. Again I stopped and explained my circumstances and location for the record. I continued my commentary as I made my way around the perimeter of the room. I noted that there were several speaking machines of varying designs, some in states of disrepair, scattered around

the space, but not one of them was in action. I was on my third circuit of the room when I was startled by sound from the central column. A loud, metallic clang rang out as if something had struck it with some force. As I approached the pillar, I became conscious of the whirring I had heard before becoming louder—the sound came from within the column!

Examining the pillar more closely I found a curved, hatch-like door set in to it on the opposite side to the furnace. The entrance was not obvious at first, fitting tightly and almost seamlessly into the surface of the riveted metal, a heavy iron latch being the only real clue to the door's location and functionality. Once again I stopped to speak for the record, my face mere inches from the door. Again there came a clang from within the column followed by another and another. The latch rattled, and I realised with some apprehension that the fastener was not securely closed; its bar only partially resting in place. It was then, amid that whirring and the continued banging, that I—and the contraption strapped to my chest—bore witness to those muffled words "Is there anybody out there?" emanating from behind that metal door.

I reached for the latch before I knew quite what I was doing. The metal was hot and hissed against my skin as I lifted the bar from its cradle in one quick, foolhardy motion. The door was flung open with tremendous force, a great cloud of steam issuing from within. I tried to turn away, but the door struck me heavily on the side and I was propelled across the room, the force of my impact bringing shelves and tools raining down upon me. Had I stood elsewhere however, I would surely have been scalded to the bone by that cloud of boiling vapour. Upon the cylinder the sudden violent hiss of the escaping steam is soon eclipsed by that dreaded, maddening drone once more. As I lay dazed and injured amid splintered wood and machine parts, I felt certain that I was to die there in that oubliette; trapped beneath a nightmare London now populated by murderous lunatics hell-bent on destruction. Though certain nothing could be heard above the din, I screamed then; I screamed as loud and as long as I could. That scream is there upon the cylinder today, and when at last my howl is at an end there is a silence. The drone had stopped.

A figure stepped toward me through the scalding haze; inky black and human in outline save for a grotesquely large and misshapen head. There is laughter recorded upon the cylinder then that is my own. As the creature drew nearer, my laughter grew all the more uproarious—whether out of defiance, mania, or some combination of the two I cannot rightly say.

"Who are you?"

The voice is muffled, as if it were still coming from the other side of a metal door. The question comes again and again until at last I scream my name belligerently.

The creature knelt before me, an oversized hand, black as pitch and slick with moisture reaching out to lift my chin. I glanced up but all I saw was a mirror, my own wretched face staring back at me. Leaning back, the figure's hands moved to its neck and began turning the malformed head, unscrewing it as if it were a fruit-jar lid. Presently, he lifted the helmet and, pointing to the still whirring machine strapped to my chest, asked "How did you come by that?"

Through hysterical tears of joy I explained that I was a consulting detective and that my associate and I had been employed to investigate Mr. Sam Thonlemes' business. When I spoke of Mrs. Shandon's mental unrest the man frowned with a mixture of puzzlement and concern but did not speak. I went on relating everything as well as I could recall it, laying there still amongst the debris. The rubber-suited man seemed to grow ever more agitated as I spoke, at times striking himself upon the forehead with a gloved hand as he paced before me. Only when I spoke of the mayhem I had witnessed upon the street did he interrupt.

"Damn it to Hell! The latch must have fallen and I was trapped … I … there was no way to deactivate the machine from inside. I *swear* I did not know! The sound … it was never meant to *harm* anyone … The resonator was only supposed to work *inside* the theatre. I … I am an inventor … just an inventor. I never dreamed …"

He reached out suddenly and, as he pulled me to my feet, and I asked his name.

"No point in lying now," he replied bleakly and then, leaning in toward the machine upon my chest, "My name, my real name, is Thornton. Culann Thornton."

I was about to ask another question when he interrupted me: "How many dead?"

I told him I had no way of knowing, but that I feared it would be many. After a few moments of silence, Thornton seemed to make his mind up about something. He asked me if I could walk, and when I found that I could he had me take out my pocket watch and check that it was still running. Thornton told me I would have five minutes—no more, no less—to get myself and anyone else I encountered clear of the building. Before I could utter another word he began counting down "Three-hundred and two-hundred and ninety-nine and two-hundred and ninety-eight and …"

I had barely set foot in the hallway of the house, its tiles sickeningly slick with blood from some battle I had mercifully not been a part of, when I was struck from behind by an invisible wall of sound—a deafening blast which seemed to turn the air momentarily solid. Still upright somehow, I was propelled forward; skating across the gore soaked floor as if it were ice. Spreading my arms wide I managed somehow to catch hold of the doorframe and prevent myself from being fired like a missile through the now open front door and into the street. The house rocked and shock, and I was enveloped in a great cloud of steam and dust and plaster as the rear of the building collapsed. Thonlemes' great, rounded theatre twisted in on itself as water spirals down a spout, crushing that engine of madness—and its architect—beneath a tonne of wood and brick.

Upon that last cylinder, there follow the gentle creaks and falls of the settling debris.

One can hear little but groans and coughs from those out on Edward Street until someone cries out in surprise "Look! In the doorway! A man!"

The final words recorded upon that sixth and last cylinder are spoken loudly and clearly. They are the words of my dearest friend, my companion and protector, Grober.

"That is no man, it is Doppler!" ✦

for a new age to rise an old one dies:
WATERLOO

by Richard Marsden
illustration by Suzanne Walsh

The world of Victorian-age steampunk is a fascinating place of machinery and sorcery, where Gyro-blimps sail the skies and Dr. Martin's Aqua-submersible prowls the seas. It is a world of regal imperial pomp and a time of Empires, most notably Britain and Germany. But how did these Empires come about?

It was outside a small town in Belgium that the new world was crafted in 1815. A portly exile had fled his island prison and, with a handful of the Old Guard, wound his way to Paris. The Parisian newspapers at the time were shocked at first, calling him an "outlaw," but when Napoleon entered the gates of France's capital, the papers reassessed their opinion and labeled him as their "Emperor."

The European leaders in Austria instantly declared war, not on France, but on Napoleon himself. They had little cause to believe Napoleon's claims that he desired to rule over France alone and was an advocate of peace. The European powers had lived for ten years with the chaos of the French Revolution and spent fourteen years thwarting Napoleon's desire to unify the continent under his Imperial glory. Napoleon had toppled thrones, pillaged nations and brought devastation. Only by combining were the nations of Europe able to defeat Napoleon and exile him to the island of Elbe in 1814. In 1815 the dramatic return of Napoleon meant another generation of warfare unless he could be stopped once and for all. Plans for peace were put aside as a final struggle between the upstart Corsican and the monarchs unfolded. Only two nations were prepared to take on Napoleon: Britain and Prussia.

Napoleon once said, "I may have lost battles, but I have never lost time." He raised a new army of eager Frenchmen, bolstered by old soldiers, to take on the Allied forces. Marching swiftly and favoring offense, Napoleon crashed into Belgium and placed his Armée du Nord between the unprepared British and Prussian forces. On July 16th and 17th Napoleon's army sent the British and Prussians into retreat. He had divided his foes this way before, but unbeknownst to the would-be Master of Europe, the Allied armies were retreating parallel with each other, not in opposite directions as he hoped.

July 18th marked a momentous day. Napoleon planned to launch his numerically superior army at the Anglo-Dutch army of Wellington. Wellington had chosen a series of low rises and stone houses outside Waterloo to make his stand. Rain the night before had turned the fields muddy. Fond of his artillery batteries, Napoleon broke his own maxim and waited for the day to dry out the field. While Napoleon watched mud dry, the Prussians, under the venerable (and assuredly mad) General Bluch-

er, were marching to join the battle. If the Prussians could arrive in time, the Allies could crush Napoleon between them. If the Prussians did not arrive before the sun set however, Wellington himself was certain he would lose the battle.

When the Emperor was ready to attack, he unleashed a furious cannonade upon the Anglo-Dutch positions. The sound of hundreds of guns was tremendous, and the destruction, from Napoleon's point of view, equally catastrophic. But Wellington was a veteran of the Peninsular Campaigns in Spain, and well versed in French tactics. He placed his men on the reverse sides of the hills, or in the safety of the stone mansions, securing his center and flanks. For all the noise and fury of the Emperor's grand batteries, they achieved relatively little.

The infantry attack went little better. Napoleon's plan was to strike at Wellington's flanks and secure the stone farmhouses. If this could be done, then he was sure Wellington's army would respond, making their center vulnerable. A similar tactic had worked for Napoleon at Austerlitz in 1805 and had won him near-mastery over the continent.

It must have been with great frustration that Napoleon watched Wellington's flanks hold firm. On Napoleon's left, 900 entrenched British soldiers of the Cold Stream Guards fended off nearly a third of his army. On the right, the enemy had fled, but Wellington had made no moves to retake the position. Napoleon's plan to force the Anglo-Dutch army to divide had failed.

Ill from years of campaigning, weary from his rapid reclaiming of France and the battles of the day before, Napoleon decided to take a nap. The Emperor knew the battle wasn't going according to plan, but he outnumbered Wellington and felt that time was on his side. The perfidious English could only resist him for so long. Napoleon slept, and Michael Ney, bravest of the brave, took command.

Bold, adventurous and somewhat reckless, Ney decided to win a great battle for his Emperor. But Ney misjudged British troop movements. He believed they were on the verge of retreat, when in truth they were simply reorganizing their lines under the capable, and cool-headed, Wellington. Ney launched French cavalry, without the support of the infantry or artillery, into the Anglo-Dutch lines. While Ney's mistake might be forgivable once he realized that his efforts to sweep the enemy aside were in vain, he went on to order cavalry charge after cavalry charge. Wellington's army formed massive squares of men, using their bayonets to turn them into a hedgehog of spikes. French cavalry, no matter how brave, couldn't penetrate the wall of steel on their own. The best of France's horsemen died in the attempt. Rumors say amongst the piled up dead of Cuirassiers was a woman warrior.

Napoleon awoke to find two rude surprises. First, Ney had wasted most of the French cavalry on pointless attacks. Second, the Prussians had started to arrive on his right flank. Not just a few either, up to 80,000 soldiers in Prussian black were moving quickly across the Belgian countryside. Glancing to the sky, the Emperor realized that the sun was setting. If he could break Wellington before the sun set, he could stall the Prussians and beat them on the following day. He had been in tight positions before (Austerlitz, Marengo, Aspern-Essling) and won, he could do it again. He just needed a sign.

At that moment, the farmhouse securing the Anglo-Dutch center fell into French hands. Napoleon was sure that Wellington would not let such a valuable position fall unless he was spent. With cavalry, Napoleon could have launched a mighty assault down Wellington's throat, but Ney had seen an end to that. However, Napoleon did have one final trick to play. He had with him the finest, most disciplined, most experienced force in Europe: the Old Guard.

The Old Guard had marched with Napoleon from Egypt, to Italy, to Russia and back again. They were called the "immortals," "the gods," and with some affection by Napoleon, "grumblers." It was to these men that Napoleon turned and asked to win the battle. They were jovial about the affair, and in a blocky formation, their Eagles held high on banner

poles, marched to the sound of steady drumbeats. Napoleon marched with them, until the Old Guard forced him back. Victory without Napoleon was no victory at all.

Wellington had been waiting for the Old Guard. He knew the Emperor would only use them as a last resort. As the sun began to set and cast orange light over the field, the shooting lulled. All eyes turned onto the sight of the Old Guard marching towards Wellington's center. By a lone tree, Wellington waited, and all around him British soldiers were lying down, unseen by the closing French.

"Now's your time, Maitland," the hook-nosed man said to one of his officers. As the Old Guard neared the rise, hundreds of British soldiers rose to their feet and let loose with a hellish volley of shot. Weaker men would have run; the Old Guard marched on. Another volley and another dropped rank upon rank of the men whose hair had long ago turned gray, men who willingly served with Napoleon when they could have retired. Weaker men would have run; the Old Guard retreated. They stepped back from the formidable British lines in good order, but it didn't matter. The gods had been cast down.

The French army, upon seeing the Old Guard retreat, ran for their lives. Broken sword in hand, having had several horses shot out from under him, Ney tried to rally the troops. They ignored him. Napoleon begged his men for another hour but even his charisma had no effect. Napoleon was swept off the field of battle and in the process he lost his hat.

The Austrian diplomat Metternich later picked it up and blamed it for all the trouble in Europe for the past two decades and Wellington told him that the hat, or rather the man who owned it, was worth 50,000 men on the field.

Hatless and without an army, Napoleon retreated. The Old Guard made a final stand on the road as the combined Allied army spilled onto the field, driving the French before them. Under the final rays of the sun, the Old Guard held back the will of Europe, and like Napoleon's dreams, died on that June day.

Napoleon was exiled once again to a bit of rock off the coast of Africa, which he would never escape from. The glorious French army was disbanded, and many of its heroes were dead. Ney himself was taken by the restored monarchy and shot, as an example to all others who would betray them in favor of the Corsican. The dreams of the Napoleonic Empire were over, and the victors, Prussia and Britain, embraced as friends. For about ten minutes.

With French power over Europe shattered, Britain remained as the dominant force. It was Britain who held the most influence at the Congress of Vienna which reshaped Europe in 1815. It was Britain who began to colonize uncontested Africa and Asia, and it was Prussia who watched with growing jealousy. The seeds of World War One were sown in fields of Waterloo and watered with French blood.

For the world of steampunk, Waterloo is a critical and memorable moment. The Victorians were fascinated by the era, it was a defining moment in their history. One that marked the death of one age, and the start of another. With Napoleon's passing, the Industrial Revolution came to Europe. Inventors could spend their time creating mills and presses, rather than marching around Europe killing one another. France and Britain, enemies since the Middle Ages, came to an understanding with one another that Prussia (and later Germany) was a threat. As for the Prussians, their military success at Waterloo convinced them that war was the best way to gain power, and in 1871 the Prussians would march into Paris—and leave as Germans.

As steampunks, we can only dream of what Waterloo would have been like if British forces used mechanized cavalry, or if Napoleon launched a sudden balloon attack on his enemies. Besides, who can't see the charm in a mad French scientist developing an army of automatons in his basement so as to get revenge on the perfidious English? *Vive L'imperur!*

BLOWIN' IN THE WIND

a study on the construction of windmills

by Professor Offlogic

SEA-FARING PEOPLE HAVE BEEN USING THE wind to move their craft for at least 4,000 years, but land-lubbers didn't start harnessing the power of the wind until a clever bunch called the Persians created the first known windmill (circa 500-900 CE) for pumping water and grinding grain.

Where one leads, many can follow: soon simply *everybody* who was *anybody* was building windmills. Though fickle, the wind is free, which makes up for a lot.

While it blows it can do lots of useful things: milling, pumping, running sawmills, and providing wonderful accents to the view of the countryside with no smokestacks required. Useful stuff, this wind!

So, Just How Much Power is in the Wind?

The classic equation for power carried by the wind is:

$$P = 1/2\, \rho\, \Pi\, r^2\, V^3$$

Where:

P = power in watts

ρ = that's "rho," density of air per cubic meter (in Kg/meter3), or 1.22 at sea level

r = radius of your swept area (in meters)

V = wind velocity (in meters/second)

Don't get hung up on the math; just note that the two most prominent terms of the equation are the "r," or length of the blade (which is squared), and "V," or velocity of the wind (which is cubed): doubling the size of your 'mill increases the power four times, while doubling the wind speed increases power 8 times. So, if your 'mill gives you 50 watts out at 8 mph, you'll see 400 watts at 16 mph. Finding a windy site is better than making a bigger 'mill. (Note: water is even nicer! Plug "1000" in for the value of rho: YEEE-HAW!).

Mechanical to Electrical Conversion

THANKS LARGELY TO the work of Hugh Pigott, the *dual rotor axial flux alternator* has become a stalwart tool for turning wind power into electricity. This is a design that is relatively simple to build in a home workshop (by a dedicated tinkerer), brushless, and environmentally sealed. Unlike brushed DC motor/generators, the axial flux scheme produces no "cogging" (the resistance produced by the attraction of magnets to the iron cores in motor/generators, felt as "bumps" when turning the shaft of a motor) prior to reaching the start-up speed, when battery charging commences. This makes for a smoother start in lower wind conditions.

Two Tribes

WINDMILLS FALL INTO two general structural types: Horizontal Axis Wind Turbines (HAWTs) and Vertical Axis Wind Turbines (VAWTs).

The HAWT, similar to a child's pinwheel in operation, is now the prevalent design used by utilities

for electrical power generation; whereas VAWTs look more like the spinning "egg-cup" anemometers you'll see on weather stations. Both types have their places, strengths, and drawbacks.

Horizontal Axis Wind Turbines

HAWTs ARE WELL suited for making electrical power due to their generally higher RPMs. They tend to be more efficient, but have to be able to turn to catch changing winds and only function to their fullest capacity if elevated 20 feet or more above surface obstructions. The longer the blade (and the larger the "swept area"), the slower they turn. Large, utility-scale types seen in windmill farms require electric motors to start them, turn them to face the wind and many have gearboxes the size of a sedan to synchronize them with the power grid.

Small (~1-4 KW) systems can be built in a home workshop if one has access to strong magnets and magnet wire (essentially bare copper wire covered with a thin polymer coating, whether "virgin" or, much less preferably, salvaged from motors, automobile alternators, or etc.).

Turbine blades are readily constructed from native wood using little more than a saw and draw-knife. It is indeed possible to construct such a device by hand.

"Whirling Blades 'o' Power!"

MANY SCRATCH-BUILDERS HAVE found that PVC/ABS drain-pipe (whether scavenged or purchased new) can be made into very inexpensive and serviceable blades for small HAWTs. These materials are easily worked with common hand tools.

Aerodynamics is one of the more complex sciences and is often extremely counter-intuitive, though good information is available to builders of 'mills on the design of efficient blade airfoils, as well as documented designs of functioning turbines.

Watts "Betz" Got to Do With It?

Watt was to steam as Betz was to wind. In 1919 the German physicist Albert Betz answered the musical question: "Just how much power can we get from the wind?"

His analysis showed that 16/27th (about 59%) of the total available energy was the theoretical limit for what could be harnessed. This is still known as the "Betz Limit." In practical terms, the best wind generator will harness only <u>20-40%</u> of the available energy, tops!

Blade design is of critical importance in a HAWT, not only from an efficiency standpoint, but also to minimize noise. VAWTs tend to turn more slowly and be very "forgiving," but HAWTs are driven by lift: the blade tips of a HAWT will often reach speeds six times that of the wind driving them, and poorly designed blades can be noisy!

Vertical Axis Wind Turbines

VAWTs ARE GOOD for high torque applications like pumping water, grinding grain, or powering tools via belts and pulleys. Easily constructed using scrounged materials, they are less sensitive to turbulent surface winds and can capture the wind from any direction without tails or yawing mechanisms, but are less efficient than HAWTs. They are said to require higher maintenance (due to the weight born by the lower bearings), but being mounted low to the ground, any maintenance is easier to perform.

The Savonius VAWT

THE MOST COMMON, useful, and easily constructed version of the VAWT is the Savonius rotor. The Savonius (AKA "**S-rotor**") was named for its inventor, Finnish engineer Sigurd J. Savonius, who introduced the design in 1922. When viewed from above his basic design looks similar to the letter "S" or a "yin-yang" pair, as shown in *figure 1*.

The S-rotor has several advantages over most HAWTs:

• Simplicity. They can be constructed from scrounged materials (split 2-liter bottles, 55 gallon barrels, scrap flooring materials, wheel-barrow tubs or even framed fabric or animal skins). Lower RPMs also make them less sensitive to minor mechanical imbalances.

• S-rotors can start up in very low wind-speeds (~3 MPH) and still deliver significant torque. Unlike HAWTS over-speed conditions aren't a problem for S-rotors.

• S-rotors catch wind from any direction and function well in the turbulent air flow down low to the ground.

• S-rotors are unique in that they also work well as watermills in "flow of river" installations without earthworks or dams; just anchor two floats in the water and lay the s-rotor shaft across them with the "scoops" half-submerged: excellent for pumping water!

Just Want to Get Your Feet Wet?

Any DC motor (whether a stepper motor from a scrapped printer or a brushed type from a dead toy or cordless drill whose battery packs have all gone flat) will harvest energy from the wind at near zero cost,

figure 1: VAWT, seen from above

Wind Turbinology, in Brief

Cut-In Speed: the wind speed required to produce rotation. This includes overcoming the friction of the system, and is influenced by the number and aerodynamics of the blades.

Start up Speed: the wind speed required to generate electricity. For a 12 volt battery system, this would be the wind speed to get 13.5 volts from your generator.

Maximum Power Output: this is the most transparent term here, the peak power level on the power output curve (a plot of power out versus wind speed for a given pairing of turbine and load).

Tip Speed Ratio: the ratio of the speed of the blade tip to the speed of the wind driving it. S-rotors are pretty much limited to the .8-1.1 region; HAWTs routinely achieve 5-6.

as well as providing you with a usable power for charging batteries. In general, if it spins when DC power is applied, it will likely produce power when you spin it (AC motors from fans & etc can also be used if you disassemble the motor and grind out places for permanent magnets to be added).

Outputs of 100 watts can be harnessed using treadmill motors. Treadmill motors have carbon brushes that will eventually wear out, but they are easily replaced. Key selection criterion for these motors is a) high DC voltage, b) low RPMs and c) sturdy construction (especially the bearings).

Rolling Your Own S-Rotor: Smaller is Better

SINCE I'M FAIRLY cheap and a leisurely sort, I wanted to find the simplest and cheapest way to make my first S-rotor. One of the large home improvement stores in my area had plastic 5 gallon buckets for $3 each. I bought two and used a jig-saw to slice them in half lengthwise. These made up the "scoops" for my small S-rotor.

The S-rotor benefits by having the "scoops" overlap, leaving a gap for air to pass through from the windward to the lee side, imparting some lift to the "scoop" that's rotating against the wind. I went with 2 inches, though 20% of scoop diameter has been documented as being the optimal value.

The S-rotor also gets a slight boost in efficiency (by a few percent) by having a disk that's 5-10% wider than the diameter of the overlapped scoops affixed at top and bottom, to help capture some of the wind that would otherwise slip around the ends. I used some scrap plywood for my end disks, sloppily cut into 30 inch diameter circles.

My split buckets (with split lids attached) were screwed to the plywood end disks with drywall screws, with the two layers mounted 90 degrees from each other. This makes for easier start-up: if one layer of the rotor stopped edge on to the direction of the next breeze, the other layer would be there to catch it.

For the axle I used a $5/8^{ths}$ inch steel rod. I fitted an 11 inch v-belt pulley around the axle, then drilled and screwed it to the bottom plywood disk for a power take-off.

Since my small yard is surrounded by a 6 foot wooden fence, a ground level mounting would be rather pointless, so I invested in a 10 foot length of 1 ¼" electrical conduit. I found an axle bearing with a $5/8^{ths}$ inch bore that nested neatly into the end of the conduit.

I hoisted my "Flying Bucket" S-rotor on its mast eight months ago (firmly c-clamping it to a fencepost). A $10 bike computer was added to measure the RPMs and total rotations. It has been spinning happily in my back yard for 8 months without maintenance of any kind. I've clocked it at a maximum 233 RPM, and in 20 MPH winds it has with enough torque that I can't stop the axle by hand (without burns!).

While the maximum power output from this rig is a mere 50-75 watts (in anything short of gale-force winds), that's not too shabby for a total investment of $50. Compared to the cost of a solar panel of similar output, it's practically free!

The Future Past

AT PRESENT, THERE are many "off-grid" communities based on the energy they produce/collect themselves. The confluence of the "mortgage crunch," "banking crunch," and "peak oil" economic realignment will no doubt spur the establishment of many more (if we featherless bipeds *shouldn't* become extinct).

Here in the twilight days of Crude Technology, $100+a-barrel oil may be our only hope to avert catastrophe: if the *status quo* isn't painful then no change is likely to happen. As more communities shift to locally maintained, resilient micro-grids (rather than the oligarchic, single point of failure "macro-grid" we now "enjoy") we will achieve true freedom.

Every step of small-scale change that happens from the ground up will be a tweak on the noses of the Oil Barons, their methods and madness, as we set out on a new and more sustainable path.

The Useless Pistol
by Leah Dearborn
illustration by Ivan McCann

Picture me today as you would the famous painting of devout revolutionary, Jean-Paul Marat, as he lay murdered in his bathtub. From the coffin on my balcony, overlooking the gaslit French Riviera, I mirror his positioning almost exactly—paper held close in my decaying left hand and an inkwell at my side. My name is Olivier Brouillard, and I died on March 17, 1789.

As I lean into the satin lining and hear the crackling laughter of today's living from over the black water, I feel a sudden inclination to create something of beauty. But I am no longer human, and lack human potential to expand upon artistic skill. And so I must settle upon the only thing I *do* possess: my memories. All of my gears are wound for the night. The dainty brass pieces implanted in my wrists shine brightly even in dim candlelight. Some nights, I pretended that they are only a trail of buttons following the fabric of my sleeve. Tonight, however, I must put aside such a charade.

Perhaps I have something to give to this world yet. Even if these pages only serve as an obscure, didactic warning for those who yearn to change society as intensely as I once did.

Dying, as the uninitiated often fail to realize, is a unimaginably long process. My own fate was set in motion long before my actual death occurred. It started years before, in fact, when a foreign man stepped off the Paris docks. He was charming and brassy and brilliant, and he soon had the town at the tips of his shoes. The words that came from his lips contained all the chemistry of chocolate: decadent sentences constructed with enough opioids to trick the female brain

into a night beneath silk covers. Although he was getting on in years, there was not a countess that was born immune to his wit. His name was Benjamin Franklin, and the gentry loved him.

He had come from a country torn by war. The revolution across the frigid Atlantic—which he himself had helped to kindle into life—was beginning to disintegrate. After a Bacchanalian night of champagne fountains and pantomime—of gold-threaded bodices in the candlelight and the slip of masked figures before a hall of mirrors—the nobles sat down at cards. Wigs askew and powdered faces smudged, they listened as the clever American humored his hosts with uproariously funny, and well aimed-jabs at the British. The aristocracy fell across their hands with laughter, dripping cards onto the carpet like tears of hysteria. When the dukes and barons and barons' mistresses could at last sit straightly (or almost straightly) once again, they put on pouting faces.

"Thazz terrible!" they slurred. "About your revolus-hun, that is. Isn't there anysing you can do? Not nearly time to throw in the towel yet!"

"Well, now that you mention it," Franklin must have remarked casually, "That's actually why I'm here in Paris."

It's not difficult to imagine the twinkle in his eyes as he sipped the wine more slowly than anyone. Franklin had come to France with an intuitive understanding of the upper class, and left with its money. But the money had not been the providence of France to give.

It was borrowed, and in following years there was nothing to repay it. The economy rapidly declined, and the poorest of the poor were the ones who felt the sting. The most meager, maggot-infested loaf of bread became unaffordable. But this was unimportant. It was as things had always been for the members of the Third Estate—the lowest level of the French social hierarchy—beneath the Second Estate, the noblemen, and the country's First Estate: the church. This was the *ancien regime*, the order of things, ordained by God and King for as long as anyone could remember.

It was surmised that, because the nobles were the descendants of France's most ancient and revered warriors, it was their spilt blood that watered the grain and the olives. In payment for their family's sacrifices of antiquity, nobles were exempt of taxes and received ten percent of most crops grown on their land. So it was that chaos reigned across the countryside. The Second Estate simply did not give *un l'âne d'un rat* . They painted pictures of figs, and learned new dance steps.

The nobility remained indefinitely in their cloistered *chateaux*, deaf to the howls of the giant silver wolves that had begun to surround their elegant homes and murder the village children. Blind to the decaying roads into the cities that now crawled with murderous thieves and bandits. Sometimes, the peasants whispered that roguish men rode on the backs of wolves beneath a low, red moon as villainous companions in their savagery. Even the most frugal man living at court, King Louis XVI himself, spent 2,190 livres a year on *lemonade*.

It was in this world of heinous inequality that I spent my entire life. Injustice, hatred, and oppression brewed in the air I breathed like stale ale. I couldn't wake up in the morning without being reminded of who I wasn't. Eventually, my society made a monster out of me.

The day I died was cold and windy. I was drunk, and had gone to crash a wedding. A pair of kissing pistols were tucked into my tattered shirt for when the appointed moment came. The river of wine glasses that I had consumed earlier that morning dispelled any remaining fear about the deed that I was going to perform. As I staggered across the muddy fields, the old stone manor house jolted across the line of the horizon. I felt nauseous then, so I stopped to empty my stomach beneath a leafless tree. Only then, wiping my lips, did I approach the house.

Peals of laughter and the tinkle of piano keys echoed from within. I knew that I could not enter through the front, and so I began to climb towards an open third floor window. It is amazing to me now that I made the climb in such a state. Had I fallen and broken my back … I do not know. I suppose that would have been the end. There would be no black ink words upon this paper now. But the mortar between the stones was loose and crumbling, and provided me with footholds.

Perhaps by fate, or by the will of Nemesis (the only woman that I had ever worshiped, beloved goddess of revenge) I made it to the window. I entered into a room of women who were sitting speaking quietly and practicing their stitching by the fire. I clattered to the wooden floor and stumbled to my feet, swearing drunkenly.

I remember how my entrance produced quite a horrendous cacophony as though I had disturbed a brood of nesting hens. They taught wenches to be so timid in those days! One drunk man comes in through their window and they all start screaming their damned heads off. The women of today's France tend to view the situation with a form of joyous anticipation—great ladies and street whores alike.

The chaos came to standstill when I grabbed the nearest girl and put my pistol to her temple.

"All right!" I shouted. "*Je veux que vous tous de fermer votre putain de bouche!*"

Silence reigned. They stared as though I were a fox that had managed to infiltrate their coop. I bared my fangs, and smiled.

"That's better girls," I said softly, almost gently. "A definite improvement. Now, I want one of you ladies to be a lamb and go fetch me the Lord of this manor."

The girl nearest to the exit slowly unfroze, and inched her way out the door. Before she rounded the corner I called out,

"And tell him to come to me alone, sweetheart, or I'll shoot the sheep's brains out from between these fine ladies' ears."

There was a sharp intake of breath around the room. One girl, a mousy thing, fell into another's arms. I looked around at them, disgusted. They were so weak. I despised what others found so fashionable: those soft, unblemished hands; the fine damask dresses; their creamy, untanned skin. I abhorred it all as a sign of the selfish class that they belonged to.

The girl that I had sent away reentered with a tall man at her side. He was as pale and gangly looking as I remembered from last autumn.

"Sir!" He was attempting to use his noble bearing to cow me into submission. "I suggest you drop that weapon immediately."

I laughed at him and fired a shot at the chandelier over our heads. A rain of crystal dust exploded overhead as I drew the second pistol from my belt. The women screamed again. The Lord flinched as diamond shards tracked tears of blood across his pampered skin. In my manic mirth, I pulled the girl that I was holding into a clumsy minuet. The dust sparkled around us, I tried to catch the crystal flakes on my tongue. Her eyes were huge with fear.

I whispered to her softly, "Just like snow."

I realized how close I was to what I'd come to do. I simply wanted to enjoy one moment before it ended. But the Lord was yelling again. The moment passed.

"State your business, festering street sore. Do you mean to murder me? I know from those rags that you are no gentleman, but please, at least have the decency to commit the deed away from the sight of these impressionable ladies. I'll even stoop to a compromise: I will face you alone in an equitable and legal duel." He was talking to me now very delicately—the way one speaks with a lunatic. "You can't really hope to have my blood and escape alive, not in my own house on the eve of my son's wedding. The guards will have you as soon as you try to leave the room. They'll shoot you down like a duck as you scale the manor walls, and they'll hang your filthy body from the town yard for crows to pick at. If you duel me legally and win, then you can leave unharmed."

"No." I sighed, pausing mid-trot. My mood was changing rapidly again. I was beginning to feel nostalgic and melancholic. Best to get things done fast. "I'm not interested in your offer. Not that I believe that I could ever leave unharmed. I don't intend to kill you, not if I don't have to."

I didn't budge from my position with my arm wrapped tight around the girl's waist. "But you have my word that she *will* die if you don't meet with my demands."

The Lord's already bleached skin whitened to further resemble bone. A bubble of triumph welled in my breast: his fear was transparent.

I thought, *I've caught his son's precious bride.*

"I have always speculated that peasants are born into the world as soulless things. Here is another fine example of that fact."

I focused my own eyes on his beetle-black pupils.

"My only demand is this—take me to the room with your most expensive carpet."

The aristocrat's plucked brows raised like Roman archways.

"My most expensive carpet?"

"Yes, that's what I said."

With a shrug, he gestured towards the door. I followed behind and bolted it shut behind me. Listening to the screams that the action produced, you would have thought I'd thrown a live cobra into their midst. I began to wonder if howling was the only thing that these girls were taught to do. I walked my captive down the hallways that the Lord chose. I began to

study her. She was definitely the bride, that much was obvious to me now that I thought to look. Her gown was one of remarkable quality. Dark locks of hair had been pinned to the top of her head, and curled like shavings of carved wood down to touch a fox pelt that warmed bare shoulders.

"What's your name?"

"Marie." She trembled.

"Marie," I repeated. "An uninteresting name."

She didn't say anything.

"Don't worry, Marie," I told her. "This will all be over soon."

The Lord swung open a large mahogany door and waited for us to enter.

"This is my parlor," he informed us. "I do most of my entertaining here."

Cushioned armchairs surrounded a large oval table. The carpet was a pale blue Persian.

"Perfect," I said to myself. "How much did you pay for this carpet?"

He thought for a moment. "About 20,000 livres."

"Excellent." I sat on it, pulling the girl down beside me. "Now I am going to tell the both of you a story. I was born in that village at the bottom of the hill. I know you've probably never noticed it, but humor me. For the past eighteen years I had a father. For the past seven I had a sister. Our mother died giving birth to her, but we lived in quiet harmony together just the same. That is, until a certain Lord," I inclined my head, "taxed us until we had absolutely nothing. My sister withered away until she was less substantial than scarecrows in the fields. She died of starvation, every one of her ribs showing as clearly as if there was no skin to cover them at all. We dug through the snow to hard, frost-scarred ground so that we could find worms for our meals. For five months we dined on them, and all for nothing. She was just seven years old! Seven!"

I stopped and realized I was screaming my head off. Marie was watching me with eyes as big as saucers.

"And now, you stupid bitch, you cow, you think you pity me. But you would never lead the life that she led. You would never step into the ragged clothes and eat the fleas in your hair, just to live for one more day."

By now my voice was hoarse and coming in gasps. "I can't destroy the old order by myself—the evil *ancien regime*. I can't kill you, because then you won't be able to think about what I am about to do. I am going to put a bullet through my heart, and bleed all over your carpet. The blood will soak through and stain the wood beneath it, so that even when you remove the tasteless rug that cost more than my father made in his lifetime, the splotch will still be there. *My* splotch. And whenever you entertain, when you serve tea to all the fucking dandies that visit you, that stain will still be there. A little piece of me in your manor house, until the day it falls to ruin. A stain on your floor—it's not much to trade my life for, but it's enough."

I took the gun away from Marie's head and put it to my chest. But I felt her lily-white hands around my waist, trying to twine long fingers through the trigger, to wrench it away from me.

Then there was a quiet *click* and the bullet exploded through both our bodies, and the last thing that I heard was my own heart exploding. The last thing I saw was hers: a crimson pulp upon the floor.

There would not be one eternal stain in the Lord's manor house—but two.

My next conscious memory is of a crow. It was staring at me with curious black eyes like dewy beads of ink. A brass clock gear (at least that's what I thought it was) hung from its large beak. I closed my eyes again then, unable to keep the heavy lids open any longer.

I do not know how much time passed before I finally awoke again, but when I did it was with far greater sense of clarity. I saw that I was surrounded by the rusted skeletal ribs of an iron cage, hung high above the cobblestone streets of my village. A full moon rose over the horizon, swollen and pale like the corpse of a drown victim. It showered the single hooded figure that was moving quickly through the rutted carriage lanes in sickly, lime-colored light.

The figure stopped below my cage—my gibbet, I realized with dawning horror—and propped a ladder against the side of the court house from which I swung. A gust of cool wind blew up from the river Rhône and the sound of the rungs of the wooden ladder shaking against the brick wall was audible, along with a string of soft curses.

Tufts of wild white hair rose into my line of vision, and below them, the face of a wizened, elderly gentleman. He was smiling as though the Second Coming had arrived, and the Lord Himself was handing out free breakfast crêpes. A crow perched contentedly on one drooping shoulder.

"There's my *étoile chanceux*, my lucky star! How are you doing tonight, awake at last?"

I tried to speak, to ask who in Hell's loins he was, but found my jaw was wired shut.

"Sorry, sorry!" sang the petite gentleman. He reached forward and pulled at something behind my cheek where the jaw bones connected. There was a loud grinding noise in my ear, then a tickling sensation. "I just installed that gear last Thursday. I suppose I must have forgotten to wind it when I left in such a hurry. Mustn't let anyone find me here, you see."

"Where am I?" the words were expelled from my throat with fine cloud of dust and debris.

"You are dead. Correction: *were* dead. I fixed you."

I squinted my eyes. Something clicked into place.

"I believe you are Monsieur Engins, the town clockmaker."

The little man appeared to be delighted that I had recognized him. He gave his crow a hard pet on the head, and it flew to perch elsewhere with a look of obvious irritation.

"That is true, my criminal friend. Clocks are my trade and my life. But I have always been fascinated by the human body, the greatest working mechanism ever made. So one night I decided, as I sat drinking a glass with my crow friends, that I would attempt something rather different from the routine. I had fixed clocks successfully my whole life, hadn't I? So why not people?"

It was now at last that I ventured to look down at the rest of my body. Screws protruded from every socket. When I flexed my dead fingers, I felt the coil of metal springs.

"Your heart was completely gone," Monsieur Engins was

saying now from some distant place. "So I replaced it with a piece that functions much like internals of a grandfather clock. Your human chest acts as the chamber for a pendulum. As you breathe in and exhale, the hand on the piece advances and eventually trips a pivotal gear. That gear lifts a pin which then pulls back a chime hammer that strikes a tuned steel tube. Everything is put together, and you have a synthetic heartbeat."

I didn't know what to say. I wanted to cry, but couldn't quite remember how it was done.

At last I asked, "What about the girl who was shot with me? Marie?"

A puzzled look crossed the wrinkled face.

"There was no girl that I know of. She must have been buried. I chose you because you were situated so high above everything in this cage, right in my line of sight for when I needed to make my measurements. See the wonders that civil dissent can do for you?"

A single tear, the last one I can ever recall shedding, slid down my nose then. I think it was the last my corpse would allow, as the tear ducts were already mostly atrophied.

"There is no greater curse on any man than a cage," I said. "And mine is now tenfold stronger than it ever was before. When I carried my pistol with me up to the manor house that day, I thought I was oppressed then. I was wrong."

"Why, sir?" The clockmaker spread his arms wide to the night and almost toppled from the ladder. He regained himself and added, "The entire world is yours again. In Paris the people's revolution gains momentum. Why not stick your foot into that?"

And so I did. I hid my gears beneath baggy peasant clothes and headed to the city. I stormed the Bastille and the palace, staring death in its eyes of red gore and not flinching for fear. I shoved the writhing bodies of nobles into the waiting embrace of the guillotine. I saw the headless cadaver of the Lord who murdered my family—a wriggling mass against a mound of sawdust. I drank in blood and justice.

When Monsieur Engins succumbed to fever some several years later, I returned to my village completely unrecognized. The young apprentice now running the clock shop presented me with a box that the old man had saved for me. Inside it was my old pistol, rusted, but with flecks of crimson blood still clinging to the trigger. I sat and thought then about Marie, as I had many times since I woke up on that full moon night in a gibbet. She may have lived ninety years more in sheltered oblivion, unaware of the hunger of every street beggar, content to feed her children from silver spoons.

But I do not regret on that account. And so it is exactly as I said: Olivier Brouillard became a monster, and a machine.

AND NOW I have traveled the earth, always moving as discreetly as possible. My time has passed, my purpose served. Now it is no longer my world to tamper with. Exactly one century after my human lifetime ended, I came back to the country of my birth. It is a more peaceful place now, and I allow myself to feel just the smallest bit compensated by it. But I must still spend each night in the coffin that I ship ahead of myself everywhere I travel.

And that is the truth of it: I am no longer human. And I might as well be dead.

STEAMPUNK MAGAZINE
NEW AND FUTURE WORLDS

LIFESTYLE
MAD SCIENCE
THEORY
FICTION

#7

The definition of insanity is doing the same thing over and over and expecting different results.

- *Rita Mae Brown*
Sudden Death

"Calm down, Maston," said Mr. Barbicane. "I merely said it was impossible. I never said we wouldn't find a way to do it."

- *Molly Brown*
The Selene Gardening Society

The cover, 'Kids These Days', was illustrated by Paul Ballard

My dear punks of steam,

Lords and ladies, doxies and dandies, workers, rakes and fakes. Have I insulted everyone? Let me know if I've missed you and I shall correct the error at my earliest convenience.

I think we have all felt that persistent itch under our skin. The feeling that things here, the world that we live in … somehow isn't right. The feeling, in fact, that something is *wrong*. But no matter how broken or tarnished you feel our society is, you'd be a damned fool to throw it away. As foolish as you would be to discard a broken chest of drawers, or a pocket watch with a smashed face. These things aren't suddenly devoid of function, rather their function has changed. A broken watch becomes jewellery and a broken chest of drawers becomes a writing desk. We're Steampunks: Putting things to good use that others have discarded as broken is what we do.

At the moment, the path of least resistance for Steampunk is for it to become an aesthetic: A meme devoid of meaning. It's a path that leads to buying Steampunk Halloween outfits in Wal*Mart and Tesco in five years time, and yet another song about Victoria's glorious Empire conquering Mars playing on MTV. Individuality in Steampunk is paramount. We're not insisting everyone obey our 'vision' of Steampunk, but if I ever see anyone in a 'sexy clockwork automaton' costume they picked up off a supermarket shelf I'm going to beat them to death with their plastic cog mini-skirt. I digress …

The future isn't some kind of diffuse thing that will happen the day after tomorrow. The revolution started yesterday. We have to scratch that itch, but what kind of society do we want to live in? What kind of society do we want to create for our Steampunk community? Do we want a vital, sustainable community or do we want a group of usernames on a message board? Who are we, where are we, where are we going? The only way we can lead is by example: By getting out of our houses, by recycling, upcycling and reimagining; by supporting the live artistic performances of musicians, actors, dancers, all of the above or something else entirely; and by knowing our own flaws and breaking through them.

So think of this issue not as a map, but as a set of tools. We have lessons of cultural domination from the past, both through politics and war, and through the far more insidious medium of popular fiction. We have some lessons from the present, too, suggesting we might not be as clever and classless and free was we like to think we are. And, of course, we have plenty of suggestions about what to do with the future: From dancing the night away to literally raising your own country from the deathless oceans.

The simple truth of human nature is that you can not bully or coerce people to change, that is, if you do not want to stoke their fears and their prejudices. The only thing you can do is inspire them. If we inspire you, then go out there and infect others. You know the great thing about inspiration? It's a system driven by positive feedback: The more of it there is, the more of it there is!

So tell me: What have you done to change the world today?

—*Dylan Fox*

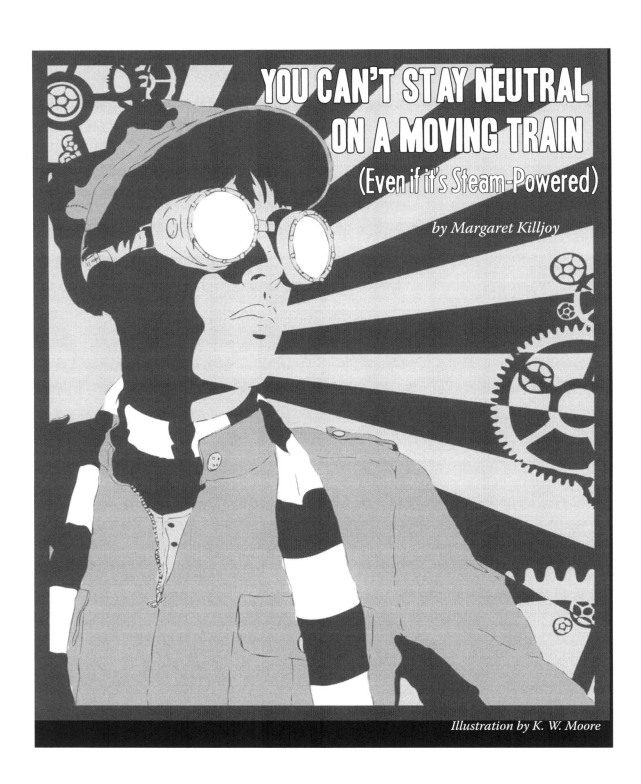

Illustration by K. W. Moore

Much has been said in the past few years about steampunk and politics. Is steampunk political? Is it radical? If it's political, is it anarchist or socialist or democratic or techno-utopian or neo-luddite?

Yes. On all counts.

Since day one of *SteamPunk Magazine*, months before the first issue saw the light of day, we've been under attack for our explicitly political position. "We have no interest in publishing pro-colonial, racist, homophobic, sexist, or otherwise useless work," has been in our submission guidelines since *SteamPunk Magazine* was a static webpage and a fantasy.

"How can you be against colonialism and be steampunk?" asked the comments in one particularly vitriolic LiveJournal thread.

How indeed? Well, for one: by being steampunk, not neo-colonial or neo-Victorian. As the former editor of SPM, I can say assuredly that I didn't set out to subvert steampunk towards politics: I was simply responding to what steampunk was (and, I would like to argue, should be again). Steampunk began as a radical strain of fiction (albeit a somewhat satiric one), and it truly breaks my heart to see what it has become.

This is not to say that steampunk is or should be about politics. Steampunk is not a party platform, and *SteamPunk Magazine* has never intended to be a propaganda tool for any position (aside the steampunk one). I believe that this is partly what people are confused about.

Apolitical is a Political Position

Howard Zinn died a few weeks ago. He doesn't really have anything to do with steampunk (aside from learning his politics as a poor kid in early twentieth century New York, which is pretty steampunk if you ask me). But he wrote a book called *You Can't Be Neutral On A Moving Train*, the title of which you've no doubt noticed that I've appropriated for this article.

Apolitical is a political position. Apolitical is a vote for the status quo. The status quo, you might have noticed, is doing a fine job of destroying the earth (and with it, all of us).

I think people get confused by this because when they hear, "You should be political," they think they're being told to (in the USA, at least) be active as a democrat or a republican. Or if you're really out there: A libertarian or a green. That isn't politics, that's a puppet show, a bread and circus.

It's the difference between watching the superbowl and playing a game of football with your friends.

If we can dream up alternate worlds full of scheming scientists and smoking machines, are we really so bereft of imagination that we

can only imagine politics on the convenient "liberal vs. conservative" axis that's been provided for us?

When we talk about politics, we talk about being concerned with the over-arching systems of control. About the ways that we organize society.

Our Political Roots

To be blunt, steampunk has always been political. The finest and most important works of steampunk have been, perhaps without exception, influenced by anti-authoritarian or anti-colonial trends in society.

Jules Verne wrote his breakthrough novel *Five Weeks In A Balloon* about his friend Nadar—a radical Parisian socialite who pioneered hot air balloons and put them to use during the Paris Commune (and took the first aerial photographs, and many of the radical milleu of his time, such as Peter Kropotkin and Mikhail Bakunin). Verne wrote Nemo, an anti-civilization touchstone. And he wrote a sympathetic, explicitly anarchist protagonist in his book *The Survivors of the Jonathan*. I mean not to claim Verne as a radical himself—he was a nuanced politician, but no firebrand.

HG Wells, however, was. He was an outspoken advocate of socialism, believing that society should eventually reach a single world state and dissolve into an intentional anarchism.

Skip forward to the 1970s, and Michael Moorcock's influential proto-steampunk novel *The Warlord of the Air*. Containing the historical Ukranian anarchist Makhno as a prominent character in these alternate histories, the stories set anti-authoritarian anti-heroes against the forces of colonialism and racism. As for Moorcock himself, in an interview with me for my book *Mythmakers & Lawbreakers, Anarchist Writers on Fiction*, he said:

> "I'm an anarchist and a pragmatist. My moral/philosophical position is that of an anarchist. This makes it very easy for me to make a decision from what you might call a Kropotkinist point of view."

And then there's steampunk proper: The first generation that consisted primarily of K.W. Jeter, James Blaylock, and Tim Powers. In the article *The Nineteenth Century Roots of Steampunk* that serves as an introduction to the 2008 anthology *Steampunk*, (edited by Ann & Jeff VanderMeer), Jess Nevins writes, "Steampunk, like all good punk, rebels against the system it portrays (Victorian London or something quite like it), critiquing its treatment of the underclass, its validation of the privileged at the cost of everyone else, its lack of mercy, its cutthroat capitalism."

Into more contemporary steampunk, look at Alan Moore, author of *The League of Extraordinary Gentleman*, which is by far one of the most influential steampunk works. Alan Moore is also an anarchist (which, by the way, is no more realistically represented by bearded men with bombs than "communism" is by the Soviet Union). I asked him about the central question of this article, about how politics are a part of everything we choose to do. He told me:

> "We don't really live in an existence where the different aspects of our society are compartmentalized in the way that they are in bookshops. In a bookshop, you'll have a section that is about history, that is about politics, that is about contemporary living, or the environment, or modern thinking, modern attitudes. All of these things are political. All of these things are not compartmentalized; they're all mixed up together. And I think that inevitably there is going to be a political element in everything that we do or don't do. In everything we believe, or do not believe."

Our Lamentable Present

Jess Nevins, in the introduction to the aforementioned *Steampunk* anthology, sums it up quite well: "second generation steampunk authors have changed steampunk from an argument to a style and a pose, even an affectation ... This abandonment

of ideology is an evolution (or, less charitably, an emasculation) that is inevitable once a subgenre becomes established—witness how cyberpunk went from a dystopic critique of multinational capitalism to a fashion statement and literary cliché. But its loss is nonetheless to be mourned."

And that's the thing. Lewis Shiner, one of the cyberpunk pioneers, told me in my book *Mythmakers*: "I think it's inevitable that if a certain perceived movement becomes successful, it's going to get commodified and people are going to try to jump on the bandwagon. And cyberpunk, like magical realism, had the misfortune of being easy to imitate. Mirrorshades and implant wetware in the one and butterflies and ghosts in the other."

Michael Moorcock told me: "I was attracted to Fantasy originally because it wasn't a defined genre. Like rock and roll, you could make something of your own out of it. If I was a young writer today, I'd have absolutely nothing to do with it."

Which is all pretty doom and gloom for the future of steampunk, to be honest.

Punk Isn't Dead

I can't seem to find the quote, but I've read Bruce Sterling talking about how punk was neat at the time, but that punks today are clinging to the past, are essentially anachronistic. And this shit has been said forever: "Punk is dead." But it's not. It's just underground now. Actually, it has been this whole time. It never went away. Punk is a vibrant, dynamic subculture. The punks today don't, by and large, look like the 70s punks. They don't look like the 90s punks. Green Day and Blink 182 went on the radio, but it didn't stop the underground. Punk will never die. Our critics are, by and large, completely and utterly ignorant of who and what we are.

Punk isn't dead, and steampunk isn't dead. There are people who put a shiny brass cog on something and call it steampunk. But sticking goggles up your butt doesn't make you a chicken.

At the risk of sounding absurd, if you don't want the punks showing up to your party, don't throw a punk show. You're the ones who called yourself punks. Don't get upset when anti-authoritarians with blue hair make an appearance.

I love you all, it's been a pleasure. For fuck's sake, keep it real.

THE GREAT STEAMPUNK DEBATE
1st May - 30th June 2010
WWW.GREATSTEAMPUNKDEBATE.COM

A few months ago, SPM got together with a whole bunch of other people who run steampunk magazines, websites, events and communities and began to talk about the elephant in the room: The small matter of politics and personal beliefs in steampunk.

Whether you're an anarchist, a capitalist, a liberal, a conservative or staunchly apolitical, steampunks have never really had the opportunity to talk about how they mix their personal beliefs with their steam.

Well, my friends, that is about to change because for two full months this year, steampunks from all across the board will be given the chance to come together to discuss politics, ideology, the Empire, discrimination, inspirations, environmentalism and, most importantly, steampunk.

The debate will also serve as an opportunity for steampunks of all different camps and creeds to come together and set our differences aside, in recognition of the fact that we are all part of the same community, and that our community is important.

Whatever your own personal beliefs may or may not be, we hope to see you all there for the ride, because it sure as hell is going to be a lot of fun!

For more details (or to register an account) please go to: WWW.GREATSTEAMPUNKDEBATE.COM

TOWARDS A BRAVE NEW LAND
(and the Making Thereof)

by Professor Offlogic
illustration by Sarah Dungan

"A courageous Future lies ahead of us. We wave goodbye, on no uncertain Terms, to the invisible Workings of the cyberian World. Our Future lies in an honest Technology, a Technology that is within our Reach, a Technology that will not abandon us, a Technology that requires not the dark Oils of subterranean Caverns."
-A Steampunk's Guide to the Apocalypse

Past attempts at colonizing the high seas have usually remained at the conceptual level, with plans running aground due to "inside-the-corporate-box" thinking, high up-front costs of marine superstructures or outright chicanery.

Capital has been very leery of investments in a field of uncertain precedent such as creating Free Enclaves in international waters. While there is at least one "residency" cruise liner (*The World* of ResidenSea was launched in 2002), no claims of sovereignty are made for it, and the sticker-price limits it to multi-millionaire residents.

Might a more ad hoc, low-cost and Low Tech approach to creating a new nation on the High Seas fare any better?

Terminology & Pejoratives

The term **"microstate"** isn't branded with the same giggle-factor as the term **"micronation"**, which has come to be used in a pejorative sense to refer to abortive and/or crackpot schemes to usurp the "rights" of "legitimate statehood" from presently recognized "nations" of the status quo (AKA 'The Old Boys' Network').

The term "neostate" might be applied to a newly declared independent nation and the human population proclaiming allegiance to it, but since the "state" part of neostate still carries the usual baggage of intrusive regulation of personal behaviors, public morality, excessive taxation etc, the term **"Free Enclave"** will be used in this

writing, as it is the author's hope that anyone going to the trouble of creating a New Land will not be taking with them the outmoded ways of the Old Lands (including racial, ethnic, economic, spiritual/religious or gender disparities). Any entity achieving this is a truly Free Enclave.

Microstates: Where Size Doesn't Matter

Let's look at present-day examples of internationally recognized microstates, with an eye for common traits. Most are remnants of the consolidation of European states, or former island colonies.

State of the Vatican City

A landlocked, walled sovereign city-state within Rome, the Vatican holds the current record for smallest cost of carpeting. Contrary to the popular, it didn't officially exist as a sovereign state until the Lateran Treaty of 1929 (a good year if your name begins with "His Holiness"). As the smallest sovereign squat on the map, at just over 0.17 square miles, it has a unique economy based on a "spiritual protection racket".

The crime rate within the territory measured against the resident population of some 824 persons would seem enormous: Civil offences committed each year corresponding to 87.2% of the population, with penal offences running at a staggering 133.6%. The most common crime is petty theft—purse-snatching, pick-pocketing and shoplifting. "The Vatican—soft on crime? You be the judge!"

Reason for statehood: Fear of being sent to Hell.

The Republic of Nauru

Basically a small rock in Micronesia, it is currently the smallest island nation, just 8.1 square miles, and the least populated member of the United Nations. Declared a colony by Germany in the late 19th century, it was then passed around between Australia/New Zealand/England, briefly the Japanese Empire then back to the Aussies again, until gaining independence in 1968.

Nauru was good for only one thing: Mining phosphate rock. While that lasted the Nauruans boasted the highest per capita income in the world. Once the phosphates ran out they dabbled at being a tax haven, experimented with money laundering and for a bit ran an outsourced detention center for Australia (the *Pacific Solution*). That cash-cow recently gave out as well.

Reason for Statehood: Depleted of all resources, nobody wanted it anymore.

The Most Serene Republic of San Marino

Bar none, the oldest sovereign state and constitutional republic in the world, having been founded on 3rd September 301 by Marinus of Rab, fleeing the religious persecution of the Roman Empire. San Marino was the world's smallest republic from 301 to 1968, until Nauru gained independence. It is devoid of natural level ground, landlocked and completely enclosed by Italy.

If one gets elected to head of state there, one must accept or be jailed (wow, drafting politicians, what a great idea!). Even Napoleon refused to conquer them, saying "*Why? It's a model republic!*" and continued his devastation on states with less model republics.

Reason for statehood: San Marino was a refuge for those supporting Italian unification in the 19th Century, so in appreciation, Italy left them alone. What with being way the hell up in the mountains and having nothing worth going to the trouble of taking (except for a wonderful view) everyone was happy.

The Principality of Monaco

Completely enclosed by France, Monaco—occupying about .76 square miles—is largely regarded as a tax-haven, with around 84% of its population made up of foreign (and wealthy) citizens. Monaco retains its status as the world's most densely populated sovereign (and smallest French-speaking) country.

Starting with a land grant from Emperor Henry VI in 1191, Monaco was re-founded in 1228 as a colony of Genoa. It has been ruled by The House of Grimaldi since 1297, when Francesco "The Malicious" Grimaldi (disguised, coincidentally as a Franciscan monk, or "Monaco", in Italian) and his men took over the castle on the Rock of Monaco. It's been an up-hill battle ever since. The French Revolution swallowed them up, and then they got assigned to the Kingdom of Sardinia, which made a lot of patriotic Monegasques very surly.

Reason for statehood: As part of the Franco-Monegasque Treaty of 1861, the ruling prince ceded some 95% of the country to France in return for four million francs and sovereignty. In 2002 a new treaty with France removed the stipulation that Monaco would remain independent only so long as the House of Grimaldi continued to produce heirs.

Micronations & Pitfalls to Avoid

Now we'll briefly survey both ends of the micronation spectrum, their strengths and weaknesses.

The Principality of Sealand

Located on a former World War II sea fort (HM Fort Roughs) about six miles off the coast of England, Sealand is ruled by Prince Roy and Princess Joan (and *de facto* Prince Regent Michael, since Prince Roy retired to the Suffolk). Total 'land' area is a whopping 0.000193 square miles (about 500 square meters). Although Sealand is held in dubious regard as a micronation and is without acknowledged diplomatic relations, its existence has resulted in the closing in certain loopholes in the United Nations Convention on The Law Of The Sea (UNCLOS 1982, Article 60 sub 8, relating to artificial structures *within an Exclusive Economic Zone*, with Article 80 applying mutandis to artificial islands, installations and structures *on the continental shelf*).

Reason for statehood: Not worth the trouble, and has arguable standing of sovereignty under established legal precedents at the time of its founding.

The United States (Under Emperor Norton I)

Perhaps the most unruly, rebellious, and treasonous micronation, it occupied the approximate space between Emperor Norton I's ears between 1859 and 1880.

Eccentric, yes, perhaps even insane, but Robert Lewis Stevenson's step-daughter, Isabel, wrote that Norton "was a gentle and kindly man, and fortunately found himself in the friendliest and most sentimental city in the world, the idea being 'let him be emperor if he wants to.' San Francisco played the game with him."

Reason for statehood: Pre-existing condition that ignored the "Emperor of these United States and Protector of Mexico" (those treasonous curs!).

Common Threads & Loose Screws

From the point of view of the Old Boys, it is easier to leave a small state with insubstantial natural resources alone than bother with taking it over. Geographic remoteness or being otherwise inaccessible helps in retaining independence, as does payola and/or the ability to dole out anathemas. Providing useful services like being a tax-haven or money-launderer can be a double-edged sword if you don't do it for the 'right people.'

As regards to micronations and their rulers, bestowing yourself a royal or imperial title may severely dent your credibility in the area of establishing formal relations, either with other countries or your own.

The Electric Reef: A New Approach

Professor Wolf Hilbertz developed a process for accretion of mineral structures by electrolysis of seawater in the 1970s. As BioRock, the electro-deposited minerals are comparable, if not surpassing, the compressive strength of reinforced concrete ... and self-repairing, as long as the power supply is maintained. Hilbertz and his colleague Dr. Tom Goreau established programs to use the BioRock to repair and sustain damaged coral reefs in 15 countries around the world.

Mimicking the way clams, oysters and coral produce their shells from the minerals in sea water (though far less sophisticated), low voltage direct current is applied to a metallic frame (rebar, chicken-wire, metal mesh) submerged in sea water. Calcium carbonate accretion (as the mineral *aragonite*) occurs at up to 5cm per year on the submerged frame, sequestering CO_2 in the process. Power requirements are modest, about 3 watts per square meter.

The Autopian Dream

Hilbertz went on to survey suitable sites located on undersea mountains that met certain desirable criteria: Locations in international waters, relatively shallow, easily harnessed ocean currents, good prospects of aquaculture and sea floor resources. His aim: Creating autonomous, self-assembling island micro-nations.

Two likely sites were identified as prime locations for the project, to be known as Autopia Ampere, on the Mediterranean sea mount of Ampere (about halfway between the Madeira Islands and the tip of Portugal) or Autopia Saya, on the Saya del Halha Bank (east of Madagascar and southeast of the Seychelles) in the Indian Ocean.

In the 1997 *Popular Mechanics* article, Hilbertz said the fact that ocean-grown cities could stand on their own economically and become independent and self-governing entities poses what he believed to be one of the biggest barriers to their creation: There is no legal precedent regarding national ownership of a newly formed island that is beyond a nation's territorial waters.

His plan: "We'll establish our presence there and stake a claim, and see what happens. If anyone challenges us, we have lawyers ready to argue our case. We've had so many legal opinions that we decided just to go ahead and see what happens."

Sadly, the Autopia project was interrupted by the sudden death of Dr. Hilbertz in August 2007.

Et Tu, Nemo?

Suppose an anarchist collective, tired of the oppression of those land-lubber states, decide to pool resources and head out for the Low Frontier of the High Seas to found a Free Enclave?

Site selection for a Free Enclave is a matter of "looking for loopholes" (as W.C. Field explained of his leafing through the Bible); in this case the term for "loophole" may be "terra nullius", a place belonging to nobody else.

At one time, a nation's territorial waters were defined by the range of their cannons (the *Ultima Ratio Regnum* principle). Nowadays, cannon-shot goes a lot farther, and every 'budding democracy' (or junta) with a few yards of beachfront property can declare an "Exclusive Economic Zone" out to 200 nautical miles of their sea-coast baseline. In addition to this, the Old Boys' rights to resources on or under their slice of continental shelf are codified in the Nations Convention on the Law of the Sea.

Assuming you've done your homework ahead of time, you've located a likely sea-mount or bank that is not in an Exclusive Economic Zone or on the continental shelf of a nation signatory to the United Nations Convention on the Law of the Sea (this is the loophole you are looking for, since there is no Article dealing with artificial structures/islands except in those two cases).

The Plan

1. Sink metal forms connected to low-voltage power sources as discretely as possible (to avoid 'Imperial entanglements');
2. Accrete artificial coral foundations for at least a year;
3. Establish your outpost on the BioRock structures, then expand the Enclave to your heart's content;
4. Establish sustainable economic activities to support the Enclave.

Load up supplies (metal framework components, windmills, diving equipment and maybe a VIVACE array or two) and make the first expedition to, say, a suitable site bordering one of the North Pacific Gyres.

The initial metal framework could be installed within a week, with the placement of sacrificial anodes, floating windmills or submerged VIVACE arrays (to keep the framework power flowing) could take a bit longer. After this, it's a waiting game, but time is on your side.

The artificial coral will continue to slowly accrete a nucleus for your new Free Enclave. The denser your metal framework, the faster the structural strength will improve

(though at the cost of a higher power level to keep it growing). More BioRock frameworks over time would improve the stability and permanence of the Free Enclave, as well as provide a better habitat for future aquaculture.

'Soylent Black' and Its Deadly Legacy

Even though Providence chose to secrete the bulk of Liquid Petroleum at great depths inside the Earth or under the vastness of the Seas (surely a major hint to "use sparingly"), few resources of such diverse potential have been squandered so blithely, most of it having gone literally "up in smoke" via Infernal Combustion. Much of that which was not used to darken the Skies Above still haunts us in the form of Petro-Plastic, esteemed so lightly that it was considered disposable, to be cast off without a second thought, imagining that what was out of sight was out of mind.

In Shelley's words:

"My name is Ozymandias, king of kings:
Look on my works, ye Mighty, and despair!"
Nothing beside remains: round the decay
Of that colossal wreck, boundless and bare,
The lone and level sands stretch far away."

We may now reassess the true meaning of "out of mind": The formerly 'lone and level sands' of once pristine beaches, even on the most remote archipelagos on Earth, are covered many feet thick in plastic flotsam, jetsam and dead sea creatures, with the enduring plastic legacy remaining sea-born clotting expanses of the ocean so thickly that it surpasses the mass of marine life, in some regions by seven-fold or more.

Down and Out in the Growing Enclave

A budding oceanic Enclave can harvest many things from the seas, including the hundreds of tons of free-floating plastic debris. Plastics don't *biodegrade*, per se, but they do *photo-degrade*: The UV rays of the sun break plastic masses down into smaller bits and pieces commonly referred to as "nurdles" or "mermaids' tears". These granules, typically under 5mm in diameter and resembling fish eggs, are responsible for the deaths of millions of birds and other sea creatures ... all in the name of disposable plastic "culture".

A harvest of mixed plastic nurdles can be sieved from the water by the proprietors of a Free Enclave and separated from fish and zooplankton (plastic isn't generally phototropic, doesn't instinctively swim up-stream, etc) in skimming troughs. Nurdles can be sorted by type of plastic using a series of vats containing fluids of decreasing specific gravity. The first vat will allow the heavier plastics (and other debris) to sink, the next heaviest plastics will settle out in the second vat, and so on.

Solar collectors could be used to heat the harvested plastic batches (for recycling into a variety of items useful for the Enclave) or desalinating water without wasting the precious electricity needed for mineral deposition.

Pontoons made of recycled plastic could be arranged into a grid around the ever-accreting base structure, with salvaged fishing nets strung over them to give your Enclave a little more elbow-room. If these pontoons were to be equipped with simple two-stroke pumps (perhaps bellows molded into them during manufacture), the energy of the waves could be easily captured to provide additional electrical power.

"Growing" construction panels on metal mesh would be a natural progression for the Enclave. These could comprise solid floors and walls connecting the coral columns, as well as provide an exportable product.

With a little ingenuity and recycled plastic, frameworks for sub-

marine quarters could be grown, sealed and inhabited, with access via BioRock elevator shafts: Picture a "sea-scraper" as a sky-scraper in reverse. Like a medieval fortress, the subsurface quarters could provide submerged refuge in times of trouble.

So, What Could Possibly Go Wrong?

Technology, as usual, is the easy part. Dealing with the Old Boy network of traditional states is likely going to be the major hurdle faced by the new Free Enclave. Since Hilbertz's *Autopia* plans were interrupted without firm precedent being set, the usual tools remain available for dealing with conflict that may arise:

Lawyers: If you do create a new island, better be prepared to spend years in court defending your title to it, unless you have plenty of …

Guns: Sealand has had to rely on force of arms to protect their claims of sovereignty a time or two. In general, anything you can do to make yourself indispensable or more trouble than you are worth to annex (rhythms with "Switzerland") is worth the cost, which brings up …

Money: The universal lubricant. The more "bread" you have … the better tasting your sandwiches will be (to put it politely). Engage in sustainable aquaculture, BioRock panel exports, etc. to build financial reserves.

The Free Enclave, artificial or not, will be private property, with any attack viewed internationally as an act of piracy. The international community/Old Boy network will likely write the pirates a *very sternly worded memo* (stained with their crocodile tears) if your Free Enclave is attacked.

The Nemo Doctrine

Existing clauses of the UNCLOS-1982 state that artificial islands and structures have no claims to territorial waters, so a prudent level of defensive capabilities within a reasonable radius of the Free Enclave is probably advisable to make moot that point of contention. The mechanics of maintaining territorial integrity are beyond the scope of this text, though the "Nemo Doctrine" that freedom hinges on nullification of the power of any state to subjugate, should be a guiding principle. Remotely triggered buoyant "aquatic RPGs" placed in a series of defensive radii on the sea floor might be worth investigating. Augmentation of these relatively passive perimeter defenses with super-cavitating torpedoes, MANPADS, "Phalanx" type air defenses and selective jamming of SATNAV signals would likely ensure de facto sovereignty of a Free Enclave.

Playing Nice

Building on shallow water sea-mounts/banks the Free Enclave will sidestep any "hazard to navigation" clauses in the UNCLOS (the hazard being well known and charted), and if anything, the Enclave on top diminishes the hazard by increasing visibility and provides another trading port for commerce. The beneficial bioremediation of coral destruction and CO_2 sequestration will lend you emotional resonance with the populace outside the Enclave and generate political 'brownie-points' (or even swing a lucrative CO_2 sequestration outsourcing contract from members of the Old Boys network in the process). "Doing well by doing Good" is at least karma neutral and would be a 'no harm—no foul' alternative to the tax-dodge/data haven/money laundering schemes usually resorted to by other microstates.

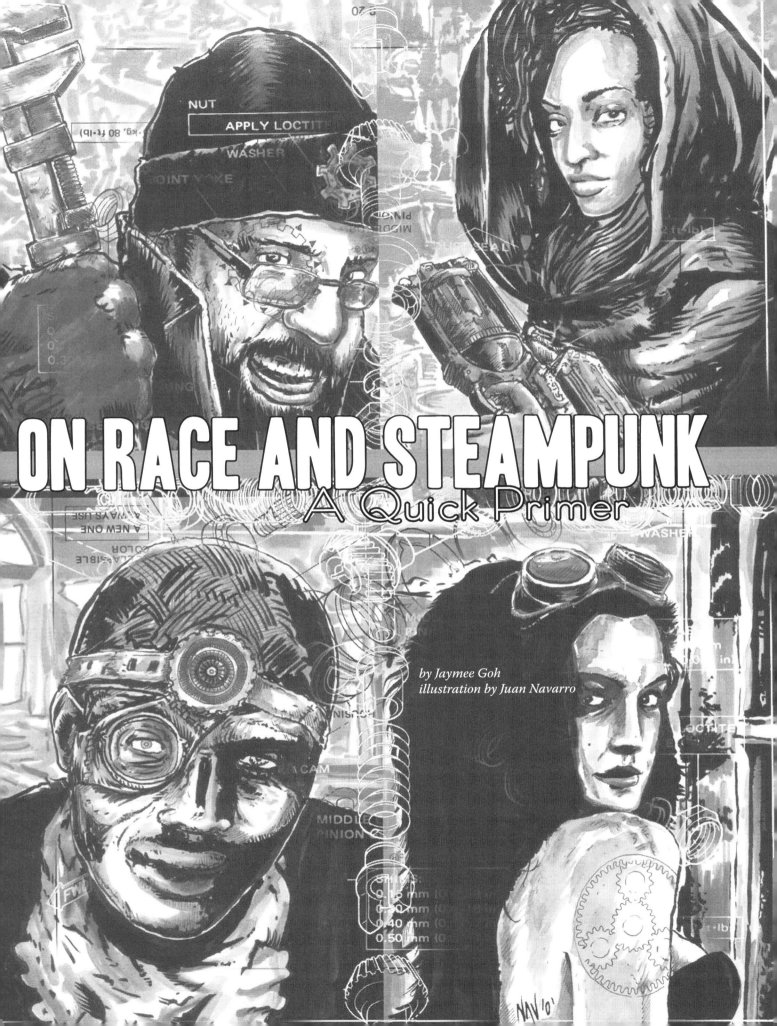

ON RACE AND STEAMPUNK
A Quick Primer

by Jaymee Goh
illustration by Juan Navarro

"Race! The final frontier. No matter what channel you watch, no matter what feed you aggregate, it seems like everybody is talking about race right now. And when everybody everywhere is talking about race, it means sooner or later you're gonna have to tell somebody that they said something that sounded racist."
 - Jay Smooth, How To Tell People They Sound Racist

Introduction to the Concept of Race

There are three very important things you need to know about the concept of race. The first and least important of the three is that race is a construct. It has no true biological basis. A man who is considered "black" can very much resemble a man who is "white". In fact, the term "Caucasian" does not actually refer to "white" people, but rather to a range of peoples covering European, African and Asian geographical ranges. In the American context, the terms "white" and "black" were created to polarize working-class people after slaves were emancipated, with goalposts moving around—Italians, Jews and Irish were not considered "white" at first. Even the term "Oriental" was applied first to the Middle East and India. Over time, it spread to encompass the Far East, but it is only called "Oriental" insofar as it refers to the Occidental point of view, and thus, still centers one specific experience over another.

The second, more important thing you need to know about race, is that we all see it. This isn't that cute little "everyone's a little bit racist" refrain, but a reminder that racism benefits or harms whole groups of people. You (the general you), whether white or non-white, may claim that you "don't see race", that it isn't important to you, or that you don't discriminate based on skin colour. When you do that, you erase what is possibly a large part of who I am and my history, deny what is important to me, and ignore the fact that this racism thing isn't just about individual me and individual you: it's an institutional thing that encompasses much more than just how you think you see or treat me.

The third, and most important thing you should know about race is that, even though it is a construct and a term with fluid meanings, race has very real effects on very real people, in a very real system that most people go about without seeing. One person suffering discrimination on account of race is an exception. A few, a coincidence. But when whole groups are at a disadvantage, it is a pattern. Parts of the pattern are manifested in how, even today, employers are likely to dismiss a resume on the basis of a foreign-sounding name, or how prisons have a large percentage of African-Americans which does not reflect the general population of the USA, or the "white flight" phenomenon.

In James Joseph Scheurich and Michelle D. Young's article, "Coloring Epistemologies" (available on JSTOR), they lay out three levels of racism:

> "The first is institutional racism, which 'exists when institutions or organizations … have standard operating proced-

ures (intended or unintended) that hurt members of one or more races in relation to members of the dominant race.'

The second is societal racism, which 'exists when prevailing societal or cultural assumptions, norms, concepts, [or] habits ... favor one race over one or more other races.' For example, the OJ trial revealed societal racism.

The third is epistemological racism, which 'comes from or emerges out of what we have labeled the civilization level—the deepest, most primary level of a culture of people. The civilization level is the level that encompasses the deepest, most primary assumptions about the nature of reality (ontology) ...'"

This essay is a simplification, of course, and meant to be an introduction. The issue of race is much more nuanced. It requires a great deal of time and patience to understand, and a willingness to learn and accept that one is more / less advantaged than others, even if it's not felt.

The Presence of Race in Steampunk

Race is as difficult a topic to discuss as cultural appropriation, systemic oppression, and privilege. Many steampunks don't really think about it, and indeed, what role does race play in costuming, in DIY, or in roleplay? The excuses for not thinking about race are vast and varied—we assume that since everything is made up, we're free to create spaces as we please.

There are other realms of marginalization noted in steampunk. Discussing class is easily done: the upper-class elite oppressing the poor is well-recorded by the likes of Charles Dickens, Elizabeth Barrett-Browning and other Victorian writers of the time. Gender is also easily subverted, as many women re-imagine the steampunk world to be a more gentle time for their gender, unfettered and unlimited. There are many women who play sky captain, or other roles that would, in more realistic play, be denied to them.

However, race is a bit more difficult to discuss, and a bit more difficult to portray. If a visible minority dresses in high Victorian fashion, inspired or derived from English or American sources, is it a sign of overcoming the ills of the time period? Owning the fashion of the oppressors? Or is it a form of assimilation into the dominant culture? If a visible minority creates a steampunk persona based on his or her heritage, is s/he bucking the overwhelming Victorian trend? Exoticising themselves? Are they even recognizably steampunk? What about a member of a recognizably dominant group using fashions of the subordinate group? Is it a sign of taking inspiration from a foreign source? A respectful tribute? Is it cultural appropriation? A flippant dismissal of the importance of a cultural artifact and trivializing of a fashion as "exotic"?

We do well to ask these questions of ourselves, no matter what group we belong to. As steampunk is a pastiche made of many elements, it is difficult to categorize something as quintessentially steampunk, and thus difficult to categorize something non-Victorian as steampunk unless it incorporates elements that are absolutely recognizable. (Gears and cogs do not count.)

Then there is the obvious dearth of steampunk media derived from non-Victoriana sources, often eclipsed by the overwhelming variety

> Whether or not we are conscious of it, we carry prejudices and racial biases wherever we go. It touches everything we do, say, or think. Without examining these unconscious biases, it is incredibly difficult to create a space where everyone is equal in a meaningful way.

of Victorian-derived steampunk that feature a certain kind of people, who are clearly not a minority in steampunk. There are a few examples of steampunk works and subcultures—James Ng, for example, is heralded as a great example of Chinese steampunk. Bruno Accioly is a spokesperson for the Brazilian steampunk subculture. Yet, these examples are notable because they spring from people and places who are not immersed in Victorian / North American steampunk to begin with—James Ng only heard of steampunk after he produced his famous works; Bruno Accioly filters Victorian steampunk through his uniquely Brazilian perspective. Where does this leave steampunks of colour living in white-dominated cultures, such as North America and Britain?

Like in any other mainstream spaces, discussions of race are far and few in between. If race is even discussed at all, it is in simplistic terms—how awesome it is, for example, that there are steampunks of colour stepping up to express their heritage. The racism that is discussed is obvious: like how awful it was that slavery existed, and we certainly don't want to reproduce those attitudes. There is very little room for more nuanced discussions about cultural appropriation, microaggressions or unconscious prejudices made manifest.

The presence of race in steampunk, for many, is often theoretical, and not a messy reality that the average steampunk has to deal with. Even steampunks of colour would prefer not to have to deal with the problems of race, because steampunk is a fantasy, a made-up world, an escape.

The Importance of Race in Steampunk

There are arguments and questions deployed to deflect honest discussions of race. The first runs thusly: If steampunk is so rife with these problems, *why participate at all?* If there is nothing for visible minorities, then why not find something else to be interested in?

This one is simple to answer: ask a woman why she participates in re-creating an era where she would have been oppressed, and she will tell you that within the re-creation, she can play as an equal. History is altered and adjusted by whole groups of participants so that women can participate meaningfully, in a way that fulfils gender-egalitarian fantasies. The actual oppression is not really all that important: Steampunk has many attractive facets, and steampunks of colour are not immune to the aesthetic, the love of history, or the love of crafting. That we can create spaces where we can participate meaningfully is a bonus. (That it is a bonus is pretty pathetic, as it is something we should be able to take for granted if the genre was as egalitarian as folks claim it to be.)

The second argument is a bit more insidious, and harder to tackle: *If steampunk is an escape, a fantasy, a made-up world, then why is it so important to discuss race?* Why bring in problems from reality and mar the fantasy?

Allow me to draw up the argument for gender again: Understanding how gender has played a role in the actual history, how gender obstructed and constructed a woman's life, and learning the boundaries, enables us to break them. It is a bonus if gender in the present day is deconstructed for further subversion in the steampunk world, and not unusual.

Whether or not we are conscious of it, we carry prejudices and racial biases wherever we go. It touches everything we do, say, or think. Without examining these unconscious biases, it is incredibly difficult to create a space where everyone is equal in a meaningful way. Without questioning how Orientalism is damaging, speculation of Asian steampunk can be tinged with racial caricaturing and stereotypes and also blot out the voices of those who are actually Asian. Without confronting how the institution of slavery has set white people at an advantage today by holding black people back, it is hollow to assert that the fantasy is in any way better than reality. In a discussion of multiculturalism, it is ironic for the voices of a single group to dominate, while the voices of marginalized groups are silenced or unheard.

If we allow the problems of reality to permeate our fantasy, we continue the marginalization of specific groups, which in turn limits the genre and playing ground, alienating the very people we claim to welcome.

Resisting Racism in Steampunk

It is incredibly difficult to prevent or eradicate racism, as racism is internalized starting in childhood. Moreover, contemporary racism is not as overt as it was before, making it harder to identify racist predilections within personal interactions or public actions. Research on Aversive Racism shows that even while people vocally denounce overt forms of racism and deny personal prejudice, they can still hold negative feelings and biases unconsciously.

Yet, there are a great many things that people can do to recognize and critique racism in steampunk. With the advent of the Internet, steampunks, even those in isolation, can find ways to connect and speak to each other. We also live in an age where we can access information more easily. This same tool gives us access to spaces which exist to educate people on the possibilities. The following are Google-able phrases which will lead any intrepid adventurer into the challenges that anti-racist activists navigate on a frequent, if not daily, basis: "Resist Racism", "Racism 101", "invisible knapsack", "race and pop culture", "IBARW" (the latter term stands for "International Blog Against Racism Week"). More readings will lead to more nuanced discussions, although it is vital to understand the basics before jumping into these discussions. Persons to seek out and read include Tim Wise, Latoya Peterson, K. Tempest Bradford, and Edward Said.

It is to the imaginative credit of many steampunk participants that today we attempt to incorporate elements of cultures beyond the conventional, Victorian-era Europe into manifestations of steampunk. (Or, conversely, we attempt to inject elements of steampunk into cultures beyond Victoriana.) And yet, this must be undertaken with a strong sense of caution and sensitivity. While it is commendable for steampunks to claim that the movement is anti-racist and anti-imperialist, it is necessary to recognize the current hegemony that pervades literature and global consciousness.

Steampunks are, as a specific community, under no special onus to educate themselves. Yet as a creative community, indulging in a form of historical revisionism, we are uniquely placed to examine closely the effects that history has had on the present day.

THE MARY GOLDEN

by C. Lance Hall
illustration by Juan Navarro

The ship moved through the air with her sails fully deployed, like a whale through deep water. The *HMS Mary Golden* was an older ship, a tall brigantine with dual masts and two majestic wings spreading from either side of her hull. Airships like her didn't sail much anymore, but those that survived wars were constructed well enough to remain airworthy. The steam engines bolted to the fo'c'sle thrummed like a heartbeat, steadily running two giant wind wheels set just under the Captain's cabin. The sails were not strictly needed, but the more air they caught the more pull the ship had, and that meant less work for the wheels. Running at full sail, even when inconvenient, was one of the reasons the *Golden* stayed in service so long.

This was due, at least in part, to Captain Wolfeson. He'd served under Lord Nelson at Trafalgar, personally coordinating several pivotal recces from a command position in the Royal Balloon Fleet. Lord Nelson rewarded the young Wolfeson with command of the *Golden*. It was a proud moment for the naval officer, the proudest until the birth of his daughter. He found himself a crucial part of the most powerful fleet on Earth, and Captain of his own tall ship.

That was 25 years ago, and now commanding the same vessel seemed less grandiose, and more like steering his own oversized coffin. But this would be his last voyage, the last outing for him and his beloved ship. Both were to be decommissioned upon landfall.

"When we get to America, I want to visit New York first thing."

The Captain's daughter sat on the end of the bed that had been his on every other voyage the *Golden* made under his command. She was eighteen now, and had grown into a beautiful and intelligent woman. Sometimes he worried that she was becoming too smart, too interested in the world around her. Such things could mean trouble for a father. Captain Wolfeson smiled and twirled his graying moustache absently.

"Caroline, my dear, Florida and New York are as far apart as Glasgow and Nice. We shall plan a trip there someday to be sure, but for now you must content yourself with the South."

"I still don't understand why we can't take the *Golden*, or at least one of the lifeboats. They'd get us there in a week or so. I hear there's so much to see in New York, I simply must visit." She slumped, resigning herself to her father's wishes. "What is there in Florida, anyway?"

"Hmmm." He thought a moment, ticking off the things he shouldn't mention.

"Swamps," he said finally.

"Swamps?"

"Well. I hear they are absolutely teeming with wildlife. Good hunting, I'd wager."

"Swamps." Caroline fell back on the bed, staring at the darkened beams bisecting the low ceiling.

She was wearing one of only three dresses that weren't packed in chests down in the hold. The pink one was her favorite of the three, but she found them all ill-suited for the daily life on an airship. Climbing the modest few stairs from the deck to the cabin was travail in itself, exploring further on the ship required extra effort, but she'd managed to find a way to the most interesting places. She spent most of her days either reading, or out on the quarterdeck, to which she could just barely navigate. She enjoyed leaning over the rail, feeling the wind in her hair and just letting her mind wander. She watched the clouds float by and listened to the hypnotic lullaby of the twin wheels humming softly beneath her feet.

It was one such outing on the quarterdeck that she had happened upon young Mr. Hawthorne. He was just a lowly sailor that she knew by name and face only because he had the unique responsibility of working on the massive engines propelling the *Golden* through the clouds. This specialty granted him a higher status than a regular airman, but only philosophically. Technically, he was still a midshipman like most other crewmen, but he had skills that the Captain and the Lieutenants needed, so he was treated better. They jokingly referred to him as "Midshipman of the Red."

When Hawthorne saw the Captain's daughter standing along the rail just over the wind wheels, his instinct was to find somewhere else to be post haste. She was singularly beautiful and he would gladly spend 10 years in a London workhouse to simply talk to her, but she was of a different station. His father was most fond of stories involving some lowly born person crossing the tempers of Nobility and the consequences that soon followed. All his life Hawthorne had been aware of the trouble one could get into attempting to get to know someone like her. He wasn't bitter about his lot, but accepted it the same way one accepts the rain.

"Excuse me. Boy?" Caroline spoke just as the midshipman turned to leave. He stopped, and turned around slowly. She was standing straight now, her pink dress blowing around her in the wind so Hawthorne could just make out what the shape of her body must be like beneath the folds of fabric.

"Yes, miss?" He mumbled, casting his eyes to the wooden-planked deck.

She took a step forward and the hem of her dress entered his field of vision. The toe of her right shoe, scuffed from shuffling around the ship, peeked out from underneath.

"Aren't you the boy who works on the wheels?"

He nodded silently.

"I'm interested in the mechanism. The tiresome days spent on board this bloody ship are driving me mad."

Hawthorne took a chance and looked up. Green eyes, the color of the meadows back home. They weren't the eyes of a spoiled Captain's daughter, but something more erudite. They were inquisitive eyes that looked through what they saw to seek the understanding beneath. He shivered. Her hair danced as she breathed, like the twisted tendrils of a man-o-war.

"So, tell me everything you know about how these wind wheels work."

"You want to know how it works?"

"Yes. I do." She leaned over the rail again, gazing down at the spinning wheels. "Is it that they move the wind, or the reverse and the wind animates them?"

"Well." Hawthorne moved cautiously beside the Captain's daughter. "It's a bit of both. In truth, each wind wheel consists of two wheels, one inside the other like Russian dolls. They turn in opposite directions."

"Why two?"

"The ones on the inside are run by the steam engines up front and they produce a continuous blast of air that's pushed out of the back."

"It produces forward thrust."

"Right. If there's a bit of wind in the sails to help the wheels along we can go as fast as 20 knots."

"I see." She wasn't as easily impressed as he expected. "The outer wheels then?"

"The outer wheels are turned by the wind as we move forward and it is transferred into more energy for the steam engine or to run onboard devices like the Captain's Analytical Engine."

"That infernal thing."

"You don't like it?" He'd had only limited access to the most famous invention in his lifetime, and thought of the devices as near-sacred objects.

She shrugged. "It's a great waste of space and time, and the cards get so easily bent or torn. Mr. Babbage is an engineer, and thought little of how actual people might use his invention."

"But that's wrong," he protested. "With respect, Miss Wolfeson, the whole reason he designed the engine was to free people from having to do all the sums themselves."

"To free Babbage from doing them, more like." She snorted, and went back to gazing at the spinning wheels. "If a seamstress, or one of those poor computers, had designed the engine instead of an engineer, then we'd have something everyone could use."

"Why would everyone need to use an Analytical Engine?"

She laughed. "My, my you do sound like Mr. Babbage! Why wouldn't someone want a better life? Make the engines a bit smaller and replace the cards with something reliable that can be used over like a metal drum with holes that can be pounded out and punched again, and then the uses of such a thing would be astronomical."

"You're a very strange girl, Miss Wolfeson," he managed.

It was the most polite thing he could think to say.

"Thank you Mr. Hawthorne."

She snuck a glance at him. He was as shoddy as the others, but the stains on his uniform were grease, not dirt. He was covered in the grime of a higher calling, she thought.

"I don't often get to speak my mind," she said.

"That is probably a good thing. You are very knowledgeable of the mechanical world for a Captain's daughter."

She put a finger to her lips.

"Don't let on. Father thinks I'm such a bore."

"Where did you learn all of this?"

"I read," she said. "And I had a great mentor. My tutor from when I was a little girl. He taught me much more than he was supposed to. But now my education is in my own hands. If I were to talk to father as I have talked to you, then he would probably send me to a convent or an influenza colony."

Hawthorne thought a long time before he spoke again. By confiding in him, she had flattered and doomed him all in the same breath.

"May I ask a question about your theoretical device? The Analytical Engine Two, shall we say?"

"Of course."

"Wouldn't the energy expended in pounding the holes out of the metal drum exceed, or at least equal, what it would take to create a new drum and therefore make it redundant?"

She turned to face him.

"Not if it was done automatically by the engine itself."

"What, with a hand crank?"

"Don't be silly. A wind wheel like this one, or a steam engine, or one of Faraday's motors could power the device, whether doing mathematical functions or trip hammering copper drums."

"I suppose, but it's hard to imagine making an Analytical Engine so small and commonplace that one could be acquired by a midshipman."

"I know that imagination can be difficult, Mr. Hawthorne. Twenty years ago it would be unimaginable that you and I would be having a conversation aboard a flying ship headed toward the coast of America at 20 knots."

He smiled.

"At the moment," he said, "I'm rather flummoxed by it myself."

Caroline visited the quarterdeck more often in the weeks that followed. She didn't see Mr. Hawthorne every day, but she saw him enough to learn about the inner workings of the *Mary Golden's* engines and wind wheels. She didn't think anyone noticed how often they spoke.

Her father would certainly be against the friendship, so Caroline was careful to keep her distance whenever he was on the deck.

However, today there were special circumstances. Hawthorne had mentioned several days before that it was time for the regular inspection and maintenance of the wind wheels. That meant he was going on an airwalk. The Captain would certainly be present during the tricky maneuver, but she was determined to watch Hawthorne dance on the clouds.

"What are you doing up here?" Captain Wolfeson asked as she shuffled across the quarterdeck, holding the hem of her dress.

She smiled at her father without looking at Hawthorne.

"I would like to observe, father. It's not every day one has the opportunity to observe an airwalk."

"Very well." He raised a graying eyebrow. "Just stand clear, this is a dangerous business and we can't have Hawthorne here distracted."

She glanced over at the young man, whose eyes were glued to her with a look of animal panic.

"I'll stay so quiet, you'll not know I'm here." She smiled at him.

The Captain grunted and turned back to Hawthorne, who was busy strapping on a leather harness. The straps stretched over his shoulders and down between his legs with cross straps on the chest and waist. Buckles and straps hung off the back and sides like tentacles. Captain Wolfeson lifted a metal object about the size of one of the large photographic cameras Caroline had been fascinated by as a girl. This strange device had two metal bottles, enclosed on both ends, mounted to a copper box. Tubes ran from the bottles to the box

in a way that suggested the transference of liquid. On top of the box were several dials and switches that apparently controlled the machine. On each side were hollow copper pipes that protruded a few inches.

Working slowly and precisely, the Captain connected the machine to the back of the harness. Hawthorne stood like a dressmaker's dummy as the contraption slowly took shape. With the help of a few shipmates, the Captain attached large canvas wings to either side of the machine, fitting them into the copper tubes and tightening them down with a wrench. The wings were each about a man's height when unfurled completely, but they could fold in on themselves like a giant bat. A tail, also made of canvas, was fitted to the bottom of the machine. Caroline thought the tail looked more like a vertical fin than a horizontal feather. Come to think of it, she decided the wings looked more like oversized fins as well.

Once all of this was attached, Hawthorne unceremoniously stepped overboard. Caroline gasped with shock, expecting a warning of some sort before he leaped into the empty sky. She ran to the railing just in time to see him ignite the machine and unfurl the wings. The thing on his back spat a cloud of white smoke and thrummed softly. The wings fluttered up and down in time with the machine. She saw for the first time that a rope led from Hawthorne's waist back to the deck. He used the rope to pull in closer to the bottom of the hull. The contraption strapped to his back seemed to be more for maneuvering and gliding.

He reached the wind wheels, which had been turned off for the inspection, and connected to them with two magnetic discs strapped to his knees. Once connected, he pulled in the wings and turned off the machine on his back. He stayed stuck to the belly of the ship for what seemed an age, busily working with tools produced one after the other from the numerous pockets of a well-worn leather apron.

"How long does this take?" she asked her father, who had moved to the rail beside her.

"He should be done in an hour's time," the Captain answered. "I'm sure you don't want to stand around all morning watching this, eh?"

"On the contrary, father. It's the most interesting thing I've witnessed since boarding."

"As the Captain of this airship, I'll try not to take offense at that," he said with a smile.

"Oh, you know what I mean."

She turned her attention back to Hawthorne, studying his every move. She was torn between two fantasies: One in which she was the one riding the tides of the sky, and the other where she was with Hawthorne alone somewhere quiet where they could talk freely. She couldn't decide which she desired more. Captain Wolfeson didn't look back at Hawthorne. Instead, he watched his daughter. Her frequent trips to the quarterdeck hadn't gone unnoticed. He'd hoped this was simply out of boredom, but he saw something in the way she watched the young midshipman. It was unmistakable. It was also unallowable.

"Caroline, we need to talk," the Captain announced the next evening.

They were alone in his cabin and for the past couple of hours he'd been working up his fatherly courage. Caroline had never caused him a moment's worry, or forced him to use a cross word, so this was uncharted territory.

His daughter looked up from a book she was rereading for the third time. "Certainly, father. What do you want to talk about?"

"It's about Mr. Hawthorne." He spoke in the manner he used to lecture the crew. "You are spending far too much time with him. It's unacceptable. You mustn't talk to him again. Is that clear?"

She smiled warmly.

"We only discuss the workings of the wind wheels and the engines. I'm terribly bored and it's been an amusing distraction from this cabin. However, if you think it unseemly, I'll not speak to him again."

"Thank you, dear. I'm glad you see the situation so clearly."

The conversation was a relief, but again he detected something in his daughter's eyes. It was something he'd seen there a long time ago, when he'd given her the news her mother was dead: Panic.

"Of course."

She turned her attention back to the book, but the words were a blur. She was suddenly acutely aware that she'd fallen in love. She resigned herself to comply with her father for the duration of the trip to Florida. There was no other course of sane action as long as she remained aboard the *Golden*. Once in America, she could find a way to be with Hawthorne. And, if it meant running away and living a rugged life with an engineer for a husband, then so be it.

On the main deck, Hawthorne gazed into the cloudless sky marveling at the countless stars. Of course, he was thinking of her, as he'd been almost every moment since that first afternoon. He knew every word they spoke led him inexorably closer to the ruin of his career, but whenever he thought of a way out, the scenario ended with her in his arms. He was a problem solver by trade, it was his gift. The ability to work out puzzles and figure out how to fit seemingly incongruous pieces together had come easy to him since he was a boy. This was more than a puzzle though, it was a catastrophe.

"Ship ho!" A voice yelled in the darkness, breaking his thoughts. "Starboard, three degrees!"

The voice belonged to the first lookout of the night. Hawthorne instinctively rushed to starboard and narrowed his eyes, trying to make out what the lookout had seen. Some distance away there was a twinkle of orange light, not a star, but a glowing lantern, probably in the captain's cabin of another airship.

Captain Wolfeson was immediately on deck. He watched the other ship for a long while, trying to make out the ink black shape against the stars it blotted out.

"Reduce speed." Wolfeson barked. Hawthorne had already made his way to the fo'c'sle and immediately began turning the large hand crank that closed the boiler and slowed the inner wheels.

For the next three hours the *Golden* drifted, letting the dark blot drift away. They were just one day out of St. Augustine, and although pirates were scarcer now than in the

decade previous, caution was still warranted. The Captain dared to hope the other ship was unaware of the *Mary Golden.* They were too close to landfall to take chances on an aggressive attack, and besides that, the *Golden* held a more precious cargo than ever before. Finally, he understood why it was bad luck having a woman on board.

Caroline awoke with a start to the sound of the *Golden's* guns firing. The jolt of the blasts rocked the ship to and fro pendulously, giving the illusion that it was back on the sea rather than miles above in the clouds. She quickly pulled on the same dress she had worn the past three days, and scampered to the deck, not bothering with stockings or shoes. The deck planks were surprisingly warm and foreign to her bare feet.

A few hundred yards in front of the *Golden* was another ship. It was smaller, with only one mast. Like the *Golden*, it had two wings on either side of the hull for stability, but not the dorsal rudder that helped the larger ship stay level and true. As she looked on this small ship she saw it flash. A moment later she heard the boom of the cannon and the whistle of the lead ball that missed the *Golden* by about twenty-five feet on the port side.

"Caroline!" She heard her father's voice bellow from behind her. "What in blazes are you doing up here. Get below this instant!"

"What's going on Father? Who are they?"

"Pirates."

He said the word in a hushed tone adults use when speaking of the unspeakable around children. Before the voyage, there had been a brief discussion of piracy off the coast of the Americas and how her presence on the *Golden* would mean that surrender was impossible.

The ship would have to go down rather than give up. All the crew would be sacrificed because of her. Without another word, she did as her father asked and returned to the cabin.

The captain's cabin had two small portholes, and from the starboard side Caroline could just make out the bow of the enemy ship. The *Golden's* cannons continued to rock her back and forth with each blast. She watched hopefully for a sign the ball had found its mark. Occasionally, she heard the whistle of a near miss. Once, there was a loud pop from the deck that was the unmistakable sound of one of the masts taking a hit. Caroline closed her eyes and curled up on the small mattress. She imagined herself far away, sitting at an outdoor café having tea with Mr. Hawthorne sitting opposite her. It was a rather modest dream, but at the moment it was as far away as a fairy story.

As the crimson sun sank over the western horizon, Captain Wolfeson knew they'd lost the battle. They would be able to hold out during the night, but come morning, the pirates would surely board. He couldn't let that happen. One of the main masts was completely gone, the dorsal rudder was all but destroyed, and one of the wind wheels was badly damaged. They were still airborne, but couldn't maneuver to starboard and could only travel at half speed. The pirate ship had looped around at full speed and was now at the stern of the *Golden*. Holding at about fifty yards. They were waiting there until sunrise when the final attack would come.

"Captain?" A voice broke the surreal peace of the sunset. Wolfeson turned around and saw young Hawthorne standing at attention. He was in his airwalk harness.

"Yes Hawthorne? What is it? Why are you wearing that harness?"

"Let me go, sir. If I'm not tethered then I should be able to reach the

other ship. If I cut the pack off about half way, I'll be able to glide in."

"To what end?" The Captain watched the final sliver of orange disappear over the horizon.

"Sabotage, sir," Hawthorne answered quickly. "I can use my tools to immobilize their ship and possibly even destroy it. If I can find an accessible boiler valve to block off …"

"And how would you get back on board the *Golden*?"

"Chances are I won't need to if I get caught, sir, but if I'm lucky enough to survive, I can certainly get close enough to the *Golden* for someone to throw me a tether and reel me in. I wouldn't risk coming in full wing."

"Sound logic, Hawthorne." Wolfeson looked him in the eye. "It's very risky, and certainly beyond your duty, son. What do you hope to gain from this act?"

"My life, surely." Hawthorne held his gaze. "But I also have feelings for your daughter."

"I suspected as much. And for that, you are willing to risk sacrifice."

"Yes sir. I ask only one thing."

"Yes?"

"That you allow me to marry Caroline."

The Captain remained silent for a long time, then spoke softly.

"Yes. I will."

A few moments later, the two men were standing by the quarterdeck railing. Hawthorne was rigged and ready. Quietly, he stepped off the deck into the black sky. For a few heartbeats he fell freely, then he pulled the cord that sparked the burner in the pack, and he felt it hum to life. The wings were unfurled and beating slowly. The cool night air blew in his hair as he felt himself rising on the wind. The hull of the *Golden* was visible just above him, and he was careful to swing clear. Hawthorne took himself around in a giant loop that brought him about a hundred yards to the stern of the pirate ship. He used his legs to adjust the angle of the tail section which changed the direction of the glide. He could see the faint smudge on the starry night just ahead. He made sure his trajectory was above the level of the enemy ship's deck by at least a few hundred feet. When he was twenty yards away he cut the pack's power and unfurled the wings to their maximum span so he could glide in silently. He hoped the lookouts were too preoccupied with the *Golden* to notice something so small coming in the other direction. It would be a tricky thing to connect to the smaller ship's single wind wheel, nestled underneath like a steel barnacle.

He could tell he was too high and too fast as he glided in, so with no room to spare he pulled in the wings and spread his arms and legs wide, like making angels in the snow. This slowed him just enough for his path to fall under the stern of the ship, but not too far away to lash onto the casing of the spinning wind wheel. When he was within a few feet of the large wheel, he threw out the grapple rope. The magnet found its target with a thud that echoed in the midshipman's ears. He pulled himself close to the wheel and went to work.

First, he removed the outer plate and let it fall into the blackness of the night. Once inside the wheel, it was child's play to disable the drive gear and remove the primary axle. The inner wheel spun to a stop noiselessly.

Using two of the bolts he'd removed from the outer plate, he successfully jammed the outer wind wheel so even the wind would not set it in motion. The pirate ship was now completely helpless and simply gliding in the sky on its hull wings. He followed the intake pipe that powered the inner wheel, and quickly located a release valve. With both wind wheels at a standstill, more steam than usual released into the night. With a quick turn of a wrench the valve was sealed, and Hawthorne let go of the underbelly of the pirate ship.

Shots rang out behind him just as he re-ignited the pack. The pirates had realized they were drifting and had at last come to investigate, moments too late. Their voices yelled curses at him as he floated away into the night. He didn't even look back as he heard the main steam engine give way to the pressure and blow a hole in the side of the ship. The ship and crew would fall back to Earth, back to the sea. The gruesome images of their fall and ultimate reunion with the Atlantic Ocean were quickly replaced with the full understanding of his accomplishment.

Caroline would be his.

As he approached the *Golden*, Hawthorne noticed her engines firing full and the hull wings set in an ascent position. He unfurled his wings and turned the valve on the front of his harness to maximum pressure. This was enough to get him close enough to the *Golden* to see the Captain standing alone on the quarterdeck. His white uniform glowing in the moonlight.

"Outstanding work!" The Captain yelled through cupped hands.

Hawthorne yelled back, even as he swooped faster toward the quickening ship.

"Throw me a tether, sir! You're getting away from me!"

"I'm afraid I can't, son!"

Hawthorne kicked off his boots, and detached the tail section from the harness, making himself lighter and faster. He was just about there. The Captain was closer to him now. He could hear his voice on the wind.

"I'm terribly sorry. It's the only way. You understand, of course."

Hawthorne didn't answer; he threw the grapple rope with all his might and felt the rewarding thud of the magnet connecting with the wind wheel.

The Captain leaned out over the rail. "What good will that do you, son? You can't get on board from there."

"I can do to you what I did to them," he yelled through angry tears.

The Captain shook his head.

"No you can't, son."

He stared at the wind wheels, knowing he could stop the *Golden* in her tracks and watch her crash into the sea beneath them, but that would mean Caroline too. He let go of the rope and turned off the machine strapped to his back. He watched the *Mary Golden* drift into the night as he glided there on the clouds. He would soon join the pirates in the ocean. He didn't have enough water in the pack's reservoirs to get him back to land, and the irony of falling into an ocean from lack of water made him smile despite himself.

"Farewell to thee, my *Mary Golden*." ✾

Museum

by Brenda Hammack
illustration by Sarah Dungan

1.

Some things we don't mean to collect,
like ailments and disappointments.
She keeps hers in a cabinet:

all those should-have-been
children, those premature Ophelias,
who died before they could cry.

Suspended in jars like translucent
coffins, they could have been
manikins, or *objets d'art*,

some things that she'd conjured
to occupy empty space
when nature forgot.

2.

As a seeker of nebulae—ghosts—
and a maker of chimeras—goats
fused with snake, cat, and ape

from his embryo trove—he
gives her what the artist
goads into imaginal

existence. He forges bones
to buttress the gossamer,
grafts wings to uplift

her soul when prayers
aren't enough. He gives
her angels of nature.

3.
In the usual mode of evolution,
butterflies would not cluster
like cloisonné pendants

on winter evenings. Hippogriffs
would not graze the Downs of
Kent or of Hampshire. Wolves

would not wisp through cloisters
like gas flames, and orphans
would not dangle woodworms

for Humbugs to fend off incontinent
woes. Such comfort, he gives her: a child
who won't die, won't grow old.

4.
The museum he lives in
is no vault of natural history,
is no tomb for fossils or rogues

set in wax. Its corridors
open on *tableaux vivant*,
or living dioramas where

mammoths and unicorns
roam amid bluestone,
where stelae keep time

by shadow, and creation does
not wait on fault, whim, or law,
and is not contingent on God.

THE FUTURE OF STEAMPUNK FASHION
in Two Parts

by Libby Bulloff
illustration by Amanda Rehagen

PART ONE
Bitchin' About the State of Things

Steampunk fashion has indubitably mainstreamed. With articles describing its aesthetic in publications like the *New York Times* and internationally-distributed fashion magazine *Women's Wear Daily*, it is safe to say we'll be seeing anachronistic Victoriana on the runways and sale racks for some time to come. Hardcore steampunks seem both amused and infuriated by the attention given to them by the garment industry, claiming that the scrutiny will either assist the expansion of ready-made steampunk clothing lines (a boon to folks without the desire or aptitude to sew their own), or annihilate the inherent DIY nature of the subculture. Some voice concern that the media machine will assimilate and bastardize steampunk fashion until there's no culture left within it, or worry that trendsetters latching onto the fad will execute the look poorly.

However, I fear that it won't be the mainstream that will ruin steampunk fashion—I believe it will be those within the subculture themselves who will lower it to a mere passing trend. Steampunk clothing is often impractical, uncomfortable, and inappropriate for wear outside of conventions, parties, and formal affairs. While it has been popularized to the point where it is represented at clubs, and while it has appeared in couture lines and on celebrities, steampunk has not become highly visible as a common street fashion trend. Or,

if it has become a fashion trend, it hasn't yet entirely metamorphosed into a functional, sustainable *style*. Fashion lasts a season (if that); style is internal, eternal, and transcends time.

The only way to save steampunk fashion from being consumed and pitched away is to, ironically, casualize it. The author of the aforementioned New York Times article, David Colman, wrote about trends in anachronistic dress. "There are all kinds of societies that are about dressing up in period costume and then going back to your oversize jeans the next day," he said. "**This is about style as a way of being**." But so many of the steampunks I see are not ready to commit to rocking the aesthetic as their regular attire, claiming that it's too difficult, expensive, or socially inhibiting. Thus, it's not mainstream interest that makes steam fashion fadlike—it's the folks within the subculture who misguidedly view only heavily embellished outfits with their goggles, functionless gears, and sepia and brown as the one true look of steampunk. We're no better than our wealthy, trendy, hipster counterparts when we cease the continuous metamorphosis of our look, when we won't fearlessly model our style at our desk jobs, and when we eschew making old garments into new, upcycled ones because it's easier to buy them from the mall. As deftly put by Walt Kelly: "We have met the enemy and he is us".

Casualizing steampunk is as simple as seeing the aesthetic as broader than just a cosplay affectation. The props involved in much of steampunk convention-wear, whilst interesting, are cumbersome and alienating, or just downright ridiculous for the office or the grocery store. Clothes can be costumes, but not all costumes are clothes. On the other hand, the inherent timelessness of all steampunk clothing is what makes it attractive on a day-to-day basis. The finest steampunk outfits are a flirtation of formal and casual, a blend of old and new. This cannot be achieved by snobby fashionistas who won't make the time and care it takes to create a sustainable, unique, nuanced wardrobe, and this is where we have the upper hand.

PART TWO:
Fixin' Them

Many of us are suffering from the effects of the economic recession in the United States and elsewhere in the world, or else renouncing materialism and capitalist money systems. Therefore, steampunk's rise as a fashion aesthetic is timely, as the very best of it is handmade, upcycled, collected, and one-of-a-kind. Fighting the mainstream by DIY is both cunning and affordable. One does not have to be rich or thin to look great in casual steampunk garb, and the most fantastic items for padding your steampunk wardrobe usually don't have a little label discerning them as steampunk, either. Folks who complain that they do not know where to find steampunk clothing they can wear every day are often seeking that label, rather than looking at the clothes they already have with an eye for modification. Don't limit yourself to wearing only clothes with a Victorian flair. Other antique, vintage, and ethnic influences definitely bring new interest to your wardrobe, and keep the mainstream from copying your look.

If your closet is bare, nipping over to your local Salvation Army, Goodwill, thrift or vintage store and digging in the bins for treasures is a thrilling and inexpensive way to acquire new looks. Sometimes whole pieces can be gathered as they are directly from secondhand stores (I am notorious for finding the most gorgeous embroidered Indian tunics at Value Village).

If you can't find perfect clothes right off the rack, look for basic items that fit your body that can be fixed up. My close friend, Finn von Claret (ex-member of Abney Park and a professional dancer and designer), is an absolute expert at creating her own steampunk clothing, and she has no ability to sew from a pattern. Her secret is an uncanny ability to look at a vest and see in its seams a belly dance choli with a hood, or to view a pile of old curtains as a potential walking skirt. She looks for garments with quality, interesting fabrics for modification. Finn drapes

clothes on her own body, sometimes enlisting a friend to safety pin pleats or trim in place, and the finished product fits and looks worlds better than whatever the fashion industry tells us to buy.

Much of the clothing that we've upcycled is still completely appropriate to wear to work, to play, to worship, and to family events. Keeping things simple, and leaving the goggles and ray guns at home legitimizes the look. Accessorizing carefully with boots, neckties, jewelry, hats, scarves, and socks (often in colors other than brown) pulls the whole aesthetic together.

In sustainable steampunk fashion, the needle is mightier than the dollar. If you can use a needle and thread, you are well on your way to having totally unique garments (and if you can't, learn). Adding beaded fringe to a boring jacket, sewing a pocket over a stain on a vest, or raising a hem into a bustle can morph a basic garment into a work of art. Sometimes all a coat needs to look steampunk is a different set of buttons.

Finn and I stockpile grommet tape, bits of velvet ribbon, feathers, thread and embroidery floss in brilliant colors for quick, inexpensive alterations. I save my used tea bags for tinting faded beaters and dingy tops. Our friend, Bergen McMurray (of www.deviantdesign.org), screenprints and paints graphics onto upholstery samples she acquires for free to make incredibly unique patches. We use onion skins and turmeric to brighten unbleached muslin to a monk-friendly shade of saffron, and drop old trousers and dress shirts into steaming RIT dye baths. Finn's favorite tool for making an army surplus jacket look tattery is oddly enough, a cheese grater. Shredding the sleeves and splashing bleach up the back gets upcycled thrift store finds mistaken for Dolce & Gabbana.

Not only are you doing yourself a favor by recycling cheap clothes into wearable art that fits your body and style, you're thwarting the passionless fashion industry, and you're adding to the integrity of steampunk as a style that is here to stay and can't be taken away from us.

The Man Who Ate Germany

by Dylan Fox
illustration by Ivo Gregurec

London's pea-soup-filled streets and huffing smokestacks—with secret revolutionary societies in its cellars and murderers in its shadows—is a wonderfully evocative place to play. Tower Bridge housing vast government difference engines, Zeppelins drifting through the skies, and the chance to escape to the country and breathe Brighton or Bath's clear, clean air. Since the French Revolution, the placid waters of Britain remained largely unruffled until the Great War. Just across the water, though, what we understand today as Continental Europe was being forged in fires of revolution and war. The national borders we take for granted moved like flags in the wind. The revolutionary societies of Britain looked across the waters and dreamed of following in the footsteps of the French or the Germans. It would only take a different person in the same place at the same time for the history of Europe to be changed utterly. At some moments, all it would take would be a different word in the same place. If you wanted to change the world, it wouldn't take more than moving just one or two of the irons that were in the fires of European politics and warfare.

Dominating the history of nineteenth century Europe is the coming together of modern Germany. And dominating the birth of that nation is Otto von Bismark.

Otto von Bismark was a glutton. Landed aristocracy from Prussia's social elite, he spent the first thirty years of his life eating and drinking to excess, duelling and running up debts. Despite being a crack shot and able sportsman, reports had him smoking 14 cigars a day and stating it was his ambition to drink over 5,000 bottles of Champaigne before his death. He was hard-headed with a violent temper, and prone to over-emotional outbursts. His weight dropped from 114 kilos to 89 after being put on a herring diet by his doctor, but his unscrupulousness and ruthlessness remained unaffected. Perhaps not surprisingly, he could also be witty and charming, entertaining and a wonderful conversationalist. This was a man whose appetite demanded great things. Bismark would have to become a great man to ensure he controlled it, and not it him. By the end of his life, he had consumed the disparate collection of Duchies and kingdoms which had been the Holy Roman Empire and branded the resulting meal 'Germany'.

Bismark didn't sit down at the table until 1862. The meal had been served in 1849, but no one came to eat. One of history's great opportunities grew cold and stale for almost fifteen years. 1848 was a year of

revolution in Europe, and the states of the German Confederation were swept up in the revolutionary tide. Peasants and workers took to the streets after two disastrous harvests, demanding food and reasonable working conditions. Middle-class political idealists hitched their chariots of socio-political change to the lower-classes, determined to make life fair and reasonable.

The fruit of their vision was the Frankfurt Parliament, a body that contained one representative for every 50,000 'economically independent' citizen 'of age' in the German Confederation. This parliament was to draw up a constitution for a united Germany. By uniting the German Confederation into a new country, they could start fresh and build a country which represented its people, and was fair and free. The German people would be freed of their bickering monarchs and would have a shared identity. For those starving in the streets, a sense of their suffering being shared with 'their people' was almost as welcome as actual food.

In Prussia's capital, Berlin, the riots turned into a civil war: Barricades were erected in the streets, the army was called in to bring order, and the workers fought back. Despite being armed with two-by-fours and wood axes, the workers made the army pay for every cobblestone. By the evening of 16th March 1848, the streets of Berlin were a bloody mess. At three a.m. on the morning of the 19th, Prussian king Fredrick William IV wrote a heart-felt plea to his 'dear Berliners' which was immediately copied and stuck to every available post in the city. On the 21st, he rode through the streets of Berlin, proudly displaying the red, gold and black of a united German people. He spoke of Prussia being dissolved in Germany and told his subjects how humbled he felt by their outpouring of desire for union with their German brothers.

Fredrick William safely withdrew from Berlin, smarting and speaking of how he had been humiliated. Nevertheless, he did organize elections for an assembly to draw up a constitution for Prussia, and appointed a few liberal ministers to his cabinet. Where Prussia (the largest and most powerful state of the German Confederation after Austria) led, the other states would most likely follow.

Sure enough, concessions were made and constitutional bodies planned for in other German states.

The Frankfurt Parliament was elected indirectly. Those who were of age and economically independent elected representatives to elect people to the parliament for them. Women were, of course, excluded from the vote as were servants, farm labourers, those on poor relief and anyone else who didn't own property. The parliament which assembled was mostly composed of middle-class moderates who wanted their united Germany ruled by a monarch, answerable to an elected body, and subject to a constitution which guaranteed rights to the people. The first question they addressed was whether they should include the German-speaking parts of the Austrian Empire and make Austria the dominant state, or exclude the Austrian Empire and hand dominance over to Prussia.

The Frankfurt Parliament was directionless. It was a house of oarsmen with no one to beat the drum, a group of idealists who lacked the firm hand of a charismatic and determined leader.

Without any form of decisive leadership, the parliament bickered for months. People went back to work, and the monarchs were free to repeal the concessions that the revolutionary riots had won. Of all the concessions granted, every monarch was careful to ensure they maintained control of their army. The army existed to enforce the will of the state, and the will of the state was the will of whoever controlled the army. The armies appeared on the streets, reintroducing press censorship, dispersing political gatherings and arresting those who spoke against the monarch.

The Frankfurt Parliament had no army, no administration and apparently no sense of urgency. When it finally produced its constitution in March 1849, the states of the German Confederation were free to ignore it, and promptly did so.

Perhaps strangely, the constitution wrestled from Fredrick William's reluctant hand was al-

lowed to stand, even after all the dust had settled. It provided an upper and lower house of representatives. Both would have a say in legislation and, importantly, the budget. The lower chamber was the first place in Europe to be elected by universal manhood suffrage, and the upper chamber was elected by men over thirty who owned enough property that they probably hadn't come by it honestly. Perhaps the king allowed the parliament to remain because the constitution also allowed him to make any change to the way the country worked, whenever he felt like it.

When Bismark entered political life in 1847, it didn't take long for his star to rise. During the 1848 uprisings he busied himself with counter-revolutionary plots. In 1850 Fredrick William was forced to back down from armed conflict with the Austrian Emperor Francis Joseph, and Bismark gave a magnificent speech in the king's defence which was widely carried by the newspapers and earned him a promotion to the Prussian envoy of the German Confederation's meeting body, the Federal Diet. He stayed there for the next nine years, gaining a reputation for being rude and arrogant and becoming more and more convinced that in order for Prussia to thrive, Austria must be 'dealt with'. In what would become signatory of his time in charge of Prussia, he proposed alliances with France, Russia and anyone else he thought would destroy Francis Joseph's influence in the Confederation.

In September 1862, History knocked on Bismark's door. Bismark berated it for being so late, downed his brandy and lit a fresh cigar as he marched onto the international stage.

Always a bit flaky, Fredrick William had been declared insane in 1857 and succeeded by his younger brother Wilhelm I. The Army Reform Bill was before parliament, and they refused to pass it. Wilhelm was threatening to resign if the bill didn't pass. It was his country, and if he couldn't rule it the way he wanted, then what was the point? Bismark assured the distraught monarch that he had a plan, and left as the Minister-President of Prussia.

Bismark stood before the elected parliament and told them it was none of their damned business how the army was organised or how long the conscripts served for, withdrew the bill and signed it into law. The liberal parliament declared his actions illegal and urged people not to pay the taxes which sustained the army. Bismark pointedly reminded the people that if they had any trouble paying their taxes, then he was sure his 200,000 soldiers would be able to help them.

Although Wilhelm was thoroughly pleased with his new Minister-President, the people he ruled were less than thrilled about the destruction of their illusions of democracy.

Throughout the 1850s, the standard of living of the workers and farmers had slowly risen under the paternal hand of Otto von Mauteuffe. With an able and willing workforce, Prussia's industry grew. At the same time, Wilhelm—a military man from epaulettes to spurs who had never expected to become king—set about reforming the army from the embarrassing disaster zone it had been under his brother. Bismark inherited a country with a strong economy, and a strong army. In 1863, Francis Joseph gave him the chance to show it.

The Duchies of Schleswig and Holstein had been under Danish rule for over 400 years. Schleswig was mixed German and Danish, and Holstein almost entirely German and a member of the German Confederation. When the King of Denmark died without issue, the Austrian court and Prussia monarchy clashed over the future of the Duchies. Bismark, Minister-President of Prussia was able to convince Francis Joseph, Emperor of Austria, to occupy the Duchies with military force. The Austrian-Prussian army rolled into the lands with relative ease. A series of conferences were arranged and promptly broke down as the occupying forces argued over what to do with the spoils. Francis Joseph wanted to install one of the claimants to the Danish throne, and Bismark wanted the Duchies to be granted independence and made part of the German Confederation. The two countries glared over the borders, fingers twitching over their holsters while Bismark's *agent provocateurs* encouraged resistance from the occupied Danes and made promises of help from the English.

The truth was that neither country wanted war. Despite Wilhelm's almost monomaniacal army reforms since taking the throne, Bismark wasn't sure his army was in a fit state to win, and Francis Joseph simply couldn't afford it. It also allowed diplomatic relations between Austria and Prussia to become hostile without Prussia bearing the blame. Bismark had laid the table for his first meal of the German Confederation.

At the Convention of Gastein in August 1865, administration of Schleswig in the north was handed to the Prussia monarchy, and Holstein in the south to the Austrian court. The new Danish king shut up and took his medicine. Outright war between Austria and Prussia had been postponed, and Bismark didn't waste a moment of the time he'd bought.

Having been assured of Britain and Russia washing their hands of Continental Europe, he started work on the French Emperor Napoleon III and the newly-unified Italy's monarch, Victor Emmanuel I. Whereas the British and Russian governments were content so long as Germany remained divided and therefore no threat to their power, Napoleon and Victor Emmanuel had territorial interests in the German Confederation. In April 1866, Bismark signed a secret treaty with the Italian premier declaring that if Prussia found itself at war with Austria, Italy would follow. Bismark would settle the question of dominance in the German Confederation— one way or another—and Victor Emmanuel would walk away with Venetia. The treaty put Bismark on a very tight schedule: Victor Emmanuel's promise lapsed after only three months.

Napoleon was far harder to tie down. Bismark extracted verbal promises of French neutrality, and Napoleon extracted promises of the Rhine frontier as 'compensation' for French neutrality. Napoleon struck an almost identical deal with Austria's Francis Joseph.

The hardest ally for Bismark to win over was Wilhelm. The king hated the idea of waging war on his 'brother Germans' and his sense of honour couldn't conceive of the idea. Bismark's relationship with Wilhelm was tempestuous. Their

meetings would often be fraught, emotional affairs with both sides shouting, crying and throwing around small furnishings. Bismark was an intelligent, forceful creature who loved his monarch and wanted the best for him. Wilhelm was chosen by God to rule his people. Up until Wilhelm's death 1888, the monarch never exercised his power to replace, circumvent or publicly speak against Bismark. When Bismark died 1898, his grave was marked with the words, 'A faithful German servant of Kaiser Wilhelm I'.

Eventually, Wilhelm gave his consent to Bismark to make arrangements, should Prussia need to defend herself.

While the ink was still wet on the Italian treaty, Bismark introduced a Reform Bill proposing an assembly elected by universal manhood suffrage. Predictably, the Austrian representatives objected. Fearing a surprise attack by Prussia, Francis Joseph ordered his antique army mobilized in April 1866. Wilhelm responded by mobilizing Prussia's the next month. Much to Bismark's chagrin, the British, Russian and French foreign offices offered to broker a peace between the two states. Bismark couldn't refuse without losing the moral high ground. Luckily for him, the Austrian foreign minister Count Mensdorff did refuse. Bismark held his nerve and kept his war dogs on the leash.

On the 1st June, the Count Mensdorff decided to break off the torturous negotiations with the Prussian ministers over Schleswig and Holstein. Bismark responded by letting the leash slip and sent the Prussian army in.

Again, to his chagrin, his war stalled. Francis Joseph simply watched.

Bismark introduced an extended version of his Reform Bill to the Federal Diet that represented the German Confederation. In response, the Diet censored the Prussian government for aggression in sending its army into Holstein.

The increasingly ravenous Bismark seized on the opportunity again: He withdrew Prussia from the Confederation, drew a line and demanded that the other German states pick a side. The next day, Prussian troops marched into the states whose representatives had supported the Austrians in the Diet: Hanover; Hesse-Cassel; and Saxony. As the Italians attacked Austria from the south, Bismark was finally able to bury his moustache in the German pie.

The battle for Germany was decided on the 3rd July at Sadowa in the modern Czech Republic, then part of the Austrian Empire. The battle involved nearly half-a-million men and the landscape still bears the scars.

Prussian military technology won the day. The Austrian infantry were armed with traditional muzzle-loading rifles. In 1836, the son of a German locksmith had invented a new breach-loading rifle which allowed for far more rapid fire. By 1864, it was standard issue in the Prussian army.

Numbers are disputed, but the Austrians lost in the region of 44,000 men (either to the Prussian guns or as prisoners of war) to the Prussian's 9,000. The Austrian army shattered like a discarded brandy glass, and the road to Vienna—the capital of the Austrian Empire—was wide open.

With Austria at their mercy, Bismark and Wilhelm clashed again. Flush with military victory, Wilhelm wanted to be Cain to Francis Joseph's Able. Bismark wanted to live and let live.

In the end, Bismark got his way. Once Francis Joseph agreed to have nothing more to do with the Confederation, Bismark wanted to keep him as a possible friend and ally. The Italian King Victor Emmanuel, though, got his pound of flesh and was given Venetia.

The northern states of the German Confederation weren't so lucky. Hesse-Cassel, Nassau, Hanover, Frankfurt, Schleswig, Holstein and Saxony were annexed and made part of a 'North German Confederation', which amounted to Prussia by another name.

In truth, Bismark could have taken as much as he wanted. The doors to the buffet were open and Wilhelm was egging him on. But as much as he was a glutton, Bismark was well aware of the dangers of over-indulging. Each of the states of the German Confederation had its own culture, its own history and its own traditions. Every territory Bismark ate would be a threat to Prussian culture. If he ate too many at once, Prussian culture would be overwhelmed and Germany would end up eating *him*. Far better to allow some time to digest what he could manage before moving on. This wasn't the unification of the Fatherland yearned for by the revolutionaries of 1848 and the Frankfurt parliament. This was conquest.

The Battle of Sadowa is one of the most decisive in modern European history. If Prussia had lost, Bismark would have been ingloriously kicked to the curb. But with a decisive victory, he returned to Berlin a national hero. Parliament voted him £60,000 and he was a appointed to the rank of Major General. From then on, he never appeared in public without his uniform.

Napoleon's reward for French neutrality was a Germany still divided on France's east border and, rather than the Rhineland territory he lusted after, suggestions from Bismark he go after Belgium, or maybe Luxemburg.

After Prussia's unexpected victory, French press and parliament demanded some show of strength to prove that she was still the dominant power in Europe. Although small, Luxembourg would be better than nothing, and was a safer bet than Belgium.

But it turned out Bismark's intentions were far from honourable. In the German states, he appeared in the newspapers referring to Luxembourg as 'German' and talking of the 'age old enemy of France'. Any strike against Luxembourg, he contended, was a strike against the German people. It was a strike against German culture, German history, against the founding principles of what it meant to be quintessentially German. Abroad, he presented himself as a man striving for peace who would have to be pushed into armed conflict with France. 'I strove for peace then, and I will do so as long as may be; only, remember German susceptibilities must be respected, or I cannot answer for the people not even for the King!' he told a Times of London journalist in September 1867. Like the revolutionary liberals of 1848, he was hitching his chariot to the desire of the German people for a united Fatherland. Unlike the Frankfurt Parliament, he had no problems whipping his horses into submission.

Napoleon suggested to the Dutch king that he should protect himself from probable Prussian aggression by allying himself with France, and that they they seal the deal by selling Luxembourg to him. The Dutch king agreed ... but only if Wilhelm consented. Napoleon was humiliated at home and Bismark's second war became only a matter of time.

The wounds festered until July 1870. Popular opinion in the German states was slowly absorbing the idea of France as their natural enemy, Bismark's rhetoric shouting far louder than any historical evidence. Importantly, France wasn't the natural enemy of Prussia, or Saxony, or Bavaria ... but of *Germany*.

An otherwise minor spat about who would inherit the Spanish throne provided the spark for growing Franco-Prussian animosity.

The new Spanish Government was looking for a monarch, and approached Leopold Hohenzollern. In 1849 the Hohenzollern lands had become part of Prussia, and Leopold's father wouldn't give consent unless Wilhelm did. Wilhelm wouldn't, and Leopold didn't want to go to Spain anyway.

Once again, Bismark had other ideas. Having a Prussian on the Spanish throne to the south of France and a recently enlarged Prussia to the east was a temptation he couldn't resist. In mid-June, Leopold accepted the candidature and on the 21st Wilhelm—upset by the skulduggery behind his back—gave his consent.

There was uproar in the French parliament. The new foreign minister, Duc de Gramont, raved in the chambers at the insult to French honour. De Gramont telegrammed Berlin, demanding to know if they'd known about it. He then sent the French Ambassador to ambush Wilhelm as he was 'taking waters' in Ems, making it clear that if he supported Leopold then France would be left with no choice but to declare war. Already annoyed at whole affair, Wilhelm consented and tried to return to his spa.

Bismark rushed back to Berlin, angry and threatening to resign. De Gramont, presumably in the name of French honour, wanted to grind Prussia's nose in his diplomatic triumph. Dramatically overplaying his hand and giving Bismark an early *Nikolaustag* present, he sent his ambassador back to Ems to demand an apology from Wilhelm, and a promise to never, ever endorse Leopold ever again. Insulted, Wilhelm refused and sent the ambassador on his way. Later that evening, Wilhelm sent a telegram to Bismark to pass on to the press and Prussia's ambassadors.

Bismark's subtle reworking of the Ems telegram is a masterpiece of editing. When Wilhelm saw it, he shuddered and whispered, 'this is war'. French confirmation of that fact followed six days later.

The south German states reluctantly followed Prussia into war against France. Francophobia in those outside the North German Confederation was balanced against a hatred of Prussia. But in the summer of 1866, the heads of the south German states had entered into a secret military alliance with Bismark: If Prussia became involved in a war which threatened her borders, the south German states would place their armies under Prussian control.

The 400,000 French soldiers squared off against the

850,000 Germans. The equipment, training, management and tactics of the Prussian troops outclassed the French. On September 1st, Napoleon personally led his army at the Battle of Sedan. That night, he was Bismark's guest, discussing the terms of France's surrender.

However, the war lasted another six months. Revolution had broken out in Paris, the Second Empire toppled and a Third French Republic was proclaimed. The Prussian troops advanced and, by mid-September, were getting comfortable as they starved the city into surrender.

The new French Minister of the Interior, Leon Gambetta, rose out of the besieged city in a hot air balloon and toured the country, raising a peasant army to fight the invaders. The first President of the Third Republic, Alphones Thiers, toured the courts of Europe, looking for support. Guerilla armies nipped at the encamped Prussians, and Jules Favre—the new Foreign Minister—declared with a heart of French pride that not a centimetre of their country would be ceded. The siege of Paris captured the imagination of Europe.

On the 18th January 1871, Wilhelm I was proclaimed the first Kaiser of Germany. His coronation was held not in Berlin, but in the French palace of Versailles, in the Hall of Mirrors.

Gambetta failed to fire the imaginations of the European courts enough to win any substantial help. Thiers's peasant army was enthusiastic and patriotic, but lacked proper training, discipline and equipment. On the 28th January the government offered its surrender.

By the time the news was reported in the German states, Bismark's hopes had been realised. Shared victories, shared defeats and ceaseless propaganda against the French had brought the people of the German states together in shared hatred. Prussia entered the war, and Germany left it. Bismark had manipulated, contrived and bullied the states of the German Confederation into a new land of his designing. He picked up his napkin and dabbed the blood off his chin. As he leaned back, his chair creaked under the weight of his bloated stomach.

A nation on paper is not a nation in practice, and Bismark was well aware of the dangers of indigestion. The revolutions of 1848/9 had shown that—no matter the machinations of their princes and principles—a nation could not be ruled unless the people allowed it. Power was sucked up from individual provinces and into the growing gravitational body of Berlin, and in their place were ejected standard bodies with standard practices, and standard lines of communication and decision-making leading back to Berlin. Rail lines were built all over the country. Within a few years, the people of Saxony could easily swap their lives with the people of Bavaria or Hohenzollern. With everyone working to the same system and railways making transportation of goods easy and reliable, capitalists could treat the new country as a sandbox, and became very rich very quickly.

Despite the new German nation being recognised by the powers of Europe as someone to be reckoned with, Bismark still saw enemies which needed to be defeated. Firstly, he targeted the Catholics of the new German nation, and later the Socialists. Both groups had a loyalty to something above and beyond their nation. If push came to shove, they would side with their Pope or their comrades over Germany. He pushed laws through curtailing their rights and filled the newspapers with inflammatory rhetoric. In both cases, the campaigns had the opposite effect.

In March 1888, Wilhelm I died. He was replaced by his grandson Wilhelm II. Wilhelm II was young, headstrong and convinced of his divine right to rule. He had no need for 'the old man' Bismark. In early 1890, Bismark, by then aged 75, resigned under the cloud of a bitter and personal struggle with the young Kaiser. He died on 30th July 1898.

To take a cursory look at Bismark's life and political career, it seems he crawled fresh from the womb with a plan to unify Germany and fought his whole life to see it realised. It was a view that Bismark himself did much to promote while writing his memoirs. Having carefully constructed the German nation, he busied himself constructing the legend of Otto von Bismark: The first and only true German.

The truth is that he was an opportunist, a schemer and a man utterly without scruples. He kept Napoleon as an ally against Francis Joseph, and then Francis Joseph as an ally against Napoleon. He kept Francis Joseph and Tsar Alexander II suspicious of each other. Against both Francis Joseph and Napoleon, he was prepared to wait and work until Prussia could appear the injured party.

No matter what happened, Bismark seemed to have a plan for it, and made sure it played out in his favour.

It wouldn't take much to change the course of history. Like the present, it is little more than certain people manipulating events in certain ways—with greater or lesser degrees of success. Bismark's success wasn't all of his own making. It required the Prussian military strength built by Wilhelm, the distractions of the Austrian Empire on Francis Joseph, the woolliness of Napoleon and a dozen other things utterly out of his control. Each of the things Bismark used and abused was built on the foundations of a thousand other things.

What if Napoleon III had never taken control of France in 1851, and instead the French had been lead by someone more in the mould of Napoleon I? Or if Fredrick William had been treated for his mental instability instead of deposed, and the Prussian army had remained weak and unable to fight? What if the inventor of the Prussian breach-loading rifle had been born in Austria, or Russia? Or if Bismark had been killed in one of the duels he was so fond of in his youth? What if one of the assassination attempts on Wilhelm had been successful?

If Britain had been dragged into a European war, then her resources would have gone into weapons and not telephones and steamships. The stability that an empire relies on to thrive would have been destroyed and the echoes felt in Africa, China, Australia ...

Bismark leans over the history of Continental Europe as much as—maybe more than—Napoleon I. Without any of the thousand things which made Bismark's vision possible ... what if? ✺

Alice's Tumble
by Katie Casey
illustration by Eric Orchard

What if, instead of tripping down a hole
(after watching the White Rabbit run by
with sleepy, stupid eyes)
Alice, clever schoolgirl that she was,
had paused, considered,
and crawled carefully in after—
never minding the grass stains on her skirt—
pulled on by the promise of adventure?
Would she pause to practice curtsying
in mid-air as she tumbled:
thoughts drifting like cotton-topped
dandelion seeds, or like the words of
a book printed without pictures?

If she'd solved the poison's puzzle
and made it through the garden door,
and was never swept away, red-faced,
by that sea of tears;
(It would have been best anyway—
Women are so unattractive
when they cry).
If she had refused to babysit the piglet,
and instead explored the woods
beyond the house with the fish in livery;
if she had demanded the Queen
play croquet fairly,
charming her flamingo into cooperation
as Aesop's fox charms crows,
would she have wished so fervently
to abandon wandering
for home, and lessons in
manners and in needlepoint
and in how to read those books
that are printed without pictures?
(But not too many, because reading
might lead her to hysteria
in tight-laced corsets).
 "We're all mad here," the cat said,
 disappearing into a white grin,
 but poor Alice protested, because
 to go among these madmen
 she would have to wear pants.

The White Rabbit's Other Story
by Dylan Fox

You remember our old friend, the fussy page,
With his fur a royal white,
With his strange manners and the odd habit that he had
To keep his pocketwatch wound tight,
His tatty jacket and his muddy paws ...
Oh, what a dashing sight!

Let us suppose then, on that sleepy summer day,
His watch wound down.
Let's make believe his senses faltered
And that he was lost in town.
Or that he'd watched a train bully along
And gotten lost in the smoke and sound.

What would our baffled bunny do
On the wrong side of the rabbit hole?
Where knaves are swapped for kings,
And the red queen is trumped by one black as coal.
Where court is kept in parliament
And the braying asses rule the world?

Would he have kept his senses, then,
As he walked past the butchers' grim display?
Or would the bloody, hanging corpses
Send him quickly quite deranged?
Would he end his stay as pelt or pie?
And would his foot bring luck to someone's day?

Or would he try and make a life,
And take a job as banker's clerk?
Sell his days and drink his nights
For a home that he sees only when it's dark?
And all for coins he never sees
And hope as faint as match's sparks?

What would our friend say, then,
After years of playing dumb,
(For common man has common thoughts, common brains,
A common soul, and that's the poor man's sum),
Of shells and tanks and mustard gas
And the horrors that were yet to come?

Would he find his comfort then
Amongst girls in lace and men in ties?
Would he play their games of social grace
To keep his name, and cheat, and lie?
Would he tut at the rape of Africa,
Sip at his tea and say, "My ... my"?

Can you see him sitting with his paper,
As he watches politicians posturing like bulls and bears,
Chittering like crickets
In their vainglorious political affairs?
Would he watch their pointless squabbling
And find some comfort there?

What would he make, then,
Of our houses of the mad?
No whim or whimsy there though,
Just the desperate and the sad.
Would he weep to see such pain in them,
Or pay his penny to witness the charade?

Perhaps the rabbit's better down the rabbit hole,
Among playing cards and croquet games.
He would be happier with tea parties,
With potions and with piscine footmen, in the main.
Amongst the people who, to give them due,
Will at least admit they're all insane.

SHIMMIES AND SPROCKETS

by Ay-leen the Peacemaker
illustration by Lisa Grabenstetter

Analyzing the Use of Belly Dance in Steampunk

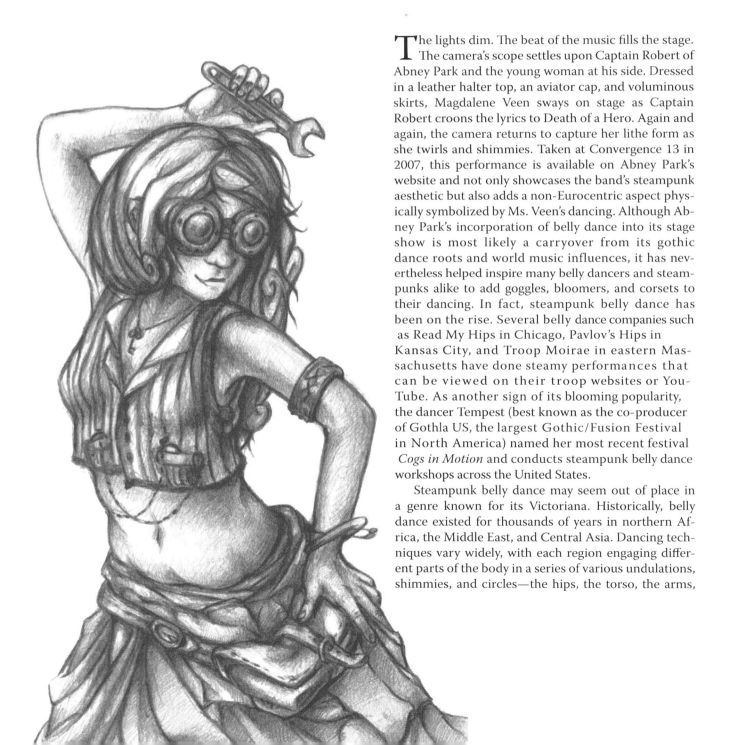

The lights dim. The beat of the music fills the stage. The camera's scope settles upon Captain Robert of Abney Park and the young woman at his side. Dressed in a leather halter top, an aviator cap, and voluminous skirts, Magdalene Veen sways on stage as Captain Robert croons the lyrics to Death of a Hero. Again and again, the camera returns to capture her lithe form as she twirls and shimmies. Taken at Convergence 13 in 2007, this performance is available on Abney Park's website and not only showcases the band's steampunk aesthetic but also adds a non-Eurocentric aspect physically symbolized by Ms. Veen's dancing. Although Abney Park's incorporation of belly dance into its stage show is most likely a carryover from its gothic dance roots and world music influences, it has nevertheless helped inspire many belly dancers and steampunks alike to add goggles, bloomers, and corsets to their dancing. In fact, steampunk belly dance has been on the rise. Several belly dance companies such as Read My Hips in Chicago, Pavlov's Hips in Kansas City, and Troop Moirae in eastern Massachusetts have done steamy performances that can be viewed on their troop websites or YouTube. As another sign of its blooming popularity, the dancer Tempest (best known as the co-producer of Gothla US, the largest Gothic/Fusion Festival in North America) named her most recent festival *Cogs in Motion* and conducts steampunk belly dance workshops across the United States.

Steampunk belly dance may seem out of place in a genre known for its Victoriana. Historically, belly dance existed for thousands of years in northern Africa, the Middle East, and Central Asia. Dancing techniques vary widely, with each region engaging different parts of the body in a series of various undulations, shimmies, and circles—the hips, the torso, the arms,

and even through certain facial expressions and hand gestures. However, ever since European explorers made their way eastward, accounts of belly dance have been recorded in their travelogues. With the rise of Western imperialism in the nineteenth century, many travelers from Europe and America added belly dance to their Far East itineraries: The most famous account is French author Gustave Flaubert's series of letters about his intimate encounters with Egyptian dancer Kuchuk Hanem (and just one of many cases of Western associations between sex, prostitution, and the Eastern woman).

Additionally, Middle Eastern dance was showcased at many world's fairs throughout the late nineteenth century, but the dance form achieved popular recognition in the West at Chicago's Columbian World's Exposition in 1893. According to Anthony Shay and Barbara Sellers-Young, authors of *Belly Dance: Orientalism, Transnationalism, and Harem Fantasy,* Sol Bloom, manager of the Midway Plaisance, promoted his Egyptian dancers' performances as "belly dance" in order to attract audiences. Academic professor Zeynep Çelik spoke about how the press couldn't get enough of the "new obsession" at the World's Exposition. Thousands flocked to see the performers, and newspapers cheekily remarked how "the soiled devotees of Constantinople and Cairo corrupted Western morals by the seductive allurements of the danse-du-ventre". Thus, ever since its first forays into Western cultural consciousness, belly dance has been (and remains) associated with hyper-sexualized Orientalist imagery. Its resurgence as a popular dance form today has triggered concern within the Muslim community about popular misconceptions of Middle Eastern culture. As frequent contributor Fatemeh writes on the blog Muslimah Media Watch, "I take offense at the presentation of Middle Eastern 'culture' through things like transparent veils, coin necklaces, and henna tattoos because reducing the Middle Eastern experience to some jingly coins and a scimitar takes the humanity right out of us."

So the position of belly dance within steampunk art is a polemical one. Dancers have interpreted steampunk as a current fad, a fashion aesthetic, and a form of neo-Victorian inspiration. Yet the intersection of steampunk and belly dance raises the concern about whether steampunk sanctions romanticized Orientalism. Not only that, but the questions over co-opting come into play. Co-opting in general is defined as the use of something from a particular culture by members outside that culture. This "use" isn't inherently bad, but can cross the line of cultural respect between the users and the originators. By applying a Westernized aesthetic to a dance form that has non-Western origins, does appreciation for the cultural roots of the dance get lost in its Europeanized glamour? Does the participation of and emphasis upon Eurocentric, Western dancers in the community overshadow the historically marginalized dancers who originated it? With steampunk, is the West "stealing" belly dance from its native culture? These questions aren't the easiest to answer, but one way to investigate them is by looking at how belly dancers interpret and use steampunk in their art and how modern belly dance itself became established as an art form.

How Belly Dance is Steampunk'd

For this article, I interviewed several belly dancers who have used steampunk as a source of inspiration. All of them identify as dancers first and foremost before steampunk, and many have practiced and performed for several years. Each dancer has his or her specific favorites when using steampunk costuming and props. Many were used to making their own outfits for belly dance, so DIY-ing their steampunk-ware was no challenge. Amidst traditional belly dance items (like fans and veils) the dancers have also constructed their own corsets, mini top hats, bloomers and bustles. Personal styles range across various time periods as well. Several enjoy incorporating parasols and typical Victoriana items, but they also confess to mixing steampunk with other fashion influences, such as the Prohibition-era and dieselpunk. Other muses varied from saloon girls, grease monkeys, and Bollywood to the Middle Eastern film vamp Theda Bara, early modern dancer Ruth St. Denis, and Mata Hari. Similarly, a wide variety of performance music was listed: Abney Park, Dr. Steele, Vernian Process, and Rasputina were the most common steampunk staples, but others referred to more era-related music played by accordions and stringed instruments. There were even left-field preferences like Akasha Afsana's suggestion that "a lot of synth-pop 80s music works well for this genre too". Indeed, steampunk belly dancers are no different from any other steampunk enthusiast in their embrace of the eclectic.

When combining steampunk and belly dance, none of my interviewees expressed much interest in imitating the nineteenth-century style of their inspiration—the historically accurate layers of pantaloons, vests, head coverings, scarves, belts, and coin necklaces. If anything, steampunk belly dancers actively co-opt the props of Victoriana in performances which create an image of the Victorian Other, much in a way that traditional props of belly dance in the West had been used to emphasize the image of the Oriental Other. Interestingly enough, several dancers—all self-identified as white men and women—spoke about steampunk costumes and props in ways that value the foreign yet avant-guard quality of using Western imagery in an Oriental dance. Most telling is Andromacke's remark: "I think they're both exotic and they both come from a similar time period."

The classification of both steampunk and belly dance as "exotic" contributes to the interpretation that belly dancers' use of steampunk "exoticizes" Western culture and history. The perceived exoticism is what dancers find so inspirational; when asked why steampunk and belly dance seem to go so well together, many responses emphasize the creative potential of drawing from history and literature. For instance according to Salomé, a dancer from San Diego, "Steampunk is ideal for the creativity that a gifted dancer can bring to her costuming and performance."

Furthermore, the dancers consider their work to be an enactment of a fantasy world, not a reflection of reality. That is not to belittle the seriousness with which they practice their craft; in fact, many are very specific in their artistic approaches to steampunk belly dance. Movements drawn from various belly dancing schools and other dance styles

like cabaret and flamenco are incorporated and modified to form character-driven choreography. Tempest, for example, has arranged performances from aggressive, stomping sky pirates, to gothic-tinged Lovecraft-inspired solos. "As long as that history is kept in mind while developing the story and character of the dance, I think it makes for a great pairing," she explained. "The key thing though is to really take the music and movements into consideration—far too many people do 'gratuitous gears' which is [when] they think adding a few keys and cogs to a costume will make it steampunk—steampunk isn't just a look, you have to consider how the music and character would affect the dance and bring that influence wholly to the piece." Performance, then, is key: Steampunk belly dance isn't all about being pretty or dancing provocatively, but acting out a persona on stage.

The Transnationality of Belly Dance

Thus, when creating steampunk belly dance, the focus lies in subversive reinterpretation as opposed to reenactment. But is this attitude typical of the belly dance community or for these steampunks in particular? Interestingly enough, all of my interviewees identified as being from the United States. Initially, this fact appeared only incidental: I had asked for interview volunteers widely, expecting a diverse response. Further research, however, revealed a correlation between the general attitude my interviewees had toward belly dance and steampunk, and how the dance developed in the United States. Therefore, in order to understand the context in which these dancers interpret their art, we must also consider the development of belly dance in American culture as an organized dance form.

After its Western introduction during the Columbian World's Exposition, belly dance transferred from Chicago to Coney Island, becoming a cabaret highlight and appealing to America's working and middle classes. These belly dancers were usually white performers with Middle Eastern-sounding stage names who dressed in two-piece costumes popularized by Streets of Cairo dancer Little Egypt (who, mostly likely was not Egyptian at all, but a traveling American stage performer) and modern dancer Ruth St. Denis. Belly dance imagery also captured the imaginations of high culture, with a series of Orientalist ballets such as *Scheherazade* that inspired later Hollywood interpretations, including Theda Bara in film and Broadway shows like *Kismet*. Moreover, characteristics of cabaret became fused with belly dance: for instance, the formation of line dancing or wearing high heels. The use of comedic routine, wit repartee with the audience, and singing were also qualities of cabaret that were added to belly dance.

During the first feminist wave in the 1960s, women sought to reclaim their bodies from a history of male domination. At the same time, the Arab-American community was establishing a cultural space where Middle Eastern immigrants and non-Middle Easterners would end up: Ethnic restaurants. At these restaurants, non-Middle Easterners were able to participate in group and solo Middle Eastern dances led by male and female dance entertainers. Eventually, young women, looking for an outlet to express their sexual liberation, approached dancers about lessons. Jamila Salimpour was one of those dancers. Later on, she would take the techniques she learned from her fellow Arab-American friends and the moves her father learned as a young Navyman stationed in the Middle East, and fuse them with the adapted Middle Eastern culture gleaned from Hollywood and Egyptian films. Together, these influences came to establish a teachable style of belly dance. Author Danielle Gioseffi became one of the first feminists who advocated belly dance as a form of artistic expression, which celebrated the power of female sexuality. Gioseffi wrote the romanticized history of belly dance *Earth Dancing*, and toured college campuses with her message. Carolena Neroccio and John Compton are two other dancers who, inspired by Salimpour, created their own belly dance companies. Together, all three instructors are credited with developing what is now generally classified as American Tribal Dance.

My interviewees either practiced a form of American Tribal or identified as having an American interpretation of belly dance taught by dance instructors like Jamila's daughter Suhaila Salimpour. Thus, considering this history, there is a disconnection between the dancer's mindset and the outside viewer's perspective. Sellers-Young argues that belly dancers—and Tribal dancers in particular—do not see what they do as disrespectful toward Middle Eastern culture because belly dance itself has evolved into a separate tradition endowed with its own significant meaning. Sellers-Young explained this tradition best:

> "The women performing it are not attempting to allay an internalized version of the oriental *femme fatale*. They are instead creating an alternative image in which the erotic power of a woman exists with her communion with other women on stage as performers and off stage in the emotional support they provide for each other."

Belly dance subculture in America is seen by its participants as distant—if not divorced—from its cultural roots. Sadly, the cultural meaning of belly dance in the Middle East has changed as a result of the sexual Orientalist connotations it acquired during Western European colonialism. Although belly dance is still practiced culturally, its public performance has become associated with prostitution and men and women are discouraged from dancing professionally. There are exceptions to this rule, such as the most well-known Egyptian performers Fifi Abdou and Raqia Hassam, who is also the head organizer behind the international belly dance festival Ahalan Wa Sahalan. Contrastingly (and ironically), belly dance has grown in the West to become a respected art form. As Suhaila Salimpour emotionally acknowledges in a video on her website: "My Persian family doesn't speak to me because I became a belly dancer ... Here is the best part of this country—we don't connect belly dancing to the culture of the Middle East".

Admittedly, Orientalist Western media shaped the evolution of modern belly dance: Sellers-Young summarizes that "American Tribal and other forms of *raqs sharqi* [belly

dance] are a commodity fetish that is both a site of Orientalist fantasy and a site of self-agency for the self-realization in which the media has played a significant role in its creation and evolution". Thus, the interplay between the oppressive fantasy and its empowering consequence has been a zone of contention in discussions concerning belly dance, Orientalism, and cultural appropriation. As belly dance continues to be identified as a solely "Middle Eastern" dance and as long as that dance and its participants are placed within an Orientalist framework in Western eyes, this debate will continue.

The steampunk belly dancers I interviewed do not aim for cultural or historical verisimilitude in their performance. Instead, they concern themselves with fostering that "alternative image". "I think that fantasy aspect is a giant contributor to [the appeal of steampunk in belly dance]," M'chelle commented, "especially with Tribal Fusion. Steampunk is a sort of 'turned on its head' version of history, and there's a huge aspect in belly dance that's very similar—no written history so a lot of it's assumed and made up". This may also explain why many dancers embrace the fantasy element offered by steampunk while also choosing to interpret that fantasy as Victoriana-based—an interesting reversal of how Victorians interpreted the Orient.

The use of belly dance to express steampunk subversion, however, should not be confused with disrespectful co-opting of non-Western cultures to emphasize Western aesthetics. First of all, as previously stated, the use of Victoriana in belly dance does not promote the message of Western superiority over an Eastern art form but, instead, subverts that superiority by exoticizing it. Moreover, a common belief among belly dancers is that steampunk in belly dance is a welcome form of cultural incorporation—an attitude that's based in modern belly dance tradition. Today, belly dance is a globalized art form where people draw from various identities and inspirations in order to create. Thus, when asked for their opinions about cultural appropriation in belly dance, some interpreted this term positively. Akasha addressed the question in terms of fusion dance: "As fusion dancers, we're always looking for new inspirations to keep the dance fresh and exciting". Dizzy's response had been especially insightful, which encompasses both the progressive "punk" attitude associated with steampunk as well as her own feelings as a Cajun woman:

> "I am from New Orleans, Louisiana, I'm a Cajun, and have adapted things into my costuming from my own culture, as well as symbolism from the voodoo religion and culture which I hold very dear. This being said I also adopt Middle Eastern ideas like harquis into my costuming as well. I have worn bindi dots, Afghani jewelry and turbans. The key I think is to borrow with respect. For me, it is important to take and blend all these influences together to create something new—that is, a mix of lots of different ideas and places to create something that is unique, and yet respectful to the meanings behind the cultural symbols you are adapting. You do this through sincerity and educating yourself about the cultures. This combination of curiosity and respect cause us to really try and understand the people who share our very small world with us, and go a long way towards healing rifts between people."

This isn't to say that all dancers share this same attitude toward the complicated historical and cultural background behind their art. What modern belly dance and steampunk have in common, then, is their status as permissible areas for the creation of new histories. As Kansas City-based dancer M'chelle pointed out, both steampunk and belly dance are at least in part the product of invented histories. Despite (or, perhaps, because of) this belief that the histories of both are piecemeal and open to individual interpretation, this unique combination of Western aesthetic and Eastern form has had a definitive impact upon this ever-expanding subculture, one that will not be going away anytime soon.

Works Cited

- Donna Carlton – *Looking for Little Egypt*

- Zeynep Çelik – 'Speaking Back to Orientalist Discourse At the World's Columbian Exposition' in *Noble Dreams, Wicked Pleasures: Orientalism in America, 1870-1930*

- Fatemeh – 'The Belly of the Beast: Belly Dancing as a New Form of Orientalism' on the *Muslimah Media Watch* website

- Anthony Shay and Barbara Sellers-Young – *Belly Dance: Orientalism, Transnationalism, and Harem Fantasy*

- Stavros Stavrou Karayanni – 'Dismissal Veiling Desire: Kuchuk Hanem and Imperial Masculinity' in *Dancing Fear and Desire: Race, Sexuality, and Imperial politics in Middle Eastern Dance*

- Sahaila Salimpour – 'The Legacy' on the *Sohaila International* website

- Barbara Sellers-Young – 'Body, Image, and Identity: American Tribal Belly Dance' in *Belly Dance: Orientalism, Transnationalism, and Harem Fantasy*

Author's Note

I'd like to thank the following belly dancers for the helpful insight and information they provided for this article: Akasha Afsana, Andromacke, Dizzy, General Malcolm Kane, M'chelle, Tempest, and Salomé of San Diego. Their profiles can be found in the tie-in post to this article written for my blog series "Beyond Victoriana" at: http://dmp.dreamwidth.org/tag/%20beyond+victoriana%20

THE BRADY BUNCH OF CALCUTTA 1910
An interview with Sunday Driver

illustration by Lisa Grabenstetter

The seven piece, sitar-wielding spectacular that is London-and-Cambridge-based Sunday Driver, arrived on the UK steampunk scene when they played at the Asylum in Lincoln last year. The next day (while we were all a little worse for wear at the SteamPunk Magazine stall) someone put their album, In the City of Dreadful Night, *on in the trading hall. From that moment onwards it was inevitable: steampunks had taken to these people, and we were not about to let them go.*

The strangest thing about all of this is that they seem to be quite happy about that. But that's just Sunday Driver for you: As well as creating music that sounds like a musical production set in Calcutta under the Raj, they also happen to be some of the nicest people that we know.

A little while ago, we managed to catch up with Chandy (vocals), Joel (guitar/sitar) and Kat (clarinet/spoons et al) for a chat about their unique take on steampunk, music hall and prejudice.

SPM: *Sunday Driver, just why are you called Sunday Driver?*

Joel: I'll let Kat explain that one—however I will say this, before we were Sunday Driver we were called Incensed! That's rubbish ... especially if you say it quickly, it sounds like something very wrong!

Kat: We're named after a gene found in fruit flies. When we started the band I was working in a lab. Just before we went into the studio to record our first songs, I was talking to a colleague who told me about the gene and I thought it was be a good name for the band.

SPM: *Your album,* In the City of Dreadful Night, *has Indian influences and a dream-like feeling which occasionally seems to have come straight out of a West End musical. Was it a conscious decision to cover such a broad range of musical styles?*

Joel: I think Chandy should explain our West End influences. The breadth of styles from the boys on strings (Me, Melon and Chemise) goes back to the late 90s—think Seattle, RATM, Blind Melon, Down, Pantera—it never left us. Melon is a huge Tool fan, I just bought tickets today to go and see Alice in Chains. Chemise was into Frank Zappa when I was just discovering Indian music in 2003. And I love classical sitar music, there's something so ... METAL about it. It's all those drones in D!

Kat: We have such diverse influences. I love modern and early 20th century classical music—Reich, Glass, Debussy, Ravel—as well as bebop jazz, electronica and hip-hop. I like to think that helps to tone down the boys a bit.

Chandy: The "West End" style is a lot to do with my musical background. I was raised on a diet largely consisting of sanskrit prayers and West End musicals (does Charlie and the Chocolate Factory count as West End?), all of which surface in our music at some point or another.

SPM: *Speaking of the West End, do you think the steampunk scene is developing a certain theatricality? Do you think it had one already?*

Joel: Definitely. I would use the word melodrama. Bands like Trousseaux and ourselves have that in bounds, even though their sound and melodies are totally different to us.

Kat: I love the theatre of it—some of us in the band are certainly drama queens anyway! We put on a big Victoriana gig in Cambridge last year with a performance poet, burlesque, comedy and music—everyone dressed up and we decorated the stage with grandfather clocks and rat traps. It's a step up from your average grimy pub gig.

Chandy: I think that theatricality is an intrinsic part of the steampunk scene. Perhaps it's to do with the fact that it draws on caricatures and is so reminiscent of the whole "music hall" era—that's why I love it !

SPM: *As pretty much the only multicultural band in steampunk, why do you think that so few people from different ethnic backgrounds are involved in steampunk at the moment?*

Chandy: Controversially I would say it is because people from different ethnic backgrounds often have to pigeon-hole themselves as world music/fusion or some other well-known niche to get established. They cant afford to take the risk of getting involved in scenes they haven't traditionally been visible in. This is all drawn from personal experience though—I don't know how many times people said to me: "Your voice is great so why aren't you doing more 'ethnic' stuff" when I first started song writing.

SPM: *Steampunk borrows the best bits from the past, and increasingly it is also beginning to borrow from other cultures as well. Do you think that borrowing means that we are in danger of the same sort of ignorance and cultural imperialism as Victoria's 'Great' British Empire?*

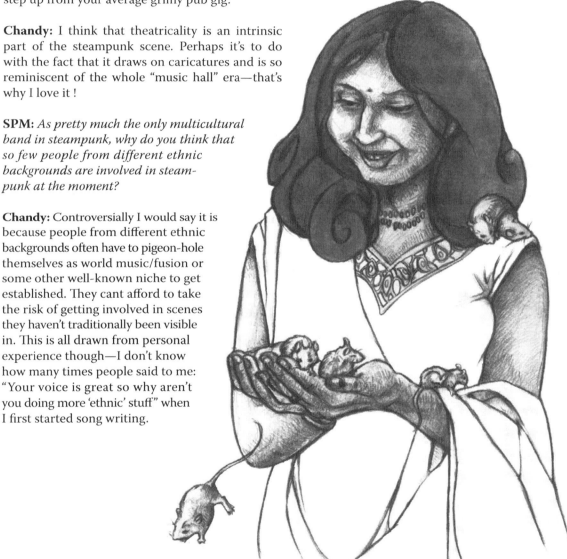

Chandy: Not at all! Cultures have always borrowed from each other and that's what enriches them. However, sometimes I worry that by borrowing snippets of other cultures, we are in danger of thinking we understand them in their entirety, when really all we have is a snapshot.

Joel: I'll say this: The melting pot of culture in Britain is its best point, bar none. That's why Sunday Driver exists.

SPM: *How do you think steampunk reconciles itself with the oppression and colonialism of the Victorian era? Do you think it reconciles itself at all?*

Kat: I don't think that it needs to. To me, it's an aesthetic. It draws on stylistic influences and the spirit of adventure. It feels very inclusive and accepting as a movement.

Chandy: I am not sure if steampunk really addresses such complex issues yet, but I hope it will in future. It's very tongue in cheek, and I think the best way it can confront these issues is to make a mockery of them. It's something that I am looking forward to being a part of.

SPM: *You're self-confessed newcomers to the steampunk scene, how did you discover it and what about it attracted you?*

Joel: I think we stumbled into it, but then again we were already doing it! Basically we wanted something that blended London and the Raj. Matthew (the tabla player who performed on the album) has a grandmother in Calcutta. At one time we were thinking of going to her house and recording on her roof! She lives at Bakul Bagan Road, a name we've borrowed for a few things. Matthew's a very well read man and he presented us with JJ Thompson's poem *The City of Dreadful Night*. It's an image of London in 1870.

It opens not too brightly:

"O melancholy Brothers, dark, dark, dark!"

Kipling wrote a short story by the same name about Calcutta:

> "So, at ten o'clock of the night, I set my walking-stick on end in the middle of the garden, and waited to see how it would fall. It pointed directly down the moon-lit road that leads to the City of Dreadful Night."

When we read those two pieces, the imagery and beauty wrapped around that dark centre besotted us. I know we're not exactly Joy Division or Korn, but there is something dark and malignant sitting at the root of a lot of Chandy's songs, even though they are wrapped up in beautiful melodies and bouncy rhythms. 'Black Spider' is a good example: listen hard and think of prejudice in its many ugly forms in all walks of society. That Black Spider has to be stamped out.

One day we found ourselves having a photo shoot at Cambridge's industrial museum dressed up like we were the *Brady Bunch* of Calcutta 1910! We were Victorians in 2009, and we were only a hop skip and jump from steampunk.

After a gig in Brighton for Refugee Radio we realised we were street urchins without a home. We needed the steampunk community, and hopefully they need us! We love the people, the flair, the fun, the history, the depth, the creativity—and the corsets!

Kat: It's fantastic to stumble upon a whole bunch of people who really understand our influences and what we're trying to do. For a long time we felt at odds with the music scene: We would turn up to gigs all dressed up, with sugar mice, cupcakes and these strange, melodramatic songs, but we didn't really fit alongside the usual indie rock bands or singer/songwriter groups. And I do love wearing corsets!

SPM: *Will steampunk influence the sort of music that you make now that you've discovered it?*

Joel: Hard to say. I think creativity is a result of your surroundings, so I guess it will, but it won't consciously dictate our directions.

Kat: I recently started writing a song about a spaceship made of brass, but it needs some work!

SPM: *Finally, if you were all involved in a mortal-combat-style deathmatch, which one of you would be the one left standing at the end?*

Joel: Chemise—he's silent but violent. He'd do a fatality with his right eyebrow.

Kat: Yeah, it's the quiet ones you've got to watch.

You can listen to Sunday Driver on their MySpace page: WWW.MYSPACE.COM/SUNDAYDRIVERINUK *and also via their website:* WWW.SUNDAYDRIVER.CO.UK *where you can pick up a copy of their album.*

All Fashions of Loveliness
WOMEN IN VICTORIAN PENNY DREADFULS

by Allie Kerr
illustration by Ms. Scary Boots

Stay away from them: They'll turn you to crime; they'll wreck your virtue; they'll make you steal horses from the livery stables and go riding through the streets at midnight.

Introduction: The Penny Dreadfuls

In the late 1800s, London literary critics raged against an unlikely foe. The culprit was a new form of popular entertainment, steeped in "sentimentality and sensational supernaturalism": The Penny Dreadfuls. Brewed from a blend of Gothic novels, true crime chapbooks and the pirated works of Dickens, the dreadfuls were printed on thin, cheap paper, and sold weekly in installments of eight to ten pages. At a penny an issue, the dreadfuls were among the first reading materials accessible to a working class audience. They were an immediate success: Dickens' bestselling *Pickwick Papers* sold about 40,000 copies a week; the same year, publisher Edward Lloyd sold over 100,000 penny dreadfuls a week.

The dreadfuls have been neglected by historians because few have survived in their entirety. They were printed to be disposable, and issues were literally read to pieces. Historian E. F. Bleiler says:

> "[Dreadfuls] were hawked by newsboys, sold by vendors, shipped by train to the factory towns, smuggled home by boys, read by candlelight by workers, who sometimes had one person read aloud to them while they worked … and then thrown away."

Of the hundreds of penny dreadfuls published in the late 1800s, only a few stories still exist in their entirety. Some of the most popular dreadfuls have been reprinted, including *Varney the Vampyre* and *Sweeney Todd, the Demon Barber of Fleet Street*.

In spite of, or perhaps because of their popularity, they became targets for moralists, who claimed that the genre's sensationalism put the wrong ideas into the heads of London's youth. This sensationalism is what makes them so invaluable as historical sources. As an early form of popular literature, they offer an on-the-ground perspective on Victorian gender roles and sexuality. Two dreadfuls in particular offer volumes on these subjects: *Varney the Vampyre* and *Wagner the Wehr-Wolf*

Varney the Vampyre

Easily the most popular of the penny dreadfuls, *Varney the Vampyre* was first published in 1845. It runs a full 237 chapters in length, for a total of 868 closely-printed, exhausting-worded pages. In fine penny dreadful form, the text is long-winded, rambling, and often contradicts itself. Occasionally, the story loses whole characters, who walk out of climactic scenes, never to return.

Women in *Varney* are depicted as well-intentioned, delicate and beautiful. They are also irrational and generally dependent upon male support and protection: The ultimate Damsels in Distress. In an interview with another male character, Varney refers to women as "that fairer half of … creation which we love for their very foibles." At one point, when Flora attempts to argue with her fiancé, she declares: "I have not power of language, aptitude of illustration, nor depth of thought to hold a mental contention with you." Men are described by their clothing and their bearing, particularly as it denotes their class or profession;

women are described according to their emotional state, their beauty, or their sexuality. Floral comparisons are particularly popular: after Varney's first attack on Flora, her fiancé notes that her beauty has changed—"the flower that to his mind was fairer than them all, was blighted, and in the wan cheek of her whom he loved, he sighed to see the lily usurping the place of the radiant rose." Women, like these flowers, are part of the scenery in *Varney*.

In crisis situations, the men of *Varney* respond with trepidation, but remain in control of their faculties; women descend into swoons, a panic, or madness. During the opening of the first chapter, Varney attacks Flora Bannerworth and then leaps out the window. Four women appear on the scene, and each responds to the vampire's attack upon Flora with hysteria. Flora is petrified with fear, but only after giving a small speech about her horror does she think to call for help, and by this point, she is too terrified to do so effectively: "That one shriek is all she can utter—with hands clasped, a face of marble, a heart beating so wildly in her bosom, that each moment it seems as if it would break its confines, eyes distended and fixed upon the window, she waits, froze with horror."

Sexuality in *Varney* is a fearsome, violent force, and Varney's predations carry now-familiar sexual overtones, particularly the opening scene of the dreadful, which resembles a rape. However, the focus of the scene is not the attack itself, but the fear of becoming a "ruined woman." Later in the story, a character expresses concerns that Flora's "condition" will make her an undesirable match:

> "The family [your nephew] wishes to marry into is named Bannerworth, and the young lady's name is Flora Bannerworth. When, however, I inform you that a *vampyre* [sic] is in that family, and that if he marries into it, he marries a vampyre, and will have vampyres for children, I trust I have said enough to warn you upon the subject."

This warning, particularly the part about vampire children, carries racial allusions as well. The letter writer is concerned that Flora is no longer marriageable, not only because she is "ruined," but also because she has associated with an undesirable group.

Flora's distress escalates over the course of the first few chapters, until she begins expressing a fear that she will go mad. At several points in the story, Flora lapses into a trance in which she loses all touch with reality: Not only do the women of *Varney* fragment under pressure, their sexual purity is directly tied to their sanity and self-identity.

Wagner the Wehr-Wolf

In *Wagner the Wehr-Wolf*, George William MacArthur Reynolds introduces the role of the Femme Fatale to the genre. Reynolds used eroticism and exoticism to maintain a fantastical narrative environment. The story of *Wagner* is set in 1520, in the style of a "costume opera": what we would now identify as historical fiction.

Women in *Wagner* may be either active or passive, but their roles are limited regardless. Femme Fatale characters are socially dominant, outspoken, capable in verbal or physical conflict, and generally in control of their own affairs. They are always antagonists: Dangerously fanatical, usually seductive, and murderous. Nisida, Wagner's lover, is an epitomal Femme Fatale. She is obsessively devoted to Wagner, but in her jealousy she imagines rivals for her lover's affection (including Wagner's granddaughter Agnes, whom she kills). Nisida spends the better part of the story pretending to be "deaf and dumb," a role she constructs to exact pity from men she wishes to control. Nisida also uses her sexuality as a tool on several occasions, to visit Wagner in prison, and to secure revenge upon others.

Women who play passive roles, such as Agnes, are dependent upon male assistance in crisis situations, and are portrayed as "good", if ineffective characters. These Damsels in Distress are in constant danger and active, evil female characters

will often attempt to take advantage of the passive, pure women. Passive women may take a temporarily active role, if motivated by piety or by love. They invariably triumph at the end of the story, usually with the last-minute assistance of a male lover or relative. In *Varney*, the Damsel in Distress is pure but helpless; in *Wagner*, the Femme Fatale is powerful, but tainted with evil.

Social Responses

While these roles seem limited to a modern reader, in the mid 1800s they broke new ground. Wealthy publishers and concerned literary critics spearheaded the moral outcry against the dreadfuls. Edward Salmon, usually a strong proponent of women's education, was concerned by the impact of penny literature on working class girls. In *Juvenile Literature As It Is*, Salmon's choice of phrasing is particularly telling:

> "If we were to trace the matter to its source, we should probably find that high-flown conceits and pretensions of the poorer girls of the period, their dislike of manual work and love of freedom, spring largely from notions imbibed in the course of a perusal of their penny fictions … indeed, there is hardly a magazine read by working-class girls which it would not be a moral benefit to have swept off the face of the earth."

The "dislike of manual work and love of freedom" that Salmon feared may have been in part a product of the gender roles portrayed in the dreadfuls. In *Youth, Popular Culture and Moral Panics: Penny Gaffs to Gangsta Rap, 1830-1996*, historian John Springhall notes that the gender roles occupied by young women in the dreadfuls were more lenient than those depicted in conventional literature:

> "Women in 'penny dreadfuls' were, none the less, allowed a more independent, even aggressive, role than could be occupied by the polite middle-class heroines of most adult three-decker novels."

Springhall calls the heroine type of the dreadfuls a "virago." As it was used during the Victorian period, virago could mean either "a man-like, vigorous, and heroic woman; a female warrior; an amazon," or a "bold, impudent (or wicked) woman; a termagant, a scold." While there is a clear link between agency and wickedness in these female characters, the Femme Fatales and Damsels in Distress of the dreadfuls were free to act out in ways their highbrow counterparts could not. Furthermore, the female characters in the dreadfuls lampooned depictions of women in higher literature and mocked traditional Victorian gender roles. The wild success of the dreadfuls indicates that their readers found such satire satisfying entertainment. The critical response of the upper middle class to the dreadfuls may have been anger—not at the poor literary quality or immoral themes they represented—but at the truth concealed in their grotesque caricatures of real Victorian social mores. ✽

Author's Note

This article is drawn from excerpts of a broader thesis, which may be found in its unabridged form in the digital archives of the Lewis & Clark College Library.

Liberty

by C. Allegra Hawksmoor
illustration by Sam Haney

These papers were first published in the *The Liberty Journal of Chandisha Chattopadhyay*, 1800.

Letter to Caroline Herschel, 30th November 1799
'Lina,

Doubtless by now someone—perhaps even our mutual friend at the Royal Society—has informd you of my arrest along with that of Mr Darvell. For now, he and I are accommodated together at the Borough Compter, although I fear that it will not be long before we are separated, or else transferr'd to Newgate.

I may not have long, and this letter must be sent in haste. It will likely only be through the kindness of our friend Sir J. that this letter reaches you at all. I urge you to convince him of our cause: He may be the only hope that we have of escaping this disaster before it goes too far!

The King holds you and your brother in high regard, and if the three of you were to speak to him, then I am certain that you may convince him of the futility of funding this second venture to the moon.

You yourself have seen what good the B.E.I. Co. has done to Mysore and Bengal. England must not repeat her mistakes. She must let the Selenites alone! Sir J. will help you, I am sure of it. He still feels keenly enough the situation of his making in the South Pacific, and if you are willing to incite him with that then he will be easily convinc'd.

I was able to bring little with me at the time of my arrest. But a few fragments of my lunar journal, and the three-foot telescope that Ozias has convinced our captors to allow us. He has set it up beneath the window, and in the last two nights he has only desistd from staring up at the moon for long enough to complain about the haste with which she moves across the narrow window through which we are afford'd a view of the sky. I can only guess that he is searching for some trace of *she* that he has left behind—as surely as you must have search'd for me during my long weeks of absence. Perhaps he has just gone out of his mind.

You must now think only of convincing your brother and Sir J. to assist you in preventing this madness from going any further.

I have included what disorder'd scraps I was able to salvage from my journals, and also a letter that I addressd to you three days ago. Perhaps Ozias was hoping to dissuade me, because he did not send it.

I hope that these fragments help, if only a very little. If nothing else, then it should make sense of all of this for you, beloved.

Do not delay. Not when we have so very much at stake.
Yours forever,
Eesha

From Journals, 13th April 1799

Sir Joseph Banks has ask'd that I begin to keep a journal, now that my passage upon the *Liberty* has been agreed. It is his insistence that Mr Davell and I are both to document our findings down to the finest of details, so that this first historic voyage to the moon (I could not help but notice that he failed to mention the fates of Mr Blanchard and Mrs Sage) may be shared with the wider public.

This morning, Sir Joseph request'd my presence for breakfast at his residence in Soho Square. On my arrival, I found that Mr Ozias Darvell—whom has financed and overseen the construction of the *Liberty*, and upon whom my passage on her was dependant—had been there for some time, as he was already deep into discussions with Sir Joseph.

Both regard'd me with the peculiar sort of fascination that I have become accustomed to in the short time since we arrived here from Madras, although Sir Joseph at least had the common decency to pretend otherwise.

He is far from what I imagind he would be from your fervid descriptions of him, 'Lina. I cannot help but wonder if age and illness have bested him in the years that you have been away. Now, he appears to be confin'd almost entirely to a wheel-chair, overweight and swollen with whatever sickness that has put him there. Still, there is some of the fire you have spoken of behind his eyes. True to your word, I found him to be more polite and kind than any man that I have yet met in England.

Mr Darvell is young (I should even say *too* young), able, dark-haired, and crackling with energy in the peculiar way that appears to be fashionable here. He began our conversation by referring to me with that vile moniker "The Calcutta Tigress" that was award'd me by the officers of the British East India Company. He seem'd unimpressed to learn that we had travell'd from the Madras Observatory aboard one of Meusnier's dirigibles. He then proceed'd to inform me that the *Liberty* is quite a different beast from any simple hydrogen balloon ship, and that I should have to learn again how to navigate the skies.

However, he did at least agree to my accompanying him so that I may take the astronomical observations which you and William require, and in which Mr Darvell has predictably little interest.

For now, I shall have to take some comfort from that fact.

From Journals, 10th July 1799

It is now but two days before Mr Darvell and I are to be borne aloft by *Liberty* to risk our fate upon the Heavens. Over the past weeks I have found myself increasingly anxious to be at it and have done with it, so that I may know if we are to live, or die in the attempt. My anxiety has led to my often wondering what I am doing here with you, 'Lina—about to embark upon the British Empire's first ascent up to the moon. I often feel as though I should still be in the hills and lakes of Mysore, risking my life to a different sort of fate.

They say that Tipu Sultan is dead, did you know that? Kill'd by the those dogs of the East India. I cannot help but feel the burden of not having died beside him. I am not un-

grateful for your taking me out of India. You doubtless sav'd my life in doing so, but still…

I tell myself that now at least I may continue to fight for freedom for Mysore and Bengal, when I would do them little good were I dead with Tipu Sultan.

Tonight, these thoughts would not leave me alone, which is why I left you sleeping, 'Lina, and walked along the Thames. I had intend'd to find some solace in Nature, but there is so little that is natural left within this city. And so I came to the Strand, where the Lyceum is selling three-shilling tickets to see the *Liberty* before her launch.

Even so late into the evening there was quite a crowd about the theatre, although I was able to avoid them and get inside before being intercepted.

I saw the *Liberty* for the first time as I secret'd myself along the Grand Circle above the crowd. Or rather I saw the balloon itself, since the *Liberty*'s gallery had prov'd too large to fit into the Lyceum, much to Mr Darvell's disappointment. Yet, even the envelope alone is spectacular—drap'd from stage to ceiling in the candlelight. I stood for quite some time in silent awe at this mass of silk and rubber that will, by the good grace of Parvati, bear us to the moon.

After perhaps an hour I was interrupted by Mr Darvell, who had happen'd upon me in my airial hiding place.

He told me that he had heard about my unpatriotic (although he did not use the word) exploits in Mysore, and ventur'd that he did not know what business a Hindu woman would have in fighting for a Muslim king. To begin with, I assumed that he was ignorant, and did not know that the division between Hindus and Muslims only exists because it has been driven there by the East India Companies so that they may better fight us both. However, as it transpires, his concerns were of a different nature.

When he was a child, his father went missing in Persia while en route to an expedition into the African interior. The moment that he reach'd adulthood, Mr Davell himself spent much time out there in search of him and now counts himself a Sufi. It would seem that his concern was that I may persecute him for it.

I will admit that over the passage of the last few weeks I have heard much more about his exploits of a different sort—particularly those which involvd his experiments with Mr Davy's nitrous *gaz*, and the many rumours about how exactly the son of a Wiltshire surgeon manages to find the funds to build the *Liberty*. Once I assur'd him that he need not view me as some sort of natural enemy to him on account of his religion or his nationality (which doubtless all the rumours of the Calcutta Tigress did little to assuage), he became far more animated with me.

I believe that we must have spoken for a full hour on the design and functioning of the *Liberty*.

He has constructed her after the kind developd by Monsieur Pilâtre de Rozier (under whom Mr Davell has studied), and is of the same sort which de Rozier used to cross the channel some several years hence.

As such, the *Liberty* combines both the control of the Montgolfier brothers' hot air balloons (in the lower, cylindrical section of the envelope), as well as the superior lifting power of the Charlière, or hydrogen *gaz* balloon (in the larger spherical portion above it). The design will, when she is inflat'd, give her all the appearance of a mace or of a sceptre.

Mr Darvell has also designed a system of many hundred miles of coil'd rubber tubing which is to be attachd to the *Liberty* on one end, and on the other to a vast set of bellows which he has had construct'd on the Artillery Grounds in Moorfields. The bellows shall provide us with breathable air for much of our ascent, and once we are cut free from them, the *Liberty* should hold sufficient momentum and breathable *gaz* for us to reach the moon before we are forc'd into exhausting either. Once there, he insists that it shall be a simple matter of signalling when we wish to return, so that the guide balloon may return the umbilicus (for so he terms our breathing tube) to us so that we may descend back towards the Earth. Simple, he says! As though Britain has not already lost two of her explorers in the attempt of it.

On this matter, Mr Darvell remains unconvinced. Rumours, he insists, still persist of Mr Blanchard and Mrs Sage's survival—perhaps strand'd somewhere on the lunar landscape. Mr Darvell has a limitless capacity for hope, but I cannot help but feel as though these rumours about Mr Blanchard and Mrs Sage will prove to be as unfounded as those which once led him out to Persia.

Perhaps I am too cynical, and Mrs Sage really is still alive up there amongst the lunar forest—looking towards the Earth for her salvation.

Presently, neither of us have any way of knowing. However, perhaps in weeks from now we may be able to say for sure.

From Journals, 12th July 1799

We are now two miles over London with the thousand lights of the city beneath us and a million stars above. The *Liberty* rises, only now it is impossible to tell which is up and which is down. We have cut loose into this island universe, and now can only fall into the sky.

For the first two hours of our ascent, Ozias was detain'd within the gallery consulting maps of the fix'd winds so that we could be sure to rise directly upwards, and not risk being swept northwards to the pole. I instead stood on the balcony (while I still had opportunity, for we soon were forc'd to seal up the doors) and watched as the whole of London reced'd slowly into the aether beneath us.

At first, the roar of the crowd unsettld me, but it soon lapsed into the faintest of rush of sound, like the murmur of the ocean. Eventually, I could no longer make out the pale thumbprint of your bonnet, 'Lina, in the lamplight beneath the trailing cord of the umbilicus.

The people below (on Ozias's encouragement, I am certain of it) releasd hundreds of tiny paper balloons to accompany us on our foray into Heaven. For perhaps half an hour afterwards I watched them rise around us, until they burnt themselves out and fell back down towards the earth. Perhaps their short and desperate flights should have given me cause to worry over the far larger flying lantern to which Ozias and I have entrustd ourselves, but all I could think was how much they looked like a bloom of luminescent sea blub-

bers that were swimming in the ocean of the sky with us.

Oh, how I wish that you could see it up here, 'Lina. It is like that first night at the Madras Observatory all those years ago, when you shewed me how to look into the telescope and for one terrifying moment I felt as though I were falling through the tube to be drown'd amongst the stars.

It is so quiet! So immense! There is an awful stillness which Ozias tells me can drive people out of their minds—stamping their feet and laughing or clambering out of the basket to plummet to their deaths, just so that they can escape it.

Now the windows are fill'd with a million swimming points of light, and Ozias and I have seal'd ourselves within the gallery to wait out the rest of our ascent.

After sev'n weeks of taking pleasure from his unending struggle to call me "Miss Chattopadhyay", I now have acquiesced to "Eesha" with him as well as you and William. If I am to live, and to return to England, then I suspect that I shall have to content myself to settle for it any way.

Conditions within the *Liberty* are cramped and dark, for Ozias does not suffer to have even a single candleflame in such close proximity to the straw and wool which we must continually feed into the brazier.

For now, we must be power'd by straw and by starlight alone, and see what fate will do with us. I do not know if we will live, but, my dearest Caroline, there is an awful beauty in the firmament which I am beyond the ability to explain to you. I am floating amongst ghosts of light in a graveyard full of stars that are extinct beyond our island universe.

If I still live tomorrow, then I shall begin to document these readings for you and write them in the tables that you laid out so precisely. If I do not, then do not mourn for me. Say only that I died o'er leaping this parapet of stars.

From Journals, Approx. 5th August 1799

It never rains upon the moon, but the wind is always blowing—chasing this thin atmosphere across the wake of sunlight.

We have land'd upon the Mare Tranquillitatis—although the only kind of water here is frozen amongst great valleys, or else in the forests that rest in the lee of the mountains. There, it seems to vary from the thinnest dusting of frost, to frozen waves of unimaginable scale that seem to have paused, hesitant in breaking.

Oh, 'Lina! You can tell William he was right! The large, circular impressions upon the surface moon are structures which have been constructed to catch the half-reflectd light. But whatever civilisation that there once was here is waning, even as our own island universe is waning—that is to say, if the peoples that built these enormous circuses have not already been extinguish'd all together.

The pale pillars and archways are overgrown with strange plants and vines. I am reminded of the painting of the moon over the Acropolis that you once shewed to me. How strange to think of that solitary artist seat'd there amongst the ruins in the moonlight, while now here I am amongst these lunar ruins in the earthshine.

The structures are enormous, and in the openings there appears to be sails of the sort that you may see on a mill. These sails were still turning in the never-ending lunar wind. We can only guess at the fact that they must once have harnessd it somehow.

In the planetshine, everything is bath'd in a perpetual twilight of blew-green that sparkles on the ice-flats and upon the crumbling and vine-coverd circuses.

We have neither of us slept in many days now. How many, I do not know as 'day' and 'night' no longer hold their meaning away from the quixotic rotations of the Earth.

We have to sleep.

Our expeditions beyond the Ocean of Tranquility and into the lunar interior shall have to wait for now.

From Journals, Approx. 6th August 1799

We woke (I shall not say this morning, for there is no morning here but the kind that comes once every twenty-eight terrestrial days) to find ourselves surround'd by a sort of people which no one on Earth has ever seen before.

These Selenites are taller than any human being on the Earth. Their skin at first appears to be chalk-white, but over prolongd inspection it seems to be akin to that of a cuttle fish—as the pigmentation seems to shift and alter itself in tune with the their mood and inclination. In fact it is more than this, because the shifting colours of their skin seem to be a passive form of communication—conveying unspoken thoughts and feelings just as the sky conveys its moods through the colour and the patternation of the clouds.

They have ridg'd, fin-like protrusions running the length of their arms, and others which begin just below their jaw and curve about their faces to meet at the crown of their heads. Behind these, they have a profusion of fleshy headtresses, decorat'd with beads of silver and of turquoise.

They are long-neck'd and high-ankl'd, and they move with a light, fluid sort of grace in the gentler lunar gravity.

Each of them has a band of blew-black pigmentation about the eyes, which Ozias is certain must be some form of tattooing. Their lips are of a similar hue, and many of them—particularly the men—are further decorat'd with banding, markings and strange, geometrical patterns that are drawn in the same ink. The men are also differentiated from the women through the wearing of silver torcs of the kind that antiquarians may find at ancient burial sites. I cannot help but wonder, then, if we are indeed the first human beings to see the Selenites, or whether this may indicate some ancient kind of contact between our people and theirs.

Their society is evidently rul'd by the women of their species, for it was they who shewed the far greater interest in us as we withdrew from the *Liberty*—while the men mostly remained at the back of the group and observ'd us from a distance. They barely seemed to move or speak to one another, while the women did both constantly as they circl'd us, discussing our sudden appearance in their lands in a strangely melodic tongue.

We were outnumbered, unarmed, and easily overpowered and yet ... and yet we were as fascinated by them as they were by us. Ozias could barely contain his elation at what we had discovered.

We walk'd for several miles with them to one of their circuses which is far from being abandoned and overgrown like the one we saw before sleeping.

On entering one of the structures, we were shewn into the company of a female Selenite. She sat beside a rent that had open'd in the lunar rock, through which a thin haze of heat and smoke was rising. This Selenite introduced herself to us as Aper'chi, for she spoke English very well indeed. Ozias was at once incredibly excited to hear from whence she had learnd it (and whether this could mean that Mr Blanchard and Mrs Sage still yet surviv'd somewhere) but Aper'chi simply bade him sit, and Ozias was oblig'd to obey her.

For now, Aper'chi has seen to it that we have been given space to sleep and work alongside the other members of her tribe. We have been well fed and cared for, and even as I write this, Ozias is consulting further with our host so that we may learn about her position in the tribe, and of the culture that he and I have discover'd up here upon the moon.

When he retires, I have concluded that I shall talk with her myself. Then may I tell her some stories of the Empire which Ozias may not be counted on to share.

From Journals, Unknown Date. Approx. Early September 1799

Today, Ozias and I finally found relics of the previous expedition, which appears to have ended in disaster. He has struggled to collect the desir'd botanical samples through the past period of sunlight (I am beyond considering it in terms of days and weeks now, but neither am I yet quite able to accept it for what it truly is—a single lunar day). Now that the sun has set and we were once again bath'd in this cool kind of evenshine, he has been much occupied.

Conversely, while the light and heat had previously afforded me much opportunity to document and map the landscape in the area around the circus (as well as around the Sea of Tranquility where we have left the *Liberty*), the drop in temperature and light which accompanies the shift from day to night as left me without either the facility or the inclination to continue with any further cartographic endeavors.

Ozias continues to spend his every spare moment with Aper'chi, placing himself entirely at her convenience and whim. I find more and more that he is adopting Selenite habits of dress and decoration—the former of which he insists is insulating against both the lunar wind and the shift in temperature which accompanies our 'monthly' change from night to day. I am convincd, however, that it is about more than him simply adapting to our environment. He has begun to wear a Selenite torc about his neck, and has even consented Aper'chi to mark his wrists with the blue-black bands and tattoo'd markings that is the fashion amongst the other men.

On rising, I found him to be occupied in the great forest that lies in the lee of one of the larger glaciers. Here, the trees are enormous—akin to the pine trees that you may see on Earth, but green-black in colour and over three times in height.

It was in this murky, emerald twilight that he had located the remains of Mr Blanchard and Mrs Sage's balloon. The envelope had been reduc'd to mere tatters (although the Union Flag was still evident in its colours even so), and the gallery had for the most part been absorb'd into the undergrowth.

Beside the wreckage there was evidence of a grave that was mark'd with a crude crucifix and a scattering of lunar flowers. The cross had been fashion'd from the windfall, and tied together with a few thin slivers of balloon silk. There was no indication of whether the grave belonged to Mr Blanchard or to Mrs Sage, but Ozias and I had little stomach to unearth the remains simply to satisfy our sense of morbid curiosity.

There was no sign of a second grave—which, aside from all else aren't known to dig themselves—and so we must assume that the *Comet*'s second occupant surviv'd for long enough to bury their companion and teach English to the local tribe. Although we now have no chance of finding them, I cannot help but wonder if they may still survive some-where, just as Ozias once insisted that they must.

He was, of course, reluctant to admit that with the coming of the lunar night we must turn back towards the *Liberty* and prepare ourselves to leave. In fact, I think that, if I did not need him to navigate the fix'd currents of the wind on our descent, then perhaps he would have stay'd.

Aper'chi may be aggriev'd to lose him (and he all the more for losing her), but ultimately, he understands that we have already erred too long and that we can wait no longer. We must now fetch the signaling mirrors from the *Liberty*, and turn back towards the Earth.

Letter to Caroline Herschel, 12th November 1799
'Lina,

We must undo all of this talk of taking the moon from the Selenites for our own gain and profit. The longer that I spend bound back to the Earth (and believe me when I tell you that after the sheer weightlessness and silence of the lunar landscape, returning here has all the sensation of having my wings torn away from me) the more that I am glad that I spent that time around the fire-rent with Aper'chi and her tribeswomen. At least now they will have some idea of what may come for them, even as I write to you. At least now they have been warn'd about the wedge of hatred that the despicable colonists of their lands will try to drive between them and the other tribes. I pray that the state of affairs which you and I have seen in Bengal or in Mysore may somehow—I know not how yet—be avoided with the Selenites.

This morning, Sir Joseph request'd we meet with him for breakfast at New Burlington Street, in the apartments where Ozias has put on a public exhibition of our lunar specimens.

Sir Joseph was wheel'd into the reception room as though he were the latest exhibition piece to be brought in for display. He looked older, somehow. Greyer. All his talk of how well the lunar saplings have been growing at Kew Gardens

did not disguise the heaviness in him—heavier than even he had right in being, earthbound and dropsical in his wheeled wicker basket.

Many times over the course of breakfast, he would pause and look at the Selenite jewelry, their tools and their musical instruments, or else the skins of lunar animals or the hundreds of carefully annotat'd maps and diagrams we made. He would look at all of this, and sigh, and make some further paltry effort at conversation before he would lapse into silence once again.

Then finally, he told us.

He told us that the King has agreed to have the *Liberty* refitt'd and renamed as the *Resolve*. In fact, the process has already begun out on the Artillary Grounds from which we launch'd ourselves into

the stars. This second expedition will be led by Captain Hatley, and will settle for nothing less than the establishment of a trading outpost amongst the Selenites. It is clear enough that they plan to claim the moon in honor of King George. Apparently, the French have already begun construction of their own lunar vessel in the wake of our success, and the King is eager to beat them to it.

This cannot be right, Caroline! Within the year, we shall have lunar animals in the Royal Menagerie alongside the giraffes, and enslav'd Selenite dancers on display in Drury Lane! It does not matter how well the Selenites defend themselves (and they are more than capable of doing so), the damage to their tribes, to their way of life, to their very *civilisation* is unavoidable.

Even if they are not enslaved and subjugat'd to a woman as we have been in India, then we will see this struggling civilisation wiped out by some terrible European venereal disease, or else dominat'd by the British *Lunar* Company.

Do you not think that Banks would have rescued his belov'd Otaheite from the curse of his Endeavour if he only had some idea of what was to become of paradise because of it?

Ozias still wears his Selenite torc and tattoos despite all of his attire as a British gentleman-explorer, and although his heart must long to take up the place upon the *Resolve* that Captain Hatley waves beneath his nose, *he must know that we cannot do this.*

We must act swiftly before the *Liberty* has been transformd and is ready for her flight. I can convince Ozias to help me, and Sir Joseph, too. If I cannot, then I can at least make sure that they look the other way *while it is done*. I am only sorry that I cannot wait for you to read this before I take what action that you surely know I must.

By the time we are finished with her, the *Liberty*—or the *Resolve*—will be going nowhere at all, least of all to see the Selenites.

However all of this ends, 'Lina, I pray that you will understand.

Yours forever,

Eesha.

From Journals, 30th November 1799

Another breakfast with Sir Joseph, only this time under slightly different circumstances.

Bread and water only, and not a morsel of it touch'd—not quite the warmth of the reception rooms at Soho Square.

Ozias is asleep beneath the telescope—spread out on the straw with Aper'chi's torc still around his neck. I cannot help but be reminded of him standing in those lunar forests in the oppressive shade with the tiny moon-birds singing in the needl'd canopy.

I remember how he plac'd his hand across his throat—across the small opening in the torc—when I told him we must leave.

This is the narrow passage of my life, Eesha. The space between the head and the body through which all breath must come. All blood flows through it. Without it, all life is impossible. It is the umbilicus of breath and blood, and I desire nothing more than to wear her *clasp around it. Do you not understand me?*

This morning he seems alter'd somehow—crumpled upon the floor as though he is still sleeping in the straw-loft of the *Liberty*. Only now the *Liberty* has burnd to ashes and her soot is on our hands. I can still smell it upon my clothes and in my hair. All chance of seeing *she* for whom he wears a clasp about the narrow life-passage of his neck, is gone.

Sir Joseph was push'd into our miserable cell along with the bread and water. He brought me paper, pen and ink, and the promise of a desk at which to write. Regardless of what became of us, he said, we cannot abandon the duty to document our findings for the public. He assur'd me that what he may salvage from our journals (doubtless after Captain Hatley's men have had their fill of them) will follow.

I understand his meaning well enough, no matter how callous it may seem: Without public support for Selenite freedom from imperial rule, they are doom'd to fight and die for it and so, perhaps, are we.

Burning the Liberty will only delay the inevitable, or else it shall hand the lunar colonies to French endeavors.

If we are to win this war, then we must also convince the whole of the world to listen.

I dared not to wake Ozias yet. Not with news like this.

Instead, I thank'd Sir Joseph and shook him by the hand. He will do what he can in all of this, I know he shall. And I shall use this paper first and foremost to write a letter that he shall take to you, my 'Lina.

Then, I know that you shall do the best you can, as well.

LESS BRASS GOGGLES, MORE BRASS KNUCKLES

An interview with The Men That Will Not Be Blamed For Nothing

*A*narcho-cockney grindcore-and-musical-saw outfit The Men That Will Not Be Blamed For Nothing need little introduction to those familiar with the emerging steampunk scene in the United Kingdom. Funny, angry, sarcastic, and producing more noise than should be possible for four guys and a drum kit. Cornering all four of the Men for long enough to interview them was a challenge, but after the recent London Steampunk Spectacular we managed to lure them into a small room with a dictaphone and the promise of beer.

Here is what Andrew (guitar/vocal), Andy (vocal/saw), Marc (bass) and Ben (drums) had to say for themselves ...

SPM: *Most obvious question out of the way first: What exactly made you choose a name like The Men That Will Not Be Blamed For Nothing?*

Andrew: I did a stand up show called *Winston Churchill Was Jack the Ripper* a few years ago, and as a result got slightly obsessed with the Ripper murders. In a fun way. Not in a morbid way. And it's part of the Ripper story: "The Juwes are the men that Will not be Blamed for nothing". Someone wrote it on a doorway on Goulston Street in Whitechapel and the Ripper put a piece of Catherine Eddowes' apron underneath it. Idiots think that they were done by the same person, but my theory is that the Ripper was a little bit too busy fleeing the people that were looking for him after he did two murders to be doing graffiti.

SPM: *For those of us that haven't heard you, can you describe what you sound like?*

Ben: It's starting to get a bit more metal and punky and raucous, but it started off just playing between the guitar and vocals, which lends itself to something that's slightly more folky.

Andy: There are two versions of the band … The full on punk electric version with drums and bass, and a stripped down acoustic alter-ego that plays in cabaret, burlesque and fetish clubs … It's a sign that the songs are strong that they sound good both ways!

Andrew: There's lots of music hall, major key influences in the songs we wrote originally. And then with 'Moon' I wanted to write a fairly serious song that was slightly musically better. 'Blood Red' is me pushing it as metal it can go without really, really alienating the other people in the band or the people that come to see us. It's good to have a balance and a mix. I've never been in a band before where no one said 'No' to a stylistic input, and that's really nice. Everyone brings stuff to the table.

SPM: *What convinced the four of you to form a band together, and what drew you to steampunk once you had?*

Andy: It started when me and Andrew were living in the same place. He was doing a comedy show called *Andrew O'Neill's Spot On History Of British Industry*, and we did a complimentary set of Victorian-themed songs to go with it.

Andrew: We went to see The Black Heart Procession, and off the back of that Andy bought a musical saw. I was living in Andy's spare room, and we just started writing some songs. We sat in Andy's garden just jamming. There wasn't a particular focus to it, we just did a couple of gigs and that was good fun. This is our last gig with Ben, but Marc sort of came on as a session musician. Now he's sort of a full member of the band. He essentially has the right of veto

SPM: *So you've been accepted into the family, Marc?*

Marc: Apparently so. Actually, I didn't realise that I was initially a session musician until just now.

Andy: Nor did I!

Andrew: I did my *Industry* show over four nights in London, and we put a band together to play that. It sounded about a hundred times better straight away, because we had an electric guitar and that sounds a bit odd when you don't have a drummer behind it. So that's how we got together as a four piece, and then what drew us to steampunk …

Ben: Nothing.

Andrew: Ben doesn't like steampunk.

SPM: *You're not a fan, Ben?*

Ben: I'm a big comic book fan. Absolutely love fantasy… *in my head*. I mean, each to their own, but I just think that when you start believing the fantasy you're ignoring the normal problems in life. You can say that it's escapism to get away from them, but a lot of the time there's so many other things out there to care about.

Andrew: Also, we're all very averse to the class-roleplay element of steampunk. We're not pretending that we're anything other than middle class, but Ben and I have played in punk bands for years and to do a gig where, when the lights come up, people shout "Huzzah!" just dicks me right off. We're not particularly politically motivated, but to me personally that stuff really rankles. I've always been a big fan of Victoriana, but the part that interests me is the nasty underside of it. Proper throwing bombs at monarchs anarchism came out of the Victorian era, and that's far far more interesting to me than regimental insignia.

Marc: You never do see battle re-enactments with Chartists, do you?

Andrew: No. No, you absolutely don't. I mean, we know that the punk in steampunk doesn't mean 'Punk', but to me what it does mean is a subversion of Victoriana. It's not Neo-Victorianism, there should be some sort of subversion there. I suppose it's the convention end of things and the cosplay end of things that's just not my thing.

Andy: I love some of that, though. Modding keyboards and shit. What attracted me to the steampunk scene was the sense of elegance, style and creativity—there's a real feeling of community drawing in writers, artists, clothing- and jewellery-makers, engineers and now musicians. I've been struck by the open friendliness of the people involved … It makes a real change! It also means I can indulge my love of sci fi, history and dressing up! I am a huge geek and exhibitionist, so really the scene is tailor-made for me.

Andrew: Oh, I love dressing up. I'm probably more committed to that than most of you, but I like bands who burn churches down.

Marc: What's going to be quite interesting is when we go to America where the cosplay angle of steampunk is the primary aspect of it, from what I can gather.

Andrew: I do wonder how many Americans are going to be disappointed by the fact that we're English but we talk like this. You know, we're not saying, "Good evening" and doffing our hats, we're going: "Where's the fucking bar?" The cosplay side of things is just not what we're used to. We're quite used to being the *least punk* people in the room when we do a gig.

Ben: I play in a particularly fast, crusty band, and the point that I was going to make is that it's the same there. I have the same feelings towards the stupid punks with their nine-inch Mohicans that they've spent hours on.

Andrew: But the thing that you're overlooking there is that, in constructing that Mohawk, they're putting cracks in the foundation of the system.

Ben: True. Doctor Martin's, for example, have always been such a non-profit, radical organisation. So, yeah, I have exactly the same problem with that as I do with this. It's just that I'm more used to that situation.

SPM: *Is that why they're throwing you out, though?*

Andrew: We're not throwing him out. Ben's in eighteen other bands and despite his efforts, he's got no fucking money. For me, it's been really nice just because Ben's a good friend of mine. Because I do stand-up, my social life is completely fucked. It's been nice to have an excuse to spend time with each other. I mainly see people who hang out with comedians, and they're generally cunts.

Ben: And that's my point, it applies to pretty much any kind of subculture. It's just that this one is more alien to me. I mean frankly, there's a lot of positives to be said for it. There's an amazing kind of community spirit.

Andrew: There are elements of the steampunk subculture that are completely punk. The DIY ethic, the fact people are getting out the house and doing stuff is just fucking brilliant. That's the thing that I always liked about punk as averse to metal. Metal is the music I most like, but there's a massive division between the people on stage and the people in the audience.

SPM: *How so?*

Ben: Because the people on the stage are rock stars.

Andrew: Yeah, and when I was in hardcore bands, the people in the audience would just get up and be the next act. There's no division. The people are active and get involved, but with metal there are bands and there are people who consume what the bands do. Steampunk seems to be far more about people getting involved, and that's fucking great.

Marc: What indicates that is that there are no set rules for what a steampunk band sounds like—because they are just people that like steampunk, who are in bands.

Andrew: Exactly. It's like punk before the Sex Pistols.

Ben: And that's quite interesting as well, because you think that we've just played a show with three completely different bands, and the lady with the awesome steel drums. Especially with the harder songs that we've got, most of the people there won't have any music like that in their collections, but they're still going to watch us and cheer and have a go, which is great.

SPM: *Do you consider yourselves full-time steampunks, or is it an outfit that you put on now and again?*

Andrew: In terms of mentality, definitely. I mean, I'm a transvestite so I wear girl's clothes. Well, they're my clothes, but they were built for girls. Most of the time I just dress like a metaller, but if I've got an occasion to dress up for then I'll quite often dress steampunk. This waistcoat was made for me for my *Industry* show. I didn't actually have to buy anything for the band.

SPM: *So the dressing up aspect doesn't bother you?*

Andrew: I love it. I fucking love dressing up. I mean, probably five days a week I'm dressed very feminine anyway.

SPM: *What about you, Marc? You haven't said very much.*

Andrew: Yeah, shut up, Marc. What you have said has been shit.

Marc: What I think is quite interesting is that I sit somewhere between Ben and Andrew. I don't consider myself a steampunk, I consider myself someone in a steampunk band. But the only difference between how I dress most of the time, and how I'm dressed now in my steampunk garb is I'm wearing trousers and not jeans. I've been in punk bands and worn eye liner for about ten years, so actually it syncs quite nicely into how I see myself anyway.

SPM: *How about you, Andy? Do you consider yourself a full-time steampunk? Certainly the bright pink mutton chops would seem to indicate that you do.*

Andrew: The band has grown out of mine and Andy's interests and obsessions. The way we approach it is a very exact representation of who we are and where we come from.

Andy: Yeah. I mean, I dress like this most of the time anyway. I always dress like this when I go out, I love people's reactions to it… They accept punks, goths, emos and chavs, but really cannot work out how to deal with someone in Victorian garb! At home I like to relax in a a smoking jacket and fez, and put my gouty foot up on a stool in front of the open fire! I love that hunting—searching for the perfect item of clothing for an outfit… But the whole thing is starting to be marketed as an off the peg style, and that kills the individuality. Have you typed steampunk into Ebay recently? A few months back you would only get one or two results…now you can buy an entire look with no effort. Stick a bit of a broken watch on to a tatty old hat and sell it to a mug, seems to be the attitude.

SPM: *Tell us a little bit about your influences.*

Andrew: 'The Talons of Weng-Chiang'. And I had a tape that my brother gave to me called *One More Time* that was recorded in this working club. 'They're Moving Father's Grave To Build a Sewer' is from that. It's a D-90 full of fucking cockney songs. It's amazing, and I've never really had a chance to do anything with it. Music hall, British punk, and like I say, I listen almost entirely to metal, but we've all got quite varied tastes.

Andy: A sticky mess of *Doctor Who*, Alan Moore, Marie Lloyd, HG Wells, Jules Verne, Lovecraft, *The Good Old Days*, *Chitty Chitty Bang Bang*, *Oliver* and the V&A mixed up with a big dollop of cynical humour.

SPM: *A lot of your songs are quite humorous, but are we supposed to be laughing at you, or at ourselves? Who's the butt of the joke?*

Andrew: Andy.

SPM: *Andy, you should say something to defend yourself.*

Andy: They never told me that. All this time, you've just been laughing at me?

Andrew: Well, with 'Steph(v)enson' it's you, mainly, because you play it dumb.

Andy: Yeah. And we've got a really nice creationist song: 'Charlie'.

Andrew: 'Goggles' is an explicitly feminist song. I'm a pretty radical feminist. 'Blood Red' is fairly political. It's weird, because there's a lot of post-colonial writing about the Empire, but it doesn't seem to have seeped into the consciousness of British people. We kind of think that we went there and gave them trains and roads. Yeah, and then we left *with all their stuff*. We were in charge of Zimbabwe and we took everything of value and then people say: "Oh, look, but we left and they're killing each other". Yeah, they're killing each other because we took *all of the valuable things* out of their country. The Empire was essentially us raping the world, and anyone who is supportive of the Empire and racist needs to fuck right off. At the very least we owe the Commonwealth the ability to come and live in a country that is only rich because we stole everything of value from the places we invaded.

SPM: *So you do have a political ethic that you're trying to convey?*

Andrew: In that song, yeah. But our politics are all different. I'm approximately anarchist.

Ben: I'm a BNP voter.

Andrew: Ben is *not* a BNP voter, for the record.

Ben: That's what you think. It's a secret ballot, my friend.

Andrew: Ben's a disillusioned ex-anarchist. Andy's got a mortgage.

Marc: And I'm a wooly liberal.

Andy: Yep, in Victorian times I would have been in the Marshalsea debtors' prison by now. Politically I'm as far left as I can get, but I do feel nowadays that you have to vote tactically to keep the right-wing scum out of power. That's where me and Andrew disagree: He won't vote, whereas I think that just lets other people win. You've got to play the system from inside to pervert it!

Andrew: We're all pretty much left-wing. It's fairly clear when you look at the Victorian era that there were things that were right and things that were wrong. It's not hard to write a political song, all you've got to do is put some of your opinions into a song as opposed to your feelings.

Ben: Just get something you're angry about and write a song about it, that's a punk thing to do. Also, I think in any sort of walk of life, always be prepared to lose an argument and be convinced by someone else.

Andrew: It's really, really good to argue, because it tests you views. When I was eighteen or nineteen, I reckon I could have picked any ideology and been vehement about it, but looking at it now I think that anarchism is the least nasty way of living, because it's about removing concentrations of power. It's removing people's ability to screw each other over. State communism is a lovely idea, but when you put it into practice it ends up fucking loads of people over.

Ben: We don't want to get into a big political discussion, anyway. Next question?

SPM: *Yeah, we could be here all night. Ok, next question: what would you like to see more of in steampunk, and what would you like to see less of?*

Andrew: Steampunk's great as it is. It can carry on. We don't want to destroy anything, but we would like to bring in a few more people that are more into music, I suppose. There isn't a big music side of it yet. I'd like more punks and metallers to come out to our gigs.

Andy: And people who aren't put off by the fact that other people are dressing up. People can just dress normally and come and see us. It can be a mental thing rather than an outwardly dressed up thing.

Andrew: I don't want to see less of those people. I just want to see more of the people that are into it in a political or subcultural or subversive way.

Ben: Less brass goggles, more brass knuckles.

SPM: *You've got an album out in the very near future. Tell us a bit about it.*

Marc: It pretty much represents all sides of the band.

Andrew: Yeah, because it's *all of our songs*. You know the songs we play? *It's that.*

Marc: There are metal songs on there and there are incredibly catchy pop songs, and I genuinely think that it's a brilliant album in that respect. A lot of my favourite albums have that balance. There's a great mixture of pop songs and more interesting stuff going on.

Andy: It was recorded nice and quick so there's no sort of overdubs and messing around. It's all pretty raw.

Marc: Basically the bare bones of the album we did in a day. We just set up microphones and played the songs through.

SPM: *Do you think that gigging is important for a band then?*

Andrew: Yeah. It's the thing. It's all there is. The record is basically there so that people can learn the songs and sing along when we play them live.

Ben: We're a raucous live punk band. That's the point. That's why we started doing it.

SPM: *So do you think that steampunk should be more of a live experience and less of an online one?*

Andrew: Yeah. Definitely. Get out of your house! I mean, steampunk attracts geeks and geeks are online and that's the nature of it, but it should be more about socialising and getting out in the world. But then everything should be like that. I spend far too much time on my computer, and I'd far rather be outside with my mates having a laugh and creating something. We're not creating anything important, but our lives are a little bit richer because we've gone out and are actually doing something rather than just consuming stuff.

Marc: Live music is always going to do that. That's the one thing that you can never fake and the one thing that's never going to be digitised and taken online. That experience of watching a live band, or a live comic, or a piece of theatre, or a piece of performance art. That's kind of the purpose of what we do.

SPM: *Ok, well, that's it. Thank you.*

Andrew: I particularly like the fact that you recorded your thanking us.

SPM: *Fuck off.*

You can listen to the Men on their MySpace page: www.myspace.com/blamedfornothing. *Their debut album,* Now That's What I Call Steampunk Volume 1, *will be available for purchase and download from May. And, if that's not enough, then you can check the back pages of this very magazine for a review.*

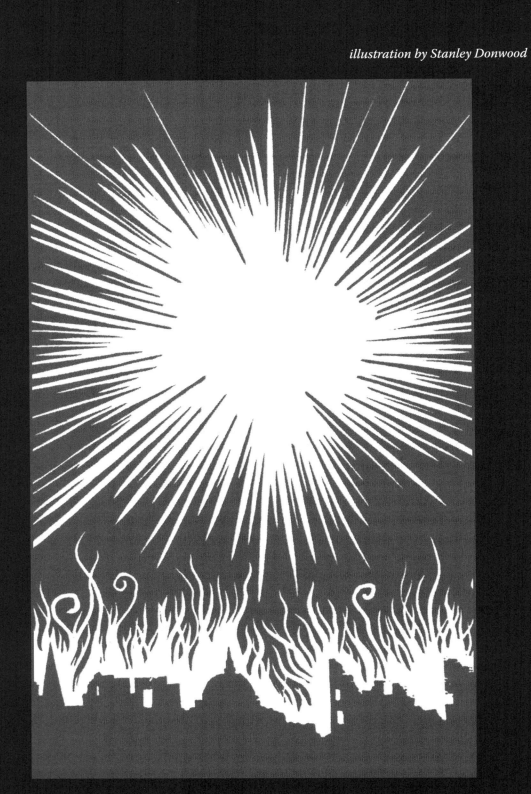

illustration by Stanley Donwood

HARTMANN THE ANARCHIST

a 1892 novel by Edward Douglas Fawcett
brought back into print by Tangent Books

If he is remembered at all, Edward Douglas Fawcett is probably known for his essays on metaphysics. A few people may have heard of the popular adventure books he wrote. Most people will probably remember him as the elder brother of Percy Fawcett: The celebrated Edwardian adventurer, who disappeared without a trace on an expedition to find the semi-mythical Lost City of Z in the Brazilian rainforest. Before all that, when he was just sixteen, Edward wrote *Hartmann the Anarchist*.

In 1892, when *Hartmann* was first published, socialists were distrusted and anarchists were the enemy. They were the Communists, the Middle-Eastern terrorists, the spectral monsters that all good-thinking members of the civilised nations needed to be on their guard against. Fawcett saw through all the crap and found the heart of the matter—that socialists and anarchists are, above all else, human beings.

The novel's dynamic comes from the interaction when the protagonist, Stanley, talks first with his friend Burnett, and then with Hartmann.

Stanley is a local politician and socialist—trying to walk the middle ground of evolution not revolution, he's attacked by the moderates for being too extreme and the extremists for being too moderate. The passion of the debate in Fawcett's time is personified in Stanley's:

> "I had spoken for about half an hour when the audience refused to let me proceed ... [A] violent uproar arose, the uproar led to a fight, and a rush was made for the platform ... I had the pleasure of knocking over one ruffian who leapt at me brandishing a chair."

If only modern ruffians felt so strongly ...

Despite being presumed dead, the shadow of Hartmann still looms over the anarchist movement after a botched attack on Westminster Bridge ten years ago which killed over fifty people. Burnett entices Stanley to a clandestine meeting and teases him with the chance to prove he's not all talk. Stanley shortly learns that Hartmann is still alive and joins him on the *Attila*, a genius device which Hartmann is

going to use to bring down civilisation.

The *Attila* is something between an airship and an aeroplane. Made of a magical metal which weighs almost nothing, its lift is provided by compressed hydrogen, height controlled with sand ballast, propulsion given from giant propeller screws and its direction controlled by riding the thermals of air like a bird of prey. Fawcett dwells on the details as Stanley is overcome by the beauty and freedom of riding in the craft, and changes the experience of riding in an aeroplane for the modern reader.

Hartmann, however, plans to use the *Attila* to raze Western civilisation to the ground. "We are Rousseaus who advocate a return to a simpler life," he explains, and of the faceless workers at the heart of civilisation: "They are like the creatures generated in a dying body. The maggots of civilisation."

So no desire to win over the hearts and minds, then. Anyway, it's for their own good:

> "The victory in view is the regeneration of mankind, the cost will be some thousands, perhaps hundreds of thousands or millions of lives … On how many massacres has one ray of utility shone? … At worst we can shed no more blood than did a Tamerlane or a Napoleon."

Hartmann's arguments and the passion in which he believes them are compelling, and it's easy for Stanley to see the threads of logic. Riding through the skies, it's also easy for him to forget that Hartmann's followed those threads a little too far.

Soon the *Attila* is flying over the skies of London, bombs raining down on the political and economic heart of the state as gangs of sympathisers rampage through the streets with flaming torches. He doesn't expect to destroy the whole city, but expects to bring down civilisation nonetheless:

> "His aim was to pierce the ventricles of the heart of civilisation, that blood that pumps the blood of capital everywhere, through the arteries of Russia, of Australia, of India, through the capillaries of the fur companies of North America, mining enterprises in Ecuador and the trading steamers of African rivers."

With the city of London in flames, it's not politics or dynamite that decides the fate of Hartmann's revolution. Instead, it is Stanley's desperate attempts to find his fiancée among the flames and Hartmann's attentive love for his mother. In the midst of a war of ideas, it's something very human and very personal which decides the outcome.

There are flaws with the novel, to be sure: Casual conversations become vehicles for political debate and the social dallying of the first couple of chapters seems awkward and strange; Hartmann takes great pride in all men on the *Attila* being equal, and yet reserves private spaces for himself; there are two female characters, and although both are intelligent and articulate, both are passive and incapable of taking action on their own. But quibbling over these things seems like being handed a million pounds in cash, and being upset that the notes are creased and dirty.

The question of what is to be done with the working-class masses—who make up the backbone of the tyrannical state—isn't wrapped up in a neat bundle by the last page. How can it be? Victim, conscript or co-conspirator, each of those faceless multitudes is a human being who baulks at the idea of being labelled and put in a neat box. That's a point Fawcett makes with a subtlety a writer of any age would be pleased with.

Between the airships and the anarchy, *Hartmann* is a novel which needs a place on any Steampunk's bookshelf. Publisher *Bone*'s reprint comes with an insightful and provocative introduction by Ian Bone, and beautifully evocative illustrations by Stanley Donwood which ape those which the book was first published with. Discovering it feels like finding a great-grandfather the family had forgotten about: One who's life runs along an eerie parallel to your own.

REVIEWS

We are quite happy to review whatever it is that you feel counts as steampunk enough to warrant review. We will, however, only review physical submissions (rather than pdf books or mp3 albums). Contact us at collective@steampunkmagazine.com *to find out where to send things!*

ALBUM
Mr B the Gentleman Rhymer
Flattery Not Included
Grot Music, 2008
www.myspace.com/mrbthegentlemanrhymer

On a quest to reintroduce manners to the modern proletariat, Mr B is a pipe-smoking, Banjolele-playing purveyor of 'chap-hop'—hip-hop as performed by Noel Coward.

Drawing inspiration from a genre notorious for its misogyny, love of violence and its desire to shock, *Flattery Not Included* takes those stereotypical staples and subverts them by making them ridiculous. Instead of rhymes about turf wars and paranoid husbands, Mr B raps about being thrown out of Gentleman's Clubs and defending the honour of a lady after a fellow chap-hopper dissed her cream teas. He also issues a challenge to Prime Minister Gordon Brown's policy on smoking in public, and boasts of his prowess with a cricket bat.

It takes skill to create a farce, and you can only mock something you love. *Flattery Not Included* is silly and sharp, like satire should be. The rhymes are skilled and the beats—erm, phat? For those who know hip-hop there are hidden gems a-plenty. For the rest of us there's the delight of laughing with the fool as he lampoons both popular culture and our own top-hat wearing, stiff-upper-lip keeping, monocle-wearing foibles.

NOVEL
Lavie Tidhar
The Bookman
Angry Robot, 2010
www.lavietidhar.wordpress.com

An accomplished short story writer who has forced the gaze of speculative fiction beyond its traditional, Anglo-centric haunts, Tidhar has now turned his hand to writing a novel.

Orphan is a poor poet living in the capital of a British Empire ruled by a royal family of lizard-type creatures who have shrouded their origin in myth. Words and narrative carry the ultimate power, the worlds of poet and politician are dissolved into each other. The power words hold is given dramatic personification when the love of Orphan's life is apparently killed in an explosion erupting from a book. The mythical Bookman has returned. It's his desire to recapture her which drives Orphan throughout the novel.

Orphan's voice anchors each sentence. He exists in the moment. We're not told about Orphan's wholehearted nature, we're shown it.

The narrative is populated with outsiders, from Orphan himself to dis-empowered autons, blind beggars, and a ruling class of a different species altogether. All are fighting to find a place in mainstream society, and it's those fights that drive this story. There is little space left to explore the society, but the brush strokes Tidhar uses illustrate it sufficiently.

The Bookman is a book for people who love words. It's quintessentially Steampunk with only a hint of dirigibles and a whisper of Victorian smokestacks. In their place, there is a world of mysterious islands, political unrest, pornographically evocative bookshops and a conflict which is at the heart of Steampunk ideology. The world of Steampunk is richer for it.

TWO ALBUMS
iLiKETRAiNS
Progress Reform/Elegies to Lessons Learnt
Beggars Banquet, 2006/7
WWW.ILIKETRAINS.CO.UK

I have no idea whether the pessimistic post-rock band iLiKETRAiNS have ever even heard of steampunk, but if they haven't then someone should probably tell them about it.

Currently, the band have released one full-length album (*Elegies to Lessons Learnt*—2007) and an earlier EP (*Progress Reform*—2006). Both are filled with bleak stories-told-in-songs of history's great tragedies and most often-repeated mistakes.

The song that will undoubtedly draw the steampunk community to them is 'The Beeching Report' on the *Progress Reform* EP, which paints a haunting picture of the loss suffered by the British working classes during the closure of vast swathes of the public railway system during the 1960s. That said, iLiKETRAiNS have also written songs about the ill-fated Scott expedition ('Terra Nova'—*Progress Reform*), the Salem witch trials ('We Go Hunting'—*Elegies*) and the 1812 assassination of the British Prime Minister by a desperate man who felt that he had no other recourse ('Spencer Perceval'—*Elegies*). There is even a timeline for the *Elegies* album on the band's website which provides much of the historical backdrop to each of the songs.

No one could accuse iLiKETRAiNS of being the happiest or most uplifting of bands, but their music is often intense, moving and deeply thought-provoking. That, and how grounded the band are in the past, makes them more than worth a listen.

ALBUM
The Men That Will Not Be Blamed For Nothing
Now That's What I Call Steampunk Volume 1
Leather Apron, May 2010
WWW.MYSPACE.COM/BLAMEDFORNOTHING

The Men That Will Not Be Blamed For Nothing are not the best steampunk band that I have ever heard, because they may just be the only steampunk band that I have ever heard. For a long time, we have been waiting for a band that likes to mix a little punk into their Victoriana, and now, with the release of the Men's debut album *Now That's What I Call Steampunk Volume 1*, we finally have it. The album is filled with guitar- and drum-driven cockney punk songs, complete with the musical saw and comedy lyrics that have made the Men notorious.

But if the Men have ever been accused of being all laughs and no substance, then this album puts pay to that rumour once and for all. In that respect, 'Blood Red' stands out above all others as a chilling and bitterly angry commentary on colonialism that will give supporters of Victoria's Empire pause for thought.

Of the other tracks on the album, 'Boilerplate Dan' and 'Moon' are also exceptional, but to be perfectly honest the album doesn't have a single weak link, and most of the songs are not only very good, but also very, very catchy.

It is impossible for me to recommend the Men highly enough to you. If you are only going to buy one album this year, then make absolutely fucking certain that it's this one.

ILLUSTRATED HARDBACK
Paul Guinan and Anina Bennett
Boilerplate
Abrams, 2009
WWW.BIGREDHAIR.COM/BOILERPLATE

Subtitled "History's Mechanical Marvel", *Boilerplate* is invented history of the finest sort. Providing the background to the 'much overlooked' Victorian automation of the same name, *Boilerplate* tells the story of how Professor Archibald Campion (with the help of, among others, Nikola Tesla) invented a robotic soldier with the lofty hopes of ending the all human death in war.

Predictably, Campion's endeavours never went entirely to plan, and so instead he ended up touring much of the world with his mechanical marvel and getting embroiled in many well-known events. However, what is most interesting about *Boilerplate* is the way in which Campion's automa-

ton is often shown as fighting on the side of the oppressed—the Buffalo Soldiers, the suffragettes and Victorian child labourers, amongst others. In fact, despite being a book about a robot that was designed for the express purpose of making war, *Boilerplate* is far from being the Empire-touting Victoriana that you may expect it to be. Instead, it presents a view of the late 19th and early 20th century that is filled with wonder and detail, but also the home of persecution, discrimination and inequality. It tells us, through Archie Campion's realisations at the end of the Great War, that technology will never be the only single answer to all of humanity's problems. *Boilerplate* also illustrates the many varied social and economic factors that determine technological progress, which is so often wrongly viewed as a straight line from ignorance to enlightenment, with technological perfection at the end. Instead, the book displays some of history's lost technology in all its glory, and asks us to imagine what else could have been developed and rejected for being too far ahead of its time.

It is an expert mixture of fact and fiction (that manages to both educate and entertain while at the same time leaving you unsure of where history ends and the story begins) and also beautifully and incredibly cleverly illustrated throughout. Perhaps most impressively of all, it manages to insert a mechanical wonder into the major events between 1890 and 1920 without taking anything away from the real men and women that lived through them.

ANTHOLOGY
Ann and Jeff VanderMeer (eds)
Steamupunk
2007, Tachyon Publications
WWW.TACHYONPUBLICATIONS.COM

Ann and Jeff VanderMeer have written, edited and won awards for more anthologies and magazines than most people have read. From people who are, as Jeff almost put it, steampunks until their next project, one might expect a collection of depressing Steampunk clichés. But if you were expecting that, then you would be very wrong.

The stories in the anthology showcase Steampunk at its eclectic best. Opening is an extract from Michael Moorcock's 1972 novel *The Warlord of the Air*, watching as the vast dirigibles of the international powers loom over a resilient town, attempting to subjugate it. James P Blaylock's 'Lord Kelvin's Machine' is to modern Steampunk what the Great Apes are to humanity. Ian R. MacLeod's 'The Giving Mouth' and Jay Lake's 'The God-Clown is Near' are wonderfully engineered, surreal worlds with a Steampunk aesthetic and ideas woven deep into their fabrics. Joe R. Lansdale's 'The Steam Man of the Prairie and the Dark Rider Get Down: A Dime Novel' is a tribute to one of Steampunk's many roots, capturing the adventure of a dime novel, but burying their imperialist morality. Molly Brown's 'The Selene Gardening Society' is the sort of Steampunk story a post-Monty Python Oscar Wilde might write, and Ted Chiang's 'Seventy-Two Letters' is a breath-taking exploration not just of another world, but a whole other imagined biology.

The beauty is, you might find 'Seventy-Two Letters' dull as dishwater but be captivated by Mary Gentle's tale of science and matriarchy, 'A Sun in the Attic', or vice-versa. But frankly, Jess Nevins's introduction is worth the cover price alone. The VanderMeers may be transitory Steampunks, but all those editing credentials aren't for nothing. They have captured the heart of what makes Steampunk so compelling and inspirational.

SteamPunk Magazine Continues!

SteamPunk Magazine is on its fourth year and eighth issue as I type this in September, 2011. We're all-volunteer and sometimes our schedule is a bit sporadic, but we love what we do and are excited to continue.

We're always looking for submissions, but for specific deadlines and the occasional theme, please check our website at www.steampunkmagazine.com. We're also revising and expanding our web presence. Our submission guidelines:

Fiction: We appreciate well-written, grammatically consistent fiction. That said, we are more interested in representing the underclasses and the exploited, rather than the exploiters. We have no interest in misogynistic or racist work. We will work with fiction of nearly any length, although works longer than six thousand words will be less likely to be accepted, as they may have to be split over multiple issues. We will always check with you before any changes are made to your work. Submissions can be in .RTF, .DOC, or .ODT format attached to email.

Illustration: We print the magazine in black and white, and attempt to keep illustrations as reproducible as possible. Ideally, you will contact us, including a link to your work, and we will add you to our list of interested illustrators. Any submissions need to be of print resolution (300dpi or higher) and preferably in .TIFF format.

How-tos: We are always looking for people who have mad scientist skills to share. We are interested in nearly every form of DIY, although engineering, crafts, and fashion are particularly dear to us. We can also help to adapt things to print format, if you need it.

Comics: We would love to run more comics. Contact us!

Reviews: We run reviews of books, movies, zines, music, etc. You may submit material for us to consider.

Fashion: Although we are quite interested in steampunk fashion, we are more interested by DIY skill-sharing than exhibition of existing work. If you want to share patterns or tips for clothing, hair, or accessories, then please let us know!

Other: Surprise us! We're nicer people than we sound.

READERS@STEAMPUNKMAGAZINE.COM
WWW.STEAMPUNKMAGAZINE.COM

About Combustion Books

Combustion books is a collectively-run publisher of dangerous fiction. We specialize in genre stories that confront, subvert, or rudely ignore the dominant paradigm and we're not afraid to get our hands dirty or our houses raided by the government. How many fiction publishers can promise you that?

Rejecting the dominant paradigm doesn't end with the stories we tell. We operate without bosses and we pay ourselves and our authors outright for work in order to keep us from getting mired in the world of profit-driven publishing.

One of our goals is to break down the hierarchy of the publishing world and develop relationships with our authors and audience that go beyond those offered by a traditional press.

We're open to manuscript submissions and delight in working with new and un-agented authors. We are primarily interested in novel-length (40,000+ words) genre fiction of a radical bent. Genres we're seeking include SF, Fantasy, Horror, Steampunk, Mystery, and New Weird.

Please attach completed manuscripts for consideration, in .rtf, .doc, .odt, or .docx format, to an email directed to SUBMISSIONS@COMBUSTIONBOOKS.ORG. We will respond within 30 days of receiving your submission. Please do not send multiple manuscripts: send only your best work. If you have written a series, send only the first in the series.

WWW.COMBUSTIONBOOKS.ORG